# ART GALLERIES & MUSEUMS
## *of Britain*

*Art Galleries & Museums of Britain*

Published by:
**KGP PUBLISHING**
54 Castlegate
Penrith
Cumbria
England
CA11 7HY

ACKNOWLEDGMENTS

Editor - Ken Plant

Design - Jennie Prior

Administration - Joanne Cullen
& Carole Douglas

Foreword - Dr Darryl Mead

Editorials - Karl Stedman

ISBN Number 0-9522807-9-5

Distributed worldwide by Portfolio

*The Art Galleries & Museums of Britain*
54 Castlegate
Penrith
Cumbria
England
CA11 7HY

Web Site: http://www.kgp-publishing.co.uk

Foreword

# ART GALLERIES & MUSEUMS

## *of Britain*

Whether you are an adult with a free day, a student looking for information, a tourist from overseas or a family looking for something new and different to do, a museum or an art gallery can provide you with a special experience.

If you ask your children which they would rather go to - a museum or a theme park - almost all of them would say the theme park, unless of course they had paid a recent visit to one of Britain's fabulous museums like the Natural History Museum in London or the extraordinary Imperial War Museum at Duxford. This guide can launch you on an adventure. With its help, there will be fewer wet afternoons in front of the television and fewer holiday grumbles of boredom. As an added bonus, a day at a museum remains one of the most reasonably priced sources of entertainment there is.

Not only are many museums already free, but in a rare and welcome development, new Government funding will see many of our best-loved national art galleries and museums reintroducing free entry for everyone by 2001.

A hundred years ago Britain led the largest empire the world has ever seen. Although the empire is gone, many of the greatest treasures of the world are now in Britain's art galleries and museums. Many treasures were home grown from artists of the calibre of Turner, Constable and Whistler whose paintings are on display at a variety of locations all over the country. Equally exciting are objects such as the world's oldest locomotives in the National Railway Museum at York or the first steamship to cross the Atlantic, the SS Great Britain, now docked in Bristol. Did you know that Charles Babbage's third mechanical computer was invented in 1834? It has now been recreated at the Science Museum in London.

Art can be for everyone. Britain is blessed with dozens of national, regional and city galleries crammed with billions of pounds worth of

art treasures. Whether your taste runs to fine pictures, sculpture, tapestry, furniture or decorative art, some of the worlds' finest examples can be found in Britain. There are now quite a number of galleries and museums with individual audio 'guides' that you slip on your shoulder and take along with you. Some, such as the Tate, have random access audio guides where you dial in a number and sit back and listen to the story behind the painting you are viewing.

The greatest art from classical civilisations can be found not only in the British Museum but in many regional centres, especially the university museums. These objects take you back to the days of the Pharaohs, with glittering sarcophagi, to Ancient Greece with the Elgin marbles and to the time of the Assyrians, with some of the fiercest battle scenes ever carved.

Contemporary and modern art are well served by numerous dedicated galleries in London as well as innovative centres such as the Tate at St Ives, the Museum of Modern Art in Oxford, Glasgow's controversial Gallery of Modern Art and the Scottish Gallery of Modern Art in Edinburgh. As well as cutting edge art, these venues often provide rich programmes of events and activities for all ages and abilities.

Equally fascinating are the many great country houses that have become museums in their own right while some of their owners have founded museums that have turned their hobbies into an exciting experience for everyone. Lord Beaulieu's National Motor Museum is a shining example.

Local history fascinates many of us. Sometimes it can be a reconnaissance into one's own past, while at other times it is simply interesting to look at how others lived. Britain's past is made accessible through museums such as Ironbridge Gorge, the cradle of the Industrial Revolution and Beamish, the North of England Open Air Museum where an entire town of the nineteenth century exists as a living, operating recreation.

In our museums and galleries you will find whatever you look for, be it excitement, discovery, scholarship or just plain fun. You will find fine clothing, rare jewels, fabulous art, dinosaurs, racing cars, trains, ships and massive steam engines, stories from the past and glimpses into the future. You can look at real objects, explore the world through interactive exhibits, contemplate great art, or simply enjoy being in a different time and place. There is something to interest everyone, whatever your age or personality.

*I hope the taster that this guide offers will whet your appetite to sample some of these wonderful Art Galleries and Museums. The choice is yours.*

Dr Darryl Mead, Glasgow
February 1999

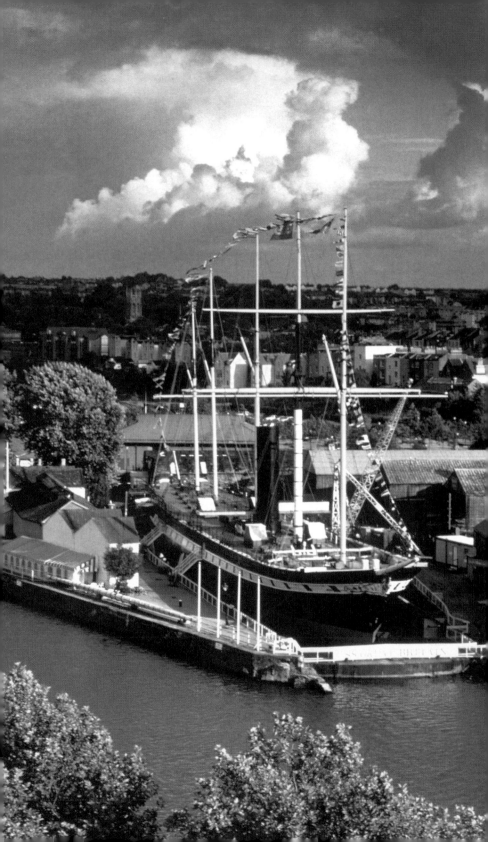

# BATH, BRISTOL & NORTH EAST SOMERSET

A district which has changed its name so frequently has never really had the opportunity to establish a clear county identity, nevertheless whatever it is called, here is an area of outstanding interest and beauty. Bristol, the largest city in the southwest of England...a cathedral and university city, an industrial and commercial centre with a long history of maritime adventure and commerce, houses a wealth of historic treasures. Included is the remarkable SS Great Britain, the first ocean-going propeller ship, designed by Isambard Kingdom Brunel, the architect of the spectacular Clifton Suspension Bridge which spans the equally spectacular Avon Gorge.

The jewel of this lovely region is undoubtedly Bath, built on hills rising steeply from the River Avon. This delightful city, a spa centre since Roman times became a centre of fashion and manners during the eighteenth century. The tradition and history of this region is innovatively and fascinatingly revealed to the visitor through a wealth of fine galleries, museums and displays. The Bath Industrial Heritage Centre recreates a Victorian engineering brass-foundry and mineral-water business, while the Bath Postal Museum wonderfully explains the history of the Post and its Bath connections. The Herschel House Museum in New King Street was the fine eighteenth century home of William Herschel, the distinguished scientist, astronomer, musician and composer. The American Museum with its Shaker furniture and delightful quilts, whose contains in its grounds the remarkable American Arboretum, Bristol offers the superb Exploratory Hands-on Science Centre - a remarkable display of lights, lenses, lasers and illusions, all housed in Brunel's original engine shed and drawing office; and the Bristol Industrial Museum describing the history of the city and region. Of course, not to be missed is the Harveys Wine Museum...a great visitor attraction.To add to this there is the region's wealth of stately homes, in homes, in many cases presenting their own galleries of treasures or museums of rural life associated intimately with their particular district.

There are more than two thousand museums and galleries within the United Kingdom, offering a stimulating insight into virtually every aspect of human life and endeavour and this particular region can claim an extremely wide and comprehensive selection.

# WILLIAM HERSHEL MUSEUM
19 New King Street, Bath BA1 2BL
Telephone 01225 446865

William Herschel was a distinguisted Ashonoman and scientist who lived in this house in the 18th century. He was also a musician and composer and at one time Director of Music for Bath. The Herschel Museum is a delightful period house depicting life in the 19th century and the many achievements of William and his sister Caroline and their impact on modern science and space explanation. It was from this house using a handmade telescope that Herschel discovered the planet Uranus in 1781. The drawing room, dining room, kitchen, workshop and garden present a cameo of the 18th century in fashionable Bath. The Astronomy room shows Herschel's telescopes and recent NASA photographs of the planets.

The Museum has a Schools Education Programme.

▲ The workshop of 19 New King Street, Bath

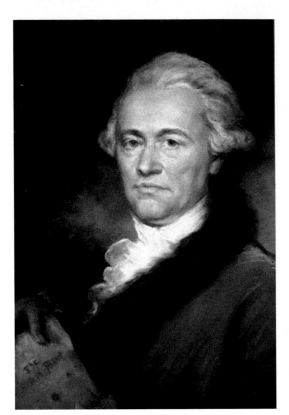

▲ Portrait of William Herschel by John Russell 1794

### Opening times

Daily February 1st - 30th October
2.00pm to 5.00pm
Last Admission 4.30pm
November - February
Saturday & Sundays only 2.00pm to 5.00pm
Last Admission 4.30pm
Closed Mondays
Open Tuesday and Friday Mornings

### Directions

New King Street is situated a couple of minutes walk from Queen's square. Turn from the square into Chapel Row take the second road on the right

# THE HOLBURNE MUSEUM & CRAFTS STUDY CENTRE

Great Pulteney Street, Bath BA2 4DB
Telephone 01225 466669 Fax 01225 333121

This museum is situated at the end of Bath's elegant Great Pulteney Street in the heart of the famous Sydney Gardens. Originally an 18th century hotel, it now houses collections of fine and decorative art made by Sir William Holburn (1793-1874), and includes superb English and Continental silver, porcelain, Italian maiolica, bronzes, glass, furniture, portrait miniatures and old master paintings. The collections have been later enhanced by acquisitions and bequests, particularly of 18th century portraits by Gainsborough, Stubbs, Turner and Ramsay, and Plura's marble masterpiece made in Bath in 1752. Fine examples of work by leading British 20th century artist-craftsmen in the crafts study centre include printed and woven textiles, calligraphy, furniture and ceramics by Leach, Hans Coper and Lucie Rie.

A licensed teahouse serves homemade lunches and teas inside or in the garden. Guided tours by arrangement. Free parking. Admission £3.50 with concessions. Temporary exhibitions on art and craft include Rare miniatures February-June 1999, and 2nd March-11th April, wood engraving and

collage by Anne Desmet. "One of the most perfect Museums in Europe in such a fine classical setting" (quote by Hugh Skully) special group and exhibition rates. Coach parking space. Facilities for disabled.

### Opening times
Open mid February to mid December except from November to Easter when closed Mondays 11.00am to 5.00pm (last admission 4.30pm) Sundays open 2.30pm to 5.30pm Open Bank Holidays (except Christmas)

### Directions
Rail Bath Spa Bus 17/8 mini bus from bus station town centre. Car: A4 from London via London Road into Bath, Bathwick Street, Sydney Gardens roundabout right turn museum at the end of Great Pulteney Street. A431 from Bristol A367 from Wells A36 from Warminster 10-15 minutes walk from Railway Station.

▲ The Holburne Museum, Bath

▲ Henrietta Laura Pulteny by Angelica Kauffman

▲ Woman Bathing by Susini once owed by King Louis XIVth

▲ Diana & Endymion Marble Masterpiece by Joseph Plura, Bath, 1752

BATH, BRISTOL & NORTH EAST SOMERSET

# THE ROYAL PHOTOGRAPHIC SOCIETY

The Octagon Galleries, Milsom Street, Bath BA1 1DN
Telephone 01225 462841 Fax 01225 448688

The Octagon Galleries are situated in the centre of Bath ten minutes walk from the railway and coach stations. The Historic Octagon Chapel, built in 1789, is home to the world famous Royal Photographic Society and its prestigious Photographic Galleries and collection.

1999 dates include the following: Into The Light: Photographic printing after the darkroom, by Adam Lowe and Paul Caffel. 1st April to 6th June. Young Meteors 12th June to 29th August. Kobal Portrait Awards 7th August to 26th September.

For full details of the latest RPS programme including exhibitions, events and workshops please contact 01225 462841.

A friends scheme of the RPS Octagon Galleries is open to all. For £20 friends can enjoy free entry to exhibitions and invitations to private views amongst many other benefits. Contact Lorinda Coombes.

Society Membership is open to everyone and gives free entry to the Octagon Galleries and many other benefits,

contact Sara Beaugeard Membership Development Officer for details.

EMail: info@rps.org Web Site: http://www.rps.org

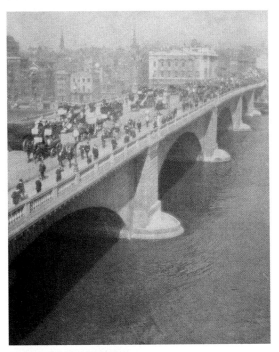

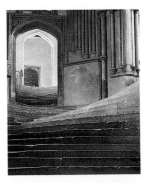

▲ Alvin Langdon Coburn, London Bridge, 1905, From Into The Light

▲ Madame Yevonde, Lady Milbanke as Penthesilea, The Dying Amazon, 1935

10

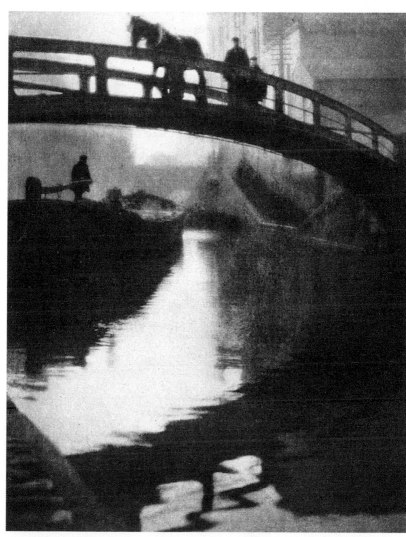

▲ Alvin Langdon Coburn,
Regent's Canal 1905,
From Into The Light

◀ Fredick H. Evans,
The Sea of Steps, Wells
Cathedral, 1900

### Opening times

Open every day
except Christmas Day
& Boxing Day
from 9.30am to 5.30pm

Last Admission
to the exhibitions
is at 4.45pm

### Directions

The Octagon Galleries
are situated on Milsom
Street in the centre of
Bath, ten minutes walk
from the railway and
coach stations. Visitors
are advised to use public
car parks.

BATH, BRISTOL & NORTH EAST SOMERSET

*BATH, BRISTOL & NORTH EAST SOMERSET*

# AMERICAN MUSEUM IN BRITAIN
Claverton Manor, Claverton Devon, Bath BA2 7BD
Telephone 01225 460503 Fax 01225 480726

The museum shows, largely by way of period rooms, the development of North American decorative arts from the late 17th to mid 19th century. The rooms include a 17th century keeping room, a new Mexican chapel, and an 18th century New England tavern.

Other exhibits include a gallery of American folk art, and displays of silver and pewter. The museum's collection of over 200 American quilts is the finest outside North America and 40 of these are always on display. The map room shows a changing selection from the Dallas Pratt collection of early printed maps from 1472 to the early 17th century.

The extensive grounds include a replica of part of George Washington's garden at Mount Vernon in Virginia and an arboretum of North American trees and plants.

The 1999 special exhibition is entitled Animals in American Art, and shows the way animals were represented in a variety of media including pictures, sculpture, weather vanes and hooked rugs.

The museum hosts 4 reenactments each year.

For details of these or any other queries phone the Museum Secretary on 01225 460503

▲ The American Museum in Britain Claverton Manor

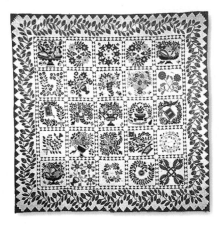

▲ Baltimore bride's quilt

### Opening times

March 20 - November 07
Daily except Monday
Open Bank Holidays
and Mondays in August
Grounds
1.00pm to 6.00pm
Museum
2.00pm to 5.00pm

### Directions

Situated 2 miles south east of Bath. Next to the University.

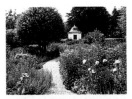

▲ Mount Vernon Gardens

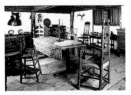

▲ 17th century Keeping Room

# HARVEYS WINE CELLARS

12 Denmark Street, Bristol BS1 5DQ
Telephone 0117 9275036 Fax 0117 9275001

Bristol's unique experience of wine through the ages is set in the original 13th century cellars of the Monastery of St Mark.

The cellars have been in constant use by Harveys since 1796 when John Harvey & Sons first began trading as a family wine merchants.

Today, in addition to telling the story of wine, the cellars are home to a famous collection of antique silver, rare glassware and Georgian furniture.

The Glass Gallery contains one of the finest collections of early English lead crystal drinking glasses. There are also exhibits of bottles, decanters, labels and coasters, giving a further insight into Bristol's wine trade.

The Unicorn, originally a claret bottling cellar, has been transformed into an Elizabethan inn - the perfect setting to complete the Harveys experience.

Admission to the Wine Cellars includes a complimentary glass of Bristol Cream for over 18's.

Prices: £4 adults
£3 OAP's and students
£8 family.

Harveys Wine Cellars offer guided tours and tastings from £6.50 per person. A special one course lunch is also available at Harveys Restaurant - £8.50, including a glass of your favourite tasting wine.

▲ Dockside scene

### *Opening times*

Open
Monday to Saturday
10.00am to 5.00pm

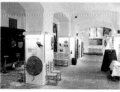

▲ Main gallery

### *Directions*

Easy to find in city centre. Close to Swallow Royal Hotel. Parking in nearby NCP. 10 minutes from Temple Meads station. M4/M5 junction M32 to Bristol.

▼ Harveys Wine shop          ▲ Unicorn

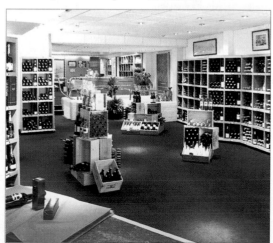

# SS GREAT BRITAIN
Gas Ferry Road, Bristol BS1 6TY
Telephone 0117 9260680 Fax 0117 9255788

The SS Great Britain was built in the dry dock in which she stands being refurbished to original configuration circa 1843.

She was the first Iron-built, steam-propelled, passenger carrying vessel and for some time was the largest ship in the World. Designed by Isambard Kingdom Brunel in the early 1840's.

She was launched by Prince Albert on July 19th 1843 when all of Bristol closed down and attended the launch ceremony.

During her lifetime she carried passengers from England to America, England to Australia and cargo from South Wales to San Francisco.

However she ended her days in the Falkland Islands as a floating store, from 1886 to 1937.

After this she was towed away and left to rot. In 1970 she was brought back to her birthplace on a pontoon. About two thirds of the refurbishment is complete.

### Opening times
Winter
(November-March)
10.00am to 4.30pm
Last Admission 4.00pm
Summer (April-October)
10am to 5.30pm
Last Admission 5.00pm

### Directions
From M5 north/south junction 18, A4 to city centre, pickup brown/white signs. From M4 east/west junction 19, M2 to city centre, pickup brown/white signs.

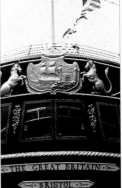

▲ The stern of the SS Great Britain

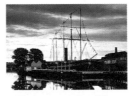

▲ Dawn over the SS Great Britain

▲ The propeller of the SS Great Britain

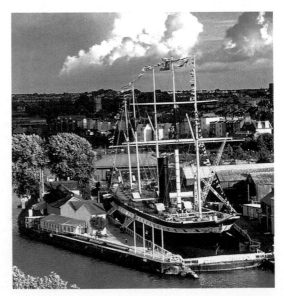

## BATH POSTAL MUSEUM
8 Broad Street, Bath BA1 5LJ
Telephone 01225 460333 Fax: 01225 460333

The story of the post, tracing 4,000 years of communication. The first stamp was sent from this building in 1840. Video Room, Airmail Room and Children's Activity Room always open.

*Opening times* Open all year daily 11am to 5pm except Sundays 2pm to 5pm

## BATH INDUSTRIAL HERITAGE CENTRE
Campden Works, Julian Road, Bath BA1 2RH
Telephone 01225 318348 Fax: 01225 318348

Displays concerning the social and industrial history of Bath through the reconstructed engineering and mineral water factory of J B Bowler in its entirety. Also Stone Mining, other manufacturers, etc.

*Opening times* Open Easter to November 1st 10.00am to 5.00pm, every day (last admission 4.30pm) November 1st to Easter 10.00am to 5.00pm weekends (groups all year by appointment)

## THE EXPLORATORY HANDS-ON SCIENCE CENTRE
Temple Meads, Bristol BS1 6QU
Telephone 0117 907 9000 Info Line 0117 907 5000
Fax: 0117 907 8000

It's science you can handle. Over 150 experiments to thrill and amaze. New Body Lab gallery, Stardom Planetarium. Science Shows on Sundays. Science Shop. Special events throughout the year. Coffee Shop open Weekends and School Holidays only.

*Opening times* Open daily 10.00am to 5.00pm, closed Autumn, 1999

## BRISTOL INDUSTRIAL MUSEUM
Princes Wharf, City Docks, Bristol BS1 4RN
Telephone 0117 925 1470 Fax: 0117 929 7318

Transport and industrial history of the Bristol area. Working exhibits on every weekend through the Summer. Free admission for everyone.

*Opening times* Open April to October daily, except Thursday & Friday 10am to 5pm, Open November to March Saturday and Sundays only 10am to 5pm.

## BLAISE CASTLE HOUSE MUSEUM
Henbury Road, Henbury, Bristol BS10 7QS
Telephone 0117 950 6789 Fax: 0117 959 3475

Bristol's Museum of every day life including domestic equipment, toys and costume.

*Opening times* Open 1st April to 31st October from 10am to 5pm, closed Thursdays and Fridays, closed 1st November to 31st March

## ASHTON COURT VISITOR CENTRE

Ashton Court Estate, Long Ashton, Bristol BS1 9JN
Telephone 0117 963 9174 Fax: 0117 953 2143

Permanent exhibition of landscape makers and occasional special exhibitions.
Information point for 850 acre estate with historic landscape. Monthly Sunday tours
of mansion. Golf Course open daily.

*Opening times*  Open Weekends 11.00am to 5.30pm Easter to End September,
Weekdays 1.00pm to 5.00pm July and August,
Golf Course open daily 8.00am - dusk all year round

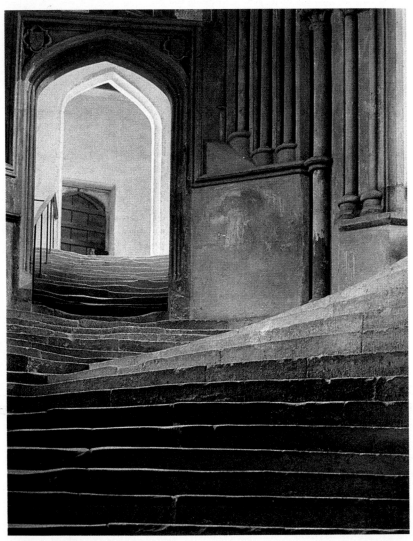

'The Sea of Steps' by Fredick H. Evans, The Royal Photographic Society, Bath

**16**

BATH, BRISTOL & NORTH EAST SOMERSET

# BEDFORDSHIRE, BERKSHIRE, BUCKINGHAMSHIRE & HERTFORDSHIRE

These four counties encapsulate much of the English way of life. At the very heart of the country and surrounding the capital, the region was the culmination of ancient tracks and trade routes, the Ridge Way and the Icknield Way dating back to the Bronze Age. The Romans too in their turn left their road building mark. In a country of magnificent medieval castles, this area being so close to the country's heart felt safe from invaders and as a consequence, what it lacks in military architecture it more than makes up for in glorious domestic architecture.

The marks indelibly stamped on these four counties by their early occupants are thankfully well recorded in their splendid museums and heritage centres. The excellent Stockwood Craft Museum and Gardens explain the craft traditions of Bedfordshire. Here there are displays and workshops, including blacksmith, wheelwright, saddler, and thatcher...established in an interesting eighteenth century stable block. Bedfordshire's long tradition of lace making is reflected in the Cecil Higgins Art Gallery and this area's close connection with the wool trade is echoed in Hitchin's fine Museum and Art Gallery.

At St. Albans, in 100 acres of parkland, the prize-winning Verulamium Museum records every day life in Roman Britain. There are hands-on Discovery Areas and touch screen databases that bring each subject studied alive. At the Museum of St. Albans the story is told of the rise of the city from its humble coaching days to present day St. Albans. Outside is a wildlife garden and wooded trail. Of course not all museums are static. The Mill Green Museum at Hatfield has its fully working mill, and the Organ Museum at St. Albans holds a wonderful collection of working mechanical musical instruments.

The Stevenage Museum houses an intriguing display telling the story of the town from the Stone Age to the present day. At Cookham is the Stanley Spencer Gallery exhibiting work by the twentieth century artist who was born in the attractive town; and at Aylesbury, the Buckinghamshire County Museum houses the Roald Dahl Children's Gallery.

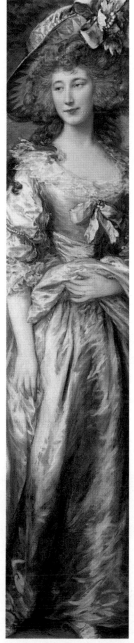

## CECIL HIGGINS ART GALLERY

Castle Close, Castle Lane, Bedford MK40 3RP
Telephone 01234 211222 Fax 01234 327149

Housed in an elegantly converted and extended Victorian mansion, original home of the Higgins family of wealthy Bedford Brewers, the Cecil Higgins Art Gallery is home to one of the most outstanding fine and decorative art collections outside London.

The gallery offers: a remarkable collection of British and European watercolours from the 18th to the 20th centuries and International prints from Impressionism to the present. Includes works by Rembrandt, Turner, Blake, Cotman, Rossetti, Burne-Jones, Whistler, Dali, Picasso, Warhol, Hockney. Exhibition changes regularly.

A distinguished group of ceramics and glass from the Renaissance to the 20th century, with particular focus on 18th century porcelain, Whitefriars glass, and ceramics of the Arts and Crafts movement.

Authentically re-constructed Victorian room settings in the Victorian mansion, suggesting the life of a prosperous 1890s household.

The William Burges room: a complete Gothic experience with Burges' own furniture in a full decorative setting. Hands on activities for children and workshops for all ages. Changing exhibitions from the collection and elsewhere.

Program of events, lectures, performances, and more. Fully guided tours available for groups on request (charges vary).

Admission free, but variable charges for tours, etc.

***Opening times***
Open
Tuesday to Saturday
11.00am to 5.00pm
(last admission 4.45pm)
and Sunday &
Bank Holiday Monday
2.00pm to 5.00pm
Closed Mondays, Good
Friday, Christmas Day
& Boxing Day

***Directions***

Centre of Bedford, just off the Embankment. (From North: M1 junction 14, A422, A428 or A6 to centre. From South: M1 jct13, A431 and B531 to centre. Between High Street and Newnham Road).

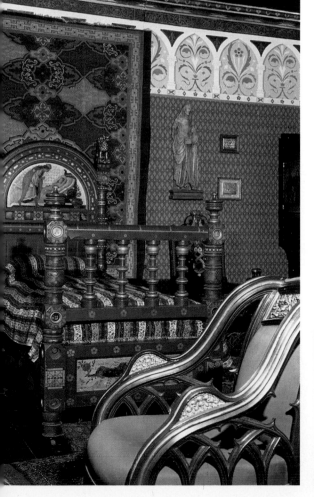

(far left top)
Whitefriars glass vase, early 20th century

(far left bottom)
"The Loss of an East Indiaman"
JMW Turner c.1818

◀ The Burges Room

▼ "Artist and Model"
by David Hockney
1973/74

BEDFORDSHIRE, BERKSHIRE, BUCKINGHAMSHIRE & HERTFORDSHIRE

## BROMHAM MILL & GALLERY

Bridge End, Bromham, Bedford  MK43 8LP
Telephone 01234 824330 Fax 01234 228531

Restored Watermill on the River Great Ouse which grinds flour each Sunday (water level permitting).

Baking sessions for experts and beginners as well as a range of arts, crafts and countryside activities.

Programmes of events issued 3 times during open season. Art Gallery shows changing exhibitions of quality contemporary art and craft work including local professional makers and national touring exhibitions.

Quality crafts are offered for sale from the Crafts Council recognised 'Fenny Lodge Gallery', Bletchley. A shop sells souvenirs, gifts, books and childrens items. Light refreshments are on offer and local pubs serve good meals.

Activities are offered each weekend and pre-booked workshops take place during the week. For details of either, please request the free programme list.

At any time of year though the site offers peace and tranquillity, a picnic venue or a suitable place to start a waymarked walk of north Bedfordshire.

Toilets are open during daylight and car parking is free. The museum holds items of milling equipment and associated farming tools and has trails, quizzes and DIY activities for children.

### Opening times

Open March to October daily except Monday and Tuesday Wednesday to Saturday 12.00pm to 4.00pm Sunday and Bank Holiday 10.30am to 5.00pm (last admission half an hour before closing) Other times by arrangement

### Directions

Bromham Mill is situated at the west end of Bromham Bridge, 3 miles west of Bedford. Sign posted off the A428 Bedford to Northampton Road.

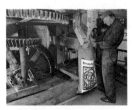

▲ Milling takes place each Sunday, water level permitting

▲ 8 acres of meadow mean lots of outdoor activities

▲ Bromham Mill enjoys a tranquil setting alongside River Great Ouse

▲ Bread dinosaurs are popular but trouble-shooting for adults too

BEDFORDSHIRE, BERKSHIRE, BUCKINGHAMSHIRE & HERTFORDSHIRE

# STANLEY SPENCER GALLERY

King's Hall, Cookham on Thames, Berkshire SL6 9SJ
Telephone 01628 520890

The Stanley Spencer Gallery is unique as the only gallery in Britain devoted exclusively to an artist in the village where he was born and spent most of his life.

To Spencer (1891-1959), Cookham was the scene of heavenly visitations. Set in the heart of the village he immortalised, the gallery occupies the former Victorian Methodist Chapel where Spencer was taken to worship as a child. It contains a permanent collection of his work, together with letters, documents, memorabilia, and the pram in which Spencer wheeled his equipment when painting landscapes.

It also displays important works on long-term loans, and mounts a winter and summer exhibition each year. Over a thousand works have been shown since the gallery opened in 1962.

GROUP VISITS
Groups wishing to visit the gallery should telephone 01628 520890

GALLERY SHOP
The Shop stocks book, facsimile drawings, colour reproductions, postcards, etc.

TRANSPORT
Maidenhead 3 miles, London 28 miles, Windsor 9 miles. There is a car park nearby. There are also trains and buses to Cookham.

Refreshments can be found in the village.

## *Opening times*

Open
Easter to October
Daily
(including weekends)
10.30am to 5.30pm
November to Easter
Saturday, Sunday
and Bank Holidays
11.00am to 5.00pm

## *Directions*

In Cookham village
High Street opposite
'Bel and Dragon' pub.
Cookham Station
ten minutes walk.

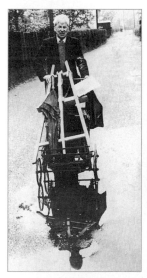

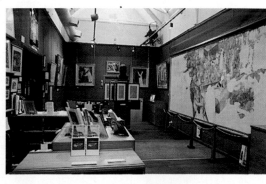

▼ Inside the Stanley Spencer Gallery

◄ Stanley Spencer R.A. (1891-1959)
Going painting with his push chair

BEDFORDSHIRE, BERKSHIRE, BUCKINGHAMSHIRE & HERTFORDSHIRE

# THE URE MUSEUM OF GREEK ARCHAEOLOGY
Whiteknights, Reading, Berkshire RG6 6AA
Telephone 0118 9318420 Fax 0118 9316661

The Ure Museum of Greek Archaeology is a small but important collection of ancient objects within Reading University Department of Classics.

It serves three different roles: firstly as a Teaching Resource for Archaeologists and Art Historians at Reading; secondly, as a place of Research renowned among specialists in the field; and finally as a Public Museum, with individually attractive and fascinating exhibits as well as displays on aspects of ancient life such as eating and drinking, and human adornment.

The Museum is popular with local schools, which regularly bring parties of children. They come mainly to look at the pride of the collection: Ancient Greek vases and pottery from the Stone Age to the Roman Empire; but also held is a collection of Egyptian Antiquities and rarer relics from Ancient Greece such as the Reading Aulos (a reed-pipe musical instrument) - one of only a handful to survive.

### Opening times

Open
Monday to Friday
9.00am to 5.00pm

### Directions

The Museum is located at the north-east end of Reading University Faculty of Letters, Whiteknights, Reading. Access is off Shinfield Road (A327). Leave the M4 at junction 11.

▶ Fragments of Athenian painted pottery from the 6th century BC

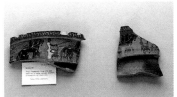

▶ A Corinthian miniature Amphora from the 6th century BC

▶ Apulian (South Italian) Amphora. 4th century BC

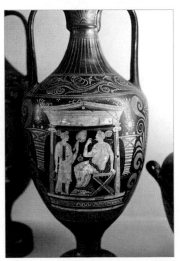

# MUSEUM OF ENGLISH RURAL LIFE

University of Reading, PO Box 229, Whiteknights,
Reading, Berkshire RG6 6AG
Telephone 0118 9318663 Fax 0118 9751264

The Museum of English Rural Life is part of the University of Reading and is set on the attractive Whiteknights campus. It was established nearly 50 years ago by staff from the University's agriculture departments who were keenly aware that, with great changes in farming and country life taking place, efforts should be made to record the older ways before they disappeared.

That work has continued and today the Museum is part of the Rural History Centre which is a national research and information base for the subject. On display are many examples from the Museum's collections drawn from around the country.

The exhibition areas are open to the general public and provide a glimpse of life in the countryside when the horse was still vitally important and when so many people's lives were still directly dependent upon farming and its related crafts and industries.

There is a very active schools programme, which includes drama based and hands-on activities on a number of themes such as Life on a Victorian Farm.
The extensive collections of records, photographs and books in the Rural History Centre are available for consultation by appointment.

Find us on the web at http://www.rdg.ac.uk/Instits/im/rural/mus.html

## *Opening times*

Tuesday-Saturday
10.00am to 1.00pm
2.00pm to 4.30pm.
Open all year
but closed between
Christmas & New Year

## *Directions*

Leave M4 at junction 11 and follow B3350 to University. From central Reading follow signs A327 to the Campus. From the Railway Station buses 7,8,12,20 pass the University Campus.

▲ Ransomes lawn mowers publicity material: from our archive collection

▲ Bamfords agricultural implements trade catalogue: from our archive collection

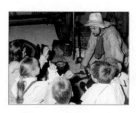

▲ Regular drama - based schools activity called "learning through action"

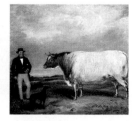

▲ Champion Shorthorn painted by William Smith: From our object collection

**23**

# BUCKINGHAMSHIRE COUNTY MUSEUM & ROALD DAHL CHILDREN'S GALLERY

Church Street, Aylesbury, Buckinghamshire HP20 2QP
Telephone 01296 331441 Fax 01296 334884

Museum of the Year 1996/97; Gulbenkian Award for Education 1997/98; Special Commendation, European Museum of the Year 1998. A lively hands-on museum complex consisting of county heritage displays, Art Gallery and the Roald Dahl Children's Gallery in a garden setting.

Discover how clay was formed and how bricks were made by hand; find out about the people who worked the lace-making bobbins; touch a Mammoth's tooth; listen to stories; make your own jewellery; & meet Tim Burr, the wooden man.

The stunning Buckinghamshire Art Gallery features a changing programme of exhibitions as does the smaller Special Exhibitions Gallery. The Textiles Gallery is well worth a visit as are the other galleries, including the Ceramics Gallery, Mediaeval Room, Victorian Dining Room and Aylesbury Gallery.

The Gulbenkian Award judges described the Roald Dahl Children's Gallery as "without doubt the UK's best hands-on museum for children". Using real museum objects, history, natural history, science

and technology are brought to life through the wonderful and often surprising world of Roald Dahl. Ride the Great Glass Elevator, go inside the Giant Peach, discover Willy Wonka's inventions and let your imagination run wild!

A buggy park is available as pushchairs are not allowed around the gallery.

### *Opening times*
Main Museum
Monday to Saturday
10.00am to 5.00pm
Sunday
2.00pm to 5.00pm
Roald Dahl
Children's Gallery
Monday to Friday
during term time
3.00pm to 5.00pm
(off peak)
Monday to Friday
during school holidays
10.00am to 5.00pm
Saturday
10.00am to 5.00pm
Sunday
2.00pm to 5.00pm
Open all year except
Christmas Day and
Boxing Day

### *Directions*
An hour by train from London Marylebone or 25 minutes off the M25 via the A41. The Museum is a short walk from the Market Square, near St. Mary's Church.

▲ Buckinghamshire County Museum

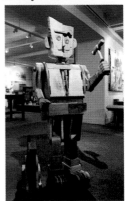
▲ Tim Burr, the Wooden Man

▲ Investigating "A Touch of Bucks"

▲ The Road Dahl Children's Gallery

24

# COWPER & NEWTON

Orchard Side, Market Place, Olney,
Buckinghamshire MK46 4AJ
Telephone 01234 711516

The Cowper and Newton is sited in Orchard side, which was the home of the 18th century poet and letter-writer, William Cowper.

The collection includes displays of his works, portraits and memorabilia, plus those of his friend John Newton, a former seaman and slave trader. Newton was converted to evangelical Christianity, ordained and came to Olney as curate in 1764. He wrote a great many hymns, including "Amazing Grace". Later in life he assisted William Wilberforce in the fight against the slave trade.

There are two gardens to enjoy at Orchard Side. One has informal plantings of varieties brought to England before 1800. The other garden is a kitchen garden in which is the famous Summer House where Cowper wrote several of his poems.

For over 300 years Olney was the centre of the bobbin lace making industry. Visit the collections of Buckingham and Bedfordshire pillow-lace.

Discover Olney's past through its collections of fossils, including the fossil bones of cetiosaurus; its Roman coins; it mediaeval artefacts and Civil War relics.

Come and browse in our shop where there is a wide variety of goods available.

Conveniently for visitors there are 2 free car parks nearby.

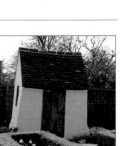

▲ The Summer House built as a Smoking House around 1750

---

### Opening times

Open
March to December
10.00am to 1.00pm
2.00pm to 5.00pm
Tuesday-Saturday
inclusive

---

### Directions

Olney is located on the A509. Exit junction 14 of the M1. The museum is located next to the Market Square.

▲ One of the displays of Bedfordshire pillow lace

---

▲ The Viper Barn, a Victorian Wash House

▲ The brick facade of Olney's Museum circa 1700.

## WADDESDON MANOR
Waddesdon, nr, Aylesbury, Buckinghamshire HP18 0JH
Telephone 01296 651211 Booking Office 01296 651226  Fax 01296 651142

Waddesdon Manor was built at the end of the last century for Baron Ferdinand de Rothschild to entertain his guests and display his vast collection of art treasures. It has won many awards including Museum of the Year and Best National Trust Property 1997.

This French Renaissance-style château houses one of the finest collection of French 18th century decorative arts in the world: Savonnerie carpets, Sèvres porcelain, Beauvais tapestries and furniture by the best French cabinetmakers, as well as important portraits by Gainsborough and Reynolds and works by Dutch and Flemish Masters of the 17th century.

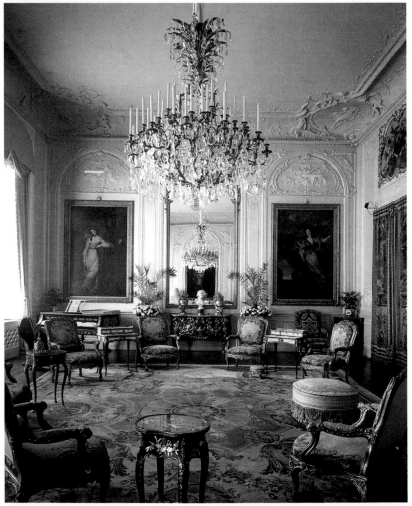

▲ The Grey Drawing Room

BEDFORDSHIRE, BERKSHIRE, BUCKINGHAMSHIRE & HERTFORDSHIRE

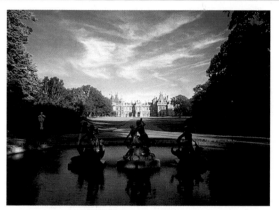

▲ Waddesdon Manor, North Front
▼ The dining room with Choiseul Sèvres service

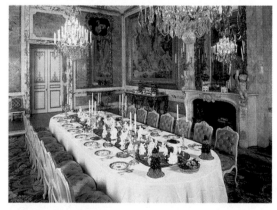

***Opening times***
Gardens, Aviary,
Restaurant and Shops
Open 3rd March to 24th
December Wednesday
to Sunday & Bank
Holiday Mondays -
10.00am to 5.00pm

House (including Wine
Cellars) Open 1st April
31st October
Thursday to Sunday,
Bank Holiday Mondays
and Wednesday in
July & August
11.00am to 4.00pm
(Last recommended
admission 2.30pm)

Bachelors' Wing open
Thursday & Friday,
& Wednesdays in
July & August
11.00am to 4.00pm
(access cannot be
guaranteed)

***Directions***
20 minutes from Junction
7 (northbound) and 9
(southbound) of the M40,
off the A41 between
Bicester and Aylesbury.
45 miles from London
and 20 miles from Oxford.

Other displays include
collections of gold boxes,
buttons and drawings,
plus the Choiseul Sèvres
dessert service in the
Dining Room. The
refurbished Bachelors'
Wing is also now open.
Waddesdon has one of the
finest Victorian gardens
in Britain, famous for its
landscape of specimen
trees and parterre. The
Rococo-style aviary
houses a splendid
collection of exotic birds
and thousands of bottles
of vintage Rothschild
wines are found in the
wine cellars. There are
gift and wine shops and a
licensed restaurant.
Many events are
organised throughout the
year including Collection
study days, floodlit
openings, wine tastings,
and garden workshops.

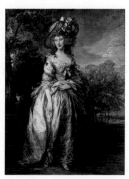

▶ Lady Sheffield
by Gainsborough

## MILL GREEN MUSEUM & MILL

Mill Green, Hatfield, Hertfordshire AL9 5PD
Telephone 01707 271362 Fax 01707 272511

Fully restored 18th century watermill producing organic wholemeal flour every week. The local history museum for Welwyn Hatfield is based in the Mill House, formerly the home for generations of millers and their families.

There is a small temporary exhibitions gallery and a programme of craft demonstrations and special events at summer weekends. There are two further galleries displaying local and social history, archaeology and a Victorian kitchen.

A recent new addition to the displays at Mill Green is the magnificent Roman coin hoard of 95 silver denarii featuring Roman Emperors including Claudius, Nero and Hadrian. There is also an attractive garden and riverside setting.

Temporary exhibitions planned for 1999 include watercolours and oils by local artist Richard Baker and Cinema 100 - a look at 100 years of cinema with information on the history of local cinemas.

Telephone 01707 271362 for further details.

Pre-booked parties are welcome. Admission is free.

### Opening times

Open Tuesday to Friday 10.00am to 5.00pm
Saturday, Sunday & Bank Holiday 2.00pm to 5.00pm

### Directions

In the hamlet of Mill Green between Hatfield and Welwyn Garden City at the junction of the A1000 and the A414.

▼ Gearing, Mill Green Mill, Hatfield

▲ Mill Green Museum & Mill, Mill Green, Hatfield

▲ Railway display, Mill Green Museum

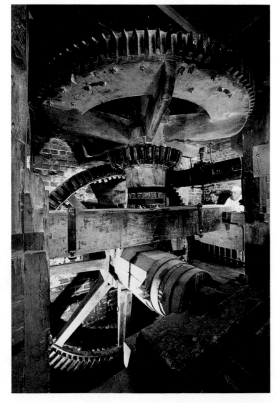

**28**

# HITCHIN MUSEUM
Paynes Park, Hitchin, Hertfordshire SG5 1EQ
Telephone 01462 434476 Fax 01462 431316

The Museum is housed in a converted Victorian home and contains a wide variety of displays.

They include a unique 19th century Pharmacy reconstructed in one gallery, an exhibition of historic costume, and displays on local Industries and domestic life.

There is a Physic garden to accompany the Chemist's shop and a Study Room for local history research.

The Museum has regularly changing temporary exhibitions, and a busy events programme.

School or group visits can be arranged by contacting our Education Officer.

There is a small car park behind the museum for use by people with disabilities.

There is plenty for parking in the nearby multi storey in Old Park Road.

*Directions*

The Museum is next to the library, close to the Town Square. By road the Museum is opposite the junction of the A602 from Stevenage and the A505 from Luton.

▲ The Physic garden at Hitchin Museum

▲ The Museum regularly holds workshops for children and adults

▲ Hitchin Museum

*Opening times*
Open
10.00am to 5.00pm
Monday to Saturday
2.00pm to 4.30pm
Sunday
Closed Bank Holidays

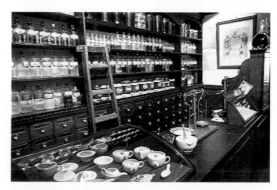

▲ A reconstruction of a Victorian Pharmacy in Hitchin Museum

# LOWEWOOD MUSEUM
High Street, Hoddesdon, Hertfordshire EN11 8BH
Telephone 01992 445596

Lowewood is a listed Georgian building dating from the 1750's, and is the perfect setting for the museum's collection.

The story of the local area is told from the present day back to the Prehistoric times, through displays including geology, social history and photographs.

Exhibitions on all topics displayed in the temporary exhibitions gallery change frequently, and are not to be missed.

Lowewood is a fully registered museum with the museum and galleries commission.

### Opening times

Open Wednesday, Friday, Saturday
10.00am to 4.00pm
Closed Christmas and other Bank Holidays

### Directions

Bus 310, 311, 310a, 310b.
British Rail.
Broxbourne half a mile junction 25, M25, A10,

▲ Serpent playing

▲ The museums Petter Gallery

▲ The successful temporary exhibitions gallery

▼ Lowewood, High Street, Hoddesdon, 1950

# ROMAN THEATRE
Gorhambury Drive, St Alban's, Hertfordshire AL3 6AH
Telephone 01727 835035

The theatre was first discovered on the Gorhambury estates in 1847 and was fully excavated by Dr. Kathleen Kenyon in 1935. The theatre as visible today is the remains of a complex structure that grew up over a long period.

First constructed between AD 140-AD 150 it was altered about AD 160 to enlarge the stage area. By AD 300 a new outer wall had been built providing extra seating.

Near the site of the Roman Theatre, flint and mortar foundations of a town house can be seen, also an underground corridor terminating in an apse which has been interpreted as a shrine.

### Opening times

Open daily
March - October
10.00am to 5.00pm
November - February
10.00am to 4.00pm
Closed Christmas Day
& Boxing Day
(New Years Day limited
hours or by appointment)

### Directions

M25 exit 21A take A405
St. Albans next
roundabout B4630
Chiswell Green approx
2 miles turn left at
King Harry pub next
roundabout A4147 St
Albans after pedestrian
crossing turn left into
Gorhambury drive

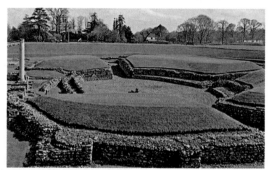

▲ Roman Theatre, Verulamium

▼ Aerial view of the Roman Theatre of Verulamium

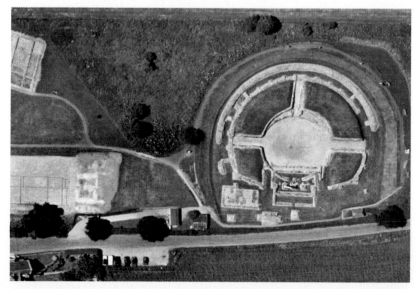

# MUSEUM OF ST ALBANS

Hatfield Road, St Alban's, Hertfordshire AL1 3RR
Telephone 01727 819340 Fax 01727 837472

The story of historic St Albans from the departure of the Romans to the present day.

All displayed in lively galleries, with an extensive handling collection for school visits.

The museum of St Albans is also home to the world famous Salaman Collection of trade and craft tools.

In nice weather you can enjoy a stroll in the peaceful wildlife garden and relax near the pond.

There is a changing programme of special exhibitions throughout the year.

▲ Doll Collection

▼ Louis Wain Tennis party at Napsbury

### Directions

By car in St Albans city centre take A1057 Hatfield Road.
By rail 5 minutes walk from St Albans City station, Thameslink from Kings Cross.

▼ (bottom picture) Salaman Collection of trade and craft tools

### Opening times
Open all year
Monday to Saturday
10.00am to 5.00pm
Sunday
2.00pm to 5.00pm

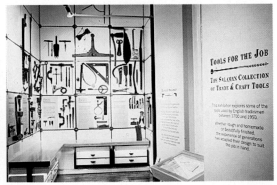

▲ Wildlife Garden

# VERULAMIUM MUSEUM
St Michael's, St Alban's, Hertfordshire AL3 4SW
Telephone 01727 819339  Fax 01727 859919

Verulamium The Museum of everyday life in Roman Britain. An Award Winning museum on the site of Britains 3rd largest Roman city.

The museum contains some of the finest mosaics outside the Mediterranean.

Recently extended, the new rotunda houses new galleries with recent Iron Age finds. Inside are recreated Roman rooms, with original wall plaster and mosaics.

For the modern visitor, videos and computer graphics bring archeology to life.

Every 2nd weekend of the month Roman soldiers give a vivid demonstration of Roman Warfare.

Set in 100 acres of parkland with lots of activities for children.

### Directions

10 minutes drive from junction 21a on the M25, or junction 9,7 or junction 6 on the M1; follow signs to St Albans and Roman Verulamium.

▲ Statue of Venus

◀ Ceramic jar

▼ Roman legionary performing in front of famous shell mosaic

### Opening times

Open all year
10.00am to 5.30pm -
Monday - Saturday
2.00 to 5.30pm
Sunday
Last Admission 5pm

▼ Part of the Roman city wall set in a beautiful park

# ST ALBANS ORGAN MUSEUM
326 Camp Road, St. Albans, Hertfordshire AL1 5PB
Telephone 01727 869693 or 851557 Fax 01727 851557

St. Albans Organ Museum houses a permanent playing exhibition of mechanical musical instruments and theatre pipe organs.

The magnificent sounds of the organs by Mortier, Decap and Bursens and Wurlitzer and Spurden Rutt, can be heard every week of the year, together with reproducing pianos by Steinway and Weber.

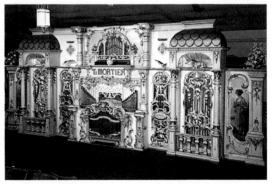

▲ The magnificent Mortier Dance Organ which was built in Belgium

Musical boxes dating from the 1800s are demonstrated together with hand-turned table organettes, and a very rare Mills Violano-Virtuoso produces its own unique sound of violin and piano duet.

Two theatre pipe organs are housed at the museum - a Wurlitzer three manual (keyboard) organ with 10 ranks of pipes plus extensive percussion and sound-effect section, formerly installed at the Granada Cinema, Edmonton, North London, and a rare survivor of only three theatre-type instruments, built by the R. Spurden Rutt Organ Company, with six ranks of pipes plus percussion, played from a three-manual console featuring a striking illuminated glass surround, and formerly in the Regal Cinema, Highams Park, East London.

Aside from being open every Sunday afternoon, throughout the year, when all the instruments are demonstrated, concerts by top British and Overseas Organists are a regular feature of the Museum's activities.

### Directions

The Museum is two miles from St. Albans city centre at 320 Camp Road. Bus services S2 and C2 serve direct from city centre and city British Rail Station.

### Opening times

Open every Sunday from 2.00pm until 4.30pm. Organised groups are welcomed at other times by arrangement - evenings preferred except Tuesday. Advertised Theatre Organ Concerts by Top UK and Overseas Artists take place about once a month on Saturday evenings.

Adult £2.50
Child £1.00
Family £6.00.

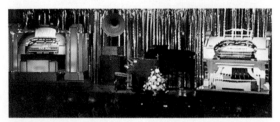

▲ On stage are the Spurden Rutt and Wurlitzer Pipe Organs

# STEVENAGE MUSEUM

St George's Way, Stevenage, Hertfordshire SG1 1XX
Telephone 01438 218881 Fax 01438 218882

Discover the story of Stevenage and its people through our hands-on displays and videos. See a fabulous coin hoard, a reconstructed 1950s sitting room and test your knowledge with our computer challenge.

We offer an exciting programme of changing special exhibitions which include activities built in for children to enjoy. In addition, there are plenty of free quizzes and colouring sheets.

We run frequent Saturday and midweek events and specialist short courses covering a wide range of activities, from mystery walks to embroidery sessions to creepy crawly days! For details of events, contact the museum visit the Stevenage Borough Council home page on http://www.stevenage.gov.uk

The education service welcomes schools and groups in the community and pupils and students from 5 years to 100 years.

Informal and formal sessions include role play, story telling and object handling, historical talks and walks and various activities for children during school holidays. New from 1998 is the sensory garden,

developed in conjunction with a local school and other community groups. The garden, which includes a geology wall, provides a quiet place to enjoy natural habitats of the local wildlife.

### *Directions*

The museum is underneath St. Andrew and St Georges Church on St Georges Way. It is just a few minutes walk from the town centre and is sign posted from there.

▼ R2D2 and yoda, stars of space heros exhibition

▲ Bugs, beasts and bushes exhibition.

▲ Let's Dance Exhibition Winner 1996 Interpret Britain Award

### *Opening times*

Open Monday - Saturday
10.00am to 5.00pm
Closed Sunday
& Bank Holidays

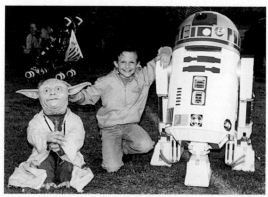

BEDFORDSHIRE, BERKSHIRE, BUCKINGHAMSHIRE & HERTFORDSHIRE

# WELWYN ROMAN BATHS
Welwyn Bypass, Welwyn, Hertfordshire AL10 9LN
Telephone 01707 271362 Fax 01707 272511

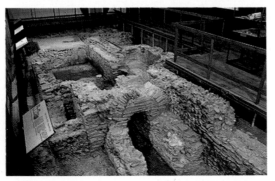

## Opening times

Open
January to November
Saturdays, Sundays
and Bank Holidays
2.00pm to 5.00pm
(or dusk when earlier)
School half-term
and holidays
Monday to Sunday
2.00pm to 5.00pm
(or dusk when earlier)
Closed December.
The site is open
at all hours to
pre-booked groups

The baths are a small part of a villa which was built at the beginning of the 3rd century AD and occupied for more than 150 years.

The villa had at least 4 buildings, 2 of which had bathing suites. One of these has been preserved in a steel vault within the A1 motorway embankment.

The different rooms of the monument can be clearly seen; there are also panels on Roman bathing and villa life and displays of artefacts found locally.

▲ Furnance Arch, Welwyn Roman Baths

▼ Welwyn Roman Baths, Welwyn, Herts

## Directions

Situated under the A1(M) at its junction with the A1000 just off the central roundabout of the Welwyn Bypass.

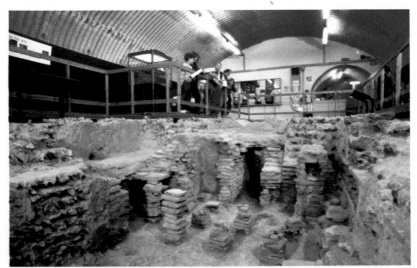

## FIRST GARDEN CITY HERITAGE MUSEUM

296 Norton Way South, Letchworth, Hertfordshire SG6 1SU
Telephone 01462 482710 Fax: 01462 486056

The Museum tells the story of the development of Letchworth, the world's first garden city. Regular programme of social exhibitions and events. Talks and guided tours of the town.

*Opening times*  Open Monday to Saturday 10.00am to 5.00pm,
Closed Christmas Day and Boxing Day

## WATFORD MUSEUM

194 High Street, Watford, Hertfordshire WD1 2HG
Telephone 01923 232297 Fax: 01923 232297

Local History Museum. Changing temporary exhibition programme. A comprehensive education service is available and presentations of local history buildings is also offered. Visit the 1900 C gallery to remember the past.

*Opening times*  Open Monday to Friday 10.00am to 5.00pm, Saturday 10.00am - 1.00pm and 2.00pm to 5.00pm Closed Bank Holidays.

## RHODES MEMORIAL MUSEUM

South Road, Bishop's Stortford, Hertfordshire CM23 3JG
Telephone 01279 651746

Life and times of Cecil John Rhodes including the Birthplace Room, guided tours by arrangement.

*Opening times*  Open Tuesday to Saturday 10.00am to 4.00pm throughout the year Closed Sunday and Monday (last admission 3.30pm)

## HARPENDEN RAILWAY MUSEUM

235 Luton Road, Harpenden, Hertfordshire AL5 3DE
Telephone 01582 713524

Collection of local railway relics in a garden setting, signal box, working signals, notices, signs and much more.

*Opening times*  Open one or two periods in the Summer, 11.00am to 5.30pm, please phone for details

## ROYSTON & DISTRICT MUSEUM

Lower King Street, Royston, Hertfordshire SG4 8UG
Telephone 01763 242587

Displays local history and archaeology. There are monthly temporary Art Exhibitions. Royston tapestry on display. Loan collection of ceramics and glass. Reserve collection of local stamps and postmarks. Local painters.

*Opening times*  Open all year Wednesday, Thursday and Saturday 10.00am to 5.00pm, in addition Easter to end October, Sunday and Bank Holiday Monday 2.00pm to 5.00pm, other times by appointment

BEDFORDSHIRE, BERKSHIRE, BUCKINGHAMSHIRE & HERTFORDSHIRE

*BEDFORDSHIRE, BERKSHIRE, BUCKINGHAMSHIRE & HERTFORDSHIRE*

### ASHWELL VILLAGE MUSEUM
Swan Street, Ashwell, Hertfordshire SG7 5NY
Telephone 01462 742956

Village life from the stone age to the present day displayed in a Tudor timber framed building.

    ***Opening times*** Open Sundays and bank Holidays 2.30pm to 5.00pm, parties any time by appointment

### WYCOMBE LOCAL HISTORY & CHAIR MUSEUM
Castle Hill House, Priory Avenue, High Wycombe, Buckinghamshire
HP13 6PX
Telephone 01494 421895 Fax: 01494 421897

Both permanent and changing displays and events exploring the history and culture of the Wycombe district, with particular focus on the furniture industry.

  ***Opening times*** Open daily 10.00am - 5.00pm except Sundays and Bank Holidays

### STOCKWOOD CRAFT MUSEUM & GARDENS
Stockwood Country Park, Farley Hill, Luton, Bedfordshire
LU1 4BH
Telephone 01582 738714/546739 Fax: 01582 546763

Rural trades and crafts Museum, exquisite period gardens and the Mossman collection of horse drawn vehicles plus free admission make a lovely day out for everyone. Ring for more information.

  ***Opening times*** Open March to October Tuesday to Sunday 10.00am to 5.00pm, November to March Saturday and Sunday only 10.00am to 4.00pm. Closed Christmas Day, Boxing Day and New Years Day

### WEST BERKSHIRE MUSEUM
The Wharf, Newbury, Berkshire RG14 5AS
Telephone 01635 30511 Fax: 01635 519562

Housed in 17th Century cloth hall and 18th Century granary building. Displays include natural history, archaeology, local history and rural crafts, costume, the Civil War in Newbury and the history of ballooning. Access to ground floor only for disabled. Nearby Council car park.

  ***Opening times*** Open April to September daily, except Wednesdays during School Terms 10.00am to 5.00pm, Sunday and Bank Holidays 1.00pm to 5.00pm. October to March close at 4.00pm and closed Sundays and Bank Holidays

### LETCHWORTH MUSEUM & ART GALLERY
Broadway, Letchworth, Hertfordshire SG6 3JB
Telephone 01462 685647 Fax: 01462 481879

The museum features a downstairs natural history gallery with attractive modern displays. The art gallery upstairs has monthly changing exhibitions. Don't miss the archaeology gallery with the Chieftan's burial display. Guided tours on request.

  ***Opening times*** Open all year Monday to Saturday, 10.00am to 5.00pm (last admission 4.55pm). Closed during Bank Holidays

# CAMBRIDGESHIRE & NORTHAMPTONSHIRE

No other region in the British Isles can claim quite such a vast variation of scenery as Cambridgeshire... a flat, wide and almost treeless landscape interwoven with rivers and criss-crossed by canals. The region contains a large expanse of the Fens, through the centuries drained until virtually all that is left in its original state is Wicken Fen, the National Trust's nature reserve.

Northamptonshire, 'the county of spires and squires' is primarily a farming county. However the traditional boot and shoe industry of Northampton, the county town, is wonderfully illustrated in the quite remarkable footwear collection in the Central Museum. The Bedford Level, low and marshy by the Cambridgeshire border rises to the south towards Towcester and its fascinating Canal Museum. The western uplands of the county, a range of chalk is an extension of the Oxfordshire Cotswolds...a region of gloriously undulating landscape and fine stone churches.

Cambridgeshire, which includes the Soke of Peterborough and the Isle of Ely can boast a wealth of historic sites and spectacular buildings. Ely, the octagonal tower of its superb cathedral standing like a beacon over the surrounding low-lying land is home to a magnificent Stained Glass Museum. Peterborough's impressive Norman cathedral, one of the finest in Britain contains the tomb of Catherine of Aragon, Henry VIII's first wife, while at the Peterborough Museum and Art Gallery are the quite remarkable Bronze Age Flag Fen archaeological discoveries. But for sheer beauty few cities can match Cambridge, the county town. Dominating the city is King's College Chapel, renowned for its magnificent fan-vaulting, and its Rubens' painting, 'The Adoration of the Magi'. The city is a veritable treasure house of remarkable architecture and historic building. Much of its history and traditions imaginatively displayed in the excellent County Folk Museum and the impressive Imperial War Museum.

Cambridgeshire and Northamptonshire are counties of personalities, their stories carefully preserved in collections of memorabilia...the Abington Museum tells the story of Northamptonshire's military history both at home and abroad, in a glorious fifteenth century manor house.

**39**

# CAMBRIDGE & COUNTY FOLK MUSEUM

2-3 Castle Street, Cambridge CB3 0AQ
Telephone 01223 355159  Fax 01223 576301

Cambridge and County Folk Museum is housed in a fine late 15th century timber-framed building. It was "The White Horse Inn" from the 17th century until 1934.

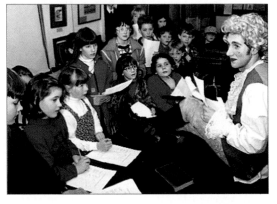

Two years later the museum opened in its place. The collection reflects the everyday lives of people in Cambridge and the surrounding area from 1600 onwards.

The 9 display rooms each have a different theme-ranging from toys and games, to the fens and domestic life. With over 20,000 objects on display visitors can always find something that particularly catches their eye - from butter churn to stuffed alligator to 200 year old wedding cake decoration.

The museum also offers temporary exhibitions, children's activity sheets, guided tours and an education service for schools.

Admission charge:
£2 Adults, £1 Concessions, 50p Children

### Opening times
Open April to September,
Monday to Saturday
10.30am to 5.00pm
Sunday
2.00pm to 5.00pm
Open October to March,
Tuesday to Saturday
10.30am to 5.00pm
Sunday
2.00pm to 5.00pm

▶ Print of a 19th century town and gown fight

▶ A doll from the extensive toy collection

▲ Activity for schools

### Directions
The Folk Museum is on the corner of Northampton and Castle Street (entrance on Castle Street). It is next door to Kettle's Yard House and Gallery.

▲ Cambridge & County Folk Museum

# IMPERIAL WAR MUSEUM DUXFORD
Duxford, Cambridge CB2 4QR
Telephone 01223 835000 Fax 01223 837267

Duxford is the most popular aviation museum in Europe, housing over 150 historic aircraft spanning the 20th century, and is also home to famous civilian aircraft such as Concorde.

The Award Winning American Air Museum features the finest collection of historic American combat aircraft outside the United States. Duxford also has an impressive array of tanks and military vehicles on show in the dramatic land warfare Exhibition Hall.

During the summer months Duxford hosts World famous air displays. Historic aircraft restoration is a fascinating aspect of this dynamic museum and visitors will see this vital work taking place. Special exhibitions and interactive displays complement the museum's exhibits.

The operations rooms has been meticulously reconstructed to its Battle of Britain appearance, and the high tech ride simulator gives visitors the opportunity to experience a dogfight for themselves or you can really take to the skies with a flight in an elegant 1930's bi-plane.

Duxford is just south of Cambridge on the M11, and is open daily from 10am. The site has ample free parking and site transport, a licensed restaurant and shop, parent and baby and disabled facilities. Guided tours are available, and special reductions are offered for families and groups.

---

## Opening times

Open daily except 24th, 25th & 26th December
Summer
10.00am to 6.00pm
Winter
10.00am to 4.00pm

---

## Directions

Eight miles South of Cambridge by junction ten of the M11. Accessible from A1, M1 and the North, and by bus from Cambridge (01223 423554). And London (0990 808080). Rail information: 0345 484950

▲ A view shot from inside the Award winning American Air Museum

▲ Duxford's operations room reconstruction to its Battle of Britain appearance

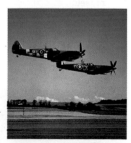

▲ Two Spitfires at one of Duxford's World famous air displays

◄ Restoration is a vital part of this living museum's work

*CAMBRIDGESHIRE & NORTHAMPTONSHIRE*

CAMBRIDGESHIRE & NORTHAMPTONSHIRE

# THE STAINED GLASS MUSEUM
Ely Cathedral, Ely, Cambridgeshire CB7 4DL
Telephone 01353 660347 Fax 01223 327367

The Stained Glass Museum, situated in one of Europe's finest mediaeval cathedrals in Ely, Cambridgeshire, is the only national museum in the United Kingdom dedicated to the rescue and display of stained glass.

Its growing collection traces the development of stained glass from the Middle Ages to the present. The United Kingdom has an unrivalled heritage of stained glass - yet of all the arts it is the least understood.

The permanent collection of which over 100 original panels are on display, allows the visitor to study at close quarters the skill and artistry of the glass painter.

The different sections of the exhibition illustrate the mediaeval and pictorial traditions leading up to the glorious Gothic Revival.

The 20th century section has examples of the work of Morris and Company, Scottish and Irish schools and examples by contemporary artists.

The museum offers lectures and guided tours, an education pack and school days in cooperation with the cathedral.

The Museum also runs stained-glass workshops and master classes on the art of glass-painting:- please contact the Museum for further details.

### Opening times
Open daily Summer
Monday-Friday
10.30am to 5.00pm
Saturday
10.30am to 5.30pm
Sunday
12.00pm to 5.00pm
Winter
Monday-Friday
10.30am to 4.30pm
Saturday
10.30am to 5.00pm
Sunday
12.00pm to 4.15pm
Last admission 30 minutes before closing

### Directions
Take A10 north from Cambridge or King's Lynn. Or A142 from Newmarket. From west A14 to Huntingdon then A1223 to Stretham to join A10 north. Find museum inside Ely Cathedral.

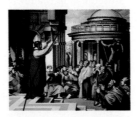

▲ Kneeling Angel 1893, Harrington Mann. Originally in Trinity Church, Glasgow

▲ Stained glass master class at the Museum

▲ St Wilfrid and St John Berchmans 1927 Harry Clarke

◄ St Paul preaching at Athens, William Collins 1820/30

# CROMWELL MUSEUM

Grammar School Walk, Huntingdon, Cambridgeshire PE18 6PH
Telephone 01480 375830 Fax 01480 459563

1999 marks the 400th anniversary of the birth of Oliver Cromwell. The Cromwell Museum in Huntingdon, his birthplace, is the old town Grammar School where Cromwell was a pupil.

The Museum is marking the year with a series of small exhibitions. January to March "Statues and Stained Glass - representations of Cromwell". April to June "Cromwell collections - past, present and future". July to September "Cromwell's head and its curious history". October to December "Remembering Cromwell - Cromwell in popular culture".

These exhibitions form part of a national programme of events which includes a special anniversary weekend in Huntingdon on 24th and 25th April. For further details contact the Museum.

The museum's permanent collection includes portraits of

Cromwell and leading figures of the period. There are also coins, medals and personal objects known to have been owned by him. The Museum is the only collection concerned solely with Oliver Cromwell and is provided by Cambridgeshire County Council.

## Opening times

Open 1st April to 31st October Tuesday-Friday
11.00am to 1.00pm/
2.00pm to 5.00pm
Saturday-Sunday
11.00am to 1.00pm/
2.00pm to 4.00pm
1st November to 31st
March Tuesday-Friday
1.00pm to 4.00pm
Saturday
11.00am to 1.00pm/
2.00pm to 4.00pm
Sunday
2.00pm to 4.00pm
Closed Bank Holidays
except Good Friday

## Directions

Huntingdon is on the A14, 16 miles west of Cambridge. The Museum is in the town centre at the north west corner of the Market Place, opposite All Saints Church.

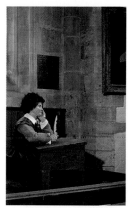

▲ Cromwell was taught in the Grammar School now the Museum

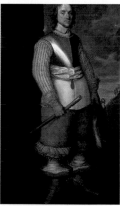

▲ Oliver Cromwell 1599-1658 by Robert Walker

▶ Cromwell's personal seal, made with three faces

CAMBRIDGESHIRE & NORTHAMPTONSHIRE

# NORRIS MUSEUM

The Broadway, St Ives, Huntingdon, Cambridgeshire PE17 4BX
Telephone 01480 465101

The Norris Museum is the Museum of Huntingdonshire. It tells the story of this historic county from earliest times to the present day.

The oldest objects in the Museum are fossil remains of animals that lived in Huntingdonshire 160 million years ago, when the county lay at the bottom of the sea. Our displays include fossils and models of the great marine reptiles - Ichthyosaurs and Plesiosaurs, relatives of the dinosaurs - that lived here then.

A more recent inhabitant was the Woolly Mammoth, which lived in Huntingdonshire during the Ice Ages - you can see its bones, teeth and a tusk.

People have lived in Huntingdonshire for a quarter of a million years. On display at the Norris are the flint tools of the first Stone Age settlers, weapons and pottery from the Bronze Age and the Iron Age, and finds from Roman settlements and cemeteries.

We have arms and armour from the Civil War (Oliver Cromwell was born at Huntingdon in 1599) and a display on the local sport of ice skating on the flooded Fens.

The Museum also has an art gallery and temporary exhibition room and the Museum building stands in a picturesque riverside garden.

## *Opening times*

Open all year
May to September:
Monday to Friday
10.00am to 1.00pm,
2.00pm to 5.00pm;
Saturday
10.00am to 12.00pm,
2.00pm to 5.00pm;
Sunday
2.00pm to 5.00pm.
October to April:
Monday to Friday
10.00am to 1.00pm,
2.00pm to 4.00pm;
Saturday
10.00am to 12.00pm
Closed Christmas Day,
Boxing Day, New Year's
Day, Good Friday

## *Directions*

St Ives is close to the A14, between Huntingdon and Cambridge. The Norris Museum is beside the river, near the parish church - follow signs for "Town Centre West"

▲ A model plesiosaur and other exhibits in the display gallery

▲ Finds from the Roman town of Godmanchester

▲ Part of an officer's uniform from the old Huntingdonshire regiment

◄ The Norris Museum in its attractive garden

## PETERBOROUGH MUSEUM & ART GALLERY

Priestgate, Peterborough, Cambridgeshire PE1 1LF
Telephone 01733 343329 Fax 01733 341928

The Museum tells the story of Peterborough· from the time of the dinosaurs to the present day.

Displays range from prehistoric reptiles which swam in the area 150 million years ago, to bone and straw artefacts made by Prisoners of War at the famous Napoleonic Prison Camp at Norman Cross.

There are also extensive displays of local archaeology and social history, and small displays of famous people such as the local poet John Clare (1793-1864), and Mary Queen of Scots who was executed at nearby Fotheringhay.

The art gallery has an ever changing programme of exhibitions to cater for all tastes. The museum is located in the city centre and admission is free.

### Opening times

Open Tuesday-Saturday
10.00am to 5.00pm
Except Good Friday,
New Years Day and
Christmas

▶ The art gallery is spacious and very welcoming

### Directions

Located in city centre five minutes walk from rail and bus stations. Well signposted from all main routes, follow city centre. Car parking available at Queensgate and elsewhere nearby.

▲ The Museum

◀ A spine from a dinosaur found in a local brickpit

▼ 'Jurassic Week' one of many exhibitions held recently

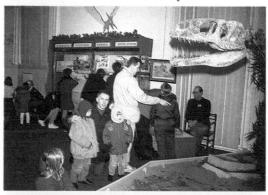

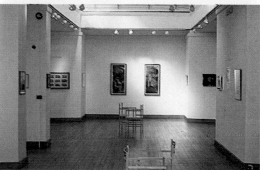

CAMBRIDGESHIRE & NORTHAMPTONSHIRE

# THE CANAL MUSEUM

Stock Bruerne, Towcester, Northamptonshire NN12 7SE
Telephone 01604 862229 Fax 01604 864199

Housed in a restored cornmill in the picturesque village of Stoke Bruerne, the collection vividly portrays the heritage of 200 years of inland waterways.

The fascinating and colourful insight into a transport system, fundamental to the industrial revolution in Britain, its complemented by the 'living canal' outside with its flight of locks, boats and one and three quarters mile long Blisworth Tunnel.

Explore the mysteries of this intriguing part of our heritage through working models, videos, pictorial and three dimensional displays portraying every aspect of waterways. From amazing feats of engineering to the shining brass and colourful decoration that contrasts so sharply with the harsh reality of canal life, you will find something to interest all the family.

The museum runs courses on narrow boat decoration and ropework.
The Museum shop stocks fine quality souvenirs, postcards, painted canal ware and a wonderful selection of waterway gifts.

In particular we offer the most comprehensive range of canal books in the country. Boat trips are usually available.

### *Opening times*

Summer season daily
10.00am to 6.00pm
including Bank Holidays
Winter Season
Tuesday to Sunday
10.00am to 4.00pm
Closed Mondays
and also Christmas Day
and Boxing Day
(last admission 30
minutes before closing)

### *Directions*

The Canal Museum is south of Northampton, 10 minutes from both the A5 and junction 15 of the M1 motorway.

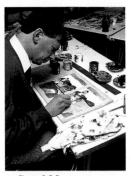

▲ Canal Museum course in traditional narrow boat decoration

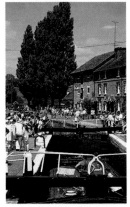

▲ Canal Museum, top lock and Morris Dancers at Stoke Bruerne

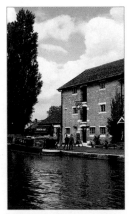

▲ Canal Museum, Stoke Bruerne on the Grand Union Canal, Northamptonshire

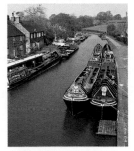

▲ Working narrow boats, canal museum, Stoke Bruerne, Grand Union Canal

# RAILWORLD

Oundle Road, Peterborough, Cambridgeshire PE2 9NR
Telephone 01733 344240 Fax: 01733 344240

Railworld highlights modern train travel worldwide and how transport relates to the environment. Railworld's Model Railway is impressive. There are "Steam Age" exhibits, two large locomotives, Britain's Hover train and Flowerbeds! Guided tours by arrangement, Cafe open at weekends.

***Opening times*** Open March to October daily, 11am to 4pm (last admission generally 4pm) Open November to February same times but Mondays to Fridays only

# LONGTHORPE TOWER

Thorpe Road, Longthorpe, Peterborough, Cambridgeshire PE1 1HA
Telephone 01733 268482

Finest mediaeval secular wall paintings in Northern Europe, housed in the camber of a fortified 14th Century tower which is joined to a manor house: Tower owned by English Heritage. Custodian will give talks on the paintings.

***Opening times*** Open April to end October weekends and Bank Holidays only 12.00pm to 5.00pm (last admission 4.30pm)

# SACREWELL FARM & COUNTRY CENTRE

Thronhaugh, Peterborough, Cambridgeshire PE8 6HJ
Telephone 01780 782254 Fax: 01780 782254

Working water mill, bygones, gardens, children's play area and many friendly farm animals, suitable for all ages. Gift shop and Miller's Kitchen. Open for light refreshments between 9.30 am to 5.30 pm.

***Opening times*** Open all year round

# DAVENTRY MUSEUM

The Moot Hall, Market Square, Daventry, Northamptonshire NN11 4BH
Telephone 01327 302463 Fax: 01327 876684

Local and social history of Daventry and district, with regularly changing temporary exhibitions of arts and crafts. History of local BBC transmitter station and iron age Hillfort on Borough Hill.

***Opening times*** Open April to September Monday to Saturday 10.00am to 5.00pm
October to March Monday to Saturday 10.00am to 3.30pm

# RUSHTON TRIANGULAR LODGE

Desborough Rd, Rushton, Kettering, Northamptonshire NN14 1RP
Telephone 01536 710761

Probably the strangest building in Britain, this bizarre building has three sides and three storeys. Built to represent a mans Catholic faith during the 16th Century.

***Opening times*** Open April to October 10.00am to 6.00pm April to September
10.00am to dusk October

## ABINGTON MUSEUM

Abington Park, Northampton
Telephone 01604 631454

The museum is housed in a 15th Century Manor House. Displays include a room with 16th Century oak panelling, Victorian cabinet of curiosities, military history, fashion gallery and Northampton life.

*Opening times*  Open Tuesday to Sunday 1.00pm to 5.00pm, Bank Holiday Mondays
1.00pm to 5.00pm Closed Christmas Day, Boxing Day and New Years Day

## CENTRAL MUSEUM & ART GALLERY

Guildhall Road, Northampton NN1 1DP
Telephone 01604 639415 Fax: 01604 238720

The museum houses the largest boot and shoe collection in the world. Also on display, Northampton's history, Oriental and British ceramics, Italian 15th -18th Century paintings and British art and leather work.

*Opening times*  Open all year, closed Christmas Day, Boxing Day, New Years Day
Monday to Saturday 10.00am to 5.00pm and Sunday 2.00pm to 5.00pm

## DIANA - A CELEBRATION

Althorp, Northamptonshire NN7 4HQ
Telephone 01604 770107 Fax: 01604 770042
Website http://www.althorp.com

An exhibition celebrating the life of Diana, Princess of Wales and honouring her memory after her death. The freshness and the modernity of the facilities are a unique tribute to her. All visitors are requested to apply in advance for an invitation to visit Althorp.

*Opening times*  Opening times and admission charges
to be announced in January 1999

## IRCHESTER NARROW GAUGE RAILWAY MUSEUM
Irchester Country Park, Wellingborough, Northamptonshire
Telephone 01234 750469

Industrial narrow gauge Railway Museum - working exhibits and regular demonstrations. Four steam locomotives and four diesel locomotives plus rolling stock. The museum is a registered charity.

*Opening times*  Open every Sunday throughout the year (except Christmas) and
Bank Holidays Summer 10.00am to 5.00pm, Winter 10.00am to 4.00pm

## WOLLASTON MUSEUM
102 High Street, Wollaston, Northamptonshire NN29 7PQ

Archaeological finds, old maps and photographs, pillow lace and hand-made footwear tools. Industrial and agricultural equipment. Paintings by local artists. Postcards available of village.

*Opening times*  Open Easter Sunday until last Sunday in September
2.30pm to 4.30pm

# CHESHIRE, MERSEYSIDE & GREATER MANCHESTER

In 1974 Merseyside was formed from Cheshire and Lancashire to cover the sprawling city of Liverpool, Britain's chief trans-Atlantic port. Three miles inland from the Irish Sea the city has no less than 2,000 acres of docks. The days of the great ocean going liners have gone but much of the associated architecture remains...the Royal Liver Building of 1911 and the Cunard Building of 1917. The Albert Dock has been innovatively renovated to include cafes and shops, and the northern Tate Gallery. William Hesketh Lever, Lord Leverhulme, industrialist and philanthropist is remembered in the Port Sunlight Village. Here the Lady Lever Art Gallery contains Leverhulme's world-famous collection of Pre-Raphaelite paintings.

Liverpool's sister Manchester, though dating back to the Roman era is predominantly Victorian. The Castlefield district, the junction of the network of canals leading into the city from outlying industrial towns has been wonderfully developed as an urban heritage park. The magnificent Gothic town hall with its rich interior and spectacular paintings by Ford Madox Brown tell of the city's Victorian prosperity.

Chester, a port until silting-up forced it to relinquish its sea trade to its neighbour Liverpool, is a city of great age, remarkable charm and some of the finest half-timbered buildings in the world. The city's long military associations are wonderfully displayed in the Cheshire Military Museum at the castle, while at the opposite end of the scale, Chester's Toy and Doll Museum displays a wonderful collection of children's toys through the ages. Chester is of course the hub of Cheshire life. In the past, as guardian of the Welsh Marches, the city played a dual role as centre of opposition to Welsh incursions and as a base for attacks into Wales. It was during the Middle Ages that the quaint two-tier shopping galleries known as the Rows were built.

The rolling farmland changes abruptly in the northwest of the county where Alderley Edge, a National Trust property overlooks the Cheshire plain. The interesting Salt Museum at Northwich deals with the history of salt making in Cheshire, while in Roe Street, Macclesfield, the award winning Silk Museum offers guided tours of Paradise Mill, a working silk mill until 1981. In Wilmslow, Quarry Bank Mill is a fine Georgian water-powered cotton spinning mill set in 300 acres of parkland.

*CHESHIRE, MERSEYSIDE & GREATER MANCHESTER*

# MERSEYSIDE MARITIME MUSEUM

Albert Dock, Liverpool L3 4AQ
Telephone 0151 4784499 Fax 0151 4784590

Set in the heart of Liverpool's magnificent waterfront, the Merseyside Maritime Museum offers a unique insight into the history of the Great Port of Liverpool, its ships and its people.

Discover the opulence of the floating Palaces of the Edwardian age, in a gallery telling the dramatic stories of the Titanic and Lusitania.

Highlights include the original shipbuilders model of the Titanic and a survivors life jacket from the ill-fated ship. Embark on a voyage in the Emigrants to a New World Gallery.

Experience the hardships of the nine million people who sailed from Liverpool between 1830 and 1930. Visit the Transatlantic Slavery Gallery and discover the African story that must never be forgotten. This award-winning gallery seeks to increase the understanding of what has happened to people of African descent in the modern world by looking at the origins of Transatlantic Slavery and its legacy today.

The Maritime Café and shop overlook the historic Albert Dock. The cafe offers a selection of hot and cold meals, cakes and refreshments.

The Museum Shop has a wide selection of gifts and souvenirs including books, postcards and posters.

## Opening times

Open all year
10.00am to 5.00pm daily
Closed 23rd to 26th
December and
1st January

## Directions

The Museum is in the Albert Dock which can be reached by heading into Liverpool city centre and following brown signs. Nearby is James Street Railway Station (Merseyrail).

▲ Outside view of the Merseyside Maritime Museum

▲ On board a Packet Ship in Emigrants to a New World

▲ Notorious local smuggler Mother Redcap at the Customs and Excise Museum

▼ Visitors are shown how to put a ship in a bottle

# SUDLEY HOUSE
Mossley Hill Road, Liverpool, L18 5BX
Telephone 0151 7243245

Sudley House. Proof that the greatest treasures aren't always in the best known places.

Home of Victorian Shipowner George Holt, filled with his fine collection of 18th and 19th century art, Sudley House belongs to Merseyside. Bequeathed to Liverpool by George Holt's daughter Emma in 1944, the house holds her father's collection still intact.

Victorian Liverpool was full of great merchant's houses with their own private art collections. Only the pictures at Sudley House have survived in their original setting.

The house contains George Romney's haunting portrait of the beautiful Mrs Sargent and works by Gainsborough, Landseer, the Pre-Raphaelite Brotherhood and landscapes by Corot and Turner.

Furniture, tiles, mosaics, stained glass, original wallpapers, Victorian interior decoration and craftsmanship at its finest.

Sudley House tells you as much about the man as it does about the paintings. Come and see why they meant so much to him.
When you have finished enjoying the art works, refresh yourself in the elegant surroundings of Sudley House's delightful Victorian tea rooms.

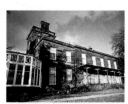
▲ Sudley House

### *Opening times*

Open all year except 23rd to 26th December and 1st January
Monday to Saturday 10.00am to 5.00pm
Sunday 12.00pm to 5.00pm

▲ Main staircase at Sudley House

### *Directions*

Sudley House is in the suburb of Mossley Hill, north from the city centre. Railway stations at Mossley Hill and Aigburth are a short walk away.

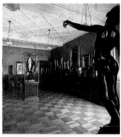
▲ ▼ Interior views at Sudley House

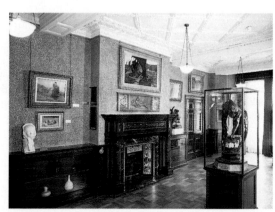

CHESHIRE, MERSEYSIDE & GREATER MANCHESTER

## LIVERPOOL MUSEUM
William Brown Street, Liverpool, L3 8EN
Telephone 0151 4784399 Fax 0151 4784390

Founded in 1851 and occupying more than 15,000 square metres. Displays range from the wonders of the Rain Forests to Outer Space.

Key features include the Natural History Centre, Time and Space Galleries and a Planetarium, Vivarium and Aquarium. There are also Decorative Art, Archaeology and Ethnology and Land Transport galleries.

There is a changing programme of temporary exhibitions. Liverpool Museum is an encyclopaedia brought to life.

Take a fascinating journey from the Dawn of time through past ages when Dinosaurs ruled the earth and on to life as we know it in the space age.

Visitors can travel across Continents from the Tundra, through Rain Forests to the African Savanah. Take a look at the Natural World in the Aquarium, from Britain's canals and ponds to our own coastlines and seas around the World.

Find out about treasures from ancient Egypt, including Mummies, the Greeks and the Romans and

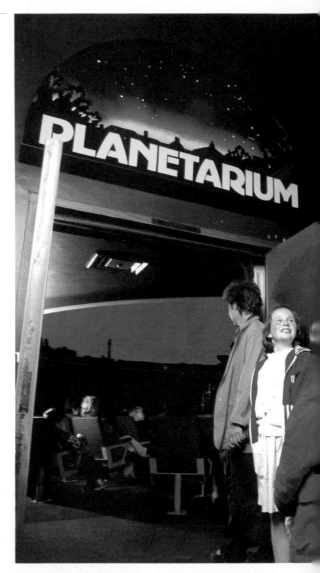

then travel to Anglo - Saxon England. The Transport Gallery has fine examples of 19th century vehicles including a horse-drawn steam powered fire engine and the steam locomotive Lion.

Explore the world around you at Liverpool Museum.

### Opening times

Open all year except
23rd to 26th December
and 1st January
Monday to Saturday
10.00am to 5.00pm
Sunday
12.00pm to 5.00pm

### Directions

The Museum is in
Liverpool City Centre.
Follow road signs for
same then brown and
white signs for Museum.
Lime Street Railway
Station and Queen
Square bus station
are nearby.

▼ View of the Natural History Centre

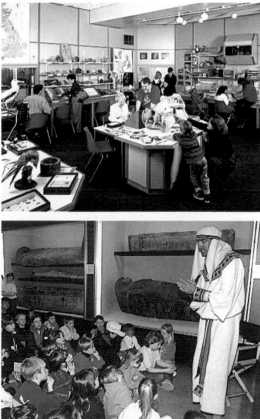

▲ Children's storytelling session

CHESHIRE, MERSEYSIDE & GREATER MANCHESTER

## PARADISE MILL
Old Park Lane, Macclesfield, SK11 6TJ
Telephone 01625 618228 Fax 01625 617880

Paradise Mill was a working Silk Mill until 1981. Today it is a living museum.

The Jacquard Silk Handlooms have been restored with knowledgeable and entertaining guides, many of whom have worked in the industry, demonstrating the intricate production processes.

Exhibitions and room settings illustrate life in Paradise Mill in the 1930s.

Visits can be arranged outside opening hours. The Silk Museum is five minutes walk away.

▼ Jacquard Handlooms in Paradise Mill

### Opening times

Open
Tuesday to Sunday
1.00pm to 5.00pm
Closed Monday except
Bank Holidays
1.00pm to 5.00pm
Closed Christmas Eve
to 4th January.
November to March
1.00pm to 4.00pm.
Last admission half an
hour before closing.

### Directions

Follow brown signs to
town centre from
Churchill Way
turn into Roe Street.
Parking available on
right in Duke Street,
walk downwards and
turn right into
Old Parklane at the
bottom of the hill

▲ Demonstration of weaving at Paradise Mill

## THE MUSEUM OF SCIENCE AND INDUSTRY IN MANCHESTER
Liverpool Road, Castlefield, Manchester M3 4FD
Telephone 0161 8322244 Fax 0161 8332184

The Museum of Science and Industry in Manchester is based in the buildings of the world's oldest passenger railway station. Using colourful displays and hands-on exhibitions it demonstrates the region's cultural heritage.

Permanent exhibitions include the Power Hall, containing the world's largest collection of working steam mill engines, and the Air and Space gallery, packed with magnificent planes that made flying history. In Xperiment! the hands-on science centre, visitors can see colours reflected in bubbles, write their name in lights and make music in the air.

The Electricity and Gas Galleries examine how energy has changed people's lives. Underground Manchester traces the development of water supply and lets you walk through a reconstructed sewer!

Manchesters textile industry, past and present, is explored in Fibres, Fabrics and Fashion. Discover how cotton made 19th century Manchester one of the most powerful cities in the world!
The Futures exhibition

looks at the history as well as the future of leading-edge technologies. It features a rebuild of the world's first stored program computer, known as 'The Baby' and a Digital Access Centre.

The Museum has a programme of changing exhibitions, including (in 1999) Dinosaurs- Big Bold and Dangerous! K'nex and Science of Sport. Call for more details on 0161 8322244

### Opening times

Open all year
10.00am to 5.00pm
except 24,25,26
December
Last admission 4.30pm

### Directions

Museum is in Castlefield (follow brown tourist signs). Nearest railway station - Deansgate. Nearest metrolink station - G-mex. Bus no.33 from Piccadilly Gardens stops outside the Museum on Liverpool Road.

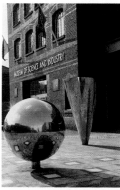

▲ The Museum of Science and Industry

▲ The wheels of industry turning in the Power Hall

▲ Xperiment! the hands-on Science centre

▲ Air and Space Gallery

CHESHIRE, MERSEYSIDE & GREATER MANCHESTER

## GALLERY OF COSTUME
Platt Hall, Rusholme, Manchester, M14 5LL
Telephone 0161 2245217 Fax 0161 2563278

The Gallery of Costume was opened at Platt Hall in 1947, and was the first Museum in Britain to specialise in dress and fashion.

Its collection of dress and accessories is one of the largest in Britain, containing around 20,000 items.

The clothes in the collection date from 1600 to the present day, and relate to all ages, social classes and both sexes.

An extensive library of fashion books, magazines, catalogues and prints is available to students and researchers by appointment.

Only a small amount of the collection is on display at one time. Current displays include: 17th century dress and embroidery, women's dress 1740-1840, Victorian dress, women's fashion 1890-1950, fashion since the sixties, textiles and embroideries from India, and "Cover Up", an interactive display for children. Admission free.

▲ French fashion illustration showing outfits for February 1931

▲ Detail of Man's embroidered court suit, about 1780

Special activity sessions
for schools can be booked.
Wednesday afternoon
talks and Saturday
embroidery and textile
workshops held
September-April. Contact
Gallery for details.

***Opening times***
Open daily
March to October
10.00am to 5.30pm
November to February
10.00am to 4.00pm
Last admission 15
minutes before closing

***Directions***
The gallery is based in
Platt Fields Park on
Wilmslow Road in
Rusholme, three miles
south of the city centre.
Buses 40-49. Free
parking available.

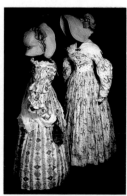

Printed cotton summer ▶
dresses, about 1835

CHESHIRE, MERSEYSIDE & GREATER MANCHESTER

# LADY LEVER ART GALLERY

Port Sunlight Village, Wirral, L52 5EQ
Telephone 0151 4784136 Fax 0151 4784140

Over 100 years ago, William Hesketh Lever had a dream: to transform a barren piece of land on the Wirral peninsula into a beautiful place to live for his soap factory workers.

Today, the picturesque village of Port Sunlight (named after his famous Sunlight soap) is his wonderful legacy.

The Jewel in the Crown of this delightful garden village is truly Wirral's best kept secret - the magnificent Lady Lever Art Gallery, named in honour of his beloved wife. Within its opulent walls you will find a superb collection of romantic Pre-Raphaelite masterpieces including works by Millais, Ford Madox Brown and Rossetti as well as dramatic landscapes by Constable and Turner.

Explore further to discover magnificent collections of Wedgwood ceramics, outstanding carved and inlaid 18th century furniture, superb tapestries, fine Greek vases, imposing Roman sculpture and delicate Chinese porcelain.

These works of art are brought to life with a personalised tour using a hand-held audio guide which is included in the admission price.

The Gallery Shop has a superb range of souvenir gifts and postcards. Visitors can choose from a mouth watering selection of hot and cold meals, cakes and refreshments in the popular Lady Lever Cafe.

### Opening times

Open all year except 23rd to 26th December and 1st January
Monday to Saturday 10.00am to 5.00pm
Sunday 12.00pm to 5.00pm

### Directions

From Liverpool, drive through Birkenhead Tunnel following signs for Port Sunlight then brown and white signs for gallery. By train to Bebington Station (Merseyrail). Gallery is two minute walk away.

▲ William Hesketh Lever - founder of the Lady Lever Art Gallery

▲ Lady Lever Art Gallery

▲ Cafe at the gallery

▼ The main hall at Lady Lever Art Gallery

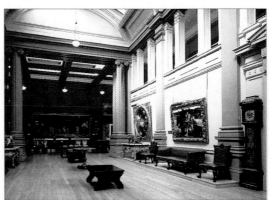

# DUNHAM MASSEY HALL

The National Trust, Altrincham, Cheshire WA14 4SJ
Telephone 0161 9411025 Fax 0161 9297508

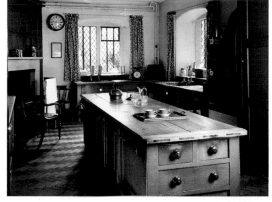

Originally an early Georgian house, Dunham Massey was extensively reworked in the early years of this century; the result is one of Britain's most sumptuous Edwardian interiors, housing exceptional collections of walnut furniture, paintings and Huguenot silver.

Over thirty rooms are open, the 2nd Earl of Warrington's Library still houses three thousand books and his scientific instruments, including an 18th century orrery. In the Victorian billiard room an unusual wooden bed billiard table, together with "maces", the precursors to cues, can be seen. There is a vast kitchen complex.

The richly planted garden contains waterside plantings, late - flowering azaleas, as well as an Orangery, Victorian bark house and well house. The surrounding deer park was laid out in the early 18th century and contains a series of beautiful avenues and walks.

### *Opening times*

House & Garden:
Open April to October
House: Saturday to
Wednesday
12.00pm to 5.00pm
(last admission 4.30pm)
Garden: Daily
11.00am to 5.30pm
(last admission 5.00pm)
Shop, Restaurant, Park
open daily all year

▲ The Butler's pantry

▼ The 2nd Earl of
Warrington's orrery

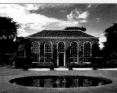

▶ The 18th century
orangery

▼ The Great Gallery

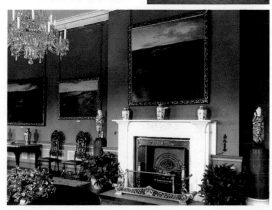

### *Directions*

Three miles south-west of Altrincham off the A56. Junction 19 of M6, junction 7 of M56. No.38 bus from Altrincham interchange (served by rail and metrolink).

CHESHIRE, MERSEYSIDE & GREATER MANCHESTER

# CHESHIRE MILITARY MUSEUM

The Castle, Chester, Cheshire CH1 2DN
Telephone/Fax 01244 327617

"Interesting",
"amusing",
"educational",
"delightful"
"brilliant"
- comments from our
visitors.

The Museum features
the life and times of the
soldiers of Cheshire
over the last three
hundred plus years.

The Cheshire
Regiment, Cheshire
Yeomanry and
Representative
collections of 5th Royal
Inniskilling Dragoon
Guards and 3rd
Carabiniers with new
from 1999 Eaton Hall
Officer Cadet School.

Uniforms, weapons,
medals, badges and
memorabilia on display
and a big archive is
also available for
researchers if booked
in advance.

The museum is to be
redeveloped in 2000
to a modern
interpretation.
Meanwhile see a
more traditional
representation with
tableaux, models and
interpretative notes.

Art in the army and a
special self guided walk
around tour for the
ladies. Well worth
spending a couple of
hours here whilst in
Chester.

## Opening times

Open daily
10.00am to 5.00pm
(last admission 4.30pm)

## Directions

From town centre
follow castle signs
we are left wing
building of the
Greek Revival Castle
buildings next to the
Crown Court
nearest to town.

▲ Yeoman in action
1941 Syria last mounted
campaign

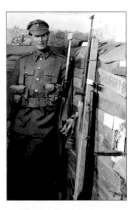

▲ Soldier in the
trenches World War I

▲ Volunteer uniform
1802

◄ World War II drum
hidden 1940 returned in
1995

## SILK MUSEUM

Roe Street, Macclesfield, Cheshire SK11 6UT
Telephone 01625 613210 Fax 01625 617880

The Silk Museum is housed within the Heritage Centre, built in 1813 as a Sunday School to provide education for the children who worked in the Silk Mills.

The development of the Silk industry in Macclesfield is told through an award winning audio visual programme, exhibitions, models and silk textiles and fashions.

The Silk Shop has an exciting range of attractive and unusual Macclesfield silk gifts, scarves, ties, textiles silk cards, and woven pictures plus inexpensive gifts for children.

The Mulberry Tree Coffee Shop offers visitors light snacks and a full restaurant service. Paradise Mill Museum is five minutes walk away. Visits can be organised outside regular opening times.

The story of silk is fascinating and links China and the far East and shaped the development of the town.

▲ Jacquard woven fabric birds of Paradise 1924

### Opening times

Open
Monday to Saturday
11.00am to 5.00pm
Sunday
1.00pm to 5.00pm
Closed Christmas Eve,
Christmas Day,
New Years Day &
Good Friday

### Directions

Follow brown signs to town centre. From Churchill Way turn into Roe Street, parking available in adjacent car parks.

Block making set in the Silk Museum ▶

CHESHIRE, MERSEYSIDE & GREATER MANCHESTER

# WEST PARK MUSEUM

West Park, Prestbury Road, Macclesfield, Cheshire SK10 3BJ
Telephone 01625 619831 Fax 01625 617880

West Park Museum opened in 1898, a gift from Marianne Brocklehurst for the people of Macclesfield.

The collections include a wide range of fine and decorative art and objects relating to local history.

The well known bird artist Charles Tunnicliffe R.A. was born near Macclesfield. The Museum specialises in his early work which reflects his interest in and knowledge of farm life.

West Park Museum's collection of ancient Egyptian antiquaries was acquired by Marianne Brocklehurst during visits to Egypt between 1873-4, 1882-3, 1890-91.

Displays take the visitor on a journey through life in ancient Egypt and include a Mummy case and objects relating to mummification.

The Museum is the venue for Macclesfield Museums temporary exhibition programme.

It is located in one of the earliest public parks with the largest bowling green in England.

▲ West Park Museum's Mummy

***Opening times***

Open
Tuesday to Sunday
1.30pm to 4.30pm

***Directions***

From Manchester follow Chester signs then towards Prestbury. Museum is located opposite hospital in park.
From Chester turn left signed Prestbury just past Regency Hospital.

# NORTON PRIORY MUSEUM & GARDENS

Tudor Road, Manor Park, Runcorn, Cheshire WA7 1SX
Telephone 01928 569895

The beautiful 38 acre woodland gardens with an award winning walled garden are the setting for the now demolished mansion of the Brookes, built on the site of a former Augustinian Priory.

Excavated remains of the Priory and the atmosphere 12th century undercroft can be found with displays on the Medieval Priory, the later houses and gardens in the museum.

Contemporary sculpture is situated in the grounds.

Year round programme of events and activities for all the family: free parking, picnic area, produce shop, value-for-money family ticket plus season tickets for regular visitors. Please telephone for details of our award winning educational programme, arrangements for prebooked party visits, volunteers scheme and provision for those with special needs.

## *Opening times*

Open April to October
12.00pm to 5.00pm
weekdays and to 6.00pm
weekends and public
holidays November to
March 12.00pm to
4.00pm daily

Walled Garden open
March to October Closed
24th to 26th December
and 1st January

## *Directions*

From M56, junction 11
turn for Warrington
and follow the
Norton Priory signs.
From all other
directions follow the
"all other Runcorn
traffic" and then follow
the Norton Priory signs.

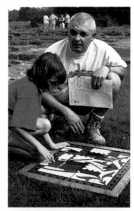

▲ Family event in the Cloister area of Norton Priory

▲ Exploring the Sculpture Garden at Norton Priory

▲ School group ringing the replica medieval bell

▼ Inside the Walled Garden at Norton Priory

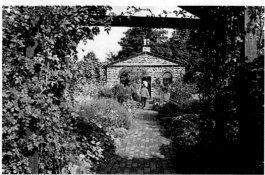

# ASTLEY CHEETHAM ART GALLERY

Trinity Street, Stalybridge, Cheshire SK15 2BN
Telephone 0161 3431978/3382708 Fax 0161 3398246

<div style="writing-mode: vertical">CHESHIRE, MERSEYSIDE & GREATER MANCHESTER</div>

Astley Cheetham Art Gallery was built as a gift to the town of Stalybridge in 1901 by John Frederick Cheetham, a local mill owner.

Originally, it operated as a lecture hall but developed into an art gallery when Cheetham bequeathed his collection of paintings to the town in 1932.

The permanent collection is exhibited twice a year and includes Italian paintings from the 14th and 15th centuries and works from British masters such as David Cox and Sir Edward Burne-Jones.

The collection has grown with gifts from the National Arts Collection Fund, such as Turner's "Aske Hall", and with works by renowned local artist Harry Rutherford.

The gallery now has a varied and exciting annual programme of temporary exhibitions featuring paintings, textiles, sculpture and prints from regional artists and selections from the gallery's own collection.

## Opening times

Open all year
Monday, Tuesday,
Wednesday, Friday
1.00pm to 7.30pm
Saturday
9.00am to 4.00pm
Closed Thursday,
Sundays and
Bank Holidays

## Directions

From Manchester take the A635 to Ashton through to Stalybridge.
By train from Manchester Victoria or Piccadilly to Stalybridge.
From Birmingham take the M6, M56, M66 and the A635.

▲ Study of a head by Sir Edward Burne-Jones c.1850

▲ Young gallery visitors enjoying a schools workshop

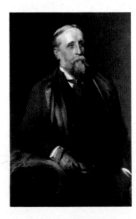

▲ John Frederick Cheetham, founder of the gallery

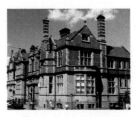

▲ Astley Cheetham Art Gallery

# QUARRY BANK MILL

Styal, Wilmslow, Cheshire SK9 4LA
Telephone 01625 527468 Fax 01625 539267

This beautiful restored Georgian Cotton Mill offers you the chance to step back in time to when cotton was King and the Mill was a major player in Manchester's 'Cottonpolis'.

Discover what life was for pauper apprentices through live demonstrations and displays in The Apprentice House.

Take a hands-on approach to learning about water and steam power in the new Power Galleries.

Exciting interactive exhibits invite you to stoke your own steam engine, imagine you are a Mill manager and climb over the rare Lancashire boiler, a smaller version of the type used to power the Titanic.

View the restored 1840's beam engine which can be seen steaming daily, the world's largest working water wheel weighing in at 50 tons and an underground audio visual theatre.

You can even climb down the original 1784 water wheel pit and feel the force of the River Bollin as it rushes inches below your feet. Visitors to Quarry Bank Mill can enjoy fabulous walks through 300 acres of picturesque country park, enjoy a delicious home cooked meal in The Mill Kitchen, or a quick snack in The Pantry.

Before you go home, pick up gifts and souvenirs from the Mill's award winning gift shop.

▲ Quarry Bank Mill offers a full calender of family events

▲ Fred Dibnah admires the restored 1835 Beam Engine

### Opening times

Open
in Summer
11.00am to 6.00pm
in Winter
11.00am to 5.00pm
(last admission one
and a half hours
before closing)
Closed Mondays -
October until the
end of March

### Directions

From M56 junction 5 follow brown signs for Quarry Bank Mill. It is situated off the B5166.

▲ Interactive exhibits in the Power Galleries help make learning fun

◄ Quarry Bank Mill, situated in 300 acres of country park

*CHESHIRE, MERSEYSIDE & GREATER MANCHESTER*

CHESHIRE, MERSEYSIDE & GREATER MANCHESTER

# MUSEUM OF THE MANCHESTERS

Ashton Town Hall, Market Place, Ashton-under-Lyme,
Greater Manchester OL6 6DL
Telephone 0161 3423078/3431978 Fax 0161 3398246

The Museum of the Manchesters displays uniforms, weapons, awards and medals, which detail the colourful history of the Manchester Regiment and its relationship with the local community.

The Museum examines the Manchester from its origin in the 63rd and 96th Regiments to its amalgamation with the King's Regiment in 1958.

Displays in the Ladysmith Gallery relate to the varied campaigns of the Regiment including the West Indies, the American War of Independence, the Crimea, the First and Second World Wars and Malaya.

The Forshaw gallery details the involvement of the local population in the First and Second World Wars, featuring uniforms of the land Army, the W.A.A.F. and oral history of life on the home front.

Visitors can see a reconstructed First World War trench complete with battle sands and can see the work of the war poet, Wilfred Owen, a Lieutenant in the Regiment. "The

Manchester", an exciting computer interactive specifically designed for the museum, is the most recent addition to the displays visitors can access detailed images and information relating to the major campaigns of the regiment.

▲ The Museum of the Manchesters in Ashton Town Hall

## Opening times

Open all year
Monday to Saturday
10.00am to 4.00pm

## Directions

By road: M62, A635.
By Rail: Ashton Under Lyne Station.
By Bus: No 29, Piccadilly Bus Station. The Museum is in Ashton Town Hall, Market Place, Ashton Town Centre.

▼ Boer War, 1900. Private Pitts and Scott defend Ladysmith

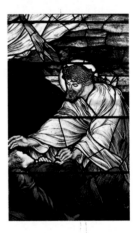

▲ A stained glass memorial window dedicated to Manchesters soldiers, 1915

# CENTRAL ART GALLERY

Central Library & Art Gallery, Old Street, Ashton-under-Lyne,
Greater Manchester OL6 7SF
Telephone 0161 3422650/3421978 Fax 0161 3398246

Central Art Gallery opened in June 1998 housed in a beautifully restored Victorian Gothic building.

The gallery occupies the first floor, which was originally used as an art school. With its huge vaulted ceilings the gallery is an ideal space for exhibitions.

There are three impressive gallery spaces which house a varied programme of temporary exhibitions featuring work from regional artists, touring exhibitions and community art projects.

A series of workshops and educational activities are arranged throughout the year. Details of exhibitions and events can be obtained from the gallery.

The gallery shop stocks a selection of art collection cards, prints and stationery as well as gifts and a range of art books.

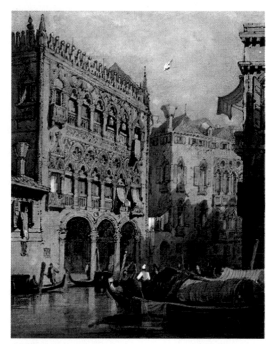

▲ Venice
by Samuel Prout

▲ Central Library and
Art Gallery, Ashton

◄ A school workshop as
part of the educational
programme

### Opening times

Open all year
Tuesday, Wednesday
and Friday
10.00am to 5.00pm
Thursday
1.00pm to 7.30pm
Saturday
9.00am to 4.00pm
Sunday & Monday closed

### Directions

By Road: M62, A635.
By Rail: Ashton Under
Lyne Station.
By Bus: No 21 Piccadilly
Bus Station.
The Gallery is in
Central Library,
Old Street,
Ashton Town Centre.

CHESHIRE, MERSEYSIDE & GREATER MANCHESTER

CHESHIRE, MERSEYSIDE & GREATER MANCHESTER

## CHESTER TOY MUSEUM

13a Lower Bridge Street, Chester, Cheshire CH1 1RS
Telephone 01244 346297 Fax: 01244 340437

7000 exhibits of all types of playthings but is best known for world's biggest collection of Matchbox Toys and is the headquarters of Matchbox International Collectors Association.

**Opening times** Open every day from 10.00am to 5.00pm except Christmas Day
(last admission 4.30pm)

## TATTON PARK

Knutsford, Cheshire WA16 6QN
Telephone 01625 534400 Fax: 01625 534403

Magnificent parkland, beautiful gardens, Old Hall neo-classical mansion, 1930's working farm, children's play area. Special events include RHS Flower Show, July 1999. Garden, Gift and speciality food shops. Restaurant.

**Opening times** Deer park and gardens open all year except Mondays.
Mansion, Old Hall, & Farm open April to October.
For dates times and prices please telephone 01625 534400

## NANTWICH MUSEUM

Pillory Street, Nantwich, Cheshire CW5 5BQ
Telephone 01270 627104

A museum of local history that reveals the development of the market town of Nantwich. Special displays include cheese making, local tapestries and a programme of temporary exhibitions.

**Opening times** Open April to September Monday to Saturday 10.30am to 4.30pm,
October to March Tuesday to Saturday

## THE SALT MUSEUM
162 London Road, Northwich, Cheshire CW9 8AB
Telephone 01606 41331 Fax: 01606 350420

Videos, models, old photographs, paintings and traditional working tools help tell the fascinating story of an ancient Cheshire industry. New "Hands On" gallery now open.

**Opening times** Open Tuesday to Friday 10.00am to 5.00pm, Saturday and Sunday
2.00pm to 5.00pm (last admission 4.30pm)

## STRETTON WATERMILL

Mill Lane, Stretton, near Malpas, Cheshire
Telephone 01606 41331 Fax: 01606 350420

A picturesque working watermill set in beautiful countryside. The whole milling process can be seen. Interpretive display and shop in adjoining stable block.

**Opening times** Open April Saturday and Sunday 1.00pm to 5.00pm,
May to August Tuesday to Sunday 1.00pm to 5.00pm,
September Saturday and Sunday 1.00pm to 5.00pm

## SALFORD MUSEUM AND ART GALLERY

Peel Park, Crescent, Salford, Cheshire M5 4WU
Telephone 0161 736 2649 Fax: 0161 745 9490

Admission free. Group Bookings in advance. World's largest collection of work by L S Lowry, Victorian Gallery and temporary exhibitions. Museum consists of reproduction period street including sounds.

*Opening times* Open Monday to Friday 10.00am to 4.45pm,
Saturday and Sunday 1.00pm to 5.00pm
Closed Good Friday, Christmas Day, Boxing Day and New Years Day.

## LANCASHIRE MINING MUSEUM

Buile Hill Park, Eccles Old Road, Salford, Cheshire M6 8GL
Telephone 0161 736 1832 Fax: 0161 736 7851

Museum of former Lancashire coal industry. Three floors of displays including recreated mines. Mining art gallery mounting changing temporary exhibitions throughout the year. Archives and reference library available by appointment.

*Opening times* Open Monday to Friday 10.00am to 12.30pm, 1.30pm to 5.00pm
Closed Saturday, Sunday 2.00pm to 5.00pm Closed Christmas Day, New Years Day,
Boxing Day & Easter Monday (last admission 12.20pm and 4.50pm)

## LYME PARK

Disley, Stockport, Cheshire SK12 2NX
Telephone 01663 762023 Fax: 01663 765035

1400 acres of Deer Park and moorland surround the magnificent house and 7 acre historic garden. Something for everyone.

*Opening times* Park - Open April to October 8am to 8.30pm November to March
8am to 6pm Hall - April to October Friday to Tuesday 1pm to 5pm (last entry 4.30pm)
Garden April to October Friday to Tuesday 11am to 5pm (last entry 4.30pm)
Wednesday and Thursday 1pm to 5pm (last entry 4.30pm)

## BUNBURY WATERMILL

Mill Lane, Bunbury, near Tarporley, Cheshire CW6 9PP
Telephone 01829 261422

Restored working 19th Century Watermill operated by North West Water Ltd. Flour process demonstrated and available for sale to visitors. Guided tours available. Party visits throughout the year by arrangement with the warden.

*Opening times* Open Easter to end September, Sundays, Bank Holidays 2.00pm - 5.00pm (last admission 4.30pm)

## UNIVERSITY OF LIVERPOOL ART GALLERY

3 Abercromby Square, Liverpool L69 3BX
Telephone 0151 794 2347/8 Fax: 0151 794 2343

Fine and decorative art from the University collections displayed in an elegant Georgian house. Works by J M W Turner Wright of Derby, Burne-Jones, Augustus, John Epstein, Freud and Frink.

*Opening times* Open Monday, Tuesday, Thursday 12,00pm to 2.00pm, Wednesday and Friday 12.00pm to 4.00pm (Closed weekends, Bank Holidays and August)

CHESHIRE, MERSEYSIDE & GREATER MANCHESTER

## TATE GALLERY LIVERPOOL
Albert Dock, Liverpool L3 4BB
Telephone 0151 709 3223 Fax: 0151 709 3122

Showing modern and contemporary art from the National Collection and hosting special exhibitions. Admission to displays from the National Collection is free. Admission charged for special exhibitions. Please telephone for details.

*Opening times* Open Tuesday to Sunday 10.00am to 6.00pm, Closed Mondays, Good Friday, 24th - 26th December, 1st January, Open Bank Holiday Mondays

## MUSEUM OF LIVERPOOL LIFE
Pier Head, Liverpool L3 1PZ
Telephone 0151 478 4080 Fax: 0151 478 4090

A unique insight into a great city and its people. Experience "Mersey Culture". A tribute to the home of The Beatles, The Grand National and great football. Visitors can also appear on Brookside!!
*Opening times* Open daily 10.00am to 5.00pm,
(Closed 23rd to 26th December and 1st January)

## GREATER MANCHESTER MUSEUM OF TRANSPORT
Boyle Street, Cheetham Hill, Manchester M8 8UW
Telephone 0161 205 2122 Fax: 0161 205 2122

Public Transport history of the Manchester conurbation with over 70 road vehicles from a 1890 horse bus to a metrolink car. A grand day out.

*Opening times* Open all year round Saturday, Sunday, Weekdays and Bank Holidays 10.00am to 5.00pm

## THE WHITWORTH GALLERY
The University of Manchester, Oxford Road,
Manchester M15 6ER
Telephone 0161 275 7450 Fax: 0161 275 7451

Internationally-renowned collections of fine art, textiles and wallpapers show as well as a programme of temporary exhibitions and events. Guided tours by arrangement.

*Opening times* Open all year except Easter Monday and between Christmas and New Year, Monday to Saturday 10.00am to 5.00pm and Sunday 2.00pm to 5.00pm

CHESHIRE, MERSEYSIDE & GREATER MANCHESTER

# CORNWALL

Cornwall is truly a county of romance with its tales of King Arthur who legend has it was born and held court at Tintagel, The River Tamar, in separating the county from the rest of England successfully preserved the distinct Cornish character. Although you are never more than twenty miles from the sea in Cornwall the difference between the north and south coasts is considerable. The Cornish association with the sea is well recorded in the Cornwall Maritime Museum in Falmouth.

The northern coast has its glorious sandy bays but it is largely the south coast - the Cornish Riviera - which attracts the large numbers of visitors to its quaint fishing villages, picturesque coves and inlets with their history of smuggling and piracy. The seaside is by no means Cornwall's only attraction. Bodmin Moor, that great mound of granite gives from its western edge quite glorious views from Sharp Tor, Hawkstor Downs and Twelve Mens Moor over the valleys of the Tamar and the Lynber. The moor is bleak and lonely but highly emotive, scattered with neolithic tombs and ancient long forgotten villages. Here, Jamaica Inn, the setting for Daphne du Maurier's novel of smugglers, houses the intriguing Potter's Museum of Curiosities. The North Cornwall Museum and Gallery at Camelford, displays a fascinating reconstruction of the upstairs and downstairs of a Cornish cottage; while at the Lanreath Folk and Farm Museum is a fine Tithe barn in which mill workings are assembled.

Cornwall is unashamedly a highly popular holiday region, its three hundred miles of coastline punctuated by holiday towns and villages of every description. The county is a magnet to artists, many attracted to St. Ives where the Tate has established a fine gallery concentrating upon the post-war modern movement. The Penlee House Gallery and Museum explains the social history of man in the Land's End peninsular and displays paintings by the Newlyn school of artists. The Royal Cornwall Museum at Truro, as well as a fine collection of Newlyn School paintings, houses a world famous mineral collection.

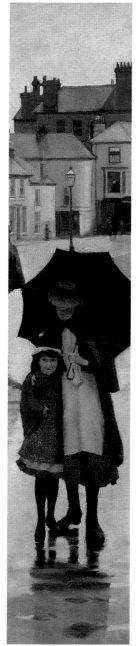

CORNWALL

# MILITARY MUSEUM BODMIN
The Keep, Bodmin, Cornwall PL31 1EG
Telephone 01208 72810 Fax 01208 72810

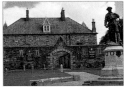

This museum is now recognised as one of the best small military museums outside London.

The museum follows the history of Cornwall's regiment, The Duke of Cornwall's Light Infantry from 1702. A remarkable story touching every military action of Britain over the last three centuries.

The capture of Gibraltar, the American War of Independence, the Napoleonic Wars, the Crimean War, the Indian Mutiny, the Boer War, the Great War and the Second World War are well covered as are many smaller actions.

There is a remarkable collection of badges and uniforms of the periods. A breathtaking display of medals, including eight VCs, providing a feast for medal experts. A complete collection of muskets and rifles used by the British Army from 'Brown Bess' to current issue rifle the 'SA80' is on display, together with foreign weapons and machine guns.

Also on display is General George Washington's bible captured by the

Regiment in 1777 and the subject of several failed attempts to get it returned to America.

The museum is housed in a listed building originally built in 1859 as a mobilisation store for the Cornwall Militia.

▲ "The Keep" a fine listed building houses the Military Museum

## Opening times

Open
Monday to Friday
10.00am to 5.00pm,
Sunday
10.00am to 5.00pm
(August and July only)

▲ An impressive collection of rifles

## Directions

From the centre of Bodmin follow brown signs to Military Museum and half a mile towards Lostwithiel, the War Memorial will be seen, the museum is in the building behind

▲ The History Gallery

▼ A breathtaking display of medals

## PENDENNIS CASTLE - ENGLISH HERITAGE
Pendennis Headland, Falmouth, Cornwall TR11 4LP
Telephone 01326 316594 Fax 01326 319911

Discover the Wartime secrets of Pendennis Castle, Cornwall's greatest fortress, spectacularly located on the headland at Falmouth.

The castle has protected Britain's shores from attack for 450 years. See the complete history revealed in the Discovery Centre and explore the restored underground defences. Descend through the tunnel to the "Big Guns", active throughout WWII.

Enter the restored observation post and experience the activity as the alert sound warning of an enemy attack. Experience garrison life at the turn of the century and complete with sounds and smells!

Besides this there is the restored WWI Guardhouse complete with cells and the mighty 15th century Keep to explore with a complete Tudor gun deck, where you can experienced the sights and sounds of battle.

From Henry VIII fortress to secret WWII base, all the family will be able to enjoy the fascinating history, secrets revealed, exciting events and the best views in Falmouth which marks Pendennis Castle as the ideal venue for a great day out.

### Opening times
Open
April to October daily
10.00am to 6.00pm,
(5.00pm in October)
Open from 9.00am
July and August,
November to March
10.00am to 4.00pm.
Closed 24th to 26th
December and
1st January

### Directions
On Pendennis Headland, one mile south east of Falmouth town centre. Follow brown and white signs. Half mile from Falmouth Docks Railway station

▼ Aerial View Looking North

▲ WWI Guardroom

▲ Civil War Siege Special Event

▲ Hands On Discovery Centre

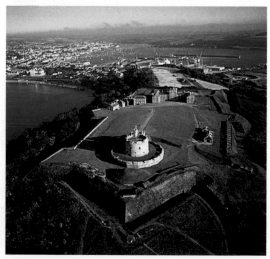

CORNWALL

# CORNWALL MARITIME MUSEUM
2 Bell's Court, Market Street, Falmouth, Cornwall TR11 2AZ
Telephone 01326 240670

Cornwall Maritime Museum is housed in Falmouth's historic Bell's Court which dates from its use in the 1700s as the Packet Ship Service Office.

There's much to see including the famous Packet Ship Gallery, dedicated to Britains International Mail Service during the 150 years before Victorian Times.

Visitors to this fascinating museum can step back in time to discover the many and varied aspects of Cornwall's rich Maritime history.

As well as marvelling at the detailed models of boats, tall ships and 19th century windjammers, visitors can study unique ship and port records, see the many interesting Maritime artefacts, and enjoy viewing rare pictures, prints and old photographs.

Falmouth is rightly proud of Cornwall's Maritime Museum and Heritage, of its role in the Cutty Sark Tall Ships Races, and of being the future home of the new National Maritime Museum Cornwall.

▶ A unique Maritime heritage based on fishing and commerce

### Opening times

Open April to October
Monday to Saturday
10.00am to 5.00pm
November to March
Monday to Saturday
10.00am to 3.00pm

### Directions

From Falmouth's main square (the Moor), walk towards waterfront, then turn right into Market Street. On the right (opposite Marks & Spencer's), look for alley into Bell's Court.

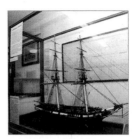

▲▼ Splendid models and artefacts of the magnificent 19th century tall ships

▲ The Museum focuses on the Maritime skills of the Cornish people

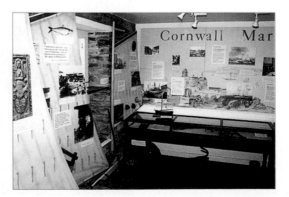

# JAMAICA INN & MUSEUMS
Bolventor, Launceston, Cornwall PL15 7TS
Telephone 01566 86250 Fax 01566 86177

CORNWALL

One of the last truly Victorian Museums, created by Walter Potter, the famous Taxidermist, Mr Potter's Museum of curiosities first opened in Bramber, Sussex in 1861.

Now sited in the Jamaica Inn courtyard, it contains over 10,000 unique exhibits of worldwide memorabilia. Begun as a hobby in his teens, and starting with the preservation of his pet canary when it died, the Taxidermy work took over his life after the creation of this first large tableau "The Death and Burial of Cock Robin".

He went on to create many other tableaux including the Kitten's wedding. The Victorian Rabbit School and the guinea pig's crick match all of which feature in the museum.

In Daphne Du Maurier's Smuggler's at Jamaica Inn (just across the road from the inn, a little way down the St. Cleer Road) we introduce you to the life and works of Daphne Du Maurier, and our arch villain, Demon Davey, the Vicar of Altarnun invites you to enter the exciting theatrical presentation of the Jamaica Inn story told in tableaux, light and sound.

Finally, on to see probably the finest collection of Smugglers' relics dating from today back into the mists of time.

### Opening times

Inn is open all year
Museum High Season
10.00am to 8.00pm
Mid Season
10.00am to 5.00pm
Low Season
11.00am to 4.00pm

### Directions

The Jamaica Inn is located halfway between Bodmin and Launceston just off the A30 at Bolventor. Look for brown signs to Jamaica Inn and Museums. The Inn is within easy travelling distance from Plymouth, North Devon and the Cornish coastal resorts.

▼ The Smugglers at Jamaica Inn painted by Wilf Plough

▲ Kittens

▲ Interior of Dolls' House

▲ "Who killed Cock Robin"

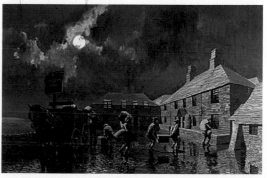

CORNWALL

# FALMOUTH ART GALLERY

Municipal Buildings, The Moor, Falmouth, Cornwall TR11 2RT
Telephone 01326 313863 Fax 01326 210564

Falmouth Art Gallery is both an art Museum and a temporary Exhibition Gallery.

It has over 200 works of art in its collection, from 18th century prints to 19th and 20th century paintings mainly by British artists. Including A. Munnings, L. Knight, W. Strang, J.W. Waterhouse, E.C. Burne Jones, H.S. Tuke, C. Napier Hemy.

The permanent collection is displayed on rotation every 6 months. The gallery also holds 9-10 temporary exhibitions per year.

These include contemporary local, national and international art, crafts and photography as well as historic art.

▲ Temporary Exhibition, Space and Shop

### *Directions*

From Truro, A39. From Helston, A394. From Penzance or St. Ives, A30 then A393 via Redruth. Train from Truro to Falmouth or Penmere Halt. Many busses. Parking and disabled parking nearby.

▶ Boys Bathing (study for) 1912, oil on canvas, by H.S. Tuke Falmouth Town Council

▶ Falmouth Art Gallery - Lift extension built 1996 when galleries renovated

### *Opening times*
Open all year Monday to Friday, 10.00am to 5.00pm Saturday 10.00am to 1.00pm Closed Sundays, Bank Holidays & during change of exhibition (except shop and permanent collection) Closed 25th, 26th and 28th December. Admission free

**1999 Exhibition Programme**

*until October 1999*
Permanent Collection Gallery
20th anniversary exhibition
of Falmouth Art Gallery.

*9th January to 6th February*
A Celebration of Craftmanship
20 years of teaching furniture
design and making in the South
West.

*13 February to 13th March*
'Sacred Cow'
Dot Searle Clarissa Beöthy and
Cathy Wade paintings and
installations.

*20th March to 17th April*
Carnsew - A Cornish granite
quarry - Kurt Jackson paintings.

*24th April to 22nd May*
Aspects of Abstraction - R.
Freeman, Michael Finn, Jeremy
Annear & Carole McDowell.

*29th May to 26th June*
Tim Shaw, Sculpture.

*3rd to 31st July*
Lydia Bauman, Landscape
paintings.

*7th August to 2nd October*
John Park, Painters of Light,
exhibition of early 20th century
St Ives art.

*9th October to 6th November*
Eastern Approaches,
printmaking from Japan, China,
Thailand and the Republic of
Korea- (Off-Centre Gallery,
Bristol).

*13th to 27th November*
Childrens art exhibition on
eclipse theme.

*4th to 31st December*
Paul Wilkinson, paper collage &
Alison Cameron, paper jewellery.

▲ In the Coulisses - oil on panel,
by Laura Knight. Falmouth Town Council

CORNWALL

# FLAMBARDS VILLAGE
Culdrose Manor, Helston, Cornwall TR13 0QA
Telephone 01326 573404 Fax 01326 573344

Flambards is an all weather family leisure park with internationally acclaimed exhibitions, rides, amusements, entertainment, shows and gardens.

Flambards Victorian village with over fifty life-size shops, homes and traders is a turn of the century village with cobbled streets, carriages and fashions.

Britain in the Blitz is a life-size street shortly after an air raid showing blitz damage, and period shops and homes. The War Galleries pay tribute to the men, women and children who fought for our freedom.

Many special exhibitions deal with pioneers of flight and the collection of classic aircraft and helicopters, Concorde interior and hovercraft delight enthusiasts.

Collection of early motorcycles, 1896 car, wedding fashions 1870 to 1970 and wedding cakes down the years show Flambards has interest for everybody.

Childrens play areas, Cornwall's Exploratorium with

hands-on science, the Space Quest laser show takes the viewer on a trip from the dawn of time through the total solar eclipse of August 1999 to space ships battling in the future.

A full day out for the whole family with interest and fun for everybody no matter what their taste or age- Flambards is the best day of the week.

▲ Wedding dresses down the years 1870 to 1970 at Flambards

### *Directions*

Follow signs to Helston then follow white on brown signs to Flambards which is on the A3083 Helston to Lizard Road near the hospital roundabout.

CORNWALL

***Opening times***

Open most days
Easter to the
end of October
10.00am to 5.00pm
Closed some
Mondays and Fridays
in low season
Extended openings
until 6.00pm in the
last week of July and
the whole of August

Last admission 3.30pm

◀ Royal Naval Wessex
helicopter at Flambards

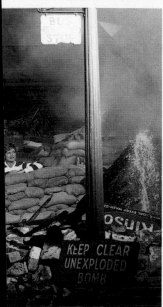

◀ Britain in the Blitz.
How did they survive?

▼ Flambards Victorian
Village, cobbled streets,
carriages and fashions

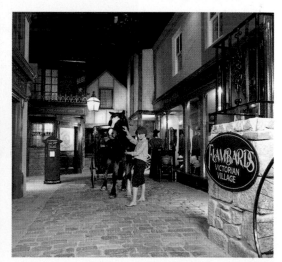

CORNWALL

# PENLEE HOUSE GALLERY & MUSEUM
Morrab Road, Penzance, Cornwall TR18 4HE
Telephone 01736 363625 Fax 01736 361312

Built in 1865, Penlee House was the former home of J.R. Branwell, a wealthy miller and merchant.

Since 1949 it has been home to the town and district's historic collections. Completely refurbished and extended in 1997, it offers a modern gallery and museum within the settings of a Victorian House and Park.

The gallery holds the largest art collection in west Cornwall, ranging from 1750 to the present day, concentrating mainly on the work of the Newlyn School of Artists (1880-1930) including Walter Langley, Stanhope Forbes, Lamorna Birch and Laura Knight. A changing selection of their work is featured on the ground floor, together with Newlyn Copper and Crysede textiles.

The museum was originally founded in 1839 by Penzance Natural History and Antiquarian Society and has a collection covering 6000 years of history in west Cornwall from the Stone Age to the present day, with displays on archaeology, mining, agriculture, fishing, local government, home life and tourism.

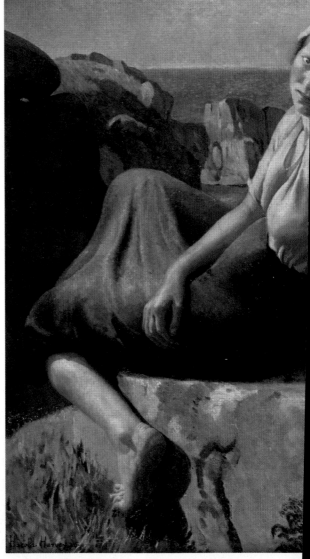

▲ 'Girl on a Cliff' by Harold Harvey - 1926

The photographic archive featuring over 10,000 images can now be studied by means of an interactive image data-base sited within the gallery. Images of paintings not on display can also be viewed in this way.

**80**

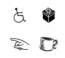

### Directions

Drive along promenade turning right up Morrab Road. Turn left at traffic lights, straight across roundabout and into Wellfield car park on left. Follow signs through park.

▶ 'View from Madron Carn' by Richard Pentreath - 1839

▼ 'Spring Morning' by Samuel John Lamorna Birch - 1904

▲ 'The Rain is Raineth' by Norman Garstin - 1889

### Opening times

Open all year round
Monday to Saturday
10.30am to 4.30pm
(last admission 4.00pm)

**CORNWALL**

# TATE GALLERY ST IVES
Porthmeor Beach, St Ives, Cornwall TR26 1TG
Telephone 01736 796226 Fax 01736 794480

Tate Gallery St Ives opened in 1993 and offers a unique introduction to modern art, where many works can be seen in the surroundings and atmosphere which inspired them.

The gallery presents changing displays of twentieth century art in the context of Cornwall, focusing on the modern movement St Ives is famous for.

Changing displays include the work of Ben Nicholson, Barbara Hepworth, Alfred Wallis, Naum Gabo, Peter Lanyon, William Scott, Bryan Wynter, Terry Frost and Patrick Heron.

The displays are complemented by a series of exhibitions and contemporary artists' projects.

The Tate Gallery also runs the Barbara Hepworth Museum in St Ives.

Exhibitions: 14th November to 11th April - Displays 1998-9: Partnerships and Practice. Eric Cameron: English Roots. Veronica Ryan: Quoit Montserrat. May to November - As Dark as Light: A major exhibition to coincide

▲ Barbara Hepworth Museum and Sculpture Garden

with the solar eclipse in August, seen in its totality in West Cornwall.

▲ William Scott - 'Mackerel on a plate'.

*Opening times*

Open
Tuesday to Sunday
10.30am to 5.30pm
and Monday in
July & August
Last admission
5.00pm

*Directions*

By rail: regular service between London Paddington and Penzance.
Local services between Penzance and St. Ives.
By road: M5 to Exeter and A30 to St. Ives.
Situated overlooking Porthmeor Beach.

▼ Tate Gallery St Ives

► Peter Lanyon - 'Thermal'.

CORNWALL

# DAIRYLAND FARM WORLD & HERITAGE CENTRE

Tresillian Barton, Summercourt, near Newquay,
Cornwall TR8 5AA
Telephone 01872 510246 Fax 01872 510349

Discover three hundred years of Cornish farming history in this unique and fascinating all weather facility.

Covering all aspects of rural life in the West Country, this extraordinary collection of machinery, memorabilia, artefacts, tools and ephemeris offers you the chance for a real hands-on experience and you will find more than a few surprises! Gran's washing machine for example. It would take her all day to do the family wash with tub, dolly or washboard and most of the week to dry and iron it! She also churned butter, beat the rugs and had to fetch heavy pails of water from the pump outside. See the equipment she would have used in wash house, kitchen and dairy.

In the tractor house and smithy you can see a super collection of restored First World War tractors. Somewhat strange now, they pulled their weight once.

Also see how the blacksmith and farrier worked, the tools, furnace and ironwork. Dairyland also includes a milking parlour, nature trail and playground as well as lots of animals to see and touch. There are special reductions for schools, playgroups and coach parties.

### *Opening times*

Open April to October,
10.30am to 5.30pm
Daily - from 10.00am
during school holidays
Last admission 4.00pm

### *Directions*

Dairyland is on the
A3058 Newquay to St
Austell Road
just four miles from
Newquay between
Kestle Mill and
Summercourt.

▶ All the machinery of cider making in the cider press

▼ Mangles, irons and washing machines in the Victorian wash house

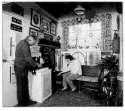

▲ The Cornish range was the focal point of the kitchen

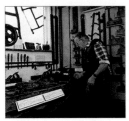

▲ The carpenters shop full of hammers, chisels, planes and screwdrivers

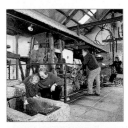

# ROYAL CORNWALL MUSEUM

River Street, Truro, Cornwall TR1 2SJ
Telephone 01872 272205 Fax 01872 240514

Cornwall's largest and liveliest museum has a new look after a £1.5 million development programme. New galleries, full wheelchair access and a cafe with a continental air have made this 'visitor friendly' museum one of the most popular in the region.

Here, you can discover the history of Cornwall from Stone Age to the present day, see a world famous collection of minerals, admire old master drawings, paintings from the Newlyn School and superb ceramics.

There's a new Natural History Gallery, with models, sets and hands-on displays designed to give visitors a taste of Cornwall's unique wildlife habitat. Another new gallery has been earmarked to house the museum's impressive textiles collection, which includes Alec Walker's stunning Crysède designs from the 1920s and other rarely seen gems.

As well as Cornish history and archaeology there are Egyptian, Greek and Roman collections, plus a changing programme of temporary exhibitions, some with free admission. Hockney, Picasso and Baltimore quilts have been recent highlights.

The museum has an active education service, with new rooms recently opened for its popular school workshops.

For researchers, there is the oldest Cornish historical Research Centre in Cornwall, plus an easily accessed photographic archive.

### Opening times
Open
Monday to Saturday,
10.00am to 5.00pm
(last admission 4.30pm)
Closed Sundays and
Bank Holidays

### Directions
The museum is situated in Truro town centre in River Street, 500m from the Cathedral, at the foot of the hill leading down from the railway station to the centre.

▲ A world famous collection of minerals

▲ A workshop in progress

▲ The Trewinnard Coach, one of the earliest in existence

▼ Inside the café at the Royal Cornwall Museum

CORNWALL

### BUDE STRATTON MUSEUM
Lower Wharfe, Bude, Cornwall EX23 8LG
Telephone 01288 353576 Fax: 01288 353576

Former blacksmiths forge featuring Bude Canal display, shipwrecks, railways and local history. Guided tours by arrangement. Car park and coffee shop nearby.

> *Opening times* Open from Good Friday to end of September daily 11.00am to 5.00pm (last admission 4.30pm)

### NORTH CORNWALL MUSEUM & GALLERY
The Clease, Camelford, Cornwall PL32 9PL
Telephone 01840 212954

Museum of rural life in North Cornwall, 50 to 100 years ago and monthly exhibitions in the gallery of paintings and crafts. Car parking opposite in council car park.

> *Opening times* Open April 1st to 30th September daily except Sundays from 10.00am to 5.00pm

### SHIPWRECK AND HERITAGE CENTRE
Quay Road, Charleston, Cornwall PL25 3NJ
Telephone 01726 69897 Fax: 01726 68025

Situated in an unspoilt 18th Century Harbour - largest shipwreck. Artifact collection in British Isles, Lifeboat, Titanic display, diving display, audio visual theatre, life size tableaux of village life. Children free if accompanied by adult. Guided tours by prior arrangement.

> *Opening times* Open March 1st to October 31st 10.00am to 5.00pm, Open 7 days a week (last admissions later in high season)

### LANREATH FOLK AND FARM MUSEUM
near Looe, Cornwall PL13 2NX
Telephone 01503 220321

South east Cornwall's famous farm and folk museum. 300 exhibits catalogued. Hands on experience. Educational and fun. Historical building with bronze age tomb. Mill workings, kitchen bygones and engines galore.

> *Opening times* Open Easter to 31st October, 1999 10.00am to 6.00pm

### NATIONAL MARITIME MUSEUM
National Maritime Museum Outstation, Cotehele Quay,
St Dominick, Saltash, Cornwall PL12 6TA
Telephone 01579 350830

Cotehele Quay forms a fine setting for the Tamar Barge 'Shamrock' and the museum describes the River Trade, also along the coasts of South Devon and Cornwall.

> *Opening times* Open April 1st to 31st October 11.00am to 6.00pm

# CUMBRIA

To many, Cumbria is synonymous with the Lake District, but in fact there is considerably more to this county than the holiday delights of lakeland. South Cumbria, sandwiched as it is between the Lake District and the Yorkshire Dales has its own particular charm. William Turner and Ruskin were both fascinated by the area. On the west coast of the county are a succession of ports once busy exporting coal from local mines now long closed but the towns, Maryport, Whitehaven and Workington have taken another lease of life and are busy innovatively developing their marinas and coastal holiday attractions. The Senhouse Museum at Maryport houses a fascinating display of Roman artifacts in a port, once the headquarters of Hadrian's coastal defence system. In the north, Carlisle, the county town, stands guard over the flat lands leading to the Scottish border, its castle for centuries a bastion against the marauding Scots.

The Lake District is wonderfully fortunate that its amazing variety of scenery is contained within a relatively small area. Not so fortunate of course is the fact that it attracts so many visitors to sample its delights virtually the whole year round! The Cumbrian towns too have their special character. Kendal, in the south, the Auld Grey Town, famous for its ancient yards and its castle home of Catherine Parr, Henry VIII's last wife boasts the splendid Abbot Hall Art Gallery and Museum of Lakeland Life, as well as the Kendal Museum of Natural History and Archaeology. Ambleside, on the shore of Windermere, at the very heart of the Lake District dates back to Roman times standing on the route from the Roman port of Ravenglass to Penrith. Keswick in the north on Derwentwater, the largest lakeland town, was an important copper and lead mining town in Elizabethan days. Its admirable Museum and Art Gallery contains a fine collection of manuscripts from the Romantic Poets.

But the little village that draws the visitors to this wonderful area is Grasmere, the home of William Wordsworth, and now home to the excellent Wordsworth Museum. In the graveyard of the lovely church of St. Oswald are the graves of Wordsworth and his family. Cumbria can lay claim to some outstanding museums, from the world famous Laurel and Hardy Museum in Ulverston; the Windermere Steamboat Museum with its story of life on the Lake in bygone days, to the impressive Border Regiment and Kings Own Royal Border Regiment Museum with its uniforms, weapons and trophies telling the story of 300 years of military tradition.

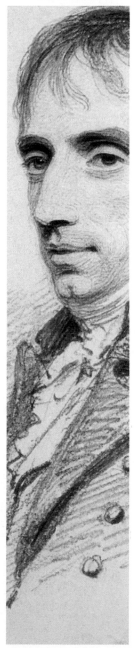

CUMBRIA

# RYDAL MOUNT & GARDENS
Ambleside, Cumbria LA22 9LU
Telephone 015394 33002 Fax 015394 31738

Rydal Mount, in the heart of the Lake District, lies between Ambleside and Grasmere and commands glorious views of Lake Windermere, Rydal Water and the surrounding fells.

The house, which now belongs to descendants of the poet, retains a lived-in, family atmosphere and has seen little change since Wordsworth and his family came to live there in 1813.

The Dining Room, part of the old Tudor Cottage, with its original flagged floor and oak beams, contrasts pleasingly with the larger proportions of the Drawing Room and Library, added in 1750.

Also to be seen are the family bedrooms and Wordsworth's attic study which he used when he was Poet Laureate.

The house contains portraits, personal possessions and first editions of the poet's work. Wordsworth was a keen landscape gardener and the four acre garden remains very much as he designed it. It consists of fell-side terraces, lawns, rock pools and an ancient mound. There are rare shrubs and, in season, the daffodils, bluebells and rhododendrons produce a spectacular display of colour.

Reciprocal discounts with Dove Cottage and Wordsworth House. Pre booked groups of ten or more offered special rates.

### Opening times

Open Summer
March to October
Daily 9.30am to 5.00pm
Winter
November to February
Daily except Tuesday
10.00am to 4.00pm

### Directions

1 ½ miles from Ambleside on the A591 Grasmere Road.
Free parking.

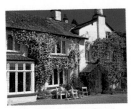

▲ Rydal Mounts front entrance with the wisteria and clematis

▲ Dining room at Rydal Mount, home of William Wordsworth

▲ The poet's original summerhouse overlooking Rydal Water

▼ Rydal Mount from the main lawn

# WINDERMERE STEAMBOAT MUSEUM

Rayrigg Road, Bowness-on-Windermere, Cumbria LA23 1BN
Telephone 015394 45565 Fax 015394 48769
Website WWW.STEAMBOAT.CO.UK

The exhibits include - steam yacht 'Esperance' built in 1869 for Henry Schneider, the Industrialist who discovered Iron Ore in the Furness Peninsula and founded Barrow in Furness.

'Esperance' is the oldest vessel on the Lloyd's register of yachts and was immortalised in Arthur Ransome's 'Swallow and Amazons' as Captain Flint's houseboat.

'Dolly' which was built before 1850 and is the oldest known surviving mechanically powered boat in the world with its original engine in working order. Her survival is undoubtably due to her having sunk on Ullswater in 1896 in a depth of water inaccessible at the time. She was recovered and restored in 1962 and is a prime exhibit in the museum.

'Raven' was built for the Furness Railway company as a freighter in 1871. Economical movement of bulk goods was not possible on Lake Windermere until the coming of the railway 'Raven' was built to transport these goods from the railway terminus at Lakeside to the communities around the lake. She was

named after the biblical story of ravens feeding the people in the wilderness!

The Windermere Steamboat Museum is a registered charity.

___

### *Opening times*

Open third weekend in March until end of October 7 days a week 10.00am to 5.00pm

___

### *Directions*

On A592 by the Lake, half a mile north of Bowness on Windermere town centre. Bus route 555. Nearest Railway Station Windermere. Free parking for customers.

___

▼ 'Osprey' 1902 in steam most days during season. Weather permitting

▲ Steam Ship 'Raven' 1871

▲ Steam launch 'Branksome' 1896 the ultimate in Victorian launch design

▲ 'Dolly' 1850 oldest mechanically powered boat in the world

CUMBRIA

# BORDER REGIMENT & KINGS OWN ROYAL BORDER REGIMENT

Queen Mary's Tower, The Castle, Carlisle, Cumbria CA3 8UR
Telephone 01228 532774 Fax 01228 521275

Located within the Inner Ward of Carlisle Castle, the Museum relates the history of Cumbria's County Infantry Regiment, the Border Regiment and its successor The King's Own Royal Border Regiment, local Militia, Volunteer and Territorial Army units from 1702 to the present day.

Displays on two floors include uniforms, weapons, equipment, medals, silver, pictures, memorabilia, dioramas, video presentations, and anti-tank guns.

Outside is a 25-Pounder Field Gun of 1940 and a Ferret Scout Car. The Castle founded in 1092, is a superb Border fortress owned by the Crown, maintained by English Heritage, with virtually continuous military buildings dating from the 19th century, which formed the Regimental Depot of the Border Regiment from 1873 and 1959.

The present Regiment's HQ is located here and a Company of the Regiment's TA Battalion.

The Museum has extensive archives and family history and other enquiries are welcome; personal visits by appointment. No fixed charges are made for research, but as enquiries occupy a considerable amount of staff time a donation is appreciated.

School/Educational visits - all groups welcome, visits to schools by arrangement - telephone or write for information.

The Museum has its own shop with a wide range of souvenirs and publications; catalogue available on request. Send A5 SAE for list.

### Opening times
Open
November to March
10.00am to 4.00pm
Monday to Sunday
April to September
9.30am to 6.00pm
Monday to Sunday
October
Monday to Sunday
9.30am to 6.00pm
or dusk.
Entry as part of
admission to
Carlisle Castle

### Directions
North side of the City centre (within easy reach from M6, J43 and 44), 10 minutes from railway station. Adjacent car-park Devonshire Walk on the west side of the Castle. Disabled parking in the Castle.

▲ Border Regiment recruiting poster 1922

▲ World War Two display case

▲ Carlisle Castle gateway with soldier 34th Cumberland Regiment 1835

# BRANTWOOD
Coniston, Cumbria LA21 8AD
Telephone 015394 41396 Fax 015394 41263

Brantwood is the most beautifully situated house in the Lake District. It enjoys the finest lake and mountain views in England and there is no other house in the district with such a diversity of cultural associations.

The home of John Ruskin from 1872 until his death in 1900, the house is filled with Ruskin's drawings and watercolours, together with much of his original furniture, books, and personal items.

Brantwood also has more than 30 acres of gardens, including the famous harbour walk and the professor's garden.

Other attractions include: bookshop, video programme, restaurant, craft gallery, nature trails and seasonal programme of changing exhibitions and events.

Please contact Brantwood on 015394 41396 for full details.

### *Directions*

Off B5285. Sign posted from Hawkshead and Coniston. Coniston launch and Sy Gondola also call at Brantwood Jetty.

▲ The turret Brantwood

◀ The 7 lamps window

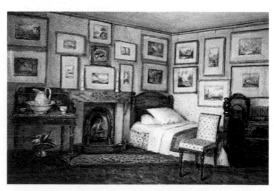

▼ View of Brantwood from Coniston water in winter

▲ Ruskin's bedroom at Brantwood by Emily Warren

### *Opening times*

Open mid March to mid November daily
11.00am to 5.30pm
Winter Season
Wednesday to Sunday
11.00am to 4.00pm

# THE WORDSWORTH MUSEUM

Grasmere, Cumbria LA22 9SH
Telephone 015394 35544/35547/35003 Fax 015394 35748

The Wordsworth Museum was built in 1981 to help house the ever growing library of manuscripts and books collected by the Wordsworth Trust since its foundation in 1891.

Visitors combine a trip to the museum with a guided tour of Dove Cottage, the Grasmere home of Wordsworth, which remains almost exactly as the poet would have known it 200 years ago.

The award-winning museum is a converted coaching barn, situated close to Dove Cottage. It houses a permanent exhibition, introducing visitors to the life and works of Wordsworth.

Displays include original manuscripts, letters, items of clothing and other personal artefacts. Recordings of Wordsworth's best loved poems are available on headsets.

The museum also includes a fine collection of early watercolours of the Lake District.

A programme of special exhibitions runs throughout the year. These focus on a specific element in Romantic poetry. Previous exhibitions have centred around Keats, Coleridge, Mary Shelley, and Hayden.

▼ The Wordsworth Museum

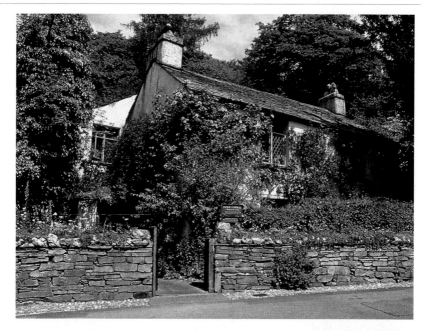

▲ Dove Cottage

There are reduced priced tickets for families, students, YHA members, OAPs and groups of over 15 people.Reciprocal discounts with Rydal Mount and Wordsworth House.

*Directions*

Immediately south of Grasmere Village on A591 Windermere to Keswick road. Hourly bus service (555). In summer open top bus (WI) Windermere-Grasmere every 20 minutes.

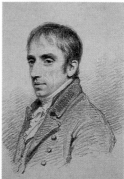

▶ William Wordsworth 1805 by Henry Edridge

*Opening times*
Open daily
9.30am to 5.30pm
(last tickets
sold at 5.00pm)
Closed 11th January
to 7th February &
24th to 26th December

▶ "Grasmere" by
Fennel Robson

CUMBRIA

# ABBOT HALL ART GALLERY
Abbot Hall, Kendal, Cumbria LA9 5AL
Telephone 01539 722464 Fax 01539 722494

This impressive Grade I Listed Georgian Villa is one of Britain's finest small galleries.

Overlooked by the ruins of Kendal Castle, the gallery is situated in Abbot Hall Park by the banks of the River Kent.

Downstairs you will find yourself in a fine 18th century town house surrounded by a superb collection of British art and furniture of the period. These restored rooms also contain lively ink drawings and paintings by George Romney, who started his career in Kendal.

Abbot Hall is highly acclaimed for its stimulating changing contemporary exhibitions in the upstairs galleries.

In addition, there is a large collection of watercolours, many of the Lake District, a small collection of miniatures and a growing twentieth century collection.

The gallery has a Coffee Shop with outdoor seating overlooking the river. It has a high reputation locally for its interesting menu and delicious home made cakes.

Situated at the southern end of Kendal, Abbot Hall is just a 10 minute drive form M6 (J36) and only 8 miles from Windermere.

Nearby attractions: Museum of Lakeland Life and Industry Kendal Museum of Natural History and Archaeology.

▲ Still Life by Samuel John People

## Opening times

Open 7 days a week
10.30am to 5.00pm
(4.00pm in winter)
12 February -
24 December 1999

▲ Portrait of Emma Hamilton by George Romney

## Directions

Situated at the southern end of Kendal, follow brown signs and signs for Abbot Hall. 10 minute drive from J36 of the M6 and 20 minutes from Windermere.

▲ Passage of St Gothard by J.M.W. Turner

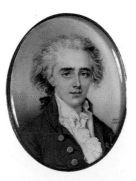

◀ Miniature portrait, 1787 by Hill

## MUSEUM OF LAKELAND LIFE
Abbot Hall, Kendal, Cumbria LA9 5AL
Telephone 01539 722464 Fax 01539 722494

The Museum of Lakeland Life looks at 300 years of local history. Popular with families, the displays show how our Cumbrian ancestors lived and entertained themselves in days gone by.

Exhibits include a Victorian street scene, reconstructed workshops and farmhouse rooms, displays of toys, costume, furniture and items from the Arts and Crafts Movement.

Children particularly enjoy the recreation of Swallows and Amazons writer, Arthur Ransome's study and the Postman Pat room.

The Museum is situated at the southern end of the market town of Kendal in Cumbria and is 10 minutes drive from junction 36 of the M6. Oxenholme station is the nearest station on the West Coast main line (2 miles from the centre of the town). A 20 minute drive will take you from Kendal into the heart of the English Lakes.

Nearby attraction: Kendal Museum of Natural History and Archaeology.

### Opening times

Open 7 days a week 10.30am to 5.00pm (4.00pm in winter) 12 February - 24 December 1999

### Directions

Situated at the southern end of Kendal, follow Brown signs and signs for Abbot Hall. A 10 minute drive from J36 of the M6 and twenty minutes from Windermere.

▲ 18th Century farmhouse kitchen

▲ Selection of toys from the collection

▲ Arthur Ransome's desk

◄ 18th century clothing

CUMBRIA

# KENDAL MUSEUM OF NATURAL HISTORY & ARCHAEOLOGY

Station Road, Kendal, Cumbria LA9 6BT
Telephone 01539 721374

Kendal Museum is one of the oldest museums in the country. It houses outstanding displays of geology, archaeology and natural history.

There are many exhibits for children to enjoy including local Roman finds and a new interactive display based around recent discoveries at Kendal Castle.

Explore the fascinating Wildlife Gallery full of specimens including a polar bear and all manner of birds, mammals and butterflies.

In the recreation of Honorary Curator and great fell walker, Alfred Wainwright's office many of his personal possessions are on displays.

A 20 minute drive will take you from Kendal into the heart of the English Lakes, where you can follow in his footsteps walking the fells.

Nearby attractions: Abbot Hall Art Gallery and Museum or Lakeland Life.

▶ The Wainwright Gallery

### Opening times

Open
Monday-Saturday
10.30am to 5.00pm
(4.00pm in winter)
12 February-24
December 1999
Closed Sundays

### Directions

Situated at the northern end of Kendal, follow signs to Kendal Museum - opposite the Railway Station. A ten minute drive from J36 of M6. Twenty minute drive from Windermere.

▲ Scaly manis

▲ Golden Eagle in one of many wildlife dioramas

▲ Hiberno Norse Cross

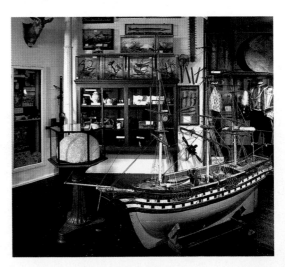

# KESWICK MUSEUM & ART GALLERY

Fitz Park, Station Road, Keswick, Cumbria CA12 4NF
Telephone 017687 73263

Keswick Museum is this town's local museum, with varied displays of local and natural history. There are curios and curiosities, including the 500 year old cat, and the musical stones.

With Flintoft's famous scale model of the Lake District, which is 12ft across, a walk round Lakeland couldn't be easier! See a Golden Eagle up close, see how a pencil is made and see our large collection of beautiful crystals from mines all across the county.

The Art Gallery contains the poets' corner, showing work by Robert Southey, William Wordsworth, and Hugh Walpole, and shows a different exhibition by local artists and crafts people every month.

The galleries are all on one level with a front ramped and stepped entrance.

▼ Skaters on
Derwentwater
by Joseph Brown

Admission is 50p for people with disabilities, OAP's, students, the unwaged and children, and just £1.00 for adults. A real value for money visit for families.

Groups of 10 or more receive a 10% discount and with educational groups, teachers and helpers come free.

Follow the signs for "Museum and Art Gallery" for a Victorian experience not to be missed. Just 5 minutes walk from the town centre.

### Opening times
Open Easter
(Good Friday) to
October 31st Daily
10.00am to 4.00pm

▲ Keswick's purpose
built Victorian museum

### Directions

M6 (junction 40), A66 from Penrith, A591 from South Lakes and Windermere to Keswick. Follow brown and white signs for "Museum and Art Gallery". 5 minutes from Information Centre.

▲ Local history,
Archaeology, Geology
and Natural history
displays

▲ Mountaineering and
Flintoft's famous model
of the Lake District

CUMBRIA

# WETHERIGGS POTTERY
Clifton Dykes, Penrith, Cumbria CA10 3HW
Telephone 01768 892733 Fax 01768 892722

Wetheriggs has been a working pottery since 1855. Surviving two World wars and the Industrial Revolution and is now the only steam powered Country Pottery in the UK. The pottery was scheduled as an Industrial Monument in 1973, and continues to thrive to this day.

The steam engine has been restored by steeplejack and TV personality Fred Dibnah, and can be seen working, even powering the old potter's wheel on special event days.

You can have a go at throwing a pot yourself in our studio or choose a pot to paint from the many blanks available. Once painted your pot can be fired for you to return and collect another day.

▲ Beehive kiln

▼ Terracotta edging tiles

Wetheriggs' 7.5 acres is set in the beautiful Eden Valley we even have our own natural newt pond that is home to three types of newt and is protected by English Nature.

Our tea-room has an excellent reputation serving wonderful country breakfasts, lunches, snacks and afternoon teas.

Everyone enjoys to shop and Wetheriggs has a number of shops including of course, a pottery shop which sell all that is made here on site and a seconds pottery shop for bargain hunters.

Contact us for details of special events and activities throughout the year.

### Opening times
Open April to October
7 days a week
10.00am to 5.30pm
November to March
Wednesday to Sunday
10.00am to 5.00pm
Tea Rooms closes half
an hour before site
closing time

### Directions
From M6 junction 40,
take A66 towards Scotch
Corner, then A6 south
towards Shap for 1 mile.
Take left turn towards
Cliburn. Wetheriggs is
one and a half miles
on the right.

▶ Throwing your own
pot in the studio

▼ Fred Dibnah with
Steam Engine
'Josephine'

CUMBRIA

## PENRITH MUSEUM
Robinson's School, Middlegate, Penrith, Cumbria CA11 7PT
Telephone 01768 212228 Fax 01768 891754

Originally a charity school for poor girls, this attractive 17th century building has been converted into a local history museum and exhibition gallery.

The building was refurbished and extended in 1990 to include a modern, purpose - built tourist information centre.

The temporary exhibitions area provides gallery space for historical and contemporary art shows. Proposed exhibitions for 1999 include

"Eden Artists Residencies" (February to March).

"Julian Cooper and Andrew Ratcliffe - Recent Work" (April to May).

"Appleby Jazz Festival" - photographs by David Herrod (June to July).

"Alan Stones- Recent Work" (August)

"Cheryl Jane Matthews - Paintings" (September)

"Penrith in Camera" (October to December).

▶ Local history on display in the Museum

For further information and detailed exhibitions, opening times please contact the museum.

### *Opening times*
Open
Monday to Saturday
10.00am to 5.00pm
Sunday
1.00pm to 5.00pm
(Closed Sundays
October to April)

### *Directions*
The museum is located at the northern end of the town, next to the Tourist Information Centre and close to the Town Hall. The nearest motorway exit is junction 40, M6.

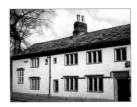

▲ Robinson's School in Middlegate

▲ Inside Penrith Museum

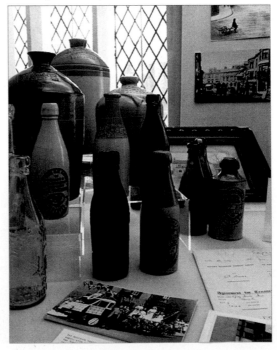

CUMBRIA

## STOTT PARK BOBBIN MILL

Low Stott Park, Ulverston, Cumbria LA12 8AX
Telephone 015395 31087

Built in 1835, the Mill was typical of many Lakeland Mills which grew up initially to supply the cotton and weaving industry of Lancashire with wooden bobbins.

Over the years it turned its versatile machines to produce all kinds of wooden objects which it exported worldwide. It continued in use up until 1971.

The Mill is not re-created in any way all the machines spent their working lives at the Mill and anyone who worked there in the 19th century would be totally familiar with the Mill today.

Power is provided by electric motor, water turbine and steam engine. The steam engine which came to the mill secondhand in 1880 is steamed on Tuesday, Wednesday and Thursday.

Stott Park provides the opportunity to see 19th century machinery and techniques. Entering the mill is like stepping back a hundred years to experience at first hand conditions in which bobbin makers worked.

You can see how coppice trees harvested locally are fashioned under one roof into finished bobbins.

Guided tours last about 45 minutes.

Free educational visits are available with prior booking from the Mill.

English Heritage members visits are free, a discount is available for groups over 11 in number.

### Opening times

Open
1st April to 31st October
Daily 10.00am to 6.00pm
or dusk if earlier.
Last tour commences
1 hour before closing
time.

### Directions

On the Newby Bridge to Hawkshead Road half a mile north of Lakeside steamer pier on the west shore of Windermere.

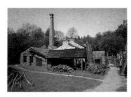

▲ Exterior view of Stott Park Bobbin Mill, Cumbria

▲ Interior view of the lathe shed

▼ The Mill steam engine

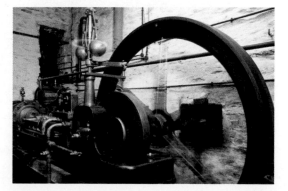

**SENHOUSE ROMAN MUSEUM**
The Battery, Sea Brows, Maryport, Cumbria CA15 6JD
Telephone 01900 816168

Sculpture and inscriptions from the Roman Fort at Maryport which lies next to the museum. The collection begun by John Senhouse in the 1570's is the oldest in Britain.

*Opening times* Open April to July and Bank Holidays, Tuesday, Thursday, Friday, Saturday and Sunday 10.30am to 4.00pm. July to October everyday. November to March Friday, Saturday and Sunday

**LAUREL & HARDY MUSEUM**
4c Upper Brook Street, Ulverston, Cumbria LA12 7BH
Telephone 01229 582292

This most extensive Laurel & Hardy Collection, situated in the town of Stan's birth. Includes letters, photographs, personal items and furniture. Also the cinema shows, films and documentaries all day.

*Opening times* Open February to December daily 10.00am to 4.30pm

Selection of toys on display at Museum of Lakeland Life, Kendal: Cumbria

# DERBYSHIRE & STAFFORDSHIRE

These are busy counties as any visitor to Derby, Burton upon Trent or Stoke can tell. Here was the cradle of the Industrial Revolution...but these two counties contain some of England's finest scenery. Stretching from the Pennines in the north to the Black Country in the south, the landscape varies from windswept bleak mountain scenery to lush rich dairying country. In the Peak District National Park situated in the north of Staffordshire and northwestern Derbyshire there are 555 square miles of lonely moorland and fine walking country. The Peak District Mining Museum at Matlock gives a brilliant insight on 2,500 years of lead mining. Queen of the district is undoubtedly Buxton, a town intended to rival Bath, and like Bath a spa town greatly valued by the Romans. Arguably the most impressive part of this spectacular region is Dove Dale, Beresford Dale and Monsal Dale with their attractive villages. This is a wonderful caving region and at Castleton is Peak Cavern, the largest cave in England. To the north is Mam Tor, known as 'Shivering Mountain' because of its all too frequent landslides.

Derby, the county town of Derbyshire, famous for its Royal Crown Derby porcelain as well as its Rolls-Royce engines, has a fine cathedral, and despite its industrial heart fine scenery is never far away. Staffordshire too offers quite remarkable contrasts. Within a short distance of the busy county town of Stafford lies Cannock Chase, over 20,000 acres of glorious heath and woodland. It was at Lichfield in 1709 that the process of smelting iron ore with coke instead of charcoal was invented, and so enabled the mass-production of iron. Today it's difficult to visualise this picturesque city as a heavy industrial centre.

The industrial and creative expertise of these two counties is clearly reflected in their fine museums and activity centres. The Potteries Museum at Stoke-on-Trent houses the world's finest collection of Staffordshire ceramics; At Barlaston the Wedgwood Visitor Centre is located in the Wedgwood factory, situated in a 500 acre country estate, while the Derbyshire National Tramway Museum gives a wonderful opportunity to actually ride in historic trams. The Etruria Industrial Museum houses Britain's last surviving steam powered potters mill, and for the railway enthusiasts the Churnet Valley Railway at Cheddleton is a great attraction.

DERBYSHIRE & STAFFORDSHIRE

# THE DONINGTON GRAND PRIX COLLECTION
Donington Park, Castle Donington, Derby, Derbyshire DE74 2RP
Telephone 01332 811027 Fax 01332 812829

Donington Grand Prix Collection is home to the worlds largest display of single seater racing cars. It was founded in 1973 by Tom Wheatcroft and in 1998 celebrated it's own 25th Anniversary.

Step into the Donington Grand Prix Collection, and you start an incredible journey through motor sport history.

You'll be able to get closer to these fantastic machines than ever before, as the 5 halls reveal their secrets including Mika Hakkinen's McLaren.

Here are the actual car which gave him his first Grand Prix victory in the 1997 European Grand Prix at Jerez, Spain and Senna's car which won the 1993 European Grand Prix at Donington Park.

Other famous cars found within the collection include Jim Clark's Lotus 25, Nigel Mansell's famous Red 5 Williams, Stirling Moss's Lotus Climax, Jackie Stewart's BRM and Tyrrells. Plus the worlds only complete collection of Vanwalls and many more.

We are open seven days a week throughout the

year, excluding the Christmas period.

This unique collection of racing cars is situated at the worlds most famous Donington Park Circuit just two miles from M1 Junction 23a/24 and M42/A42.

### *Opening times*

Open 7 days a week, all year except over Christmas and New Year period, 10.00am to 5.00pm (last admission 4.00 pm)

### *Directions*

Ideally situated The Donington Grand Prix collection is located near to the cities of Derby, Nottingham, Leicester, and Birmingham. Just turn off at junction 23a on the M1.

▲ Mika Hakkinen's 1997 Winning West McLaren Mercedes

▲ The largest collection of McLaren racing cars

▲ A selection of Pre and Post war Grand Prix Cars

▼ Nigel Mansell's 1992 Championship Winning Red 5 Williams

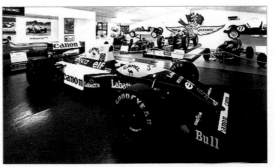

# DERBY INDUSTRIAL MUSEUM

Silk Mill Lane, Off Full Street, Derby DE1 3AR
Telephone 01332 255308 Fax 01332 716670

Derby Industrial Museum is located in the centre of Derby on the sites of the World's oldest factories, George Sorocold's Silk Mills of 1702 and 1717.

The displays introduce visitors to Derbyshire's Industries, Stationary Power, the development of Railways and Railway engineering in Derby from the 1830's to the present day.

You can also see the world's finest collection of Rolls Royce Aero Engines, from the Eagle of 1915 to the modern RB211. There is also a programme of changing exhibitions.

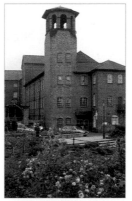

▲ Derby Industrial Museum, housed in a rebuilt 18th century Silk Mill

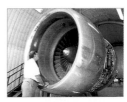

▲ RB211 Jet Engine, part of the Rolls Royce Aero Engine collection

▼ 19th century 'Grasshopper' beam engine, steamed on special event days

### Opening times

Open Monday
11.00am to 5.00pm
Tuesday to Saturday
10.00am to 5.00pm
Closed Sunday
(pending review)
Open Bank Holidays
2.00pm to 5.00pm

### Directions

The Museum is 400 metres from Derby Cathedral. Visitors arriving by car should head for Assembly Rooms car park (signed for Tourist Information Centre). Museum is short walk from here.

DERBYSHIRE & STAFFORDSHIRE

# THE NATIONAL TRAMWAY MUSEUM
Crich, Matlock, Derbyshire DE4 5DP
Telephone 01773 852565 Fax 01773 852326

The National Tramway Museum.... probably the most delightful different "Action Attraction" around!

Children are just as enthusiastic as their elders, for trams have novelty appeal and it's also one of the few museums where dogs (on leads) are welcome to enjoy your visit with you.

You can ride and compare these historic vehicles with the new trams now appearing in various towns and cities.

If you can't remember the originals, this is a fantastic opportunity to discover the experience. The museum is a real "Bridge to the Future'.

Special rates and offers are available with our 'Great Groups' bookings scheme.

There are multi-lingual 'Welcome' leaflets,

wheelchair ramps to all facilities and Braille Guide Books plus text version for sighted companions.

It's the Museums proud boast that there's always something new to see or do.

1998 saw a newly converted tram come into service, specially imported and converted to lift and carry wheelchairs. 1999 promises a new indoor play area, new Education packs and a Guide Book. The indoor attractions are equally beguiling. A vast Exhibition Hall houses 'Track in Time' experience, a dramatic 'Tram at Night' light'sound section plus the chance to visit a turn-of-the-century Trade Exhibition.

◀ Catch up with a different pace of life, at 'Town End'!

### Opening times

Jan/Feb/Mar/Nov/Dec
Tues pre-bookings only
10.30am - 3.00pm
Sun 11.00am - 3.00pm

April/May/Sept/Oct
Daily 10.00am - 5.30pm
(Open until 6.30pm Bank
Holiday weekends)

June/July/Aug
(Open until 6.30pm
Sat/Sun/Bank Holidays)
(Starlight Special Event
until 7.30pm)

▲ That 'on top of the
world' feeling you'll get
here!

### Directions

Fifteen miles north
of Derby,
six miles Matlock,
eight miles
junction 28 M1.
Tourist signing from
A6 and A38.
Trains from Derby
to Matlock or Belper.
Buses call Bus line
01332 292200

▲ The top deck's always
popular, whether you're
grandma or baby

▼ Down the track
beneath the elegant
Bowes-Lyon Bridge

**DERBYSHIRE & STAFFORDSHIRE**

## MIDLAND RAILWAY CENTRE

Butterley Station, Ripley, Derbyshire DE5 3QZ
Telephone 01773 747674 Fax 01773 570721

The Midland Railway Centre is much more than just a Railway. With its huge Railway Museum, Farm Park and Country Park, it is a complete day out.

Also at the centre is the Princess Royal Class Locomotive Trust Depot, the Midland Diesel group collection of over 70 main line Diesel Locomotives, our demonstrations signal box, Victorian Railwaymans church, shops, buffets and much more.

The newly extended narrow gauge Golden Valley Light Railway will operate weekends and Wednesdays April to October and the Butterley Park Miniature Railway on Sundays Easter to October.

Special events operate throughout the year including the very popular "Friends of Thomas The Tank Engine" and our "Santa Specials".

On train dining under our "Midlander" banner includes afternoon teas, Birthday parties and Sunday lunches as well as special charter trains. The centre is also licensed for wedding ceremonies.

The centre is home to one of the largest collections of Locomotives and rolling stock in the country ground Railway history from the 1860's to the 1960's, and from humble industrial machines to the largest main line express Locomotive.

### Opening times

Please telephone for opening times

### Directions

On the B6179 one mile north of Ripley town centre. Also signposted from A38 five miles from junction 28 of M1 towards Derby.

▲ Vintage stock from the 1800's normally in the Museum are used occasionally

▲ Our new narrow Gauge "Golden Valley Light Railway"

◄ "Princess Elizabeth" is one of the largest Locomotives in the collection.

▼ A view in the museum building

# CHURNET VALLEY RAILWAY

Cheddleton Station, Station Road, Cheddleton,
Staffordshire ST13 7EE
Telephone 01538 360522 Fax 01538 361848

The Churnet Valley Railway is a working museum with Steam Train rides through the Churnet Valley. We have a small Railway Relics Museum situated in our station building. The station itself is a Grade II Listed building.

A truly beautiful Victorian rural station deep in the heart of the Staffordshire Moorlands.

Our tea rooms are in the old station master's house which is surrounded in history.

We have a traditional signal box which is being restored to full working order.

The locomotive sheds are working sheds where we have two engines on loan from The National Railway Museum - The North Staffs No.2 plus the Battery Loco, both dated to the last century.

There is always various restoration projects on the go in the shed, currently the Joshua Wedgwood Engine is being restored.

We have recently opened a further two and a half miles through to the valley to the idyllic hamlet of Consall Forge.

It was the first time in thirty four miles that passenger trains have been down the valley.

We are refurbishing our museum to the full splendour of railway memorabilia.

## Opening times

Open
Easter - 3rd October,
Weekends only plus
every Wednesday
in August,
10 am - 5 pm

## Directions

Cheddleston Station
is three miles north
from Cellarhead
along the A520
the road that links
Leek with Stone
once in Cheddleton.
Look for Station Road.

▼ Train passing over
bridge at Consall Forge

▲ Train approaching
level crossing at
Cheddleton Station

▲ Platform two at
Cheddleton Station

▲ Train awaiting
departure at Consall
overhanging waiting
shelter over canal.

DERBYSHIRE & STAFFORDSHIRE

**DERBYSHIRE & STAFFORDSHIRE**

# MILL MEECE PUMPING STATION PRESERVATION TRUST

Cotes Heath, Eccleshall, Staffordshire ST21 6QH
Telephone 01270 873683 Fax 01782 791339

Take a step back in time and experience the sight, sound and smell of two powerful steam engines which once pumped over three million gallons of water a day to the potteries towns.

The Grade II Listed buildings of the Mill Meece Pumping Station are home to these gentle giants, which are the only engines of their type still operational in the UK.

After more than half a century of sterling service, the engines were pensioned off in favour of electric multi-stage centrifugal pumps down the boreholes, but through a happy liaison between Severn Trent Water and a band of the steam enthusiasts, an independent preservation trust was formed to lease the station and preserve the engines, boilers and all their supporting equipment.

Visitors are welcome without charge on most weekend afternoons throughout the year, to view the gentle giants at rest.

During the summer months steaming weekends, with special events and rallies, attract an admission charge, but with concessions for families, children and senior citizens.

The large rural site offers free off road parking and picnic areas, in addition to the standard facilities.

Dogs are welcome, but only in the spacious car park.

### Opening times

Open most weekends from 12pm to 5pm throughout the year

### Directions

Mill Meece is on the A519 roughly halfway between Newcastle and Eccleshall and is sign posted in the vicinity.

▲ An engine detail showing complex oiling system

▲ One of the twenty feet diameter thirty one ton flywheels

▼ The Mill Meece Pumping Station

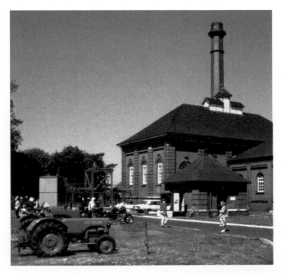

## WALL ROMAN SITE

Watling Street, nr Lichfield, Staffordshire WS14 0AW
Telephone 01543 480768

Wall was a posting station on the Roman road now called Watling Street, and is the most complete example of its kind in Britain.

Traces of a fort and a granary, as well as a twenty acre defended settlement have been found, although stone robbing and imperfect recording make interpretation difficult.

The site is limited to the footings of a mansion, a sort of Roman hotel, and a baths area.

Unfortunately, the hyporcaust system associated with the latter has had to be re-buried to preserve it, and it is therefore not viewable.

There is also a museum containing many finds from this Roman site.

▲ Tiles from the museum

### Opening times

Open
1st April
- 31st October daily
10.00am to 6.00pm
(5.00pm in October)

▼ The Bath House Remains

### Directions

Situated off the A5
at Wall near
to Lichfield.
OS Map 139
ref. SK099067

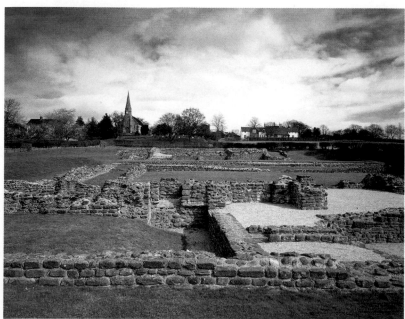

DERBYSHIRE & STAFFORDSHIRE

# GLADSTONE POTTERY MUSEUM

Uttoxeter Road, Longton, Stoke-on-Trent,
Staffordshire ST3 1PQ
Telephone 01782 319232 Fax 01782 598640
Website http://www.stoke.gov.uk/gladstone

**DERBYSHIRE & STAFFORDSHIRE**

Gladstone Pottery Museum remains the only complete Victorian pottery factory from the days when coal-burning bottle ovens made the world's first bone china.

Preserved by the City of Stoke on Trent, this unique working museum allows visitors to see how 19th century potters worked.

Traditional skills, original workshops, the cobbled yard and huge bottle kilns create an atmospheric time-warp which has no equal.

The Potteries are well-known for the expertise of the local workforce. Here at Gladstone you can see a wide range of pottery skill in action: decorating, casting, throwing and many more.

A visit of Gladstone is not complete without visiting the Museum's impressive collection of ceramics tiles and period sanitaryware.

Only at Gladstone can you reach out and touch the history of the Potteries.

Feel the clay slipping and sliding through your fingers, make pots and china flowers to take home.

Explore an exciting maze of passageways, workshops, bottle ovens and galleries from long ago.

Gladstone is the very heart of the Potteries and the perfect place to begin exploring this world famous area.

### Opening times

Open daily all year
10.00am to 5.00pm
(last admission to
museum 4.00pm)

### Directions

Road: From M6 follow
A500 and take
the A50 to Longton.
Bus: frequent bus
service to Longton
from across the city.
Rail: Stoke Station
(link bus service)
Longton Station
(check for service
details).

▲ Young visitors get their hands on the clay

▲ Ceramic artist Marie Graves adds finishing touches

▲ 'Mrs Carter', Head Clerk in 1910 greets visitors to the factory

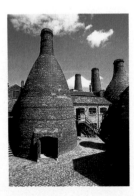

◄ Gladstone Pottery Museum's yard with bottle oven in foreground

# ORD GREEN HALL

Ford Green Road, Smallthorne, Stoke-on-Trent,
Staffordshire ST6 1NG
Telephone 01782 233195 Fax 01782 233194

This small and intimate house is one of the hidden gems of Stoke-on-Trent and a rare survival of the city's pre-industrial past.

Built as a farmhouse in 1624, it was extended in brick in the early 18th century and today is fully furnished with a collection of oak furniture, furnishings and domestic objects as used by a middle-class family in the 17th and 18th centuries.

Immediately behind the hall, a small 17th century style period garden has been created, containing a collection of herbs and other plants grown in 17th century gardens.

The hall holds regular events throughout the Summer months and at Christmas is decorated throughout with traditional greenery.

It also has an award winning education service and is a licensed wedding venue.

Children's quiz and family tickets available, small gift shop and tearoom (drinks only).

Access for disabled people on the ground floor only (Wheelchair users free of charge).

▶ Regular activities bring the past to life

### Opening times

Open all year daily (except Fridays and Saturdays) 1 - 5pm (Last admission 4.45 pm) closed 25th December - 1st January inclusive

### Directions

Located on the north-east edge of Stoke-on-Trent on the B5051 Burslem to Endon Road. Regular bus services from Hanley and Newcastle-under-Lyme stop outside.

▲ Ford Green Hall
A rare survival of Stoke-on-Trent's pre-industrial past

▲ The hall is fully furnished as a 17th century home

▶ The recreated period garden contains 17th century plants and herbs

DERBYSHIRE & STAFFORDSHIRE

## BOLSOVER CASTLE

Castle Street, Bolsover, Derbyshire S44 6PR
Telephone 01246 823349

A 17th century enchanting romantic mansion, the little castle has elaborate Jacobean fireplaces, panelling and wall painting. An indoor riding school one of the oldest in Europe. Audio tours are included in the admission.

*Opening times* Open April 1st to October 31st 10.00am to 6.00pm
(last admission 5.00 pm)
Open Wednesday to Sunday 1st November to 31st March
10.00am to 4.00 pm (last admission 3.00pm).
Closed Monday and Tuesday

## PICKFORD'S HOUSE MUSEUM

41 Friargate, Derby, Derbyshire DE1 1DA
Telephone 01332 255363 Fax 01332 716670

A beautiful Georgian town house showing the accommodation and furnishings of a late Georgian professional man. Also fine collection of 18th and 19th century costume. Regular events and temporary exhibitions.

*Opening times* Open Monday 11.00am to 5.00pm
Tuesday to Saturday 10.00am to 5.00pm
and Bank Holidays 2.00pm to 5.00pm

## TREAK CLIFF CAVERN

Castleton, Hope Valley, Derbyshire S33 8WP
Telephone 01433 620571 Fax: 01433 620571

An underground wonderland of stalactites, stalagmites, rocks, minerals and fossils. Home of the world famous Blue John stone. See the richest known deposits of this beautiful mineral inside the cavern.

*Opening times* Open every day except Christmas Day (weather permitting)
1st March to 31st October 9.30am to 5.30pm
1st November to 28th February 10.00am to 4.00pm
(last tour 40 minutes before closing time)

## PEAK DISTRICT MINING MUSEUM

The Pavilion, Matlock Bath, Derbyshire DE4 3NR
Telephone 01629 583834

A hands-on museum where you can climb and crawl through shafts, including a disaster tunnel. Discover the story of lead and examine the minerals in our exhibition. Guided tours on request.

*Opening times* Open all year except Christmas Day
Winter 11.00am to 4.00pm
and Summer 10.00am to 5.00pm

## MUSEUM OF CANNOCK CHASE

Valley Road, Hednesford, Staffordshire WS12 5TD
Telephone 01543 877666 Fax 01543 462317

Delightful museum illustrating the history of Cannock Chase from mediaeval hunting forest to coalfield community. Special events, temporary exhibitions all year. Admission free. Pre-booked hands on activities, special group rates apply.

*Opening times* Open Easter to September 11.00am to 5.00pm
(last admission 4.30pm)
October to Easter 11.00am to 4.00pm (last admission 3.30pm)
Closed December 19th to January 3rd

## STAFFORDSHIRE REGIMENT MUSEUM

Whittington Barracks, Lichfield, Staffordshire WS14 9PY
Telephone 0121 311 3229 Fax: 0121 311 3205

The Museum tells the story of the soldiers of the Staffordshire Regiment and its predecessors. Exhibits include vehicles, uniforms, weapons, medals and memorabilia relating to the 300 years of regimental history, including distinguished service in the First and Second World Wars and the Gulf War.

*Opening times* Weekdays April to December
Tuesday to Friday 10.00am to 4.00pm. Closed Mondays.
Weekends and Bank Holidays from May 1st to 30th August 1.00pm to 5.00pm

## BOROUGH MUSEUM AND ART GALLERY

Brampton Park, Newcastle-under-Lyme, Staffordshire ST5 0QP
Telephone 01782 619705 Fax: 01782 626857

Permanent displays include Victorian Street scene, militaria, childhood, industry, civic life and ceramics. Two temporary exhibition areas with frequently changing exhibitions. Set in park with aviary, model railway and play area.

*Opening times* Open Monday to Saturday 10.00am to 5.30pm,
Sunday 2.00pm to 5.30pm
Closed Bank Holiday Monday (except Spring Bank Holiday Monday, Good Friday and 25th December to 1st January inclusive)

## ANCIENT HIGH HOUSE

Green Gate Street, Stafford ST16 2JA
Telephone 01785 240204

The High House is England's largest timber-framed town house. It contains a registered museum as well as Stafford's tourist information centre. The Staffs yeomanry museum is on the top floor.

*Opening times* Open April to October Monday to Friday 9.00am to 5.00pm
Saturday 10.00am to 4.00pm November to March Monday to Friday 9.00am to 5.00pm Saturday 10.00am to 3.00pm

## WEDGWOOD VISITOR CENTRE
Barlaston, Stoke-on-Trent, Staffordshire ST12 9ES
Telephone 01782 204218 Fax 01782 374083

Wedgwood Visitor Centre and factory is home to the world famous pottery and includes demonstration arena, restaurant, museum exhibitions, art gallery and film theatre. Call 01782 204218 for more details.

*Opening times* Open all year except Christmas Week 9.00am to 5.00pm Monday to Friday 10.00am to 5.00pm Saturday and Sunday

## SPODE MUSEUM
Spode Works, Church Street, Stoke-on-Trent,
Staffordshire ST4 1BX
Telephone 01782 744011 Fax 01782 744239

On the site of the original Spode manufactory, the museum displays Spode and Copeland ceramics spanning over 200 years. Attractions include the famous Blue Room, craft demonstrations and factory tours.

*Opening times* Open 9.00am to 5.00pm Monday to Saturday 10.00am to 4.00pm Sunday, Open all year except Christmas Day, Boxing Day and New Years Day

## ETRURIA INDUSTRIAL MUSEUM
Lower Bedford Street, Etruria, Stoke-on-Trent, Staffordshire
ST4 7AF
Telephone 01782 233144 Fax 01782 233145

Includes Jesse Shirley's Mill, beam engine 'Princess' in Steam April to December. Blacksmith at work in the forge. Exhibitions, activities in Canal warehouse. Industrial history talks, new Visitor Centre, shop teas, etc.

*Opening times* Open January to December Wednesday to Sunday
10.00am to 4.00pm (except Christmas and New Year)

## THE POTTERIES MUSEUM & ART GALLERY
Bethesda Street, Hanley, Stoke-on-Trent, Staffordshire ST1 3DE
Telephone 01782 232323 Fax 01782 232500

Discover the world's finest collection of Staffordshire ceramics, the story of The Potteries and a World War II Spitfire! Plus.... a lively programme of exhibitions, events and activities. Book in advance for guided tours.

*Opening times* Monday to Saturday 10.00am to 5.00pm,
Sunday 2.00pm - 5.00pm
(Closed 25th December to 1st January inclusive)

# DEVON

Like its neighbour Cornwall, glorious Devon has two contrasting coastlines. The north coast, decidedly rocky with steep wooded cliffs, the south coast deeply indented with lovely sandy bays and a considerably softer climate. Between the coasts the county is dominated by lofty brooding Dartmoor, the largest barren wilderness in the south of Britain, a landscape of contorted rocky tors, of lonely prehistoric sites, the country's best known prison and the hardy wild Dartmoor ponies. The north of the county includes a part of Exmoor where moorland meets the sea. Exeter, the county town has a magnificent Norman cathedral holding the remarkable Anglo-Saxon Exeter book. Incidentally, Exeter's Underground Passages are an experience not to be missed. At the wonderful North Devon Maritime Museum all aspects of the regions maritime history are illustrated by models, photographs and paintings.

Of course Devon is a county of great seafarers. It was from the fine natural harbour of Plymouth that the Pilgrim Fathers sailed to the New World, and it was from here that Sir Francis Drake and Sir John Hawkins sailed to confront the mighty Spanish Armada. At the Teignmouth Museum are sixteenth century cannon and artifacts from Armada wrecks. Since the eighteenth century the city has been closely linked with the Royal Navy, as indeed has Dartmouth. Dartmouth, built into the steep hillside at the mouth of the river Dart is home to the Royal Naval College. Dartmouth Castle gives a magnificent view from its roof terrace. The Dartmouth Museum tells the local and maritime history of the town and is situated in an interesting seventeenth century merchant's house.

Devon is naturally very holiday orientated. Both north and south coasts are lined with villages, each with its own particular charm, vying with its neighbour for attention. Ilfracombe, the largest seaside resort on the north coast offers dramatic rocky headlands and sheltered bays. Clovelly, steeply dropping to the sea is picturesque in the extreme. Torquay developed during the last century from a small fishing village to become the main resort on the 'English Riviera'.

Torquay Museum is Devon's oldest museum and includes fascinating finds from Kents Cavern. At Morwellham Quay is a splendid visitor centre and open air museum. The historic Tamar Valley river port offers train rides into old mine workings...horse-drawn carriage rides...and all with costumed staff.

DEVON

# COLDHARBOUR MILL WORKING WOOL MUSEUM
Uffculme, Cullompton, Devon EX15 3EE
Telephone 01884 840960 Fax: 01884 840858

Coldharbour Mill Working Wool Museum is situated in the heart of rural Devon. Built in 1797 the five storey building has been spinning yarn for the weaving industry for 200 years.

The museum opened in 1982 and has continued the spinning tradition of both the worsted and woollen processes.

Guided tours of the Mill demonstrates the machinery in action, some of which date back to Victorian times.

The Mill produces an exclusive range of knitting yarns sold through the Mill Shop. We also own the copyright to weave the Devon Tartan. A licensed Restaurant is also available.

▼ 1867 Kittoe and Brotherhood beam engine

The Engine House contains the original 1910 Pollit and Wigzell drop-valve horizontal cross compound steam engine, a 1888 Lancashire Boiler and a newly restored 1867 Beam Engine. Both engines are in full working order and "in steam" every Bank Holiday Sunday and Monday.

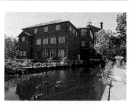

▲ Coldharbour Mill Working Wool Museum

Coldharbour Mill is a rare example of social and industrial history and an enthralling day out for people of all ages.

▲ 1898 Roving Frame in action during a guided tour

The New World Tapestry, on permanent exhibition at Coldharbour Mill, consists of 24 panels each measuring 11ft X 4ft making up a 264 ft panorama telling the story of the colonisation of the Americas between 1583 and 1642.

◀ 1910 Pollit and Wigzell steam engine

### Opening times

Open April to October
10.30am to 5.00pm
daily
(last tour at 4.00pm)
November to March
Monday to Friday,
times vary (please
telephone for details)

### Directions

Just 2 miles from
junction 27 on the M5
(Tiverton exit). B3181
to Willand, then
Uffculme, following
brown signs to Working
Wool Museum.
Alternatively A313 to
Cullompton from
Honiton.

DEVON

DEVON

# THE DEVON GUILD OF CRAFTSMEN
Riverside Mill, Bovey Tracey, Devon TQ13 9AF
Telephone 01626 832223 fax: 01626 834220

The attractive Grade II-listed Riverside Mill, which has an exhibition gallery, shop and café, is the home of the Devon Guild of Craftsmen.

Established in 1955 in order to encourage a wide appreciation of crafts and to promote the highest standards of craftsmanship and design, the Devon Guild is now a registered charity with a selected membership of over 200 makers who include such internationally renowned craftsmen as the potter David Leach and furniture maker Alan Peters.

The Devon Guild is one of the most exciting craft venues in the South West with a regular annual programme of craft shows featuring work from members and invited contributors, and which attracts some 100,000 visitors a year.

▼ Guy Martin
Conversation Chair

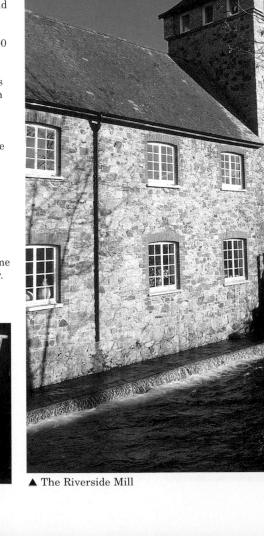

▲ The Riverside Mill

▲ Siddy Langley Glass

The shop, selected for quality by the Crafts Council, displays a wide range of members' work for sale including ceramics, furniture, prints, textiles, jewellery and woodwork.

The café is renowned for its delicious home cooked food including vegetarian dishes, excellent cakes and local wines which can also be enjoyed outside in the courtyard in the summer.

The Devon Guild of Craftsmen also promotes an active education and outreach programme including demonstrations and other craft-related events both at Riverside Mill and elsewhere.

### *Opening times*
Open 7 days a week all year (except winter Bank Holidays) 10.00am to 5.30pm

### *Directions*
20 minutes west of Exeter off A38 Expressway. Five minutes from Drumbridges exit follow brown signs into Bovey Tracey. Ample free parking.

▶ Jane Martin Necklaces

*DEVON*

# BRIXHAM MUSEUM & HISTORY SOCIETY
Bolton Cross, Brixham, Devon TQ5 8LZ
Telephone 01803 856267

Situated in the old Police Station (built in 1902) Brixham Museum was founded in 1958 for the purpose of saving and exhibiting the heritage of the town and fishing port, and features displays of interest and enjoyment for all the family.

Our spacious Maritime Gallery celebrates Brixham's illustrious seafaring past and includes displays of shipwrights' tools, sailmaking, and other nautical themes including the lifeboat service, and trawler regattas.

There are imaginative and nostalgic reconstructions of turn-of-the-century local shops, a Victorian Parlour, and an actual Police Cell.

Costume displays provide a fascinating glimpse into fashion changes from the Victorian period to the present day.

Other exhibits cover the Napoleonic Fort on Berry Head, Brixham during the two World Wars, local schools and churches.

School groups are encouraged to visit. There are free activity sheets for children.

As a Registered charity we do depend on the support of visitors and therefore make a modest charge of admission: £1.20 adults; 80p concessions; £3.50 family ticket.

### Opening times

Open April to October
Monday to Friday
10.00am to 5.00pm
(Last admission 4.30pm)
Saturday
10.00am to 1.00pm

▼ Brixham Museum situated in the Old Police Station (built 1902)

### Directions

Brixham Museum is situated at Bolton Cross next to the Town Hall by the traffic lights. Parking is 2 minutes away in Central Car Park.

▲ Scale model of Brixham trawler BM 161 "Valerian"

# DARTMOUTH MUSEUM

The Butterwalk, Dartmouth, Devon TQ6 9PZ
Telephone 01803 832923

A small and unusually interesting museum housed in an old merchants house dated 1640. Full of local and maritime information, many ship models, pictures and artefacts of this ancient little town and well worth visiting.

### Opening times
Open March to October
11.00am to 5.00pm
(Last admission 4.30pm)
October to March
12.00pm to 3.00pm

▲ Dartmouth Castle, one of 13 early watercolours

### Directions
A381 west to A3122
from Totnes.
A379 from Kingsbridge.
Ferry from Kingswear
from Torbay.

▲ Model of Steam Yacht. Built on River Dart 1895

◀ Model local fishing trawler

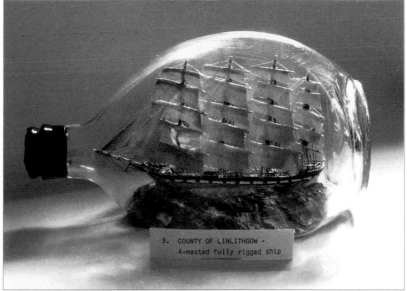

3.  COUNTY OF LINLITHGOW -
4-masted fully rigged ship

▲ Ship in bottle. One in a collection of 29

123

**DEVON**

# ROYAL ALBERT MEMORIAL MUSEUM & ART GALLERY

Queen Street, Exeter, Devon EX4 3RX
Telephone 01392 256858 Fax 01392 421252

Large regional museum in central Exeter with important collections, exciting displays and a programme of temporary art exhibitions, lectures, workshops and children's activities.

The building itself is a geological showpiece, containing a variety of local stones. Displays include local history and archaeology, geology, exotic birds and butterflies, West Country silver, clocks and watches, fine art and world cultures.

Albert's the museum shop sells fascinating items from all over the world and the Consort Cafe serves snacks, simple meals and a delicious selection of cakes and biscuits.

▶ Stoneware silver and gilt jug from Banstaple c1580

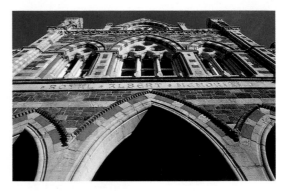

▲ The Museum building is an architectural showpiece

*Opening times*

Open all year
Monday to Saturday
10.00am to 5.00pm

*Directions*

The entrance is in Queen Street opposite Habitat. Queen Street runs off the High Street by Marks & Spencer.

▼ Tahitian mourning dress from the museum's world cultures collection

# EXETER'S UNDERGROUND PASSAGES

Romangate Passage, Off High Street, Exeter, Devon EX4 3PZ
Telephone 01392 265858 Fax: 01392 421252

One of the most remarkable museums in the country. First devised to bring water into the heart of the city at the start of the 13th Century, the passages can be visited today, little changed since the days when they were built.

No similar system of passages can be explored by the public elsewhere in Britain. Visitors to the underground interpretation centre pass through an exhibition and video presentation before being taken on a guided tour of the passages.

The guides pass on fascinating tales and facts, from rats and ghosts to the financial wheeling and dealing associated with the provision of water in the city, while pointing out everything the visitor can see in the passages around them.

Visitors should beware of the low vaults, rough or uneven floors, dark areas, and that the tunnels are constricted and should not be visited by those who suffer from claustrophobia.

Because of the nature of the ancient passages, there is no wheelchair access.

▲ A view down part of the cathedral passage

## *Opening times*

Open July to September
and school holidays,
Monday to Saturday
10.00am to 5.30pm
(Last Tour 4.45pm)
Rest of the year
Tuesday to Friday
2.00pm to 5.00pm
and Saturday
10.00am to 5.00pm

## *Directions*

The entrance is in
Romangate Passage
next to Boots in Exeter
High Street.

▼ Underground
passages interpretation
centre and shop

DEVON

## ALLHALLOWS MUSEUM
High Street, Honiton, Devon EX14 8PE
Telephone 01404 44966 Fax: 01404 46591

Situated next to the Parish Church in the High Street, the Museum buildings consist of part of the former Allhallows Chapel and the Allhallows School dining hall.

The Murch Gallery has displays illustrating the prehistory of the area. There are fossilised bones of the Honiton hippos and the teeth of elephants found nearby.

The stone, bronze and iron ages are brought to life by dressed models shown at work along with tools found in the area.

There are souvenirs of local industries, iron founding whetstones, clock making, cream making and Honiton lace.

Bobbin lace has been made in the town since about 1560 and achieved international fame for its high quality throughout the 17th and 18th Centuries.

The introduction of cheap machine lace brought about the slow death of the bobbin lace industry.

However, the daily demonstrations in the summer months show that the craft lives on in the hands of enthusiasts.

The Norman Gallery is home to the world-famous Allhallows collection of lace representing the styles and techniques through the Centuries.

### Opening times

Open Monday before Easter to end September 10.00am to 5.00pm, October 10.00am to 4.00pm Monday to Saturday

### Directions

Allhallows Museum is situated in the centre of Honiton High Street to the right of St Pauls Church. No parking but car parks are in New Street and Dowell Street.

▲ Honiton Pottery stocks and clock

▲ Lace makers keep the skill alive

▲ Bonnets from the lace collection

▼ Allhallows Museum of lace and antiquities

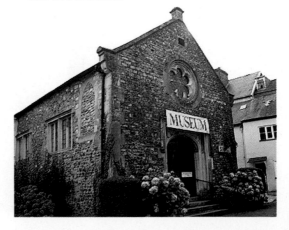

## ILFRACOMBE MUSEUM & BRASS RUBBING CENTRE

Wilder Road, Ilfracombe, Devon EX34 8AF
Telephone 01271 863541

A fascinating collection of over 20,000 items of natural history, Victoriana, Maritime , Minerals, Archaeology, Maps, Paintings, Photographs, Militaria Costume, Local history, lovingly gathered by curators and trustees for over 65 years.

### Opening times

Open April to October every day
10.00am to 5.30pm,
November to March
Monday to Friday
10.00am to 12.30pm

▼ Victorian kitchen

*Directions*

On sea front next to landmark theatre.

▲ Large collection of South American butterflies

▼ Maritime Room

# MORWELLHAM & TAMAR VALLEY TRUST

Morwellham Quay, nr Tavistock, Devon PL19 8JL
Telephone 01822 832766 Fax 01822 833808

AA Award winning Visitor Centre for Days out in a Designated Area of Outstanding Natural Beauty (often used for film and television location work). Midway between Tavistock, Devon and Liskeard, Cornwall, SW England.

Visitors can ride by electric train tramway (3 1/2 ton BEV battery electric locomotion) underground into a copper mine, last worked in 1869. Visible copper ore seam, displays of mining techniques through history. Working 5 1/2 metre diameter underground waterwheel.

Stables at Morwellham House house shire horses which pull wagonettes for visitor rides along a section of the Duke of Bedford's old carriageway.

A Tamar River style ship - Merchant Ketch Garlandstone is under restoration at Morwellham. 18th and 19th century lime kilns. Carpenters Shop. Staff at Morwellham wear costume copied from the Mid 19th century.

Visitors (their children and their dogs!) can try replica costume in the Limeburners Cottage. The Ship Inn built in c1500-1550 is now used as a restaurant for visitors.

Video shows, demonstrations and activities, some especially for children, there is also a playground. Family tickets, concessions and group rates.

### Opening times

Open all year
7 days a week
10.00am to 5.00pm
(closed 23rd December
to 3rd January incl)
last admission 3.30pm
Copper Mine and
grounds only open in
Winter with earlier
closing

### Directions

By road M5 Motorway
for Okehampton then
A30, A386 & A390,
signed tourist route
A390 via Liskeard
and Callington.
From Cornwall
By Rail/Bus Tamar
Valley Line/Western
National

▲ The 32ft diameter waterwheel at Morwellham Quay, nr Tavistock, Devon

▲ Tramway at Morwellham Quay

▼ The George and Charlotte Copper Mine Tramway for visitors

# FINCH FOUNDRY
Sticklepath, Okehampton, Devon EX20 2NW
Telephone 01837 840048

Finch Foundry is a fascinating water powered forge which used to produce agricultural and mining hand tools.

Still in working order with regular demonstrations, the foundry has three water wheels which drive the huge tilt and drop hammers, giant shears and grindstone.

There is an exhibition room upstairs and a very pleasantly situated tearoom with views over informal gardens and to the moor itself.

▶ View of one of three working water wheels

## Opening times

Open March to October daily except Tuesday, 11.00am to 5.30pm (Last admission 5.00pm)

## Directions

Four miles east of Okehampton on the old A30. Signposted from the current A30.

▶ Interior of the workshop, showing shears and the drop hammer.

D E V O N

# SOUTH MOLTON & DISTRICT MUSEUM
Town Hall, The Square, South Molton, Devon EX36 3AB
Telephone 01769 572951

In 1987 South Molton & District Museum won an illustrated London News Award for the best small museum of the year and its displays now on view offer a most coherent story line of the life and times of the town and the surrounding district with items and photographs depicting domestic activities, trades, industry and farming - all fascinating glimpses of the past.

Included are a massive wooden 18th century cider press with contemporary implements, firkins etc.

Two fire engines, one a Newsham's model bought in 1736 for £46, which price included a dozen leather buckets, 6 of which survive. The second engine is a horse drawn appliance bearing the date 1886.

We have 2 original charters on view. One from Elizabeth I dated 9th May 1590 and another given by Charles II dates 24th December 1684.

Our pewter collection which is on display is quite unique. The collection was a gift to the council in 1950 and formed the basis of the museum, established 1951.

We have 6 temporary exhibitions during our year. All of them from local people or groups which are very interesting.

We also have a varied display of minerals. Most of which are from local mine workings.

### Opening times
Open
March to November
Monday, Tuesday
and Thursday
10.30am to 1.00pm and
2.00pm to 4.00pm,
Wednesday and
Saturday
10.30am to 12.30pm

### Directions
M5 Exit at 27 A361
(North Devon Link
Road) Exit at South
Molton turn off proceed
to the square, the
museum is situated in
the town hall building
erected in 1743

▲ Newsham Fire Engine 1736 with leather buckets

▶ Lord Widgery memorabilia and our Penny Farthing bicycle

▲ A section of our household and trade display

▲ The reception area where you are assured a warm welcome

# TIVERTON CASTLE

Park Hill, Tiverton, Devon EX16 6RP
Telephone 01884 253200 Fax: 01884 254200

*DEVON*

Few buildings evoke such an immediate feeling of history as Tiverton Castle.

Originally built in 1106, it was enlarged and rebuilt down the ages, and many styles of architecture from mediaeval to modern can be seen.

Once home of the powerful medieval Earls of Devon, the Castle has witnessed extremes of peace and turbulence; drama during the Wars of the Roses, triumph and treason when a Plantagenet Princess's palace, and tragedy and treachery during a forlorn Civil War siege.

Among the displays are a notable Civil War armoury (come and try on some pieces); fine pictures and an interesting, small Napoleonic display.

There are four superb self-catering holiday apartments for rent - make a Castle your home - all modern comforts in medieval surroundings. It is also licensed for Civil Weddings - what could be more romantic than a wedding in a medieval Castle?

New gardens in among picturesque old walls - spring bulbs, rare, unusual herbaceous and colourful summer borders, woodland with mature trees, kitchen garden. With continuing conservation in the Castle and gardens there is always something new and interesting to see.

### Directions

Tiverton Castle is on the north side of the medieval centre of Tiverton next to St. Peter's Church.

▼ Mediaeval Solar Tower of Tiverton Castle

### Opening times

Open Easter to end June and September Sunday, Thursday and Bank Holiday Mondays July & August Sunday to Thursday 2.30pm to 5.30pm (Last admission 5.00pm) Open at any other time to parties of more than 12 by prior arrangement

▲ Inner courtyard of Tiverton Castle

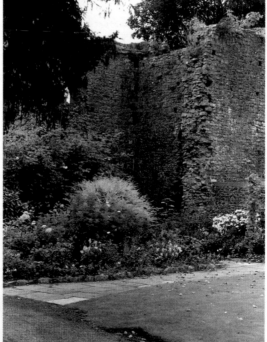

R.J. Photographic

**DEVON**

# TOPSHAM MUSEUM SOCIETY
25 The Strand, Topsham, Devon EX3 0AP
Telephone 01392 873244

Topsham Museum, a registered charity, is in a late 17th Century furnished house and sail-loft with estuary gardens.

Exhibits trace the story of maritime trade, ship building and wildlife of the Exe Estuary.

Admission charge £1.50 with concessions. Children admitted free with family party.

Home-made teas and shop. Group visits at other times by prior arrangement.

## *Opening times*

Open Easter Saturday to end of October on Sundays, Mondays, Wednesdays and Saturdays
2.00pm to 5.00pm
(last admission 4.30pm)

## *Directions*

"T" bus from Exeter to Topsham Quay or train to Topsham station then follow Quay signs. Car parking Holman Way or Quay. Museum along Strand, down river from Quay.

▶ Topsham Museum, the House, the Sail-loft and the River Exe

▲ Bed hangings in the 17th C style and the baby's cot

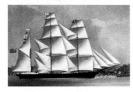

▼ The "Hugh Fortescue" built in Topsham in 1865

▶ The 1940's Kitchen

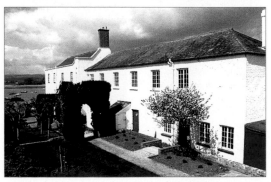

DEVON

# TORQUAY MUSEUM
529 Babbacombe Road, Torquay, Devon TQ1 1HG
Telephone 01803 293975 Fax: 01803 294186

Devon's oldest Museum now offers more to see than ever before. Eight exciting galleries include the Agatha Christie Exhibition, the largest ever staged on the world's most popular crime writer.

Torbay and its Regiments, an outpost of the Devon and Dorset Regimental Museum, and a local history gallery which includes a recreation of a turn of the century Devon kitchen.

Temporary exhibitions include World Adornment, over 200 pieces of exotic jewellery from all over the world, and 150 years of Torquay Museum which exhibits some of the Museum's more weird and wonderful artifacts.

To add to this, permanent displays include archaeology and the internationally important finds from Kents Cavern, geology and natural history of the local area, Victoriana and a splendid Victorian entrance hall, Hester Pengelly's autograph collection, World War II memorabilia and images of old Torquay on photo-CD.

Please enquire about special events including concerts and the summer exhibition and before you leave browse the unique range of gifts in the museum shop.

Discounts are available for group bookings and school parties can have the use of our well equipped school room.

---

### Opening times

Open
10.00am to 4.45pm
Monday to Friday
Weekends:
Easter to October
Saturdays
10.00am to 4.45pm
Sundays
1.30pm to 4.45pm,
allow at least 1 hour
for your visit,
closed Christmas week.

---

### Directions

Follow signs to the sea front and old harbour then turn left at the Clocktower on the Strand, Torquay Museum is 250 yards up Babbacombe Road on the left.

---

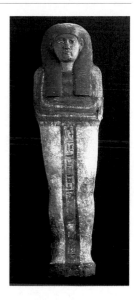

▲ Ancient Egyptian wooden coffin

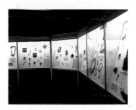

▲ World Adornment exhibition, over 200 pieces of exotic jewellery

▲ Torquay Museum built in 1876

▲ Devon farmhouse kitchen C1900 part of the local history gallery

DEVON

# YELVERTON PAPERWEIGHT CENTRE
4 Buckland Terrace, Leg 'o' Mutton, Yelverton, Devon PL20 6AD
Telephone 01822 854250 Fax: 01822 854250
EMail David.G.Hunter@btinternet.com

Established in 1968, this centre is home to the "Broughton Collection".

This is an exhibition of hundreds of glass paperweights including many rare and collectable pieces produced in such renowned studios as Saint Louis, Baccarat, Clichy, Whitefriars, and from Murano, Bohemia and other glass making regions.

Also on display is the work of Paul Ysart, Peter Homes, William Manson, and John Deacons.

In addition to the permanent exhibition there is on sale a large selection of modern glass paperweights.

These range from inexpensive gift paperweights through to collector and limited edition items from the leading contemporary studios including Saint Louis, Baccarat, Perthshire, Selkirk and Okra.

Additional to paperweight exhibition there is on view a range of original oil and water-colour paintings.

These paintings are the work of established local artists who specialise in Dartmoor and local wildlife subjects.

There are a number of low-level display cabinets for the benefit of disabled visitors using wheel-chairs.

Admission to the exhibition is free. Coach parties are kindly requested to notify in advance of their visit.

## *Opening times*

Open April to October
10.00am to 5.00pm
December 1st to 24th
7 days a week
All other months
weekends only

▶ ▼ Internal views of the display areas

## *Directions*

Situated in Dartmoor National Park between Plymouth and Tavistock on the A386. The Paperweight Centre is marked on the Ordnance Survey Map. Follow Tourist Board brown signs on A386.

▲ The Yelverton Paperweight Centre

## NORTH DEVON MARITIME MUSEUM
Odun Road, Appledore, Devon EX39 1PT
Telephone 01237 422064

Fine listed building with items from local seafaring past, models, photographs of sail and steam vessels, ship building, fishing, wreck and rescue. World War II display. Videos and Victorian school room. Some facilities for disabled people but no lift. Guided tours by arrangement.

*Opening times* Open Easter to 31st October every afternoon 2.00pm to 5.00pm (last admission 4.15pm) Also May 1st to September 30th Monday to Friday 11.00 am to 1.00pm (last admission 12.15pm)

## HARTLAND QUAY MUSEUM
Hartland Quay, Hartland, Bideford, Devon EX39 6DU
Telephone 01288 331 353

Museum devoted to local coastline. Displays on 400 years of shipwrecks, natural history of the coast, life saving, smuggling, history of the Hartland Quay, coastal industries, flora and fauna. Guided tours by arrangement. Bar and restaurant opposite museum.

*Opening times* Open 1st April to 11th and Whit Sunday through to September 30th daily 11.00am to 5.00pm

## DARTMOUTH CASTLE
Dartmouth, Devon TQ6 0JN
Telephone 01803 833588 Fax 01803 834445

The first castle built specifically for artillery in England. Guarding the entrance to Dartmouth Harbour with spectacular views from its battlements. Includes Victorian gun battery with exhibition of period artillery.

*Opening times* Open 1st April to 31st October daily 10.00am to 6.00pm 1st November to 31st March Wednesday to Sunday 10.00am to 4.00pm

## OTTERTON MILL
near Budleigh Salterton, Devon EX9 7HG
Telephone 01395 568521 Fax 01395 568521

Working watermill dating back 1,000 years. Bakery using our own flour. Gallery with programme of about nine exhibitions annually. Co-operative craft shop. Pottery. Riverside Walks. Slide/Tape Show. Lace exhibition. Free access and toilet on ground floor for disabled people.

*Opening times* Open 10.30am to 5.00pm mid March to end October, 11.00am to 4.30pm November to mid March (last admission 4.45pm)

## SID VALE HERITAGE CENTRE
The Museum, Church Street, Sidmouth, Devon EX10 8LY
Telephone 01395 516139

Local artefacts including pictures, prints, photographs, Victoriana, costumes, lace. Special displays and craft work advertised locally. Guided town walks 10.15 am every Tuesday and Thursday.

*Opening times* Open Easter to October daily 2.00pm to 4.30pm and Tuesday to Saturday 29th May to October from 10.00am to 12.30pm

**DEVON**

## TEIGNMOUTH MUSEUM
29 French Street, Teignmouth, Devon TQ14 8ST
Telephone 01626 777041

Maritime Museum containing relics from 16th century wreck including cannons. Stories of lifeboats, coast guards, pilots, port and sailors. Haldon Aerodrome and early flying. Photographic exhibition then and now. Lunys pictures.

*Opening times* Open Easter Saturday to Monday 10.00am to 4.30pm,
Easter Sunday 2.00pm to 4.30pm
May 1st through to September 30th daily
Monday to Saturday 10.00am to 4.30pm  Sunday 2.00pm to 4.30pm

## TIVERTON MUSEUM
St Andrew Street, Tiverton, Devon EX16 6PH
Telephone 01884 256295

Large social history collection. Wagons, Smithy, GWR Loco and Railway collection. Agriculture including ploughs, 8 galleries, 1/2 acre site. Adults £1.00, Children 50p, OAP/ Students 75p. Groups by arrangement, Guided tours by arrangement. Car parking very close by. Ground floor facilities for the disabled.

*Opening times* Open February to Christmas
Monday to Saturday 10.30am to 4.30pm

## TORRE ABBEY HISTORIC HOUSE & GALLERY
The King's Drive, Torquay, Devon TQ2 5JX
Telephone 01803 293593 Fax 01803 215948

Torbay's most historic building. 12th century monastery, later converted into country house. Twenty historic rooms, stunning paintings, Agatha Christie Room, Torquay Terracotta, gardens and Victorian tea room. Quest Sheet for families.

*Opening times* Open Easter to 1st November daily 9.30am to 6.00pm
(last admission 5.00pm)

## DEVONSHIRE COLLECTION OF PERIOD COSTUME
Bogan House, 43 High Street, Totnes, Devon TQ9 5NP
Telephone 01803 862857

Themed costume exhibition, changed annually, displayed in a Tudor merchant's house. Collection includes items from mid-18th century to the present day. Parties by appointment during opening dates outside normal hours and in October. Car parking and coffee shops in town centre.

*Opening times* Open weekdays Monday to Friday,
Spring Bank Holiday to end September
11.00am to 5.00pm (last admission 4.40pm)

# DORSET

A large proportion of this county's lovely heathlands have disappeared within the last half century, nevertheless this area remains very much a region of rolling downs. Central Dorset is crossed by the wide Blackmore Vale, while to the north is the chalky bulk of heavily wooded Cranborne chase. Dorset coastline is quite remarkably spectacular including the pebble ridge of Chesil Bank and Portland Bill, and to the east the great chalk arch of Durdle Door and the Isle of Purbeck.

Dorset has of course great literary connections, there being few parts of the county that Thomas Hardy has not lovingly written about. Renowned for its beautiful countryside, it can also lay claim to some delightful seaside towns...Poole, once the haunt of pirates and smugglers, was developed as a major port in the 13th century, and Brownsea Island in the bay, now a National Trust Nature Reserve was the birthplace of the Boy Scout Movement.

The county is rich in history, claiming at Maiden Castle the finest ancient Iron Age earthworks in Britain. The Cerne Abbas Giant, at 180 feet tall and over 1500 years old is certainly Dorset's largest, and one of its oldest treasures...but the county has a wonderfully wide and comprehensive selection of exhibitions, displays and demonstrations portraying its diverse heritage. The Sherborne Museum at Abbey Gate House is concerned with local history from pre-Roman times and includes much dealing with the local 18th century silk manufacturing industry.

The Priest's House Museum at Wimborne boasts an interesting childhood gallery, fascinating stationers' and ironmongers' shops and a real working Victorian kitchen. On glorious Gold Hill is the Shaftesbury Local History Museum exhibiting domestic and agricultural implements. A museum with a difference, which contains highly entertaining audio-visual, interactive and computer displays is the Dinosaur Museum at Dorchester. Here is all you want to know about dinosaurs...fossils, skeletons and wonderful life-size dinosaur reconstructions. Those interested in creatures of the sea are well catered for at Weymouth's Deep Sea Adventure.

# THE PRIEST'S HOUSE MUSEUM & GARDEN

23-27 High Street, Wimborne, Dorset BH21 1HR
Telephone 01202 882533 Fax 01202 882533

The Priest's House Museum in Wimborne features three award-winning attractions in one! An historic house, a delightful garden, and a fascinating museum.

The Priest's House dates back to the 16th century and features many original architectural highlights. Period rooms take the visitor back through the centuries; the 17th century hall, 18th century parlour and Victorian kitchen with its working range bring the past to life.

The museum includes reconstructions of local businesses that once ran here, including Mr Low's stationers and Coles ironmongers - both recreated from unsold stock.

The childhood gallery includes toys to play with, and our new Victorian schoolroom gives everyone the chance to practice their three R's.

With hands-on activities throughout the museum, there is plenty to do.

Our 1999 special exhibitions are
1st April to 20th June
'Open all hours': a nostalgic look at the history of shops and shopping, and

1st July to 31st October
'The People's Show' featuring the wonderful collections of local people.

The garden, with its changing flowering plants, fruit trees, topiary and smooth lawns, has something of interest all year.

Seats are provided where visitors can rest in this quiet retreat, and the tea room serves home made cakes June to September.

### *Opening times*
Open 1st April to
31st October 1999
Monday to Saturday
10.30am to 5.00pm
and Sundays
June to September
and at Bank
Holiday Weekends
2.00pm to 5.00pm

### *Directions*
North of Poole and
Bournemouth.
Wimborne Minster is off
the A31 between
Ringwood and
Dorchester. The
Museum is in the town
centre opposite Minster.
Signposts give directions
from car parks.

▶ Children making lemonade as part of our hands-on Victorian experience

▲ Award winning museum garden in the shadow of the Minster

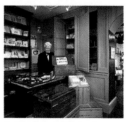

▲ Mr Low's Victorian stationer's shop, closed up for 32 years!

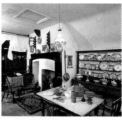

▲ The Victorian kitchen with its working Beetonette range

DORSET

# OLD CROWN COURT & CELLS

West Dorset District Council, Stratton House, High West Street,
Dorchester, Dorset DT1 1UZ
Telephone 01305 252241 Fax 01305 257039

Site of the Assizes throughout four centuries, the Court as you see it today is most famous for the trial of the Tolpuddle Martyrs held on 17th March 1834, the six Dorset farm labourers were sentenced to transportation for seven years for forming a 'friendly society' affiliated to the Trade Union of the day.

The Court & Cells are contained in the old Shire Hall, the architecture of which dates from 1796-97. The arms above the judge's seat in the court are those of George III of the Hanovarian Dynasty. Her Majesty the Queen has been graciously pleased to approve their continuing display.

Prior to 1797 an earlier court stood on this site. The court and cells have played a fascinating role in the history of Dorchester.

***Opening times***

Court Room only
10.00am to 12.00pm
and 2.00pm to 4.00pm
Monday to Friday
excluding Bank Holidays
Court & Cells
27th July to
3rd September
2.15pm to 4.15pm
Tuesday to Friday and
10.15am to 12.15pm
Wednesday
Private group bookings
available all year

▲ The Old Crown Court coat of arms above judge's seat

▲ View down the High Street and Judge Jeffrey's lodgings

▶ There are cells both old and new beneath the court

▼ South walks where the Gallows stood in the 17th century

***Directions***

Situated in
Old Shire Hall in
the town centre,
approximately 300
metres from the top of
the town car/coach park.
Reception entrance
Stratton House High
West Street.

## THE TUTANKHAMUN EXHIBITION
High West Street, Dorchester, Dorset DT1 1UW
Telephone 01305 269571 Fax 01305 268885

In 1922 Howard Carter uttered the now immortal words - "Yes, wonderful things, and gold, everywhere the glint of gold!" - in answer to Lord Carnarvon's question "Can you see anything?".

The long hunt for Tutankhamun's tomb was over. You too can experience the magnificence and wonder of the world's greatest discovery of ancient treasure at The Tutankhamun Exhibition.

Be there at the discovery, explore the ante-chamber filled with its treasures, and enter the burial chamber to witness Howard Carter raising the golden coffins.

In the Hall of Treasures marvel at the superb facsimiles of some of Tutankhamun's greatest golden treasures, including the famous funerary mask. Finally come face to face with Tutankhamun's mummified body expertly recreated using new scientific techniques.

The Tutankhamun Exhibition is a complete experience incorporating sight, sound, and smell.

The Jewels of Tutankhamun is a unique display of some of the most intricate and exquisite jewellery found in Tutankhamun's tomb.

They have been beautifully recreated and exhibited in exact facsimile.

The Tutankhamun Exhibition is the only one of its kind outside Egypt and it has recreated Tutankhamun's tomb, treasures and mummified body in innovative and exciting ways. It's an amazing experience - spanning time itself.

***Opening times***
Open daily all year
9.30am to 5.30pm
(last admissions 5.00)
November to March
9.30am to 5.00pm
(last admission 4.30pm)
Closed 24th-26th
December

***Directions***
The Tutankhamun Exhibition is in the very centre of Dorchester in High West Street. It is Pedestrian signposted from most major car parks.

◄ The Golden Funerary Mask of Tutankhamun

▲ The mummified body of Tutankhamun

▲ The Golden Funerary Mask of Tutankhamun

▲ The burial chamber with Howard Carter raising the golden coffins

DORSET

# THE DINOSAUR MUSEUM
Icen Way, Dorchester, Dorset DT1 1EW
Telephone 01305 269880 Fax 01305 268885

Visit the award winning Dinosaur Museum and you immediately enter the world of dinosaurs.

The clever use of exciting hands on displays associated with video, computer, and CDRom displays make the museum fun for all.

The museum has frequently been praised for its innovative use of interactive displays and has twice been voted one of the Top Ten Hands-on Museums.

Add to this the life-size reconstructions of some of the most famous and fiercesome dinosaurs, including Tyrannosaurus Rex, Triceratops and Stegosaurus, and it's no wonder that cries of awe and excitement are always heard from the young visitors.

The Dinosaur Museum has dinosaur remains in the form of skeletons, such as Megalosaurus, bones, teeth, and local footprints. Many other prehistoric beasts including Ichthyosaurus, Pterosaur and a mammoth skull.

It's a real treasure house of the past. If dinosaurs were alive today they would look like 'Dinosauroid' - the museum's weirdest exhibit! The Dinosaur Museum's unique family

DORSET

approach was recognised recently with the museum being voted Dorset's Family Attraction of the Year. So be sure to visit this monster all-weather attraction!

▲ Tyrannosaurus Rex - the largest meat-eating animal ever to have lived

◄ Children in awe of a reconstruction of a young T.Rex

### Opening times

Open all year, daily 9.30am to 5.30pm (10.00am to 4.30pm November to March) Closed 24th to 26th December

### Directions

The Dinosaur Museum is in the very centre of Dorchester, just off the main High East Street. It is pedestrian sign-posted from major car parks and the main shopping street.

▲ Megalosaurus skeleton and footprints

DORSET

# SHAFTESBURY TOWN MUSEUM
Gold Hill, Shaftesbury, Dorset SP7 8HB
Telephone 01747 854548

This quiet old-fashioned museum at the top of Gold Hill - possibly the most photographed street in the country- illustrates the history of the small market town that Hardy described as 'city of a dream'.

But just as Hardy's characters are anything but straight-laced Victorians, Shaftesbury was (and is) actually a vigorous living town and one with a history going back over 1100 years.

For over fifty years Shaftesbury people have been collecting evidence of this long history, from archaeological fragments dating back to the days before King Alfred founded the town in AD880 to instruments from the Town Band that started as Ben Strange's Penny Whistle Band 100 years ago and can still be heard playing near the museum in the summer.

Part of the museum was once the Sun and Moon pub which was attached to St. Peter's Church and had it's cellars under the south aisle.

The other part was a doss-house where travelling workmen and families could stay for a penny a night.

The Shaftesbury Town Museum collection includes items from the town's many pubs, the 1744 town fire engine and farming bygones from the dairying country of the Blackmore Vale.

### *Opening times*
Open Good Friday to end of September (other times by appointment)

### *Directions*
Discover the Shaftesbury Town Museum just off the High Street, behind the Town Hall, at the top of famous Gold (Hovis!) Hill.

▼ A young visitor admires bells that once rang from Holy Trinity

▲ Spitoon and Ale Muller once used in Shaftesbury pubs

▲ Aunt Sally: a rare survivor from Shaftesbury's Fair Days

# SHERBORNE MUSEUM ASSOCIATION

Abbey Gate House, Church Lane, Sherborne, Dorset DT9 3BP
Telephone 01935 812252

Sherborne Museum with over 15,000 items of local history, is in the heart of the town and close to the 8th century Saxon Abbey.

Among its exhibits are a case containing items associated with the Abbey: a scale model of Sherborne old Castle; a large Victorian doll's house, a display of Sherborne silk industry since 1753; selected items from some 1000 items of costume wear dating from 1630 to the present century; a fine mediaeval wall painting (c.1480); and a selection of rural implements.

In addition various videos of Sherborne play continually. Apart from a few purchases, the items have all been donated by local residents, and the displays are enhanced by models, illustrations and backdrops by local artists.

### Directions

Find the conduit at the south end of Cheap Street go under the narrow arch into Church Lane which leads to the Abbey the Museum is on the left.

▲ The reception area

▲▼ Sherborne Museum and the new extension

### Opening times

Open Easter to October 10.30am to 4.30pm on Tuesday to Saturdays 2.30pm to 4.30pm on Sundays and Bank Holiday Mondays

▶ The industrial exhibition in the link

**DORSET**

DORSET

# DEEP SEA ADVENTURE

9 Custom House Quay, Weymouth, Dorset DT4 8BG
Telephone 01305 760690 Fax 01305 760690

Two separate attractions under one roof: as well as a gift shop and Sharky's galley, fully licensed restaurant.

Deep Sea Adventure is a fascinating family attraction telling the story of underwater exploration and marine exploits from the 17th century through to the modern day.

Take a unique journey with us and experience one of the worlds foremost Titanic exhibitions. See how the Titanic looks today on the seabed. Learn more about the ship's short life. Read the signals from the passengers and crew and find out how she was discovered after 74 years.

The Black Hole lets you experience what it is like to be a Deep Sea diver in black water - unable to see and relying solely on touch. New for 1999 - "spider" a unique one atmosphere diving suit one of only two ever made and the last one in existence.The children will enjoy following the Ollie the Oyster Trail.

The great thing is the fun is not over yet as the children (under 5ft) dive into "Sharky's", Dorset's premier all-weather kids adventure play zone.

▶ View the wreck Titanic as she lies on the sea-bed

Children will love to swing, jump, slide and climb all four fun-filled levels. Try the drop-slide-if you dare! There is a separate area for toddlers.

***Opening times***
Open all year,
every day except
24,25,26 December
9.30am to 7.00pm
Low season
9.30am to 8.00pm
High Season Last entry
1 ½ hours before closing

▼ Experience the gripping story of the Titanic disaster

***Directions***
Take the A35 into Weymouth; follow the brown directional signs for the Deep Sea Adventure. This will take you to the Pavilion Car Park. The Deep Sea Adventure is located on the Old Harbour between the Pavilion and the Town Bridge. (On the corner of Custom House Quay and East Street).

## PARNHAM

Beaminster, Dorset DT8 3NA
Telephone 01308 862204 Fax 01308 863444

Excitingly restored Tudor Manor displaying furniture from John Makepeace studio, contemporary paintings. Shop selling quality crafts, ceramics, wood, books, items from workshop which is also open. Fourteen acres, beautiful gardens.

***Opening times*** Open April 1st or Easter to end of October
Tuesday, Wednesday, Thursday, Sunday and Bank Holidays
10.00am to 5.00pm (last admission 4.30pm)

## RUSSELL-COTES ART GALLERY & MUSEUM

East Cliff, Bournemouth, Dorset BH1 3AA
Telephone 01202 451800 Fax 01202 451851

The Museum's collection consists of an impressive assortment of Victorian and Edwardian paintings, complemented by sculpture, decorative art and furniture, as well as a Modern Art collection.

***Opening times*** Open all year Tuesday to Sunday 10.00am to 5.00pm
Closed on Good Friday and Christmas Day
Note: We are closed to the public - first phase re-opening will be Spring 1999 - please telephone nearer the time for further information. Second phase late Autumn

## THE TANK MUSEUM

Bovington, Dorset BH20 6JG
Telephone 01929 405096 Fax 01929 405360

Houses the world's finest collection of armoured fighting vehicles. New from November 1998 is 'The Trench' exhibition and Acousti-guide audio tour. Tanks in action displays are held throughout the Summer.

***Opening times*** Open every day except Christmas 10.00am to 5.00pm
(last admission 4.00pm)

## RED HOUSE MUSEUM & GARDENS

Quay Road, Christchurch, Dorset BH23 1BU
Telephone 01202 482860 Fax 01202 481924

Charming Georgian building with a rich variety of displays on local history, archaeology, natural history, costume. Also temporary exhibitions. Small admission charge.

***Opening times*** Open Tuesday to Saturday 10.00am to 5.00pm
Sunday 2.00pm to 5.00pm (last admission 4.30pm)
Closed Monday, except Spring and Summer Bank Holidays

## LYME REGIS PHILPOT MUSEUM

Lyme Regis, Dorset DT7 3QA
Telephone 01297 443370

This charming building has been restored and extended and has new displays throughout; illustrating the work of Mary Anningwith the leading pioneers of geology, Lyme's lively history and its rich literary connections, from Jane Austen to John Fowles.

***Opening times*** Open April to October daily
10.00am to 5.00pm (closed Sunday lunchtime)
Open Winter Weekends, half terms and over Christmas.
Admission £1.20, £1.00, 80p, 40p

DORSET

## PORTLAND MUSEUM

217 Wakeham, Portland, Dorset DT5 1HS
Telephone 01305 821804

The Museum was founded in 1930 by Dr. Marie Stopes, the Museum's first curator and famous birth control pioneer. Housed in two thatched picturesque cottages nestling above Church Ope Cove. One cottage inspired the author Thomas Hardy to centre his famous novel 'The Well Beloved' around it, making it the home of 'Avice', the novel's heroine.

*Opening times* Open Easter to October five days a weeks
closed Wednesday and Thursday 10.30am to 1.00pm 1.30pm to 5.00pm
(last admission 4.30pm) Open every day during August
Winter opening for schools
November to Easter by prior arrangement - phone for details

## PORTLAND CASTLE

Castle Road, Castletown, Portland, Dorset DT5 1AZ
Telephone 01305 820539 Fax 01305 860853

Experience time travel at Portland Castle. Our free audio guides will transport you from the reign of Henry VIII through to D-Day. Adults £2.50, Concessions £1.90, Children £1.30, Members free.

*Opening times* Open April to September daily 10.00am to 6.00pm Open October
daily 10.00am to dusk

## SANDFORD ORCAS MANOR HOUSE
The Manor House, Sandford Orcas, Sherbourne, Dorset DT9 4SB
Telephone 01963 220206

Tudor manor house, with gatehouse, spiral staircases, 16th-17th century panelling. Notable collections of Queen Anne and Chippendale furniture. 17th century Dutch and 18th century English paintings, 14th-17th century stained glass, 16th-18th century embroidery. Terraced gardens with topiary and herb garden.

*Opening times* Open Easter Mondays, 10.00am to 6.00pm then May to September
(inclusive) every Sunday 2.00pm to 6.00pm and every Monday 10.00am to 6.00pm

## COACH HOUSE MUSEUM

St. George's Close, Langton Matravers, Swanage, Dorset
Correspond to: The Hyde, Langton Matravers, Swanage,
Dorset BH19 3HE
Telephone 01929 423168

Exhibits tools, documents, photographs and stone masonry of Portland stone, Purbeck stone and the famous Purbeck 'Marble'; with a working capstan, machinery and rebuilt section of a former quarry mine.

*Opening times* Open April 1st to October 5th 10am to 12pm and 2pm to 4pm except
Sundays, or at other times by appointment.
School parties welcome by appointment

## NOTHE FORT - MUSEUM OF COASTAL DEFENCE
Nothe Fort, Barrack Road, Weymouth, Dorset DT4 8UF
Telephone 01305 787243 Fax 01305 766465

Victorian coastal fortress dominating Weymouth Bay and Harbour overlooking Portland Harbour. 70 rooms containing displays of guns, weapons and equipment depicting the Garrison Life of Victorian and WWII soldiers.

*Opening times* Summer Season May to September daily 10.30am to 5.30pm
(last entry 4.30pm) Winter Season Sundays and Holidays from 2.00pm until dusk

# ESSEX

Essex is a county of remarkable variations of scenery. Largely flat and open, nevertheless it has its isolated hilly areas near Danbury and Basildon. Large areas of the county have been swallowed up by the voracious Capital, where New Towns and large suburban housing estates have developed with alarming rapidity. Essex's northern bank of the Thames presents an impressive skyline of oil and gas installations and all the vast superstructure of container ports...leading to Southend-on-Sea, London's popular seaside resort with its seven miles of seafront and its incomparable pier. In contrast the coast to the north reaching to the Blackwater Estuary is a lonely, wild and windswept expanse of land, reclaimed by Dutch engineers in the seventeenth century and a haven for marshfarmers and wildfowlers. Yet fringing London and covering five and a half thousand acres is Epping Forest, are the remains of a vast royal hunting ground and a lovely oasis of woodland.

The River Blackwater, now bustling with pleasure boats and small craft, in the past gave invading Saxons and Danes an inroad to the heart of England

Essex is well endowed with interesting towns...Colchester, claiming to be Britain's oldest recorded town and with Europe's biggest Norman keep as well as, at Rollerworld, Europe's largest maple roller skating floor, ancient Chelmsford, Essex's county town and once a New Town planned in 1199 by the Bishop of London, Harlow, a 1940 New Town planned by Sir Frederick Gibberd, and beautiful Saffron Walden. All have their stories to tell in a plethora of splendid museums. The Saffron Walden Museum with its Great Hall gallery of archaeology and early history has a recently opened natural history section with interactive displays. The fine Harlow Museum houses no less than five galleries dealing with the history of the region, while the Mark Hall Cycle Museum also in Harlow, contains a quite unique collection of cycles and cycling memorabilia tracing the history of the bicycle from 1880 to the 1980s. Another museum devoted to recording the history of a form of transport is the National Motorboat Museum at Basildon. Here the long history and evolution of the motorboat; power boats, hydroplanes and leisure boats is explained.

**ESSEX**

# NATIONAL MOTORBOAT MUSEUM

Wat Tyler Country Park, Pitsea Hall Lane,
Basildon, Essex SS16 4UH
Telephone 01268 550077/88 Fax 01268 581093

Britains National collection of sporting and leisure motorboats and engines.

Throughout the 20th century, some of the world's fastest and most revolutionary motorboats were designed and built in Britain. See the best of these extraordinary machines preserved in the National Motorboat Museum at Basildon.

Trace the history of these fascinating craft from the early days of steam launches right up to the latest state of the art offshore powerboats. Many record breakers and rare examples are housed in the museum, not only among the boats but also in the extensive collection of outboard and inboard motors.

The museum shows how the motorboat evolved in all its shapes and forms. On the ground floor you will find examples of motorboats from each era of development, while upstairs the parallel story of the development of the outboard engine is told.

Some of our exhibits on display are Miss

Britain IV (World Diesel Record holder). Defender II, the earliest racing boat in collection. The Soriano outboard motor (6 cylinder). Fairey Huntress, the original boat from the James Bond film 'From Russia with Love' is here too. Admission free, funded by Basildon District Council.

### *Opening times*

Open
Thursday to Monday
including weekends
10.00am to 4.30pm -
closed Tuesday
and Wednesday
(apart from all school
holidays when we are
open 7 days a week)

### *Directions*

Take A13 off the M25
toward Southend.
Take Pitsea exit and
follow signs for Wat
Tyler Country Park,
past Pitsea Rail
Station. 4 minute drive
from Station.

▲ Charlotte, (Pinnace) built in 1928 by Morgan Giles

▲ Soriano outboard motor, 6 cylinder racing engine, first built 1930s

▲ Miss Britain IV, broke World Diesel record in 1982 - 124mph

DEFENDER II

◀ Defender II, built 1909, earliest race boat in collection

# VALENCE HOUSE MUSEUM & ART GALLERY

Becontree Avenue, Dagenham, Essex RM8 3HT
Telephone 0181 5958404 Fax 0181 2528290

A local history museum and art gallery in a historic house, the earliest parts of the building date from the 1400s.

The jewel in the crown of the museum's collections are the Fanshawe Family Portraits and Archive. This includes fine paintings by famous artists such as William Dobson, Sir Peter Lely, Marc Gheeraedts and Sir Godfrey Kneller.

Local history displays feature archaeological finds, a chemist's shop, the story of Dagenham and the Becontree Housing Estate and a Victorian servant's parlour.

There is an attractive herb garden and the remains of a moat in the grounds.

A café is open on Saturdays only.

We are situated next to a public park with a play ground.

### Directions

Nearest stations are Chadwell Heath (British Rail) and Becontree underground (District Line). Buses 5, 62, 87, 128, 129, 364 and 368 all stop nearby.

### Opening times

Open all year
Tuesday to Friday
9.30am to 1.00pm
2.00pm to 4.30pm
Saturday
10.00am to 4.00pm
(last admission half an house before closing)

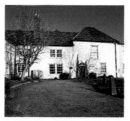

▲ Valence House Museum and Art Gallery

▼ Reconstruction of a Becontree Estate living room, 1945

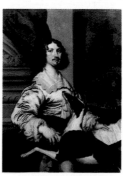

▲ Portrait of Sir Richard Fanshawe by William Dobson

▲ Pond dipping at Valence moat

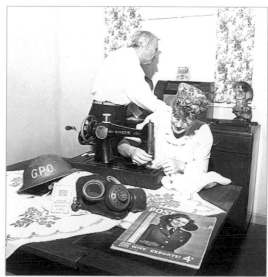

# MARK HALL CYCLE MUSEUM

Muskham Road, Harlow, Essex CM20 2LF
Telephone 01279 439680 Fax 01279 442786

Opened in 1982, Mark Hall Cycle Museum displays a unique collection of cycles and accessories illustrating the history of the bicycle from 1818 to the present day.

This fascinating collection of cycles, accessories and memorabilia has been attractively housed in five galleries within the award winning conversion of the 19th century stable block of Mark Hall Manor.

The main galleries cover the evolution of the bicycle from the Hobby Horse of 1818, through the development of the Penny Farthing and later safety cycles to the bikes of today. A wide range of specialist machines, including tandems, tricycles, a five-seater and an all plastic bike are also displayed, in addition to a large collection of lamps, saddles, tools, posters and documents.

Behind the museum the manor's three walled gardens have been beautifully and individually landscaped, the largest being divided into sections showing rose, cottage, kitchen and herbaceous gardens.

The two smaller gardens are laid out as a 17th century herb garden and unusual fruit orchard.

## *Opening times*

Open all year Tuesday and Wednesday
10.00am to 4.30pm
1st and 3rd Sunday in each month 11am to 4pm
Monday to Thursday by appointment only
Gardens:
Monday to Friday
10.00 am to 3.00pm
Sunday 11am to 3.30pm

## *Directions*

Follow the brown tourist signs on the A414 from Hertford and the M11. Nearest train station Harlow Town British Rail.

▲ Mark Hall Cycle Museum

▲ See the wood framed racer

▲ The development of the Penny-farthing

▼ Tricycles for ladies and safety cycles

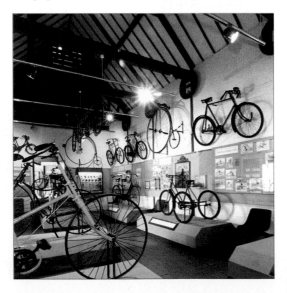

# HARLOW MUSEUM
Passmores House, Third Avenue, Harlow, Essex
Telephone 01279 454959 Fax 01279 626094

Opened in 1973, Harlow Museum displays objects that relate to the history of the area, from prehistoric times to the establishment of the modern new town.

The museum is situated on a site that has been occupied since at least the 11th century and one arm of the medieval moat can still be seen in the museum's gardens. Most of the present house dates from 1727, but parts of an older building also remain.

The museum tells the story of the Harlow area through exhibits displayed in several chronological galleries.

Important prehistoric and Roman artefacts explain the origins of man's association with the area, including many objects from the Roman Temple from which Harlow gets its name.

The local 17th century Metropolitan Ware Pottery Industry is also examined, as are domestic and agricultural items from the last hundred years.

There is also an exhibition concentrating on the geology of the local area and a gallery dedicated to changing temporary exhibitions.

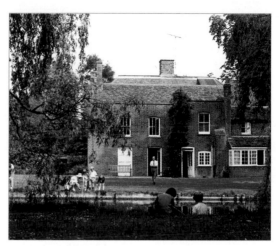

The grounds include a Butterfly Garden set within the walls of the old kitchen garden.

▲ Harlow Museum

### *Opening times*

Open all year Thursday, Friday and Saturday
9.30am to 12.30pm
1.30pm to 4.30pm
Tuesday and Wednesday by appointment only

### *Directions*

Follow the brown tourist signs from the M11.
Nearest train station is Harlow Town British Rail.

▼ School children admiring items in the shop

**ESSEX**

# SAFFRON WALDEN MUSEUM
Museum Street, Saffron Walden, Essex CB10 1JL
Telephone 01799 510333/4 Fax 01799 510334/3

The "friendly family-size museum", Saffron Walden Museum won the Museum of the Year award 1997 for Best Museum of Social History.

Opened in 1835, the collections are remarkably fine and varied, from moccasins and mummy cases to woolly mammoths and Wallace the lion. As well as internationally renowned ceramics, ethnography, local history, archaeology and geology galleries there are costume, needlework, dolls and toys, furniture and woodwork and an Ancient Egyptian 'tomb'.

New natural history displays include a 'hands-on' Discovery Centre with touch-screen computer and video microscope.

Disabled visitors are well catered for with access ramps, w.c., lift, stair lifts, sound loops, reserved parking and wheelchairs on loan.

School parties and other groups form an important part of our audience with 'hands-on' sessions from Ancient Greeks and Egyptians to Invaders, Tudors and Victorians.

Visitors can also enjoy the ruins of Walden's

12th century Norman castle in our grounds, which are ideal for picnics.

The beautiful mediaeval market town and splendid parish church are on our doorstep, with many fine timber-framed buildings dating from 1400 to 1700, when the Saffron crocus flourished and gave the town its name.

Entrance: Adults £1; Discounts 50p; Children free. Annual season tickets £3 and £1.50.

### Opening times
March to October
Monday-Saturday
10.00am to 5.00pm
Sundays and
Bank Holidays
2.00pm to 5.00pm
November to February
Monday-Saturday
10.00am to 4.30pm
Sundays and
Bank Holidays
2.00pm to 4.30pm
Closed 24th and 25th
December

### Directions
Museum close to
Parish Church. Train to
Audley End Station
(3 miles). By car, M11
from north exit 10 only
(Duxford). From south
exit 8 or exit 9. Buses
from Cambridge
(15 miles) Bishops
Stortford (15 miles).

▲ Archaeology gallery and Egyptian 'tomb' guarded by Wallace the lion

▲ 'Worlds of Man' shows African, American, Pacific and Australian cultures

▲ Autumn-flowering Saffron crocus on sale from mid-August

## UPMINSTER TITHE BARN
## AGRICULTURAL & FOLK MUSEUM

Hall Lane, Upminster, Essex RM14 1AU
Telephone 01708 447535 Fax 01708 447535

This Museum is housed in a large 15th century thatched barn and contains over 12000 exhibits mainly from Victorian times onward, basically domestic and agricultural.

*Opening times* Open April to October - 1st weekend 2.00pm to 6.00pm
Other times by appointment

## CHELMSFORD & ESSEX MUSEUM,
## ESSEX REGIMENT MUSEUM

Oaklands Park, Moulsham Street, Chelmsford, Essex CM2 9AQ
Telephone 01245 353066 Fax 01245 280642

Local, social history, prehistory to present day; Essex Regiment Museum; Ceramics, coins, costume, glass; rocks, fossils, animals; Exhibitions, events, talks. Admission free.

*Opening times* Open Monday to Saturday 10.00am to 5.00pm
Sundays 2.00pm to 5.00pm Closed only 2nd April (Good Friday),
25th and 26th December 1999

## COLCHESTER CASTLE MUSEUM

14 Ryegate Road, Colchester, Essex CO1 1YG
Telephone 01206 282939 Fax 01206 282925

A hands-on interactive museum designed with families in mind. Group discounts available for groups of 20+ who have pre-booked. Housed in a Norman Castle built on the foundations of the Roman Temple of Claudius.

*Opening times* Open Monday to Saturday 10.00am to 5.00pm (last admission 4.30pm) Sunday 2.00pm to 5.00pm March to November

## FIRSTSITE
## THE MINORIES ART GALLERY

74 High Street, Colchester, Essex CO1 1UE
Telephone 01206 577067 Fax 01206 577161
Converted Georgian townhouse housing changing exhibitions of contemporary art from craft to live art. Full exhibitions and events programme. Call for details.

*Opening times* Open April to October (mid) 10.00am to 5.00pm October (end) to March 10.00am to 4.00pm Open Monday to Saturday Admission Free

## NATURAL HISTORY

The High Street, Colchester, Essex
Telephone 01206 282941 Fax 01206 282925

A hands-on interactive museum of local wild life. Education programme for schools available if pre-booked.

*Opening times* Open All Year Tuesday to Saturday
10.00am to 1.00pm 2.00pm to 5.00pm Closed Sundays and Mondays

ESSEX

## TYMPERLEYS MUSEUM

Trinity Street, Colchester, Essex
Telephone 01206 282943 Fax 01206 282925

A Clock Museum in a beautiful Tudor building.

*Opening times* Open 1st April to 31st October Tuesday to Saturday
10.00am to 1.00pm and 2.00pm to 5.00pm. Closed Sunday and Monday

## MERSEA ISLAND MUSEUM

High Street, West Mersea, Colchester, Essex CO5 8QD
Telephone 01206 385191

Displays are concerned mainly with Island history and occupations. There are special exhibitions from time to time. There is also a permanent display of historic cameras and photographic equipment.

*Opening times* Open May to September Wednesday to Sunday 2.00pm to 5.00pm

## THURROCK MUSEUM

Orsett Road, Grays, Essex RM17 5DX
Telephone 01375 382555 Fax 01375 392666

Over 1,500 objects illustrating 250,000 years of Thurrocks Heritage. Displays include archaeology, social history and themed areas. A number of temporary displays are held each year. Contact museum for details.

*Opening times* Open Monday to Saturday 9.00am to 5.00pm

## SOUTHCHURCH HALL MUSEUM

Southchurch Hall Close, Southend on Sea, Essex SS1 2TE
Telephone 01702 467671 Fax 01702 215631

Southchurch Hall is a moated Mediaeval Manor House with Elizabethan extensions. Complete with period reconstructions and talks, the hall is highly successful in interpreting the Tudors for schools and groups.

*Opening times* Open all year Tuesday to Saturday (inclusive) 10am to 1pm
2pm to 5.00pm Closed Bank Holidays and Tuesday following Bank Holidays Mondays

## EPPING FOREST DISTRICT MUSEUM

39-41 Sun Street, Waltham Abbey, Essex EN9 1EL
Telephone 01992 716882 Fax 01992 700427

A local museum for the Epping Forest District. Lots to see, from a Bronze Age bracelet to 19th century photos, plus plenty of hands-on exhibits.

*Opening times* Open all year 2.00pm to 5.00pm Friday, Saturday, Sunday and
Monday 12.00pm to 5.00pm Tuesday Group bookings only Wednesday and Thursday

## BEECROFT ART GALLERY

Station Road, Westcliff-on-Sea, Essex SS20 7RA
Telephone 01702 347418

Changing exhibitions through the year, including the Summer Open Exhibition.
A selection of local topographical views of the Southend area is always on view.

*Opening times* Open all year Tuesday to Saturday 9.30am to 1pm, 2pm to 5pm

# GLOUCESTERSHIRE

No matter from which direction you approach this lovely county there is beauty and interest, both in the countryside and in the towns and villages. Gloucestershire separates conveniently into three sections...the Forest of Dean, the Cotswold Hills and the Severn and Berkeley Vales. The Forest of Dean, an ancient forest of oak and beech between the Rivers Severn and Wye, and a royal hunting reserve in medieval times became Britain's first National Forest Park in 1938. From Roman times this area was exploited for timber, iron and coal. Now this mecca for walkers is a glorious region of heath and woodland, criss crossed with trails. The Dean Heritage Centre housed in an old corn mill tells the fascinating and unique story of the Forest. The Cotswold Hills, heavily quarried for centuries for the wonderfully honey coloured stone used in the building of the picturesque cottages and drystone walling of the region are now designated an area of Outstanding Natural Beauty, preserving the hill landscape. The vales of Severn and Berkeley are lovely low-lying areas of farm land and gently flowing waterways dominated by the extremely well preserved Berkeley Castle in which Edward III was murdered in 1327. Church Lane, in Berkeley houses the Jenner Museum which commemorates the work of Edward Jenner, the discoverer of the smallpox vaccine.

Cheltenham, the small spa village was transformed into an elegant fashionable town in 1788 through the visit of George III and the consequent patronage. These elegant years are beautifully recorded in the Pittville Pump Room Museum which presents a fine collection of original costume from 1760 to present times. The Holst Birthplace Museum in Cheltenham, concerned with the life and music of Gustav Holst also shows an interesting working Victorian kitchen. The Cheltenham Art Gallery and Museum, as well as dealing comprehensively with the history of the region also houses a splendid Arts and Crafts collection which includes furniture and metalwork produced by Cotswold craftsmen inspired by William Morris.

Gloucester with its magnificent cathedral, the nave of which is dominated by the largest stained glass window in Britain created in 1349, was once a commercially important port. The National Waterways Museum housed on three floors of a dockside warehouse tells the story of Britain's canals, While the nearby Robert Opie Collection at the museum of Advertising and Packaging brings over a hundred years of package advertising to life.

**157**

GLOUCESTERSHIRE

# THE EDWARD JENNER MUSEUM

The Chantry, Church Lane, Berkeley,
Gloucestershire GL13 9BH
Telephone 01453 810631 Fax 01453 811690

Born in 1749, Edward Jenner was a country doctor in Berkeley, Gloucestershire. He was intrigued by country-lore which said that milkmaids who caught the mild cowpox could not catch smallpox, which killed up to 20% of the population. He devised a crucial experiment involving a milkmaid, a young boy and a cow called 'Blossom', publishing his results in 1798.

'The Chantry', his home for 38 years, is now a museum dedicated to the man and his work.

The consequences of Jenner's observations are eloquently explained in an exhibition on modern immunology, using models and computer games, helping visitors to appreciate the importance of that first experiment 200 years ago.

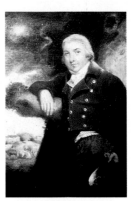

▲ Edward Jenner, who taught the world how to eradicate smallpox

As a direct consequence, in 1980 the World Health Organisation announced that it had eradicated smallpox from the Earth!

Jenner's discovery has now been developed into one of the most important parts of modern medicine-Immunology.

Jenner made many other important contributions to science, associating angina with hardening of the arteries, unravelling the nesting behaviour of cuckoos, publishing evidence that some species of birds migrated to other countries, and studying the hibernation of hedgehogs.

Jenner was probably the first Briton to fly a balloon and to discover a Plesiosaurus fossil.

### *Opening times*

Open 1st April
(or Good Friday,
if earlier)
until end September
Tuesday to Saturday
12.30pm to 5.30pm
Sundays
1.00pm to 5.30pm
Closed Mondays (except
Bank Holiday Mondays)
October:
Open Sundays only

### *Directions*

Leave M5 at
junction 13 or 14 and
take A38 to Berkeley
turning.
Follow brown signs into
centre of Berkeley.
Turn left at
"Berkeley Arms": then
left into Church Lane.

▲ The little hut where Jenner vaccinated the poor, without charge

▲ Jenner's home: now a museum to his life and achievements

▲ Jenner's study, recreated as it was when he died in 1823

# HOLST BIRTHPLACE MUSEUM

4 Clarence Road, Cheltenham, Gloucestershire GL52 2AY
Telephone 01242 524846 Fax 01242 262334

Cheltenham's hidden gem, where you can discover the life of Gustav Holst, composer of The Planets, see his piano and hear his music, the story of the man and his music.

A Regency terrace house showing the 'upstairs downstairs' way of life in Victorian and Edwardian times, including working kitchen, elegant drawing room, and children's nursery.

▲ Music room, Holst Birthplace Museum

▲ Drawing room furnished in the style of the 1830s

### Directions

Situated north of town centre, 8-10 minute walk or local metro bus route D. Large public car park nearby (Portland Street).

### Opening times

Open all year
Tuesday to Saturday
10.00am to 4.20pm
Closed Bank Holidays

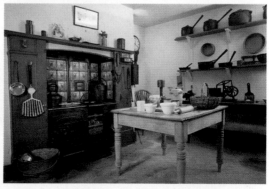

▲ Victorian kitchen

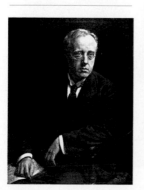

◀ Gustav Holst (1875-1934) by Bernard Munns

GLOUCESTERSHIRE

# CHELTENHAM ART GALLERY & MUSEUM

Clarence Street, Cheltenham, Gloucestershire GL50 3JT
Telephone 01242 237431 Fax 01242 262334

There is a treasure trove... on three floors. A world-famous collection relating to the Arts & Crafts Movement, including fine furniture and exquisite metalwork, made by Cotswold craftsmen - inspired by William Morris.

Rare Chinese and English pottery. 300 years of painting by Dutch and British artists. The story of Edward Wilson, Cheltenham's Antarctic explorer.

Also discover the town's history, Britain's most complete Regency town. Archeological treasures from the neighbouring Cotswolds.

Special exhibitions throughout the year - always something to see. Museum shop and café museum.

Free admission, donations welcome.

## Opening times

Open all year
Monday to Saturday
10.00am to 5.20pm
Closed Bank Holidays

## Directions

Situated in the town centre, 1 minute walk from the Promenade and the central bus station.

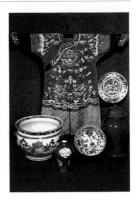

▲ Chinese robe and ceramics

◄ Arts and Crafts interior showing furniture and metalwork by Gimson and Barnsley

▼ Autumn Calf, 1952, by William Simmonds (1876-1968)

# PITTVILLE PUMP ROOM MUSEUM

Pittville Park, Cheltenham, Gloucestershire GL52 3JE
Telephone 01242 523852 Fax 01242 526563

Housed in an elegant spa building, overlooking a beautiful lake and gardens, original costumes imaginatively bring to life the history of Cheltenham from its Regency heyday to the present day.

A varied programme of special exhibitions, usually relating to textiles, embroidery and costume, throughout the year.

### *Opening times*

Open all year
daily except Tuesdays
May to September
10.00am to 4.30pm
October to April
11.00am to 4.00pm

### *Directions*

Situated on the north side of Cheltenham town, not far from Racecourse, just off Evesham Road (A435). Local metro bus route D, from town centre (12 minute walk).

▲ Fashion dating from 1760-1790 on display at the museum

▶ Costume Accessories dating from 1845-1870

# DEAN HERITAGE CENTRE

Soudley, Cinderford, Forest of Dean,
Gloucestershire GL14 2UB
Telephone 01594 822170

Discover the story of the unique landscape of the Forest of Dean and the people who have inhabited it, from prehistoric times until the present day.

Four galleries of displays include a working beam engine, a 'freeminer's level' and hands-on models and activities.

The Forester's cottage and wash-house recreate Victorian life for a Forest family complete with a hen house and a pig-sty, home to Dotty the Gloucester Old Spot pig.

The museum also houses the nationally important collection of 18th century long-case clocks made locally by the Voyce family.

The museum's woodlands include a nature cabin, with an observation bee hive and ants' nest, a demonstration charcoal stack, woodland sculptures and an adventure playground.

Picnic tables and barbecue facilities are available and nature trails start from the museum's car park.

Dean Heritage Kitchen offers home-cooked meals and light refreshments.

Craft shops sell high quality locally made crafts as well as local souvenirs and books and a blacksmith and potter each have a workshop on site.

Dean Heritage Centre has an active programme of temporary exhibitions and special events, including traditional charcoal burning. Season tickets are available.

Group visits are welcome and active learning packages for schools are available.

### Opening times

Open April to September
daily 10.00am to 6.00pm
Open February,
March and October
daily 10.00am to 5.00pm
Open November to
January Weekends
10.00am to 4.00pm
Closed 24th to 26th
December
Open 27th December
to 1st January
10.00am to 4.00pm
(Last admission 45
minutes before closing)

### Directions

Dean Heritage Centre is situated in the heart of the beautiful Forest of Dean. From M5 (J11) or M48 (J22) follow A48 to Blakeney. Take B4227 to Soudley.

▲ Dean Heritage Centre has a beautiful and dramatic woodland setting

▲ A reconstructed coal mine recreates conditions for a Forest 'freeminer'

▲ Feed the ducks and meet Dotty the Old Spot pig

▲ Step back in time in the Forester's cottage and wash-house

## THE ROBERT OPIE COLLECTION AT THE MUSEUM OF ADVERTISING & PACKAGING

Albert Warehouse, Gloucester Docks, Gloucester GL1 2EH
Telephone 01452 302309 Fax 01452 308507

The result of one man's enthusiasm, Britain's only Museum of Advertising and Packaging is the culmination of 35 years of collecting by Robert Opie. His collection, the largest of its type in the world, numbers some 500,000 artefacts relating to the history of our consumer society, dating from about 1870.

This fascinating insight into our way of life now includes such items as games, toys, newspapers, magazines and comics. A new feature - "The Time Tunnel Experience" - will awaken memories in everyone. Wartime 1940s, fun 1950s, swinging 60s or trendy 70s; here they all are - the toys, games and comics of childhood, the sweets, breakfast cereals, biscuits, cigarettes and fashions; remember flares and platform shoes?

The material is set out in historical sequence, so that changes in pack design, brand development, advertising techniques, women's roles, taste and fashion can be studied.

There is a total relevance in the displays to the National Curriculum, particularly in History and Technology.

Entrance fees:- Adults £3.50, Seniors and students £2.30, School children £1.25, Discounts for groups 10+, Family ticket (2 adults and up to 4 children) £8.50.

### Opening times

Open all year
March to October
10.00am to 6.00pm
November to February
Tuesday to Sunday
10.00am to 5.00pm
Closed Mondays
Open on all
Bank Holidays.
Closed 25th & 26th
December

### Directions

Approaching Gloucester by car, follow signs to 'Historic Docks'. The museum is in the heart of the docks. From Gloucester station a 10 minute walk through city centre to docks.

▼ A century of shopping basket history

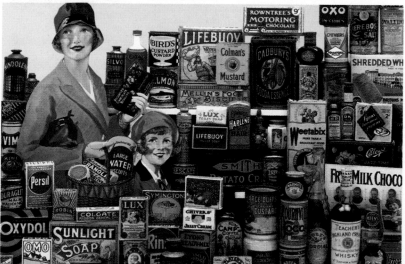

GLOUCESTERSHIRE

# THE NATIONAL WATERWAY MUSEUM

Llanthony Warehouse, Gloucester Docks, Gloucester GL1 2EH
Telephone 01452 318054 Fax 01452 318066

The National Waterways Museum, open daily 10.00am - 5.00pm.

Based within Gloucester Docks, the Museum's flexible entry ticket, allows freedom of access on the day of purchase. Housed on three floors of the listed Victorian Llanthony Warehouse, this Award winning Museum takes you into the fascinating world of inland waterways.

See how, in this working National Museum, canals were built, the effect on the countryside, family life, fortunes lost and gained.

Practice steering a simulated narrowboat, no need to worry about damage if you hit the bank, it will only be a case of dented pride.

Explore the variety of historic vessels moored at the two quaysides, including the No4 Steam Dredge. Compare the living space on the narrowboat 'Northwich' who during 1998 celebrated her 100th birthday.

Investigate the blacksmith's forge, try your hand at many different crafts in the Activity Room during school holidays.
The Tea Room offers visitors an opportunity to enjoy a light snack or home-made cakes on their journey through the Museum. Get out onto the Gloucester & Sharpness Canal aboard Queen Boadicea II a small Dunkirk veteran boat, offering 45 minute cruises Easter to October.

King Arthur offers a programme of longer cruises departing from Merchants Quay, Gloucester Docks along the Canal and River Severn. An all weather all year destination The National Waterways Museum, within Gloucester Docks. For details telephone on 01452 318054

## Opening times

Open daily
10.00am to 5.00pm
(last admission one
hour before closing)
Closed only 25th
December

## Directions

M5 junction 11, 11a, 12.
Follow brown signs
'Historic Docks'. A40
follow "Historic Docks"
signs. Enter docks from
Southgate Street, first
left after cottages,
Museum car park
on right.

▲ Experience a walk along the canal. Showing the construction

▲ Children understanding the way of life aboard traditional narrowboat

▲ Dredger Buckets turning worked by friends of the museum

▲ Activities for all ages encouraging hands-on learning

# NATURE IN ART

Wallsworth Hall, Twigworth, Gloucester GL2 9PA
Telephone 01452 731422 Fax 01452 730937
Website www.nature-in-art.org.uk

Nature in Art fills a gap in the museums and galleries accessible to the public by presenting an exclusively nature-inspired collection of the very highest standards.

It is a world first for Gloucester that has twice been specially commended in the National Heritage Museum of the Year Awards! International in scope, appeal and stature, Nature in Art's continually changing displays embrace work in all media from any period and any culture.

Visit Nature in Art and you could see work by artists as diverse as Shepherd, Picasso, Scott, Moore, Audubon, Sutherland, Lalique, Ethnic art and Thorburn.

To complement the exhibits this unique museum, housed in a fine Georgian Mansion dating from the 1740's, also arranges an unrivalled programme of artists in residence.

On average, 70 artists from 10 countries demonstrate to visitors each year (February to November). In addition to world class exhibits you might see a chainsaw sculptor, Chinese calligrapher, oil painter or glass engraver at work! A vibrant

programme of special exhibitions, art courses, lectures, films, and other activities are also held - call us for details!

Special discounts for groups and schools. Full wheelchair access. Free parking. Gardens with outdoor sculptures. Shop.

### *Opening times*

Open all year
Tuesday to Sunday
10.00am to 5.00pm and
Bank Holiday
Closed 24th-26th
December and closed
other Mondays

### *Directions*

2 miles north of Gloucester on the main A38. Just 5 minutes drive from J11 and J11a M5. Look for brown tourism signs on A38.

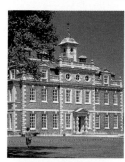

▲ Wallsworth Hall, the home of Nature in Art

▲ Animals entering Noah's Ark by Jan Van Kessel Younger (1654-1708)

▼ Woodducks by John Sharp (USA)

## CORINIUM MUSEUM
Park Street, Cirencester, Gloucestershire GL7 2BX
Telephone 01285 655611 Fax 01285 643286

One of the finest collections of antiquities from Roman Britain, brought to life by full scale reconstructions of a Roman kitchen and garden. Programme of events and exhibitions throughout the year.

*Opening times* Open Monday to Saturday 10.00am to 5.00pm Sunday 2.00pm to 5.00pm Closed Mondays November to March, Christmas and New Year

## SWINFORD MUSEUM
Filkins, Lechlade, Gloucestershire GL7 3JQ
Telephone 01367 860209

Home life in a Cotswold village and the trades, especially stone working.

*Opening times* Open first Sunday in month May to September 2.00pm to 5.00pm or by arrangement

## COTSWOLD HERITAGE CENTRE
Fosseay, Northleach, Gloucestershire GL54 3JH
Telephone 01451 860715 Fax 01451 860091

A Museum of Cotswold Rural Life with the Lloyd Baker Collection of agricultural implements housed in a former 18th century prisons. Changing exhibitions throughout the season.

*Opening times* Open 1st April to 31st October Monday to Saturday 10am to 5pm Sunday 2pm to 5pm Bank Holidays 10am to 5pm. Other times by arrangement

## THE JOHN MOORE COUNTRYSIDE MUSEUM
41 Church Street, Tewkesbury, Gloucestershire GL20 5SN
Telephone 01684 297174

A natural history collection exhibited in an historic 15th century timber framed house. Displays of British woodland and wetland wildlife. Plus metal wildlife sculptures. Full programme of events and exhibitions.

*Opening times* Open 1st April to 31st October Tuesday to Saturday 10am to 1pm and 2pm to 5pm Open all Bank Holidays Open other times by prior arrangement

## THE LITTLE MUSEUM (THE MERCHANT'S HOUSE)
45 Church Street, Tewkesbury, Gloucestershire GL20 5SN
Telephone 01684 297174

A fine 15th century timber famed house, restored to show the construction of a Merchant's Shop and house in medieval times. Full programme of living history workshops.

*Opening times* Open 1st April to 31st October Tuesday to Saturday 10am to 5pm Also open Bank Holidays. Open other times by arrangement (last admission 4.45pm)

## WINCHCOMBE RAILWAY MUSEUM & GARDEN
23 Gloucester Street, Winchcombe, Gloucestershire GL54 5LX
Telephone 01242 620641

A hands on museum of Railway life with collections covering every aspect of operating as well as the "personal" side. Something for all the family to see and do.

*Opening times* Open Saturdays & Sundays, Easter to end of October 1.30pm to 5.30pm Daily throughout August 1.30pm to 5.30pm

# HAMPSHIRE & ISLE OF WIGHT

Hampshire is a county of many faces...the North Downs, which slope down to Aldershot, and the South Downs, rising to Butser Hill, and between them wonderfully fertile agricultural farmland. And then there are the glorious watermeadows and rippling streams associated with the River Test which make this region a magnet to fly-fishermen...rising in the west to the oak, beech and birch woods of the New Forest, the land of wild ponies. Hampshire is of course very much a naval county. The naval dockyard established in Portsmouth's sheltered harbour in the seventeenth century developed enormously during the next century, and despite closing in 1984 Portsmouth is still deeply involved with the Royal Navy. This involvement is shown to great effect in the royal Navy Submarine Museum at Gosport and the Mary Rose Museum and Ship Hall in College Road.

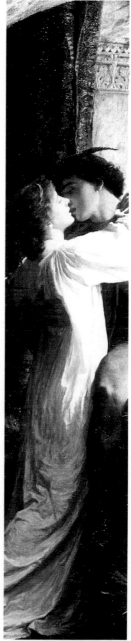

The county has a strong army tradition too. Aldershot became the 'home' of the British Army in 1854 when 6,000 acres of scrubland was bought, on which to build permanent barracks. By the end of the nineteenth century Aldershot was a large and thriving town. The history of this remarkable development is told at the Aldershot Military Museum. Here also is the inspirational Parachute Regiment and Airborne Forces Museum.

On a more pastoral note Breamore, one of Hampshire's most picturesque villages of thatched cottages, with a fine mainly Saxon church, has a most intriguing museum providing a glimpse into the days when such villages were self-sufficient. At Andover, a small medieval town until in the 1960s it was selected to take London overspill, there is a splendid museum in an old grammar school, depicting stories of the town and its surrounding countryside.

Winchester, the county town was the capital of Wessex from the days of Alfred the Great and the capital of the whole of England from the tenth century until the Norman Conquest. The magnificent cathedral houses the Winchester Cathedral Library and Triforium Gallery telling the story of this very special place. As well as Hampshire's wealth of specialist museums and galleries there are the traditional Art Galleries, Southampton's being a fine example displaying a major collection of British and European paintings and sculpture from the fourteenth century to the present day, with an emphasis on twentieth century British art.

## WINCHESTER CATHEDRAL LIBRARY & TRIFORIUM GALLERY

Hampshire SO23 9LS
Telephone 01962 853137 Fax 01962 841519

HAMPSHIRE & THE ISLE OF WIGHT

Winchester Cathedral Triforium Gallery has a spectacular position in the Cathedral's south transept. It is among some of the most powerful Norman architecture in England and displays sculpture, woodwork and metalwork from II centuries.

The strength of the displays are the fragments of 15th century statuary from the Great Screen, or reredos, destroyed at the Reformation in the 16th century. They are of superb quality and even in their battered state remain breathtakingly beautiful.

Also to be found here is the chair in which Queen Mary Tudor sat during her marriage to Philip of Spain in 1554, and a silhouette of Jane Austen, said to have been 'done by herself in 1815'.

Below the gallery in a quiet, barrel-vaulted room is the library of Bishop George Morley, comprising 2,000 volumes bequeathed to the Cathedral in 1685.

It is a delightful 17th century gentleman's book room complete with a pair of Dutch Globes, terrestrial and celestial. On permanent display in

the Cathedral Library is the Winchester Bible. Written on vellum in the 12th century, it is a unique and supreme example of the art of manuscript illumination.

There are also regular exhibitions from the Library's collection of manuscripts and printed books.

### *Opening times*

Open Easter to October
Monday
2.00pm to 4.30pm
Tuesday to Friday
10.30am to 1.00pm
2.00pm to 4.30pm
Saturday
10.30am to 4.30pm
(last admission 4.00pm)
Limited opening
out of season

### *Directions*

Winchester Cathedral, Winchester, Hampshire, M3 junctions 9 or 11. The Library and Gallery are in the south transept, signed from the entrance at the west end of the Cathedral.

▲ Winchester Cathedral's Triforium Gallery

▲ Fifteenth century sculpture from the Great Screen

▲ Winchester Cathedral Library. Bishop Morley's 17th century book room.

▲ The Winchester Bible. Initial from the book of Ezekiel. 1160-80

## THE PARACHUTE REGIMENT & AIRBORNE FORCES MUSEUM

Browning Barracks, Aldershot, Hampshire GU11 2BU
Telephone 01252 349619 Fax 01252 349203

The Airborne Forces Museum is located in Browning Barracks, Aldershot just off the A325 Farnborough Farnham Road. The Museum is easily recognised by the Dakota aeroplane in front of it. The Museum traces the history of British Airborne Forces since their beginning in 1940 to the present day.

With the help of weapons, equipment, dioramas and briefing models we tell the story of the many actions in which members of the parachute regiment and other airborne soldiers took part; Actions such as DDay, Arnhem, Rhine Crossing, and the Post War campaigns including the Middle East, Far East, the Falklands and Northern Ireland.

### Opening times

Open all year except Christmas period Daily 10am to 4.30pm (last admission 3.45pm)

▲ Arnhem cameo

### Directions

From M3 follow the A325 through Farnborough, forward at the Forte Posthouse Hotel roundabout. Continue on the A325 for approximately half a mile, turn first left. Museum sign posted.

▼ Ford Willys 4x4 Jeep created for parachuting

▼ Dakota aeroplane outside the museum

*HAMPSHIRE & THE ISLE OF WIGHT*

# ALDERSHOT MILITARY MUSEUM

Queens Avenue, Aldershot, Hampshire GU11 2LG
Telephone 01252 314598 Fax 01252 342942

The Aldershot Military Museum and Rushmoor local history gallery is unique. It tells the fascinating stories surrounding the birth and development of Aldershot, which became known the world over as the home of the British Army. It also shows the growth of the surrounding Civil towns of Aldershot and Farnborough.

The themes of the museum are related through colourful displays featuring reconstructions and a wide variety of objects from a military hoof pick to a 60 ton main battle tank.

A special section is devoted to Samuel Franklin Cody and his early flying exploits at Farnborough where the first officially recognised powered flight was made in 1908.

School parties and group visits are especially welcome with group rates available.

Ample free car parking exists on site and access is level throughout for visitors in wheelchairs.

**Opening times**
Open March to October
daily 10am to 5pm
November to February
daily 10am to 4.30pm

**Directions**
Pick up either A325 or A331. Follow signs to "Aldershot Military Town (north)" the museum is situated at the northern end of Queens Avenue.

▲ A 60 ton Chieftain Tank is regularly run all year

▲ A fully authentic Barrack room recreates life in the 1900s

◄ A late Victorian lancer. Typical of many of Aldershot past soldiers

► Flying models capture the variety of early aviation at Farnborough

HAMPSHIRE & THE ISLE OF WIGHT

# ANDOVER MUSEUM & THE MUSEUM OF THE IRON AGE

6 Church Close, Andover, Hampshire SP10 1DP
Telephone 01264 366283 Fax 01264 339152
E-Mail andover.museum@virgin.net

Andover Museum tells the story of an area rich in Archaeological finds and old English myths. From the palaeolithic to the present day, features include a Natural History Gallery and Aquarium, a wealth of local archaeological finds up to Saxon and medieval times, a nineteenth century period room, Victorian Andover, including the Weyhill Fair and the workhouse scandal, and the rapid growth of Andover over the last generation.

There is also an exciting programme of temporary exhibitions in our art gallery and a local Resources Room.

Then step inside the museum of the Iron Age and discover a way of life that was destroyed by the Romans. This unique museum tells the story of nearby Danebury, an Iron Age hillfort excavated by Barry Cunliffe over a twenty year period.

See life size models of a plough, weaving loom, Iron Age warrior and a Roman soldier, a reconstructed rampart section, a roundhouse and a miniature street scene.

Also on display are many excavated

artefacts - metalwork, including currency bars, tools and weapons, loom weights, spindle whorls and weaving combs, pottery, querns, "Celtic" coins, personal ornaments and the Hampshire mirror, all from Danebury and its Environs and also Roman artefacts, some from Silchester.

## Opening times

Open all year
Tuesday to Saturday
10.00am to 5.00pm
Iron Age also
open Sundays
2.00pm to 5.00pm
from Easter to end
of September

## Directions

Follow the brown signs from the A303. Church Close, Andover is next to St. Mary's Church near High Street.

▲ Andover Museum and the Museum of the Iron Age

▲ The Andover Workhouse scandal diorama "the inmates gnawed crushed bones"

▲ Bone and antler "weaving combs" from excavations at Danebury Ring

▲ The Iron Age Warrior C.100BC

HAMPSHIRE & THE ISLE OF WIGHT

# NATIONAL MOTOR MUSEUM - BEAULIEU

Montagu Ventures Ltd, John Montagu Building, Beaulieu,
Hampshire SO42 7ZN
Telephone 01590 612345 Fax 01590 612624

*HAMPSHIRE & THE ISLE OF WIGHT*

Set in the heart of the New Forest, Beaulieu is home to the world famous National Motor Museum which traces the story of motoring from 1894 to the present day through a collection of more than 250 vehicles.

See how transport has developed over the years as you travel on 'Wheels' - a surprising ride, exploring 100 years of motoring history.

View legendary World Record Breakers like Bluebird and Golden Arrow. Get close to 'Film Star' cars, Formula 1 racers, including one of the cars used by Damon Hill in his World Championship year, touring limousines and family cars from the 30s, 40s and 50s.

See motoring eccentricities, such as a giant orange on wheels, as well as a host of motorbikes and commercial vehicles.

Fascinating motoring memorabilia, displays and a 1930s street scene, complete with a full scale replica of a typical country garage packed full of tools and artefacts of the era, help recreate an altogether less hurried time of

shops, vehicles and tradesmen.

When visiting Beaulieu you can also view Palace House which has been the ancestral home of the Montagus since 1538 plus Beaulieu Abbey and an exhibition of monastic life.

### *Opening times*

Open daily
10.00am to 5.00pm
Easter to September
10.00am to 6.00pm
Closed Christmas Day
(last admission 40
minutes before closing)

### *Directions*

London to Beaulieu
(about two hours) M3,
M27 west to junction 2,
A326 then follow brown
tourist signs to
Beaulieu.

▼ Interior of National
Motor Museum

▲ Lord Montagu of Beaulieu inside the National Motor Museum

▲ Palace House overlooking the Beaulieu River

▲ Beaulieu Abbey remains

# BREAMORE COUNTRYSIDE MUSEUM

Breamore, near Fordingbridge, Hampshire SP6 2DF
Telephone 01725 512233 Fax 01725 512858

The Breamore Countryside Museum takes the visitor back to when a village was self sufficient.

Visitors can see full size replicas of a farm worker's cottage before the advent of electricity, a blacksmith's shop, a dairy, a wheelwrights shops, a brewery, a saddler's shop and boot makers. The village shop, school, cooperage, bakers, laundry and early garage provide further light on a previous existence.

A fine collection of farming implements and tractors represent the village industry. Robert Thorne's workshop for repairing threshing tackle is a recent addition, which complements the drum on view.

The Burrell Traction Engine 1926 and the Robey portable are two examples of the steam era. For the Millennium the museum intends to renovate and restore a 16th century four train turret clock. This can be seen at present but not working.

The museum also has a small children's playground and is home to the great British maze.

Schools are welcomed out of hours but they must pre-book through John Forshaw 01725 512468. He will be pleased to supply further information.

---

### *Opening times*

Open April Tuesday, Wednesday and Sunday May, June, July, September daily except Monday and Friday August open every day 1.00pm to 5.30pm and all Bank Holidays

---

### *Directions*

Take A338 from Salisbury towards Ringwood or M27 to junction 1 then B3078 to Downton and left to Breamore.

▲ The Wheelwright shop

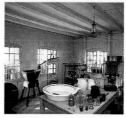
▲ The Dairy

▲ The Saddlers shop

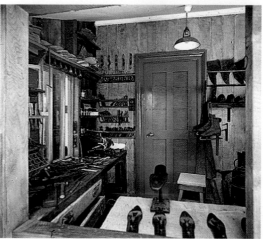

▶ The Boot maker/Cobbler

# ROYAL NAVY SUBMARINE MUSEUM

Haslar Jetty Road, Gosport, Hampshire PO12 2AS
Telephone 01705 529217 Fax 01705 511349

The Museum is located next to Fort Blockhouse which was the home of the Royal Navy Submarine Service 1901-1994.

The Museum is primarily a Memorial Museum, with the addition of a new image for tourism and education.

Features: a short audio-visual presentation in the submarine control room cinema introduces you to the world of submarines.

The star attraction is the post-war submarine HMS Alliance, through which you are guided by an ex-submariner. See the cramped living quarters for 65 men, how torpedoes are loaded and then brace yourself for a depth-charge attack! Holland I, the Royal Navy's first submarine, is on display. She is nearing the end of a four-year conservation period.

Before or after your tour of Alliance you can visit the Historical Gallery, which shows the history of the Submarine Community, and the Nuclear Gallery which features an interactive reconstruction of a nuclear submarine control room, complete with working periscopes.

Special Family ticket 2 Adults and up to 4 Children £10.

Diving Exhibition. Midget submarine X24 on display. Deep Submergence Rescue Vessel LR3. JIM Articulated Diving Suit. Coffee shop, gift shop, picnic area, Accessible by Harbour boat trips. Please allow at least two and a half hours for your visit.

### *Opening times*

Open April to October
10.00am to 5.30pm
November to March
10.00am to 4.30pm
(last tour 1 hour
before closing)

### *Directions*

M27 to junction 11 follow A32 through Gosport over Haslar Bridge. Museum car park is 2nd left. Also accessible by boat from Portsmouth Hard or Gosport Ferry with a short walk.

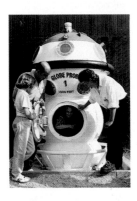

▲ The Globe Probe Deep Submersible

▲ WWI artefacts in the Historical Gallery

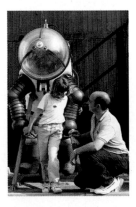

▲ Jim the all in one diving suit

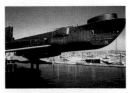

▲ HMS Alliance features in Britains only submarine museum

## GOSPORT MUSEUM & GOSPORT GALLERY

Walpole Road, Gosport, Hampshire PO12 1NS
Telephone 01705 588035 Fax 01705 501951

Gosport Museum is housed in an attractive art nouveau building of 1901. The museum was completely redisplayed in 1992 by Hampshire County Council in partnership with Gosport Borough Council.

The new displays tell the story of the Borough of Gosport from the earliest times, highlighting the aspects that make Gosport unique. Showcases full of numerous fascinating objects are displayed, together with old photographs, paintings, archive film and life sized costumed figures.

Take a journey back millions of years in the Gosport time machine in the new Geology Gallery. The museum coffee shop provides both refreshment and a venue for local exhibitions. Come and enjoy the best cup of freshly brewed coffee in town.

The Gosport Gallery has a regular programme of exhibitions. Contact the museum for current programme.

***Opening times***
Open
Tuesday to Saturday
10am to 5pm
Sunday 1pm to 5pm
May to September only
Closed Monday and
winter Sundays

***Directions***
The Museum is right in the centre of Gosport, a few minutes walk from the ferry and bus station. Signs around the town provide directions to the Museum. Parking nearby.

▶ An Edwardian Cooper at the Royal Clarence yard ' Gosport'

▲ The Geology gallery

# THE MARY ROSE MUSEUM & SHIP HALL

College Road, HM Naval Base, Portsmouth, Hampshire
PO1 3LX
Telephone 01705 750521 Fax 01705 870588

The world held its breath as the Mary Rose was raised from the Solent seabed in 1982. Today visitors can view the hull of the world's first purpose-built warship from air-conditioned viewing galleries.

Nearby is a museum of reconstructions, audio-visual presentations and over one thousand artefacts: the perfect Tudor Time Capsule.

The Mary Rose is located within Portsmouth Historic Dockyard alongside HMS Victory, HMS Warrior 1860 and the operational vessels of today's mighty naval fleet.

The Royal Navy Museum forms the backbone of this collection; the world's finest collection of historic warships.

### Opening times

Open every day except Christmas Day
10.00am to 5.30pm
(last admission 5.00pm)

### Directions

By road:
enter Portsmouth along the M275 and follow the brown 'Historic Ships' signposts.
By coach and rail:
regular services from the adjacent Hard Interchange/Portsmouth Harbour Station.

▲ Mary Rose leaving Portsmouth harbour, Summer 1545

▲ A selection of personal items displayed against a decorative pouch

▼ View of the Mary Rose, the upper deck, main gun deck, and the orlop (storage) deck

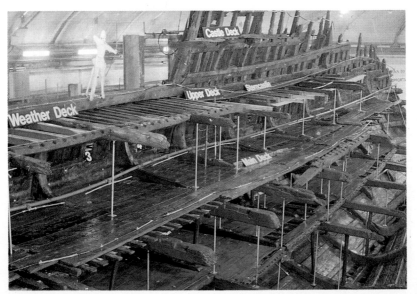

# WINCHESTER COLLEGE TREASURY

College Street, Winchester, Hampshire SO23 9NA
Telephone 01962 866079

Small museum with collections of Chinese porcelain, Greek pottery, Greco-Roman archaeology and Honduran pre-Columbian ceramics.

Also displays books, scientific instruments, silverware, crafts, paintings, photographs and pupils' work. Admission free.

Main collections: Duberly Collection of Chinese porcelain, including a well-preserved Tang horse, collection of Greek vases, with many beautiful and valuable pieces.

Exhibitions change every few months. The medieval setting of the museum (the ancient buildings of Winchester College) is an attraction in itself.

### *Opening times*

Open all year
Thursday, Saturday
and Sunday
2.00pm to 4.00pm
and by arrangement
with curator.
Closed in December

### *Directions*

From the town centre go through Cathedral Close and Kingsgate Arch. Turn left into College Street. Enquire at Porter's Lodge (Winchester College main entrance).

▶ Court Lady, pottery figure from the Tang dynasty (8th century)

▲ Lady teasing her lover, 18th century Chinese porcelain (Ching dynasty)

◀ Dragon bowl, Ming dynasty (16th century)

▲ Floral dish, blue and white Chinese porcelain, early 15th century

## SOUTHAMPTON CITY ART GALLERY
Civic Centre, Commercial Road, Southampton, Hampshire SO14 7LP
Telephone 01703 832277 Fax 01703 832153

Southampton City Art Gallery's permanent collection spans six centuries of European art, including 17th century Dutch landscapes, 18th century portraiture and a small number of French Impressionist works, Edward Burne-Jones's "Perseus Series" and a recent installation by Daniel Buren.

20th century British art is particularly well represented: the collection includes many fine works of art by artists such as Stanley Spencer, Antony Gormley, Gilbert and George, Barry Flanagan, Rachel Whiteread and Helen Chadwick.

Southampton has a progressive exhibitions programme encompassing displays from the collection, complimented by temporary exhibitions of historical, modern and contemporary art.

Gallery staff regularly give tours of the gallery to the public. The gallery also programmes artist-led practical workshops for children, families and adults.

▶ 'Romeo and Juliet' by Frank Dicksee, 1853-1928

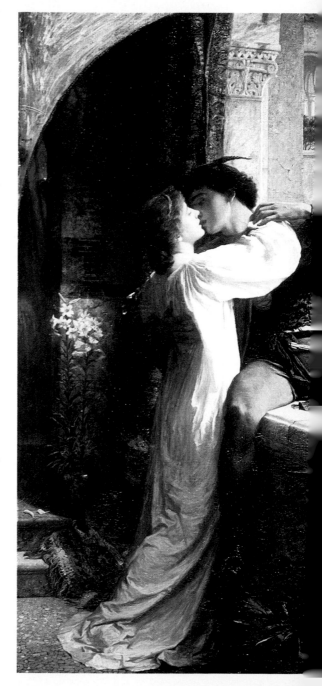

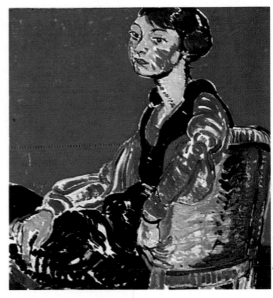

The Education Officer organises tours and workshops for primary, secondary and tertiary level students and teachers.

▲ 'Dulcie' by Matthew Smith, 1879-1959

### *Directions*

Located in the centre of Southampton, the gallery is housed within the Civic Centre. A short walk from the train station, on Commercial Road, opposite Watts Park.

### *Opening times*

Open
Tuesday to Saturday
10.00am to 5.00pm
Sunday
1.00pm to 4.00pm
Closed Mondays and
all Bank Holidays
(last admission half an
hour before closing)

▼ 'Untitled (Fast Breeder)' 1997, detail by Fiona Rae b.1963

◄ 'Mydlow Village, Poland' by Robert Bevan, 1865-1925

HAMPSHIRE & THE ISLE OF WIGHT

# THE MUSEUM OF ARMY FLYING & EXPLORERS' WORLD

Middle Wallop, Stockbridge, Hampshire SO20 8DY
Telephone 01980 674421 Fax 01264 781694

Celebrating over one hundred years of army aviation, this award winning museum is home to one of the country's finest historical collections of military balloons, kites, gliders, aircraft and helicopters.

The museum's imaginative dioramas and static displays trace the developments of Army flying from pre World War I years through to today's modern Army Air Corps. An inspiring and profound tribute to the Army's vital contribution to enemy observation and reconnaissance.

*Explorers' World* - the Interactive Science and Education Centre - features an imaginative range of hands-on activities and experiments for children of all ages. Experience the Hall of Mirrors. Sensory Trail, Light Waves

▲ Do you have the aptitude to become a pilot?

Exhibition, IT Suite with internet access and the largest tin-can telephone in the world! Explorers' World also houses one of the finest camera obscuras in the country giving a breathtaking view of the surrounding Hampshire countryside.

### Directions

M3 westbound to Junction 8. Exit to A303. Exit A303 at A343 signposted to Salisbury. Continue on this road for approximately 5 minutes. The Museum is located on the left.

▲ See what it is like to fly a Scout Helicopter

▼ An original Sopwith Pup which flew in WWI

▲ A Horsa glider landing

### Opening times

Open 7 days a week all year except week before Christmas 10.00am to 4.30pm (last admission 4.00pm)

# BRADING ROMAN VILLA

Morton Old Road, Brading, Isle of Wight PO36 0EN
Telephone 01983 406223

Brading Roman Villa, the finest on the Isle of Wight, was begun as a few timber buildings about AD 50 but by the early fourth century (AD 300) had developed into a large and complex house with farm buildings grouped around a courtyard.

Recent evidence has shown that more lies under the car park and beyond but this will be for future generations to excavate.

Come and see the magnificent mosaic floors, all under cover in the preserved West Wine.

Be greeted by the mythical Orpheus, playing his lyre at the entrance and attracting birds and animals captivated by his magical notes.

See the unique and strange 'cock-headed' man in his brightly coloured coat with his winged griffins.

Marvel at the superb mosaic of Medusa with her devastating stare, surrounded by other figures from mythology - the very centre piece of this once proud house.

The many exhibits found during the excavation are displayed in the West Wing - see the magnificent Roman glass that once adorned the tables of our Roman ancestors that indicates the luxurious lifestyle of many of the villas of Britain.

### *Opening times*

Open
1st April to 31st October
daily 9.30am to 5.00pm
(last admission 4.30pm)

### *Directions*

Roman Villa signposted
from A3055
Sandown to Brading
road at
Morton Old Road.
Please follow brown
tourist signed marked
"Roman Villa".

▲ 4th century mosaic of "Medusa"

▲ Interior view Kiest Wing Brading Roman Villa with mosaics

▲ 4th century mosaic of cock-headed man

◄ Artists impression of North Wing under construction

*HAMPSHIRE & THE ISLE OF WIGHT*

# ARMY MEDICAL SERVICES MUSEUM

Keogh Barracks, Ash Vale, Aldershot, Hampshire GU12 5RQ
Telephone 01252 340212 Fax 01252 340224

Museum tells the story of the Army Medical Services from 1660 until the present. Includes medical items, ambulances, uniforms and medals.

*Opening times* Open all year Monday to Friday 9.00am to 3.30pm
(last admission 3.00pm)

# ARMY PHYSICAL TRAINING CORPS MUSEUM

Army School of Physical Training, Fox Lines, Queens Avenue,
Aldershot, Hampshire GU11 2LB
Telephone 01252 347168 Fax 01252 349015

Graphic APTC History and Development of Physical training in British Army since 1860-photos/records of APTC National/International sportsmen/sportswomen - evolution of PT clothing - small library - free entry.

*Opening times* Open all year Monday to Thursday 8.30am to 12.30pm 2pm to 4.30pm
Friday 8.30am to 12.30pm Except School leaves periods viz: 1 week each side of Easter, all of August, 1 week each side of Christmas

# WILLIS MUSEUM

Market Place, Basingstoke, Hampshire RG21 7QD
Telephone 01256 465902 Fax 01256 471455 or 57383

Three floors including Natural History and new Social History gallery which charts 200 years of Basingstoke with open displays. Special interest gallery of clocks and watches and temporary exhibition programme.

*Opening times* Open Monday to Friday 10am to 5pm Saturday 10am to 4pm
Open all year round except Sundays and Bank Holidays

# ROYAL ARMORIES AT FORT NELSON

Down End Road, Fareham, Hampshire PO17 6AN
Telephone 01329 233734 Fax 01329 822092

Restored 19th century fortress home of the Royal Armories Artillery Collection, including the famous Dardanelles gun, 1464 and lengths of the Iraqi 'Supergun'. Live displays and exhibitions throughout the season.

*Opening times* Open April to October  daily 10.00am to 5.00pm,
November to March Thursday, Friday, Saturday and Sunday 10.30am to 4.00pm

# FORT BROCKHURST

Gunner's Way, Elson, Gosport, Hampshire
Telephone 01705 581059

A vast site with restored casemates showing the Armoury, Mess Room and Wash-room of Victorian soldiers. A Museum documenting the history of Aviation in Gosport is free to visitors.

*Opening times* Open 1st April to end of October, Weekends and Bank Holidays only,
10.00am to 6.00pm

## PORTCHESTER CASTLE

Castle Street, Porchester, Fareham, Hampshire PO16 9QW
Telephone 01705 378291 Fax 01705 378291

Surrounded by the most complete Roman Walls in Northern Europe, you can discover the 14th century Palace of King Richard II and climb to the top of the vast Keep.

**Opening times** Open 1st April to 1st November 10.00am to 6.00pm (October 10.00am to 5.00pm/dusk) 2nd November to 31st March 10.00am to 4.00pm/dusk Closed 24th to 26th December

## ROCKBOURNE ROMAN VILLA

Rockbourne, Fordingbridge, Hampshire SP6 3PG
Telephone 01725 518541 Fax 01202 481924

Large Roman Villa with mosaics and foundations exposed. Modern Museum with fascinating displays of objects from the site. Small admission charge. 3 miles west of Fordingbridge off B3078.

**Opening times** Open April 1st to September 30th Monday to Friday 12.00pm to 6.00pm Saturday and Sunday 10.30am to 6.00pm July, August 10.30am to 6.00pm daily (last admission 5.30pm)

## HAVANT MUSEUM

56 East Street, Havant, Hampshire PO9 1BS
Telephone 01705 451155 Fax 01705 498707

Local history displays. Local studies collection. Temporary exhibitions and the Vokes collection of Sporting Firearms. Admission free.

**Opening times** Open all year daily except Sundays and Mondays 10am to 5pm

## BROADLANDS
## (including MOUNTBATTEN EXHIBITION)

Broadlands, Romsey, Hampshire SO51 9ZD
Telephone 01794 505010 Fax 01794 505040

All-inclusive ticket covers guided tour of Broadlands House, admission to Riverside Lawns, Mountbatten Exhibition and Mountbatten A-V presentation. Special group rates for groups of 15+. Contact Mrs Vivien Andrews 01794 505010.

**Opening times** Open 14th June to 3rd September daily 12.00pm to 4.00pm, last tour of house leaves at 4.05pm and the Mountbatten Exhibition closes at 5.30pm

## MEDIEVAL MERCHANTS HOUSE

58 French Street, Southampton, Hampshire SO1 10AT
Telephone 01703 221503

Restored Wine Merchants House built 1290, furnished as would be 14th century. Entrance £2.00 adult, £1.50 concession, £1.00 child, under 5 years free. Includes audio tour.

**Opening times** Open 1st April to 31st October 10.00am to 6.00pm, 7 days

## CALSHOT CASTLE

Calshot Spit, Fawley, Southampton, Hampshire SO45 1BR
Telephone 01703 892023

Henry VIII built 1539-40 part of coastal defences. In 1913 Calshot became one of the first Royal Navy Seaplane bases. It was manned during both World Wars, known for link Schneider Trophy.

*Opening times* Open 1st April to end October 10am to 4pm (last admission 3.30pm)

## ROYAL MARINES MUSEUM

Southsea, Hampshire PO4 9PX
Telephone 01705 819385 Fax 01705 838420

The 330 year story of Britain's sea soldiers, told through dramatic displays, exciting films and videos and state of the art interactives. Allow up to three hours for your visit.

*Opening times* Open 7 days a weeks all year (except for 3 days over Christmas) 10.00am to 5.00pm (4.30pm in winter) Last admission 1 hour before closing

## THE ROYAL HAMPSHIRE REGIMENT MUSEUM

Serles house, Southgate Street, Winchester, Hampshire SO23 9EG
Telephone 01962 863658 Fax 01962 888302

Displays the history of the Royal Hampshire Regiment 1702-1992. Guided tours by arrangement.

*Opening times* Open all year Monday to Friday (except two weeks at Christmas and New Year) 10.00am to 12.30pm 2.00pm to 4.00pm April to October Saturdays, Sundays and Bank Holidays 12.00pm to 4.00pm

## COWES MARITIME MUSEUM

Beckford Road, Cowes, Isle of Wight PO31 7SG
Telephone 01983 293341 and 01983 293394  Fax 01983 293341

Models, paintings and photographic archive illustrating Island's Maritime History and ship building heritage, and the development of yachting. Collection of boats designed and built by UFFA Fox.

*Opening times* Open all year Monday, Tuesday, Wednesday, Friday 9.30am to 6.00pm Saturday 9.30am to 4.30pm Closed Thursday, Sunday

## ROMAN VILLA

Cypress Road, Newport, Isle of Wight PO30 1HE
Telephone 01983 529720 or 823366

Excellent example of bath suite in this villa. Planted Roman herb garden. Many artefacts. Guided tours by arrangement. Education room available with artefacts including millstone and loom. Discounts for OAP's, students and families.

*Opening times* Open daily 1st April to 31st October (except Sundays) 10.00am to 4.30pm Visits out of season by arrangement

## NATIONAL WIRELESS MUSEUM

Arreton Manor, Arreton, Newport, Isle of Wight PO30 3AA
Telephone 01983 567665 Fax 01983 564708

A unique collection of vintage wireless and television receivers dating back to the first World War. Antique crystal sets with "catswhiskers" and headphones and receivers with bright emitter valves. The very first television - a 30-line mechanical disc Logle Baird model dating from 1930. Shortwave transmitting station GB3WM operating on 40 metres.

*Opening times*  Open 10.00am to 5.00pm weekday 1.00pm to 5.00pm Sundays
Closed Saturdays

## ISLE OF WIGHT STEAM RAILWAY

Haven Street Station, Haven Street, Ryde, Isle of
Wight PO33 4DS
Telephone 01983 882204 Fax 01983 884515

A working museum  the Island's railway history. A 10 mile round trip in 100 year old carriages hauled by a equally old engine. Museum display of smaller artefacts.

*Opening times*  Please telephone for opening times

## MUSEUM OF ISLE OF WIGHT GEOLOGY

High Street, Sandown, Isle of Wight PO36 8LB
Telephone 01983 404344 Fax 01983 402748

See Britain's newest Dinosaurs! Skeletons and footprints. Giant ammonites, turtle shells, and much more! Find out about the Island's 120 million year history! School groups welcome by appointment. Fossil identification.

*Opening times*  Open Monday to Friday 9.30am to 5.30pm (last admission 5.15pm)
Saturday 9.30am to 4.30pm (last admission 4.15pm)

## BLACKGANG SAWMILL & ST CATHERINE'S QUAY

Blackgang, Ventnor, Isle of Wight PO38 2HN
Telephone 01983 730330 Fax 01983 731267

Two award winning exhibitions, one about the story of 19th century wood crafts, and the other about shipwrecks, RNLI and the history of this beautiful but rugged coastline.

*Opening times*  Open 22nd March to 31st October daily 10.00am to 6.00pm

## APPULDURCOMBE HOUSE

Wroxall, Isle of Wight PO38 3EW
Telephone 01983 852484

Small exhibition in entrance lodge showing history of Appuldurcombe House and the family who lived there. English Heritage members free entry.

*Opening times*  Open weekends only in March 10.00am to 4.00pm daily 1st April to 30th September 10.00am to 6.00pm (last admission 5.00pm) October daily 10.00am to 4.00pm and weekends only November to 10th December 10.00am to 4.00pm

# HEREFORDSHIRE & WORCESTERSHIRE

Since 1974 when the ancient counties of Herefordshire and Worcestershire were joined, the glorious Malvern Hills, rather than separate these two lovely counties now link them. The Malverns, stretching from the Welsh Marches in the west to the Cotswolds in the east offer magnificent views and were the inspiration of much of the music of Sir Edward Elgar. The defensive advantages of this range were exploited by Iron Age Man and two extremely well preserved examples of their hillforts remain, Worcestershire Beacon and Herefordshire Beacon. The River Wye, one of Britain's most picturesque rivers and famous for its salmon, runs east and south across southern Herefordshire linking innumerable beauty spots not least being Simonds Yat where Yat Rock towers over a spectacular meander in the river. The Wye Valley Heritage Centre here, set in lovely woodland, houses one of the country's largest collection of historic farm machinery and vintage tractors.

The region can boast some singularly handsome towns - Hereford, once the capital of the powerful Anglo-Saxon kingdom of Mercia, stood firm against the hostile Welsh. The magnificent twelfth century cathedral towers over the banks of the River Wye and houses a remarkable chained library of over fifteen hundred books. Home town of David Garrick and Nell Gwynne, the city has a wealth of museums telling its fascinating story. The Hereford City Museum and Art Gallery currently has a 'Get in Touch' hands-on exhibition which gives the visitor an opportunity to actually handle some of the museum's exhibits. The Old House in High Town is a superb 'black and white' house of 1621, furnished in the style of the seventeenth century. Not to be missed in Ryelands Street is the Cider Museum, telling the whole history of cider making.

Worcester too has its proud history. An important centre during the Civil War, the history of which is told in the Commandery, a fifteenth century timber-framed building used as Charles II's headquarters during the Battle of Worcester. The social and domestic history of the city is well recorded in the Tudor House Museum of Local Life in Friar Street. The Saint John Medieval Museum at Coningsby Hospital is an excellent small museum with a chapel dating back to the thirteenth century. The fine Avoncroft Museum of Historic Buildings, including a working windmill, together with the Bewdley Museum, concerned with the lives and past trades of the folk of the Wyre Forest area, are a small sample of the large number of excellent museums and galleries dealing with this rich region.

## CIDER MUSEUM & KING OFFA DISTILLERY
21 Ryelands Street, Hereford, Herefordshire HR4 0LW
Telephone 01432 354207

Explore the fascinating history of cider making at the Cider Museum in the City of Hereford.

The Museum is an independent charitable Trust and is situated off the A438 (the main Brecon road).

On view are a wide range of historic artefacts including cider mills, presses, bottling equipment, champagne cellars, bottles, advertising material and Pomonas (illustrated books on apples and pears from the 19th Century onwards).

See the King Offa Distillery, a working exhibit within the Museum where Cider Brandy is produced. Sample the distillery products including Cider Brandy, Apple Aperitif and Cider Liqueur.

View the coopers' workshop with all its specialised tools which were used for making wooden casks and barrels - essential for the old cider industry.

End your visit with a walk through the Museum shop. A full programme of temporary exhibitions and events is held throughout the year, including coopering and cidermaking demonstrations.

The annual Cider and Perry Competition takes place in May, and the Apple Day celebrations in October include the popular display of cider apples.

For further information about events, special facilities for schools, and discounts for group visits contact the Cider Museum on telephone 01432 354207

### Opening times

Open April to October daily 10.00am to 5.30pm
November to March 11.00am to 3.00pm
Closed Mondays
(Please allow approx. one hour for your visit)

### Directions

The Cider Museum is located to the west of the City of Hereford on the A438 Brecon Road. Situated by Sainsbury supermarket approximately 15 minutes walk from the City centre.

▲ Coopering display. Barrels were an essential vessel for storing cider

▲ Travelling cider makers tack milled and pressed apples for farmers

▲ King Offa Distillery distills cider and produces Hereford Cider Brandy

▶ Shop. For purchases of distillery products, cider and quality gifts

# BEWDLEY MUSEUM
Load Street, Bewdley, Worcestershire DY12 2AE
Telephone 01299 403573

Bewdley Museum, situated in the heart of the picturesque Georgian town of Bewdley, offers a friendly welcome and entertaining experience for the whole family.

The Museum, housed in the town's old butchers shambles, provides a fascinating insight into the growth and trades of the town and the lives of its people.

Displays represent the work of basket and besom makers, charcoal burners, pewterers and brass founders.

Traditional craft techniques are brought to life through daily demonstrations - why not lend a hand making a rope or clay pipe?

Other attractions include herb garden, picnic area, resident crafts people and special events and exhibitions. Incorporated Tourist Information Centre

Discounts are available for groups and schools parties are welcome (hands-on activities on offer).

▲ Demonstrations of rural crafts

### Opening times

Open daily
Good Friday to 31st October
11.00am to 5.00pm
(Easter 30th September)
11.00am to 4.00pm
(1st to 31st October)
(Last admission 30 minutes prior to closing)

▼ The herb garden

### Directions

Bewdley is situated on the edge of the Wyre Forest, four miles to the west of Kidderminster off the A456 Leominster road, on the B4190. The Museum is on Load Street.

▲ Activities for schools

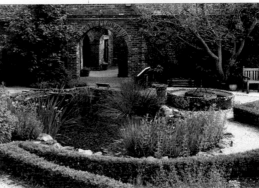

# AVONCROFT MUSEUM OF HISTORIC BUILDINGS

Stoke Heath, Bromsgrove, Worcestershire B60 4JR
Telephone 01527 831886/831363 Fax 01527 876934

Avoncroft is an open air museum dedicated to rescuing and preserving historic buildings which would otherwise be destroyed.

The collection of over twenty buildings covers 600 years of the history of central England, and includes everything from a Tudor merchant's house to a working windmill, a fully furnished 1940's prefab and the National Telephone Kiosk collection! The newest exhibit is an elaborate late Victorian showman's living waggon with exquisite decoration; the Rolls Royce of caravans!

The Museum organises a variety of exciting special events and demonstration days throughout the season. Events include concerts, car rallies, arts festivals, pet shows and living history!

Details of forthcoming events and demonstrations, such as chain and nail making are available from the museum. School, college and other parties are welcome at Avoncroft.

Details of the Museum's award-winning Education service are available on request. Located in the beautiful Worcestershire countryside, Avoncroft

Museum is also easily accessible from the Midlands motorway network.

Only minutes from the M5 and M42. There is plenty of free parking, a peaceful picnic site, and quality tea room and shop. There are special rates for children, OAPs, students and party bookings. All children under 5 go free!

### Opening times

Open at 10.30am daily from March to the end of November, but is closed on Mondays in April, May, June, September and October and on Mondays and Fridays in March and November. Closed at 4pm in March and November, at 4.30pm (5pm at weekends) in April, May, June, September and October, and at 5.00pm (5.30pm weekends) in July and August

### Directions

2 miles south of Bromsgrove off the A38 by-pass (400 yards north of its junction with the B4091). It is 3 miles north of the M5 junction 5, and 3 and a half miles south of M42 junction 1.

▲ A view of the barn and granary from the pond

▲ Heavy horses ploughing near the working windmill from Danzey Green

▲ Children like the view from the 15th century merchants house

▶ A gentle game of croquet during one of the museum's special events.

HEREFORDSHIRE & WORCESTERSHIRE

# HANBURY HALL

Droitwich, Worcestershire WR9 7EA
Telephone 01527 821214 Fax 01527 821251

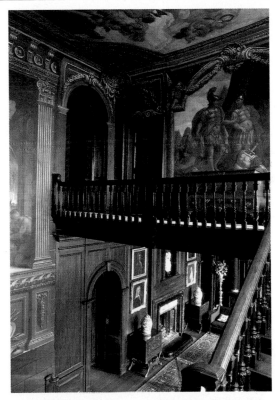

Set in four hundred acres of parkland and gardens, this delightful William and Mary house was home to the Vernon family for three centuries.

The permanent home of the Watney collection of fine Porcelain and Dutch flower paintings. Hanbury Hall also boasts magnificent staircase and ceiling paintings by Sir James Thornhill.

It also has restored 18th century garden, orangery and ice house. It is also available for civil weddings, receptions and corporate events.

### Opening times

Open 14th March to 17th October 1999 Sunday to Wednesday 2.00pm to 6.00pm (last admission 5.30pm)

### Directions

From J5 of the M5, follow the signs for Hanbury Hall. 4¹/₂ miles east of Droitwich. Between B4090 and B4091.

▲ The painted staircase and ceiling by Sir James Thornhill

▼ Hanbury Hall and its re-created 18th century gardens

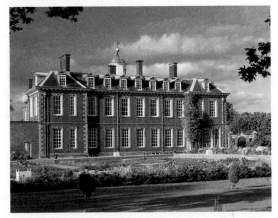

HEREFORDSHIRE & WORCESTERSHIRE

**191**

# WORCESTERSHIRE COUNTY MUSEUM

Hartlebury Castle, Hartlebury, near Kidderminster,
Worcestershire DY11 7XZ
Telephone 01299 250416 Fax 01299 251890

Worcestershire County Museum is housed in Hartlebury Castle, the sandstone home of the Bishops of Worcester for over a thousand years. A number of recently - refurbished room settings show life in the castle's Victorian heyday; whilst ladies take refreshment in the drawing room and children are taught in the nursery, servants work in the scullery and laundry under the watchful eye of house keeper Mrs Gibbs.

Elsewhere in the museum are comprehensive collections of costume, nineteenth-century domestic ware, toys and displays of the many craft products made in the county.

A separate gallery houses a large collection of horse-drawn vehicles, gypsy caravans and bicycles, whilst the nearby archaeology gallery tells the story of the Roman presence in the county. The Museum has a full annual programme of events and temporary exhibitions, copies of which can be obtained from the Museum.

There are roleplay activities and other events for schools, 'holiday happenings' for children, discounted rates for adults, parties and the opportunity for group bookings in the museum's own Orchard Cafe.

For more details please contact the Museum.

## Opening times

Open February 1st
to November 30th
Monday to Thursday
10.00am to 5.00pm
Fridays and Sundays
2.00pm to 5.00pm
Closed Good Friday
and every Saturday

## Directions

The Worcestershire County Museum is four miles south of Kiddersminster on the A449 road to Worcester, and is clearly signed with brown and white attraction signage.

▲ May Day celebrations at the Worcestershire County Museum

▲ Housemaid Annie prepares for Christmas

▲ Mrs Gibbs the Housekeeper with young visitors

▲ Members of the Veteran Cycle Club arrive at the Museum

# MALVERN MUSEUM OF LOCAL HISTORY

The Abbey Gateway, Abbey Road, Malvern, Worcestershire
WR14 3ES
Telephone 01684 567811

The building which houses Malvern Museum was the gatehouse to the mediaeval Benedictine monastery and dates back to c.1470. The original hinged wooden gateposts can still be seen under the archway.

The Geology Room tells of the formation of the Malvern Hills between 600 and 1,000 million years ago. Also mentioned are the Iron Age Hill Forts and the founding and work of the Malvern Hills Conservators.

The Mediaeval Room highlights the history of Malvern Chase, plus aspects of the Priory Church, and also evidence of prehistoric and Roman activity in the area.

The Water Cure Room traces the history of Malvern Spring water and its uses, including widespread bottling. Depicted here are the hydropathic establishments, the doctors who worked there and the rigours of the 19th century hydropathic patient.

The Victorian Room looks at Victorian enterprise, local government, leisure, costume and education

and has an exhibition on the life and work of Sir Edward Elgar.

The Modern Room shows the invention of the 19th century Santler car and Morgan motors, the development of the signals and radar establishment during WWII, and the birth of the Malvern Festival which was heavily influenced by George Bernard Shaw.

## Opening times

Open Easter to end of October
10.30am to 5.00pm daily except Wednesday during school terms
(Last entry 4.30pm)

## Directions

In Great Malvern find the main street, Church Street. Walk uphill to the junction. Turn left at the large Post Office and continue walking for 100 metres.

▲ A selection of Victorian costume which was worn by local people

▲ A collection of souvenirs dating back to the 19th century when Malvern was a famous and flourishing spa town

▲ The observation hive that was built by a local beekeeper

◀ Malvern Museum is housed in the fifteenth century Priory Gatehouse

HEREFORDSHIRE & WORCESTERSHIRE

# THE COMMANDERY CIVIL WAR CENTRE
Sidbury, Worcester WR1 2HU
Telephone 01905 355071 Fax 01905 764586

The Commandery is a stunning complex of buildings covering the mediaeval to Georgian period.

In 1651 The Commandery was Worcester's Royalist Headquarters.

Today, Period Rooms offer glimpses of life in Tudor and Stuart times, whilst museum displays tell the story of England's Civil War.

Take your place at the trial of Charles I, visit a royalist encampment on the eve of battle and enjoy a video presentation of the final battle of the English Civil War as narrated by Charles II and Oliver Cromwell.

As well as permanent displays the Commandery has a wealth of events throughout the year.

Regular events programme features include time travelling, re-enactments, open air theatre, childrens' holiday activities, candlelit ghost tours. Alternatively you can hire the Commandery for an event of your own.

Our extensive schools programme is designed to meet the demands of the National Curriculum for Key Stages 2 and 3.

Our shop stocks a large selection of books, CD-roms, gifts and souvenirs.

### Opening times

Open all year except Christmas Day, Boxing Day and New Year's Day
Monday to Saturday
10.00am to 5.00pm
(last admission 3.45pm)
Sundays
1.30pm to 5.30pm
(last admission 4.45pm)

### Directions

By car: leave the M5 motorway at junction 7.
By Rail: get off at Foregate Street Station and follow brown pedestrian signs to the City Centre.

▲ Talking model displays tell the dramatic story of England's Civil War

▲ Special events include audiences with King Charles II

▲ Tudor and Stuart educational workshops all year

◄ The Commanderly is a delightful mainly timber framed building

## HEREFORD MUSEUM & ART GALLERY

Broad Street, Hereford, Herefordshire HR4 9AU
Telephone 01432 260692 Fax 01432 342492

"Get in Touch", hands-on exhibition, until May 1999. "Carry on Collecting", celebrating 125 years of collecting at the Museum, May 1999 to September 1999. Art Gallery has regularly changing exhibitions.

*Opening times*  Open Tuesday to Saturday
10.00am to 5.00pm all year
Sunday and Bank Holiday Monday (including Easter)
10.00am to 4.00pm
April to September

## THE OLD HOUSE

High Town, Hereford HR1 2AA
Telephone 01432 260694 Fax 01432 342492

The Old House is one of Herefordshire's most famous 'Black and White' houses. Built in 1621, the whole house is furnished in 17th century style.

*Opening times*  Open Tuesday to Saturday10.00am to 5.00pm all year
Sunday and Bank Holiday Monday (including Easter)
10.00am to 4.00pm  April to September

## ST. JOHN MEDIEVAL MUSEUM AT CONINGSBY

Widemarsh Street, Hereford HR4 9HN
Telephone 01432 272837

13th century building. There are armour emblazons and information about the history of the ancient order of St. John and the Wars during the 300 years of the Crusades.

*Opening times*  Open daily 2.00pm to 5.00pm
Easter to end of September
Closed Mondays and Fridays

## CHURCHILL HOUSE MUSEUM AND HATTON GALLERY

Venns Lane, Aylestone Hill, Hereford HR1 1DE
Telephone 01432 260693 or 267409

Victorian room settings and a costume gallery. The Hatton Gallery shows works of the local artist Brian Hatton. Spectacular views of Hereford and the Welsh borderlands from the Museum gardens.

*Opening times*  Open April to September (including Easter)
Wednesday to Sunday 2.00pm to 5.00pm

HEREFORDSHIRE & WORCESTERSHIRE

## MAPPA MUNDI & CHAINED LIBRARY
## AT HEREFORD CATHEDRAL

5 College Cloisters, Cathedral Close, Hereford,
Herefordshire HR1 2NG
Telephone 01432 359880 Fax 01432 355929

Hereford's beautiful Romanesque Cathedral dates from 676, and contains the famous mediaeval Mappa Mundi & Chained Library in the award winning New Library Building. 1999 includes International Mappa Mundi Conference & Exhibition (July to October).

*Opening times* Open Easter to October Monday to Saturday 10.00am to 4.15pm
Sunday 11.00am to 3.15pm
October to Easter Monday to Saturday 11.00am to 3.15pm Closed Sunday

## GOODRICH CASTLE
## (ENGLISH HERITAGE SITE)

Goodrich, Ross-on-Wye, Herefordshire HR9 6HY
Telephone 01600 890538

View the spectacular and remarkably complete red sandstone fortress rising out of its rocky outcrop. Explore its 12th century keep as well as its maze of small rooms and passageways. Climb the steep and narrow staircase to admire wonderful views across the Wye Valley.

*Opening times* Open 1st April to 31st October daily 10am to 6pm (5pm in October)
November to 31st March daily 10am to 4pm
Closed 24th to 26th December

## DROITWICH SPA HERITAGE CENTRE

St. Richard's House, Victoria Square, Droitwich Spa,
Worcestershire WR9 8DS
Telephone 01905 774312 Fax 01905 794226

See the fascinating history of Droitwich from Salt to Spa Town. Discover the era of radio broadcasting with "hands on" display. Brass Rubbing Centre.

*Opening times* Open all year Monday to Saturday 10.00am to 4.00pm
Closed Sundays and Bank Holidays

## MUSEUM OF LOCAL LIFE

Tudor House, Friar Street, Worcester WR1 2NA
Telephone 01905 722349

Free admission. Reflects the history of Worcester and its people, including Worcester at War. Victorian kitchen scene. Turn of the century schoolroom. Workshops and handling sessions available on Victorian homefront.

*Opening times* Open 10.30am to 5.00pm Closed Thursday and Sunday Open Bank Holiday except Christmas, Boxing Day, New Years Day and Good Friday

# KENT

Kent stands as the gateway from Europe, the closest county to the continent through which poured the Roman armies of Julius Caesar, the Saxon hordes of Horsa and Hengist...and on a quieter note, missionaries from Rome on their way to Canterbury. This is a county teeming with interest. To the west, large areas of the county have been swallowed up by the ever expanding Capital - and little wonder. Long known as the 'Garden of England', this pleasant region has always attracted the powerful and wealthy to build their manors and mansions here. Kent is delightfully varied. In the distant and wet southwest are the Romney Marshes with their romantic tales of smugglers. In the north are the magnificent rolling North Downs crossed by the ancient Pilgrim's Way, while to the south lies the lovely Weald with its orchards, fields of vegetables, market gardens and hop-gardens.

Canterbury is the spiritual capital of England, its great cathedral founded by St. Augustine in AD602 became, apart from Rome, the most popular shrine in Europe. Pilgrims flocked to the shrine of Thomas Becket...including Chaucer's merry band. Today, the Canterbury Tales Visitors Attraction in St. Margaret's Street proves extremely popular. Another literary giant, Charles Dickens, is honoured with an excellent museum at Broadstairs. The Dickens House Museum on the main seafront includes with fascinating letters and memorabilia, the restored parlour where Dickens and his son Charles had tea with Miss Mary Strong, as described in 'David Copperfield'.

The Kentish coast, so significant in English history, has now at Folkestone the landfall point of the Channel Tunnel. The Folkestone Museum and Art Gallery contains an admirable display of local, natural and social history of the region. At Chatham, that busy town on the Medway, established as a naval port by Henry VIII, developed further by Elizabeth I and the home port of Nelson's flag-ship Victory, the dockyards are now a magnificent living museum. The Historic Dockyard covers 80 acres and records a century of Chatham's naval history. Not to be outdone, there is a splendid Royal Engineers Museum at Gillingham dealing with the characters, lives and work of Britain's soldier-engineers from 1066 to the present times.

KENT

## HALL PLACE
Bourne Road, Bexley, Kent DA5 1PQ
Telephone 01322 526574 Fax 01322 522921

Hall Place is a beautiful Grade I Listed building dating from the 16th century. Built for a former Lord Mayor of London, Sir John Champneis, the house was extended in 1650 for Sir Robert Austen.

The notorious Sir Francis Dashwood also owned the property at one time. Hall Place is set in award-winning formal gardens, and houses art galleries, Bexley Museum, and the Local Studies Library.

There is an on-going programme of temporary exhibitions, ranging from paintings, photography and sculpture to crafts and local history displays. Other events take place throughout the year, including an annual Garden Festival in September.

Guided tours are available (if pre-booked), and the charge for these is £1.00 per head (minimum £20). Otherwise, entry is free.

The magnificent Great Hall and Minstrel's Gallery are available for hire. A restaurant, and a nursery which raises plants for displays in Bexley Borough are on site.

Within the nursery are model gardens and a glasshouse containing exotic plants including a banana tree.

### *Opening times*

Open daily throughout year (closed Christmas and New Year, and Sundays in Winter)
British Summer Time
Monday to Saturday
10.00am to 5.00pm
Sunday
2.00pm to 6.00pm
Winter
Monday to Saturday
10.00am to 4.15pm
(closed Sundays)

### *Directions*

Bourne Road (A223), Bexley. Beside Black Prince interchange on A2. Second exit on A2 from M25 junction going towards London follow road towards Bexleyheath turn right at second roundabout.

▲ Hall Place - the 1650 extension

▲ The formal gardens at Hall Place - the Topiary

▲ The Friends' Musick singers performing Madrigals at Hall Place

◄ Hall Place - East Wings

# DICKENS HOUSE MUSEUM
2 Victoria Parade, Broadstairs, Kent CT10 1QS
Telephone 01843 862853

The house, once the home of Miss Mary Strong on whom Dickens based much of the character of Betsey Trotwood, David Copperfield's Aunt, was the scene for what Charles Dickens Junior called "the famous donkey fights". These fights, with the description of Miss Srong's Parlour, both found their way into the novel.

Originally, two houses, one thought to be Tudor, the other Carolean was joined and given a late Georgian frontage soon after 1800. A balcony with an early Victorian crinoline rail was added later.

With the Parlour refurbished as Dickens described, the other rooms contain memorabilia, including his letters from and about Broadstairs, Dickensiana, costumes and Victoriana.

The museum is open daily during the summer season. Groups by arrangement with the Honorary Curator.

▶ Betsey Trotwood's Parlour

*Opening times*

Open April to mid October Daily
2.00pm to 5.00pm
(last admission 4.45pm)

▲ Dickens House Museum, Broadstairs

*Directions*

By road: M2, A2, A299.
By train: Victoria to Broadstairs down High Street to main Seafront.

**KENT**

# THE CANTERBURY TALES
# VISITORS ATTRACTION
St Margaret's Street, Canterbury, Kent CT1 2TG
Telephone 01227 454888 Fax 01227 765584

The Canterbury Tales is an visitors attraction, enjoyed by over 1 million visitors of all ages.

Designed and built by the team which created the Jorvik Viking Centre in York.

Using sounds and smells to capture the mediaeval age this award winning modern "museum" displays a superb re-creation of mediaeval Canterbury and Thomas Becket's shrine.

The exhibition brings to life five of Chaucer's best loved tales as you join his pilgrims on their trip from the Tabard Inn to the shrine of Thomas Becket at Canterbury.

Meet the Knight with his tale of jealousy in love, the Miller with his bawdy tale of betrayal, the wife of Bath to find out what every woman most desires, the handsome nun's priest who will tell you a thing or two about a cockerel and a fox and finally the Pardoner with his spooky tale of greed and death.

Enjoy the tales and take home enjoyable memories of your visit before returning to the 20th century and our excellent gift shop.

Visit the Mediaeval Mint where our coin striker may strike you a groat (subject to availability).

We have facilities for disabled visitors.

Whether you are 5 or 105 there is something for you at the Canterbury Tales.

▲ Meet the wife of Bath as she tells her tale

***Opening times***
Open March to June
and September to
October
9.30am to 5.30pm
July to August
9.00am to 5.30pm
November to February
10.00am to 4.30pm
Sunday to Friday
9.30am to 5.30pm
Open every day except
Christmas Day

***Directions***
15 minutes walk
from the Coach Park.
Located around 200
yards from the
Cathedral, across the
High Street, Down
Street, Margaret's
Street. City car parks
close by. Follow
pedestrian signs.

▲ The Tabard Inn

▶ The Miller's Bawdy
story

◀ Ideal for children
developing an interest
in history

# ST AUGUSTINES ABBEY MUSEUM

Longport, Canterbury, Kent CT1 1TF
Telephone 01227 767345

St Augustines Abbey founded in 598AD, is one of the oldest monastic sites in Britain.

During its long history its style and complexity have developed through the Anglo Saxon, the Norman and Mediaeval periods but its presence as a powerful religious institution remained unchanged until it was dissolved by Henry VIII in 1538.

To celebrate the importance of St Augustines Abbey English Heritage have built a new museum and interpretation centre designed to both explain the history of the Abbey and display some of the many hundreds of fascinating artefacts discovered on site.

These range from larger pieces of architecture such as a pair of 10th century Corinthian Capitals and intricate Mediaeval carving to smaller personal effects and burial goods.

Perhaps the most impressive item is the burial mitre of Abbot John Dugon, dating from the early 16th century. It is believed to be one of the only examples of its type in the world.

As well as this comprehensive display featuring computer generated images of the Abbey throughout its development.

In addition a free audio guide gives a detailed commentary of the ruins.

Our shop offers a wide range of souvenirs and gifts too.

## Opening times

Open
April 1st to October 31st
9.00am to 6.00pm
November 1st
to March 31st
9.00am to 4.00pm
(during October
sites may close
earlier than 6.00pm
if dusk is earlier)

## Directions

St Augustines Abbey is in Longport a quarter of a mile east of Canterbury Cathedral. It is three quarters of a mile away from both east and west stations. Cars, take A28, A2 or A257 into Canterbury and follow signs.

▲ A new museum and free audio guide offers detailed interpretations

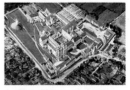

▲ St Augustine's Abbey, one of the oldest monastic sites in Britain

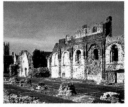

▲ The Abbey as it may have appeared in the 16th century

▲ A Mediaeval Gold Cloisonne Plate with colourful enamelling. Probably a mount for a ring

# THE HISTORIC DOCKYARD
Chatham, Kent ME4 4TZ
Telephone 01634 823800 Fax 01634 823801

The Historic Dockyard Chatham is the most important Maritime Heritage site in the country, set amongst forty-seven ancient monuments and with nine galleries.

Wooden Walls allow visitors to experience the sights, sounds and smells of warship building in the 18th century.

Join William Crockwell, a young carpenter's apprentice, as he explains how the Valiant was built from planning through to the maiden voyage.

Lifeboat! tells the 170 year history of the RNLI with 15 boats displayed, allowing visitors to climb aboard two of them and imagine the terrible conditions these brave volunteers battle through to save others.

Operating in hostile waters as a spy Submarine, Olelot was one of the most secret craft in the world. Her mysteries are revealed to visitors as they discover the cramped conditions her crew endured.

Displays are given most days in the quarter mile long ropewalk to demonstrate the traditional methods used to make rope for some of the world's most famous ships.

The Historical Society Museum contains hundreds of artefacts from the Dockyard's past as a centre of marine engineering excellence.

Facilities include gift shop, licensed restaurant and picnic area. Please telephone for details of special events.

## Opening times
Open April to October daily 10.00am to 5.00pm Open February, March, November on Wednesday, Saturday and Sunday only 10.00am to 4.00pm

## Directions
Less than one hour from London. Sign posted from junction 3 of the M2 and junction 6 of the M20. Follow signs for Chatham, then A229, A230 and A231.

▲ Mast houses and mould loft

▲ Ropemaking today: master ropemakers forming 'strands' on the ropewalk

▲ The historic Lifeboat collection

▼ HMS Gannet, under restoration in No3 Dry Dock.

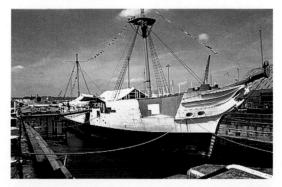

# DARTFORD BOROUGH MUSEUM
Market Street, Dartford, Kent DA1 1EU
Telephone 01322 343555

Dartford Borough Museum is a small but lively community history museum right in the centre of Dartford. Permanent displays feature fascinating geological, archaeological and historical objects associated with the Borough of Dartford.

Stone Age implements, everyday objects from local Roman and Saxon sites, and the amazing 'Darenth Bowl' (c. 450AD) feature in the colourful and educational displays.

A programme of regular temporary exhibitions ensures that there is always something new to see.

Visitors can view a part-reconstruction of a local draper's shop complete with working 'cash railway' mechanism, or admire the museum's stuffed Dartford Warblers - a bird originally named after the town.

Dartford Museum operates a free Object Identification Service and School Loans Service, and organises competitions and special events for younger visitors during the main summer period.
Access to the reserve collection is by appointment with the Curator.

Local history publications, postcards and souvenir items are available from the museum's sales point.

A French language guide to the Museum and its collection is available on request. Dartford Museum offers something for everyone whether young of old.

Curatorial staff are always on duty to answer visitors' enquiries and to provide information about the history of the Dartford area.

### Opening times
Open Monday, Tuesday, Thursday and Friday
12.30pm to 5.30pm
Saturday
9.00am to 1.00pm and
2.00pm to 5.00pm
Closed Wednesday and Sunday. Additional opening hours during school holidays

### Directions

The Museum is in Dartford town centre adjacent to Central Park. Only 10 minutes walk from Dartford Railway Station. Follow the Dartford town centre signs from the M25 or A2.

▲ Kerr's draper's shop (part - reconstruction) with working 'Cash Railway' mechanism

▲ Some younger visitors looking at everyday objects from Victorian times

▲ Past exhibition showing fittings from an old Chemist shop

▲ Victorian kitchen display highlighting world-famous local cook Isabella Beeton

# FOLKESTONE MUSEUM & SASSOON GALLERY

2 Grace Hill, Folkestone , Kent CT20 1HD
Telephone 01303 850123 Fax 01303 256710

We feature a brand new interpretation on the history of Folkestone, due to reopen in June 1999.

With the help of audio and visual presentations the museum highlights important incidents in the story of the town.

New 'hands-on' interactive exhibits complement fresh displays of old favourites such as the Anglo Saxon skeleton.

Folkestone Museum has been a storehouse of exhibits for over 100 years. Modern methods of display and lighting highlight the important objects that have been collected.

Research facilities are available in the adjacent Heritage Room. Modern art and craft exhibitions are held in the Sassoon Gallery.

For the first time, the whole of the upper floor is fully accessible to the disabled. An audio loop has also been installed.

For opening date please telephone for details.

Artist's impression - Interior of Folkestone Museum. Reopening Summer 1999
*Opening times*

Open all year Monday to Thursday and Saturdays
9.30am to 5.00pm
Friday
9.30am to 7.00pm
(last admission half an hour before closing)

▼ Folkestone Library Museum and Sassoon Gallery
*Directions*

In the centre of Folkestone, the Victorian Library and Museum at Grace Hall is near the bus station and multi-storey car park. By road on M20 (take J13), or A260 from Canterbury, or A20 from Dover.

FOLKESTONE MUSEUM
INTERIOR VIEW OF NEW MUSEUM
© 1998 GREEN & MAYNES

# ROYAL ENGINEERS MUSEUM

Prince Arthur Road, Gillingham, Kent ME4 4UG
Telephone 01634 406397 Fax 01634 822371

This prize-winning museum tells the story of the Sappers - Britain's soldier-engineers and their world-wide work in peace and war.

Learn about the first military aviators, divers, photographs, surveyors, distinguished Sappers such as John Chard VC of Rorke's Drift, General Chinese Gordon and Kitchener of Khartoum.

See the Duke of Wellington's battlemap of Waterloo, the silk robes given to Gordon by the Chinese Emperor, the Brennan torpedo, a Harrier Jump Jet, even a section of the Berlin Wall.

Superb medal displays include 24 Victoria Crosses, 3 George Crosses, Lord Kitchener's regalia and unique gallantry awards from the Falklands War. Something for everyone.

Group visits welcome. A superb aid to teaching the National Curriculum in history, geography, design and technology. Fully equipped schools room available.

Working models and realistic sound effects.

The only museum in Kent designated by the Government as a museum with an outstanding collection.

Just a few minutes drive from Chatham Historic Dockyard and Fort Amherst, both built by Royal Engineers, and Rochester Cathedral, full of memorials to Royal Engineers.

Allow at least two hours for your visit to the Royal Engineers. Much more than just a military museum, more a history of the British people.

### *Opening times*

Open all year round
Monday to Thursday
10.00am to 5.00pm.
Saturday, Sunday and
Bank Holiday Monday
11.30am to 5.00pm
Friday by appointment
only Closed 25th and
26th December,
1st January
and Good Friday

### *Directions*

Prince Arthur Road is
the B2004 Lower
Rainham Road. The
museum is near junction
with A231 Chatham,
Gillingham Road.
Nearest rail station is
Gillingham with fast
service from London
Victoria.

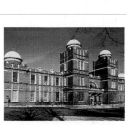

▲ The museum building designed by a Sapper, opened in 1905

▲ 15 ton bulldozer dropped by parachute in the jungles of Borneo

▲ Mulberry, the artificial harbour built in Normandy in 1944

▶ Bomb disposal during the blitz in the Second World War

## THE WHITE MILL FOLK MUSEUM TRUST LTD

Ash Road, Sandwich, Kent CT13 9JB
Telephone 01304 612076

Oldest restored
Windmill, built in 1760
approx, in Kent with the
complete mill complex
i.e. cottage, granary,
stable, cartlodge etc.

All with relevant
displays of artefacts.
Also working forge,
working wheelwright's
shop display of
agricultural artefacts,
laundry artefacts.

Shortly to have a
cobblers shop with all
the relevant machinery.
Corn grinding engine
also special rates for
school parties and other
groups.

Entrance fee adults
£1.00 seniors and
children 50p.

▼ Complete Mill
complex

▲ Sandwich White Mill

### Opening times

Open
Friday and Sunday
10.30am to 12.30pm
all year
Sunday and
Bank Holidays
Easter to mid
September
2.30pm to 5.30pm

### Directions

The Mill Museum is on
the A257, Sandwich to
Canterbury quarter of a
mile out of Sandwich
between Sandwich and
the A256 Ring Road.

# MAIDSTONE MUSEUM & ART GALLERY
St Faith's Street, Maidstone, Kent ME14 1LM
Telephone 01622 754497 Fax 01622 602193

This exceptionally fine regional museum housed in Chillington Manor, a delightful Elizabethan manor house, boasts a rich and impressive variety of historical objects. In the centre of Kent's County Town.

Fine and decorative arts including European and British paintings, ceramics, glass, furniture, costume and textiles from the 17th to 20th centuries are on display.

An extensive archaeological collection contrasts artefacts from the prehistoric, Roman, Anglo-saxon and Mediaeval periods, and an Egyptian collection including a Mummy.

▶ Japanese lacquered Inro from the 'Samuel' Collection

▲ South Pacific Shells, 'Julius Brenchley' Collection, Natural History

The Japanese collection of Edo period ceramics, lacquer, metalwork and prints is one of the finest outside London.
The natural history galleries exhibit extensive displays of British birds, flora and fauna, fish shells, fossils and Maidstone's very own dinosaur - the ignanadon. The museum's ethnography gallery is entitled 'Juluis Brenchley' - Gentleman

▲ Egyptian Eye of Horus Necklace and statue

***Opening times***
Open
Monday to Saturday
10.00am to 5.15pm
Sunday
11.00am to 4.00pm
Closed Christmas Day &
Boxing Day

***Directions***
Trains from London
Victoria to Maidstone
East 18 minutes and 48
minutes past the hour.
By car - M20 junction 6,
from Folkestone junction
8. Located 2 minutes
from Maidstone East

▼ New Guinea Dance
Mask, 'Julius Brenchly'
Collection, Ethnography

Explorer and contains the collections from the Islands of the South Seas of Maidstone's own 19th century explorer and benefactor.
In addition Maidstone Museum offers a stimulating temporary exhibition programme, an identification and recording service and an inhouse and outreach education service.
For further details please call 01622 754497

# TUNBRIDGE WELLS MUSEUM & ART GALLERY

Civic Centre, Mount Pleasant, Royal Tunbridge Wells, Kent TN1 1JN
Telephone 01892  526121 and 554171

The Museum displays local history, Tunbridge ware, dolls and toys, archaeology, agricultural and domestic bygones, and natural history.

The Art Gallery has frequently changing exhibitions, including contemporary art and craft, touring exhibitions, and displays from the Museum's reserve collections, Victorian oil paintings, pioneering photographs by Henry Peach Robinson, Pamela McDowall cartoon collages, and works by the Dodd family of Tunbridge Wells artists.

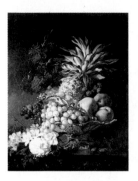

▲ 'Fruit and Flowers' by Annie Mutrie

▶ The Art Gallery

▲ The Museum

## Opening times

Open 9.30am to 5.00pm Monday to Saturday Closed Sunday, Bank Holidays and Easter Saturday Admission is free.

## Directions

Situated off the A264 in Royal Tunbridge Wells, in the Library and Museum building, next to the town hall.

▶ Tunbridge ware work table by Edmund Nye, c.1850

# RICHBOROUGH ROMAN FORT (MUSEUM)
Richborough Road, Sandwich, Kent CT13 9JW
Telephone 01304 612013 Fax 01304 612013

Richborough Roman Fort was one of the landing sites for the successful Roman invasion of Britain in AD43. It was used as a supply base, and subsequently developed into a thriving town and port, with a monumental entrance to the Roman province of Britannia.

Later in the third century the impressive walls were added Richborough also provides some of our earliest evidence for Christianity in Britain.

The small museum at Richborough houses some of the Roman finds dug up in the excavations earlier this century. The objects include domestic items such as dice and a gaming board, oil lamps and Samian ware.

Mortaria cooking pots and an amphora are also on display. Examples of building materials and a relief statue (thought to be the goddess Hygeia) can also be seen.

Admission includes an audio tour of the site and access to the museum with a new exhibition on Roman life. 15% discount for groups of eleven or more. Many daytime special events including archeological workshops, talks and battle re-enactments are hosted at Richborough during the summer season.

### Opening times
Open
1st April to 31st October daily 10am to 6pm (dusk if earlier)
1st to 30th November Wednesday to Sunday 10.00am to 4.00pm (closed Monday & Tuesday)
1st December to 28th February weekends only 10.00am to 4.00pm
1st March to 31st march Wednesday to Sunday 10.00am to 4.00pm (closed Monday & Tuesday)

### Directions
Take the road into Sandwich from the roundabout where the A257 joins the A256. Take the second left turn after the level crossing, opposite Fire Station. Follow lane for ¾ mile.

KENT

# THE ELLEN TERRY MEMORIAL MUSEUM
Smallhythe Place, Tenterden, Kent TN30 7NG
Telephone 01580 762334 Fax 01580 762334

Ellen Terry, England's most beloved actress and stage partner of Sir Henry Irving for nearly a quarter of a century, owned this 16th century half-timbered house for 28 years and died there in 1928.

The house contains displays of her sumptuous stage costumes, her personal and theatrical possessions, including her make-up box and her copy of the "Globe" Shakespeare and many mementos of other great names of the theatre.

Numerous paintings and prints of Dame Ellen and her family and actors and actresses from the past adorn the walls of every room. The pretty grounds include a charming cottage garden and a fragrant old-fashioned rose garden. The Elizabethan barn, adapted as a theatre in 1929 is open to view most days by courtesy of The Barn Theatre Society.

### Opening times

Open April to October
daily except
Thursday and Fridays
1.30pm to 6.00pm
(last admission 5.30pm)

### Directions

2 miles south of
Tenterden on east side
of the Rye Road (B2082).

▼ The Ellen Terry
Memorial Museum,
Smallhythe Place

▲ Marble bust of Ellen
Terry by Fontana

▲ Ellen Terry's bedroom

# WALMER CASTLE & GARDENS

Kingsdown Road, Walmer, Kent CT14 7LJ
Telephone 01304 364288 Fax 01304 364826

Walmer Castle is the official residence of the Lord Warden of the Cinque Ports, an office held by many famous people.

Among these was the Duke of Wellington, victor of the battle of Waterloo in 1815 and Prime Minister from 1828-30.

Walmer was one of three castles (Walmer, Deal and Sandown) built by Henry VIII to protect the Downs, an important offshore anchorage, at a time when England was under threat of invasion by Spain and France.

Experience the centuries of history leading up to the 1920s when the castle was lived in by the Beauchamps family, the inspiration for Evelyn Waugh's 'Brideshead Revisited'.

Explore delightful gardens where, in summer the herbaceous borders are in full bloom.

### Directions

By car, on the coast south of Walmer near Deal on A258 from Dover follow signs for Deal. By bus freephone 0800 696996 for details. By train one mile from Walmer Station.

### Opening times

Open 1st April to 1st November daily 10.00am to 6.00pm or dusk if earlier in October 2nd November to 31st December Wednesday to Sunday 10.00am to 4.00pm January to February weekends only. Closed 24th-26th December and when Lord Warden is in residence (last admission 30 minutes before closure)

▼ Aerial view, Walmer Castle and Gardens

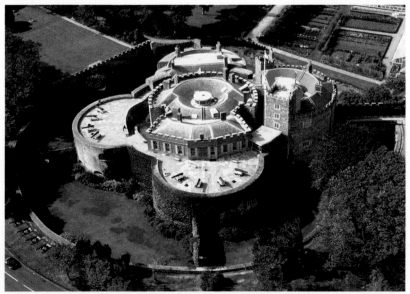

KENT

## CRAMPTON TOWER MUSEUM
The Broadway, Broadstairs, Kent CT10 2HB

Museum to the works of Thomas Russell Crampton. Patents, drawings model railways, local and general transport, Broadstairs to Canterbury Stagecoach. Housed in Crampton Tower, built in 1859 by Crampton. First Waterworks in Broadstairs.

*Opening times* Open Easter (Good Friday) to early October Monday, Tuesday, Thursday, Friday and Bank Holiday Sunday only 2.30pm to 5.00pm Admission charged

## MEDWAY HERITAGE CENTRE
Dock Road, Chatham, Kent ME4 4SM
Telephone 01634 408437

Story of the tidal stretch of the River Medway. Artefacts and photographs giving details of the history, industries and people that were and are on the River.

*Opening times* Open October to Easter Wednesday 10.00am to 4.00pm Sunday 2.00pm to 4.00pm Easter to October Wednesday, Thursday, Friday, Saturday 10.00am to 4.00pm Sunday and Bank Holidays 2.00pm to 4.00pm

## CRABBLE CORN MILL
Lower Rod, River, Dover, Kent CT17 0UY
Telephone 01304 823292 Fax 01304 826040

Restored working Watermill built 1812. Organic flour for sale, Mill tours, cafe with home baking, Art Gallery, garden. Open for coach parties all year inc. evening "Supper Tours" by arrangement.

*Opening times* Winter Sundays only 11.00am to 5.00pm (February to Easter, September to Christmas) Easter to mid July 11.00am to 5.00pm Saturday, Sunday and Bank Holidays School summer holidays 11.00am to 5.00pm Wednesday to Sunday (Closed Monday to Tuesday)

## CHART GUNPOWDER MILLS
Westbrook Walk, Faversham, Kent
Telephone 01795 534542

Oldest gunpowder mills in the world. Made powder for Nelson at Trafalgar, Wellington at Waterloo. Free admission.

*Opening times* Open weekends and Bank Holidays Easter to October 2pm to 5pm
At other times by prior arrangement

## OSPRINGE MAISON DIEU
Ospringe, Faversham, Kent ME13 8TS
Telephone 01795 539933

Founded by Henry III, 16th century building built on to remains of 13th century Hospice. Local history with Roman pottery from nearby Roman Cemetery (no longer visible). Guided tours available if requested.

*Opening times* Open Saturdays and Sundays only 2.00pm to 5.00pm and Bank Holidays time vary Other visits by appointment phone 01795 539933

## CHANTRY HERITAGE CENTRE
Commercial Place, Fort Gardens, Gravesend, Kent DA12 2BH
Telephone 01474 321520

Housed in a 14th century Chapel exhibits include finds from excavations from Roman settlement at Springhead plus local social history.

*Opening times*  Open Wednesday to Sunday 10.00am to 4.00pm 1st March to 23rd December (inc.) plus Bank Holidays (last admission 3.30pm)

## HYTHE LOCAL HISTORY ROOM
Oaklands, Stade Street, Hythe, Kent CT21 6BG
Telephone 01303 266152 Fax 01303 262912

Small comprehensive museum covering the history of Hythe, a cinque Port Town. The local history room includes paintings and artefacts on the town of Hythe including its Civic and Social history.

*Opening times*  Open Monday 9.30am to 6.00pm Tuesday, Wednesday and Thursday 9.30am to 5.00pm Friday 9.30am to 7.00pm Saturday 9.30am to 4.00pm (last admission 30 minutes before closing time)

## MUSEUM OF KENT LIFE - COBTREE
Lock Lane, Sandling, Maidstone, Kent ME14 3AU
Telephone 01622 763936 Fax 01622 662024

Kent's award winning, open air museum is home to an outstanding collection of historic buildings housing both static and interactive exhibitions on life in Kent over the past 100 years. Explore the oast, barn, granary, hopper's huts, and 18th century farmhouse. Enjoy hop, herb and kitchen gardens, farm animals, working craftsmen and women. There is so much to see and do indoors and out!

*Opening times*  Open March to end October daily 10am to 5.30pm (last admission 4.30pm)

## BROMLEY MUSEUM
The Priory, Church Hill, Orpington BR6 0HH
Telephone 01689 873826

Situated in mediaeval/post-mediaeval building. Archaeology of Bromley LB from earliest times. Life and work of Sir John Lubbock, eminent Victorian responsible for Bank Holidays. Changing Exhibitions. Education service.

*Opening times*  Open all year Monday to Friday 1.00pm to 5.00pm Saturday 10.00am to 5.00pm. In addition Sundays and Bank Holidays 1st April to 31st October 1.00pm to 5.00pm

## RAMSGATE LIBRARY GALLERY
Guildford Lawn, Ramsgate, Kent CT11 9AY
Telephone 01843 593532 Fax 01843 293015

Opened in December 1982, Ramsgate Library Gallery has been constructed to provide a continuous, high quality programme of exhibitions and related events, covering all aspects of the visual arts.

*Opening times*  Open all year round Monday to Thursday 9.30am to 6.00pm, Friday 9.30am to 7.00pm, Saturday 9.30am to 4.00pm

KENT

## RAMSGATE MUSEUM
Ramsgate Library, Guilford Lawn, Ramsgate, Kent
CT11 9AY
Telephone 01843 593532 Fax 01843 852692

Ramsgate Museum illustrates the development of Ramsgate from a fishing village to a Victorian seaside resort and a twentieth century port.

*Opening times*  Open Monday to Thursday 9.30am to 6.00pm
Friday 9.30am to 7.00pm Saturday 9.30am to 5.00pm, except Bank Holidays.

## UPNOR CASTLE
High Street, Upper Upnor, Rochester, Kent ME2 4XG
Telephone 01634 718742

Upnor Castle is a Tudor fort built on the banks of the Medway for the purpose of protecting Queen Elizabeth's warships anchoring in the Medway alongside the growing dockyard at Chatham.

*Opening times*  Open 1st April to 30th September daily 10.00am to 6.00pm
(last admission 5.30pm) 1st to 31st October daily 10.00am to 4.00pm
(last admission 3.30pm). Closed 1st November to 31st March or Good Friday

## C.M. BOOTH COLLECTION OF HISTORIC VEHICLES
63-67 High Street, Rolvenden, Kent TN17 4LP
Telephone 01580 241234

Unique collection of Morgan three wheelers. Plus other vehicles, toys and automobiles.

*Opening times*  Open January to December Monday to Saturday 10.00am to 6.00pm
Closed Sundays, Christmas Day and Boxing Day

## COURT HALL MUSEUM
High Street, Milton Regis, Sittingbourne, Kent ME9 9QY
Telephone 01795 521515

A collection of objects, artefacts and interpretation panels describing the history of the Royal Manor Town and Port of Milton housed in a magnificent mediaeval timber framed court house. Admission 50p.

*Opening times*  Open April to September inclusive Saturdays 2.00pm to 5.00pm
(last admission 4.50pm)

## BRATTLE FARM MUSEUM
Brattle Farm, Staplehurst, Kent TN12 0HE
Telephone 01580 891222

Vast and varied collection agricultural domestic blacksmith and wheelwrights, dairy vintage cars, stationary engines tractors. Working saddler. Working oxen its all here on a working farm.

*Opening times*  Open all year to groups by appointment only

# LANCASHIRE

Here in the powerhouse of England, large tracts of land were stripped away during the reorganisation of 1974 leaving the county without its scenic Furness region. Nevertheless, despite its heavy industrial heritage, Lancashire is far from devoid of natural beauty. Morecambe Bay is a region of sandflats, nature reserves and glorious skies. The Forest of Bowland, although no longer a forest is a tract of open peaty moorland on the edge of the Pennine Range providing wonderful walking country and exhilarating views. The cities and towns of the county reflect in their buildings the prosperity brought to the area by the Industrial Revolution. The seaside resorts, which in turn prospered from the crowds of holidaymakers who flocked to them from the industrial towns, still retain their well-deserved popularity. Blackpool, with its spectacular illuminations, its piers and its golden beaches, remains arguably Britain's most popular seaside resort.

The cities of Lancashire, proud of their industrial heritage, present through their museums a quite remarkably comprehensive history of the Industrial Revolution....Lancashire's manufacturing methods of cotton goods being at the forefront of the revolution. The skills and innovations originating in this county were to be exploited the world over. At Burnley there is the Weavers Triangle Visitor Centre, a wonderfully well-preserved Victorian industrial area including displays of the history of the cotton industry. The Towneley Hall Art Gallery and museum at Burnley is a fine museum of local history and an environmental study centre.The Lancaster City museum also deals with social history, while the Lancaster Maritime Museum located in the 18th century Custom House, tells the story of Lancaster as a port and the fishing industry of Morecambe Bay. A museum very much in keeping with the county's industrial associations is the British Commercial Vehicle Museum at Leyland. The museum holds the finest collection of historic commercial vehicles in Europe. It includes horse drawn, steam vehicles and fire engines.

Not that Lancashire museums and galleries present only its industrial face...the fine Blackburn Museum and Art Gallery displays a lively programme of changing exhibitions of paintings. Then there is the Rossendale Museum, housed in a nineteenth century woollen manufacturer's home in glorious parkland. And at Southport, home of Britain's biggest summer flower show there is the lovely Botanic Gardens Museum.

LANCASHIRE

# LEWIS TEXTILE MUSEUM
Exchange Street, Blackburn, Lancashire BB1 7AJ
Telephone 01254 667130 Fax 01254 695370

The Lewis Textile Museum was created in 1938 by Blackburn textile manufacturer TB Lewis as a memorial to the main industry of the town - cotton.

He acquired full-sized replicas of the machines which revolutionised textile production and put them on display in a converted shop on Exchange Street.

The replicas included John Kay's Flying Shuttle, James Hargreaves' Spinning Jenny, Richard Arkwright's Water Frame and Samuel Crompton's Mule.

TB Lewis' replica machines can still be enjoyed by visitors today as well as original Blackburn-made Lancashire looms from earlier this century.

The Museum has also been updated to include a children's interactive activity area exploring weaving and spinning techniques and looking at textiles. Another new feature is the "Clothes of the Local and Famous" display.

Older visitors will enjoy the reminiscence corner with photographs depicting mill life in Blackburn and Darwen from the turn of the

century - to the 1950s. A handling table gives everyone an opportunity to see and touch the everyday tools of the mill operatives.

Also included is a "Museum Memory Bank" of recollections of local people who worked in the textile industry.

Former weavers and spinners recall working conditions and mill social life. Free admission.

### Opening times

Open by appointment only. To book ring 01254 667130. Bookings available Monday to Saturday

### Directions

Situated in the centre of Blackburn at the top end of main shopping street. Signposted from Railway Station and major entry points. Signs also in town centre itself.

▲ Spinning Mule

▲ James Hargreaves' Spinning Jenny

▲ Handloom

◀ A Lancashire loom made by Henry Livesey Ltd, Blackburn

# BLACKBURN MUSEUM & ART GALLERY

Museum Street, Blackburn, Lancashire BB1 7AJ
Telephone 01254 667130 Fax 01254 695370

Blackburn's Museum is located in a striking Victorian building in the town centre.

Its lively programme of temporary exhibitions (16 per year) guarantees that there is always something to fascinate those of all ages.

Permanent displays include the award-winning South Asian Gallery which creates a picture of the culture in which Blackburn's Asian Community have their roots. Stunning textiles, jewellery and furniture all illustrate the variety of crafts practiced on the Sub-Continent.

The history of the town is traced in the Local History Gallery through displays telling the story of the town from prehistoric times to the present day.

Discover what daily life might have been like for our Victorian ancestors from the re-created period room displays.

The Museum has remarkable collections of 19th century paintings exhibited in changing displays in the Victorian art galleries.

It also holds collections of international significance, most of which were collected by Blackburn rope manufacturer Edward Hart. His remarkable personal collections of beautiful illuminated manuscripts, rare printed books and coins are displayed alongside the largest collection of Orthodox icons outside London and the Museum's most popular exhibit - the Egyptian Mummy. Free admission.

### *Opening times*

Open all year
Tuesday to Friday
12.00pm to 4.45pm
and Saturday
9.45am to 4.45pm
(Closed Bank Holidays)

### *Directions*

Situated in the centre of Blackburn on the corner of Richmond Terrace and Museum Street. Signposted from Railway Station and major entry points. Signs also in town centre itself.

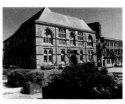

▲ Blackburn Museum and Art Gallery

▲ Award-winning South Asian Gallery

▲ Greek Icon (19th Century)

▼ Mother and Child (Cherries) by Frederick Lord Leighton

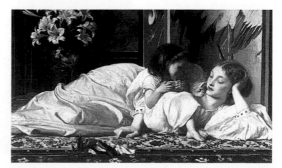

LANCASHIRE

# BOLTON MUSEUM, ART GALLERY & AQUARIUM

Le Mans Crescent, Bolton, Lancashire BL1 1SE
Telephone 01204 522311 ext 2190 Fax 01204 391352

Bolton Museum, Art Gallery and Aquarium is one of of the largest regional art galleries in the north west, and has one of the finest collections of contemporary ceramics in the country.

It also houses a large number of watercolours and drawings, and has a prominent collection of modern British based prints and 20th century sculpture.

The Museum's collections are based in two broad areas, human and natural history.

Human history includes displays of Egyptology, Ethnography, Industrial and local history with examples of machinery and working models.

Our Natural History department has an interactive Wildlife Gallery, and a weird and wonderful collection of colourful minerals on display.

The Art Gallery also has a continuing programme of changing exhibitions.

Over the year, look out for the following highlights: German Expressionism, The Unexplained - an exhibition of the Paranormal, Jan Niedojadlo, - contemporary tactile sculptures, and in 2000, British Impressionism, Noah's Ark plus lots more!!

For more information, please ring: 01204 522311 ext 2209

### Opening times

Open Monday, Tuesday, Thursday, Friday
9.30am to 5.30pm
Saturday
10.00am to 5.00pm
Closed Wednesdays
Sundays and
Bank Holidays

### Directions

Above the Library in the Town Centre, opposite the Octagon Theatre and behind the Town Hall - look for the tall Clock Tower. Five minutes from the bus and train stations.

▲ Still Life of Fruit in a Delft Dish (Dutch School)

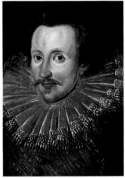

▲ Portrait of Sir Philip Sidney, by John de Critz Jnr

▼ A Madagascan Cichlid

# TOWNELEY HALL ART GALLERY & MUSEUMS

Burnley, Lancashire BB11 3RQ
Telephone 01282 424213 Fax 01282 436138

Towneley Hall offers the perfect day out for all the family - a country house, a museum and an art gallery all in one. And there's more!

The Museum of Local Crafts and Industries, Natural History Centre, Aquarium, gardens and woodland walks are all in the park. Today visitors can see how the family and the servants lived and enjoy the museum collections which include 17th century oak furniture, the 14th century Whalley Abbey cloth of gold vestments and Zoffany's famous painting of Charles Townley.

"Bill" the Black Bear is extremely popular with younger children as are the live grey squirrels and ducks in the park. You can find out more about them in the Natural History Centre with its interactive displays. If it's history that interests you, you can step back in time in the Museum of Local Crafts and Industries.

Admission and car parking are free and there is a cafe in the grounds. There are lots of exhibitions and events throughout the year including winter guided tours. These can be booked for groups or you can join our regular tours on Tuesday, Wednesday and Thursday at 3.00pm.

The Hall is also available for functions.

### Opening times
Open Monday to Friday
10.00am to 5.00pm
Closed Saturday
Sunday
12.00pm to 5.00pm
Open all year except
over Christmas
& New Year
Open on Bank Holidays

### Directions
Follow brown tourist board signs. From west M65 junction 9 to Halifax from east M65 junction 10 or 11.
By bus from town centre
Towneley Bus
01282 423125

▼ William Salmon's ordinary bicycle, 1880s

▲ Towneley Hall

▲ 17th century oak bed

▲ Great Hall, Plasterwork c.1725

221

Lancashire

# THE WEAVERS' TRIANGLE VISITOR CENTRE

85 Manchester Road, Burnley, Lancashire BB11 1JZ
Telephone 01282 452403

The Visitor Centre is located in the former Wharfmaster's House and Canal Toll Office at Burnley Wharf on the Leeds and Liverpool Canal.

There are displays about the Weavers' Triangle - the modern name for a well-preserved Victorian industrial townscape - and Burnley's cotton industry and its workers.

A weaver's dwelling contrasts with a Victorian parlour, where light refreshments are served. A working model fairground forms the centre of a display about workers' holidays.

The toll office has been restored, with copies of photographs, maps and documents illustrating the history of the canal in Burnley.

The visitor can follow a self-guided trail through the Weavers' Triangle or walk along the canal towpath to the Burnley embankment which carries the canal sixty feet above the town centre and is regarded as one of the seven wonders of the British Canal System.

On several occasions during the summer the Visitor Centre holds

guided walks through the Weavers' Triangle and these can be arranged for parties at other times.

The Centre also provides educational visits for schools. Parking and full meal facilities are available at the adjacent "Inn on the Wharf" and there is mooring for those travelling by canal-boat.

## Opening times

Open 2.00pm to 4.00pm Easter to September - Saturday to Wednesday October - Sunday only At other times by appointment for groups

## Directions

Near the town centre, 200 yards uphill from the Town Hall and Mechanics' TIC. From M65 junction 10 follow signs for Towneley Hall and then Weavers' Triangle Visitor Centre.

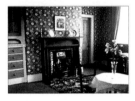

▲ The Weavers' Triangle Visitor Centre

▲ Victorian Parlour in the Wharfmaster's House

▲ One of the last looms from the Weavers' Triangle

▼ Working model of Burnley's annual fair

# FUSILIERS' MUSEUM, LANCASHIRE

Wellington Barracks, Bolton Road, Bury, Lancashire BL8 2PL
Telephone 0161 7642208 Fax 0161 7642208

The Lancashire Fusiliers came into being in 1881 but trace their origins back to 1688. Now part of The Royal Regiment of Fusiliers, it has served in many famous campaigns and has included several distinguished officers such as Major General James Wolfe and General Robert Boss.

The Museum covers three hundred and ten years of the Regiment's history. Important displays include - memorabilia of James Wolfe, Battle of Minden, Napoleonic relics (the Regiment buried Napoleon on St Helena in May 1821), Peninsular War, Crimean War, Omdurman Boer War, 1914-1918, 1939-1945, Post War campaigns Canal Zone 1958, Kenya, Cyprus, Ulster, the Gulf War.

Uniforms 1814 to date. Silver and a unique collection of medals including four Victoria Crosses. Regimental Silver.

Limited archive material is available for research purposes.

### Opening times
Open 9.30am to 4.30pm daily except Wednesday and Sunday Open Bank Holidays

### Directions
Located on A58 Bury-Bolton Road, approx one mile from centre of Bury. Regular bus service form Bury and Bolton. Bus stop approx 50 yards from Museum.

▲ General view of display

▲ Silver memorial drums the Lancashire Fusiliers

▲ Exterior view of Fusiliers Museum

▶ Medal Room display of Victoria Crosses

**LANCASHIRE**

# CLITHEROE CASTLE MUSEUM
Castle Hill, Clitheroe, Lancashire BB7 1BA
Telephone 01200 42463 or 443071

When visiting Clitheroe do not miss the opportunity to visit the 12th century Castle Keep on top of the hill overlooking the town of Clitheroe.

Below the Keep is the Georgian steward's house which accommodates the Castle Museum with two floors of exhibits, some with accompanying sound tracks.

A well-stocked gift shop on the ground floor offers nostalgic toys and gifts for all ages. Small admission charge.

Open 7 days a week including Easter and Summer Bank Holidays. 5 days a week in November, December, February and March.

▲ Clitheroe Castle Museum (exterior)

*Opening times*

Open
February to March,
Monday, Tuesday,
Wednesday, Saturday
and Sunday
Closed
Thursday and Friday
From Easter-October 31st
7 days a week
11.00am to 4.30pm
November to December
5 days a week
Closed at
Christmas & January

*Directions*

Follow A59 to Clitheroe into centre Moor Lane. Museum in the castle grounds up the hill

▼ Clitheroe Castle and Grounds

# PLATFORM GALLERY

Station Road, Clitheroe, Lancashire BB7 2JT
Telephone 01200 443071

The Platform Gallery is situated in the market town of Clitheroe at the centre of United Kingdom.

Operated by the Ribble Valley Borough Council it offers a regularly changing programme of visual art exhibitions with the focus being on contemporary arts and crafts.

▲ Platform Gallery, Clitheroe (exterior)

Opened in May 1994 it is housed in a refurbished Victorian railway station building which was originally built in 1870.

### Opening times
Open
Monday to Saturday
10.00am to 4.30pm
Closed Sunday

### Directions
Platform Gallery at
Clitheroe Railway
Station next door to
Booths car park.

The gallery houses on average 9 exhibitions per all year all featuring new works by talented local and national artists.

There is also a gallery shop which has changing examples of craft and Saturday Craft markets which give you the chance to buy directly from the crafts makers.

To find out the present programme of exhibitions and events contact the gallery at the address or telephone number above.

▶ Platform Gallery
(interior)

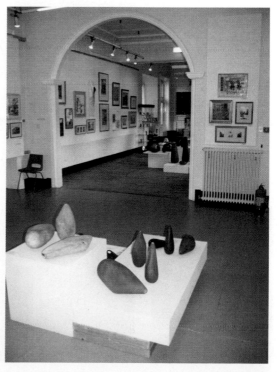

LANCASHIRE

# KINGS OWN REGIMENTAL MUSEUM
Market Square, Lancaster, Lancashire LA1 1HT
Telephone 01524 64637 Fax 01524 841692

Regimental Museum of the King's Own Royal Regiment (Lancaster) 4th Foot established 1680.

The recently redisplayed Museum shows in an up-to-date fashion the history of the Regiment which fought at The Boyne, Culloden, America, the West Indies, Waterloo, The Crimea, South Africa, Abyssinia, and in both World Wars.

The displays show what ordinary men and women saw during military service - conditions, pay, education, wealth and leisure.

▶ World War One Machine Gunner

▼ Battle of Culloden picture with Militia Officer's uniform

▼ (bottom picture) Crimean War Case

***Opening times***
Open all year except Christmas & New Year Monday to Saturday 10.00am to 5.00pm (last admission 4.30pm)

***Directions***
In city centre, 5 mins walk from rail and bus stations.

▲ First World War trench scene

**LANCASTER CITY MUSEUM**
Market Square, Lancaster, Lancashire LA1 1HT
Telephone 01524 64637 Fax 01524 841692

Georgian former Town
Hall built 1783.
Museum includes new
'History of Lancaster'
Gallery and illustrates
history, archaeology, fine
and decorative arts of
Lancaster and north
Lancashire.

A changing programme
of exhibitions fills lower
galleries (See also King's
Own Regimental
Museum)

***Opening times***
Open all year except
Christmas & New Year
Monday to Saturday
10.00am to 5.00pm
(last admission 4.30pm)

▲ Victorian wash-house

▼ Victorian pawnshop
display

***Directions***
In City Centre,
5 minutes walk from
rail and bus stations

▲ Roman carved heads

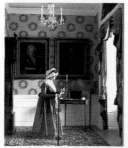

▲ Georgian Room
setting, City Museum

LANCASHIRE

LANCASHIRE

# LANCASTER MARITIME MUSEUM

Custom House, St George's Quay, Lancaster LA1 1RB
Telephone 01524 64637 Fax 01524 841692

Lancaster's rich seafaring history spans 2000 years, from Roman harbour to major 18th century port for the West Indies.

The Waterfront Museum occupies historic warehouse buildings and the Custom House of 1764, designed by Richard Gillow.

It describes the infamous transatlantic slave trade, the long-established fishing industry of Morcambe Bay and the modern-day Morcambe Gas Field. It also details the perilous route across the tidal sands of the bay from ancient times and the history of the beautiful Lancaster Canal.

Modern, colourful displays bring these and other subjects to life with the aid of reconstructions, sound effects and even smells!

Features include audio-visual show, temporary exhibitions, shop, cafe, free car parking and disabled toilet.

Access improvements fully complete in 1998. Disabled welcome. Adult entry £2. Concessions OAPs, Children, Students £1.

### Opening times

Open Easter to October
11.00am to 5.00pm
daily inclusive
November to Easter
12.30pm to 4.00pm daily
Closed Christmas
& New Year

### Directions

Near town centre close to M6 junction 34 (north) and 33 (south). Follow brown tourist signs for museums and St. George's Quay. Five minutes walk from Lancaster Bus and Railway Station.

▲ Reconstruction of the Lancaster Canal packet boat, Waterwitch (1833)

▲ Display of 18th Century warehousing in the Port of Lancaster

◀ Hannah, River Lune fishing boat

▼ Ship Bowl 'Success to the Valentine 1783'

# SADDLEWORTH MUSEUM & ART GALLERY

High Street, Uppermill, nr Oldham, Lancashire OL3 6HS
Telephone 01457 874093 Fax 01457 870336

Saddleworth Museum and Art Gallery is housed in the former Victoria Mill, in the village of Uppermill. It charts the history and ways of life of the ancient Yorkshire Parish of Saddleworth, on the Lancashire side of the Pennines.

Saddleworth is an area, made up of a number of villages, including Delph, Greenfield and Uppermill, and smaller hamlets. Each has its own identity, and this fierce local pride is reflected in the museum.

Here you can discover the story of how these moors and valleys were formed during the Ice Age.

Take a look at some local wildlife, and discover some local crafts or vanished trades such as peat cutting.

There are displays on brass band contests and Morris dancing, while other exhibits chart the inhabitants of the region, from the earliest neolithic hunters, through the Romans, Saxons and Vikings, to the Victorians.

In later years, Saddleworth's economy was based on textile production, and you can follow the development of this industry.

On special days, volunteers operate the looms and other machines housed in the textile gallery, and demonstrate the production of cloth.

Why not take home a unique souvenir of your visit, by buying an exclusive piece of material?

▲ The former Victoria Mill, Uppermill. Home to Saddleworth Museum

▲ Saddleworth Museum

▲ Children learn about Victorian life on an activity day

## Opening times

Open March 30th to November 1st daily, 10.00am to 5.00pm (last admission 4.30pm) Open November 2nd to March 29th daily except Christmas Day 1.00pm to 4.00pm We also open outside these times for groups and schools

## Directions

The Museum is on the main road through Uppermill (A670), 13 miles from Central Manchester, 13 miles from Huddersfield, 10 minutes from M62 Junction 22 (via A672).

▶ Working textile machinery in the museum, operated by volunteers

LANCASHIRE

# HARRIS MUSEUM & ART GALLERY
Market Square, Preston, Lancashire PR1 2PP
Telephone 01772 258248 Fax 01772 886764

The Harris is a Grade I listed building, opened in 1893, which dominates the centre of Preston.

The Museum houses extensive collections of fine and decorative art, contemporary art and social history. In addition to these permanent collections, we also offer a varied programme of temporary exhibitions, designed to appeal to a wide audience, from the family seeking a fun day out to the serious art lover.

Recent exhibitions have included "Moving Stories", a study of migration to Preston in the 20th century, "Lux", a display of work in light by contemporary artists and crafts people, and "Whistling Past the Graveyard", a spooky selection of photos, stories and hands-on displays providing scary thrills for all the family.

Our museum and gallery shop stocks a wide range of gifts for adults and children, books of local interest, and traditional and contemporary cards and fine art prints.

We are also able to frame almost any print, picture or photograph.

For details of our current Exhibition programme, telephone 01772 258248 for a free copy of our Exhibitions and Events Guide.

An Information Line is also available on 01772 257112.

### Opening times
Open
Monday to Saturday
10.00am to 5.00pm
Closed Bank Holidays

### Directions
From any Preston motorway exit follow signs to town centre/museum and then bus station car park. From car park walk through Guild Hall Arcade. Harris is directly opposite Exit.

▶ We offer free events and activities for all the family

▼ The Harris is a Grade I Listed Neo-Classical building

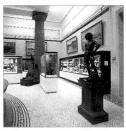

▲ Fine and decorative art is displayed in stunning surroundings

▲ The Harris has a reputation for top quality contemporary exhibitions

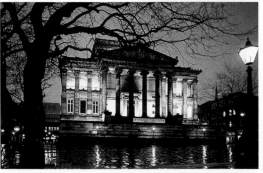

**230**

# ATKINSON ART GALLERY

Lord Street, Southport, Lancashire PR8 1DH
Telephone 01704 533133 Extension 2110
Fax 0151 9342109

The Gallery's collection includes 18th and 19th Century English water colours, Victorian paintings and academic British paintings.

There is also a small but rapidly expanding collection of Contemporary painting, sculpture and prints. Throughout the year there is a changing programme of temporary exhibitions covering all aspects of painting, sculpture, photography, print making and contemporary illustration.

▲ Padstow, Cornwall by Sir William Llewellyn

▲ Trooper in Full Marching Order

▲ Seated Mother with child II by Celia Baillie

### *Opening times*

Open Monday, Tuesday, Wednesday, Friday
10.00am to 5.00pm
Open
Thursday and Saturday
10.00am to 1.00pm
Closed Sunday
Admission free

### *Directions*

The Gallery is situated in the main shopping area on Lord Street adjacent to the Library. The nearest railway station is situated on Chapel Street a five minute walk away.

▶ The Fish Fag
by William Banks
Fortescue

# ROSSENDALE MUSEUM

Whitaker Park, Haslingden Road, Rawtenstall,
Rossendale, Lancashire BB4 6RE
Telephone 01706 217777/226509 Fax 01706 250037

Rossendale Museum is housed in a former mill owner's residence, built in 1840 for a local woollen manufacturer. The building retains much of the character of the original house.

Displays include a late Victorian Drawing Room, fine arts, furniture, costume and a Natural History Gallery featuring historic taxidermy such as the tiger and python and the popular young African elephant.

The local and social history galleries cover numerous aspects of Rossendale's history, from prehistoric times to the 20th century, including a display of items relating to Haslingden-born composer, Alan Rawsthorne.

▲ Young African Elephant c.1879

A programme of temporary exhibitions is held throughout the year. Out-of-hours visits, guided tours for groups and schools by arrangement. Disabled access: ground floor only. Audio guide.

Refreshments: At kiosk in park; seasonal

### Opening times

Open Monday to Friday
1.00 to 5.00pm
Saturday
10.00am to 5.00pm
(April to October)
10.00am to 4.00pm
(November to March)
Sunday
12.00pm to 5.00pm
(April to October)
12.00pm to 4.00pm
(November to March)
Bank Holidays
1.00pm to 5.00pm
Closed Christmas Day,
Boxing Day and
New Year's Day

◀ Rossendale Museum

▼ "The Lifeboat" by
Marshall Claxton

### Directions

Situated on the A681
Haslingden Road,
Approx. 1/4 mile from
Rawtenstall centre.

▼ William Bullock's
Tiger and Python

opening. Exhibition to
start the Millennium:
European buildings and
landscapes: paintings by
Kim Skovgaard.

LANCASHIRE

# BRITISH COMMERCIAL VEHICLE MUSEUM
King Street, Leyland, nr, Preston, Lancashire PR5 1LE
Telephone 01772 451011 Fax 01772 623404

The British Commercial Vehicle Museum at Leyland - itself the birthplace of Britain's truck and bus building industry - is the UK's only national collection of industrial vehicles.

Exhibits include many of the marques which made British commercial vehicles famous around the world for several decades.

Since road transport is the lifeblood of any national economy those vehicles played a vital role in the development of countries great and small.

Considerable efforts have been made to bring the BCVM collection alive, with imaginative sound and light displays illustrating two major themes - one showing how fire engines saved lives in blacked-out, blitz-hit London, and the other revealing the role of trucks in the Great War. These features, together with the striking vehicle liveries of some of Britain's best known retailers, hauliers and bus operators, make the BCVM truly attractive to a wide range of people, whatever their age or background. Many of the vehicles on

▲ World War One Sound and Light Show

▲ The world famous Popemobile

▲ The museum's well stocked shop

### Opening times

Open Easter to
September and
Bank Holidays,
Sunday, Tuesday
and Wednesday
10.00am to 5.00pm
(last admission 4.30pm)
Open Sunday
only in October

### Directions

Junction 28 M6
motorway follow
Museum brown signs
3/4 mile from motorway
junction.

▼ One of the exhibits in
the London Fire scene

display - ranging from
the steam era up to
modern concept trucks -
are accessible to visitors,
young and not so young,
who can experience for
themselves the thrill of
sitting at the wheel of a
famous red London
double-deck bus or of a
gleaming modern truck.

Visitors can also
purchase a wide range
of goods and automotive
memorabilia from the
museum's well stocked
shop.

LANCASHIRE

# BOTANIC GARDENS MUSEUM

Botanic Road, Churchtown, Southport, Lancashire PR9 7NB
Telephone 01704 227547 Fax 01704 224112

The Victorian Room features displays which illustrate Victorian life. There is a reconstructed middle class Victorian parlour which opened in 1961. Most of the furnishings and ornaments in the room were donated by local people.

Other displays include toys dating from the Victorian period to the present day.

A new exhibition gallery opened in 1995. It looks at the history of Southport.

A free audio guide to the gallery is available to visitors. There is a Natural History Room which contains displays of a wide variety of birds. Admission Free

### Opening times
Open all year
Tuesday to Friday
11.00am to 3.00pm
Saturday to Sunday
2.00pm to 5.00pm
Closed Mondays except
Bank Holidays

▲ Painting of the old Stocks, Churchtown by W.G. Herdman, 1855

### Directions
The Museum is situated in the Botanic Gardens, Churchtown. Easily reached by car and public transport. There is a bus service (No 8 and 9) from Lord Street, Southport.

▼ Painting of St. Cuthberts, Churchtown by R Beattie, 1852

# WIGAN PIER

Wallgate, Wigan , Lancashire WN3 4EU
Telephone 01942 323666 Fax 01942 322031

Wigan Pier is more than a museum, it's a visitor experience for all the family.

Starting your journey at the seaside for Wakes week in 1900, visitors are transported back in time to explore the hardship of everyday life - whether down the coalmine, in the mills, on the canal or bringing up your family in Piper's Alley.

Combining static displays and room sets with interpretation, interaction, and audio-visual displays, The Way We Were is brought to life by the Wigan Pier Theatre Company who perform throughout the day. From Promenade plays, to Music Hall to the famous Victorian schoolroom, visitors re-live life in 1900.

For those with an interest in specific elements of Victorian Britain, workshops are available through our Heritage Interpretation section.

Your day at Wigan Pier is not complete without a trip on the Leeds - Liverpool Canal taking you to Trencherfield Mill, home to the world's largest original working cotton mill steam engine, and the machinery hall offering cotton spinning demonstrations every hour.

In 1999, Trencherfield Mill will house our newest museum - "Opie's Museum of Memories", covering each era of our social history from Victorian times to the present day, this extraordinary visual journey through family life will capture the imagination of all.

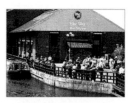

▲ The Way We Were

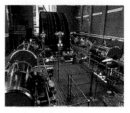

▲ Home of the world's largest working Mill Steam Engine

### Opening times

Open all year except Christmas Day, Boxing Day and Fridays
Monday to Thursday 10.00am to 5.00pm
Saturday and Sunday 11.00am to 5.00pm

### Directions

Signposted from all major road networks, follow brown and white tourism signs. Railway access via Wigan North Western or Wigan Wallgate Stations only five minutes walk. Public transport details 0161 2287811

▲ Children enjoying a day out at Wigan Pier

◀ Wigan Pier a great educational day out

**LANCASHIRE**

## HAWORTH ART GALLERY
Haworth Park, Manchester Road, Accrington, Lancashire BB5 2JS
Telephone 01254 233782 Fax 01254 301954

Visitors to the Haworth are able to enjoy not only the house itself and the Tiffany Glass collection, but also displays from the permanent collection and the temporary exhibition programme.

*Opening times* Open Wednesday, Thursday and Friday 2.00pm to 5.00pm Saturday and Sunday 12.30pm to 5.00pm Closed Monday to Tuesday (Except Bank Holidays)

## GRUNDY ART GALLERY
Queen Street, Blackpool, Lancashire FY1 1PX
Telephone 01253 478170 Fax 01253 478172    ♿

19th and 20th century British paintings and sculpture, modern prints, oriental ceramics and ivories, and a collection of craft jewellery. Lively temporary exhibition programme plus regular musical events.

*Opening times* Open Monday to Saturday 10.00am to 5.00pm Closed Bank Holiday

## BRITISH IN INDIA MUSEUM
Newtown Street, Colne, Lancashire BB8 0JJ
Telephone 01282 613129 Fax 01282 870215

The Museum was opened in 1972 and contains a fascinating collection of material including model soldiers, dioramas, postage stamps, medals, photographs, flags, neck-ties, military uniform and other memorabilia.

*Opening times* Open Monday to Friday (except Tuesday) 1pm to 5pm (last admission 4.30pm) Saturday 11am to 5pm, Closed Sundays & during Christmas holidays

## FLEETWOOD MUSEUM
Queen's Terrace, Fleetwood, Lancashire FY7 6BT
Telephone 01253 876621 Fax 01253 878088

Bringing to life the story of Fleetwood and the Lancashire Sea Fisheries. Also the fantastic full-size Dolls' House. Special events, talks and education programme.

*Opening times* Open Good Friday to 11th November Saturday, Sunday, Monday and Thursday 2pm to 5pm, Tuesday and Friday 11am to 5pm, Closed Wednesday. July to September Wednesday 11am to 5pm Saturday 11am to 5pm

## SOUTH RIBBLE MUSEUM & EXHIBITION CENTRE
The Old Grammar School, Church Road, Leyland, Lancashire PR5 1EJ
Telephone 01772 422041 Fax 01772 625363

Local Museum in Tudor Grammar School. Local collections, archaeology and industrial history. Monthly programme of exhibitions by local artists.

*Opening times* Open all year, but closed Christmas to New Year & Easter weekend. Tuesday & Friday 10am to 4pm, Thursday 1pm to 4pm Saturday 10am to 1pm

## ROCHDALE ART GALLERY
Esplanade, Rochdale OL16 1AQ    ♿
Telephone 01706 342154 Fax 01706 342154

Rochdale Art Gallery features exhibitions of contemporary and historic art. Also changing exhibitions of sculpture, painting and photography. There are also permanent collections of watercolours, contemporary works and Victorian narrative.

*Opening times* Please ring for details of opening times

# LEICESTERSHIRE, NOTTINGHAMSHIRE & RUTLAND

Once heavily forested, Leicestershire is now a largely agricultural county where, in the valley of the River Eye and the Vale of Belvoir lush Wolds pasture is scattered with coverts for foxes to breed. This is the home of the famous Quorn, Belvoir and Cottesmore hunts. However to the west of the county many of the towns belong to the industrial east Midlands. The highest land in Leicestershire lies west of the River Soar, an area of rough bracken-covered heathland and what remains of Charnwood Forest. England's smallest county Rutland, was absorbed into Leicestershire in 1974 and much of the county's 152 square miles now lies beneath Rutland Water, one of Europe's largest man-made lakes. This superbly landscaped feature is today a popular centre for sailing and water sports.

Nottinghamshire, lying in the low ground of the Trent basin is the county of Robin Hood and Sherwood Forest...although the forest is now considerably smaller than in Robin Hood's day. These counties can boast some of the best cattle raising country in the land, side by side with flourishing industrial areas, as well as the grand aristocratic estates of the Dukeries and Southwell Minster, one of England's smallest and most delightful cathedrals.

The social history of these three counties is preserved in some of the most comprehensive and attractive Museums in the land. The Rutland County Museum tells the story of life in this small county through its wonderful collection of farm vehicles and equipment and domestic paraphernalia. It also has a 1794 indoor riding school! The Snibston Discovery Park at Leicester, built on a 100 acre site is a quite remarkable 'hands-on' experience where the visitor can discover the working conditions of the nineteenth century. The Mansfield Museum and Art Gallery gives a fascinating glimpse of Mansfield's past and present. Nottingham Castle Museum and Art Gallery on the site of the medieval royal castle offers interesting multi-cultural displays. The Nottingham Industrial Museum at Wollaton Park gives insight to the city's printing, pharmacy, hosiery and lace industries.

There are museums in this region catering for all interests and tastes...At the Airfield, Winthorpe, the Newark Air Museum displays aircraft memorabilia, while at Eastwood, Nottingham there is the charming D.H.Lawrence Birthplace Museum, and at Cromwell, Newark is an amazing collection of dolls and everything associated with them at the Vina Cooke Museum of Dolls and Bygone Childhood.

LEICESTERSHIRE, NOTTINGHAMSHIRE & RUTLAND

# SNIBSTON DISCOVERY PARK
Ashby Road, Coalville, Leicestershire LE67 3LN
Telephone 01530 510851 Fax 01530 813301

Snibston Discovery Park, Leicestershire's premier all weather Science and Industrial heritage museum, where visitors of all ages can discover the wonders of science with over 30 'hands on' experiments to solve. Visitors can walk through a tornado, escape from a a virtual burning building, or cycle with Henry the Skeleton.

Alternatively, step back in time and delve into the world of Leicestershire's rich Industrial heritage, where you can wander around the intricate 18th century footwear in the textiles and fashion gallery; discover the working conditions of men, women and children at the 19th century coalface in the Extractions Gallery; explore the huge variety of transport methods in the Transport Gallery, and have a go at being a BBC Radio and TV reporter.

Other attractions include lively surface Colliery Tours conducted by ex-miners, and Sculpture and Nature Trails.

Alternatively, young visitors can let off steam in the outdoor science play area and have gallons more fun in the wild water playground.

Over 60 special events are held throughout the year from mini-beast hunts to jazz evenings, to steam rallies and the spectacular fireworks display in November.

### Opening times

Open
Easter to September
10.00am to 6.00pm
(last admission 5.00pm)
Mid September
to March
10.00am to 5.00pm
(last admission 4.00pm)

### Directions

Snibston Discovery Park is well sign posted from J13 of the A42, M42 or J22 of the M1. For further details telephone Coalville Tourist Information Centre on (01530) 813608

▲ Trying on corsets at Snibston

▲ Gallons of fun at Snibston

▼ 'hands on' fun at Snibston

# BELGRAVE HALL MUSEUM
Church Road, off Thurcaston Road, Leicester,
Leicestershire LE4 5PE
Telephone 0116 2666590 Fax 0116 2613063

Belgrave Hall (1709-1713) is a Queen Anne house set in two acres of historical gardens. The Hall is furnished with decorative arts in a series of period room settings from a Queen Ann Drawing Room through to a 1923 Bathroom.

The Museum has a strong social history background with details of previous owners and educational projects, where children can have the chance to become a servant for the day, (must be prebooked).

Throughout the year a variety of special events take place including children's fundays and outdoor music concerts.

The gardens are divided into various areas including; herbaceous borders, kitchen, woodland and water gardens as well as the formal beds.

Along with this there are stables and greenhouses to view.

Admission is free.

## Opening times

Open all year except December 24th, 25th, 26th and January 1st
Open Monday to Saturday 10.00am to 5.30pm Sunday 2.00pm to 5.30pm

▲ An education project in full swing

## Directions

Belgrave Hall is situated some three miles north of the City Centre near the junction of Thurcaston Road and Loughborough Road (A6).

▲ Rear view of hall and gardens in Spring

▶ Visitors enjoying the water garden

**241**

# D.H. LAWRENCE HERITAGE

Durban House Heritage Centre, Mansfield Road,
Eastwood, Nottinghamshire NG16 3DZ
Telephone 01773 717353 Fax 01773 713509

Tread in the footsteps of D H Lawrence... D H Lawrence the world famous novelist, poet and artist was born in the town of Eastwood near Nottingham on September 11th 1885.

The D H Lawrence Heritage Experience incorporates two very different, yet complementary attractions: Durban House Heritage Centre, Mansfield Road, Eastwood - join us in our exciting interactive exhibition on a fascinating journey through the development of D H Lawrence's hometown - Eastwood - as we explore its landscape, its people and their influence on an aspiring young writer.

D H Lawrence Birthplace Museum, 8a Victoria Street, Eastwood - more than a museum - the Birthplace is a home. The home of the Lawrence's and their growing family.

Soak up the atmosphere, as a time capsule of Victorian life unfolds before your eyes...living history for all the family.

Plus: At the end of your visit why not take the opportunity to relax in the delightful restaurant and coffee shop at Durban House, stroll around the craft workshops near the Birthplace Museum or explore Lawrence's 'Country of My Heart' for yourselves.

Discounted tickets (including a family option) are available to both attractions including group and travel trade rates.

Please call 01773 717353 for further details.

## Opening times

Open April to October daily, 10.00am to 5.00pm
November to March daily, 10.00am to 4.00pm
Closed 24th December to 1st January inclusive

## Directions

How to find us: From the M1 junction 26 or 27 follow signs to Eastwood and "D H Lawrence Heritage" brown tourist signs.

▲ The Birthplace: A time capsule of Victorian life

▲ The Birthplace: ".. I was born in the little corner shop just above"

▲ Durban House: "... a new red-brick building, almost like a mansion..."

▼ Durban House: Can you fit in our coal crawl?

# MANSFIELD MUSEUM & ART GALLERY

Leeming Street, Mansfield, Nottinghamshire NG18 1NG
Telephone 01623 663088 from February 01623 463088
Fax 01623 412922

Displays of local history, social history, fine and decorative arts and natural history.

Includes a fine collection of watercolours by A.S. Buxton.

A varied and frequently changing temporary exhibitions programme.

Gift shop. Holiday activities for children.

Education room available for hire.

Fully accessible for those with mobility problems. Disabled toilet.

Children's activity corner.

▼ A few of Mansfield Museum's extensive collection of ceramics

*Opening times*

Open
Monday to Saturday
10.00am to 5.00pm
Closed Sunday
& Bank Holidays

▼ Mansfield Museum - a museum for all ages

*Directions*

Museum is just a few minutes' walk from Mansfield Market Place along Leeming Street. By car, follow signs for Clumber Street and Toothill Lane car parks.

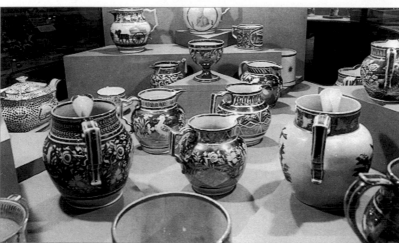

LEICESTERSHIRE, NOTTINGHAMSHIRE & RUTLAND

LEICESTERSHIRE, NOTTINGHAMSHIRE & RUTLAND

# NEWARK AIR MUSEUM

Winthorpe Showgrounds, Newark,
Nottinghamshire NG24 2NY
Telephone 01636 707170 Fax 01636 707170

When visiting our World of International Aviation visitors will discover one of the finest displays of rare British, American and European aircraft in Great Britain.

Weather need not be a worry as nearly half the collection of fifty aircraft and cockpit sections are under cover in the Aircraft Display Hall.

Here visitors can explore the diverse assortment of helicopters, jets and piston engined aircraft. From transporting cargo, reconnaissance sorties and training young pilots, to bombing missions and Fighter combat sweeps, every exhibit has a story to tell.

In the recently published National Aviation Heritage Register the airframes in the museum's care were classified as: 11 National Benchmark (top listing possible): 25 significant: and 15 noteworthy.

Inside the Engine Display Hall there are thirty restored Aero engines.

With sufficient time visitors can browse for hours around the fabulous collection of models, artefacts, equipment and memorabilia in the Exhibition Hall.

In the Cafe visitors can choose from a selection of snacks, sandwiches and hot or cold drinks.

The large Souvenir Shop stocks kits, postcards, books, videos and aviation prints. Advance booking is preferred for group visits.

The Museum has just attained Phase 2 registration with the Museum and Galleries Commission.

## *Opening times*

Open everyday except December 24th, 25th & 26th; April to September - weekdays 10.00am to 5.00pm (last admission 4.30pm) Weekends & Bank Holidays 10.00am to 6.00pm (last admission 5.30pm); October and March - every day 10.00am to 5.00pm (last admission 4.30pm) November to February every day 10.00am to 4.00pm (last admission 3.30pm)

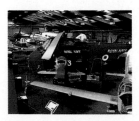

### *Directions*

Easy access from the A1, A46, A17, A1133 and the Newark bypass, follow the brown and white tourist signs. With ample free car and coach parking on site.

▲ The museum's recently restored Meteor FR.9 fighter, a Benchmark airframe on the new National Aviation Heritage Register

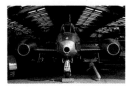

▲ One of many artefact displays at the Museum, this slide depicts a recreation of a Royal Observer Corp Post

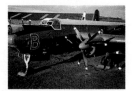

▲ View of the museum's recently restored Avro Shackleton maritime patrol aircraft

◄ Show internal views of the museum's Main Aircraft Display Hall

# VINA COOKE MUSEUM OF DOLLS & BYGONE CHILDHOOD

The Old Rectory, Cromwell, Newark, Nottinghamshire NG23 6JE
Telephone 01636 821364

Rooms full of nostalgia-thousands of childhood memories on display in a late 17th century Dower house and former Rectory of considerable interest.

Signposted off A1, 4 miles north of Newark. Next to church in the village of Cromwell.

Large collection of dolls from 18th century to present-day; toys, prams, dolls' houses, books, games, railway-models, Christening robes, children's and adult's costume, and various domestic artefacts.

Also Vina Cooke's handmade portrait dolls from Robin Hood to Royalty (past and present), and stars of stage and screen.

Handmade porcelain dolls, crafts and gifts for sale.

Dolls' Hospital. Tearoom. Picnic area in old-fashioned garden.

Ample free car and coach parking. Party bookings (W.I., schools, etc) welcome any time of day or evening. Food available by arrangement.

Special event, annual Easter Monday extravaganza.

Morris dancers, Clog dancers, craft stalls and demonstrations.

### Opening times

Open daily
(except Fridays)
10.30am to 12.00pm
2.00pm to 5.00pm
Fridays and all other times by appointment

### Directions

From A1 (North and South Bound) follow brown signs for "Doll Museum" into Cromwell. Museum is on main Village Street next to church. Cromwell is five miles north of Newark.

▼ Vina Cooke handmade cloth dolls made 1963 displayed in museum

▲ Corner of the nursery showing Nanny doing her duty

▲ Dolls' playtime

▲ Part of toy room. A glimpse of childhood past

LEICESTERSHIRE, NOTTINGHAMSHIRE & RUTLAND

*LEICESTERSHIRE, NOTTINGHAMSHIRE & RUTLAND*

# NOTTINGHAM CASTLE MUSEUM & ART GALLERY

Nottingham, Nottinghamshire NG1 6EL
Telephone 0115 9153700 Fax 0115 9153653

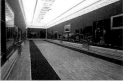

Nottingham Castle Museum and Art Gallery has now reopened following a £4 million refurbishment project, making it an accessible museum for all.

"Every object tells a story" is an innovative look at decorative arts, combining historic and contemporary objects in tactile, visual and audio displays.

The Long Gallery, displays the museum's fine art collection of 18th, 19th and 20th century works.

The Exhibition Galleries provide visitors with an opportunity to see high profile art exhibitions.

In the castle grounds there is an exciting Mediaeval playground for children and cave tours through all the secret passages.

The Castle Museum and Art Gallery has a Crafts Council approved shop and an excellent cafe.

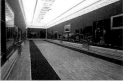

▲ The Long Gallery

### *Opening times*

Open daily
10.00am to 5.00pm
Closed Friday
from the beginning
of November to the
end of February

### *Directions*

A five minutes walk from Nottingham City Centre, off Maid Marion Way. Easy access to Coach and Rail stations. Nearby parking, follow brown tourist signs into the city.

▼ Nottingham Castle Museum and Art Gallery

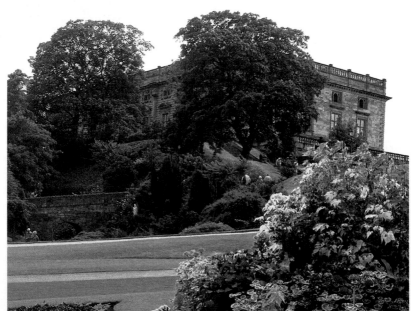

# WOLLATON HALL & PARK
Wollaton Park, Nottingham, Nottinghamshire NG8 2AE
Telephone 0115 9153900 Fax 0115 9153932

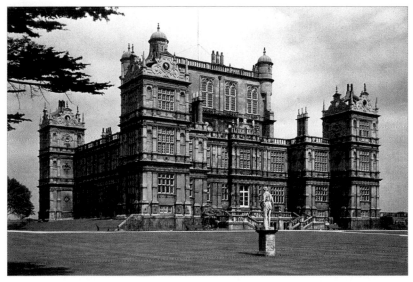

▲ Wollaton Hall

Wollaton Hall is one of the finest Elizabethan houses in England and is home to Nottingham's Natural History Collections.

Experience the excitement of the African Savannah in the World of Wildlife Gallery and explore the hidden world of nature!

The Yard Gallery and Visitor centre is set in the 18th century stable block and has an innovative temporary exhibition programme of environmental art.

At the Industrial Museum you can learn about Nottingham's rich industrial heritage.
Steam engines are on display and can be seen steaming.

A range of events and tours take place at Wollaton Hall. Set in 500 acres of natural parkland with a lake, flower gardens, a Camelia House and a Sensory Garden, Wollaton Park is the ideal day out for the family!

*Opening times*
Open
April to October daily
11.00am to 5.00pm
November to March
open daily
11.00am to 4.00pm
Closed Friday
(except for booked
school groups)
Industrial Museum
closed during Winter.

*Directions*
Entrance off A609 just 4 miles west of the city centre. Please follow brown tourist signs into the city. Regular bus service to park entrance.

# RUTLAND COUNTY MUSEUM
Catmose Street, Oakham, Rutland LE15 6HW
Telephone 01572 723654 Fax 01572 757576

The Rutland County Museum is a warm ironstone building, erected in 1794-95 as an indoor riding school for the Rutland Rencible Cavalry.

Opened by HRH Princess Alice, Duchess of Gloucester, in 1969, it houses a rich rural life collection from Rutland, England's smallest historic county.

In the riding school, with its roof of Baltic timber, displays illustrate the archaeology of Rutland, and its rural trades, domestic life and agriculture. They are strong in the tools of village tradesmen - wheelwright and carpenter, blacksmith, cooper, tinsmith.

The local brewery and the care of livestock are covered, and fittings from local buildings furnish a farm kitchen of a hundred years ago. In the 19th century Poultry Hall, more emphasis is placed on aspects of farming life such as dairying and harvesting.

Here there is a rare 1917 Saunderson tractor acquired by the Friends of the Museum with Science Museum grant-aid.

In a linking courtyard, farm implements are on display. Many objects on open display are accessible to the visually impaired or physically disabled visitors.

Special exhibitions, often of the work of local artists, and home-made light refreshments in the Colonel's Café form additional attractions, and admission is free.

### Opening times

Open
Monday to Saturday
10.00am to 5.00pm
Sunday  BST
(late March to
late October)
2.00pm to 5.00pm; GMT
(late October to
late March)
2.00pm to 4.00pm
Closed Good Friday,
Christmas Day,
Boxing Day

### Directions

Situated on the A6003 south of the Town Centre opposite Council Offices. Public car park in South Street behind the museum.

▲ Rutland County Museum: an indoor riding school built in 1794

▲ A Leicestershire Yeomanry officer in South Africa, by Snaffles.

▲ A Ferguson tractor and Bamford mower at Rutland County Museum

◄ A prize-winning shorthorn heifer bred in Rutland in 1837

## WYGSTON'S HOUSE MUSEUM OF COSTUME

12 Applegate, Leicester, LE1 5LD
Telephone 0116 247 3056 Fax 0116 262 0964

Late mediaeval house with Georgian extension. 19th and 20th century dress and textiles, 1920's draper's shop, children's dressing-up area. Special events and exhibitions.

> *Opening times*  Open Monday to Saturday 10.00am to 5.30pm, Sunday 2.00pm to 5.30pm. Closed December 24th, 25th and 26th and January 1st.

## THE ABBEY PUMPING STATION

Corporation Road, Leicester, LE4 5PX
Telephone 0116 299511 Fax 0116 299 5125

Victorian sewage works housing the largest working beam engines in the country. Hands-on displays including "Bright Spark" and "Flushed with Pride". Please telephone for details of events and activities. Free admission except on special event days. Refreshments only available on special event days.

> *Opening times*  Open Monday to Saturday 10.00am to 5.30pm, Sundays 2.00pm to 5.00pm. Closed Christmas Eve, Christmas Day, Boxing Day and New Years Day.

## NEW WALK MUSEUM & ART GALLERY

New Walk, Leicester, LE1 7EA
Telephone 0116 255 4100 Fax 0116 247 3005

Major regional venue, featuring natural history, geology, ancient Egypt and fine art. Exhibits include dinosaurs, the famous German Expressionist collection and for the children, the discovery room.

> *Opening times*  Open all year, Open except December 24th, 25th, 26th and January 1st, Monday to Saturday 10.00pm to 5.30pm and Sunday 2.00pm to 5.30pm

## THE MAGAZINE GATEWAY

Oxford Street, Leicester,
Telephone 0116 247 3222 Fax 0116 247 0403

The Magazine Gateway is a splendid 14th Century building of great architectural interest. It has approximately 300 years of civil connections and 300 years of military connections. Occasional guided tours.

> *Opening times*  Open for tours on special occasions only. Open 5th April, August 22nd and 12th September 1999.

## THE JEWRY WALL MUSEUM

St Nicholas Circle, Leicester, LE1 4LB
Telephone 0116 247 3021 Fax 0116 251 2257

Archaeology of Leicestershire from prehistory to end of middle ages. Site of public baths of Roman Leicester. Good collection of Roman Mosaics and painted wall plaster.

*Opening times* Open all year Monday to Saturday 10.00am to 17.30pm and Sunday 14.00pm to 17.30pm (No last admission time) Closed December 24th, 25th , 26th and 1st January.

## NEWARKE HOUSES MUSEUM

The Newarke, Leicester, LE2 7BY
Telephone 0116 247 3222 Fax 0116 247 0403

Over 500 years of Leicester's social history are featured in this fine 16th Century building. Displays feature toys, clocks, domestic equipment, Leicester's markets and its largest man, Daniel Lambert.

*Opening times* Open Monday to Saturday 10.00am to 5.30pm, Sunday 2.00pm to 5.30pm, Open all year except Christmas, Boxing Day and New Year's Day

## THE LEICESTER GAS MUSEUM

c/o British Gas Services, PO Box 28, 195 Aylestone
Road, Leicester, LE2 7QH
Telephone 0116 250 3190 Fax 0116 250 3190

An unusual collection of items relating to the gas industry, including production, gas lighting, cooking and heating. Displays include 1920's kitchen, working gas lights, gas hairdryers and gas powered radio.

*Opening times* Open all year Tuesday to Friday 12.30pm to 4.30pm (except Bank Holidays)

## GREEN'S MILL AND CENTRE

Windmill Lane, Sneinton, Nottingham, NG2 4QB
Telephone 0115 915 6878

Restored working tower windmill associated with mathematical physicist George Green. Hands-on science exhibits and displays tell story of milling and Green's contribution to science. Shop sells science toys, books and flour.

*Opening times* Open Wednesday to Sunday and Bank Holiday Mondays 10.00am to 4.00pm. Closed Monday and Tuesday. Please telephone for Christmas and New Year closing

## NOTTINGHAM INDUSTRIAL MUSEUM

Courtyard Buildings, Wollaton Park, Nottingham, NG8 2AE
Telephone 0115 915 3910 Fax 0115 915 3941

Displays feature the industrial history of Nottingham and the surrounding area. Beam engine and other steam and internal combustion engines operated regularly. Please ring for list of dates.

*Opening times* Open April to October daily 11.00am to 5.00pm (last admission 4.30pm) Open November to March daily (except Fridays) 11.00am to 4.00pm (last admission 3.30pm)

## PERCY PILCHER MUSEUM

Stanford Hall, Lutterworth, Leicestershire LE17 6DH
Telephone 01788 860250 Fax 01788 860870

Museum dedicated to Percy Pilcher, the first man to fly in England using unpowered machines. The main exhibit is a full size replica of his fourth flying machine - "The Hawk".

*Opening times* Open Easter to end September Saturdays, Sundays and Bank Holiday Mondays and the Tuesday following from 2.30pm to 5.30pm (last admission 5.00pm). On Bank Holidays and Events days open at 12 noon

## STANFORD HALL MOTORCYCLE MUSEUM

Stanford Hall, Lutterworth, Leicestershire LE17 6DH
Telephone 01788 860250 Fax 01788 860870

Outstanding collection of racing and vintage motorcycles ranging in date from 1924 to present day. There are also two cycle cars, many bicycles, engines and rare photographs.

*Opening times* Open Easter to end September Saturdays, Sundays and Bank Holiday Mondays and the Tuesday following from 2.30pm to 5.30pm (last admission 5.00pm). On Bank Holidays and Events days open at 12 noon

## MEZZANINE GALLERY/MILLGATE
## FOLK MUSEUM

Millgate Museum, 48 Millgate, Newark, Nottinghamshire NG24 4TS
Telephone 01636 679403 Fax 01636 613279

Displays on three floors showing the agricultural industrial and social life of Newark. The Mezzanine Gallery within the Museum is a showcase for the work of local artist's and designers.

*Opening times* Open all year Monday to Friday 10.00am to 5.00pm (last admission 4.30pm) Saturday and Sunday 1.00pm to 5.00pm (last admission 4.30pm)

## THE MUSEUM OF NOTTINGHAM LIFE AT BREWHOUSE YARD

Castle Boulevard, Nottingham, Nottinghamshire NG7 1FB
Telephone 0115 9153600 Fax 0115 9153601

The museum is housed in five 17th century cottages including a network of accessible caves between the war shopping street, toy shop, school room, Victorian kitchen, dining room, bedroom, plus interactive displays.

***Opening times*** Open daily 10.00am to 4.00pm. Closed Friday from November to the end of February Closed 24th December to 1st January inclusive

## RUDDINGTON FRAMEWORK KNITTERS MUSEUM

Chapel Street, Ruddington, Nottingham, Nottinghamshire NG11 6HE
Telephone 0115 984 6914

Unique working museum, showing how Victorian stocking knitters worked and lived, housed in their original workshops and cottages preserved by the action of the local community.

***Opening times*** Open Easter to December Wednesday to Saturday 11.00am to 4.30pm and bank Holidays. Easter to September Sundays 1.30pm to 4.30pm

## RUTLAND RAILWAY MUSEUM

Cottesmore Iron Ore Mines Sidings, Ashwell Road,
Cottesmore, Nr Oakham, Rutland LE15 6LT
Telephone 01572 813203

An open air industrial railway heritage museum with a particular emphasis on the history of iron ore quarry railway systems of the east Midlands. 30 industrial loco's on show plus quarry rolling stock.

***Opening times*** Open weekends 11.00am to 5.00pm Please telephone for dates of Steam Days. Diesel days and Santa Specials (last admission 4.45pm)

## OAKHAM CASTLE

Market Place, Oakham, Rutland
Telephone 01572 723654 Fax 01572 757576

Fine great hall of 12th century fortified Norman manor house, unique presentation horseshoes forfeited by peers and royalty to the Lord of the Manor for centuries. Licensed for civil marriages.

***Opening times*** Open Tuesday to Saturday and Bank Holiday Mondays from 10.00am to 1.00pm and 2.00pm to 5.30pm. Sundays 2.00pm to 5.30pm (BST. Closing at 4.00 GMT) Closed Good Friday, Christmas Day and Boxing Day

# LINCOLNSHIRE

Lincolnshire is largely flat, particularly where it joins the Fens and the Wash in the south, but on the eastern side the Lincolnshire Wolds rise to over 500 feet. The county is rich agricultural and horticultural land...a land of windmills and glorious open skies. Flat wide and open this county, one of England's largest, may well be but lacking in interest it certainly is not. The Holland region of drained Fen is the commercial bulb growing centre, ablaze with colour during the Spring months leading to Spalding's spectacular Tulip Parade in May. At Spalding's Ayscoughfee Hall Museum is a wonderfully detailed display of local history and explanatory information concerning land drainage, horticulture, agriculture and wildfowling.

The county town Lincoln dominates the region standing on the central chalk ridge, the Lincolnshire Edge.The impressive triple towered cathedral overlooks the ancient historic city. The Museum of Lincolnshire Life is the region's largest social history museum with a most comprehensive and fascinating collection of information and artifacts. The Usher Gallery, also in Lincoln, with its outstanding collection of fine and decorative arts should not be missed.

Skegness, Lincolnshire's seaside resort developed during the nineteenth century and flourished with the coming of the railway in 1873. The railway poster of 1908 broadcast the message, 'Skegness is so bracing' - as indeed it is! The Church Farm Museum in Skegness houses the Bernard Best collection of agricultural objects in a nineteenth century farmhouse and outbuildings. To the north Grimsby's Immingham Museum tells the story of the creation of the port of Grimsby and the history of the Great Central Railway. Another Lincolnshire town to mushroom during the heady days of the last century was Scunthorpe. Within a century the population of this iron and steel town had increased from a mere 3,000 to 70,000. However of the four ironworks of the late nineteenth century only one now remains. On a more pastoral note, Normanby Hall County Park has a fine farming museum in 350 acres of parkland.

The Boston Guildhall Museum should certainly not be missed here is a fascinating 'time capsule' of history from the fifteenth century onwards...it was here, when the building was used as a courthouse, that the Pilgrim Fathers were tried and imprisoned. The Alford Manor Museum is another 'must'...a delightful thatched seventeenth century manor house set in its own grounds.

LINCOLNSHIRE

# GREYFRIARS EXHIBITION CENTRE

Broadgate, Lincoln LN2 5AL
Telephone 01522 530401

The Greyfriars Exhibition Centre is a beautiful 13th century building located in the heart of Lincoln.

The City and County Museum are currently using Greyfriars as a base in which to display a main annual exhibition profiling an area of the extensive Museum collections. 'ROMAN RULE - life in Roman Lincolnshire' will be on show until the end of April 1999.

The main exhibition will be complemented by a series of smaller, temporary displays reflecting the variety of the Museum collections.

A new exhibition 'RAIDERS AND TRADERS -Saxons and Vikings' will open in the Greyfriars Exhibition Centre on Wednesday 2nd June 1999 and will run until the end of April 2000.

Lincolnshire is rich in Saxon and Viking history. Eastern England was invaded from the 5th century, first by Saxons followed by Vikings from Scandinavia.

The invaders brought new cultures and traditions which helped formulate the rich history of Lincolnshire.

Come along to Greyfriars and see a wealth of evidence from this turbulent period of history, learn about the daily lives of these peoples, their beliefs, trading links and their influence.

Fine examples of craftsmanship including artefacts made from bone, pottery and metal will be on display in addition to part of a Viking silk headress found in Lincoln.

A lively programme of events to link with the exhibitions including lectures, holiday events, workshops, family activity days and competitions will be organised throughout the year.

***Opening times***
Open
Wednesday to Saturday
10.00am to 1.00pm
and 2.00pm to 4.00pm
Closed for re-display
from 1st May to
2nd June 1999

***Directions***
The Greyfriars Exhibition Centre is located in the lower part of Lincoln on Greyfriars Passageway adjacent to Central Library and between Free School Lane and Broadgate

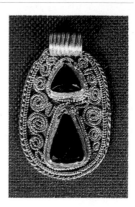

▲ Saxon gold filigree pendant set with two garnets

▲ Viking battle-axe and ferrule

▲ Head of very rare Saxon stone sceptre

LINCOLNSHIRE

## USHER GALLERY
Lindum Road, Lincoln, Lincolnshire LN2 1NN
Telephone 01522 527980 Fax 01522 560169

The Usher Gallery possesses a Nationally important collection of paintings and drawings by Peter DeWint (1784-1849).

DeWint belongs to an important generation of watercolourists who developed the depiction of the English landscape.

The Gallery also has a large collection of topographical works depicting the historic county of Lincolnshire, involving works by JMW Turner, Thomas Girtin, and other outstanding 19th century artists.

The collections feature numerous portraits of Lincolnshire notables and other works by Lincolnshire born artists such as William Logsdail, CH Shannon and WT Warrener.

The collections also include Chinese export porcelain of the K'ang Hsi period (1662-1722) and 18th and 19th century porcelain of the principal English and Continental factories.

The Gallery houses the GRG Exley Loan collections of Pinxton and Torksey porcelain, a collection of early English glass as well as continental galls dating from the 17th century.

The Usher Gallery, offers a varied temporary exhibition programme, involving both Historic and Contemporary art forms as well as a lively education programme for children and adults of all abilities.

A Saturday Club for children aged 4-7 and 7-11 runs twice a month. Audio guides to the collections will soon be available.

### Opening times

Open daily
Monday to Saturday
10.00am to 5.30pm
Sunday 2.30pm to 5pm
Closed Christmas Day,
Boxing Day, New Years
Day and Good Friday

### Directions

In the centre of Lincoln signposted by brown tourist signs. Drivers use Broadgate and Flaxengate car parks.

▲ Lincoln Cathedral,
Thomas Girtin,
1775-1851

▲ Stamford,
Lincolnshire,
JMW Turner, 1775-1851

▲ Watches circa 1800,
William Ilbery
▼ Lincoln from the
South West, Peter
DeWint, 1784-1849

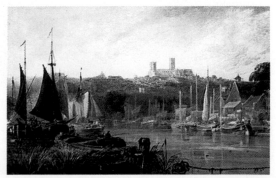

LINCOLNSHIRE

# CHURCH FARM MUSEUM

Church Road South, Skegness, Lincolnshire PE25 2HF
Telephone 01754 766658 Fax 01754 766658

Church Farm Museum is set in beautiful tranquil surroundings, just a short walk from the centre of Skegness.

The rooms of the original farmhouse are furnished in the style of 1900-1910, and there are frequent demonstrations in the kitchen using the range, or outside in the wash-house, all adding to that special "lived in" feel.

Traditional farm buildings house displays of agricultural implements and machinery and include a Forge, Saddlers and Wheelwrights workshop's.

Withern Cottage is a Lincolnshire "mud and stud" thatched building, a style unique to the county.

The Boothby and Havenhouse barns have temporary exhibition areas and the latter houses a tea-room which serves light refreshments.

Take time to wander the ample gardens full of herbs and flowers and the orchard stocked with varieties of Lincolnshire apples.

Nestled at the bottom of the orchard is an octagonal summerhouse, ideal for some quiet contemplation. In the Paddock you can find our Lincolnshire Longwool sheep, now sadly a rare breed. The Museum has a full programme of special events and regular Sunday afternoon craft demonstrations. Please contact the Museum for details of special events or group rates.

## Opening times

Open
1st April to 1st
November daily
(except Good Friday)
10.30am to 5.30pm

## Directions

Located about ½ mile from Skegness centre and easily accessed from Lincoln (A158) and Grimsby (A52) by following the brown Heritage signs as you enter Skegness.

▲ View of the farmhouse - it must be wash-day!

▲ Steam threshing, a very popular October event- sights, sounds, smells

▲ "Come and visit us at Church Farm Lincolnshire" - Longwool sheep

▼ Withern Cottage - centre for " mud and stud" studies

# AYSCOUGHFEE HALL MUSEUM

Churchgate, Spalding, Lincolnshire PE11 2RA
Telephone 01775 725468 Fax 01775 762715

Ayscoughfee Hall was begun in the 1420s as a home and business premises for Richard Alwyn, a local wool merchant. Since this time the Hall has undergone several phases of alteration.

The visitor now sees a mix of late - Mediaeval, Regency and Victorian architecture set in five acres of pleasure gardens; Yew Tree walks in the formal area of the gardens date back to the 1720s.

In 1902 the site was deeded to the local District Council for use as a Museum and Pleasure Garden and in 1987 the 'Museum of South Holland Life' opened in the hall.

The Museum has displays on Spalding, the local villages, Fenland drainage, the History of the Hall and Matthew Flinders (who was born locally).

In addition the museum houses a large collection of British and European birds which are on loan from the 'Spalding Gentlemen's Society'.

Also situated in the Hall is a Craft Case and local Art Gallery which changes its exhibitions monthly.

Opening times for the gardens are 8.00am to dusk all year round. Facilities within Ayscoughfee Gardens include a bowling green, putting green, tennis courts and children's play area.

The cafe is seasonal and opens April to September.

## Opening times

Open
Monday to Thursday
10.00am to 5.00pm
Friday
10.00am to 4.30pm
Saturday
10.00am to 5.00pm
Sunday
11.00am to 5.00pm
Closed winter weekends November to February inclusive
(last admission half an hour before closing)

## Directions

Follow Museum and Tourist Information Centre brown signs into Spalding. Ayscoughfee Hall is on the East Bank of the River Welland, three minutes walk from the Town Centre.

▲ War memorial and formal lake, Ayscoughfee Gardens

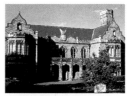

▲ West front of Ayscoughfee Hall

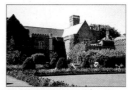

▲ East face of the hall with bowling green in foreground

▲ Late Georgian Library, south wing, Ayscoughfee Hall

# IMMINGHAM MUSEUM

Margaret Street, Immingham, N.E. Lincolnshire DN40 1LE
Telephone 01469 577066

Immingham Museum aims to show what life was really like in Immingham and its outlying areas at the turn of the century the main theme of the museum is the part played by the Great Central Railway in the building of the Dock and the Development of the Local Rail Network, the exhibits highlight how the railway influenced the people of Immingham and how it affected every aspect of their daily.

Reconstructions of Victorian/Edwardian and 1950s/60 room areas together with a local Chemist and Grocers shop recapture the flavour of the time.

▼ Part of the Grocers shop

An extensive photo and archive collection along with interesting artefacts help to illustrate further the areas history.

### Opening times
Open Monday to Friday
1.00pm to 4.00pm

### Directions
From the M180 take the A180 Immingham follow signs to Town centre, brown signs indicate to museum off the main road through the town.

▲ View of waiting room reconstruction

▲ Crest from Royal Train Locomotive dates from 1910

▲ Part of the Victorian/Edwardian room

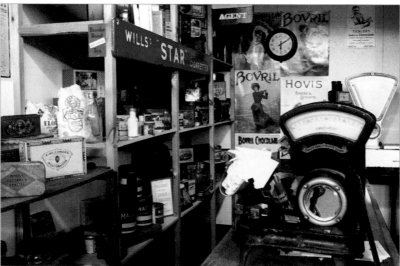

# NORMANBY HALL COUNTRY PARK

Normanby, near, Scunthorpe, North Lincolnshire DN15 9HU
Telephone 01724 720588 Fax 01724 720337 or 721248

Normanby Hall Country Park has a wide variety of facilities, which interpret life on a 19th century country estate.

The Hall is a Regency Mansion, completed in 1830, and furnished and decorated in Regency Style.

Displays in the Costume Galleries change each season. Within the recently restored Victorian walled garden, Victorian varieties of fruit and vegetables and flowers are grown as if for the "Big House".

These can be bought at the Gift Shop. Visitors can also see how the Victorian gardeners lived and worked. The Farming Museum explores country life when farming relied on heavy horses and the magnificence of the Hall can be compared with the labourers cottage.

Visitors can wander around 150 acres of parkland with woodland walks, open lawns and formal gardens. Normanby is home to red and fallow deer, peacocks, ducks and other wildlife.

Trail leaflets highlight items of interest and help explain how the park was used in the past. Many original features still remain, including the ice house, Victorian laundry, coach houses and stables, a ha-ha and even a miniature railway.

Special events are held on Sundays and Bank Holiday Mondays throughout the season.

Concessions on admission charges are available for North Lincolnshire residents.

## Opening times

We advise visitors to phone in advance for up-to-date information

## Directions

Normanby Hall Country Park is situated four miles North of Scunthorpe off the B1430, within easy reach of the M181 and the Humber Bridge.

▲ The Landau in front of the Regency Normanby Hall

▲ Red Stag with a herd of fallow deer behind

▲ Agricultural displays at the Farming Museum

▼ The herbaceous borders in the Victorian walled garden

**LINCOLNSHIRE**

## ALFORD MANOR HOUSE MUSEUM

Manor House, West Street, Alford, Lincolnshire LN13 9DJ
Telephone 01507 463073

Thatched 17th Century manor house. Now a museum, with local history displays, American connections with Alford, chemist shop, shoemaker's shop, veterinary display. Edwardian/Victorian Room, School Room, Dairy and Pantry.

*Opening times*  Open Easter to end September

## BOSTON GUILDHALL MUSEUM

South Street, Boston, Lincolnshire PE21 6HT
Telephone 01205 365954

Fine 15th Century brick building. Originally hall of St. Mary's Guild, then Town Hall, now Museum. Period rooms. Exhibits of local history. Audio guide. Monthly exhibitions.

*Opening times*  Open Mondays to Saturdays 10.00am to 5.00pm all year. Also
Sundays 1.30pm to 5.00pm April to September

## THE QUEENS ROYAL LANCERS MUSEUM

Belvoir Castle, Belvoir, Grantham, Lincolnshire NG32 1PD
Telephone 01159 573295 Fax 01159 573195

The museum tells the story of the 16th/5th The Queen's Royal Lancers and the 17th/21st Lancers. Uniforms, pictures, silver medals and weapons are just some of the artifacts that have made up this fine display.

*Opening times*  Open March to October 11.00am to 5.00pm Tuesdays,
Wednesdays,Thursdays, Saturdays and Sundays, Good Friday and Bank Holidays.
Sundays only closed in October 11.00am to 5.00 pm

## MUSEUM OF LINCOLNSHIRE LIFE

Burton Road, Lincoln, Lincolnshire LN1 3LY
Telephone 01522 528448 Fax 01522 521264

The region's largest and most varied social history museum where the past two centuries of Lincolnshire life are illustrated by displays of domestic items, industrial machinery, agriculture, a collection of horse-drawn vehicles and Royal Lincolnshire Regiment.

*Opening times*  Open May to September daily 10.00am to 5.30pm, October to April
Monday to Saturday 10.00am to 5.30pm daily Sundays 2.00pm to 5.30pm
Closed Good Friday, December 25th, 26th and January 1st.

## MEDIEVAL BISHOPS' PALACE

Minster Yard, Lincolnshire LN2 1PU
Telephone 01522 527468

In the shadow of Lincoln Cathedral explore a 12th Century hall, climb the Alnwick Tower and discover one of Europe's most northerly vineyards set amongst the ruins of this magnificent palace.

*Opening times*  Open 1st April to 31st October daily 10.00am to 6.00pm,
1st November to 31st March. Weekends only 10.00am to 4.00pm

# LONDON & MIDDLESEX

In a sense the City of London is one enormous museum. From the first century AD when the Romans settled here, through the early medieval period of the building of the first St. Paul's Cathedral; through the Norman period of the construction of the White Tower; through the prosperous years of the Livery Companies; through plague, fire and pestilence; through the gracious years of Wren's building, to the London of today, this city has drawn to itself the nation's talent and expertise. This great city of history, pageantry and ceremonial has become the treasure house of Britain's skills. From the most spectacular to the trivial, all is recorded here in a vast selection of the finest, and certainly the most fascinating museums and galleries of the world.

The Museum of London illustrates over 2,000 years of the city's social history, from prehistoric times, while the British Museum extends its borders to include the works of people from the whole world. Science, technology, industry and medicine are represented by over 200,000 exhibits at the Science Museum and at the Victoria and Albert museum is the finest collection of decorative art in the world. Western European painting is superbly displayed in the National Gallery where most of the great names of Western art are represented. The National Portrait Gallery holds a permanent collection of the portraits of famous British men and women from the middle ages to the present day. The Tate Gallery holds the national collection of British painting from 1500, together with the wonderful Turner collection and the national collection of twentieth century painting and sculpture. Contemporary art is well represented through numerous galleries including the excellent Mall Galleries who exhibit the work of mainly British contemporary artists in traditional media.

London is home to some fascinating galleries concerned with the districts and characters of the capital. The Ragged School Museum, housed in canal side warehouses which were once the Barnardo's Ragged School tells the intriguing story of London's East End. The history of the city's trams, trains and buses is revealed in the London Transport Museum. Charles Dickens, Florence Nightingale, John Wesley.and many more, have museums in the city in fact there can be few subjects of interest that are not represented in the museums and galleries of London...from the great colleges displaying their history and development to the nostalgic museums of childhood and the charming Pollock's Toy Museum.

# MUSEUM OF THE ROYAL PHARMACEUTICAL SOCIETY

1 Lambeth High Street, London SE1 7JN
Telephone 0171 7359141 Fax 0171 7930232

The rich, specialist collections of the Museum offer visitors and researchers a treasure trove of unexpected objects, images and insights into more than 5 centuries' history of medicinal drugs and their use in Britain.

▲ Historic pharmacy storage and dispensing equipment from the Museum of the Royal Pharmaceutical Society

▲ A fine English Delftware drug jar, used to store oil from foxes lungs, an ingredient in 17th century remedies for chest complaints

In a series of exhibition spaces set in the Society's impressive headquarter building in Lambeth, the museum traces the long and complex history of our medicines, the scientists and traders who have invented, developed, compounded and sold them and the patients who have swallowed the pills and fed the leeches!

▲ Equipment used in the traditional dispensary for making spherical pills

▼ Dated as 13th or 14th century this is the earliest British mortar in the Museum's collection. It is rare for such old mortar to have kept its pestle, but analysis of the metal has shown these to be almost certainly a pair

### Opening times

Open all year by appointment only Monday to Friday 9.00am to 1.00pm 2.00pm to 5.00pm

### Directions

The museum is in the Royal Pharmaceutical Society of Great Britain building, just south of Lambeth Bridge, at the junction of Lambeth Road and Lambeth High Street

# POLLOCK'S TOY MUSEUM
1 Scala Street, London W1P 1LT
Telephone 0171 6363452

Pollock's Toy Museum takes it's name from Benjamin Pollock, the Victorian toy-theatre printers, therefore toy theatres and their history spanning 200 years are a special feature of the museum.

The museum occupies two houses, one Edwardian the other Victorian. A bright frieze on the exterior walls of the house prepares the visitor for a crammed full visual feast.

The collection includes optical, mechanical and construction toys, English tin toys, puppets, wax and composition dolls, teddy bears, lead miniatures dolls' houses.

Folk toys from around the world and toy theatres. "If you love art, folly, or the bright eyes of children, speed to Pollock's". Robert Louis Stevenson - Memories and Portraits.

School parties welcome book in advance and reserve a live toy theatre performance. Aladdin, Black Beard the Pirate and Jack the Giant Killer.

Pollock's Toy Shop is on the ground floor.

### Opening times

Open every day except Sundays and Bank Holidays
10.00am to 5.00pm
(last admission 4.30pm)

### Directions

Buses 10, 24, 29, 73 to Goodge Street. Underground Goodge Street Northern Line, entrance in Whitfield Street at the back of the station.

▲ Italian Villa, crica 1870

▶ The Neptune Theatre, 1880, scene from Harlequinade and Dick Whittington

▼ Ubilda touring car, 1946

# LEIGHTON HOUSE MUSEUM
12 Holland Park Road, London W14 8LZ
Telephone 0171 6023316 Fax 0171 3712467

Leighton House was the home of Frederic, Lord Leighton (1830-1896), the great classical painter and President of the Royal Academy.

The house was built between 1864-79 to designs by George Aitchison and is the expression of Leighton's vision of a private palace devoted to art.

The Arab Hall is the centrepiece of Leighton House with it's dazzling gilt mosaic frieze and the intricate designs of Isnik tiles.

This opulent fantasy extends throughout the other rooms of the house culminating in Leighton's studio, the heart and purpose of the house.

Leighton House contains a fine collection of Victorian art. Paintings by Leighton, Burne-Jones, Millais and their contemporaries are displayed throughout the house.

### Directions

Leighton House is situated at 12 Holland Park Road; it is close to the north side of Kensington High Street and can be reached from Melbury Road. The nearest London Underground Station is High Street Kensington on the District and Circle Line. The following buses stop at Odeon Cinema/Commonwealth Institute nearby - no's 9. 9a, 27, 28, 31, 33, 49.

▲ View of Arab Hall

▼ Narcissus Hall and staircase

### Opening times

Open all year round
Monday to Saturday
11.00am to 5.30pm
Closed Sundays and
Bank Holidays

# THE CUMING MUSEUM
155-157 Walworth Road, London SE17 1RS
Telephone 0171 7011342 Fax 0171 7037415

The Cuming Museum is the museum of Southwark's history and the home of the world wide collections of the Cuming family between 1780 and 1900, Richard 1777 to 1870 and Henry Syer Cuming 1817 to 1902 collected over 100,000 artefacts from all around the world.

Today their collection consists of archaeology British and foreign, social history decorative art, geology, textiles, natural history, prints, coins, ceramics, ancient Egyptian and Etruscan objects.

The Cuming Museum also holds objects which reflect the varied history of what is now the London Borough of Southwark, one of London's most historic boroughs from the Romans to the present.

The Cuming Museum's collection of local objects illustrates Southwark's growth and development.

In the 17th and 18th century it was an area famous for Market Gardens and bawdy entertainments like bear baiting.

By the 19th century it was the larder of London where three quarters of all the food for Londoners was stored in warehouse in Tooley Street Bermondsey.

## *Opening times*

Open from Tuesday to Saturday 10.00am to 5.00pm Closed Sunday and Monday

◀ Roman Hunter God AD 300

## *Directions*

Underground Elephant and Castle. The Museum is a short walk from Elephant and Castle. Buses 12, 35, 40,171, 40, 68, 68a.

▲ Head from an Egyptian coffin, New Kingdom, c1200 BC

▲ Dog and pot sign, Hayward Iron Merchants Shop, Blackfriars Road

▲ Pewter figures faked by William Smith and Charles Eaton

**265**

## MALL GALLERIES
## FEDERATION OF BRITISH ARTISTS
17 Carlton House Terrace, London SW1Y 3BD
Telephone 0171 9306844 Fax 0171 8397830

The Mall Galleries is one of the few London venues to show the work of well-established British artists alongside that of up-and-coming students and young unknown painters. Opened in 1971 by her Majesty The Queen, the Galleries stage a packed programme of varied exhibitions of work for sale, artist's demonstrations, talks and workshops.

The Galleries are run by the Federation of British Artists, which works to educate, inspire and involve the public in the appreciation and practice of the fine arts.

The FBA is a long-established registered charity and the Umbrella Organisation for nine of the countries leading art societies: Royal Institute of Painters in Water Colour, Royal Society of British Artists, Royal Society of Marine Artists, Royal Society of Portrait Painters, Royal Institute of Oil Painters, New English Art Club, Pastel Society, Society of Wildlife Artists, Hesketh Hubbard Art Society.

Election of membership of each society is on merit. However, non-members are encouraged to submit work to the Annual Exhibition held at the Mall Galleries.

### *Opening times*
Open daily
10.00am to 5.00pm
when an exhibition is
taking place

### *Directions*
The Mall Galleries are situated on the Mall. Two minutes walk from Trafalgar Square by Admiralty Arch. The nearest tube stations are Charing Cross or Piccadilly.

▲ Interior of the Mall Galleries

▲ The Mall Galleries

▲ Robert Wraith's portrait of H.M. The Queen unveiled in 1998

▼ An Artists' workshop taking place in the Mall Galleries

# LINLEY SAMBOURNE HOUSE

18 Stafford Terrace, London W8 7BH
Telephone 0171 9370663 or 0171 6023316 Fax 0171 3712467

Linley Sambourne House was the home of Edward Linley Sambourne, a leading Punch cartoonist of the late Victorian and Edwardian period.

The house with its magnificent 'artistic' interior has survived largely unchanged. The original wall decoration, fixtures and furniture have been preserved, together with many of Sambourne's own pictures and those of his friends.

The result is a unique and fascinating survival of a late Victorian town house not only to the Londoner and the visitor to London, but also to the student of decoration and design.

It is a rare opportunity to see how a successful artist lived and worked in the heart of 'artistic' Kensington.

▲ Morning room
view looking south

### *Directions*

Nearest Underground:
High Street Kensington
Bus: 9, 9(a), 27, 28,
31, 33, 49

▲ Roy's bedroom - view
looking south

### *Opening times*
Open
March to October
Wednesday
10.00am to 4.00pm
(Last Admission 3.30pm)
Sunday
2.00pm to 5.00pm
(Last Admission 4.30pm)
Open at other times by
appointment only for
groups of 15 or more
(additional fee incurred)

▶ View of Drawing
room looking north

# FLORENCE NIGHTINGALE MUSEUM

2 Lambeth Palace Road, London SE1 7EW
Telephone 0171 6200374 Fax 0171 9281760

On the site of St Thomas' Hospital, home of the first professional Nurse Training School, this award winning museum gives a personal insight into the life of Florence Nightingale.

Highlights include Miss Nightingale's possessions, a lantern from Scutari Hospital, a life-size recreated ward scene and an outstanding 20 minutes audio-visual.

The Resource Centre is available for private research by appointment.

## *Opening times*

Open
Tuesday to Sunday
10.00am to 5.00pm
(last admission 4.00pm)
Closed Good Friday,
Easter Sunday,
24th to 26th and 31st
December and 1st
January

▲ Florence Nightingale 1861

▶ The Florence Nightingale Museum

▼ Recreated ward scene at Scutari

## *Directions*

Exit Westminster Underground station, turn left, and over Westminster Bridge. St Thomas' Hospital is on the right hand side - the Museum is at car park level of the hospital.

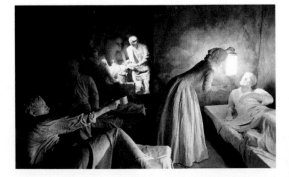

# MUSEUMS OF THE ROYAL COLLEGE OF SURGEONS OF ENGLAND

35-43 Lincoln Inn Fields, London WC2A 3PN
Telephone 0171 9732190 Fax 0171 4054438

The Hunterian Museum contains 3,500 surviving specimens from John Hunter's collection of human and animal anatomical and pathological preparations.

John Hunter (1728-1793) was a surgeon, anatomist, researcher and teacher who is regarded as a pioneer of the scientific approach to surgical practice.

Other material has been added to his original collection including specimens of extinct species; tables of veins and arteries formerly in the collection of 17th century diarist John Evelyn; the skeleton of Charles Byrne, the 'Irish Giant', historical surgical instruments; and displays on the history of preservation techniques.

The Art Collection includes three paintings of animals bought by Hunter from George Stubbs (1724-1806) and paintings of horses and quagga by Jacques-Laurent Agasse (1767-1849).

The Odontological Museum has displays on dental anatomy and pathology in humans and animals, dental instruments and dentures, and changing displays on topics of

general interest.
The Museum is rich in material of historical importance. Examples include Sir John Tomes' (1815-1895) collection of human jaws and skulls, teeth retrieved from the Battlefield of Waterloo and a necklace of human teeth brought from the Congo by the explorer, H.M. Stanley.

### Opening times

Open
10.00am to 5.00pm
Monday to Friday
except Bank Holidays
and other days when
the college is closed

### Directions

Located in central London, the Museums are within easy walking distance of Holborn and Temple Underground Stations and a short taxi journey from most major rail stations.

▲ Solitaires

▲ Quagga by Jacques-Laurent Agasse, 1767-1849

▲ Child aged 6-7 years showing developing dentition

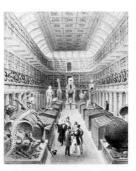

◀ View of the Museum in the 1840s - T.H. Shepherd

**269**

## DESIGN MUSEUM
28 Shad Thames, London SE1 2YD
Telephone 0171 3786055 Fax 0171 3786540

The world's first museum dedicated to the study of 20th century design. Once a 1950's warehouse the Design Museum is just one of the many imaginative warehouse renovations which are concentrated along the Thames.

Ideally located in Butlers Wharf, the Museum is not only situated in the heart of a rich and varied cultural and architectural heritage, it also commands spectacular views of the River Thames and London's sky line.

The Museum's modern and exciting framework houses a combination of permanent and temporary displays which enable visitors of all ages to explore international design evolution, ingenuity and inspiration.

The Museum's temporary exhibitions for the forthcoming year include; 'The Work of Charles and Ray Eames', two of the century's most influential designers, from architecture to movie-making and furniture design; 'The Real David Mellor', which traces the career of this great British industrial designer from his early silversmithing days; 'The Conran Foundation Collection', this years best designed products are chosen by David Constantine, from motivation, a charitable organisation for wheelchair design and rehabilitation; 'Modern Britain 1929-1939', will cross design boundaries, encompassing architecture, graphic

▲ The Museum Shop

▲ A group of wire chairs

***Opening times***
Open daily
11.30am to 6.00pm
(last admission 5.30pm)
Closed Christmas Day
and Boxing Day only

***Directions***
District and Circle Line
to Tower Hill, a pleasant
ten minute walk over
Tower Bridge. Northern
Line and British Rail to
London Bridge,
a 15 minute walk
along the River.

▼ Aluminium chair, 1958

design, furniture, textiles, interiors and product design; and Verner Panton whose work is dominated by his groundbreaking use of colour and experimental forms.

▲ Retort house Office Interior

271

**LONDON & MIDDLESEX**

# RAGGED SCHOOL MUSEUM TRUST
46-50 Copperfield Road, London E3 4RR
Telephone 0181 9806405 Fax 0181 9833481

The purpose of the Ragged School Museum is to make the unique history of the East End of London, and in particular of the Copperfield Road Ragged School, accessible to all members of the general public.

The Ragged School Museum was opened in 1990 in three canal-side warehouses in Copperfield Road, East London. These buildings were previously used by Dr Barnardo to house the largest ragged school in London.

In a re-created classroom of the period visitors can now experience for themselves how Victorian children were taught.

There are also displays on local history, industry and life in the East End and a varied programme of temporary exhibitions.

The museum runs a variety of different activities for all ages. These include workshops, history talks, treasure hunts and canal walks. These are open to all.

▶ A Victorian mask - making workshop at the Ragged School Museum

### Opening times

Open every Wednesday
and Thursday
10.00am to 5.00pm
except Christmas,
New Year
Also first Sunday
of each month
2.00pm to 5.00pm

### Directions

Metered parking in Copperfield Road most direct public transport Mile End Tube Station turn left out of the station cross Burdett Road, left into Canal Road continue into Copperfield Road.

▲ Curator, working in the stores of the Ragged School Museum

▲ Kids love doing treasure hunts at the Ragged School Museum

▲ A local volunteer tells school children about life in the East End

# THE DICKENS HOUSE MUSEUM

48 Doughty Street, London WC1N 2LF
Telephone 0171 4052127 Fax 0171 8315175

Charles Dickens (1812-70) lived at 48 Doughy Street from April 1837 to December 1839, not a long period but an important one, because it was then that he really secured his reputation.

It is, moreover, the only London house still standing that this great London writer lived in for any length of time. While at Doughty Street, Dickens finished 'Pickwick Papers' (issued serially, like most of his books), wrote all but the first five instalments of 'Oliver Twist', and "Nicholas Nickleby" in its entirety, began 'Barnaby Rudge', and worked on such minor projects as 'Sketches of young Gentlemen' and 'The Lamplighter' (a stage farce). He proved his talent to be not merely remarkable but durable, and he emerged from behind the pen name "Boz" into the blaze of fame that shows no sign of dimming today.

You many see the study in which the young writer created such immortal characters as Fagin, Bill Sikes, the Artful Dodger, and the Squeer and Crummles families. Note there R.W. Buss's celebrated painting, "Dickens Dream".

▶ Manuscript and objects connected with Charles Dickens.

You can also see the carefully reconstructed Drawing room in which the family received its guests.

## Opening times
Open all year
Monday to Friday
9.45am to 5.30pm
Saturday
10.00am to 5.00pm
(Last admission, weekdays 5.00pm
Last admission, Saturdays 4.30pm)
Open during Christmas for special events.

## Directions
Take the underground to Russell Square or Chancery Lane (10 minutes walk). Buses 17, 45, 55, 19, 38 all drop within five minutes walk of the Museum.

▶ The front of 48 Doughty Street, The Dickens House Museum

▲ Charles Dickens by Samuel Laurence

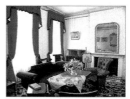

▲ The reconstructed Drawing room at the Dickens House Museum

# BANKSIDE GALLERY

48 Hopton Street, London SE1 9JH
Telephone 0171 9287521 Fax 0171 9282820

Bankside Gallery is the home of the Royal Watercolour Society and the Royal Society of Painter-Printmakers.

This friendly gallery runs a changing programme of exhibitions of contemporary watercolours and original prints.

Members of the two Societies are elected by their peers in a tradition reaching back 200 years.

Their work embraces both established and experimental practices and the exhibitions balance these different approaches.

Informal 'Artists Perspectives' take place every Tuesday evening during the course of an exhibition.

A range of practical courses and tutorials is held every year by artist members. Full details are available from the Gallery.

A Friends Organisation supports the Gallery and Societies, for details of Friends benefits call the Gallery on 0171 9287 5210

▶ Sarah Holliday - Composition with Buddleia (watercolour)

## Opening times

Open Tuesday 10.00am to 8.00pm Wednesday to Friday 10.00am to 5.00pm Saturday and Sunday 1.00pm to 5.00pm during exhibitions. Closed Monday

## Directions

Bankside Gallery on the South Bank of the Thames is easily reached from Blackfriars Station, cross the River via Blackfriars Bridge and then left along the Thames footpath.

▲ Harry Eccleston - Stratford variations no.9 (etching)

▲ Karolina Larusdottir - untitled (etching and aquatint)

◀ Jonathan Cramp - Sea Short Still Life (watercolour)

LONDON & MIDDLESEX

# THE NATURAL HISTORY MUSEUM
Cromwell Road, London SW7 5BD
Telephone 0171 9389123

The world's finest museum of nature and one of London's most beautiful landmarks, The Natural History Museum is home to a wide range of exhibitions certain to appeal to visitors of all ages.

Highlights include 'Dinosaurs' a compelling exhibition about the creatures that continue to excite the imagination, 'Mammals' with an unforgettable life - sized Blue Whale centrepiece, a walk - in 'leaf factory' in 'Ecology' and 'Human biology', a must see exhibition for anyone who has marvelled at the miracle of human life.

Major new exhibitions 'From the beginning', 'Earth's treasury' and 'Earth today and tomorrow' join with the dramatic 'Visions of earth', 'The Power within' and 'Restless surface' to bring to life the history of our planet. Together they tell Earth's remarkable story, starting with the 'big bang' and the birth of the Universe, travelling through vast expanses of geological time exploring the dynamic forces that shape the Earth and the riches within it, concluding with a glimpse into the future

to predict what might become of our world.

## Opening times

Open
Monday to Saturday
10.00am to 5.50pm
Sunday
11.00am to 5.50pm
Closed 23rd to 26th
December (inc.)

## Directions

Nearest Underground
Station: South
Kensington. Bus Routes:
14, 49, 70, 74, 345, C1.

▲ Cut gemstones a selection from 'Earth's treasury'.

▲ Dinosaurs at The Natural History Museum

◄ The Natural History Museum, London

▼ 'Visions of Earth', a striking major new exhibition

## SCIENCE MUSEUM

Exhibition Road, London SW7 2DD
Telephone 0171 938 8080 / 8000
Website nmsi.ac.uk

Enter a world of discovery and achievement. Where you can see, touch and experience the major scientific advances of the last 300 years.

Seven floors and more than 40 galleries filled with the world's finest collections in the history of science, technology and medicine.

From original working steam engines to the actual Apollo 10 Command Module. From penicillin to brain scanners, radio waves to nuclear power and running shoes to steel shoes.

The Science Museum will involve, intrigue and inspire you with its unique mixture of permanent displays and over 2000 hands-on exhibits. Enter - and open the doors to your mind.

### Opening times

Open 10am to 6pm daily, Closed 24th, 25th and 26th December

### Directions

Nearest Tube:
South Kensington
Buses: 9, 10, 14, 345, 49, 52 , 74, C1

▼ Challenge Bridge    ▲ Steel Wedding Dress

## BRITISH MUSEUM
Great Russell Street, London WC1B 3DG
Telephone 0171 6361555 Fax 0171 3238614

The British Museum is concerned with the cultural history of mankind from prehistoric times to the present day.

Permanent displays are drawn from the following departments: Coins and Medals, Egyptian Antiquities, Ethnography, Greek and Roman Antiquities, Mediaeval and Later Antiquities, Oriental Antiquities, Prehistoric and Roman-British Antiquities and Western Asiatic Antiquities.

The collections of Japanese Antiquities and Prints and Drawings are shown in a series of temporary exhibitions.

Objects of special interest include: Rosetta Stone, sculptures from the Parthenon, Portland Vase, Lindow Man, Sutton Hoo Treasure, Lewis Chessmen, Mildenhall Treasure and Indian sculpture. Guided tours of the highlights may be booked at the Information Desk, whilst a daily programme of free Gallery tours is detailed in the current 'events' leaflet (available from the Information Desk).

By Autumn 2000 the Museum's inner courtyard, hidden for 150 years, will be transformed into the Great Court, a two-acre square spanned by a spectacular glass roof.

Designed by the architects Foster and Partners, the Great Court will house a centre for education, galleries and temporary exhibition space.

At the heart of the Great Court, the Reading Room will be carefully preserved and will open in 2000 as home to a new Public Library.

### Opening times
Open
Monday to Saturday
10.00am to 5.00pm
Sunday
12.00pm to 6.00pm
Closed 1st January,
Good Friday, 24th
to 26th December

### Directions
The nearest underground stations are Tottenham Court Road, Holborn and Russell Square. Bus routes 10, 24, 29, 73, 68, 91, 188, 7, 8, 19 stop within 5 minutes of the museum.

▲ Facade of the British Museum

▲ Seated Lohan, Liao Dynasty, 907-1124AD, China

▲ Gold Buckle from Sutton Hoo Treasure, 7th century AD

▲ Horse of Selene from the Parthenon, c. 438-432BC

# GEFFRYE MUSEUM
Kingsland Road, London E2 8EA
Telephone 0171 7399893 Fax 0171 7295647

The Geffrye is the only museum in the UK to specialise in the domestic interiors and furniture of the urban middle-classes.

Its displays span from 1600 to the present day, forming a sequence of period rooms which capture the quintessential nature of English interior style.

The Museum is set in the former Almshouses of the Ironmongers' Company, Grade One Listed, 18th century buildings.

An exciting new gallery extension opened in November 1998 containing new 20th century period room displays, a temporary exhibitions gallery, a design centre, an imaginative gift shop and a 70-seater restaurant.

The Geffrye is surrounded by beautiful gardens including an award-winning herb garden and a series of historical garden rooms which highlight the key changes in the design and planting of urban middle-class gardens from the 17th to the 20th centuries (open April to October).

The Museum and gardens are regularly brought to life through an innovative programme of seminars, workshops, drama and music.

Special exhibitions are mounted throughout the year, exploring a wide variety of themes relating to the museum's displays.

A traditional favourite is the Christmas Past exhibition, when the period rooms are festively decorated to reflect 400 years of Christmas traditions in English homes.

### Opening times
Open
Tuesday to Saturday
10am to 5pm
Sunday
12pm to 5pm
Also closed 24th, 25th
and 26th December,
1st January and
Good Friday

### Directions
By Tube: Liverpool
Street, then bus 242 or
149 from Bishopgate.
Old Street (exit 2), then
15 minutes walk or bus
243. By Buses: 149, 242,
243 or 67.

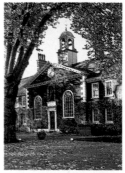

▲ Exterior of Grade One
Listed, 18th century
Almshouses

▲ Elizabethan and
Jacobean period room
1580-1640

▲ Regency period room
1800-1830

◄ Walled herb garden

# IMPERIAL WAR MUSEUM
Lambeth Road, London SE1 6HZ
Telephone 0171 4165316 Fax 0171 4165374

The award-winning Imperial War Museum tells the story of 20th century conflict - from the First World War to the present day - through artefacts, documents, art, sound recordings, photographs, films and the latest interactive technology.

Special attractions include: The Blitz Experience - a dramatic recreation of an air raid on London with sounds, smells and other special effects.

The Trench Experience - see soldiers "going over the top" in this walk-through recreation of a trench on the Western Front. Secret War - a permanent exhibition revealing for the first time the clandestine world of espionage, intelligence gathering and the work of Britain's special forces.

Survival at Sea - A small display illustrating through diaries, photographs and mementos, some of the remarkable stories of courage and survival by men of the Merchant Navy.

The First World War Remembered - Eighty Years On, this special exhibition looks at how the Great War has been remembered.

From the Bomb to the Beatles: Post War Britain 1945-1965 - A major exhibition telling the story of social and cultural change in the Post War years.

### Opening times

Open daily
10.00am to 6.00pm
Closed 24th to 26th December

### Directions

Underground: Lambeth North, Elephant Castle. Rail: Waterloo. Bus: 1, 3, 12, 53, 59, 63, 109, 171, 184, 188, 344

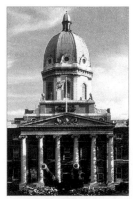

▲ Imperial War Museum: Showing 15-inch guns (HMS Resolution/HMS Ramillies)

▶ Trench Experience: Walk through recreation of trench on Western Front

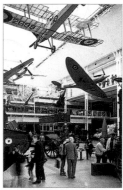

▲ Large Exhibits Gallery: Important guns, tanks and aircraft

▲ Blitz Experience: Dramatic recreation of an air raid on London

## MUSEUM OF LONDON
London Wall, London EC2Y 5HN
Telephone 0171 6003699 Fax 0171 6001058

The Museum of London is the largest, most comprehensive city museum in the world, telling the fascinating story of London from prehistoric times to the present day.

Our galleries show what London was like 100, 500 or even 2,000 years ago.

You can wander past Roman Dining Rooms, gaze at a sparkling hoard of Elizabethan jewellery or peer into an 18th century prison cell complete with prisoners' graffiti.

This is the home of the sumptuous Lord Mayor's Coach. A new fast-changing gallery will display 'Capital Concerns', a series of lively, shorter displays looking at matters of topical interest.

A packed programme of events, including family workshops, talks and lectures, walks and visits.

### *Directions*

The Museum is a modern building above street level where Aldersgate Street meets London Wall. Access is by signposted, steps and ramps. Nearest Underground Stations: St Paul's, Moorgate, Barbican.

### *Opening times*

Open
Monday to Saturday
10.00am to 5.50pm
Sunday
12.00pm to 5.50pm
Last Admission 5.30pm
Open throughout the
Easter Holidays.
Free to all visitors
after 4.30pm

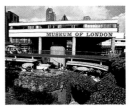

▲ Exterior of the Museum of London

▼ Reconstruction of a living room London AD300

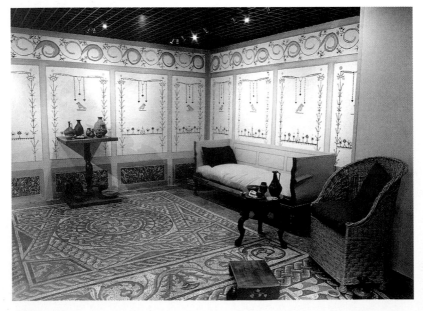

# TATE GALLERY
Millbank, London SW1P 4RG
Telephone 0171 8878000 Fax 0171 8878007

The Tate Gallery comprises the national collection of British art from the 16th century to the present day and the national collection of international modern art. The Tate in addition houses the Turner Bequest in the Clore Gallery that includes works that JMW Turner left to the nation on his death. Works are shown by theme and artist within a broad chronological framework.

Highlights from the collection include British portraiture from the Tudor period on, encompassing Joshua Reynolds, Thomas Gainsborough and John Signer Sargent. Other sections feature William Hogarth, known for his social comment and satire, landscapes by John Constable, and works by the Pre-Raphaelites John Everett Millais and Dante Gabriel Rossetti.

Rooms for modern art chart the major movements this century. 20th century themes cover Cubism, with George Braque and Pablo Picasso, Surrealism including Salvador Dalí and Pop Art with works by leading artists such as David Hockney and Roy Lichtenstein.

▶ 'Ophelia' By John Everett Millais

There are also dedicated areas for contemporary art. Displays are changed each year through enabling the gallery to show the variety and strengths of the collection. No works are on view permanently.

### Directions

Located along Millbank in between Vauxhall and Lambeth Bridges. Nearest Underground: Pimlico (Victoria Line). Buses: 88, 77a, c10, 36 all stop within easy reach of the Gallery.

▲ 'Mr and Mrs Clark and Percy' by David Hockney

### Opening times
Open daily
10.00am to 5.30pm
Closed 24th to 26th
December

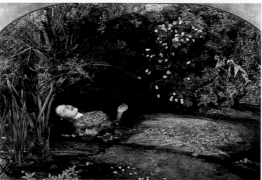

## NATIONAL PORTRAIT GALLERY
St Martin's Place, London WC2H 0HE
Telephone 0171 3060055 Fax 0171 3060058

Come face to face with great men and women of history from Elizabeth I to Queen Victoria, Benjamin Disreali to Winston Churchill, The Bronte Sisters to Harold Pinter.

Over 1000 portraits are on display of famous British men and women from the Middle Ages to the present day.

Special exhibitions are held throughout the year. 19th February to 6th June 1999 J.E. Millais: Portraits. 25th June to 26th September 1999 BP Portrait Award 1999. Contact the Gallery for further details.

ADMISSION
Admission to the National Portrait Gallery is free (except for some special exhibitions, special group rates available when pre-booked).

GALLERY SHOP
& CAFE
The National Portrait Gallery's Gift Shop, Bookshop and Portrait Cafe are open to the public throughout the year.

SOUND GUIDE
A recorded CD Rom Guide to the portraits on display is available in English, French, Spanish and Japanese.

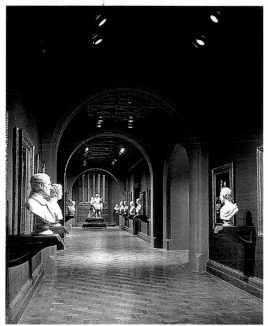

▲ Victorian Galleries ©Andrew Pulter

### Opening times

Open all year
Monday to Saturday
10.00am to 6.00pm
Sunday
12.00pm to 6.00pm
(last admission to special
exhibition 5.15pm)
Closed 24th to 26th
December, 1st January,
Good Friday & May Day
Bank Holiday

### Directions

Nearest Underground:
Leicester Square or
Charing Cross. Nearest
Mainline Station:
Charing Cross. Situated
next to the National
Gallery facing St
Martin's in the Field.

◀ ▶ Early 20th
Century Gallery
©Andrew Putter

# TOWER BRIDGE EXPERIENCE

Tower Bridge, London SE1 2UP
Telephone 0171 3781928 Fax 0171 3577935

The story behind London's most famous landmark is told in an exciting exhibition situated inside Tower Bridge's twin Gothic Towers.

State of the art technology, including sophisticated animatronic characters, video presentations and interactive displays, are used to bring the Bridge to life.

Visitors will discover why the Bridge was needed and how a design was chosen.

The original Engine rooms are now open to show visitors how this working bridge was operated. However the main attraction has to be the spectacular views over London from the high level walkways, 140 feet above the River Thames.

From this unique viewpoint, visitors can see some of London's most well-known buildings, such as the Tower of London, St. Paul's Cathedral and Canary Wharf. Closest tube stations are Tower Hill and London Bridge.

▶ Fireworks explode over Tower Bridge on it's century celebrations

### Opening times

Open April to October
10.00am to 6.30pm
November to March
9.30am to 6.00pm
Last entry 1 ¼ hours
before closing.
Closed
24th to 26th December
1st and 27th January
1999

### Directions

Rail Stations: London Bridge, Fenchurch Street. Underground: Tower Hill, London Bridge. DLR: Tower Gateway. Bus routes 15, 42, 47, 78, 100, D1, P11. Riverboat: Tower Pier.
You can't miss us.

▲ Looking up at Tower Bridge's powerful accumulators

▲ The magnificent Tower Bridge houses Tower Bridge Experience

◀ Tower Bridge with the Dolphin

## JOHN WESLEY'S HOUSE AND THE MUSEUM OF METHODISM

Wesley's Chapel, 49 City Road, London EC1Y 1AU
Telephone 0171 2532262 Fax 0171 6083825

Known the world over as the Cathedral of World Methodism, Wesley's Chapel was built by John Wesley in 1778.

It is one of London's jewels. It is both a heritage site and a living Church with a unique congregation.

Across the courtyard from the Chapel is John Wesley's House, where he spent the last 11 winters of his life. It is a fine 18th century Georgian home, furnished with Wesley's own furniture and personal belongings, including his library and Electrical Shock Machine.

Wesley's Prayer Room is considered by Methodists all over the World to be the Power House of Methodism.

In the Crypt of the Chapel is the Museum of Methodism, where the history of Methodism is explored from its beginnings to the present day.

It has one of the world's largest collections of Wesleyan ceramics and some of the finest Methodist paintings.

It is also full of unusual objects to see, like the pack of religious playing cards! In addition to Wesley's tomb, 5,452 people are buried in the graveyard too.

We offer guided tours, and have a museum shop and have a teacher's pack designed for special use by Primary schools.

### Opening times

Open all year round
Monday to Saturday
10.00am to 4.00pm
Sunday
12.00pm to 2.00pm
Closed Christmas, New
Year and Bank Holidays

### Directions

Wesley's Chapel is situated on City Road. Nearest Underground Stations:- Old Street (Exit 4), Moorgate and Liverpool Street. Buses:- 5, 43, 55, 76, 141, 214, 243, 271, 505

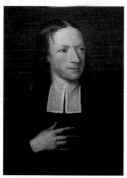

▲ John Wesley's House

▲ John Wesley
(1703-1791), painted by
Hunter, 1765

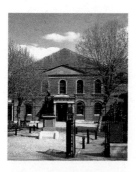

▲ Wesley's Chapel

▲ The Electrical
Machine, used by
Wesley in shock
therapy!

# RANGER'S HOUSE

Chesterfield Walk, Blackheath, London SE10 8QX
Telephone 0181 8530035 Fax 0181 8530090

Just a short walk from the historic attractions of Greenwich sits Ranger's House, a handsome red brick villa with panelled interiors, dating from the early 18th century.

Originally built for Admiral Francis Hosier, the most famous resident was, perhaps, the notorious Lord Chesterfield of whom Doctor Johnson wrote: "he has the manners of a dancing master and morals of a whore".

On the ground floor are the Stone Hall, two parlours, the dining room and Lord Chesterfield's stunning gallery which displays the magnificent Suffolk Collection of paintings.

Bequeathed to the nation by the 19th Countess of Suffolk, the collection includes stunning full-length Jacobean portraits with their exquisite costume details.

The first floor gallery plays host to visiting artists and craftspeople, many of whom are local, displaying works of a contemporary nature.

Previous exhibitors have included the Greenwich Printmakers, award winning textile artist Paddy Killer and

"Relative Values", an exhibition illustrating the changing role of portraiture through history as part of its national tour from the Harris Museum, Preston.

Further displays explore the history of the house and its inhabitants whilst the Architectural Study Centre, housed in the Coach House, displays an interesting collection of domestic architectural features from London dwellings of the 17th to 19th centuries.

### Opening times

Open daily
April to September
10.00am to 6.00pm
October
10.00am to 5.00pm
Wednesday to Sunday
November to March
10.00am to 4.00pm
(last admission 30 minutes before closing)
Closed 24th, 25th and 26th December,
4th to 17th January '99

### Directions

By Train: turn left outside Greenwich Station and right by the Ibis Hotel or walk through Greenwich Park. By Car: Ranger's House is accessible off the A2 at Blackheath.

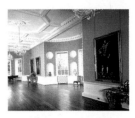

▲ Lord Chesterfield's Gallery

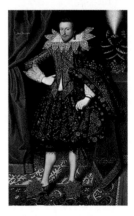

▲ Edward Sackville, 4th Earl of Dorset. Attributed to William Larkin (d. 1619)

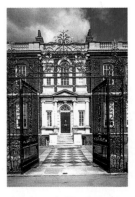

▲ Ranger's House - view from Blackheath

# THE HORNIMAN MUSEUM & GARDENS

100 London Road, Forest Hill, London SE23 3PQ
Telephone 0181 699 1872 Fax 0181 291 5506

The Horniman offers a varied programme of activities which we hope has something to interest everyone.

These activities support the museums aim to encourage a wider appreciation of the world, its people, their cultures and its environment.

Entrance to the museum is free, as are most of the activities.

There are three permanent exhibitions The Music Room, The Aquarium and The Natural History Gallery. Two new exhibitions are planned-African Worlds and Collectors.

The gardens offer superb views over London. It includes a water garden, a rose garden, an animal enclosure and several sundials.

CUE is an award-winning, innovative and environmentally friendly building. It is a delight to children and adults alike.

CUE has a dedicated team of volunteers who give up their spare time to help run CUE however we cannot guarantee that it will always be open so please call for current details.

The Library specialises in arts and crafts, anthropology, musical instruments and natural history. Photographs of museum objects may be ordered.

It is open to the public for reference purposes only. It is closed on Mondays and Bank Holidays. Please obtain a copy of our events leaflet for current activities, workshops and concerts details.

▲ Harrison Townsends striking art nouveux

### *Opening times*

Open
Monday to Saturday
10.30am to 5.30pm
Sunday
2.00pm to 5.30pm

### *Directions*

Buses 176, 185, 312, P4, 352, 122, P13, 63 stop at or near Museum. London Road (A205) is on the South circular. Forest hill Station is 5 minutes walk away.

▲ CUE (Centre for Understanding the Environment)

▲ The Walrus - a favourite exhibit for all

▲ The Music room with over 1500 musical instruments

## WILLIAM MORRIS GALLERY
Lloyd Park, Forest Road, London E17 4PP
Telephone 0181 5273782 Fax 0181 5277070

Today William Morris is best known for his wallpapers. But he was also one of Britain's most important designers of textiles, stained glass, carpets and furniture, as well as a prolific poet and dedicated Socialist.

This Georgian house, Morris's family home from 1848 to 1856, is now the William Morris Gallery.

It is the world's only museum devoted to Britain's best known and most versatile designer, with internationally important collections illustrating his life, achievements and influence.

Among outstanding exhibits are Morris's 'Woodpecker' tapestry;

▲ 'Lion Rampant' tile panel, designed by William De Morgan, 1888/1898

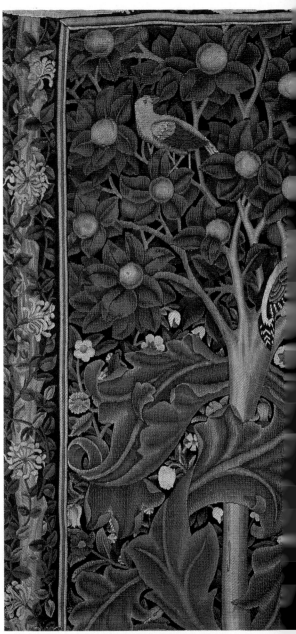

▲ Detail from 'The Woodpecker' tapestry, designed by William Morris, 1885

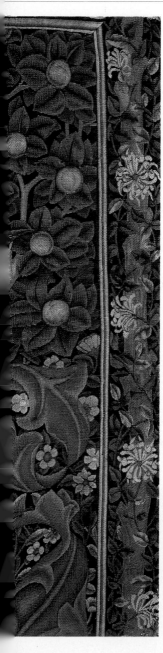

the 'Beauty and the Beast' tile panel; stained glass designed by Morris, Burne-Jones and others, as well as original designs for many of Morris's ever-popular wallpapers and textiles.

Displays also include works by Morris's followers in the Arts and Crafts Movement including ceramics by De Morgan and furniture by Mackurdo, Gimson and Voysey.
The collection of applied arts is complemented by Victorian and Pre-Raphaelite paintings and works by Frank Brangwyn, a founding benefactor of the Gallery.

In addition to the permanent displays the Gallery has a varied programme of temporary exhibitions which explore aspects of the work of William Morris and others in the Arts and Crafts Movement.

Admission is free. Nearest underground station: Walthamstow Central.

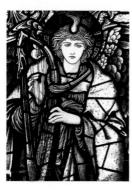

▲ 'Praising Angel' stained glass, designed by Edward Burne-Jones, 1878

### Opening times
Open
Tuesday to Saturday
10.00am to 1.00pm
2.00pm to 5.00pm and
first Sunday of Month
10.00am to 1.00pm and
2.00pm to 5.00pm

### Directions
From Walthamstow Central Station follow Hoe Street northwards to Bell Corner. Turn left into Forest Road. Gallery is then 200 yards on the right at the front of Lloyd Park.

◀ Water House, Walthamstow, built 1750. Now the William Morris Gallery

LONDON & MIDDLESEX

LONDON & MIDDLESEX

# PETRIE MUSEUM OF EGYPTIAN ARCHAEOLOGY
University College London, Gower Street, London WC1E 6BT
Telephone 0171 5042884 Fax 0171 5042886

The Petrie Museum is one of the largest, best documented and most fascinating collections of Egyptian Archaeology anywhere in the world.

There are over 80,000 artefacts, showing the development of Egyptian culture, technology and daily life from prehistoric to Roman times.

Most of these things were excavated and collected by Sir William Mathew Flinders Petrie (1853-1942), often called the 'Father of Archaeology'.

While other museums contain massive stone sculptures and monuments, the Petrie Museum is richest in the small things that illustrate daily life in ancient Egypt: Pottery, jewellery, toys, papyri, clothing.

The Museum welcomes groups but please ring to book. Admission is free.

## *Opening times*

Open
Tuesday to Saturday
1.00pm to 5.00pm
Please telephone to
confirm the times

▲ Earliest known dress in the world Tarkham, about 2800BC

▼ Seven bronze gold-dust or opium measures from Nubt, about 1500BC

▲ Wooden mummy portrait of a woman from Hawara, about 250AD

▲ Monumental limestone lion from Koptos, about 2600BC

## *Directions*

The Museum is on the first floor of the DMS Watson building, Malet Place, off Torrington Place (opposite Dillons University Bookshop).

# CHURCH FARMHOUSE MUSEUM

Greyhound Hill, Hendon, London NW4 4JR
Telephone 0181 2030130 Fax 0181 3592666

Church Farmhouse is Hendon's oldest remaining dwelling house, dating from 1660, with 19th century additions. It is Listed Grade II*.

The Museum is set in a small public garden in what remains of the old village of Hendon.

The Museum has three 19th century period furnished rooms - Kitchen, Laundry room and Dining room, and a Local History Gallery.

Four temporary exhibitions are held each year on local and social history and the decorative arts, some with special weekend events.

Each winter exhibition is especially aimed at children, and from December to January the Dining room is decorated for a Victorian Christmas.

A free audio taped tour of the Museum is available from the wide range of local history publications.

Party and school visits are welcome but groups should not exceed thirty people and must be booked in advance. (Teachers' notes and children's worksheets are available free, and the Museum also offers a free outreach service for local schools.)

Forthcoming exhibitions include 'Jigsaw Puzzles' and 'The Supernatural in Barnet Borough'.

### Opening times

Open all year
Monday to Thursday
10.00am to 12.30pm
1.30pm to 5.00pm
Saturday
10.00am to 1.00pm
2.00pm to 5.30pm
Sunday
2.00pm to 5.30pm
Closed Fridays,
Christmas Day, Boxing
Day, New Year's Day

### Directions

Greyhound Hill is reached either by turning off the A41 (Watford Way) going North from Hendon to Mill Hill or by turning off Church Road NW4 (A504) by Middlesex University.

▲ Church Farmhouse Museum, front view

▲ Church Farmhouse Museum and Garden

▲ Church Farmhouse Museum, Kitchen with open fireplace, c1820

▶ Church Farmhouse Museum, Dining room with Bible Stand, c1850

# APSLEY HOUSE:
# THE WELLINGTON MUSEUM

149 Piccadilly, Hyde Park Corner, London W1V 9FA
Telephone 0171 4995676 Fax 0171 4936576

Apsley House, home of the first Duke of Wellington, is one of the capital's finest residences.

Also known as 'Number One London' because it was the first house encountered past the toll-gate into London from the countryside, its sumptuous interiors house the Duke's outstanding collection of paintings, silver, porcelain, sculpture, furniture, medals and memorabilia.

From 1992-95 Apsley House was restored to its former glory as the private Palace of the 'Iron Duke'. Apsley House is the last great London townhouse with collections largely intact and family still in residence. Apsley House was designed by Robert Adam and built between 1771-78.

Here Wellington made his London home after a dazzling Military career in India, Spain and Portugal, culminating in his victory over Napoleon at Waterloo in 1815.

When he bought Apsley House in 1817 he was the most powerful Commander in Europe and his huge popular support gave him enormous political influence. Wellington enlarged the house to express his status, adding on the 90-foot-long Waterloo Gallery, and enriched it with his magnificent collection, creating a setting fit for a Duke.

---

### Opening times

Open
Tuesday to Sunday
11.00am to 5.00pm
(last admission 4.30pm)
Closed Monday
(except Bank Holidays),
Good Friday, May Day
Bank Holiday,
24th to 26th December
and New Year's Day

---

### Directions

By Underground: Hyde
Park Corner (Piccadilly
line exit 3). By Train:
Victoria Station
(15 minutes walk away).
By Bus: 2, 8, 10, 22, 36,
38, 52, 73, 74, 82, 137

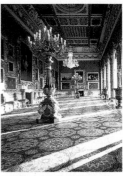

▲ The palatial Waterloo Gallery

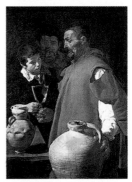

▲ The Waterseller of Seville by Diego Velazquez, c1620

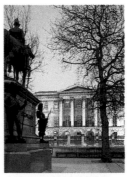

▲ Apsley House, the Wellington Museum at dusk

▲ Figure with a bowl from the Egyptian service

# CABINET WAR ROOMS

Clive Steps, King Charles Street, London SW1A 2AQ
Telephone 0171 9306961 Fax 0171 8395897

♿ ⬡

The Cabinet War Rooms were hurriedly converted in 1938-39 from a basement just off Whitehall to become emergency, underground accommodation to protect the British Prime Minister and his Government against air attack.

In operational use throughout the Second World War, they became the vital nerve-centre for Winston Churchill, his War Cabinet and his Chiefs of Staff during the greatest threat to its continuing existence the nation has ever known. Today, equipped with a free sound-guide, visitors can view the original twenty-one historic rooms just as they were before the lights were finally extinguished after six years of war.

These include the room used by Churchill's War Cabinet for meetings as the bombs rained down on London, the Spartan room kept for him to work and sleep in, and, next door, the Map room, abandoned in August 1945 and left totally intact, just as it was when it was a hive of activity of military planners.

The last display is devoted to the life and achievements of Winston Churchill during the

Second World War and comprises a selection of facsimiles of documents and photographs and a revolving exhibition of originals charting his political and personal life during these momentous years.

### *Directions*

Turn into Whitehall from Parliament square take first left (King Charles Street), follow the steps at the end of the road and turn sharp left at the bottom.

▼ Churchill in the Trans Atlantic Telephone Room

### *Opening times*
Open
April to September
9.30am to 6.00pm
October to March
10.00am to 6.00pm
Last admission 5.15pm
Closed 24th to 26th
December

▲ Views of
The Map Room

# THE WALLACE COLLECTION

Hertford House, Manchester Square, London W1M 6BN
Telephone 0171 9350687 Fax 0171 2242155

*Ope*

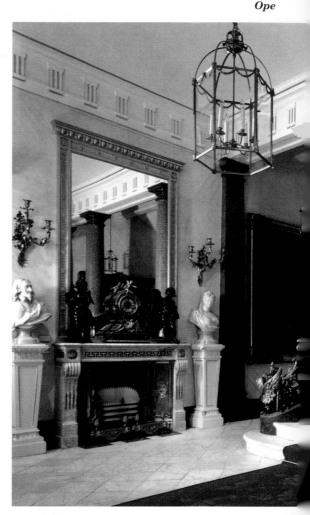

The Wallace Collection contains superb works of art displayed in an historic London town house. Many people regard it as their favourite place in the capital.

The collection was acquired principally in the 19th century by the 3rd and 4th Marquesses of Hertford and Sir Richard Wallace, the illegitimate son of the 4th Marquess.

It was bequeathed to the nation by Sir Richard's widow in 1897 and is displayed on two floors of Hertford House, the family's main London residence.

The twenty-five rooms present unsurpassed collections of French 18th century painting, furniture and porcelain together with Old Master paintings by, among others, Titian, Canaletto, Rembrandt, Hals, Rubens, Velázquez and Gainsborough.

A magnificent collection of princely arms and armour is shown in four galleries and there are further important displays of gold boxes, miniatures, French and Italian sculpture and fine mediaeval and Renaissance works of art, including maiolica, glass, Limoges enamels, silver and jewellery.

By the terms of Lady Wallace's bequest nothing must be added or loaned to the Collection. This provision has preserved the remarkable character of one of the greatest collections ever made by an English family.

▲ Entrance Hall showing the grand staircase

▶ Exterior of Hertford House

### Opening times

Open Monday to Friday
10.00am to 5.00pm
Sunday 2.00pm to
5.00pm Closed 1st
January, Good Friday,
May Day and 24th to
26th December

▲ Sir Richard Wallace's
Front State Room
(Gallery 5)

### Directions

Situated on Manchester
Square off Duke Street
which runs down the
right hand side of
Selfridges Department
store.

▲ Gallery 22

# GUNNERSBURY PARK MUSEUM

Gunnersbury Park, Popes Lane, London W3 8LQ
Telephone 0181 9921612 Fax 0181 7520686

Step inside Gunnersbury Park Museum, the beautiful former home of the Rothschild family and you will find a wealth of material illustrating many aspects of life from the past.

The collections represent social history, local industries, fashion through the ages, childhood and much more.

Set in 186 acres of parkland, there are ruins and follies to discover, as well as a boating lake, pitch and putt golf course and children's playgrounds.

There is a programme of changing exhibitions, including: 'Treasures', 'Mrs Beeton's Business', and 'The Rothschilds at Gunnersbury', as well as permanent displays.

Look out for special events when you can meet the Victorian servants and find out what life was really like backstairs.

Our Victorian kitchens are a contrast to the grand house and full of Victorian domestic objects (open Summer weekends only).

The Museum's Education Service offers workshops for school children. They can learn about the past through objects, drama, costume and music.

Adult groups can book guided tours of the house. (Information and bookings 0181 992 2247).

If you're looking for an unusual venue for a party or reception, the Terrace Room or glass fronted Orangery in historic Gunnersby Park can be hired at very reasonable costs. Phone for details.

## Opening times

Open April to October
1.00pm to 5.00pm
(weekends and
Bank Holidays
1.00pm to 6.00pm)
Last admission 15
minutes before close
November to March
1.00pm to 4.00pm

## Directions

Sited in Gunnersby
Park, off Pope's Lane.
Nearest Tube Station:
Acton Town.
Gunnersbury Park is
near the junction of the
A4, M4, North Circular.

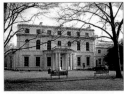

▲ Gunnersbury Park Museum once home to the Rothschild family

▲ A special event in the Museum's original 19th century kitchens

▲ Finding out what life was like as a Victorian servant

▶ Part of the Victorian dolls house in the 'Treasures' exhibition

## BEN URI ART SOCIETY
126 Albert Street, Camden Town, London NW1 7NE
Telephone 0171 482 1234 Fax 0171 4821414

The aim of the society, which is a Registered Charity founded in 1915, is to promote Jewish Art as part of the Jewish cultural heritage.

The Gallery provides an important showcase for contemporary exhibitions, as well as from the society's own collection of over 800 works by Jewish Artists including Auerbach, Bomberg, Epstein, Gertler, Kossoff, Kramer and Pissarro.

A new catalogue of the collection was published in 1994 (£18+p&p) and all works are accessible on CD-Rom.

The society is in temporary offices in Camden Town, pending the building of a new Jewish Arts and Cultural Centre in London. In the meantime various exhibitions are shown in a variety of venues, mainly in London. Visitors should phone for details of the current programme.

The collection is also used as a vital source of information for students researching the work of Jewish Artists.

Teachers packs for Key Stages I, II and III and Research Packs for GCSE and 'A' Level are available at no charge.

Access to the library of books on Jewish Artists and the Jewish Artists index of over 4,000 names can be arranged.

### Opening times

During Exhibitions
10.00am to 4.00pm
Sunday to Thursday
Office Open
10.00am to 4.00pm
Monday to Thursday
except Jewish and
Bank Holidays

### Directions

Northern Line to Camden Town, walk right up Parkway and take second turning on left to Albert Street or Buses 24, 27, 29, 31, 124, 168, 214, 253 Camden.

▲ The Day of Atonement by Jacob Kramer (1919), pencil/ink

▲ Two Rabbis with the scrolls of the law, Emmanuel Levy

▲ Untitled abstract by Robert Helman

▲ The Sabbath Rest by Samuel Hirszenberg (1894), oil on canvas

**297**

*London & Middlesex*

# NATIONAL ARMY MUSEUM
Royal Hospital Road, Chelsea, London SW3 4HT
Telephone 0171 7300717 Fax 0171 8236573

At the National Army Museum you can discover some of Britain's finest military treasures.

The Museum offers a unique insight into the lives of Britain's soldiers, from Privates to Field Marshals, from Tudor times to the present day.

The displays include weapons, paintings, equipment, models, medals and one of the world's largest collections of military uniforms.

You can see life on the Western Front in a reconstruction trench and also learn how soldiers coped with conditions as varied as the jungles of Burma, the mountains of Afghanistan, the plains of India, the snows of Canada and the deserts of Kuwait.

The fascinating exhibits on display include nine Victoria Crosses, a 50 square metre model of the Battle of Waterloo, Florence Nightingale's jewellery, even the skeleton of Napoleon's horse!

A new Gallery (opening Spring 1999) looks at the modern British Army and is packed with interactive exhibits.

The Museum is situated in the heart of historic Chelsea, just a short walk from Sloane Square and the famous King's Road and admission is free.

---

### Opening times

Open daily
10.00am to 5.30pm
Closed 1st January,
Good Friday, early May
Bank Holiday,
24th to 26th December

---

### Directions

Nearest tube is Sloane Square then a ten minute walk: Down King's Road, turn left at Smith Street and continue until you reach Royal Hospital Road where the Museum is.

---

▲ Life-size model of an English Civil War Cavalryman

▲ Try on a Civil War Helmet in the 'Redcoats' Gallery

◄ Model Rifleman as depicted in ITV's "Sharpe" series

▼ 18th century model Howitzer from the Museum's Indian Army Exhibition

## ST. JOHN'S GATE

(Museum of the Order of St. John), St John's Lane,
Claskenwell, London EC1M 4DA
Telephone 0171 2536644 Fax 0171 3360587

Tudor Gatehouse, Grand Priory Church, 12th century Crypt and Museum. Fascinating insight into religious, medical and military history of the Order of St. John, from the crusades to present day.

Includes rare 16th century wooden spiral staircase, Maltese silver and furniture, armour, pharmacy jars, prints, drawings and paintings relating to the history of the Hospitaller Knights of St. John.

St. John's gate also has historic associations with Shakespeare, Hogarth, Cave and Dr. Johnson. Collections include Order's modern work - St. John Ambulance on which there is a new multimedia interactive exhibition opening Spring 1999, and St John Ophthalmic Hospital in Jerusalem.

### *Directions*

St. John's Gate is approximately 500 metres north of the centre of Smithfield Market, and close to the Barbican. The nearest tube station is Farringdon.

▲ The Chapter Hall

▲ Crypt of the Grand Priory Church, South Chapel, c1185

▲ The Cloister Garden

▼ St. John's Gate, 1504

### *Opening times*

Open all year
Monday to Friday
10.00am to 5.00pm
Saturday
10.00am to 4.00pm
Tours (Guided) Tuesday,
Friday and Saturday
11.00am to 2.30pm
Close Christmas, Eater,
Bank Holiday
Monday/Weekends
and Sunday

## LONDON TRANSPORT MUSEUM

Covent Garden, London WC2E 7BB
Telephone 0171 379 6344 Fax 0171 565 7253
Website www.ltmuseum.co.uk

The London Transport Museum tells the fascinating story of the world's oldest and most famous transport system and its effect on the lives of Londoners.

Colourful displays of trams, bus and train simulators and touch-screen computers.

Every day, visitors to the Museum can meet characters from the past 200 years including a Victorian street sweeper and a World War II bus conductress.

15 giant hands-on KidZones combine fun and learning for kids and families. There are things to push and pull, lights to switch on and off plus feely boxes, sliders, magnifiers and more. There's also a Funbus for children under five.

There's a changing programme of events and activities with something for everyone, from special exhibitions, actors and guided tours to film shows and gallery talks.

During the school holidays there's lots of things for kids to do such as craft workshops, story telling or face painting, all included in the price of admission.

Stop off at the Museum cafe overlooking Covent Garden Piazza for light refreshments and pop into the shop for an inspiring range of unusual gifts from posters and postcards to Tube map ties and aprons.

▲ Spectacular displays of buses at the London Transport Museum

### Opening times

Open daily
10.00am to 6.00pm
(Friday 11.00am
to 6.00pm)
Closed 24th to
26th December
(Last admission 5.15pm)

### Directions

Located in the heart of London's Covent Garden. Nearest Tube: Covent Garden or Leicester Square. Bus: to Strand or Aldwych. Nearest Train Station: Charing Cross.

▲ Plenty for children to do at the London Transport Museum

▲ Kids play on the Funbus at the London Transport Museum

◀ Children play with KidZones at the London Transport Museum

Photography: Richard Kalina

# THEATRE MUSEUM

Russell Street, Covent Garden, London WC2E 7AB
Telephone 0171 8367198 Fax 0171 8365148

The Theatre Museum houses the world's largest and most important collection of material relating to the British stage. Enjoy the unrivalled collections of costumes, paintings, photographs and other theatrical memorabilia.

Whether on your own or in a group, the variety of displays and our new daily tour guide service, costume workshops, and make-up demonstrations, promise fun and interest for everyone. All activities are free with museum admission ticket.

The Theatre Museum's outstanding permanent collections include exhibitions on the development of the British stage and its Stars from Shakespeare to the present day, with reconstructions of early theatres including the 1614 Globe. From November we open our newly refurbished foyer with an exhibition on Greek Theatre - A Stage for Dionysos.

In the main Galleries an exhibition on stage design Exploding Tradition focuses on the work of Tanya Moiseiwitch, one of the key practioners to realise the vision of 19th century designer Edward Gordon Craig.

### Opening times
Open
Tuesday to Sunday
11.00am to 7.00pm
(last admission 6.30pm)

### Directions
Nearest Underground: Covent Garden.
British Rail: Charing Cross Station.
Bus to Aldwych or Strand 1, 6, 9, 11, 15, 77, 77a, 176.
The Museum is 5 minutes walk from Covent Garden Tube Station, opposite the Royal Opera House.

▲ Gordon Craig's model for a staging of Bach's St Matthew Passion lit by E Craig 1972

▼ Costume Workshop at the Museum

# GRANT MUSEUM OF ZOOLOGY & COMPARATIVE ANATOMY

Darwin Building, University College London, Gower Street, London WC1E 6BT
Telephone 0171 5042647 Fax 0171 3807096

The Zoology Museum at University College London is named in honour of its founder Robert Grant, who was the first professor of Zoology in Britain, at U.C.L.

The Museum opened in 1828 with the college, and remains the only Zoology Museum left in the London Universities. The collection comprises a wealth of over 30,000 specimens, covering the whole range of the animal kingdom.

It includes many rare and extinct specimens, for example it houses the skeleton of a Quagga, an extinct species of Zebra, one of only seven in the world.

The Museum also has relatively large collections of both Dodo bones and Thylacine, the Marsupial wolf, material.

The main use of the collection is for enhancing the understanding and knowledge of the animal kingdom.

This is a specialist teaching collection, although interested members of the public, especially school parties, are welcomed!

### Opening times
Open
9.00am to 5.30pm
Weekdays except
Bank Holidays
By prior
appointment only

### Directions
The Grant Museum is on Gower Street. Walk southwards down Gower Street, past the main entrance to UCL and enter the Biology Department. Museum is on your right. Nearest tube: Euston Square.

▲ Skeleton of turtle, Chelydra Serpentina

▲ Skeleton of six banded Armadillo, Dasypus Sexcinctus

▼ The exotic butterfly, Morpho Retenor

▲ Preserved specimen of a juvenile Limulus or horse show crab

# BURGH HOUSE - HAMPSTEAD MUSEUM
New End Square, Hampstead, London NW3 1LT
Telephone 0171 4310144 Fax 0171 4358817

Located in the heart of old Hampstead, Burgh House is a Queen Anne Grade I Listed building erected in 1703. It contains much original panelling, a fine staircase with "Barley sugar" balusters, and the Music room has 18th century panelling believed to come from the adjacent Weatherall House (now demolished).

Home to many professional families, it survived the bombs of WWII, but after being bought by the Local Council languished when extensive dry rot was found.

After a local fund raising appeal, it was reopened by the Burgh House Trust as a Community Arts Centre, Meeting Place and Hampstead Museum.

The Art Gallery shows works by local artists and sculptors, whilst the museum has regularly changed displays on many aspects of local history, architecture and notable inhabitants.

Amongst the collection is a rare example of the 1930s Isokon "long chair" designed for the flats in Lawn Road,

original works by Helen Allingham, a Constable room, displays about Wartime Hampstead and the history of the house itself.

The Music room is hired for recitals, meetings, local societies, receptions, seminars and civil weddings.

Our licensed basement buttery features home cooking, and there is a Gertrude Jekyll inspired prize-winning terraced garden.

## *Opening times*

Open
Wednesday to Sunday
12.00pm to 5.00pm
Good Friday and
Bank Holiday Monday
2.00pm to 5.00pm
Closed Monday,
Tuesday and Christmas
fortnight
(last admission 4.45pm)

## *Directions*

Underground to Hampstead (Northern Line). Buses 46/268 to Hampstead High Street. Left from station and first left along Flask Walk or along Gayton Road. Museum in Burgh House at end.

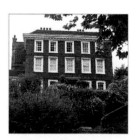

▲ Burgh House exterior showing terrace garden and Music room (left)

▼ Music room interior with panelling (18th century) from Weatherall House

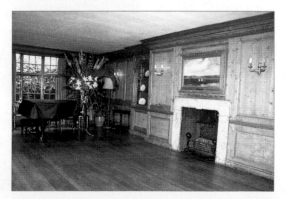

*LONDON & MIDDLESEX*

# ROYAL ACADEMY OF ARTS
Burlington House, Piccadilly, London W1V 0DS
Telephone 0171 3008000 Fax 0171 3008001

The Royal Academy of Arts, founded by George III in 1768, was the first institution in Great Britain devoted solely to the promotion of the arts.

For more than 200 years the Royal Academy has played a national role in the visual arts and today it welcomes up to one million visitors a year.

The Royal Academy enjoys an unrivalled reputation as a venue for exhibitions of international importance which are held in the Main Galleries and the Sackler Wing at Burlington House, Piccadilly, where the RA moved to in 1868.

The Royal Academy has eighty Royal Academicians who are all practising painters, sculptors, printmakers or architects. Students at the Royal Academy Schools have included Turner, Constable, Millais and Caro.

The annual Summer Exhibition, open to all artists of distinguished merit, has been held every year without interruption since 1769 and attracts around 10,000 entries, over 1,000 of which are hung and the majority are for sale.

▶ The Royal Academy of Arts courtyard

### Opening times
Open throughout
the year
(except December 25th)
10.00am to 6.00pm
(last admission 5.30pm)
Also open late night once
a week, please check
with reception on
0171 3008000

### Directions
Situated near Piccadilly Circus, the Royal Academy can be reached by underground - Green Park or Piccadilly Circus - or by bus number - 9, 14, 19, 22 and 38.

▶ Visitors enjoying the annual Summer Exhibition

▲ Sir Joshuna Reynolds, founder of the Royal Academy

# BARBICAN ART GALLERY
Gallery Level 3, Barbican Centre, Silk Street, London
EC2Y 8DS
Telephone 0171 3827105 Fax 0171 6280364

Situated within the Barbican Centre, Barbican Art Gallery is an oasis in the midst of the city, providing access to culture in the hubbub of London's financial centre.

There is a diverse exhibition programme; each year the Gallery hosts between four and six exhibitions covering an inspiring variety of subjects and art forms from fine art to fashion, painting to photography, design to decorative arts, exploring both our own and other cultures.

As the Gallery is situated in the Barbican Centre there are plenty of places to eat. Searcy's Restaurant is a three star restaurant open for lunch and evening meals, the Balcony and the Waterside Cafes are open all day and are convenient for coffee and lunch.

The Gallery runs an active programme of talks and events for each exhibition for individuals as well as schools and colleges.

▶ Vasily Kandinsky, Composition no.218, 1919

### Opening times

Open Monday, Thursday to Saturday 10.00am to 6.45pm
Tuesday 10.00am to 5.45pm
Wednesday 10.00am to 7.45pm
Sunday & Bank Holidays
(last admission 15 minutes before closing)

### Directions

Moorgate and Barbican are the closest tube stations to Barbican Art Gallery.

▶ Kazimuir Malevich, Suprenatism no. 58, 1915-16

▲ Pablo Picasso, self-portrait with "Man Leaning on a Table"

# VICTORIA AND ALBERT MUSEUM
Cromwell Road, South Kensington, London SW7 2RL
Telephone 0171 9388500 Fax 0171 9388379

The Victoria and Albert holds one of the world's largest and most diverse collections of the decorative arts. A pioneer of its time, the Museum was founded in 1852 to support and encourage excellence in art and design.

Today, 146 galleries contain unrivalled collections dating from 3000 BC to the present day. Furniture, fashion, textiles, paintings, silver, glass, ceramics, sculpture, jewellery, books, prints and photographs illustrate the artistic life of many different cultures from around the world.

The Museum's magnificent Victorian and Edwardian building also contain the National Library and some of Britain's best national collections including sculpture, glass, watercolours and the art of photography.

Superb highlights for any visit should include: The Museum's collection of Italian Renaissance sculpture, the largest

▲ Pirelli Garden at night

▲ The Dying Slave, the V&A Cast Courts

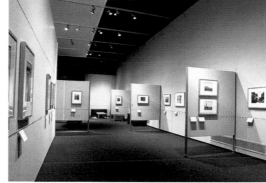

outside Italy; paintings and drawings by 19th century artist John Constable; the sparkling Glass Gallery; and the Dress Gallery, covering over four hundred years of fashion from the mid-16th century to the present day.

▲ The new Canon Photography Gallery at the V&A Museum

### Directions

Underground: South Kensington. Buses: C1, 14 and 74 stop outside the Cromwell Road entrance.

### Opening times

Open
all year daily
10.00am to 5.45pm
Wednesday Late View
(seasonal)
6.30pm to 9.30pm
Closed 24th to 26th
December

▼ Family activities in the Silver Gallery

## THE OLD OPERATING THEATRE, MUSEUM & HERB GARRET

9a St Thomas' Street, Southwark, London SE1 9RY
Telephone 0171 9554791 Fax 0171 3788383

The Old Operating Theatre Museum is London's most intriguing historic interior - it is found in the Garret of St Thomas's Church, Southwark, on the original site of St Thomas's Hospital.

It consists of: The oldest surviving operating theatre in the country (dating to 1822) used in the days before anaesthetics and antiseptic surgery. The Herb Garret was used by the hospital's apothecary to store and cure herbs used in medicinal compounds.

A fascinating collection of objects revealing the horrors of medicine before the age of science. Includes instruments for cupping, bleeding, trepanning, and child-birth. New displays on mediaeval monastic health care, the history of St Thomas' and Guy's Hospitals, Florence Nightingale and nursing, medical and herbal medicine.

Why not visit the Surgical Arena with your friends (or foes) and volunteer a "patient" for a demonstration of Victorian Surgery? All group visits between 10 and 60 people- booked in advance include a presentation by one of the Curatoral Staff.

### Opening times

Open every day
10.00am to 5.00pm
(Last admission 4.00pm)
Closed Christmas Day,
occasionally we are
shut on Mondays,
Please ring to check

▼ The Herb Garret

### Directions

Go to London Bridge Tube Station, exit into Toole Street, turn left onto the Borough High Street, turn left and walk away from London Bridge. St Thomas' Street is the third turning on the left. (The same road as Guy's Hospital).

▲ The Old Operating Theatre of Old St Thomas's Hospital

▲ Amputation sawn and "Bone Nippers"

# MARKFIELD BEAM ENGINE & MUSEUM

Markfield Road, Tottenham, London N15 4RB
Telephone 0176 3287331 or 0181 800 7061
Educational Charity 290 486

The 100 horse power Beam Pumping Engine is a fine example of Victorian public health engineering.

Built in 1886 to transfer 4 million gallons per day of sewage to the London system for treatment at Beckton outfall works. Now restored to full working order, with a video recording shown on non-steaming days.

Much of the outdoor works from before 1900 remain to be seen. A small exhibition relates to the development of Beam Engines over 200 years along with history of water supply and disposal in Greater London.

A short talk and guided tour are provided. A more detailed lecture can be provided for parties on the history, social implications, and engineering involved.

Markfield Museum is seeking to extend its membership of friends interested in the display of working examples of engineering, past, present and future developments which may affect the infrastructure of every day life.

This is to be achieved through the development plan for a new type of centre and museum for science engineering and technology providing selected facilities and services as part of the life long learning experience which will include the practice, application and demonstration of a variety of skills.

## *Opening times*

Open March to November (second Sunday of month) 11.00am to 3.00pm Last admission 2.30pm Other times and days by prior arrangement Parties by appointment

## *Directions*

Train, Bus, Underground, to south Tottenham, Tottenham Hale, Seven Sisters. Seven minutes walk from Broad Lane to end of Markfield Road. Turn left along Granite Set Road to Engine House.

▲ North end of Engine

▲ South end of Engine

▲ Parallel motion

▲ Engine Governor

LONDON & MIDDLESEX

# COURTAULD INSTITUTE OF ART
Courtauld Gallery, Somerset House, Strand, London WC2R 0RN
Telephone 0171 8732526 Fax 0171 8732589

The Courtauld Gallery at Somerset House holds one of the best collections of Impressionist and Post-Impressionist paintings in the world.

Among the paintings are Manet's Bar at the Folies Bergéres, Renoir's La Loge, Van Gogh's self portrait with bandaged ear, nine Cézannes, as well as masterpieces by Monet, Gauguin, Modigliani, Seurat and Degas.

It also has a fine collection of paintings from the Renaissance to the 18th century, including important works by Botticelli, Bellini, Rubens, Tiepolo, and the only full-length portrait by Goya in Britain.

The Gallery holds an important collection of Old Master Prints and Drawings and there are changing prints and drawing exhibitions throughout the year.

▲ Monet, Antibes

◀ Degas, Two Dancers on a Stage

▲ Cezanne, The Card Players

### Opening times

Open
Monday to Saturday
10.00am to 6.00pm
Sunday and
Bank Holidays
12.00pm to 6.00pm
(last admission 5.15pm)

### Directions

All buses to Aldwych.
Tubes: Temple,
Covent Garden.

Somerset House is
located on the
south side of
the Strand next to
Waterloo Bridge.

▼ Manet, A bar at the Folies-Bérgere

## ORLEANS HOUSE GALLERY

Riverside, Twickenham, London TW1 3DJ
Telephone 0181 8920221 Fax 0181 7440501

Overlooking the Thames, Orleans House Gallery is set in preserved natural woodland, less than half an hour from central London.

The Gallery comprises the 18th century Octagon Room and two surviving wings of the former Orleans House, now converted into an exhibition space.

This shows a changing programme of exhibitions, covering Contemporary Art and craft and the Borough Art Collection, which contains pieces by Masters such as Leighton, Corot and Tillemans.

Orleans House Gallery is a tranquil haven, reached easily from all parts of London and the South-East.

Our temporary Exhibitions programme for 1999, includes: "Light Play" - Contemporary craft workers exploring definitions of light - 16th January to 7th March. "Pallas Unveiled" - the Life and Art of Countess Burlington, 1699-1758 - 13th March to 3rd May. "Rich Living" - Contemporary use of historic houses, explored through photography - 8th May to 4th July. "Cynthia Pell : Retrospective" -

Exhibition organised by Museum of Women's Art - 10th July to 5th September. "Cultural Connections" - Contemporary interpretations of 19th century explorer, Sir Richard Burton - 11th September to 31st October. "2000 Aspirations" - artefacts of Remembrance from the 20th century - 6th November to 8th January 2000.

The Stables Gallery offers opportunities for local interest groups and artists to exhibit work and organise community-led workshops.

For further information about our activities programme, call 0181 8920221

### Opening times

Main Gallery Open
Tuesday to Saturday
1.00pm to 5.30pm
Sunday and
Bank Holidays
2.00pm to 5.30pm
October to March
close 4.30pm
Stables Gallery Open
same times April to
September inclusive

▶ The results of 'Outreach" sculpture workshops at a local school

### Directions

Mainline - Rail Access: St. Margaret's/Twicken from Waterloo. Underground access: Richmond (District Line). Call for more details of bus routes. You will find us in Twickenham, in a London A-Z.

▲ Orleans House showcases all forms of Contemporary Art and Craft

▲ Learning to sculpt like William Tucker

# WIMBLEDON LAWN TENNIS MUSEUM

All England Lawn Tennis & Croquet Club, Church Road,
Wimbledon, London SW19 5AE
Telephone 0181 9466131 Fax 0181 9446497

The Museum is located within the grounds of the All England Lawn Tennis and Croquet Club, home to The Championships each Summer - the world's leading tennis Tournament. A visit to the Museum enables you to re-live some of those special Wimbledon moments from past Championships.

Highlights include an opportunity to view the world-famous Centre Court and the actual Championship Trophies, as well as pictures, equipment, costume, film and video footage of great players from the 1920s to the present day, and other tennis memorabilia.

The Museum tells how the gentle game of lawn tennis, once all the rage on the lawns of Victorian England, with origins that go far back to mediaeval Royal tennis, has grown to become a multi-million dollar professional sport, played all over the world. As the story unfolds the Museum's rich and fascinating collection reveals the history of the game.

The Museum shop sells a wide variety of tennis gifts, exclusive Wimbledon leisure wear and souvenirs.

▶ Racket maker's workshop, c1900

Visitors can also enjoy morning coffee, a light lunch or afternoon tea in the pleasant and relaxing surroundings of the traditional Tea Room open all year.

### Opening times
Open daily
10.30am to 5.00pm
throughout the year.
Close Christmas Eve/Day
Boxing Day, New Year's
Day and during The
Championships, only
open to those visiting the
Tournament.

### Directions
Take District Line on
underground to
Southfields. Museum is
15 minute walk. Take
train or tube to
Wimbledon station and
either take a taxi or
walk for 25 minute.

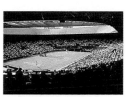

▲ The world famous Centre Court during the Championships

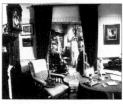

▲ View through the Victorian parlour to the garden party beyond

▲ The modern section: 1930s to 1950s

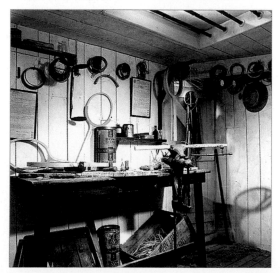

## MUSEUM OF ARTILLERY IN THE ROTUNDA

Repository Road, Woolwich, London SE18 4DN
Telephone 0181 781 3127 Fax 0181 3165402

A unique display of artillery from the 14th century to present-day, including presentation pieces and those involved in conflict worldwide.

Since 1716 Woolwich has been the home of the Royal Regiment of Artillery and the collection was begun in 1778 as a training aid for the artillery officers.

From a wrought-iron cannon salvaged from Henry VIII's Mary Rose to guns from the two World Wars and later, the collection represents major developments in artillery over the centuries, culminating in modern missile systems and the Iraqi 'supergun'.

Artillery from as far afield as China and Burma are displayed alongside European and American pieces. Among the most striking exhibits are a gun and limber presented to Queen Victoria by Emperor Napoleon III, a Burmese Dragon gun and a pair of ornate Sikh cannon.

The Rotunda is a stunning Grade 2* listed building designed by the celebrated Regency architect John Nash.

FIREPOWER! - a new Museum of Artillery will open at the Royal Arsenal in 2001, displaying the guns currently at the Rotunda together with the artefacts, photographs, books, documents and medals which are now inaccessible to the public. For further information please contact Eileen Kinghan or Sophia Galitzine on 0181 8557755

### Opening times

Open Monday to Friday
1.00pm to 4.00pm
(last admission 3.30pm)

### Directions

The Museum is in Repository Road, close to Woolwich Common. The nearest railway station is Woolwich Dockyard, on the Charing Cross to Dartford line, taxis and buses run from Woolwich Arsenal.

▲ The Rotunda

▲ Thunderbird missile system outside the Rotunda

▲ Two heavy anti-aircraft guns (World War II)

▲ Royal Arsenal Site: Old Royal Military Academy

# KEW BRIDGE STEAM MUSEUM

Green Dragon Lane, Brentford, Middlesex TW8 0EN
Telephone 0181 5684757 Fax 0181 5699978

What did "Gardy Loo" mean and how old is the New River? Our fascinating "Water for Life" Gallery has the answers in its examination of 2,000 years of London's water. From Roman times to the modern Thames Water ring main (there's a slice you can walk through) discover how sewer toshers made a precarious living scavenging down below and how Cholera's cause was revealed.

Housed in an important Victorian water works, the Museum also contains the mighty steam engines used to supply London's water for over a century.

These giants of the Steam Age include the world's largest working steam pumping engine. Visitors can see these leviathans at work every weekend, operated by our team of volunteers.

A lively schools programme covers many aspects of the National Curriculum and a number of family special events are organised each year.

Many Victorian water works had their own Railway system and a short line is demonstrated on selected weekends. The

Museum is also available for private and corporate evening events.

Operated by a charitable Trust, the Museum relies on volunteers and is always keen to welcome new faces.

### Opening times

Open all year daily
11.00am to 5.00pm
(last admission 4.30pm)
Closed Good Friday and
week prior to Christmas
Coffee shop opened at
weekends only

### Directions

M4 to junction 2, A4 to
Chiswick roundabout,
take 4th exit (A205),
straight ahead at next
two sets of traffic lights,
then first right into
Green Dragon Lane.

▲ The Steam Hall houses 4 large rotative steam pumping engines

▲ World's largest working steam pumping engine built in 1846

▲ "Water for Life" - our popular new exhibition on London's water

◄ Museum's 200ft high Standpipe Tower

## H M TOWER OF LONDON
London EC3N 4AB
Telephone 0171 709 0765

Over 900 years old home to world famous Crown Jewels, Royal Armour, Beefeaters and Ravens. Daily talks and tours plus special holiday events for families, see adverts for details. Limited facilities for the disabled. Restaurant on Wharf outside serving cold snacks only.

*Opening times* Open March to October (incl) Monday to Saturday 9.00am to 6.00pm, Sunday 10.00am to 6.00pm. November to February (incl)Tuesday to Saturday 9.00am to 5.00pm, Monday and Sunday 10.00am to 5.00pm (last admission 1 hour before closing). Closed 24th to 26th December and 1st January

## LIVESEY MUSEUM
682 Old Kent Road, London SE15 1JF
Telephone 0171 639 5604 Fax 0171 277 5384

The Livesey is a lively hands-on museum especially for under-12's, showing one major exhibition a year accompanied by a full workshop and education programme. Only partial facilities for disabled people.

*Opening times* Open Tuesday to Saturday 10.00am to 5.00pm (last admission 4.30)

## CARLYLE'S HOUSE (THE NATIONAL TRUST)
24 Cheyne Row, London SW3 5HL
Telephone 0171 352 7087

Part of a terrace in a quiet backwater of Chelsea, this Queen Anne house was the home of Thomas Carlyle. This house which contains the original furniture and many books, portraits and relics of his day. Guided tours by prior arrangement.

*Opening times* Open April to end October daily except Mondays and Tuesdays. Closed Good Friday but open all Bank Holiday. 11am to 5pm (last admission 4.30pm)

## PERCIVAL DAVID FOUNDATION OF CHINESE ART (UNIVERSITY OF LONDON)
53 Gordon Square, London WC1H 0PD
Telephone 0171 387 3909 Fax 0171 383 5163

The finest collection of Chinese ceramics outside China reflecting Chinese court taste and dating mainly to the period 10th to 18th Century.

*Opening times* Monday to Friday 10.30am to 5pm. Closed Weekends and Holidays

## THE SAATCHI GALLERY
98a Boundary Road, London NW8 0RH
Telephone 0171 624 8299

The gallery draws from a collection of over one thousand paintings, sculptures and installations. The Saatchi Gallery focuses on young British Art aiming to introduce new art to a wider audience.

*Opening times* Open 12.00pm to 6.00pm Thursday to Sunday (last admission 5.45pm) Admission £4 or Concessions at £2

## THE CRYSTAL PALACE MUSEUM
Anerley Hill, London SE19 2BA
Telephone 0181 676 0700

The museum tells the story of The Crystal Palace from 1851 to 1936. Open during weekday's by special appointment for school visits.

*Opening times* Open 11.00am to 5.00pm every Sunday and Bank Holiday Monday throughout the year

## CAMDEN ARTS CENTRE
Arkwright Road, London NW3 6DG
Telephone 0171 435 2643 Fax 0171 794 3371

The centre is a venue for contemporary visual art and education. Our programme of exhibitions, on-site projects and artist-led activities offers an opportunity to look, to make and to discuss.

*Opening times* Open Tuesday, Wednesday, Thursday 11.00am to 7.00pm, Friday, Saturday, Sunday 11.00am to 5.30pm. Closed Mondays

## THE QUEENS GALLERY
Buckingham Palace, London SW1A 1AA
Telephone 0171 839 1377 Fax 0171 930 9625

A diverse programme of exhibitions from The Royal Collection are mounted each year. Mark Catesby's Natural History of America and The Kings Head, portraits of Charles I feature in 1998 and 1999.

*Opening times* Open every day during exhibitions (except 25th and 26th December) 9.30am to 4.30pm (last admission 4.00pm). Gallery shop open every day (except 25th and 26th December) 9.30am to 5.00pm

## DULWICH PICTURE GALLERY
College Road, London SE21 7AD
Telephone 0181 693 5254 Fax 0181 693 0923

Described recently as "The most beautiful small gallery in the world" by the Sunday Telegraph. The gallery's important collection of 17th and 18th century Old Masters is closed for refurbishment until May 2000.

*Opening times* Open May 2000 (Closed for refurbishment until this date)

## MCC MUSEUM
Lord's Ground, London NW8 8QN
Telephone 0171 289 1611 Fax 0171 432 1062

Unique collection of the history of cricket including The Ashes, conducted tours can sometimes also include the famous Long Room/ Restaurant nearby. Limited facilities for the disabled.

*Opening times* Open Cricket Season Match Days Monday to Saturday 10.00am to 5.00pm and Sunday 12.00pm to 5.00pm.
Also Conducted tours 12 noon and 2pm on most days throughout the year

LONDON & MIDDLESEX

## NATIONAL GALLERY
Trafalgar Square, London WC2N 5DN
Telephone 0171 747 2885
EMail information@ng-london.org.uk
Website http://www.nationalgallery.org.uk

The National Gallery was founded in 1824. It houses the national collection of Western European paintings dating from the 13th century to the end of the 19th century. Admission free.

*Opening times*  Open daily 10am to 6pm (Wednesday until 9pm). Closed 1st January, Good Friday and 24th to 26th December.

## PITSHANGER MANOR AND GALLERY
Mattock Lane, Ealing, London W5 5EQ
Telephone 0181 567 1227§ Fax 0181 567 0595

Home of the famous architect John Soane. The museum houses a large collection of Martinware and is a prestigious contemporary art gallery. A cultural centre with a comprehensive events programme.

*Opening times*  Open Tuesday to Saturday 10am to 5pm (last admission 4.45pm)

## EAST HAM NATURE RESERVE
Norman Road, East Ham, London E6 4HN
Telephone 0181 470 4525

London's largest churchyard. Explore the nature trail's. Discover the ancient parish church. Step back in time into a Victorian school room and wartime kitchen. Some special events throughout the year.

*Opening times*  Open all year Tuesday to Friday 10am to 5pm, Weekends in Summer 2pm to 5pm, Weekends in Winter 1pm to 4pm. Closed Bank Holidays & Christmas

## HOGARTH'S HOUSE
Hogarth Lane, Great West Road, London W4 2QN
Telephone 0181 994 6757

The artist lived in the house 1749 to 1764: A permanent exhibition of his engravings is displayed. Donations welcome.

*Opening times*  Open Tuesday to Friday 1pm to 5pm (November to March 1pm to 4pm) Saturday and Sunday 1pm to 6pm (November to March 1pm to 5pm) Closed Good Friday, Christmas Day, Boxing Day and month of January (last admission 15 minutes before close)

## ROYAL ARMOURIES AT H M TOWER OF LONDON
Royal Armouries, H M Tower of London, London EC3N 4AB
Telephone 0171 480 6358 Fax 0171 481 2922

Historic home of the Royal Armouries. Nine new galleries, tell the story of the Tower and its various institutions, including the 'Line of Kings' and armours of Tudor and Stuart monarchs including Henry Vlll and Charles I. Exhibitions throughout the year.

*Opening times*  Open daily, see opening times for H M Tower of London

## KEATS HOUSE MUSEUM

Wentworth Place, Keats Grove, London NW3 2RR
Telephone 0171 435 2062 Fax 0171 431 9293

John Keats romantic poet lived here from 1818 to 1820. The museum contains memorabilia of the poet and his fiancée Fanny Brawne. Admission free. Essential to phone prior to visit.

*Opening times* Open April to October Monday to Friday 10am to 1pm and 2pm to 6pm, Saturday 10am to 1pm and 2pm to 5pm, Sunday 2pm to 5pm.
November to March Monday to Friday 1pm to 5pm, Saturday 10am to 1pm and 2pm to 5pm and Sunday 2pm to 5pm

## INNS OF COURT & CITY YEOMANRY MUSEUM

10 Stone Buildings, Lincoln's Inn, London WC2A 3TG
Telephone 0171 405 8112

Exhibition of two centuries of the combined regiments' histories, including the only complete set of drums from the Napoleonic period.

*Opening times* Open by appointment only most weeks of the year

## GRANGE MUSEUM, LONDON BOROUGH OF BRENT

Neasden Roundabout, Neasden Lane, London NW10 1QB
Telephone 0181 452 8311 Fax 0181 208 4233

Tells the story of the Borough through the history of its diverse cultural communities. Housed in a 300 year old building. Large garden, safe play and picnic area. Free admission.

*Opening times* Open Winter (September to May)Monday to Friday 11.00am to 5.00pm, Saturday 10.00am to 5.00pm. Summer (June to August) Tuesday to Friday 11.00am to 5.00pm. Saturday 10.00 am to 5.00pm, Sunday 2.00pm to 5.00pm

## DEPARTMENT OF PORTRAITS AND
## PERFORMANCE HISTORY

Royal College of Music, Prince Consort Road, London SW7 2BS
Telephone 0171 591 4340 Fax 0171 589 7740

An extensive collection of portraits of musicians, comprising some 340 original portraits and 10,000 prints and photographs. Also general musical iconography. Important performance history archive (more than 600,000 programmes).

*Opening times* Open Monday to Friday 10.00am to 5.30pm by appointment

## WIMBLEDON SOCIETY MUSEUM OF LOCAL HISTORY

22 Ridgway, Wimbledon, London SW19 4QN
Telephone 01812969914

In our Award Winning museum we show you the three thousand year history of Wimbledon in pictures words and objects.

*Opening times* Open all year Saturday 2.30pm to 5.00pm or at other times by arrangement

## HMS BELFAST

Morgans Lane, Tooley Street, London SE1 2JH
Telephone 0171 940 6320 Fax 0171 403 0719

Explore all nine decks of Europe's only surviving big gun armoured warship from World War II. Visit the Captain's Bridge and Boiler and Engine rooms well below the ship's waterline. Please note only limited facilities for disabled people.

*Opening times* Open 7 days a week Summer (1st March to 31st October) 10.00 am to 6.00pm (last admission 5.15pm) Winter (1st November to 28th February) 10.00am to 5.00pm (last admission 4.15pm) Closed 24th to 26th December

## COLLECTION & LIBRARY OF THE WORSHIPFUL COMPANY OF CLOCKMAKERS

The Clock Room, Guildhall Library, Aldermanbury, London EC2P 2EJ
Telephone 0171 332 1865

A single room containing the oldest collection specifically of clocks and watches in the world. Includes the work of many celebrated makers, such as Tompion, Knibb, Sully, Harrison and Breguet.

*Opening times* Open throughout the year Monday to Friday 9.30am to 4.30pm except public holidays

## WOODLANDS ART GALLERY

90 Mycenae Road, Blackheath, London SE3 7SE
Telephone 0181 858 5847 Fax 181 858 5847

Ten exhibitions annually of contemporary art.

*Opening times* Open all year except Christmas period Monday to Saturday 11.00am to 5.00pm, Wednesday closed, Sunday 2.00pm to 5.00pm (last admission 4.45pm)

## THE MUSICAL MUSEUM

368 high Street, Brentford, London TW8 0BD
Telephone 0181 560 8108

An amazing collection of automatic musical instruments. Demonstrated live from small musical boxes, piano and band boxes to a mighty Wurlitzer. A trip down memory lane or an education.

*Opening times* Open Saturday to Sunday April to October incl. 2.00pm to 5.00pm

## THE JEWISH MUSEUM

Raymond Burton House, 129 - 131 Albert Street, Camden Town, London NW1 7NB
Telephone 0171 284 1997 Fax 0171 267 9006

Attractive galleries on Jewish history and religious life in Britain and beyond. One of the world's finest collections of Jewish ceremonial art. Special exhibitions. Group visits welcome by arrangement.

*Opening times* Open all year Sunday to Thursday 10.00am to 4.00pm (last admission 3.30pm). Closed Public Holidays and Jewish Festivals.

## GOLDEN HINDE EDUCATIONAL MUSEUM

The Golden Hinde, Saint Mary Overie Dock, Cathedral Street,
Southwark, London SE1 9DG
Telephone0541 505041 Fax 0171 407 5908

The Golden Hinde is open to the public and is also available for living history
experiences, tudor workshops, private parties, weddings, private and corporate hire
and school field trips.

**Opening times** Open daily 10.00am to 6.00pm except Christmas Day
(last admission 5.30pm) Please call first, prior to your visit as times may vary

## THE JEWISH MUSEUM - FINCHLEY

London's Museum of Jewish, 80 East End Road, Finchley, London
N3 2SY
Telephone 0181 349 1143 Fax 0181 343 2162

Lively "Hands on" social history displays on Jewish immigration and
settlement in London, including tailoring and furniture workshops. Moving exhibition
on British born holocaust survivor, Leon Greenman. School and group visits by
arrangement.

**Opening times** Open all year Monday to Thursday 10.30am to 5.00pm,
Sundays 10.30am to 4.30pm. Closed Jewish Festivals, Public Holidays and December
24th to January 4th. Closed on Sundays in August and Bank Holiday Weekends

## OLD SPEECH ROOM GALLERY

Harrow School, Harrow On The Hill, London HA1 3HP
Telephone 0181 869 1205 Fax 0181 423 3112

Repository for Harrow School varied and distinguished collection of antiquities and fine
art. Collections comprise Egyptian and Greek antiquities, English watercolours,
modern British paintings, sculpture, printed books and natural history.

**Opening times** Open every day except Wednesday during term time
2.30pm to 5.00pm

## SHAKESPEARE'S GLOBE EXHIBITION

21 New Globe Walk, Bankside, Southwark, London
SE1 9DT
Telephone 0171 902 1500 Fax 0171 902 1515

The fascinating story of the re-creation of Shakespeare's Globe, the most important
public theatre ever built. A unique opportunity to view the faithfully reconstructed
Elizabethan Theatre built 400 years ago.

**Opening times** Open daily May to September 9.00am to 12.30pm,
October to April 10.00am to 5.00pm

**LONDON & MIDDLESEX**

## VESTRY HOUSE MUSEUM

Vestry Road, Walthamstow, London E17 9NH
Telephone 0181 509 1917

Located in a Georgian workhouse and Victorian Police Station, the museum covers the history of Waltham Forest. The displays include the Bremer car, the first British built motor car.

*Opening times* Open all year Monday to Friday 10.00am to 1.00pm,
2.00pm to 5.30pm, Saturday 10.00am to 1.00pm, 2.00pm to 5.00pm.
Closed Sundays and Bank Holidays

## MUSEUM OF THE MOVING IMAGE

South Bank, Waterloo, London SE1 8XT
Telephone 0171 928 3535 Fax 0171 815 1419

Tells the whole story of film and television with hundreds of original treasures, movie clips and a cast of actor guides. Plus many hands-on exhibits. 24 hour recorded telephone info 0171 401 2636. Car parking nearby.

*Opening times* Open daily 10.00am to 6.00pm (last admission 5.00pm.
Closed 24th to 26th December

## VINTAGE WIRELESS MUSEUM

23 Rosendale Road, West Dulwich, London SE21 8DS
Telephone 0181 670 3667

There are over 1,000 radio sets on show in the museum spaced in over 13 rooms. Radios from the beginning up to the 1950's.

*Opening times* Open by appointment only, please ring for details

## MARBLE HILL HOUSE - ENGLISH HERITAGE

Richmond Road, Twickenham, Middlesex TW1 2NL
Telephone 0181 892 5115 Fax 0181 607 0641

Henrietta Howard, Countess of Suffolk and mistress to King George ll was the first owner of this glorious Palladian villa. You can enjoy the lavishly decorated Great Room, architectural paintings and furniture.

*Opening times* Open 1st April to 30th September, daily 10.00am to 6.00pm.
1st to 21st October daily 10.00am to 5.00pm.
22nd October to 31st March, 1999 Wednesday to Sunday 10.00am to 4.00pm
(closed 24th to 26th December & 4th to 17th January)

# NORFOLK

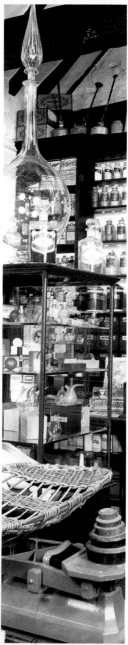

Norfolk is a county of nature reserves which stretch along the low-lying north coast, a county of wonderful skyscapes and as Noel Coward declared...flat. However, the land does rise gradually from east to west, coming to a sudden drop to the fenland on the Cambridgeshire and Lincolnshire border. To the east of Norwich are the Norfolk Broads, an area of glorious reedy lakes and meandering waterways, a popular haunt of small boat enthusiasts and birdwatchers, now the Norfolk Broads National Park. This is a region of picturesque windmills, once used to drain the farmland...most of them now regrettably defunct.The beauty of this county lies to a great extent in its isolation. Its fine coastline is little explored and is of great interest to the naturalist being Europe's largest expanse of saltmarshes. Norfolk, a highly efficient farming county was largely bypassed by the Industrial Revolution and its consequent urban development.

The jewel of the county is undoubtedly Norwich, the county town with its superb cathedral built in Caen stone, and its impressive Norman Castle. The castle, once a royal home houses one of the country's finest regional collection of archaeology and natural history, as well as a fine collection of the work of the Norwich School of painters. The lovely St. Peter Hungate Museum in Princes Street possesses an outstanding fifteenth century hammer beam roof as well as fine Norwich painted glass. There is a proud display of memorabilia associated with the County Regiment at The Royal Norfolk Regimental Museum, while two hundred years of the city's industry is wonderfully explained at the Bridewell Museum.

As one would expect in a county with such a pastoral background there are excellent rural life museums...one of the finest being The Norfolk Rural Life Museum at Dereham, in a former workhouse, concerned with the last 200 years of Norfolk's history and including a working farm with many rare breeds. Six acres of glorious gardens at Bressingham should on no account be missed...the fine working vintage steam engines being a bonus at the Steam Museum.

For such a wide and rural county Norfolk can claim a significant number of noble residents...it was here that King John lost his possessions and a large part of the country's exchequer...Anne Boleyn spent her childhood here...Lord Nelson was born here...as was Diana, Princess of Wales...The Queen has her country home here. Their stories, and many, many more are recorded in the museums and galleries of Norfolk.

# GRESSENHALL

Norfolk Rural Life Museum & Union Farm, Dereham, Norfolk NR20 4DR
Telephone 01362 860563 Fax 01362 860385

Spend a day in unspoilt Norfolk countryside and enjoy one of Britain's largest and most varied rural life attractions.

Our 50 acre site includes gardens, nature trails, a working traditional farm and extensive museum displays housed in former Georgian workhouse buildings.

Union Farm is worked by heavy horses and stocked with rare breeds of pigs, cattle, sheep and poultry.

The Museum's huge collection of bygones reflect 200 years of work on the land.

Find displays and recreations of rural life and trades such as the Smith, the Saddler and the Village shops.

▲ Follow the farming year in the Museum's spacious displays

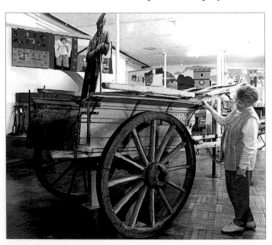

Cherry Tree Cottage, a furnished farm worker's home with coal-fired range and cosy parlour, lets you step back in time to the early 1900s. Our 1950s rooms, too, will bring back memories for many visitors.

See our award-winning workhouse exhibition and learn about the lives of the pauper inmates who once lived here.

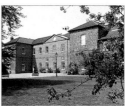

▲ Our handsome 1777 buildings were once the Gressenhall workhouse

### Directions

From Dereham Town Centre take right fork opposite George Hotel signposted North Elmham etc. After 1½ miles take left turn onto B1148 signposted Fakenham. Left turn to museum, one mile.

▲ Harvest time with Zebedee and Zulu, our Suffolk Punch Horses

Guided trails are often available with resources and special events for educational groups.

Regular events, demonstrations, cart rides, activities and quizzes make Gressenhall a great day out for young and old alike.

Phone for a leaflet with details of our many special events throughout the season.

▼ The wildlife garden is a treat for all ages

### Opening times

Open Easter to end of October daily 10.00am to 5.00pm Sunday 12.00pm to 5.30pm

NORFOLK

# BRESSINGHAM STEAM MUSEUM
Bressingham, nr Diss, Norfolk IP22 2AB
Telephone 01379 687386 Fax 01379 688085

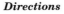

*Directions*

From South M11-A11 to
Thetford A1066 to Diss,
5 miles from Diss. From
West A14-A11 to
Thetford A1066 to Diss,
5 miles from Diss. From
North A1 to A17 to A47
Norwich A11 to
Thetford, A1066 to Diss.

There's simple nothing
to compare with
Bressingham! Where
else could you take your
pick of three different
narrow-gauge railway
rides, marvel at a
collection of magnificent
traction engines, or take
a trip back in time on a
gorgeously decorated
Victorian steam
roundabout? (Not all
rides are available every
day). And when you've
experience all the
thrilling sights, sounds
and smells of the steam
age, where else could
you wander through 6
acres of spectacular
gardens, with perennial-
packed island beds
cutting vivid swathes of
colour through the
lawn? The power of
steam, the glory of the
garden: it could only be
Bressingham!

▲ Gallopers Victorian
Roundabout, built 1890s
by Savages of Kings
Lynn

*Opening times*

Open
10.30am to 5.30pm
April to September
10.30am to 4.30pm
October (Last admission
one hour before closing)

▼ Black Prince Traction
Engine road locomotive,
built by Burrell 1904

◀ Oliver Cromwell
British Rail 70013, built
1951, Passenger Express
Locomotive

▶ Royal Scott L.M.S. No
6100, built 1927,
Passenger Express
Locomotive

# NORWICH CASTLE MUSEUM
Norwich, Norfolk NR1 3JU
Telephone 01603 493624 Fax 01603 765651

The ancient Norman Keep of Norwich Castle dominates the city and is one of the most important buildings of its kind in Europe.

▲ Norwich Castle Museum viewed from below the Castle mound

Once a royal castle, it now houses one of England's finest regional collections of art, archaeology and natural history.

Art lovers will delight in the work of the Norwich School of Painters and temporary exhibitions, including regular displays from the Tate Gallery collections, are held throughout the year.

The Museum's other collections feature many rare and precious objects from East Anglia's past such as the Snettisham gold torcs or the bones of the

enormous prehistoric West Runton elephant, a local find of international importance.

Not to be missed is the Twining Teapot Gallery which holds the world's largest collection of teapots.

The Museum also holds many fine examples of contemporary craft and ceramics, some examples of which can be found for sale in the well-stocked gift and souvenir shop.

Guided tours of the battlements and dungeons offer chance to discover the darker secrets of this 900 year old castle.

A lively programme of special events, children's activities and exhibitions is offered throughout the year.

At the end of 1999, the Castle Museum will be closing for a year so please call our information desk on 01603 493624 if you are planning to visit after September 1999.

▲ Spong Man - a rare, enigmatic example of Saxon funerary art

***Opening times***
Open
Monday to Saturday
10.00am to 5.00pm
Sunday
2.00pm to 5.00pm
throughout the year.
Please note the Castle will be closing for refurbishment late in 1999. Visitors are advised to check opening times from September 1999 onwards

***Directions***
Norwich Castle is located in the City Centre adjacent to the Castle Mall Shopping Centre where parking is available.

▲ Norwich River - Afternoon by John Crome, Norwich School of Painters

◀ Twining Teapot Gallery - don't miss the world's largest collection of teapots

**327**

# BRIDEWELL MUSEUM

Bridewell Alley, Norwich, Norfolk NR2 1AQ
Telephone 01603 667228 Fax 01603 765651

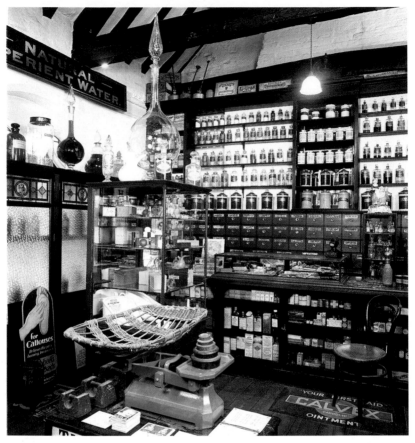

▲ 1930's Pharmacy

Formerly a Merchant's House and Prison, the Bridewell is a fine 14th century building in the centre of historic Norwich.

The Bridewell tells the story of working life in Norwich, in particular, those who worked at making fine chocolates, clocks, beautiful shoes, sumptuous shawls and fabrics.

Experience the atmosphere of fully reconstructed 1930s Pharmacy and Pawnbroker's shops programme of temporary exhibitions. Gift Shop.

## *Opening times*

Open April to September
Tuesday to Saturday
10.00am to 5.00pm

## *Directions*

City centre location.
Short walk from
Railway and Bus
stations. St. Andrew's
multi-storey car park
five minute walk
from Museum.

# ST. PETER HUNGATE MUSEUM

Princes Street, Norwich, Norfolk NR3 1AE
Telephone 01603 667231 Fax 01603 765651

St Peter Hungate Museum and Brass Rubbing Centre is situated in a charming mediaeval Church.

It has a fine hammer beam roof and retains much of its original mediaeval painted window glass.

New displays bring the social history of the Parish to life. From birth to death, discover how the Church has affected people's lives through the centuries.

The Brass Rubbing Centre has over forty replica brasses to choose from. Materials and instructions are provided.

▼ Brass Rubbing at St Peter Hungate Museum

### Opening times
Open
Monday to Saturday
April to September
10.00am to 5.00pm

### Directions
City Centre location close to Norwich Cathedral. Short walk from rail and bus stations. St Andrew's multi-storey car park ten minutes walk from Museum.

**NORFOLK**

# FELBRIGG HALL

The National Trust, Felbrigg, Norwich, Norfolk NR11 8PR
Telephone 01263 837444 Fax 01263 837032

Felbrigg Hall is one of the finest 17th century houses in East Anglia.

The Hall contains its original 18th century furniture and Grand Tour paintings. The 18th century library was designed by William Windham II to house the books which he had bought on the Grand Tour as well as those of his Father and Grandfather amongst the extensive collection housed in the library are Doctor Johnson's own copies of 'The Iliao', 'Odyssey' and 'New Testament'.

The Hall also plays host to an impressive collection of stuffed birds which originally belonged to the last squire's Grandfather who was a keen Ornithologist.

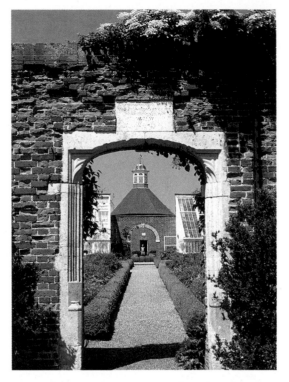

▲ The Dovecote in the walled garden at Felbrigg

***Opening times***
Open
March to October
daily except
Thursday and Friday
1.00pm to 5.30pm
(last admission 4.30pm)

***Directions***
Two miles south west of Cromer. Entrance off B1436 signposted from A148 and A140. Nearest Rail Station is Cromer or Roughton Road.

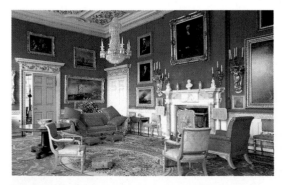

▲ The Drawing room or 'the Great Parlour' at Felbrigg

▶ The south and west fronts of Felbrigg Hall

# ROYAL NORFOLK REGIMENTAL MUSEUM

Shirehall, Market Avenue, Norwich, Norfolk NR1 3JQ
Telephone 01603 223649 Fax 01603 765651

Follow the lives of soldiers in a County Regiment in peace and War from 1685 to the present day.

Museum displays will take you on a global tour from Afghanistan to South Africa, India to America and many other exotic places.

Alternative entrance to the Museum via the Castle Museum through the Prisoners' Tunnel and a reconstructed First World War Communications Trench.

▼ First World War Trench on the Western Front

***Opening times***
Open
Monday to Saturday
10.00am to 5.00pm
Sunday
2.00pm to 5.00pm

***Directions***
City Centre location on Market Avenue. Short walk from City Rail and bus stations.

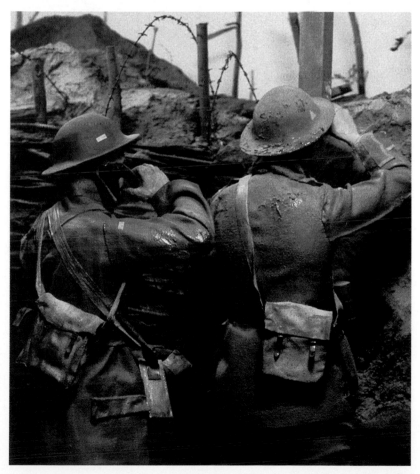

# SHIREHALL MUSEUM & ABBEY GROUNDS

Common Place, Walsingham, Norfolk NR22 6BP
Telephone 01328 820259 Fax 01328 820098

This modest building has stood in the Common Place for some five centuries. We know little of its early history but it seems likely that it was first a monastic building; a part of the Augustinian Priory which cared for the medieval shrine of our Lady.

The Administrative Business of the County was carried out by Justices of the Peace at Quarter Sessions held in various places. In 1778 this building was renovated and altered and the sessions moved here. They continued until 1861, when as an economy measure the nearby Bridewell was closed and Quarter Sessions ceased. From then until 1971 the Courthouse was used for Petty Sessions.

The Courthouse is preserved in its original Georgian state. Ante rooms contain displays of the history of Walsingham and artefacts of local interest.

There is a well stocked gift shop. Entry to the grounds of Walsingham Abbey is through the Museum.

▲ Permanent resident in the lock up

### Opening times

Open March to October
Monday to Saturday
10.00am to 4.30pm
(Last admission 4.00pm)
Abbey Grounds open all
year entrance through
Estate Office Monday to
Friday when Museum
closed

▲ Entrance to Museum and Abbey Grounds plus Information Centre

### Directions

From Norwich A1067 to Fakenham. From Kings Lynn A148 to Fakenham then follow B1105 to Walsingham.

◄ Just one of the walks in the Abbey Grounds

▲ The Courtroom with Coat of Arms

## BLICKLING HALL

Blickling, nr , Aylsham, Norfolk NR11 6NF
Telephone 01263 738030 Fax 01263 731660

One of the greatest houses in East Anglia. National award winner. The house dates back from the early 17th century and houses fine collections of furniture, pictures and tapestries.

*Opening times*  Open April to October, Wednesday to Sunday, 1.00pm to 4.30pm

## BISHOP BONNER'S COTTAGE MUSEUM

St Withburga Lane, Dereham, Norfolk NR19 1ED

Local history including local personalities. Edwardian General Store. Collection of 18th & 19th century samplers. Edwardian Toys including Dolls House. Memorabilia from local trades and industries. Local archeological finds.

*Opening times*  Open 1st May to end September, Tuesdays, Thursdays, Fridays and Saturdays from 2.30pm to 5.00pm, (last admission 4.30pm)

## MARITIME MUSEUM OF EAST ANGLIA

25 Marine Parade, Great Yarmouth, Norfolk NR30 2EN
Telephone 01493 842267 Fax 01493 745459

Former shipwrecked sailors home on sea front, now museum with displays on model boats, history of the herring fishery, wreck and rescue, Nelson, World War II in Great Yarmouth etc.

*Provisional opening times*  Open two weeks at Easter, last Sunday in May until last Friday in September from 10.00am to 5.00pm. Closed Saturdays.

## ELIZABETHAN HOUSE MUSEUM

4 South Quay , Great Yarmouth, Norfolk NR30 2QH
Telephone 01493 745526 Fax 01493 745459

16th century Merchants house on a quayside showing how families lived over the centuries. Tudor bedroom and dining room. Conspiracy room - was the King's death plotted here? Victorian kitchen and parlour. Children's toyroom.

*Provisional opening times*  Open two weeks at Easter: Sundays 2.00pm to 5.00pm, last Sunday in May until last Friday in September 10.00am to 5.00pm, (Closed Saturdays)

## TOLHOUSE MUSEUM

Tolhouse Street, Great Yarmouth, Norfolk NR30 2SH
Telephone 01493 585900 Fax 01493 745459

13th Century building still containing cells of Victorian prison. Local history displays. Brass rubbing centre. Guided tours by appointment.

*Provisional opening times*  Open two weeks at Easter 10.00am to 5.00pm, except Sundays 2.00pm to 5.00pm, last Sunday in May until last Friday in September 10.00am to 5.00pm. Closed Saturdays

**NORFOLK**

## GLANDFORD SHELL MUSEUM

Glandford, Holt, Norfolk NR25 7JR
Telephone 01263 740081

A unique collection of seashells of every hue - some exquisitely carved. There are also lovely jewels, fragments of old pottery, a piece of Pompeii, a sugar bowl used by Queen Elizabeth I, specimens of Agateware and an exceptional tapestry. Situated in the picturesque Glaven Valley 2.5 miles north of Letheringsett.

*Opening times*  Open beginning of March until the end of October open daily, except Sunday and Monday 10.00am to 12.30pm and 2.00pm to 4.30pm

## LYNN MUSEUM

Market Street, King's Lynn, Norfolk PE30 1NL
Telephone 01553 775001 Fax 01553 775001

Exciting new displays tell the story of West Norfolk's people. Discover a Saxon warrior, Victorian high street shopping, Nelson's memorabilia, Savage's colourful fairground gallopers, hands-on activities, events, changing exhibitions. Guided tours by arrangement.

*Opening times*  Open throughout the year Tuesday to Saturday 10.00am to 5.00pm

## CASTLE ACRE PRIORY

Stocks Green, Castle Acre, Kings Lynn, Norfolk PE32 2AF
Telephone 01760 755394 Fax 01760 755594

Among the most extensive priory remains in Southern England. The elaborately decorated west front of the church still stands to the full height. There is also a roofed Prior's Lodging.

*Opening times*  Open 1st April to 31st October daily 10.00am to 6.00pm.
1st November to 31st March Wednesdays to Sundays 10.00am to 4.00pm.
Closed Mondays and Tuesdays. Also 24th to 26th December.

## LOWESTOFT MARITIME MUSEUM

Sparrows Nest gardens, Whapload Road, Lowestoft,
Norfolk NR32 1XG
Telephone 01502 561963

Tells the history of the Lowestoft fishing, models of boats and replica of the AFT cabin of steam drifter, RNLI display, collection of shipwrights tools. Picture gallery and photographs.

*Opening times*  Open Good Friday, Saturday, Easter Sunday, Easter Monday, then May to October daily 10.00am to 4.30pm

## JOHN JARROLD PRINTING MUSEUM

White Friars, Norwich, Norfolk NR3 1SH
Telephone 01603 660211

Working museum of letterpress and lithographic printing with large display covering the crafts of the printer and bookbinder and the machines and tools of the printing industry.

*Opening times*  Open Wednesdays 9.00am to 12.00pm and 7.00pm to 9.00pm.
Group visits by appointment

# NORTHUMBRIA, CLEVELAND & COUNTY DURHAM

Never was such an area blessed with so many museums,exhibitions, shows, galleries and festivals as Northumbria...and little wonder. This northern region is simply seeped in history, social, industrial and military, and all minutely recorded in some of the finest museums in Britain. Added to this there are four hundred square miles of National Park telling its own story of the majestic beauty of the extreme north from Hadrian's Wall to the Cheviots and the Scottish Border. Hadrian's Wall of course, boasts a string of museums telling their story of the Roman occupation of these lands. The Newcastle University Museum of Antiquities is an ideal starting point for studying and visiting the Wall and possesses a collection of regional antiquities from 6000BC to the seventeenth century.

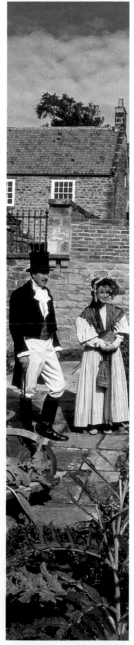

Most cities and towns of the region have their own museums. Newcastle has its Hancock Museum with a quite remarkable collection of birds, fossils and minerals as well as its Land of the Pharaohs and Living Planet exhibitions; the Hatton Gallery of contemporary art and the fine Laing Art Gallery with its award-winning interactive displays. In Stewart Park at Middlesbrough the Captain Cook Birthplace Museum records the early life and voyages of the town's famous son. The Dorman Museum displays local, social and natural history, while the nearby Middlesbrough Art Gallery is largely concerned with contemporary art. The history of industrial Sunderland is impressively told in the Sunderland Museum and Art Gallery. One of the most remarkable museums of this region is the wonderful North of England Open Air Museum at Beamish showing northern life in the early days of the twentieth century...including a re-created colliery, farm and railway station. Here are working trams and all the atmosphere of a bygone era, still vividly remembered in this region.

In the south of Northumbria the social and natural history and the close association with the sea is encapsulated in some fine collections. The Kirkleatham Old Hall Museum tells the story of local life and sea rescues...the latter a subject very familiar to the RNLI Zetland Lifeboat Museum at nearby Redcar, which houses the oldest surviving lifeboat in the world. Nobody could leave this fascinating region without visiting the Josephine & John Bowes Museum at Barnard Castle, housed in a glorious French-style chateau containing an art collection of national importance.

# THE BOWES MUSEUM
Barnard Castle, County Durham DL12 8NP
Telephone 01833 690606 Fax 01833 637163

NORTHUMBRIA, CLEVELAND & COUNTY DURHAM

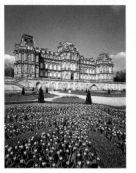

▲ The Bowes Museum,
Barnard Castle

▲ 'Interior of a Prison'
Goya

There are textiles, toys, furniture- the list goes on and on but throughout the quality of the displays is unquestionable.

For our younger visitors there are treasure trails through the Museum designed to engage enquiring minds and provide greater insight into the collections.

Visit us and discover the magnificent splendour of the Museum set in its own park and the fascinating and romantic story of its creation.

Step inside and begin to marvel at the richness of the collections. Housing an incredible and varied selection of fine and decorative art, ceramics textiles and costume, archaeology and local history, the Museum's treasures inspire people of all ages.

Wonder at paintings by El Greco, Boudin, Tiepolo, Camletto and many others.

In the Ceramics Galleries you will discover one of the country's finest collections of Sèvres porcelain.

The Museum's life size silver swan automation is guaranteed to fascinate and enthrall everyone who sees it.

▲ The Silver Swan
automation

### Opening times

Open daily
11.00am to 5.00pm
(Opening times subject
to review; please check
with museum for
further details.)

### Directions

In the Town of Barnard
Castle four miles from
Bowes Village on the
A66. Well signposted by
local Tourist signs.
Nearest Railway Station
Darlington.

◀ Tapestry
'The Birth of Sampson'

# DURHAM UNIVERSITY ORIENTAL MUSEUM

Elvet Hill, Durham, County Durham DH1 3TH
Telephone 0191 3747911 Fax 0191 3747911

▲ Album leaf depicting seasons in style of Kung Hsien, China

The Oriental Museum is the only museum in Britain devoted solely to Oriental Art and Archaeology.

The collections range from Ancient Egypt to modern Japan and are based on a number of prestigious private collections including the Duke of Northumberland's Egyptian antiquities, Malcolm MacDonald collection of Chinese ceramics and the jades of Sir Charles Hardinge.

There is a programme of frequently changing exhibitions and a well stocked gift shop.

▶ Tou-mu, Goddess of the Pole Star. Te-hua porcelain. Ch'ing, China

### Opening times

Open Weekday
9.30am to 5.00pm
Weekends
2.00pm to 5.00pm
(last admission 4.30pm)

### Directions

Museum situated on Elvet Hill. Off South Road (A177) which leaves Durham south of the City and joins the A167 leading north to Newcastle and south to Darlington.

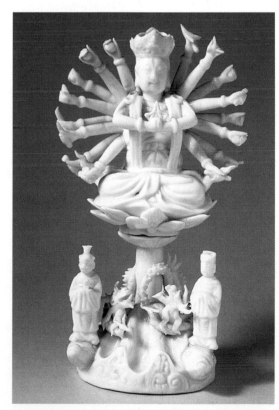

NORTHUMBRIA, CLEVELAND & COUNTY DURHAM

## BEAMISH, THE NORTH OF ENGLAND OPEN AIR MUSEUM

Beamish, County Durham DH9 0RG
Telephone 01207 231811 Fax 01207 290933

Beamish, Britain's favourite open air museum, vividly recreates life in the North of England in the early 1800's and 1900's.

Winner of both the British Museum of the Year and European Museum of the Year Awards, it covers the social, agricultural and industrial history of the region in a "living" way and provides entertainment and education for visitors of all ages and interests.

Costumed interpreters welcome visitors to The Town and into the shops, homes, sweet factory, motor works, public house and other workplaces of the early 1900s.

▲ Pit cottage life at Beamish

Nearby is a complete Colliery Village community with its school, Chapel, pit cottages and pithead buildings.

Guided tours are given down a real drift mine to see how coal was worked.

Traditional breeds of animals and poultry abound in the farmyard at Home Farm and, in the farmhouse kitchen, the farmer's wife goes about her daily chores and cheese is made in the farm dairy.

Pockerley Manor, its formal gardens and horse yard, illustrate the life of a yeoman farming family almost 200 years ago. Transportation is by tram - an experience not to be missed. Only The Town and tramway are open in winter.

◄ At work in the Home Farm kitchen, Beamish

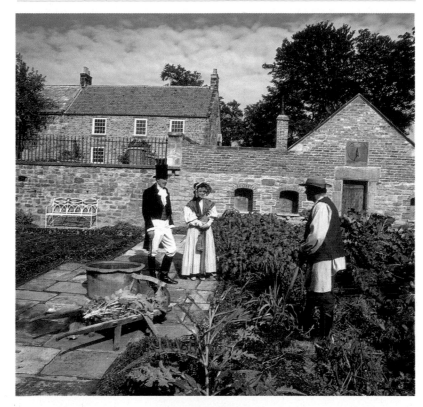

### Opening times

Please telephone for
opening times

### Directions

In County Durham and
signposted from the A1
Motorway. Follow A1M
to Junction 63,
(Chester-le-Street exit)
then follow the Beamish
Museum signs along the
A693 towards Stanley
for 4 miles.

▲ Pockerley Manor
House and gardens
illustrate life in the
early 1800s

▼ Enjoy a ride in a
horse-drawn charabanc
to The Town

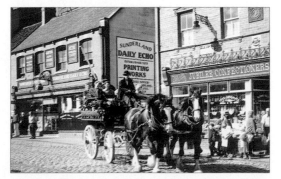

NORTHUMBRIA, CLEVELAND & COUNTY DURHAM

## SHIPLEY ART GALLERY
Prince Consort Road, Gateshead, NE8 4JB
Telephone 0191 4771495 Fax 0191 4787917

The Shipley Art Gallery's collection combines stunning contemporary crafts, Old Master paintings and exquisite glass.

Made in Gateshead, a permanent exhibition, explores the history of Gateshead's industry, its people and their skills.

The nationally renowned Craft Gallery which is the best in Britain outside London has a breath-taking display of glass, ceramics, textiles, metalwork, furniture and jewellery by the country's leading makers.

▼ Sample of pottery at the Art Gallery

▶ Shipley Art Gallery, Prince Consort Road, Gateshead

A programme of constantly changing exhibitions and activities for all ages means that there is always something new to see.

To round off your visit take a look at the Shipley shop, stocked with great ideas for presents.

Refreshments are now available at the gallery coffee point.

All exhibition are free to visit, contact the gallery to find out details of our current exhibitions.

***Opening times***
Open
Monday to Saturday
10.00am to 5.00pm
Sunday
2.00pm to 5.00pm
(Open Bank Holiday)

***Directions***
The Shipley is just off the A167 road to Newcastle. Ample free parking. Buses 24-28, 231, 709, 722-724, 728, 735 and Low Fell coaches pass the Shipley from Gateshead town centre.

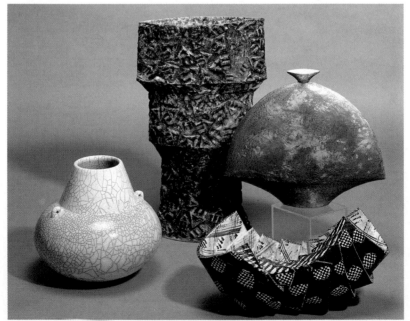

# BORDER HISTORY MUSEUM
Old Gaol, Hallgate, Hexham, Northumberland NE46 3NH
Telephone 01434 652349 Fax 01434 652425

Hexham Old Gaol is the earliest purpose-built prison in England. It was ordered to be built by the Archbishop of York in 1330, and was fitted out with chains, manacles and leg irons in January 1332.

Poor prisoners were put in the dungeons. Many died there of starvation, gaol fever or plague. Richer prisoners were kept upstairs in rooms now used to introduce visitors to the Border Reivers.

Here people are told of the special March Laws introduced to try to control the unlawful activities of the Surnames (powerful local families, class) on either side of the English-Scottish Border. Laws preventing cross-border marriages were often ignored by the Surnames in their bids to increase their power and influence.

Wardens in the Six Marches tried to prevent the raiding, kidnapping, rustling and murder that were common in the area from the 1300s to the 1600s. "Blackmail" and "bereaved" are only two of many words passed down to us from those troubled times. Visitors can also find out about the Earl of

Derwentwater and his ill-fated support for his cousin, The Old Pretender, who attempted to overthrow George I in 1715. Group rates and family ticket discounts available.

### Opening times

Open
February to Easter,
November Saturday,
Monday and Tuesday
10.00am to 4.30pm
(last admission 4.00pm)
Easter to end October
daily 10.00am to 4.30pm
(last admission 4.00pm)

### Directions

Up hill from Wentworth car park or Hexham Railway Station. Follow signs from bus station. Hexham is on A69, main Newcastle to Carlisle Road and Newcastle to Carlisle Railway line.

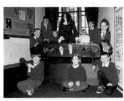

▲ Hexham old town stocks in use

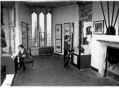

▲ View of Room Two displays

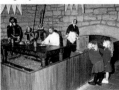

▲ Meeting a Reiver family at close quarters.

▼ Outside view of Hexham Old Gaol and Tourist Information Centre

NORTHUMBRIA, CLEVELAND & COUNTY DURHAM

NORTHUMBRIA, CLEVELAND & COUNTY DURHAM

# MIDDLESBROUGH ART GALLERY
320 Linthrope Road, Middlesbrough, Teeside TS1 4AW
Telephone 01642 247445

The gallery has a changing programme of temporary exhibitions showcasing the best of contemporary art.

▲ Middlesbrough Art Gallery

The emphasis is on presenting exhibitions by artists with national and international reputations while providing space for the best of the local artists. Located in a Victorian town house in central Middlesbrough, it holds one of the largest collection of 20th century art in the north of England.

▲ Helen Barker, 1995

The collection is shown through a series of small changing exhibitions selected through specific themes. Artists in the collection include David Bomberg, H Gaudier-Brzeskia

▲ Clare Neasham, 1997

Jacob Epstein, Frank Auerbach, Stanley Spencer, Elizabeth Frink.

The gallery has an active policy to commission and purchase new works for the collection and recent acquisitions include works by Stephen Willats and Lynne Silvermann.

### Directions

Bus: 263 Train: Middlesbrough Station (15 minutes walk) Car: A66 Middlesbrough, Canon Park exit; right at roundabout; left at traffic lights; left at traffic lights again, onto Linthorpe Road.

### Opening times

Open
Tuesday to Saturday
10.00am to 5.30pm
(last admission 5.00pm)

▼ Faisal Abdu' Allah, 1998

## HANCOCK MUSEUM (TYNE & WEAR MUSEUMS)

Barras Bridge, Newcastle Upon Tyne, Tyne and Wear NE2 4PT
Telephone 0191 2226765 Fax 0191 2226753

The Hancock Museum is the North East's premier museum of Natural History. It contains over 750,000 specimens from the biological and geological world as well as collections of Egyptian artefacts and ethnography items.

Explore the natural world in our permanent galleries. Find out all about our feathered friends in "The Magic of Birds". Explore the cosmic forces that have shaped our planet in "Earthworks", and see how 'green' you really are in our environmental gallery "The Living Planet". Don't miss the "Abel's Ark" creatures or snakes and spiders in our live animal displays, and find out about life and death in ancient Egypt in "The Land of the Pharaohs".

The Museum has a reputation for temporary 'blockbuster' exhibitions like "Dinosaurs Alive" and "Monster Creepy Crawlies", so call to find out about upcoming attractions. "Venom" - dare you enter this dangerous world. Coming soon: 19th December 1998 to 6th June 1999.

▶ Explore the world around us in Earthworks and the Living Planet

The Museum also runs family fun days, (call for details) Admission £2.25 adults; £1.50 concession; £6.50 family ticket. Various discounts available, call for details. Note! Prices may vary depending on current exhibition. Under 4's free.

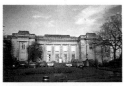

▲ The Hancock Museum

▲ Skeleton of a Moa in "The Magic of Birds"

▲ An Egyptian Mummy in "Land of the Pharaohs"

### Opening times

Open all year except Christmas Day, Boxing Day and New Years Day
Monday to Saturday
10.00am to 5.00pm
Sunday
2.00pm to 5.00pm

### Directions

Park and ride to Haymarket Metro station. Museum five minutes walk. By car follow the A167 central motorway to the "City Centre North" slip road; follow to traffic lights and turn right.

NORTHUMBRIA, CLEVELAND & COUNTY DURHAM

# LAING ART GALLERY

New Bridge Street, Newcastle upon Tyne,
Northumberland NE1 8AG
Telephone 0191 2327734

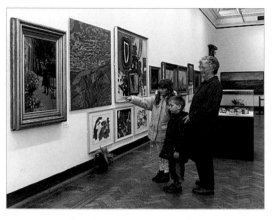

▲ Inside the Gallery

The Laing Art Gallery is free to visit and located in the centre of Newcastle.

Permanent displays include Art on Tyneside. Using sound, interactive games, open exhibits and videos, this exciting exhibition includes a re-creation of an 18th century coffee shop, a Victorian Art Gallery and even the Tyne Bridge!

There is lots of fun and games for the under fives in our lively and colourful Proctor and Gamble Children's Gallery. Purpose built to introduce the younger visitor to colours, shapes and textures, the Children's Gallery includes soft play, puzzles construction blocks and distorting mirrors to educate and amuse.

The Laing's temporary exhibitions range from nationally acclaimed pictures from the Laing's own collections to innovative touring exhibitions. Past popular exhibitions include Tate on Tyne and Treasures of the Lost Kingdom containing the Lindisfarne Gospels.

The Laing has a cafe, good disability access and a gift shop.

There are a wide selection of talks, tours and activities for all ages. For details of these and of current exhibitions please contact the Gallery on 0191 2327734.

▲ Proctor and Gamble Childrens Gallery

## Opening times

Open
all Monday to Saturday
10.00am to 5.00pm
Sunday
2.00pm to 5.00pm

▲ Laing Art Gallery

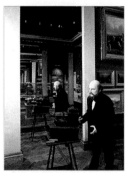

▲ The Victorian Art Gallery, Art on Tyneside

## Directions

The Laing is situated in Newcastle City centre five minutes walk along New Bridge Street from Greys Monument and Monument Metro Station.

*NORTHUMBRIA, CLEVELAND & COUNTY DURHAM*

# MUSEUM OF ANTIQUITIES

University of Newcastle Upon Tyne, Newcastle Upon Tyne,
Tyne and Wear NE1 7RU
Telephone 0191 2227849 Fax 0191 2228561

The Museum of Antiquities, recently described as a 'hidden gem', has an extensive collection of archaeological objects ranging in date from the Palaeolithic period to 1800 AD.

Its spectacular Roman collection includes much of the evidence for the World Heritage Site of Hadrian's Wall, making the museum the ideal place to start a visit to the Wall.

The Roman galleries include many famous pieces such as the birth of Mithras Stone from Housesteads, the earliest depiction of the signs of the Zodiac in Britain. The smaller objects include many internationally acknowledged masterpieces, such as the Aesica Brooch, the South Shields Bear Cameo and the Aemilia finger-ring. There are models of the wall and its structures and a life size reconstruction of a mithraeum.

The museum's prehistoric, Anglo Saxon and mediaeval collections are also of international renown and include the largest collection of prehistoric rock art in Britain, notable Neolithic stone axes, Bronze Age pottery and metalwork.

The Anglo Saxon collection includes the Rothbury Cross (earliest Christian Rood in Britain) and the Alnmouth Cross (only Anglo Saxon object with an Irish name).

The museum regularly holds temporary exhibitions based on recent archaeological work and its own reserve collection. Excellent bookshop.

### Opening times

Open daily
10.00am to 5.00pm
except Sunday,
1st January,
Good Friday,
24th to 26th December
(last admission 4.45pm)

### Directions

In the City centre, situated within the University of Newcastle quadrangle between Claremont Road and the Haymarket, 'underneath the arches' on King's Walk.

▲ Bear Cameo of Sardonyx from South Shields Roman Fort

▲ Bronze Age shield from Tribley, County Durham

▲ 15th century gold fede ring brooch from Whinfield Park, Cumbria

▼ Enamelled Bronze Cockerel brooch from South Shields Roman Fort

## BELSAY HALL, CASTLE & GARDENS

Belsay Hall, Belsay, nr, Ponteland,
Northumberland NE20 0DX
Telephone 01661 881636 Fax 01661 881043

Fine neo-classical hall a 14th century Castle and 17th century Manor House set in 35 acres of Grade I Listed gardens.

An exhibition on the history of the Belsay Estate is contained in the early 19th century Stable block including an audio visual presentation.

There are also a series of annual and one off special events throughout the year including the Rose Carnation and Sweet Pea society annual Flower Show, Craft Fairs, Car and Classic Motor Cycle Rallies.

Guided tours by arrangement.

### Opening times
Open 1st April to 31st October daily 10.00am to 6.00pm (6.00pm / dusk in October) 1st November to 31st March daily 10.00am to 4.00pm Closed 24th to 26th December

### Directions
In Belsay Village fourteen miles North West of Newcastle Upon Tyne on A696 Newcastle to Jedburgh Road.

▶ Belsay Hall, East (entrance) Front

▼ Belsay Castle from South West

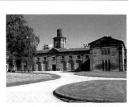

▲ Belsay Hall Stables

▲ Belsay Hall, terrace gardens

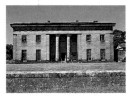

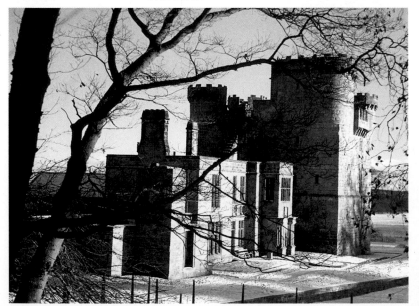

# ZETLAND LIFEBOAT MUSEUM
5 King Street, Redcar, Cleveland TS10 1RQ
Telephone 01642 486952

The Zetland Museum houses the world's oldest lifeboat "The Zetland". Built in 1802 by Greathead of South Shields it has saved owed five hundred lives and now resides in its original boathouse overlooking the Esplanade at Redcar.

The Zetland was launched by horses stabled at nearby Kirkleatham and was crewed by thirteen oarsman who were summoned to the boathouse by the beating of a drum. The original drum is also on display at the museum.

The "Laurie Pickentt: gallery on the first floor of the museum gives an interesting insight into the fishing community of Redcar and the towns' connections with the lifeboat.

▲ The Zetland now resides in its original boathouse

The museum also houses numerous displays of local and maritime interest including a replica fishermans cottage, an exhibition of the history of sea rescue as well as displays of model ships. Redcar crested china and local memorabilia.

The museum is run on a purely voluntary basis and funds raised benefit the RNLI.

*Opening times*

Open 1st May to 30th September every day 11.00am to 4.00pm It is open for Easter Sunday and Monday 11.00am to 4.00pm (last admission 3.50pm)

*Directions*

From North and South A19 to A174, to A1042. Follow A1042 straight ahead at lights and roundabout. Continue along Majliba Road. Turn left at junction, Museum is quarter of a mile on right.

▲ The replica fishermans cottage

▲ "The Zetland" the worlds oldest lifeboat

**NORTHUMBRIA, CLEVELAND & COUNTY DURHAM**

# REDCAR & CLEVELAND MUSEUMS SERVICE

Kirkleatham Old Hall Museum, Kirkleatham, Redcar,
Cleveland TS10 5NW
Telephone 01642 479500 Fax 01642 474199

Local and social history of Redcar and Cleveland. Collections of working and domestic life, photos and paintings. Permanent displays and temporary exhibitions, activities and event. 1999 Programme includes 'SEAson' to coincide with RNLI 175 year & opening of 'Sir James Knott' Lifeboat (26 June - 26 Sept '99). Kirkleatham Vehicle and Engine Rally 7th to 8th August 1999.

### Directions

A1 - A19 - A174 - Kirkleatham village off Kirkleatham Lane, Redcar

◄ 'Sir James Knott' lifeboat with former crew members

### Opening times

Open
April to September
Tuesday to Sunday
10.00am to 5.00pm
October to March
Tuesday to Sunday
10.00am to 4.00pm
Closed Mondays
(except Bank Holidays)

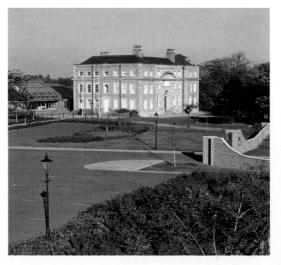

► Kirkleatham Old Hall Museum, former 1709 free school building

**348**

## ARBEIA ROMAN FORT

Baring Street, South Shields
Telephone 0191 4561369 Fax 0191 4276862

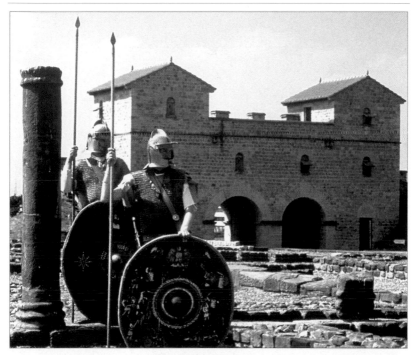

Situated beyond the Eastern most point of Hadrian's Wall, Arbeia Roman Fort stood guard at the mouth of the River Tyne.

Visit the Fort's stunning reconstruction of its West Gate and learn about the site's 1,000 year history. Walk around the excavated ruins.

Visit the museum and see site finds, including weapons, armour, jewellery and coins, and the exhibition 'The Life of a Roman Soldier'. Discover how Romans buried their dead in the original Roman tombstones found at Arbeia.

Learn how experts unravel the secrets of the past at Time Quest, the site's interactive Archaeology Resource Centre. Dig for finds on the excavation site, then identify, weigh and study them to discover what has been unearthed. Experience working on an archaeological dig, and find out what life was like in Roman times.

Admission to Arbeia Roman Fort is Free. Admission to Arbeia: £1.50/80p concessions.

▲ Arbeia Roman Fort - the West Gate

*Opening times*
Open Easter to September
10.00am to 5.30pm
Monday to Saturday
1.00pm to 5.00pm
Sunday
October to Easter
10.00am to 4.00pm
Monday to Saturday
Closed Sunday

*Directions*
From South Shields Metro Station turn right on to Ocean Road. Proceed along Baring Street. Arbeia is on the right.

**349**

NORTHUMBRIA, CLEVELAND & COUNTY DURHAM

## PRESTON HALL MUSEUM
Yarm Road, Stockton on Tees, Northumbria TS18 3RH
Telephone 01642 781184 Fax 01642 393983

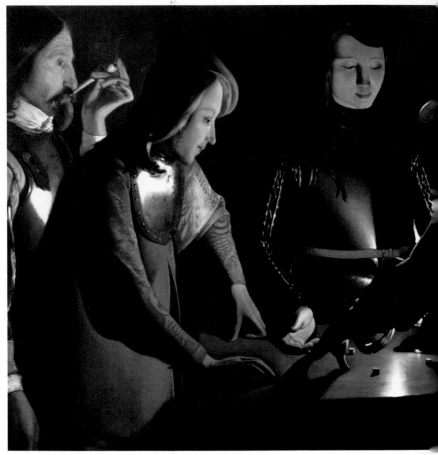

▲ The Diceplayers by George De La Tour

Situated in 100 acres of attractive parkland overlooking the River Tees, Preston Hall Museum has something for everyone all year round.

Enjoy displays of toys, costume and domestic life, many in period room settings, from an 1820's dining room, to the 1960's bedsit.

Discover the collection of arms in the mysterious gloom of the Hall's cellars. And find its most famous exhibit - George de la Tour's painting 'The Diceplayers'. Then walk back in time along a typical local High Street of the 1890's with its range of shops, and daily demonstrations of traditional craft skills.

You can also enjoy a regular programme of family events in the museum and park, including vintage vehicle rallies, a music festival, the Summer Carnival and Christmas Fair, as well as regular craft sessions for children, and handling activities for school parties.

**350**

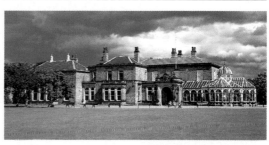

### Opening times

Open Easter to
September daily
10.00am to 5.30pm
(last admission 4.45pm)
October to Easter
Monday to Saturday
10.00am to 4.30pm
Sunday
2.00pm to 4.30pm
(last admission 3.45pm)

▲ Preston Hall Museum
photo by Andy Elliott

▲ The fishponds in
Preston Park photo by
Andy Elliott

### Directions

Preston Hall is on the
A135 Yarm road to the
south of Stockton town
centre. The museum is
easily accessible from the
A19 and A66 - follow
the brown signs.

▼ Living history in the
Victorian street. Photo
by Andy Elliott

Out in the park, you can
ride on the miniature
railway. Discover exotic
life in Butterfly World or
simply relax along the
many woodland walks.
You can even catch the
Teesside Princess river
service to Stockton and
Yarm.

There are special rates
for pre-booked parties -
please phone 01642
393983 for more details.

# SUNDERLAND MUSEUM & ART GALLERY

Borough Road, Sunderland, SR1 1PP
Telephone 0191 5650723 Fax 0191 5650713

This museum will close in Spring 1999 for re-development and will re-open in Spring 2000, with fantastic new galleries and improved facilities.

Lost Worlds takes a look at the city's history in pre-historic times and the Wildlife Gallery has real live creatures.

For art lovers, the art gallery is home to an impressive collection of watercolours, oils, and paintings by L.S. Lowry.

### Opening times
Open
Monday to Friday
10.00am to 5.00pm
Saturday
10.00am to 4.30pm
Sunday
2.00pm to 5.00pm

### Directions
Sunderland Museum & Art Gallery lies in Sunderland City Centre 2 minutes walk from Sunderland train station which links with Middlesburgh and Newcastle Stations, and 5 minutes from the bus station.

▲ Coal life and work in the East Durham Mining Communities

▼ Pressed glass items in Sunderland's Glorious Glass

▲ And Ships Were Born

Sunderland Museum and Art Gallery is a delightful Museum with a variety of permanent exhibitions.

And Ships' Were Born explores the famous tradition of ship building on the Wear.

Life and Work in the Mining Communities of East Durham are explored in Coal.

Sunderland's Glorious Glass is a celebration of glass making and features the stunning Londonderry Glass Service completed in 1924.

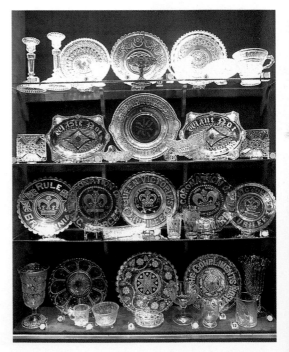

**352**

# MONKWEARMOUTH STATION MUSEUM

North Bridge Street, Sunderland, SR5 1AP
Telephone 0191 5677075

This remarkable museum features both permanent and temporary exhibitions.

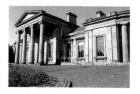

Come and see the reconstructed Edwardian ticket office, a full size bus cab that can be driven, plus the new Children's Gallery for under 5s.

Until 25th April 1999, the Railways of Sunderland exhibition looks back through nearly two centuries to explore how railways have affected Sunderland.

Beginning in June, a brand new exhibition which will look at transport toys.

◀ Monkwearmouth Station Museum

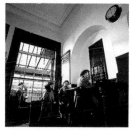

▲ Edwardian Ticket Office

### Opening times

Open
Monday to Friday
10.00am to 5.00pm
Saturday
10.00am to 4.30pm
Sunday
2.00pm to 5.00pm

▲ Bus Cab

▲ Tram Car

### Directions

By Bus, numbers 27,28,29 4 and 5, alight at the Wheatsheaf and walk towards the bridge. Ten minutes walk from the city centre and accessible by car across Wearmouth Bridge

**AYDON CASTLE**
Corbridge, Northumbria NE45 5PJ
Telephone 01434 632450

Aydon castle is a really superb complete, late 13th Century Manor House. Converted to a farmhouse in the 17th Century. Now stripped out to reveal its original style. Discounts for larger parties.

*Opening times* Open daily 1st April to 1st November 10.00am to 6.00pm,
(last admission approx 5.30pm)

---

**CORBRIDGE ROMAN SITE**
Corbridge, Northumbria NE45 5NT
Telephone 01434 632349

The museum display tells the story of Roman Corbridge, giving some insight into the way the inhabitants of the forts and town lived their lives. Sculpture, glassware, pottery are included. Limited facilities for the disabled. Walkman tape of the site.

*Opening times* Open 1st April to 30th September every day 10.00am to 6.00pm.
1st October to 31st 10.00am to 5.00pm, 1st November to 31st March
10.00am to 4.00pm Wednesday to Sunday. Closed between 1.00pm and 2.00pm.

---

**EYEMOUTH MUSEUM**
Auld Kirk, Eyemouth, Northumbria TD14 5JE
Telephone 018907 50678

Displays recording the history of the area on land and sea. Magnificent 15x4ft tapestry commemorates the great disaster of 1881, when 189 local fishermen were lost at sea.

*Opening times* Opening times please telephone for details.

---

**GISBOROUGH PRIORY**
Priory Grounds, Church Street, Guisborough, TS14 6HG
Telephone 01287 633801 Fax 01287 633801

A triumphal arch - remains of a 12th Century Priory church. A reminder that this was once a very wealthy mediaeval monastery. Also includes the Tourist Information.

*Opening times* Open Easter to 30th September daily
10.00am to 5.00pm, closed Monday
October to Easter, closed Monday and Tuesday

---

**HARTLEPOOL ART GALLERY**
Church Square, Hartlepool, TS24 7EQ
Telephone 01429 869706 Fax 01429 523408

Former church, showing contemporary and historical exhibitions of National and local significance. Paintings, drawings, photography and three dimensional work in a lively programme for all ages. Viewing tower, bookshop and TIC.

*Opening times* Open Tuesday to Saturday 10.00am to 5.30pm,
Sunday 2.00pm to 5.00pm. Closed Christmas Day, Boxing Day and New Years Day

---

NORTHUMBRIA, CLEVELAND & COUNTY DURHAM

## MUSEUM OF HARTLEPOOL
Jackson Dock, Hartlepool, TS24 0XZ
Telephone 01429 222255 Fax 01429 523477

The museum tells the story of Hartlepool from prehistory to the present day and includes many original artefacts, models, computer and hands-on displays. Admission free.

*Opening times* Open daily 10.00am to 5.00pm. Closed Christmas day, Boxing Day and New years Day

## HOUSESTEADS ROMAN FORT AND MUSEUM
Haydon Bridge, Hexham, Northumbria NE47 6NN
Telephone 01434 344363

Substantially excavated fort, containing barracks, granaries, hospital and Roman latrines plus small site museum. Admission charges apply. Car parking half a mile away from site.

*Opening times* Open 1st April to 31st October daily 10.00am to 6.00pm, 1st November to 31st march, daily 10.00am to 4.00pm. Closed 24th to 26th December

## CAPTAIN COOK BIRTHPLACE MUSEUM
Stewart Park, Marton, Middlesbrough
Telephone 01642 311211 Fax 01642 813781

Describes life and times of James Cook and his voyages of discovery. Completed £1.2 million refurbishment with the support of Heritage Lottery. Changing exhibitions. Guided tours on request.

*Opening times* Open Summer 10.00am to 5.30pm, Winter 9.00am to 4.00pm. Closed Monday. Last admission 45 minutes before closing

## HATTON GALLERY & UNIVERSITY OF NEWCASTLE
University of Newcastle, Newcastle-Upon-Tyne, NE1 7RU
Telephone 0191 222 6057 Fax 0191 222 6057

The Hatton Gallery, University of Newcastle, hosts a range of touring exhibitions of painting, sculpture, printmaking and new media. Also on display are works from the permanent collection, including African Art.

*Opening times* Open all year Monday to Saturday except Bank Holidays or installation of large exhibitions, Monday to Friday 10.00am to 5.30pm, Saturday 10.00am to 4.30pm, Sunday closed, (last admission 10 minutes prior to closing)

## NORHAM CASTLE
Norham, Northumbria
Telephone 01670 533 128

Set on a promontory in a curve of the River Tweed, this was one of the strongest of the Border Castles, built c1160. Free audio tour. An English Heritage site.

*Opening times* Open 1st April to 1st November daily, 10.00am to 6.00pm (6.00pm or dusk in October)

## PRUDHOE CASTLE

Prudhoe, Northumbria NE42 6NA
Telephone 01661 833459 Fax 01661 833459

Extensive remains of a 13th century fortress with fine views over the River Tyne. Small exhibition and a video presentation. Gift Shop. Brass Rubbing and picnic area.

*Opening times* Open April to October daily 10.00am to 6.00pm

## BRINKBURN PRIORY

Longframling, nr , Rothbury, Northumbria NE65 8XR
Telephone 01665 570628

Enjoy a visit of harmonious tranquillity at Brinkburn Priory founded 1135 for Augustinians in a secluded riverside setting fully restored late 19th century. Car parking 450 yards from the monument. Limited access for disabled people.

*Opening times* Open 1st April to 30st October 10.00am to 6.00pm
1st October to 31st October 10.00am to 5.00pm or dusk.

## TIMOTHY HACKWORTH VICTORIAN & RAILWAY MUSEUM

Soho Cottages, Hackworth Close, Shildon, Co Durham DL4 1PQ
Telephone 01388 777999 Fax 01388 777999

Former home of the world renowned railway pioneer Timothy Hackworth. Victorian garden, period rooms, 1830's beam engine and live steam locomotive rides are some of the attractions. Picnics welcome, children's activities.

*Opening times* Open Easter Friday to last Sunday in October
Wednesday to Sunday inclusive 10.00am to 5.00pm

## TYNEMOUTH VOLUNTEER LIFE BRIGADE WATCH HOUSE

Spanish Battery, Tynemouth, Tyne & Wear NE30 4DD
Telephone 0191 257 2059

1887 watch house of the world's first, still active, Volunteer Life Brigade, founded 1864. Unique collection of figureheads, models, pictures and archive of over 130 years of volunteer lifesaving. Free admission.

*Opening times* Open Tuesday to Saturday 10.00am to 3.00pm,
Sunday 10.00am to 12.00pm. Closed all day on Monday

## KILLHOPE LEAD MINING CENTRE

Cowshill, Upper Weardale, Co Durham DL13 1AR
Telephone 01388 537505 Fax 01388 537617

Restored Victorian lead mining site with 33 foot working waterwheel, working ore separation equipment which visitors can use, tours into park level mine include view of underground working waterwheel.

*Opening times* Open daily April to October 10.30am to 5.00pm,
(last admission 4.30pm), and Sundays in November 10.30am to 4.00pm

# OXFORDSHIRE

Oxfordshire, a delightful gently undulating county, is a buffer between the pastoral south and the industrial heartland of England. The Oxfordshire Plain is bordered in the north by the Cotswolds, that glorious area of honey-coloured limestone villages, and rich brown fields enclosed by drystone walls, and in the south by the Chilterns, that wonderful region of beech woods which is largely an official Area of Outstanding Natural Beauty. The boundary changes of 1974 increased the Oxfordshire county area by about a third, adding to its already spectacular scenic attributes the lovely Vale of the White Horse. The county is not renowned for its large cities and towns...Oxford the county town being the largest, but what Oxford lacks in size it more than makes up for in history and prestige. The city, an important commercial, residential and industrial centre is of course dominated by its university, the colleges of which , both ancient and modern, have their own particular character and treasures. The Oxford Story in Broad Street, brings the history of the university's past to life in a fascinating manner using audio-visual techniques, while the Museum of Oxford widens the scope, telling with graphics and models the history of the relationship between city and university.

Oxford boasts museums and galleries of international fame...The Ashmolean Museum of Art and Archaeology houses a collection of British, European, Mediterranean, Egyptian and Near-Eastern archaeology as well as a magnificent collection of Old Master and modern drawings. Oxford's Pitt Rivers Museum is one of the world's greatest ethnographic museums. The Museum of Modern Art in Pembroke Street is a venue for temporary exhibitions of modern and contemporary art from all over the world.

To discover the people, landscape and history of this county there is the excellent Oxfordshire County Museum at Woodstock, established in a grand late 17th century house...and at Witney, the Cogges Farm Museum, a working museum set in a twenty acre farm. Here in an historic manor house are regular local traditional craft activities. South of Oxford, Abingdon, an attractive town with a long history as a commercial and ecclesiastical centre, houses excellent exhibitions of local history, arts and crafts, in the former Berkshire County Hall dating from 1678. The town's Pendon Museum depicts the era of the 1930s in the Vale of the White Horse through finely detailed miniature landscapes.

OXFORDSHIRE

## ABINGDON MUSEUM
The County Hall, Market Place, Abingdon, Oxfordshire OX14 3HG
Telephone 01235 523703 Fax 01235 536814

Abingdon is a lively museum with an exciting programme of exhibitions and events, housed in a spectacular building.

The museum is set in the former County Hall for Berkshire, described as the "grandest town hall in England" by Pevsner. This fascinating building was built between 1678 and 1682, by Christopher Kempster, a master mason who worked with

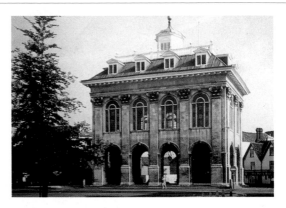

▲ The Historic County Hall, the historic heart of Abingdon

Wren on St. Paul's Cathedral.
The County Hall has been at the heart of Abingdon life for three hundred years as a court house and venue for town celebrations.

Abingdon is arguably the oldest town in Britain. A staircase display presents a history of the town using museums collections.

The Sessions Hall is a beautiful setting for exhibitions and events. Other attractions include the roof (a splendid viewpoint) and the Crafts Room, a gallery of craftwork open by prior appointment.

◀ The Sessions Hall, once a courtroom, now an exhibitions gallery

### Opening times

Open Winter daily
11.00am to 4.00pm
Summer daily
11.00am to 5.00pm
(last admission 15
minutes before closing)

### Directions

Abingdon is seven miles
south of Oxford (A34)
and is well served by
buses from Oxford and
Didcot. The museum is
in the town centre with
car parking nearby

◀ "The Woodcutter"
embroidery by Linda
Miller in the Crafts
Room

▼ Coming face to face with exhibits in an exhibition

OXFORDSHIRE

# PENDON MUSEUM OF LANDSCAPE AND TRANSPORT

Long Wittenham, Abingdon, Oxfordshire OX14 4QD
Telephone 01865 407365

Pendon Museum, located entirely indoors, brings to the visitor the beauty of the English countryside and its railway as they were around 1930.

Modelled at a scale of 1-to-76, the main exhibit displays a landscape 70-feet long with exquisitely detailed cottages, farms, fields and chalky lanes that recall the quiet charm of summer's day in the Vale of the White Horse.

A separate exhibit captures the excitement of railways of this era as a cavalcade of trains moves across a superb Brunel viaduct on the edge of Dartmoor. This is a Great Western Railway branch line depicted in the heyday of steam.

In addition to the Vale of the White Horse landscape and the Dartmoor branch line, the Museum is also the home of many railway memorabilia. One of these is the formative model railway known as the Madder Valley railway. This entirely imaginary layout was constructed in the late 30s and 40s by John Ahern, probably the first railway modeller to appreciate that the scenery is as important

as the trains in conveying a sense of realism.

Special attractions are changed twice per year. Call the museum for details of the current display.

---

## Opening times

Open
Saturdays and Sundays
2.00pm to 5.00pm also
Wednesdays during
June, July, August
and New Year's Day
(Closed December)
Early opening 11.00am
on Good Friday through
Easter Monday and
May and August Bank
Holiday Weekends
Special openings for
clubs by prior
arrangement

---

▼ Cottages of the 30s modelled in our vale scene

## Directions

Didcot exit from A34.
Follow A4130 around
Didcot. Turn left (north)
at B4016. Proceed
1/2-mile to T-Junction.
Go right towards Long
Wittenham. Brown
tourist signs will lead
to Pendon

---

▲ Goods train emerging from the tunnel on the Dartmoor scene

▲ A train on the Teignmouth seawall spotted at the Pendon Museum

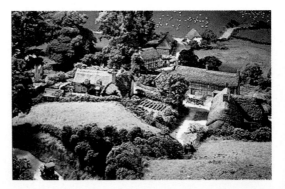

# THE OXFORD STORY

6 Broad Street, Oxford, Oxfordshire OX1 3AJ
Telephone 01865 790055 Fax 01865 791716

800 years of University history in one hour! The Oxford Story captures the very essence of Oxford University's fascinating 800 year history which is brought to life as you travel through the exhibition's impressive recreated scenes, events and even smells of a bygone era!

Learn about the University's early beginnings and the interesting facts behind its record breaking discoveries.

Meet the famous faces who came through Oxford to make their impact on our world in the field of sport, medicine, literature and politics.

Climb aboard our amazing "dark" ride and enjoy the excellent commentary which is available in a number of foreign languages, with a specially recorded English version for children.

Excellent for group visits, The Oxford Story offers special group rates, based on 20 or more people. Advance booking is always advisable for groups and there is a coach drop off/pick up point two minutes walk away in Magdalen Street East.

New for 1999 - "The Student Life" - a new film that gives a fascinating insight into a student's university life at Oxford

## *Opening times*

Open April to October
9.30am to 5.00pm
July to August
9.00am to 6.00pm
November to March
10.00am to 4.30pm
(weekends 5.00pm)
Closing times given are
of last admission.

▲ Charles I exiled in Oxford

▲ The Scrivener's Shop

▲ An imaginative portrayal of the University Museum's natural history collections

▲ St Scholastica's Day Riot (1355) Friction between town and gown

## *Directions*

The Oxford Story is located at the very heart of Oxford. Look for Broad Street or Oxford Story signs.

OXFORDSHIRE

## DIDCOT RAILWAY CENTRE
Didcot, Oxfordshire OX11 7NJ
Telephone 01235 817200 Fax 01235 510621

The Great Western railway was incorporated in 1835 to build the railway from Bristol to London and it was designed and engineered by Isambard Kingdom Brunel to be the finest in the land.

Now at Didcot, halfway between Bristol and London, members of the Great Western Society have created a living museum of the Great Western Railway.

Based around the original engine shed it is home to a large collection of GWR Steam Locomotives.

Brunel's original broad gauge trackwork has been recreated and a reproduction of the 'Firefly' locomotive of 1839 is under construction in the locomotive works.

There is a typical country branch-line with small stations, signal boxes and a Victorian signalling system.

There are Steamdays with rides on the trains on the first and last Sunday of each month from March, Bank Holidays, all Sundays June to August, all Wednesdays in July and August, all Saturdays in August.

Special events include visits from "Thomas The Tank Engine". Entry at Didcot Parkway rail station served by Great Western, Virgin and Thames Trains, signed from M4 (junction 13) and A34.

▼ Locomotives ready for action outside the engine shed

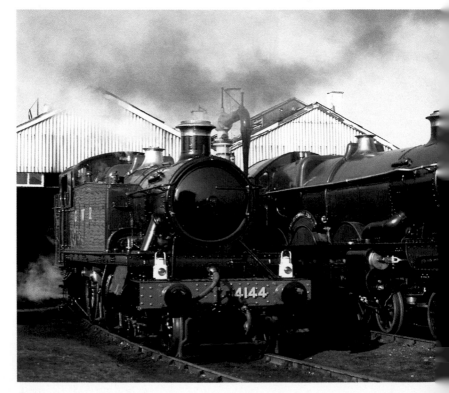

### Directions

Entrance at Didcot
Parkway Rail station.
On A4130 signed
from A34 and M4
(Junction 13)

▲ The branch line train

### Opening times

Open Saturdays and
Sundays all year
(except 25th and
26th December)
and daily from Easter
to late September
10.00am to 5.00pm
January, February,
November and
December
11.00am to 4.00pm
(last admission 30
minutes before closing)

▲ Locomotive No. 1466
under the coaling stage
during a Steamday

▲ Exchanging mailbags
at speed with the
Travelling Post Office

OXFORDSHIRE

# ASHMOLEAN MUSEUM

Beaumont Street, Oxford, Oxfordshire OX1 2PH
Telephone 01865 278000 Fax 01865 278018

Britain's oldest public museum (founded 1683) now housed in CR Cockerell's classical building of the 1840s.

On display are the university's rich and diverse collections of British, European, Egyptian and Near Eastern antiquities, European paintings and drawings, sculpture, silver, ceramics and musical instruments, coins and medals in the Heberden coin room, Oriental art, Chinese, Japanese and Islamic metalwork, ceramics, paintings, textiles and sculpture.

Temporary exhibitions run alongside permanent displays, gallery talks take place on different aspects of the collections, gift shop, cafe.

▼ Hunt in the Forest        ▲ The Forest Fire

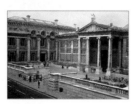

▲ Ashmolean Museum, Oxford

***Opening times***

Open all year round (except Monday) Tuesdays to Saturday 10.00am to 5.00pm Sundays 2.00pm to 5.00pm Closed at Christmas, Easter (except Easter Monday) and 3 days in September for St Giles Fair

***Directions***

The Ashmolean is situated in the centre of Oxford, near the corner of Beaumont Street and St Giles. It is a ten-minute walk from the railway station and a three-minute walk from Gloucester green bus and coach station

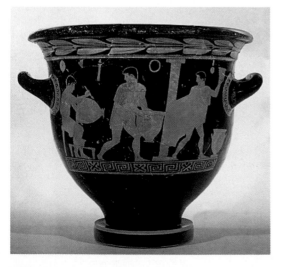

◄ Greek red figure vase, showing potters' workshop

# MUSEUM OF THE HISTORY OF SCIENCE

Broad Street, Oxford, Oxfordshire OX1 3AZ
Telephone 01865 277280 Fax 01865 277288

The Museum presents the world's finest collection of early scientific instruments in a building of outstanding importance for the history of museums.

The collection is particularly rich in early astronomical and mathematical instruments such as astrolabes, sundials, quadrants, surveying and military instruments. The collection of microscopes is one of the most comprehensive there is, while physics, chemistry and horology are all very strong.

The collection is international in scope, the Islamic material, for example, represents the finest display of the history of science in Islam.

The emphasis on the displays is on original historic material, rather than modern "hands on" simulators.

This is the real thing. The building is the original Ashmolean Museum building completed in 1683. As such it is the first purpose built museum in Britain and probably the first public museum in the world

### Directions

The museum is right in the centre of Oxford, next door to the Sheldonian Theatre and opposite Blackwell's Bookshop

### Opening times

Open
12.00pm to 4.00pm
Tuesday to Saturday
(closed Christmas week)

▲ Britain's first museum building 1683

▼ English Astrolabe C1370

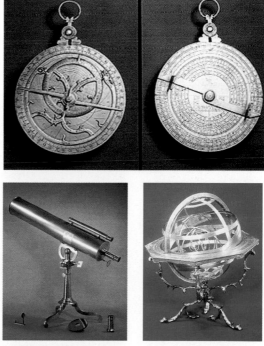

▲ Reflecting telescope by James Short of London C1765

▲ Italian Armillary sphere C1675

# MUSEUM OF MODERN ART OXFORD
30 Pembroke Street, Oxford, Oxfordshire OX2 7BA
Telephone 01865 722733 Fax 01865 722573

"One of Europe's most influential museums" The Independent Newspaper.

The Museum of Modern Art Oxford is proving ground and a power house, a series of magnificent galleries for temporary exhibitions from all over the world" The Sunday Times.

Since it opened in 1965 MOMA has established an international reputation for the high quality of its pioneering exhibition programme, which covers 20th century painting, sculpture, photography, film, video, architecture, design and performance from all over the world. MOMA does not have a permanent collection.

Originally built as a brewery in the 1880s, the premises were converted to their present use between 1965 and 1988. They now offer the public five large exhibition galleries, a cafe and a bookshop.

Visitors of all ages can take advantage of a comprehensive education and public access programme which includes evening talks, debates, workshops, holiday activities and guided tours.

Most of the museum's exhibitions tour nationally and have reached destinations as diverse as Edinburgh, Lisbon, Johannesburg, Beunos Aires, Moscow, Tokyo and Sydney.

Please telephone for more details of opening times.

OXFORDSHIRE

▲ MOMA front entrance

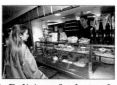

▲ Delicious food at cafe MOMA

▲ Interesting books at the MOMA Bookhouse

◄ The Upper Gallery at Moma, artist Loise Bourgeois

### Opening times

Open
Tuesday to Sunday
11.00am to 6.00pm
Thursday
11.00am to 9.00pm,
Free admission
and gallery talk
on Wednesday
11.00am to 1.00pm
Closed Monday

### Directions

MOMA is in the city
centre, a short walk
from Westgate
Shopping centre.
The entrance is next to
Marks & Spencer's
Foodhall in
Pembroke Street

### Admission

Adults £2.50
Conssions £1.50
(Over 60, registered
disabled, unwaged
& students)
Free Thurs 6-9pm
Wed 11am-1pm

**OXFORDSHIRE**

# PITT RIVERS MUSEUM
South Parks Road, Oxford, Oxfordshire OX1 3PP
Telephone 01865 270927 Fax 01865 270943

The Pitt Rivers Museum is famous both for its outstanding collections and its special period atmosphere.

Designed in 1884 it still retains a turn of the century appearance: masks peer down from the highwalls, boats sail overhead. The original display cases are crowded with amulets, beads, pots, shrunken heads, textiles, toys and much more, many objects still identified by tiny hand-written labels. Yet the appearance is misleading. Much that is on display has great relevance today.

The museum is a teaching department of the University of Oxford and popular with thousands of students of all ages, interested in crafts, technology and contemporary culture.

An audio guide to the Museum, presented by Sir David Attenborough, provides a thoughtful commentary on the Museum's history, its work and the collections.

A small shop sells ethnic crafts and a wide selection of books and postcards.

▶ Appliqué textile from a woman's mola blouse. San Blas Islands The Balfour Building,

60 Banbury Road, a ten minute walk away, is a new annexe with displays on Hunter Gatherer Cultures past and present. The Music Makers Gallery shows musical instruments from around the world.

Admission is free. All groups should book in advance. Please ring for Education Service details.

***

### Opening times

Open 1.00pm to 4.30pm Monday to Saturday all year (Please telephone to check closing dates for Christmas etc) The main displays will be closed from Spring to Autumn 1999, due to building work

***

### Directions

The museum is entered through the Oxford University Museum of Natural History on Parks Road. This is a ten minute walk from the city centre via Broad Street and Blackwells' Bookshops.

▲ Figure of Queen Victoria by Yoruba artist. Nigeria

▲ Lantern made from a Parrot Fish. Japan

▲ Mask representing a demon. Korea

# MUSEUM OF OXFORD
St Aldates, Oxford, Oxfordshire OX1 1DZ
Telephone 01865 815559 Fax 01865 202447

Discover Oxford's history by visiting the museum of Oxford - the only Museum in Oxford to tell the unique story of the city and its people from prehistoric times to the present day. Exhibits range from mammoth's tooth to a "Morris Motor" car engine.

Treasures from archaeological excavations include a preserved Roman pottery kiln, a wealth of Mediaeval pottery and a whole pavement of cattle bones.

The museum houses many fine paintings, panelling and furniture salvaged from old Oxford houses. These include an Elizabethan Inn, a Victorian kitchen on wash day and one complete shop front.

▲ A Victorian kitchen on wash day in Oxford in 1880s

Guided tours are available for pre-booked groups (minimum of twenty). School activities offer children the chance to touch the real thing with handling sessions on 'Investigating Mediaeval Rubbish' 'Explore Life in Oxford in 1646' and 'Life in Victorian Oxford'.

Information is available in German and French for language schools. Gallery activity sheets on all times of Oxford's past are available at the desk.

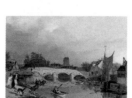

▼ 'Old Hythe Bridge and Oxford Castle' By Michael Angelo Rooker

### Directions

The museum of Oxford is part of Oxford's historic town hall, situated on St Aldates in the city centre. It is sign posted from both the bus and railway station

### Opening times

Open
Tuesday to Friday
10.00am to 4.00pm
Saturday
10.00am to 5.00pm
( last admission 30 minutes before closing)
Summer opening
July, August, September
as above plus Sundays
12.00pm to 4.00pm
(last admission 3.30pm)

OXFORDSHIRE

# BATE COLLECTION OF MUSICAL INSTRUMENTS

Faculty of Music, St Aldate's, Oxford, Oxfordshire OX1 1DB
Telephone 01865 276139 Fax 01865 276128

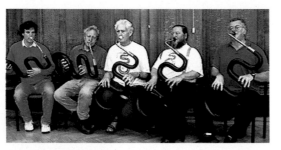

The Bate Collection in the Faculty of Music, University of Oxford is the most comprehensive collection in England of European classical woodwind, brass and percussion instruments.

It also houses a number of important early keyboards, a unique bow-maker's workshop and a collection of bows. In total over a thousand instruments may be seen on permanent display.

▲ A lunchtime concert using historic instruments from the collection

Philip Bate gave his collection to the University in 1963 to form a resource through which scholars and students could study music on contemporary instruments.

▲ A quintet of serpents from one of our study weekends

Since its original donation it has been enriched by many other gifts from musicians and writers on instrument history.

It is an international centre for wind instrument makers; many of the actual original instruments heard in recordings of early and classical music being copies of instruments in this collection.

The Bate Collection runs a number of one day workshops, weekend courses and summer schools throughout the year on instrument making, history and performance practice for a wide range of instruments. Please enquire for further details.

▶ corno da caccia, by Christian Bennett, London c.1700

### Opening times

Open
Monday to Friday
2.00pm to 5.00pm
Saturdays (in full
Oxford term only)
10.00am to 12.00pm
Please telephone for
other opening and
closing times

### Directions

The collection is in the Faculty of Music, situated between Christ Church and the Floyd's Row Police Station at the bottom of St Aldate's, a short walk from the city centre

▲ Rose sound hole, harpsichord by Jean Goermans, Paris c.1750

# THE OXFORDSHIRE MUSEUM

Fletcher's House, Park Street, Woodstock,
Oxfordshire OX20 1SN
Telephone 01993 811456 Fax 01993 813239

The first phase of The Oxfordshire Museum opened to the public in November 1998. Sympathetically designed new buildings house the town's Visitor Information Centre, a coffee shop with views of the gardens and a gallery to house travelling exhibitions.

Exhibitions during 1999 include: 11th March - 6th June 'On The Move' an interactive exploration of energy, man made and natural (this exhibition will take place in the refurbished brewhouse on the site).

26th March to 9th May 'A Taste of Things To Come': exhibitions giving visitors a glimpse of some of the objects and activities being planned for the new displays due to open in the Summer of 2000.

13th May - 6th June 'Crafts at Woodstock': an exhibition by the Oxfordshire Craft Guild in conjunction with Art Weeks. 11th June - 5th September 'Dynamic Toys': an interactive exhibition of toys from around the world.

▼ Exhibition of work by members of the Oxfordshire Craft Guild

▲ The Oxfordshire Museum, Woodstock

10th September - 21st November 'Looking for Alice': an exhibition exploring the lives of Lewis Carroll and the real Alice in Wonderland and Alice Through the Looking - Glass.

25th November - 9th January 'Christmas Crafts' an opportunity to see a selection of the best works by local craftsmen. Crafts for sale include metalwork, silk, paintings, jewellery, woodwork, embroidery and textiles.

***Opening times***
Open all year round (except Christmas Eve, Christmas Day, Boxing Day, New Year's Day and Good Friday) daily except Monday 10.00am to 5.00pm (last admission 4.45pm)

***Directions***
Woodstock lies on the A44 approximately 10 miles north of Oxford and adjacent to Blenheim Palace. The museum is in the centre of the town opposite the church

OXFORDSHIRE

**OXFORDSHIRE**

# COGGES MANOR FARM MUSEUM
Church Lane, Witney, Oxon OX8 6LA
Telephone 01993 772602 Fax 01993 703056

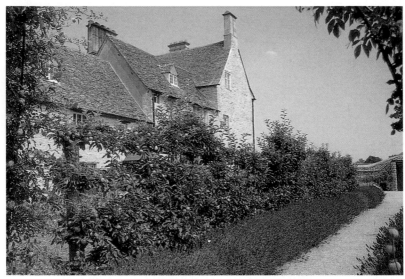

Cogges Manor Farm is a working museum of Victorian Rural Life. The 20 acre site includes manor house, walled kitchen garden, orchard picnic area, riverside walk and Cotswold farm buildings housing traditional breeds of animals, farm implements and carts.

There are regular displays of farming activities and traditional crafts. In the Manor House there is baking in the Victorian kitchen each afternoon, period room displays and interpretation room where children can follow the development of the house using a block model.

A rare example of 17th century painted panelling is in the Private Study of William Blake, wool merchant, High Sheriff of Oxfordshire and past owner of Cogges Manor.

The childrens' activity room provides traditional games and dressing up clothes.

▲ The Victorian Kitchen at Cogges Manor Farm

There is a small shop and cafeteria offering hot and cold light lunches and cream teas.

Special talks for school parties, please book in advance. Teachers pack available.

◄ The Manor House from the Victorian walled kitchen garden

Visits during November and March can be arranged.

Admission £3.50 adults, £2.25 OAP/Students £1.75 Children £9.50 Family (2+2). Group rate for pre booked parties.

Free car parking. Parking for disabled, near entrance. Also for disabled, tape commentary for first floor rooms of house.

Please telephone for further information.

▼ The Victorian bedroom at The Manor House

### Opening times

Open 23rd March 1999 to 31st October 1999 Tuesday to Friday and Bank Holiday Mondays 10.30am to 5.30pm Saturday and Sunday 12.00pm to 5.30pm (last admission 4.30pm) Closed Mondays

### Directions

At Witney, Oxfordshire just off A40 between Oxford and Burford follow brown sign with white cart

▼ Cotswold ewe and twin lambs at Cogges Manor Farm

**OXFORDSHIRE**

## BANBURY MUSEUM

8 Horsefair, Banbury, Oxon OX16 0AA
Telephone 01295 259855 Fax 01295 270556

There is an exciting programme of temporary exhibitions. The museum holds a large collection of photographs and glass plate negatives of the region, most of these can be viewed on microfiche and copies can be ordered.

*Opening times* Open April to September, Monday to Saturday 10.00am to 5.00pm,
October to March, Tuesday to Saturday 10.00am to 4.30pm

## BLOXHAM VILLAGE MUSEUM

The Court House, Church Street, Bloxham, Banbury, Oxon OX15 4ET
Telephone 01295 720283

The museum is in the Old Court House owned by the present trustees of Bloxham's ancient charities. Two new exhibitions every year reflect the past life of this beautiful village.

*Opening times* Sunday 2.30pm to 5.30pm Easter to September (and Bank Holidays)
Sunday 2.30pm to 4.30pm October,
2nd Sunday 2.30pm to 4.30pm November to Easter

## TOLSEY MUSEUM

126 High Street, Burford, Oxon OX18 4QU
Telephone 01993 823236

Wide ranging collection illustrating Burford's chequered history, maces, seals, charters from 1350, many exhibits recalling local trades, quarrying, rope-making, bell-founding, saddlery, brewing and others, unusual dolls house.

*Opening times* Open 20th March to 31st October, daily Monday to Friday
2.00pm to 5.00pm, Saturday, Sundays and Bank Holidays 11.00am to 5.00pm

## TOM BROWN'S SCHOOL MUSEUM

Broad Street, Uffington, Faringdon, Oxon SN7 7RA
Telephone 01367 820259

Items of local interest including the White Horse Hill, displays on local authors - Thomas Hughes and Sir John Betjeman. Annual changing displays in the Gallery.

*Opening times* Weekend afternoons from Easter to end October 2.00pm and 5.00pm
and Bank Holiday Mondays 2.00pm to 5.00pm

# SHROPSHIRE

Shropshire is a county of remarkable variations of scenery. In the southwest the land is rugged and mountainous particularly around the strange rocky outcrops of the Stiperstones. The River Severn cuts right across the county winding through lush verdant valleys. At the centre of the county is the Wrekin, a spectacular isolated mass of volcanic rock, the oldest in England. To the north of the Severn the land is mainly rich flat farming land scattered with delightful meres giving the region the reputation of a Shropshire Lake District. To the south is the lovely heather covered plateau of the Long Mynd. Despite being primarily a rural agricultural county it was here in the eighteenth century that the Industrial Revolution was born...in the Ironbridge Gorge of the Severn. The Ironbridge Gorge Museum Trust has established at Ironbridge a quite remarkable complex of museums centred on the world's first iron bridge cast in 1779 by Abraham Darby III. The Ironbridge Gorge is of course a World Heritage Site.

Shrewsbury, the county town, almost encircled by the River Severn was from Norman times strategically important as the gateway to Wales. In the eighteenth century it became a popular centre of fashionable society and boasts a wealth of fine Georgian buildings. The town's excellent Shrewsbury Castle and Shropshire Regimental Museum, housed in the historic castle, tells the history of the three Shropshire regiments, while in Barker Street, the Rowley's House Museum is regarded as the major regional museum. The setting of this collection is ideal being located in a sixteenth century timber-framed building and the adjoining seventeenth century brick mansion. Haughmond Abbey, beneath wooded Haughmond Hill is an interesting ruined abbey owned by English Heritage.

Shropshire can be justifiably proud of its first class museums concerned with the archaeology, natural history and social history of the region. Ludlow, one of England's best preserved medieval and Georgian towns, houses in Castle Street a wonderfully comprehensive museum telling the history of the ancient town from Norman times to the present day. The Royal Air Force Museum at Cosford houses a huge display of military and civil aircraft and a specialist collection of missiles and rockets.

# DUDMASTON HALL
Quatt, Bridgnorth, Shropshire WV15 6QN
Telephone 01746 780866 Fax 01746 780744

A late 17th century house with intimate family rooms containing fine furniture and Dutch flower painting, which were part of the late donor, Lady Labouchere's inheritance. Two rooms also display collections of her water colours and botanical art.

Sir George Labouchere collected ceramics and modern art. He is one of the longest serving members of the Society of Dilettatis a retired Ambassador he started his ceramic collection in 1940s from his period in China. He described his collection of modern art started in the 1950's as "non-figurative" or "abstract" he began to collect pictures and sculptures during his period in Brussels, helped by Baroness Cambert.

Initially he concentrated on the acquisition of British artists. Henry Moore, Barbara Hepworth, Ben Nicholson and others. They were soon augmented by works from the Paris school.

A notable later phase was the purchase of contemporary Spanish works. Since retirement Sir George has commissioned several large pieces of sculpture for the garden at

Dudmaston, including works from Anthony Robinson and the Shropshire artist Anthony Twentyman, Sir George's most important purchase during the 1980s was Barry Flangam's 'Boxing Hares'.

The collection as a whole is varied and a very important one, well worth seeing.

### *Opening times*

Open April to September Wednesday and Sunday, Bank Holidays except Good Friday 2.00pm to 5.00pm (last admission 5.00pm) Tea Room and garden open 12.00pm Booked parties Thursday 2.00pm to 5.30pm by appointment

### *Directions*

4 miles south east of Bridgnorth on A442 (138:SO746887) Teleford to Kiddermister Road

▲ Alan Davie date 1958

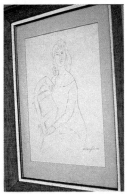

▲ Barry Flanagan date 1981 'Boxing Hare's' Bronze Latin cross base

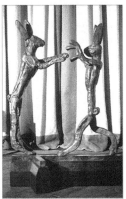

▲ Aleded Modigiani date 1900 pencil drawing of seated woman.

◄ Jan Van Huysum date 1742 'still life of fruit and flowers'

# LUDLOW MUSEUM

Castle Street, Ludlow, Shropshire SY8 1AS
Telephone 01584 875384

The Museum has four displays. First Geology. Discover how Sir Roderick Murchison, the famous Victorian Geologist, unravelled the story of Ludlow's rocks and made the area internationally famous.

Secondly the archaeology display explores the early history of the area when Stone Age man first settled in the region.

The Romans passed by, Anglo Saxons forded the River, but it wasn't until much later in Norman times that a Border stronghold of town and castle was established.

Thirdly history. Ludlow is one of England's finest mediaeval planned Towns. Fine domestic and Ecclesiastical building reflect the prosperity of the area.

During the 18th century Ludlow became a fashionable place for an aristocratic winter town house and many of the fine Tudor buildings were remodelled with brick frontages. Trade particularly in gloving flourished.

Fourthly a series of changing exhibitions visit including the Natural History of Shropshire and the County Museum Service's touring exhibitions. An excellent place to start a visit to Ludlow.

***Opening times***

Open April to October Monday to Saturday and also Sundays during June, July and August 10.30am to 1.00pm and 2.00pm to 5.00pm (last admission 4.30pm)

***Directions***

Access through the Tourist Information centre off the town square in the heart of the historic town. The local railway station is within walking distance.

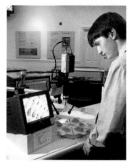

▲ Archaeology display to explore the area's history Stone Age to Tudors

▲ Changing exhibitions - Shropshire's Natural History to Museum Service's Touring exhibitions

◀ Ludlow, one of England's finest mediaeval planned towns, remodelled in 18th century

▼ Geology unravelled the story of Ludlow's rocks

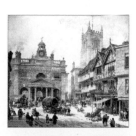

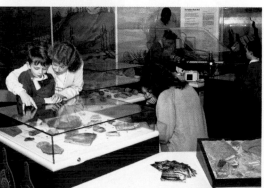

SHROPSHIRE

## ROYAL AIR FORCE MUSEUM
Cosford, Shifnal, Shropshire TF11 8UP
Telephone 01902 376200 Fax 01902 376211

Britain's largest collection of Military and Civil Transport Aircraft and the history of our civil aviation heritage from DH4A to Concorde in British Airways Exhibition.

Huge Missile collection including wartime German experimental weapons, and modern British equipment. Britian's largest collection of Research and Development Aircraft, including TSR2, Fairey Delta 2 and Bristol 188. World War II Aircraft including Spitfire, Hurricane and Mosquito.

New Visitor Centre includes restaurant, gift shop, toilets and Conference Centre.

The Centre's design is appropriately inspired by a bi-plane. Floor-to-roof windows give airfield vistas and a glazed roof scans skywards.

▲ Rolls-Royce Bristol Viper II MK200 on show in the extensive collection of aeroengines.

▲ The Museum's oldest exhibit, Louis Bleriot's 1909 monoplane is suspended from the roof of the New Visitor Centre

The approach and central display hall are designed like a runway, complete with landing lights. The Museum's oldest exhibit, Louis Bleriot's 1909 monoplane in which the aviator crossed the Channel is suspended from the roof and a Great War Sopwith Camel bi-plane and a Martel T.V. guided missile hang down the gallery displaying historic flying clothing.

The Museum's old offices, shop and storage space have been transformed into spacious, air conditioned, temperature-controlled art galleries. The gallery allows the public display, for the first time outside London, of works from the Second World War "War Artists Collection". All of which is in a large parkland setting on an active airfield.

▲ Hawker Hart can be found in the extensive collection of Research Development Aircraft

### Opening times

Open daily
10.00am to 6.00pm
(last admission 4.00pm)
Closed 24th, 25th and
26th December and 1st
January

### Directions

On A41, from the north 9 miles from junction 12 on the M6 then follow A5 to A41, and from the south one mile south of junction 3 on the M54.

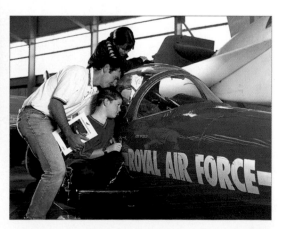

Hawker Siddeley GNAT ired from the Red Arrows play team in 1980 when the m converted to Hawks

# ROWLEY'S HOUSE MUSEUM
Barker Street, Shrewsbury, Shropshire SY1 1QH
Telephone 01743 361196 Fax 01743 358411

The building is a fantastic timber framed warehouse with adjoining brick mansion - the home of William Rowley, 17th century draper, brewer and leading citizen of Shrewsbury.

The displays show the enormous variety of the museum's collections, made over the last 160 years.

Galleries include the Rowley Room; Shropshire before the Romans; Geology; Wroxeter and the Romans; Mediaeval Shrewsbury and, new for 1999, a decorative arts display to include costume and wonderful Shropshire ceramics.

All galleries include fun activities for children. There is a regular temporary exhibition programme and events and workshops.

Rowley's House Museum is the proud holder of a Sandford Award for Heritage education.

Admission to all four museums in Shrewsbury will be free from April 1999.

### Opening times

Open
Tuesday to Saturday
10.00am to 5.00pm
Sundays from end May
to end September and
Bank Holiday Monday
10.00am to 4.00pm
Closed approx.
mid December to
mid January
please phone for full
information

### Directions

Town centre site
adjacent to Barker
Street short stay
car park and
Bridge Street
multi storey
car park.

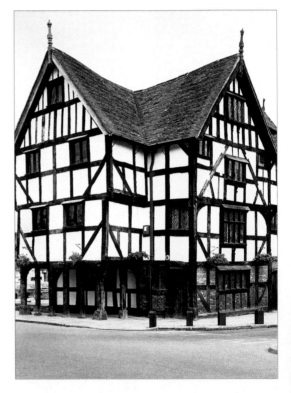

▲ Rowley's House - massive timber framing
outside: fantastic collections inside

**380**

# SHROPSHIRE REGIMENTAL MUSEUM    ♿ ▣

The Castle, Shrewsbury, Shropshire SY1 2AT
Telephone 01743 262292

The Shropshire Regimental Museum in Shrewbury's medieval castle was established in 1985 and completely refurbished following an I.R.A. bomb attack in 1992.

Reopened in 1995, the museum follows the stories of local military units - the 53rd and 85th Regiments from 1755 to 1881, the King's Shropshire Light Infantry from 1881 to 1968, the Shropshire Yeomanry from 1795 and the Shropshire Royal Horse Artillery.

It also displays collections relating to local Militia, Volunteer and Territorial Army units to date.

The collection contains over 14,000 items and has very fine displays of flags, uniforms, medals, weapons, china, silver and equipment.

Amongst its treasures are silver items belonging to "The Grand Old Duke of York", two captured American flags of 1814, a lock of Napoleon's hair, several Victoria Crosses and the Baton of Grand Admiral Karl Dönitz.

The collection is housed on three floors and tells the history of the units

on service at home and abroad and on campaign around the world. Major displays feature the 1914-18 war, World War Two and Post War campaigns in Palestine, Korea and Kenya.

### Opening times

Open March to October daily except Monday 10.00am to 4.30pm (last admission 4.00pm) October to December Closed Sunday and Monday Closed all of January and 3 day week in February

### Directions

The museum is located in Shrewsbury's medieval Castle on Castle Street. Very close to the railway station, bus station and main multi-storey car parks. No parking in museum grounds.

▲ Shrewsbury Castle which houses on three floors the Regimental Museum

▲ A view of the main hall - 1755 to 1914

▲ Uniform displays - North Shropshire Yeomanry c.1850

▲ The museum has a fine collection of medals and decorations

**SHROPSHIRE**

## IRONBRIDGE GORGE MUSEUM
Ironbridge, Telford, Shropshire TF8 7AW
Telephone 01952 433522 Fax 01952 432204

Ironbridge is a World
Heritage Site and home
to a series of unique
monuments and
museums spread over 6
square miles of the
beautiful River Severn
Valley.

Birthplace of the
Industrial Revolution the
museums explain and
interpret the remarkable
discoveries and events
which took place here
over 200 years ago.

Ironbridge Visitor Centre
- an introduction to the
museums and a stunning
model of the whole
Gorge. Blists Hill
Victorian Town - a
recreated working town
of the late 19th century,
with costumed staff and
whole community at
work.

Coalport China Museum
- riverside former China
works, now stunningly
displayed exhibition of
porcelain and "hands-on"
workshops. Jackfield Tile
Museum - beautiful

▲ At Coalbrookdale
under the triangular cover
building is the Darby
Furnace, where the
Industrial Revolution
began. In the foreground
the Boy and Swan fountain

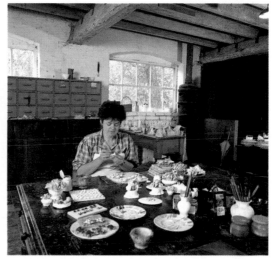

▲ Demonstrations form part of the interpretation of the ceramic industries at Jackfield and Coalport Museums

◄ Blists Hill Victorian Town

### Opening times
Open 7 days a week
10.00am to 5.00pm
Please call for details on
winter opening

kaleidoscopic displays of decorative tiles and modern manufacture.

Museum of Iron - Historic Centre of the whole valley, explains what happened here in 1709.

In addition, the Tar Tunnel, The Iron Bridge and Tollhouse, Broseley Pipeworks - all covered by The Ironbridge Passport Ticket.

### Directions
Ironbridge is on the River Severn 5 miles (8km). South of Telford in Shropshire. Take junction 4 from the M54 and the brown and white signs take you to Blists Hill Victorian Town, just one of our museums.

◄ The Iron Bridge is situated at the centre of the museums and the heart of the World Heritage Site

**383**

## NORTHGATE MUSEUM
High Street, Bridgnorth, Shropshire WV16 4ER
Telephone 01746 761859

A small museum situated in the 13th Century listed Northgate. It has collections of coins, tokens, cameras, firemarks and coats-of-arms of local families.

*Opening times* Open Easter to October Saturdays, Sundays and Bank Holidays 2.00pm to 4.00pm, during School holidays also open Mondays, Tuesdays and Wednesdays 2.00pm to 4.00pm

## HAUGHMOND ABBEY
Uffington, Upton Magna, nr Shrewsbury, Shropshire SY4 4RW
Telephone 01743 709661

Ruins of Augustiaian Abbey in 1500 chapter house rebuilt-timber ceiling remains from this time. 13th Century beautiful bay window in Abbots private rooms. Glorious place for restful picnic.

*Opening times* Open March to October 10.00am to 6.00pm (Dusk in Autumn)

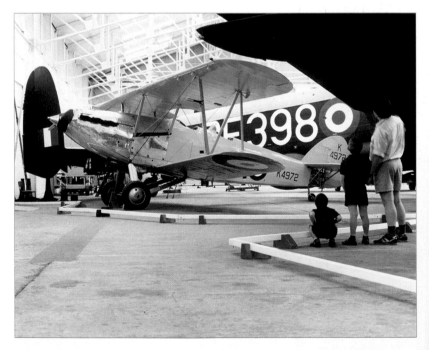

'Hawker Hart' from the Royal Air Force Museum at Shifnal: Shropshire

# SOMERSET

Somerset is an intriguing county of strange places and strange happenings and this is well reflected in its excellent museums. On the northern edge of the county are the Mendip Hills, thirty miles of limestone running from the sea to Frome, upon which are ancient Bronze Age barrows and Iron Age hillforts...and within which are fascinating caverns and caves. Many of these caves, including the famous Wookey Hole and the Cheddar caves show evidence of occupation in palaeolithic times.South of the central plain lies the Somerset Levels, a low-lying area of peat which has been dug since medieval times when the marsh was drained. The drainage ditches, known as 'rhynes', and pollarded willows are a distinctive feature of the Levels' landscape. Glastonbury Tor, rising to 521 feet is prominent from miles around and is topped by a ruined church tower. Glastonbury is closely associated with the Arthurian legends and stories of the Holy Grail and the miraculous Christmas flowering Glastonbury Thorn. Here at Glastonbury is The Somerset Rural Life Museum, its centrepiece being the superb fourteenth century Abbey Barn. Contained within the barn and surrounding farm buildings are displays and exhibitions of the tools and farming techniques of Victorian Somerset. Included also are explanations of traditional local activities which include cider making, willow crafts and peat digging.

Taunton, the county town, has been the centre of county life since Saxon times and it was here in 1685 that the Duke of Monmouth was declared King of England, and as a consequence many of the townsfolk lost their lives for supporting him. The Somerset County Museum displays a wide and comprehensive variety of objects relating to county history and includes as well as archaeology, pottery and fossils, childhood memorabilia. The Somerset Light Infantry Museum is housed with the County Museum in the castle.

Chard, to the south of Taunton has a fine classical town hall with two storeys of pillars and numerous interesting buildings. Housed in one of its sixteenth century houses is the Chard and District Museum displaying a wide range of exhibits concerned with the history of the area around Chard...the social life, farming and rural industries as well as early aviation.

SOMERSET

# SOMERSET BRICK & TILE MUSEUM

East Quay, Bridgwater, Somerset
Telephone 01823 320200 Fax 01823 320229

The only remaining brick kiln in Bridgwater and an impressive survivor of a major Somerset industry. The kiln is the heart of the museum. Visitors can view inside the kiln and see some of the many varied patterns of bricks and tiles, terracotta plaques and other wares which were the products of the industry.

### Opening times

Open Sundays in July and September 2.30pm to 4.30pm and other times by arrangement

### Directions

At the junction of the Bristol and Bath roads turn west towards the river. Turn right at the second set of lights into East Quay the museum is on the left

▼ The sole surviving brick kiln in Somerset

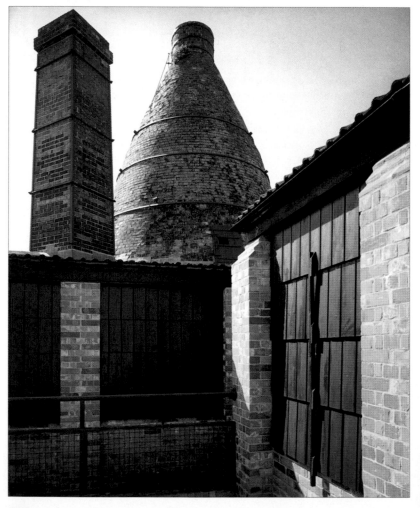

# SOMERSET RURAL LIFE MUSEUM

Abbey Farm, Chilkwell Street, Glastonbury, Somerset BA6 8DB
Telephone 01458 831197 Fax 01458 834684

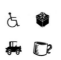

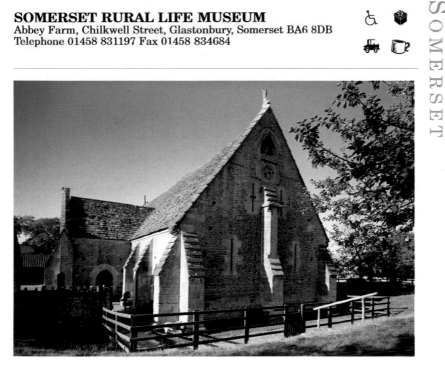

The museum is housed in the attractive setting of a Victorian farmhouse and farm buildings and includes the magnificent 14th century barn of Glastonbury Abbey.

Life in rural Somerset through the 19th and 20th centuries is illustrated in displays of traditional farming practices and the local industries of peat cutting, withy growing, cheese and cider making.

There is an original Victorian farmhouse kitchen and the lifestory of a 19th century farm labourer, John Hodges, and his family is vividly told.

Regular farming and craft demonstrations throughout the season, monthly changing exhibitions and special activities for school groups.

## *Opening times*

Open 1st April to
31st October
Tuesday to Friday and
Bank Holiday Mondays
10.00am to 5.00pm
Weekends
2.00pm to 6.00pm
1st November to
31st March
Tuesday to Saturday
10.00am to 3.00pm,
closed Good Friday
(last admission 30
minutes before
closing time)

▲ The magnificent fourteenth century Abbey Barn, centrepiece of the museum

## *Directions*

From the town centre or the Glastonbury by-pass take the A361 towards Shepton Mallet. The museum is situated on the corner of Chilkwell Street and Bere Lane in Glastonbury

SOMERSET

# WEST SOMERSET RURAL LIFE MUSEUM
The Old School, Allerford, Minehead, Somerset TA24 8HN
Telephone 01643 862529

The Rural Life Museum is housed in the old thatched school, leased from the National Trust. It was a school from 1821 to 1981 and opened as the Rural Life Museum in 1983. The collection is owned and administered by a Charitable Trust.

The exhibits are displayed in three rooms, the largest containing domestic, farm and local industry equipment from a hundred years ago.

The Victorian school room contains original desks and benches, together with slates, textbooks, books and toys of the period.

For children making educational visits there are Victorian era clothes in which they can dress up. The new room has a "theme" collection, changed annually.

A resident weaver is often to be seen at her loom and a spinner is present in the playground most Friday afternoons, with drop spindles that can be used by visitors.

Behind the school in the river-side garden are larger exhibits, a cobbler's workshop and a picnic area.

The playground is used by school activities with stilts and hoops and old singing games. Morning educational visits are enjoyed by the children and cover the National Curriculum. They are taken by experienced teachers and guides.

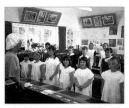

▲ A Victorian lesson for a school group

### *Opening times*

Open Good Friday to Easter week,
then May to October inc.
Weekdays
10.30am to 1.00pm and
2.00pm to 4.30pm
Sundays in Summer
School Holidays only,
last fortnight in
October pm only

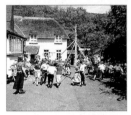

▲ Maypole dancing at the Museum June Fair

### *Directions*

A39 Minehead - Porlock.
1 1/4 miles from Porlock,
3 1/2 miles from
Minehead. Road to north
(signpost Allerford) -
museum on right after
100 yards opposite free
public car park

▲ The Victorian hearth

▼ "The Old School" home of the museum.

## SOMERSET COUNTY MUSEUM

Taunton Castle, Castle Green, Taunton, Somerset TA1 4AA
Telephone 01823 320201 Fax 01823 320229

The Museum exhibits important collections relating to Somerset's natural and human history.

The archaeology galleries contain exceptional material from prehistoric and Roman Somerset.

In the Great Hall are displayed fine collections of decorative art, including silver, ceramics, glass, costume, toys and dolls.

The skeleton of a sea serpent or ichthyosaur can be seen along with other fossils and minerals.

You can follow the fortunes of the Somerset Light Infantry, part of the Somerset Military Museum within the castle, or visit the mediaeval almshouse in the courtyard.

### Directions

The museum is five minutes walk from the Town Centre towards the bus station and behind the Castle Hotel.

▲ A muster of the Sealed Knot in the Castle Courtyard

▼ The gateway to Taunton Castle and the Somerset County Museum

### Opening times

Open
1st April to 31st October
Tuesday to Saturday
and Bank Holiday
Mondays
10.00am to 5.00pm
(closed Good Friday)
1st November to
31st March
Tuesday to Saturday
10.00am to 3.00pm

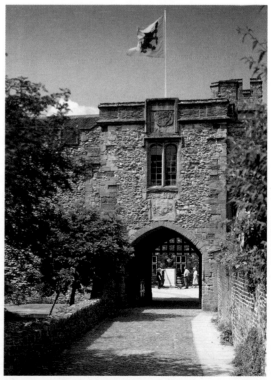

**SOMERSET**

## CHARD & DISTRICT MUSEUM

Godworthy House, High Street, Chard, Somerset TA20 1QL
Telephone 01460 65091

Displays of local history, social history and domestic life, agriculture, wheelwright, blacksmith and carpenter workshops, pioneers of early flight (John Stringfellow) and artificial limbs (James Gillingham).

***Opening times*** Open early May to late October, Monday to Saturday 10.30am to 4.30pm, also Sundays in July and August, (last admission 4.00pm)

## SOMERSET MILITARY MUSEUM

County Museum, The Castle, Taunton, Somerset TA1 4AA
Telephone 01823 32021 Fax 01823 320229

Features the county regiments of Somerset including the Somerset Light Infantry, Yeomanry and Militia. Many items of military historic interest together with fine medals gallery and paintings.

***Opening times*** Open Tuesday to Saturday, Bank Holiday Mondays, April to October 10.00am to 5.00pm, November to March 10.00am to 3.00pm, (last admission 30 minutes before closing)

## WELLS MUSEUM

8 Cathedral Green, Wells, Somerset BA5 2UE
Telephone 01749 673477 Fax 01749 675337

Mendip caves archaeology, geology samplers, mediaeval statuary are some of the attractions at the museum. There is also a full programme of temporary exhibitions throughout the year.

***Opening times*** Open Easter to end October daily 10am to 5.30pm, July and August 10.00am to 8.00pm, November to Easter, Wednesday to Sunday 11.00am to 4.00pm

## TIME MACHINE

Burlington Street, Weston-Super-Mare, Somerset BS23 1PR
Telephone 01934 621028 Fax 01934 612526

Family-friendly district museum. Displays on local life and industries, seaside holidays, wildlife and archaeology, including a 1900s period cottage. Regular programme of special exhibitions and people's collections displays.

***Opening times*** Open every day except Christmas and New Year, March to October 10.00am to 5.00pm, November to February 10.00am to 4.00pm

## FLEET AIR ARM MUSEUM

RNAS Yeovilton, Ilchester, Yeovil, Somerset BA22 8HT
Telephone 01935 840565 Fax 01935 840181

One of the world's largest aviation museums with over 50 historic aircraft on display. Fly aboard our carrier exhibition, see how sailors live, eat and work at sea.

***Opening times*** Open March to November 10.00am to 5.30pm, November to March 10.00am to 4.30pm, open every day except 24th to 26th December

# SUFFOLK

The chalky windswept land shared with neighbouring Norfolk known as Breckland has been largely planted with pine trees by the Forestry Commission, creating a glorious region of lonely scrubby heath. But between this wild area and a constantly eroding coastline is beautiful farming countryside. Not that the coastline is without its attractions. From Great Yarmouth to Felixstowe the coastline is punctuated with delightful coves and bays offering excellent sailing. Birdlife thrives along parts of this coast particularly at windswept and swampy Minsmere Bird Sanctuary where avocets and other wading birds can be seen. Felixstowe is both a seaside resort and an important container port...Aldeburgh on the other hand, having fought a losing battle with the sea has gained an international reputation from its Aldeburgh Festival, its magnificent concert hall being closely associated with the work of composer Benjamin Britten.

The superb landscape of this county has been immortalised in the paintings of John Constable who delighted in painting the lovely Stour Valley. The county is renowned for the work of another great painter, Thomas Gainsborough who was born in Sudbury.

At Lavenham, north-east of Sudbury is the wonderful Guildhall of Corpus Christi, one of the finest Tudor buildings in the country. The fine Moyse's Hall Museum at Bury St. Edmunds has a nationally important collection of archaeology and local history artifacts housed in one of England's rare surviving Norman town houses.

The Suffolk museums are by no means all concerned with the history or indeed the beauty of the county. At Leiston, the home of the Garrett family, who built the Snape Maltings, is the Long Shop Museum, an award-winning museum with three exhibition halls full of items associated with the age of steam. At the ancient market town of Stowmarket is the grand old Abbot's Hall, now the Museum of East Anglian Life, set in seventy acres of lovely Suffolk countryside.

SUFFOLK

# LONG SHOP MUSEUM
Main Street, Leiston, Suffolk IP16 4ES
Telephone 01728 832189

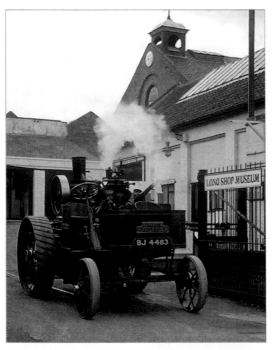

*Directions*

A12 to Saxmundham
then take the B1119
to Leiston

*Opening times*

Open
1st April daily
Monday to Saturday
10.00am to 5.00pm
Sunday
11.00am to 5.00pm

◀ 1919 Garrett Suffolk
Punch

Museum covering the
200 year history of
Richard Garrett
Engineering works.

◀ 1901 Merryweather
Fire Engine

▼ 1916 Garrett traction
engine Princess Marina

4 exhibition halls
including the Grade II
Listed Long Shop built
in 1852 as one of Great
Britain's first
production lines for
Steam Engines.

Gift shop, picnic garden
and newly opened
Garrett Room. Home of
the Garrett collection
covering local, social
and industrial history.

See the Garrett Steam
Engines on the very site
they were built.

**392**

# WOODBRIDGE MUSEUM
5a Market Hill, Woodbridge, Suffolk IP12 4LP
Telephone 01394 380502 Fax 01394 380483

This small gem of a museum on Market Hill has exhibits which reflect the history and life of Woodbridge and its townspeople - including its great benefactor, Thomas Seckford (who survived three Tudor monarchs and made investments in land in Clerkenwell, London, from which the town benefits to this day); the painter Thomas Churchyard and his family (many of whom were also artists); and the poets Bernard Barton and the more internationally known Edward Fitzgerald.

There is also a permanent exhibition centred on the Anglo-Saxon sites at Burrow Hill and Sutton Hoo - with fascinating photographs and newspaper items recording the discovery of the Ship Burial (and a model of that ship in the 1930s, with replicas of artefacts found at the time (the originals are in the British Museum) - as well as information on how the Anglo-Saxons lived and worked and what they ate and what they wore.

Carefully compiled activity sheets relating to the exhibits are available for children of all ages, free of charge, at the souvenir counter.

There is also a wide range of books and other articles connected with the exhibitions and with the town itself on sale at the same counter.

## *Opening times*

Open Easter to October
Thursday to Saturday
10.00am to 4.00pm and
Bank Holidays Sunday
2.30pm to 4.30pm
School Summer
Holidays open all week
except Wednesdays

## *Directions*

The Museum is on one side of Market Hill (facing the Shire Hall), north of the Town's main shopping street, the Thoroughfare, (Museum is well sign-posted).

▼ Olden days photographic equipment

▲ China from the 19th century

▲ Thomas Seckford (town's benefactor) from Tudor times

▲ Clocks and Thomas Churchyard paintings and related exhibits

**SUFFOLK**

## MOYSE'S HALL MUSEUM

Cornhill, Bury St Edmunds, Suffolk IP33 1DX
Telephone 01284 757488

Local history museum housed in 12th century domestic building. Important
archaeological collections and local history curios. Artefacts are complemented by a
programme of changing exhibitions and events.

> ***Opening times***  Open Monday to Saturday 10.00am to 5.00pm,
> Sunday 2.00pm to 5.00pm

## MUSEUM OF EAST ANGLIAN LIFE

Stowmarket, Suffolk IP14 1DL
Telephone 01449 612229 Fax 01449 672307

Seventy acres in the heart of Suffolk. Displays of social, rural and industrial life
including history, buildings, animals, steam and craft demonstrations, special events
and adventure playground.

> ***Opening times***  Open April to October daily Monday to Saturday 10.00am to 5.00pm
> and Sunday 11.00am to 5.00pm

## THE GUILDHALL OF CORPUS CHRISTI

Market Place, Lavenham, Sudbury, Suffolk CO10 9QZ
Telephone 01787 247646

Beautiful 16th century timber framed building in one of England's prettiest villages.
Museum illustrating the wool and cloth trade from which Suffolk's wealth grew. Also
farming and country life exhibitions.

> ***Opening times***  Open March to October 11.00am to 5.00pm

'1916 Garrett traction engine' from Long Shop Museum, Leiston: Suffolk

# SURREY

The nobility, the wealthy and the famous have been drawn to Surrey ever since William the Conqueror, after the Conquest distributed sections of the county amongst his nobles on which to build their castles and establish their hunting grounds. The county has been slowly but surely absorbed into the capital, becoming commuterland...to such an extent that Kingston upon Thames, the county's dministrative centre is actually in Greater London. Nevertheless Britain's most wooded county can still claim countryside of outstanding beauty. The magnificent North Downs cross the county from east to west and include Box Hill, a famous beauty spot for over two hundred years. To the south is the fertile Surrey Weald, while to the north is the low-lying belt of the Thames Valley. If the county is lacking a coastline it is certainly not lacking in glorious stretches of water. Great Pond at Frensham covers over a hundred acres, its neighbour, The Little Pond is not much smaller, while Virginia Waters, part of Windsor Great Park is a delight, situated in spectacular woodland. Kew Palace, where George III and his family retreated from London is in the magnificent Royal Botanic Gardens

Needless to say, Surrey, situated as it is close to London and the heart of the country is a county of historic happenings, all wonderfully recorded in its numerous museums and galleries. The county's many magnificent palaces and stately homes are in themselves museums and treasure houses and frequently add fascinating personal details to historic events. It was here in 1215 in a field at Runnymede near Egham, that King John was forced by his barons to sign the Magna Carta, one of the most significant incidents in English history.

The museums and galleries of Surrey are extremely varied in topics ranging from national and local history, local geology and archaeology, rural life and local crafts to the history of transport of the region and at Weybridge, the Elmbridge Museum is a wonderful collection of local, natural and social history, archaeology and costume. At Tilford, three miles from Farnham, with its huge triangular green dominated by three oak trees, one the reputed 'oak at Kynghoc' recorded in 1128, is a fine Rural Life Centre housing a museum of farm implements, wagons and farm machinery. Housed in an elegant Regency house, the Chertsey Museum displays a collection of local history and costume.

SURREY

## ROYAL LOGISTIC CORPS
Deepcut, Camberley, Surrey GU16 6RW
Telephone 01252 340871 Fax 01252 340875

The Royal Logistic Corps was formed on 5th April, 1993 amalgamating the Royal Corps of Transport, Royal Army Ordnance Corps, Royal Pioneer Corps, Army Catering Corps and the Postal and Courier Service (Royal Engineers).

The museum was built especially to house the large collections amassed by the Trustees of the Constituent Corps. The museum includes a large display area, lecture room and seating areas.

Guided tours, lectures, and the use of collection material for handling sessions of artefacts are all available by prior arrangement with the Curator.

Information to help cross curriculum courses by teacher is also available.

The visitor can examine how, over the last 500 years, the soldier has been transported and supplied with arms and equipment.

The many realistic tableaux, from the Crimean Commisary's Office to the Northern Ireland bomb disposal scene, allow you to extend your imagination, bringing other exhibits to life.

The museum maintains a large archive and photographic collection.

Researchers with specific queries should send their request to the Curator with a SAE. We will make every effort to help.

### Opening times
Open
Monday to Friday
10.00am to 4.00pm
Saturday
10.00am to 3.00pm
Closed Sundays and Public Holidays
(last admission 30 minutes before closing)
Free Admission

### Directions
The museum is situated on the B3015 via M3 (J3) at Deepcut near Camberley. A bus service connects Brookwood Station (Waterloo -Southampton Main Line) with the Museum. Free Parking

▲ Horses played a large part in the history of transport

▲ Children can enjoy handling bygone material and equipment

▲ A mock up of an improvised kitchen

# MUSEUM OF RICHMOND

Old Town Hall, Whittaker Avenue, Richmond, Surrey TW9 1TP
Telephone 0181 332 1141 Fax 0181 940 6899

For centuries Richmond has been a centre of fashion, the arts and the intellect, as well as home to many of Britain's monarchs.

The museum celebrates the unique heritage of Richmond, Kew, Petersham and Ham with colourful displays spanning prehistoric times to the present day.

Special features include superbly detailed models of Richmond Palace and Shene Charterhouse, the two magnificent Royal creations which invested Tudor Richmond with such importance.

An exciting programme of special temporary exhibitions, displays and events complements the permanent displays.

We try to provide something for everyone and there are always new things to see and do. Special leaflet provides details of our varied programme.

The museum is ideal for a family day out. Children are admitted free and they can use our free activity sheets to explore the displays. There is also a listening post for them to access the past, a children's database to keep them informed of special events and various

interactive exhibits throughout the museum.

Special activities are also available for school parties. For teachers we provide handling collections, replicas, resource packs and guides. Pre-booked parties can visit the museum outside opening hours. Contact the museum for details.

***Opening times***

Open
Tuesday to Saturday
11.00am to 5.00pm all
year round Sundays
(May to October)
1.00pm to 4.00pm
Closed Mondays and
Bank Holiday Mondays

***Directions***

The museum is situated
in Whittaker Avenue on
Richmond Riverside.
By train or tube exit
Richmond Station turn
left and follow signs
for an easy five
minute walk

▲ Local school children
learn about Wartime
Richmond

▲ At the start of the
Museum's displays

▲ 18th century
Richmond display at the
Museum of Richmond

▲ Model of Shene
Charterhouse,
Richmond's Tudor
monastery.

SURREY

# CHERTSEY MUSEUM
The Cedars, 33 Windsor Street, Chertsey, Surrey KT16 8AT
Telephone 01932 565764 Fax 01932 571118

▶ Embroidered
stomacher C 1725 - 35

▼ Viking sword 10th
Century

Chertsey Museum
opened in 1965 in
Chertsey's old town hall
and moved to its present
home, The Cedars, a
Grade II listed Regency
town house in 1972.

The building is owned by
the Olive Matthews
Trust and the museum is
managed by Runnymede
Borough Council.

The museum explores
the history of the
borough of Runnymede
through its outstanding
and varied collection
which includes a 10th
century.

Viking sword, mediaeval
decorative tiles from
Chertsey Abbey, an 1851
regulator clock and
historic costumes from
the Olive Matthews
Trust.

Temporary exhibitions
are held throughout the
year, often featuring
contemporary art and
craft.

The museum has a
recently refurbished
costume gallery and
Surrey's first hands-on
discovery room, focusing
on prehistory, time and
the Victorians.

A user-friendly local history research room provides a good starting point for researchers exploring the history of the area.

There is also an attractive garden and picnic area.

The museum shop has a wide selection of gifts to suit everyone.

There is ramp access for disabled users to the ground floor and level access to the garden.

A free parking space is available for vehicles displaying a valid orange badge.

*Opening times*

Open
Tuesday to Friday
12.30pm to 4.30pm
Saturday
11.00am to 4.00pm
Closed all day
Sunday and Monday
Local History
Research Room
Wednesday and
Thursday
12.30pm to 4.30pm
Saturday
11.00am to 4.00pm

*Directions*

Train:
Chertsey Station via
Weybridge or Staines 10
minutes walk.
Car: M25 (Junction 11)
A320 from Staines or
Woking/Guildford and
B375 from Kingston
for buses call
01737 242411

▲ Laleham Regatta
C1850 - 60 Oliver
Collection

▶ Chertsey Abbey tile
13th Century

SURREY

# RURAL LIFE CENTRE

Reeds Road, Tilford, Farnham, Surrey GU10 2DL
Telephone 01252 795571 Fax 01252 795571

### Directions

Halfway between
Frensham and Tilford
Farnham A31 3 miles
Milford A3 6 miles
Hindhead A3 6 miles M3
Junction 4 A331/A31
brown tourist signs
Tilford and Frensham
Rural Life Centre

◀ 18th century granary
located at the edge of
the Aborteum

The Rural Life Centre
features 200 years of all
aspects of English Rural
Life.

Set in 10 acres of
woodland and meadow,
displays cover farming,
horticulture, trades,
crafts, domestic life and
much more.

Social history of village
life from 1800 is
displayed in realistic
settings.

A diary of special events
is published annually
ranging from exhibitions,
demonstrations, craft
days to special events.

The Arboretum is a
special feature-over 100
species of trees. The Old
Kiln Light Railway runs
every Sunday and Bank
Holiday. Other features
include: indoor and
outdoor picnic areas,
cafe, children's
playground and much
more.

Highlights of the centre
include 18th century
granary, 19th century
timber chapel, horse-
drawn implements and
transport, working forge,
complete wheel-wrights
shop and representing
the village trades:
bakery, butchers, dairy,
cobblers, pharmacy and
so on.

Domestic life is
portrayed by a prefab of
late 1940s, nursery and
schoolroom.

For full diary of events
and further details
please send SAE to above
address. Main event of
the year - Rustic Sunday
on last Sunday of July.

### Opening times

Open April to September
Wednesday to Sunday
plus Bank Holidays
11.00am to 6.00pm
(last admission 5.30pm)

▲ Old Kiln Light
Railway runs on Sundays
and Bank Holidays

▲ Essex wagon

▲ 19th century Eashing
Chapel

# ROYAL BOTANIC GARDENS

Kew, Richmond, Surrey TW9 3AB
Telephone 0181 332 5000 Fax 0181 332 5197

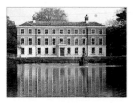

Kew Gardens in south west London already world famous for the tens of thousands of plants in its 300 acres now has a stunning new attraction in its museum.

Expenditure of £2,400,000, including £1,400,000 from the Heritage Lottery Fund, has enabled Kew to refurbish one of the Gardens, most impressive buildings.

Three floors high, it was designed by Decimus Burton in 1857 to stand across the lake opposite the world-famous Palm House.

The restored building now contains classrooms and lecture and demonstration rooms to provide an important education centre for children and adults, as well as the museum section.

▲ An exterior view, across the lake, on the other side of which is world-famous Palm House

There are four main themes in the main exhibition hall showcases: food and drink, health and well-being, clothing and diverse plant uses.

## Opening times

Open 9.30am Closing times vary with season, for more details please telephone 0181 940 1171

## Directions

Rail/Underground
Kew Bridge (SWT)
Kew Gardens
(Silverlink line)
and underground
district line.
By car A205 just south
of Kew Bridge
Junction 2 M4.
By Bus 65 391 daily R68
Sundays only

▲ Showcases with, in the base, a model of rafflesia, the largest flower in the world

▶ Interior views of the refurbished museum

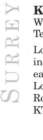

## KINGSTON MUSEUM

Wheatfield Way, Kingston upon Thames, Surrey KT1 2PS
Telephone 0181 546 5386 Fax 0181 547 6747

Local history museum and archives service with local history library, collections
include archaeology, social history and the internationally important collection of
early moving image equipment by Eadweard Muybridge.
Local history (research) room has separate address: Kingston Local History Room,
Room 46, North Kingston Centre, Richmond Road, Kingston upon Thames, Surrey,
KT2 5PE. Telephone 0181 547 6738.

*Opening times* Open all year daily from 10.00am to 5.00pm
Closed Wednesdays, Sundays and Bank Holidays

## REIGATE PRIORY MUSEUM

Reigate Priory, Bell Street, Reigate, Surrey RH2 7RL
Telephone 01737 222550

Grade I listed building. Changing exhibitions on a wide range of subjects designed to
appeal to both adults and children. The collection includes domestic bygones, local
history and costume.

*Opening times* Please telephone for details of opening times

## ELMBRIDGE MUSEUM

Church Street, Weybridge, Surrey KT13 8DE
Telephone 01932 843573 Fax 01932 846552

Elmbridge Museum was refurbished in 1995/6 and has displays on history of the
towns and villages of the area covered by Elmbridge Borough Council.

*Opening times* Open Monday, Tuesdays, Wednesday and Friday
11.00am to 5.00pm, Saturday 10.00am to 1.00pm and 2.00 to 5.00pm.
Closed on Thursdays, Sundays and Bank Holidays.

Interior of Royal Botanic Gardens at Kew: Surrey

# SUSSEX

Much has been said and written about 'Sussex by the Sea', ever since Rudyard Kipling praised its glories, and there is no doubting the fact that this county possesses an impressive coastline. This is truly a sunshine coast of shingle beaches and emotive piers stretching from Bognor Regis to Hastings, offering every conceivable seaside holiday pleasure. Brighton, the queen of Sussex seaside towns, and the largest town in the county, was mentioned in Domesday Book and was already a popular spa town when, in 1782, the Prince of Wales, later to become George IV, arrived. The building of the exotic Royal Pavilion and many elegant Regency houses heralded the town as a fashionable watering hole. The Royal Pavilion, one of Europe's premier royal palaces, has been fully restored to its full Regency glory and contains a magnificent collection of furniture, soft furnishings, decorative art, silver gilt and chinoiserie. The Brighton Museum and Art Gallery in Church Street houses an outstanding collection of both local and national importance including the remarkable Willett ceramics collection, while in an impressive Victorian villa, the Hove Museum and Art Gallery contains a superb collection of twentieth century paintings and drawings. The Hastings Museum and Art Gallery displays a collection of interesting Wealden ironwork and Sussex pottery, while the Hastings Museum of Local History tells the fascinating stories of the Cinque Ports, fishing and smuggling in this region as well as, not surprisingly, the Norman Conquest.

There is, of course considerably more to Sussex than its undoubtedly attractive coast. The spine of the county is the South Downs, an ancient ridge of chalk which runs from east to west and separates the Weald from the English Channel. The lovely Sussex Weald, once a vast forest is now largely given over to farming...however there are still areas, such as Ashdown Forest preserved in their original state.

The county town of West Sussex is Chichester, a Roman town retaining something of its Roman grid-iron street plan. The Chichester District Museum displays the history of this fine city together with the social and archaeological history of the district, while in Church Road the quite remarkable Mechanical Music and Doll Collection houses an extensive collection of working mechanical music items, including street pianos, barrel organs, music boxes and a grand collection of Victoriana.

# ARUNDEL MUSEUM & HERITAGE CENTRE

61 High Street, Arundel, West Sussex BN18 9AN
Telephone 01903 882344 Fax 01903 882456

◄ Times past - Sedan chair and robes from bygone days

▼ Prints and paintings from the picture gallery

Something old something new something borrowed. Arundel Museum and Heritage Centre has it all, arranged in nine display areas located in a listed Georgian building halfway up Arundel High Street.

Something old...discover a fascinating collection of artefacts and objects from flint tools and Roman wall plaster to Victorian tools and photographs. Don't miss the superb ship models in the Port Room, or the action packed reconstruction of the siege of Arundel Castle.

Something new...in 1999 we will feature a special display on the South Downs, arranged in conjunction with the Society of Sussex Downsmen. There is sure to be something special during the Arundel festival too.

Something borrowed... local people often lend items for short-term display. We never know quite what will turn up, so expect the unexpected and finally, see if you can find our cunningly hidden "Blue Object" - small prize for each child who spots it.

### Opening times

Open
end March to end
of September daily
10.30am to 5.00pm
Sundays
2.30pm to 5.00pm
(last admission 4.30pm)

### Directions

The Museum and
Heritage Centre is
situated half way up the
High Street, three
minutes walk from the
nearest car park and
ten minutes walk
from station

▲ One of the many models from "Port of Arundel" room

▶ Part of a large collection of old tools and implements

# BEXHILL MUSEUM OF COSTUME & SOCIAL HISTORY

Manor Gardens, Upper Sea Road, Bexhill (old town),
East Sussex TN40 1RL
Telephone 01424 210045

The display includes clothes and memorabilia from mid 18th century to the present day and includes a late 19th / early 20th century kitchen and schoolroom.

There are collections of embroidery, lace and dolls, including a special collection of costumed figures from mediaeval to Victorian times.

If prior notice is given items not currently on display will be made available for viewing from our extensive store.

The museum is staffed by voluntary helpers and is part of the Rother Museums Group.

The museum is situated in Bexhill's Manor Gardens near the ruins of Bexhill's manor house.

The gardens and the surrounding old town area of Bexhill make an attractive setting for this interesting museum.

### *Opening times*

Open
April to October daily
except Wednesdays in
April, May and October
weekdays
10.30am to 5.00pm
weekends
2.00pm to 5.00pm
(last admission 4.30pm)
June to September,
April May and October
5.00pm

### *Directions*

Buses from seafront and
town centre going
eastwards via Bexhill
old town Trains via
Hastings or Eastbourne
quarter mile walk
northwards from
station. Signposted walk
northwards from
seafront

▲ Mid 18th century costumes

▲ 1930s fashion

▲ Victorian originals

◀ A gallery of memorabilia

# THE ROYAL PAVILION

Brighton, Sussex BN1 1EE
Telephone 01273 290900 Fax 01273 292871

Universally acclaimed as one of the most exotically beautiful buildings in the British Isles, the Royal Pavilion is the former seaside residence of King George lV.

Originally a simple farmhouse, in 1787 architect Henry Holland created a neo-classical villa on the site. It was later transformed into its current Indian style by John Nash between 1815 and 1822.

Decorated sumptuously throughout in the Chinese taste, the Palace has been painstakingly restored to its full Regency glory.

Witness the magnificent Music Room with a domed ceiling of gilded scallop-shaped shells and hand-knotted carpet, and promenade through the bamboo grove at the long Gallery.

Lavish menus were created in the Great Kitchen, resplendent with whimsical cast iron palm trees, then served in the Banqueting Room beneath a huge crystal chandelier.

▶ The Music Room

▲ King George IV's magical Royal Pavilion

◀ The recently restored Yellow Bow Rooms

With the quiet grace of the drawing rooms, the charm of the King's private apartments, the style and elegance of the rooms on the upper floor and much more, the Royal Pavilion is a quite unforgettable experience.

A special programme of events takes place during the winter months, including costumed guided tours and living history activities.

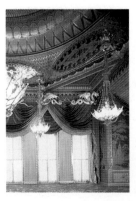

### Opening times

Open daily
June to September
10.00am to 6.00pm
October to May
10.00am to 5.00pm
Closed 25th and
26th December
(last admission 6pm
June to September,
5pm October to May )

### Directions

The Royal Pavilion is located in the centre of Brighton on the Old Steine. It is 15 minutes walk from Brighton Station

▼ The Long Gallery

# BRIGHTON MUSEUM & ART GALLERY

Church Street, Brighton, Sussex BN1 1UE
Telephone 01273 290900 Fax 01273 292841

This outstanding museum houses collections of local and national importance, from exquisite Art Nouveau and Art Deco furniture, glass and ceramics to the innovative 'My Brighton' local history project using the latest touch-screen computer technology.

Gallé Mackintosh, Clarice Cliff and Lalique are among the artists represented in the decorative art collections, while clothes from the 18th century to the 1980s are displayed in the fashion gallery.

◀ Chao Chou Puppet-China 19th-century

Fine art includes an extensive range of prints, drawings and watercolours dating from late 15th century woodcuts to 20th century drawings and paintings.

The ceramics galleries explore the development of English pottery and porcelain, as well as exhibiting the famous Willett Collection.

Nationally renowned galleries of non-western art feature fascinating exhibits from Asia, Africa, the Pacific and the Americas, while the tiny toy box contains examples from the Museum's large collection of historic toys.

See unique archaeological treasures from the Sussex area and enjoy the hands-on, archaeology discovery room, then experience Brighton's fascinating past in the local history galleries.

There is a lively programme of historic and contemporary art exhibitions, plus a range of special events and educational activities for visitors of all ages.

### *Opening times*

Open
Monday, Tuesday,
Thursday, Friday
and Saturday
10.00am to 5.00pm
Sunday
2.00pm to 5.00pm
Closed
Wednesdays,
Good Friday,
25th, 26th December
and 1st January
(last admission 5.00pm)

### *Directions*

Brighton Museum is located in the centre of Brighton on Church Street. It is adjacent to the Pavilion gardens and is approximately 15 minutes walk from Brighton Station

▲ Frank Stella 'Red Scramble' 1977

▲ Emile Gallé - Pair of cats c1880

▲ Malanggan Mask - Melanesia 19th-century

**407**

# HOVE MUSEUM & ART GALLERY

19 New Church Road, Hove, East Sussex BN3 4AB
Telephone 01273 290200 Fax 01273 292827

The Museum is housed in an impressive Victorian villa, built between 1873 - 1877. It was purchased by Hove Corporation in 1926 and opened to the public as a Museum and Art Gallery in 1927.

Hove Museum and Art Gallery is home to the South East Arts Craft Collection. The collection started in 1981 with commissioned pieces from ten leading craftsmen in the region. New work is purchased annually by selection from an open submission. There are now over 100 objects, made by fifty eight leading makers in twelve disciplines.

The childhood room houses a superb collection including dolls, books, puzzles, games, samplers, characters from children's film and television and wonderfully detailed dolls houses.

Hove's film heritage is celebrated with displays on its early pioneers - George Albert Smith, James Williamson and Esme Collings. Also featured is a comprehensive collection of early film apparatus.

In addition there are collections of fine and decorative art from the eighteenth and twentieth centuries.

There are extensive and significant examples of English pottery and porcelain. The paintings range from 18th century work by Gainsborough

and Kauffman to fine 20th century examples by Stanley Spencer and Winifred Nicholson.

The museum has a busy programme of temporary exhibitions.

### Opening times

Open all year Tuesday to Saturday 10.00am to 5.00pm and Sunday 2.00pm to 5.00pm Closed Mondays

▶ James Williamson early Hove film pioneer 1855 - 1933

▲ Edward Burra 'Birdman and Pots' 1947

◀ Dolls house and contents, 1912

### Directions

Located to the west of Hove town centre. 15 minutes walk from Hove Station. Buses 1, 1A or 6 from Churchill Square, Brighton, 20 from Shoreham, 49 from Moulscombe

▼ Richard Slee 'Plant' 1989 South East Arts Craft Collection

SUSSEX

# CHICHESTER DISTRICT MUSEUM & GUILDHALL

29 Little London, Chichester, West Sussex PO19 1PB
Telephone 01243 784683

Visit the museum and discover the past and present of Chichester District. Travel through time looking at fossils, Boxgrove man, Bronze Age, Romans, Saxons and mediaeval life.

In the social history galleries you can find out about local life from the turbulent Civil War to the Victorians and present day.

The museum may be compact but there is lots to do, with a programme of changing exhibitions and a wide range of "hands on" activities in the galleries aimed at all ages.

Look out for the leaflet of special events ranging from talks to craft workshops and living history re-enactments.

Chichester District Museum also opens the Guildhall in Priory Park. This was once the church of the Greyfriars built in 1282. After the dissolution of the monasteries it became The Guildhall and Law Courts where William Blake, artist and poet was tried, and a notorious gang of

smugglers were sentenced. Set in the beautiful surroundings of the historic Priory Park by the city walls and the site of the Norman Castle.

### *Opening times*

Museum open all year Tuesday to Saturday 10.00am to 5.30pm (Closed Sunday, Mondays, Good Friday, Christmas Day, Boxing Day and 1st January). Guildhall only open Saturdays 12.00pm to 4.00pm June to September. Other times by appointment

### *Directions*

From City cross walk along East Street to end of pedestrian precinct, turn left into Little London to Museum. For Guildhall turn left through bollards to Priory Park can't miss Guildhall Museum

▲ Children can experience what life was like through living history

▲ Ceramic tile painting during the annual Childrens Week in August

▲ Chichester District Museum, housed in a corn and seed store

▶ The Guildhall, Priory Park where many events are held

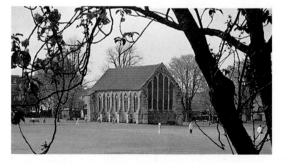

# PALLANT HOUSE GALLERY
9 North Pallant, Chichester, West Sussex PO19 1TJ
Telephone 01243 774557 Fax 01243 536038

The Pallant House Collection, born out of bequests of Walter Hussey and Charles Kearley, comprises paintings, drawings and sculpture mainly of the modern British school.

Other treasures range from an exquisite drawing by Watteau to the Amberley Castle panels (c1526) and a magnificent collection of bow porcelain.

Pallant House is the only Queen Anne house in England open to the public. The tastefully restored rooms each reflect a period of its past, from when it was built in 1712 to the end of its domestic life in the age of Queen Victoria. The house has a peaceful walled garden in the formal Georgian town house style.

There are continuous changes in the displays, stimulating temporary exhibitions, a top quality recital series, festive events for the whole family, gallery talks, workshops for adults and children, guided tours around the gallery and a tantalising range of products and artwork in the shop.

◄ Dodo at the house entrance

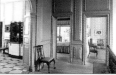

▲ Pallant House Gallery main landing

▲ Amberley Room with panels and bow porcelain collection

▲ Garden gallery with past exhibition

### Opening times

Open
Tuesday to Saturday
10.00am to 5.00pm
Sundays and
Bank Holidays
12.30pm to 5.00pm

### Directions

Come to the cross in the middle of Chichester where East, South, North, West Street meet turn into East Street first turning right is signposted Pallant House, North Pallant

**411**

# TOWNER ART GALLERY & LOCAL MUSEUM

High Street, Old Town, Eastbourne, East Sussex BN20 8BB
Telephone 01323 417961 (Information Service 01323 411688)
Fax 01323 648182
EMail townergallery@eastbourne.gov.uk

◀ Towner Art Gallery and Local Museum, Eastbourne

▼ Eighteen Thousand Tides 1996 David Nash (born 1945)

Housed in an elegant 18th century building, the Towner Art Gallery and Local Museum is set in delightful gardens in the old town of Eastbourne.

The Towner is home to a fine collection of 19th and 20th century British Art, including a gallery devoted to Eric Ravilious and a new sculpture by David Nash in the gardens.

A lively programme of exhibitions and events means there is always something to see and do.

The Museum covers the history of Eastbourne from prehistory. Artefacts range from Bronze Age axes to the original station clock and items from Eastbourne's Roman Villa to an original Victorian kitchen range.

### Opening times
Open
Tuesday to Saturday
12.00pm to 5.00pm
Sunday and Bank
Holiday Monday
2.00pm to 5.00pm
(close at 4.00pm
November to March)
Closed 24th to
27th December,
1st January
and Good Friday

### Directions
By rail: Hourly service
from London Victoria
(85 minutes).
By Road: A22 from
North, A27 and A259
from west, A259 from
east. Parking available
in nearby streets.
Ten minutes walk
from station, Bus from
Terminus Road
1, 8, 12, 14, 712.

▲ The Bedstead c 1939 Eric Pavilious (1903-1942)

◀ Soldiers Backs 1942 Edward Burra (1905 - 1942)

# HASTINGS MUSEUM & ART GALLERY

Johns Place, Bohemia Road, Hastings, East Sussex TN34 1ET
Telephone 01424 781155 Fax 01424 781165

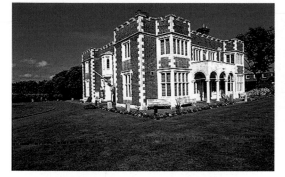

Hastings Museum and Art Gallery contains a rich and exotic mixture of fine paintings and china, the culture of other lands and a contrasting view of local wildlife today and as it would have been 150 million years ago.

There are plenty of special features for children, with fossils that transform into dinosaurs, a diorama of local animals, two Native American Galleries complete with tipi and buffalo, and a display on the Hastings born conservationist Grey Owl.

There is a display on John Logie Baird who made his break-through in the invention of television in Hastings in 1923/24.

The most spectacular part of the museum is the magnificent Durbar Hall constructed for the Indian and Colonial Exhibition of 1886.

▲ Hastings Museum and Art Gallery was built in 1923

There is also a wide-ranging programme of exhibitions by the very best local artists, national touring shows and local history topics.

### Opening times

Open daily
except Good Friday,
Christmas Day
and Boxing Day
Monday to Friday
10.00am to 5.00pm
Saturday
10.00am to 1.00pm
and 2.00pm to 5.00pm
Sunday
3.00pm to 5.00pm

### Directions

Hastings Museum is on the A21 Bohemia Road next to Summerfield Sports centre, ten minutes walk from Hastings Station and St. Leonards Warrior Square Station

▲ The Durbar Hall contains the ethnographic displays

▲ Reconstruction of a tipi in the Plains Indian Gallery

▲ Life size Iguanodon Hastings own dinosaur

SUSSEX

## HORSHAM MUSEUM
9 Causeway, Horsham, West Sussex RH12 1HE
Telephone 01403 254959

Between hustling and bustling London and Brighton lies the ancient market town of Horsham.

Over the last 15 years, Horsham has managed to weave the best of its mediaeval past into the rich fabric of modern life. Horsham Museum has achieved the same.

▼ "Fighting Grouse" bronze sculpture by J G Millais

◄ The highly scented walled garden

Set in the county's most photogenic street, Horsham Museum is housed in a mediaeval timber-framed building. With over 19 galleries, it specialises in the everyday and the ordinary but in an extraordinary way.

The building, gardens and objects have been blended together to create a place of wonderment and surprise, reflecting the fascinating history of the area.

With displays on early bicycles, to unique dinosaur bones, from saddlery to the world-famous Shelley, local trades, farming and social history, there is something for everyone.

Each year the Museum staff and volunteers put on five temporary exhibitions drawing on over 100 years of collecting. Come to Horsham Museum and see where local history matters.

***Opening times***

Open all year
Monday to Saturday
10.00am to 5.00pm
(except Bank Holidays)
Admission free

***Directions***

Use A24/A281.
No parking at Museum.
Use town centre car parks. From bandstand to Kings Head, to Town Hall. Museum 200 yards on left. Station 10 minutes' walk from bandstand

# MECHANICAL MUSIC & DOLL COLLECTION

Church Road, Portfield, Chichester, West Sussex PO19 4HN
Telephone 01243 372646 Fax 01243 370299

Visitors are taken on a guided demonstration tour through 100 years of mechanical music, enjoying the sounds of musical boxes, barrel-pianos, fair organs, orchestrions, etc.

This museum is proud of its restoration programme. All the mechanical music exhibits have been fully restored to look and play as they did originally.

In the field of disc musical-boxes, one of the curators, Lester Jones, has been responsible for a marvellous development "Renaissance Discs". He can now copy all the types and sizes of metal discs that play polyphon-style music boxes. The museum displays and demonstrates these "Renaissance" Discs and supplies them to Museums and collectors throughout the world.

As well as hearing the fabulous instruments, visitors see Edison phonographs, early gramophones, stereoscopic viewers and over 100 superb dolls dating from 1830 - 1930, in perfect condition and many in original clothes.

Although public access restricted to just one day in July and August, bookings for groups may be made for any day or evening throughout the year. It is a very popular venue for the clubs, schools, language students and suits all ages. Group rates available. Please telephone for details.

***Opening times***
Open June, July, August and September Wednesdays only 1.00pm to 4.00pm, group bookings by appointment, available throughout the year

***Directions***
Sited in old Victorian church in Church Road. Near the super-stores at Portfield Retail Park. Signed from A27 one mile east of Chichester city centre

▲ 21' high stone and marble Reredos - originally in Chichester Cathedral

▲ Continental Barrel-Piano c 1910, plays ten lively tunes

▶ A fine bisque-headed doll, made by Kesner, Germany c 1890

# PETWORTH HOUSE & PARK
Petworth, West Sussex GU28 0AE
Telephone 01798 342207 Fax 01798 342963

Magnificent 17th century house set in 'Capability' Brown landscape park immortalised by Turner.

Petworth contains the National Trust's finest collection of paintings and sculpture. Amongst the 300 paintings and 100 sculptures are works by Turner, Van Dyck, Titian, Gainsborough and Blake. The collection is displayed in grand showrooms including Grinling Gibbon's famous "carved room" and Louis Laguerre's grand staircase murals.

The servants quarters contain the old Victorian kitchens, pantry, scullery and still room.

A regular programme of exhibitions events and demonstrations takes place throughout the season and guided tours can be arranged for groups.

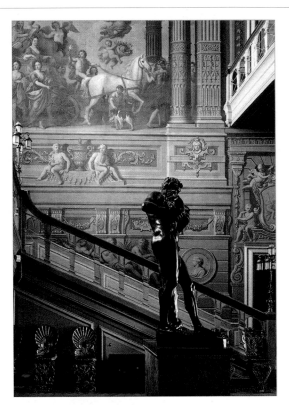

Extra rooms belonging to Lord and Lady Egremont are open on weekdays only at no extra charge.

Petworth Park offers stunning views and gentle walks at any time of the year.

National Trust gift shop and licensed restaurant serving traditional meals based on historic recipes.

▲ The Grand Staircase with murals by Louis Laguerre

◀ The North Gallery

Full colour guides available for house and servants' quarters and park. Also children's guide and free quizzes and braille guides.

Short guide available in French and German.

For further information contact the National Trust, Petworth House, Petworth, West Sussex GU28 0AE.

▲ The Carved Room with wood carvings by Grinling Gibbons

### Opening times

House open
27th March to 31st October daily except Thursday and Friday (open on Good Friday)
1.00pm to 5.30pm
(last admission 4.30pm)
Car park, shop and restaurant at 12.00pm the same days as the house.
Park open daily
8.00am to dusk all year

### Directions

At the Junction of the A272 and A285 and A283 in the centre of Petworth. Car park is on the A285 or park in Petworth and use town centre entrance

◀ The Old Kitchen

## RYE CASTLE MUSEUM

Ypres Tower, Gungarden, and
3 East Street, Rye, Sussex, TN31 7JY
Telephone 01797 226728

The history of Rye Castle spans more than 700 years from the days when the sandstone rock upon which the town grew up was almost entirely surrounded by the sea. Inside the great stone walls of Rye Castle, also known as Baddings Tower and the Ypres Castle, you will find many stories from many centuries.

▼ An early Edwardian doll in the museum's collection of toys. It has a very good head by Kamer & Reinhart, c.1903

▲ Model of a life-boat: classed as the 'Liverpool type', many were built in the first decades of this century

▲ Rye Castle from the Gungarden

A contour model of the area known as Romney Marsh. The story of Rye and the sea with ship building, fishing and smuggling is told in the displays.

There is a very good collection of prints and drawings, of rye pottery from mediaeval to present day ware, and the Museum has one of the oldest fire engines in the world.

For the children there are toys and a doll's house of the 1880s, and many other interesting things. In the turrets you can witness the grim life of a prisoner in the cells.

### Opening times

Open April 1st to 31st October every day 10.30am to 5.30pm
1st November to March 31st Saturday and Sunday 10.30am to 4.00pm

### Directions

There are two sites, one in East Street and the other Ypres Tower, overlooking the Marsh and near the church. East Street is first left as you enter the town.

◀ The Sussex Pig is a traditional piece of local pottery

# THE BLUEBELL RAILWAY

Sheffield Park Station, nr. Uckfield, East Sussex TN22 3QL
Telephone 01825 723777 Fax 01825 724139

The Bluebell Railway operates historic steam trains through nine miles of Sussex countryside between Sheffield Park, Horsted Keynes and Kingscote.

In addition to the basic train service, the Bluebell Railway also operates Pullman Dining Trains (Tel: 01825 722008 for details) and Christmas "Santa Special" trains.

There also special events for families and enthusiasts through the year. Pre-booked groups of 20 plus qualify for a group discount of 25%.

Guided tours and teacher information packs are available for school parties. For further information please send a 'C4' SAE.

### Opening times

Sheffield Park Station open every day except Christmas Day, Shop and Restaurant open 11.00am to 4.00pm Trains run every weekend throughout the year, and daily May to September and during School Holidays. Please send "DL" SAE for timetable brochure

### Directions

Sheffield Park Station: on A275 two miles north of Junction with A272 at North Chailey. By Bus: 473 between East Grinstead and Kingscote, or 270 Haywards Heath to Horsted Keynes

▲ No. 3 "Baxter", built by Fletcher Jennings and Co. 1877

▲ Children's favourite - No. 55 "Stepney"

▼ "Birch Grove" at Horsted Keynes Station - 1898 or 1998?

# WORTHING MUSEUM & ART GALLERY

Chapel Road, Worthing, West Sussex BN11 1HP
Telephone 01903 239999 Fax 01903 236277

Our amazing costume collection can be seen in two galleries and often features in temporary exhibitions. It has also inspired many of the clothes seen in historical television dramas.

Each year there is a varied programme of contemporary exhibitions in three galleries and the sculpture garden.

Some displays are drawn from our own stunning collections of art and history. Others are borrowed.

There are events and activities throughout the year for visitors of all ages. Whatever your interests you should find something here which will please and excite you and we are delighted to say that the admission is free.

"Friendly", "fascinating" and "a delightful surprise" are just some of the remarks overheard around the museum, which is often compared to Dr Who's Tardis, containing more delights than might be expected to fit in it.

Award-winning displays tell the story of the Worthing area from earliest times and include a unique glass

▲ Child's blue silk dress 1855-65

goblet made in Egypt 1600 years ago, the latest hoard of Roman gold ever found in Britain and reconstructions of an old downland kitchen and a Victorian nursery.

The dolls, toys, dolls houses and teddy bears are always worth a visit.

▲ Reconstruction of a late Victorian nursery

### Opening times

Open
Monday to Saturday
10.00am to 5.00pm

### Directions

By car use the A24,
A27 or A259.
Regular train services
from London, Brighton
and Portsmouth.
Send for the museum's
exhibition leaflet which
includes an excellent
town centre map.

▲ 'Bianca' by Holman
Hunt, 1869

▼ A 'cuddle' of
teddy bears

**SUSSEX**

## BATTLE ABBEY & SITE OF THE BATTLE OF HASTINGS

High Street, Battle, East Sussex TN33 0AD
Telephone 01424 775705 Fax 01424 775059

Site of Battle of Hastings and Abbey ruins incorporating museum on monastic life of the monks and also new exhibition on the prelude to the Battle of Hastings.

*Opening times* Please telephone for details of opening times

## RYE ART GALLERY

Stormont Studio, Ockman Lane, Rye, Sussex TN31 7JY
Telephone 01797 223218

Free entry to both galleries contemporary arts and crafts, fine art including Burra, Nash, Hitchens, Short and Piper.

*Opening times* Open daily 10.30 to 1.00pm and 2.00pm to 5.30pm

## BOOTH MUSEUM OF NATURAL HISTORY

194 Dyke Road, Brighton, Sussex BN1 5AA
Telephone 01273 292777 Fax 01273 292778

The museum has permanent exhibition of birds, skeletons, insects, fossils and minerals as well as frequent temporary exhibitions on natural history and related arts themes. Roadside car parking. Access to rear of building for disabled people.

*Opening times* Open all year Monday to Wednesday, Friday and Saturday
10.00am to 5.00pm, Sunday 2.00pm to 5.00pm.
Closed Thursdays, Christmas Day, Boxing Day, New Years Day and Good Friday

## PRESTON MANOR

Preston Drove, Brighton, Sussex BN1 6SD
Telephone 01273 292770 Fax 01273 292771

The house was built C1250, rebuilt in 1738 and remodelled in 1905. The house is fully furnished as a country house museum illustrating life both above and below stairs.

*Opening times* Open all year except Christmas Day, Boxing day and Good Friday
Monday 1.00pm to 5.00pm, Tuesday to Saturday 10.00am to 5.00pm
and Sunday 2.00pm to 5.00pm. Admission charge payable.

## THE BARLOW COLLECTION OF BRONZES, CERAMICS AND JADE

The University of Sussex, The Library, Falmer, Brighton BN1 9QL
Telephone 01273 606755

The collection holds some 400 Chinese works of Art from 12th century BC to 18th century AD, it includes bronzes, jades, tomb figurines and ceramics.

*Opening times* Open Tuesdays and Thursdays 11.30am to 2.30pm.
Closed in August, Christmas and Easter

## FISHBOURNE ROMAN PALACE
Salthill Rd, Fishbourne,Chichester, West Sussex PO19 3QR  
Telephone 01243 785859 Fax 01243 539266

Remains of one wing of 1st century palace with many mosaic floored rooms, hypocausts, etc. inside coverbuilding. Important finds displayed in site museum. Audio-visual programme. Re-planted Roman garden and Roman plant display area. Museum of Roman Gardens. Guided tours weekends and school holidays only.

*Opening times* Please telephone for details of opening times

## EAST GRINSTEAD TOWN MUSEUM
East Court, East Grinstead, Sussex RH19 3LT

Small but lively independent museum of local history. Regular temporary exhibitions. In Grade II listed former private house of 1769 in public park. Due to move into town centre 1999. Guided tours available outside usual opening times.

*Opening times* Open Wednesday and Saturdays 2.00pm to 4.00pm

## THE WISH TOWER PUPPET MUSEUM
Tower 73, King Edward's Parade, Eastbourne BN21 4BU
Mailing Address 23 Grange Road, Eastbourne BN21 4HG
Telephone 01323 417776 Fax 01323 728 319

A unique display of puppets from all over the world. From Asian shadow puppets to English Mr Punch and early television puppets. For programme of events please call 01323 417776. Guided tours are to be booked in advance.

*Opening times* Open Easter to the end of October daily 10.30am to 5.00pm

## SUSSEX FARM MUSEUM
Heathfield, East Sussex TN21 0JB
Telephone 01435 812597

Farm and farmhouse 1900 to 1950 craft workers' workshops, nature trails, children's farm.

*Opening times* Open March to October daily 10.00am to 5.00pm

## LEWES CASTLE & BARBICAN HOUSE MUSEUM
169 High Street, Lewes, Sussex BN7 1YE
Telephone 01273 486290 Fax 01273 486990

Mediaeval Castle with superb views over Lewes and Barbican House, home to the museum of Sussex archaeology. Regular temporary exhibitions of art and sculpture. Year round programme of events.

*Opening times* Open daily 10.00am to 5.30pm (Sundays and Bank Holidays 11.00am to 5.30pm) Closed 25th and 28th December

## LITTLEHAMPTON MUSEUM
Manor House Church Street, Littlehampton,West Sussex BN17 5EP
Telephone 01903 715149 Fax 01903 734784

The museum may be closed for extensive refurbishment in 1999, please telephone for details.

*Opening times* Open Tuesday to Saturday 10.30am to 5.30pm all year (closed Christmas Day, Boxing day, New Years Day and Good Friday)

## ANNE OF CLEVES HOUSE MUSEUM

52 Southover High Street, Lewes, Sussex BN7 1JA
Telephone 01273 474610 Fax 01273 486990

Beautiful Tudor Wealden hall-house that formed part of Anne's divorce settlement with Henry III. Collections of Lewes and Sussex interest including Sussex iron and artefacts from Lewes's important Cluniac Priory.

*Opening times* Open 15th February to 30th November Monday to Saturday 10.00am to 5.30pm, Sunday 12.00 noon to 5.30pm. 1st to 23rd December (Closed 24th to 28th December) Tuesday to Saturday 10.00am to 5.30pm, Sunday 12.00 noon to 5.30pm. 29th December to 14th February Tuesdays, Thursdays and Saturdays 10.00am to 5.00pm.

## NEWHAVEN FORT

Fort Road, Newhaven, East Sussex BN9 9DL
Telephone 01273 517622 Fax 01273 512059

Restored Victorian fort housing military and wartime exhibitions including Dieppe raid, D-Day, Royal Observer Corps and the Home Front. Open for pre-booked school visits throughout the year.

*Opening times* Open April 3rd to October 31st daily 10.30am to 6.00pm. Also weekends during March

## BIGNOR ROMAN VILLA

Pulborough, West Sussex RH20 1PH
Telephone 01798 869259

Remains of one of the largest yet found in Great Britain. Mosaics in situ are on display, including the longest in the UK at 24m.

*Opening times* Open March to May and October 10.00am to 5.00pm. Closed Mondays except bank Holidays. June to September 10.00am to 6.00pm every day

## SEAFORD MUSEUM OF LOCAL HISTORY

Martello Tower, 74 The Esplanade, Seaford, Sussex
Telephone 01323 898222

Located in Martello Tower and its moat. Interest for whole family with wide variety of displays from pre-history to computers. Special collection of radio/TVs. Local pictures and extensive archive.

*Opening times* Please telephone for details of opening hours

## STEYNING MUSEUM

The Museum, Church St, Steyning, West Sussex BN44 3YB
Telephone 01903 813333

Steyning Museum brings the history and events of the town alive from Saxon to modern times. There are at least two special exhibitions each year and admission is free. Guided tours by arrangement with the curator.

*Opening times* Open all year: Mornings; Tuesday, Wednesday, Friday, Saturday 10.30am to 12.30pm. Afternoons; Sunday, Tuesday, Wednesday, Friday, Saturday. (October 1st to March 31st 2.30pm to 4.00pm. April 1st to September 30th 2.00pm to 4.30pm)

# WARWICKSHIRE & WEST MIDLANDS

Warwickshire is a quintessentially English county of peaceful fertile fields and a fair sprinkling of wooded land. The golden Cotswolds form the southern border of undulating chalk hills, but the heart of the county is lush and well watered by that most beautiful of rivers, the Avon. The vast Forest of Arden once clothed a large proportion of this county north west of the Avon which is now the Metropolitan County of West Midlands. The highest land in Warwickshire is the Edge Hill ridge, site of the first battle of the Civil War in 1642. Warwick, the county town, in places still retains something of its medieval atmosphere despite a disastrous fire in 1694 which completely destroyed the town centre. The magnificent Warwick Castle is one of Britain's most visited stately homes. Saint John's House and the Warwick Doll's Museum are both branches of the county museum, the former in a fine seventeenth century house, the latter in a lovely half-timbered medieval house containing displays on the history of dolls.

At Nuneaton Museum and Art Gallery there is an interesting George Elliot collection celebrating the work of the novelist who was born nearby at Astley. The local trade of leather-working is wonderfully explained at Walsall Leather Museum, housed in a restored Victorian factory. The Wolverhampton Art Gallery and Museum contains the largest collection of contemporary art in the region as well as the fascinating 'Ways of Seeing' gallery which offers hands-on ways of looking at art. An insignificant village until its medicinal waters were discovered in the 1780s, Leamington Spa's interesting history can be studied at the Art Gallery and Museum, which also exhibits outstanding paintings, porcelain and glass.

The Birmingham Museum and Art Gallery houses in a magnificent Victorian building one of the world's finest collection of Pre-Raphaelite art; while at the Lapworth Museum is displayed a remarkable collection of stone implements from the UK and around the world.

## LEAMINGTON SPA ART GALLERY & MUSEUM
Royal Pump Rooms, The Parade, Leamington Spa, Warwickshire
CV32 4AB
Telephone 01926 450000

The Royal Pump Rooms, Royal Leamington Spa which opened in 1814 is currently being restored by Warwick District Council and expects to be completed in July 1999. This multi-million pound restoration will house the Art Gallery and Museum, the Library, Tourist Information Centre, Assembly Rooms and a restaurant.

Visitors can explore life in a Victorian Spa Town, relax in the magnificent Turkish Hammam and discover bizarre water treatments which were used at the Royal Pump Rooms. The new Art Gallery will be home to important collections of paintings by leading British and local artists including L.S. Lowry and Stanley Spencer.

The temporary exhibition programme for 1999 includes: "Is that really you?", portraits from the permanent collection and Simon Lewty - towards drawing.

For children there will be an exciting interactive gallery where discovery is made fun. All of this splendour will create a major cultural and tourist attraction.

### Opening times
Please telephone for details

### Directions

Exit M40 at J13/14. Follow Leamington signs to roundabout by Ford Factory, take Princes Drive then turn right onto Avenue Road. Left at T-Junction, cross bridge, Pump Rooms on left.

▼ 1920's poster advertising the Royal Pump rooms

▲ Patient in a zotofoam bath at the 1930s

▲ Exploring paintings

# THE CADEBY STEAM & BRASS RUBBING CENTRE

The Old Rectory, Cadeby, Nuneaton, Warwickshire CV13 0AS
Telephone 01455 290462

The centre is situated on the A447, 6 miles north of Hinckley and is open on the 2nd Saturday of every month plus extras.

The Narrow Gauge Steam operated line is one of the smallest, full sized passenger carrying lines in the world, created by the late Revered Teddy Boston.

There is a large 'oo' gauge model railway demonstrating GWR running in 1935 in south Devon, a Foster agricultural engine, Fiery Elias and a miniature 5" gauge passenger carrying line.

A recent addition to the centre is the museum housing the Boston collection which won the Leicestershire County Council's Heritage Award for 1990.

The late Rev. Wilbert Awdry, author of Thomas the Tank Engine donated one of his model railways to the museum, which depicts a quarry line on the mythical island of Sodor.

The Brass Rubbing Centre is in the 13th century Church of All Saints, alongside the Old Rectory, where a collection of over 70 replica brasses may be rubbed, the instruction

and materials being provided. Extra events are held during the summer months, the Teddy Bears picnic and Morris Dance Day, Vintage Day, and Model and Miniature day.

## Opening times

Open 2nd Saturday of every month, plus 1st Saturday in November and 2nd and 3rd Saturdays in December, and Boxing Day, all from 1.00pm, at other times by arrangement

## Directions

6 miles north of Hinckley, 1 mile from Market Bosworth. Bus from Leicester to Market Bosworth hourly or train to Hinckley and bus to Cadeby (not very frequent).

▼ Model railway shed, 'oo' gauge GWR in south Devon, 1935

▲ Bagnall 2090 0-4-0 Saddle Tank, Locomotive, 2 gauge, Pixie

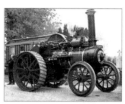

▲ Foster Agricultural Engine, 14593, built 1927, Fiery Elias

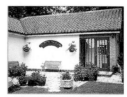

▲ The Boston Collection Museum of Railwayana

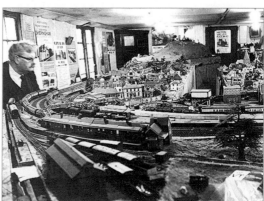

WARWICKSHIRE & WEST MIDLANDS

# NUNEATON MUSEUM & ART GALLERY

Riversley Park, Coton Road, Nuneaton, Warwickshire CV11 5TU
Telephone 01203 350720 Fax 01203 343559

Friendly Museum and Art Gallery set in award winning gardens adjacent to Nuneaton Town Centre.

Permanent display on the story of George Eliot, world-famous Victorian authoress, born locally. Also displays on the fascinating local history of the area. Displays of fine Victorian watercolour and oil paintings.

Busy programme of temporary exhibitions by local and regional artists, often with original works for sale. Special touring exhibitions in a range of media.

Exciting programme of events and activities, please ring for current programme.

Excellent visitor facilities include tearoom open throughout gallery opening hours, serving morning coffee, hot and cold meals, afternoon teas etc.

Meeting/lecture room seating up to 50 available for hire by community groups and businesses.

Shop counter selling a range of souvenirs, gifts and cards. Accessible toilets include baby-changing.

Groups welcome by appointment. Lift giving access to all areas. The museum's reserve collections are available to study by appointment - enquiries welcome.

(Other attractions locally include Nuneaton's well-known Wednesday and Saturday street market, Craft Centre and Arbury Hall Stately Home).
Gallery phone no: 01203 350720
Fax 01203 343559

### *Opening times*

Open throughout the year,
Tuesday to Saturday
10.30am to 4.30pm
(last admission 4.25pm)
Sunday
2.00pm to 4.30pm
(last admission 4.25pm)
Also open Bank Holiday Monday
(Please ring for details of Christmas opening times)

### *Directions*

By road: head for Nuneaton Town Centre, Museum is on Coton Road. Car parks adjacent. By rail: a 10 minute walk through Nuneaton Town Centre, from Nuneaton Station.

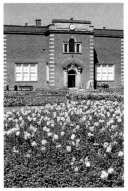

▲ Superb gardens and adjacent children's play area provide ideal surrounding

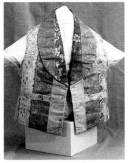

▲ Victorian waistcoat made with silk ribbons woven in Nuneaton

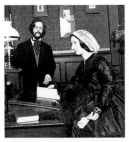

▲ Famous Victorian authoress George Eliot features in the Museum's displays

**428**

# THE MARKET HALL - WARWICKSHIRE MUSEUM

Market Place, Warwick, Warwickshire CV34 4SA
Telephone 01926 412501 Fax 01926 419840

A 17th century Market Hall, housing displays of Warwickshire geology, biology and history, including giant fossils, live bees and the famous Sheldon Tapestry Map. Temporary exhibitions offer an exciting programme of acclaimed local and national artists' work. There is a small, but well stocked shop.

### Opening times

Open all year round - Monday to Saturday 10.00am to 5.30pm May to September - Sunday 11.00am to 5.00pm

### Directions

From Junction 15 off the M40, take the A429 into Warwick centre. Turn left into Swan Street, continue to the end, the museum is ahead on the corner of Market place

▲ A Celtic gold coin of the Corieltauvi tribe

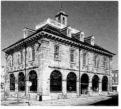

▲ Warwickshire Museum - Market Hall

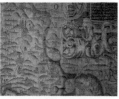

◀ Large fossil of an Ammonite

▲ A detail from the Great Sheldon Tapestry Map

**WARWICKSHIRE & WEST MIDLANDS**

**429**

## ST JOHN'S MUSEUM
St Johns, Warwick, Warwickshire CV34 4NF
Telephone 01926 412021 or 412132

An early Jacobean house with displays of Warwickshire social history, including costumes.

This Museum includes a period 19th century kitchen, parlour and school room (often used by visiting school teachers and children, dressed in period clothing, to re-enact days gone by).

St John's also houses the Museum of the Royal Warwickshire Regiment. The Museum gardens include a grassy, enclosed picnic area.

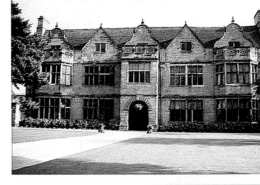

▲ St John's House

▶ War medals from Royal Warwickshire Regimental Museum, St John's House

### Opening times

Open all year round - Tuesday to Saturday and Bank Holiday Monday 10.00am to 5.30pm May to September Sundays 2.30pm to 5.00pm

### Directions

From Junction 15 off the M40 take the A429 through Warwick centre and continue toward Leamington. The Museum is on the right hand corner of Swan Street and St John's.

▶ Wash day at St John's House

# WARWICK DOLL MUSEUM
Oken's House, Castle Street, Warwick, Warwickshire CV34 4BP
Telephone 01926 495546

A picturesque 15th century house, which stands approximately fifty metres from Warwick Castle, and is home to the Joy Robinson collection of dolls. The exhibits also include toys, games and bears.

Visitors can play hopscotch, try a whip and top, or watch the video of mechanical toys in action.

There is something for everyone from children to the serious doll collector! The shop stocks a wide range of dolls, bears and books. Entrance fees for the museum are Adults £1.00; Children 70p; Senior Citizens 70p; Family tickets £3.00.

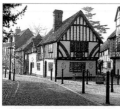

▲ Warwick Doll Museum

## Opening times

Open Easter to October
Monday to Saturday
10.00am to 5.00pm
Sunday 11.00am
to 5.00pm
November to
Easter
Saturday only
10.00am to dusk

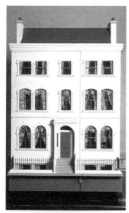

▲ Mid 19th century dolls house with particularly fine mini furniture

◀ A well loved teddy bear with his pet dog 'Fifi'

## Directions
From Junction 15 off the M40 take the A429 for 2-3 miles into Warwick, turn right into Castle Street. The Doll Museum is a short distance down on the right.

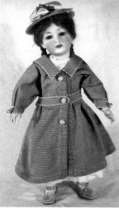

▲ A German 'Revalo Doll', 1920's

## BLAKESLEY HALL
Yardley, Birmingham, West Midlands B25 8RN
Telephone 0121 7832193 Fax 0121 7832193

Blakesley Hall is a Grade II* listed timber-framed building. The Hall was built in 1590 for Richard Smalbroke, a yeoman and a man of local standing. Richard had a mercer's business in Birmingham and owned lands in Yardley.

The Hall is furnished the way it would have looked in the mid 17th century.

The furniture on display is based on 17th century inventories of houses in the local area as well as an inventory of Blakesley Hall taken in 1684.

Oak furniture on display includes tables, carved panel-back armchairs, four poster beds, chests, livery cupboards and writing desks.

Each room also has a large number of small 17th century (household) objects on display. Replica objects, some of which are available for handling, complement the collections.

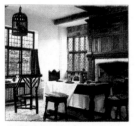

▲ The Parlour

▲ The Long Gallery

Costumed interpreters are available to answer questions about the house and its history.

From July to the end of September themed guided tours, with topics like hygiene, cooking and medicine, are offered every Sunday at 3.00pm.

▲ Blakesley Hall, view from the west

### Opening times
Please telephone for opening times

### Directions
M6 J4. Join M42 (J7) going south for 1 junction. Come off junction J6 and take A45 towards city centre. Blakesley Hall is off the A4040 which joins the A45 at the Swan Island, Yardley. Sign-posted from this Island. M5 J4A, join M42 at J1 and stay on until J6 - proceed as above.

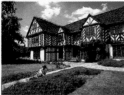

▲ Blakesley Hall, view from the south

**433**

# WALSALL LEATHER MUSEUM

Littleton Street West, Walsall, West Midlands WS2 8EQ
Telephone 01922 721153 Fax 01922 725827

This living and working museum tells the fascinating story of Walsall's leather trade.

From small beginnings in the 18th century, by 1900 the town had the greatest concentration of saddlers and leathergoods makers anywhere in the world.

Visitors to the museum will see magnificent Walsall - made saddles past and present, and will have the chance to see skilled leatherworkers making items in our workshops.

Our "contemporary design" gallery brings the story right up to date and features the work of leatherworkers of today with beautiful examples of shoes, gloves, hats and cases.

Large shop with extensive range of Walsall - made leather goods, many with substantial reductions. Cafe serving delicious home cooked food and a range of hot and cold drinks.

Beautiful gardens planted with trees associated with the tanning industry. Picnic area. Guided tours of the museum available. Group visits are very welcome.

Programme of changing exhibitions. Events and activities for both children and adults throughout the year. Free Admission.

### Opening times

Open April to October
Tuesday to Saturday
10.00am to 5.00pm
Sunday
12.00pm to 5.00pm
November to March
Tuesday to Saturday
10.00am to 4.00pm
Sunday
12.00pm to 4.00pm
Closed 24th to 26th December, 1st January, Easter Sunday

### Directions

North of Walsall Town Centre, close to junction of Ring Road and Stafford Street (B4210). From M6, approach via junctions 7 or 10. 10 minutes walk from Railway/Bus Stations.

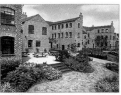

▲ View of the museum and gardens

▲ The museum's extensive shop, which specialises in locally made items

▲ At work in a Walsall factory around the year 1910

▼ Museum demonstrator Jack Halksworth welcomes a young visitor

# WOLVERHAMPTON ART GALLERY

Litchfield Street, Wolverhampton, West Midlands WV1 1DU
Telephone 01902 552055 Fax 01902 552053

At Wolverhampton Art Gallery the emphasis is as much on the visitor as our excellent temporary exhibitions and collections.

That's why we have provided a well-appointed Tearoom for those essential refreshments, a Gallery Shop for your souvenir of your visit, award-winning provisions for visitors with disabilities and a temporary exhibition programme with something for everyone.

Our hands-on ways of seeing room makes looking at art more fun and many of our exhibitions contain interactives for you to join in.

Our contemporary collection is the largest in the region and our collection of pop art is second-to-none.

Beautifully restored first floor galleries show our fine collection of 18th and 19th century paintings, also venture into the local history of Wolverhampton, just 5 minutes from the bus and rail stations and 2 minutes from a large car park.

For a leaflet on the latest exhibitions please call 01902 552040,

quoting reference AGMB98.

If you are making a special journey to visit our collections please phone first to check they are on show as you will appreciate we can't show all our treasures all of the time.

▲ It's 'hands-on' for our summer exhibitions aimed at families

### Opening times

Open
Monday to Saturday
10.00am to 5.00pm
Closed Sundays and
Bank Holiday Mondays
and Tuesdays Shop and
Tearoom open
10.30am to 4.30pm

### Directions

Follow signs for Town Centre of M6 Junction 10 or M54 Junction 2. Art Gallery is in the centre of Wolverhampton. Nearest car park - Civic Centre. 5 minutes walk from rail, bus and metro stations.

▲ Ways of seeing-fun ways to find out about art

▲ Likeness guaranteed by David Mach from our outstanding contemporary collection

▲ Also from the contemporary collection entering the kitchen - Suzanne Treister

WARWICKSHIRE & WEST MIDLANDS

*WARWICKSHIRE & WEST MIDLANDS*

## BIRMINGHAM MUSEUM & ART GALLERY
Chamberlain Square, Birmingham, B3 3DH
Telephone 0121 303 2834 Fax 0121 303 1394

Birmingham Museum & Art Gallery has one of the world's finest collections of pre-Raphaelite art, plus fascinating displays from ancient cultures to 20th century arts, crafts and science.

*Opening times* Open Monday to Thursday and Saturday 10.00am to 5.00pm, Friday 10.30am to 5.00pm and Sunday 12.30pm to 5.00pm

## SELLY MANOR
Sycamore Road, Bournville Village, Birmingham, West Midlands
Telephone 0121 472 0199 Fax 0121 472 0199

Two beautifully restored Tudor buildings with period furniture, set in a cottage garden. Guided tours for groups available. Regular events and exhibitions. Entrance fee £1.50 Adults; 50p Children. Well behaved dogs welcome.

*Opening times* Open all year Tuesday to Friday and Bank Holidays 10.00am to 5.00pm, weekends in April to September 2.00pm to 5.00pm, (closed late December to early January)

## LAPWORTH MUSEUM OF GEOLOGY
School of Earth Sciences, University of Birmingham,
Edgbaston, Birmingham, West Midlands B15 2TT
Telephone 0121 414 4173 Fax 0121 414 4942

Fossils and minerals from around the world including dinosaurs, mammals and fish together with displays of fossils from the West Midlands and the Welsh borders.

*Opening times* Open Monday to Friday 9.00am to 5.30pm (except public holidays)

## HERBERT ART GALLERY & MUSEUM
Jordan Well, Coventry CV1 5QP
Telephone 01203 832381 Fax 01203 832410

Admission free. Lots to do and see hands-on and interactive displays, quizzes, trails, frequent workshops, activities and demonstrations. Excellent facilities and access for families and disabled people. Free tape-tour guide to "Godiva City" exhibition.

*Opening times* Open Monday to Saturday, 10.00am to 5.30pm and Sunday 12.00pm to 5.00pm

## THE COVENTRY TOY MUSEUM
Whitefriars Gate, Much Park Street, Coventry, CV1 2LT
Telephone 01203 227560

Toys of every description housed in a 14th century monastery gatehouse. Admission £1.50 Adults, Children and Concessions £1.00.

*Opening times* Open April to October daily 2.00pm to 4.00pm, (School Parties 10.00am to 12am)

## BLACK COUNTRY LIVING MUSEUM

Tipton Road, Dudley, West Midlands DY1 4SQ
Telephone 0121 557 9643 Fax 0121 557 4242

Fascinating open-air museum with a reconstructed old-fashioned canal-side village with original shops, cottages and workshops brought to life by costumed demonstrators. Features include underground coalmine tours, 1920s cinema and electric tramcar rides.

*Opening times*  Open March to October every day, 10.00am to 5.00pm, November to February, Wednesday to Sunday 10.00am to 4.00pm

## KENILWORTH CASTLE

Kenilworth, Warwickshire CV8 1NE
Telephone 01926 852078 Fax 01926 851514

Largest most impressive castle ruin in England. Developed from Norman fortress to Elizabethan palace, ruined just after Civil War by Act of Commonwealth Parliament. Interactive scale model in 16th Century barn.

*Opening times*  Open every day except Christmas Eve, Christmas Day, Boxing Day or in severe ice or snow

## BROADFIELD HOUSE GLASS MUSEUM

Compton Drive, Kingswinford, West Midlands
Telephone 01384 812745 Fax 01384 812746

World famous collection of British glass. Temporary exhibitions and events programme, including annual festival in September. Daily glass blowing demonstrations. Attractive shop housed in world's largest all glass building.

*Opening times*  Open Tuesday to Sunday 2.00pm to 5.00pm, (last admission 4.30pm) Open all year except Christmas, Open Bank Holiday Mondays 10.00am to 5.00pm

## WARWICKSHIRE COLLEGE
## DEPARTMENT OF ART & DESIGN

Warwick New Road, Leamington Spa, Warwickshire
CV32 5JE
Telephone 01926 318000 Fax 01926 318111

Displays of student work alternate with visiting exhibitors. The college offers an HND/C course in model making and display with an emphasis on the exhibition and heritage industries.

*Opening times*  Open Term Times 9.00am to 5.00pm

**437**

## BOSWORTH BATTLEFIELD VISITOR CENTRE & COUNTRY PARK

Sutton Cheney, near, Market Bosworth, Nuneaton,
Warwickshire CV13 0AD
Telephone 01455 290429 Fax 01455 292841

Exhibition interpreting the famous events of the Battle of Bosworth, containing authentic finds from the period, armour, weapons and models. Also displays on life in 1485 and a video presentation.

*Opening times* Open daily 1st April to 31st October 11.00am to 5.00pm
Monday to Saturday, 11.00am to 6.00pm Sunday and Bank Holidays

## RSC COLLECTION

Royal Shakespeare Theatre, Stratford-on-Avon CV37 6BB
Telephone 01789 262870

Selection from our theatre archives of costumes, drawings, paintings, posters, properties and sculpture changing theatre exhibitions.

*Opening times* Open all year except Christmas. Monday to Saturday 1.30am to
6.00pm and Sunday 12.00pm to 4pm

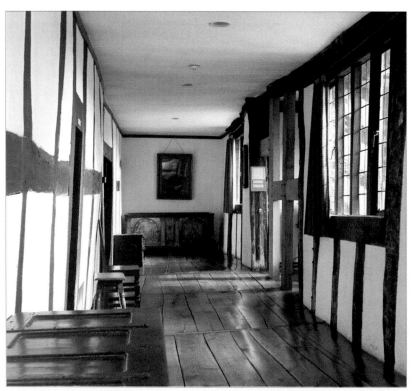

The Long Gallery at Blakesley Hall, Birmingham: West Midlands

# WILTSHIRE

In the north of Wiltshire lies the lovely wide and fertile Vale of Pewsey, running up to Devizes. Further north are the rolling chalk hills of the Marlborough Downs, but the county is dominated by Salisbury Plain, the vast expanse of chalk upland stretching twenty miles from east to west and twelve miles from north to south. A region of grassy downland from prehistoric times until the First World War when the land was ploughed up. Here on Salisbury Plain is Britain's leading concentration of major prehistoric sites...the main one being Stonehenge, a World Heritage Site drawing large numbers of visitors each year.

Salisbury, built where the rivers Avon, Bourne and Nadder meet is arguably the most perfect cathedral city in England. The cathedral, the only English cathedral to be built all in one style has a spire 123m higher than any other in the country and is set in the largest cathedral close in the country. Here the thirteenth century King's House is home to the Salisbury and South Wiltshire Museum, holding a wide range of exhibits relating to Stonehenge and Old Sarum as well as a collection of ceramics...and a pre-National Health Service surgery. The Athelstan Museum at Malmesbury, as well as some excellent displays of lace-making and local history, has an interesting collection of coins minted at Malmesbury.

Devizes, a town of elegant Georgian buildings claims a museum of international renown. Neolithic, Bronze Age, Iron Age, Roman, Saxon and Medieval Galleries display and explain the county's rich heritage. At Trowbridge there is an interesting museum dealing with the history of the town, its cloth-making tradition and Victorian times. Chippenham to the north has a fascinating museum dedicated to the life and work of William Henry Fox Talbot, the inventor of the positive/negative photographic process. At nearby Swindon, the Swindon Museum and Art Gallery deals comprehensively with the social history of the town and North Wiltshire.

WILTSHIRE

## DEVIZES MUSEUM
41 Long Street, Devizes, Wiltshire SN10 1NS
Telephone 01380 727369 Fax 01380 722150

Designated for the pre-eminence of its collections, Devizes Museum houses the world renowned collections of the Wiltshire Archaeological and Natural History Society.

With a host of galleries displaying objects of national importance, you can explore Wiltshire's heritage from Avebury to Stonehenge, prehistoric times to the Romans and the mediaeval period to more recent bygones.

There are also the natural history galleries with dioramas of Wiltshire wildlife habitats together with the remains of creatures that roamed this land before our civilisation began.

For a different scene, visit the art gallery to see contemporary shows or exhibitions based on the museum's extensive collection of paintings, prints and drawings.

Also look out for the temporary exhibition space where you can discover displays based on various aspects of Wiltshire life, both past and present.

There are regular holiday activities and education visits for children led by the Education Officer.

If you are interested in researching something to do with Wiltshire, whether it be family history, the history of a town, village or business, why not come and use the private research library (separate admission)

The museum has free admission on Mondays, Concessions at other times, welcomes party bookings. Library closed on Mondays.

### Opening times

Open all year Monday to Saturday except Bank Holidays 10.00am to 5.00pm (last admission 4.15pm)

### Directions

Main roads to Devizes, A361, A360, A342. Park in Town Centre. 300 yards south from centre of Devizes Market Place past Town Hall and St John's Church in Long Street.

▲ The Ermine Street Guard at Devizes Museum

▲ The hands-on recent history gallery

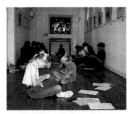

▲ Children's holiday activities in the Art Gallery

◀ Bronze Age gold grave goods, part of outstanding prehistoric collection

# SALISBURY & SOUTH WILTSHIRE MUSEUM

The King's House, 65 The Close, Salisbury, Wiltshire SP1 2EN
Telephone 01722 332151 Fax 01722 325611

Salisbury Museum, laden with awards for its exhibitions and galleries, has been 'Designated' by the Museums & Galleries Commission as one of only 43 non-national museums to have received such recognition for their pre-eminent collections.

It is home of the Stonehenge gallery, Pitt Rivers collection and the archaeology of South Wiltshire from the earliest settlers to the founding of mediaeval Salisbury and its great cathedral.

Popular exhibits include the 4000 year-old Bronze-age burial, the Salisbury Giant and Hob Nob, Turner watercolours and, of course, Stonehenge.

Ceramics and a 600-piece collection of Wedgwood are in handsome rooms decorated for the visits of James I after whom The King's House is named. The splendid clothes, Downton lace collection and embroidery in the costume gallery all originate in South Wiltshire.

Special exhibitions in 1999 include the annual show by The British Doll Association,

Pilkington Lancastrian pottery, embroidery, art and the first of the big millennium exhibitions.

Bill Bryson in his best-selling *Notes From A Small Island* says "Salisbury Museum is outstanding and I urge you to go there at once". You will be most welcome.

Adults £3. Concessions £2. Children 75p. Under 5s free. Saver tickets.

### Opening times

Open all year
Monday to Saturday
10.00am to 5.00pm
Sundays in July and
August
2.00pm to 5.00pm
Closed Christmas

### Directions

Car: City centre car parks or Cathedral Close (charge). Train: SWT and Alphaline to Salisbury. Bus: City centre or bus station. The Museum is signposted in the City and the Close.

▲ The Salisbury Giant, oldest medieval pageant figure, with Hob Nob

▲ Stonehenge. Watercolour by J.M.W. Turner

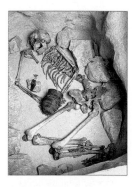

▲ The 4000-year-old Bronze Age burial

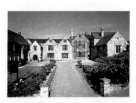

◄ The King's House in the splendid Cathedral Close

WILTSHIRE

# LYDIARD PARK
Lydiard Tregoze, Swindon, Wiltshire SN5 9PA
Telephone 01793 770401 Fax 01793 877909
Website www.swindonlink.com

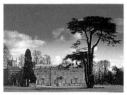

▲ Lydiard Park

Lydiard Park is the ancestral home of the St John family who were better known as the Bolingbrokes. Set amid rolling lawns and woodland this beautifully restored Palladian mansion was rescued from potential ruin by Swindon Corporation in 1943.

The ground floor State Rooms contain exceptional plasterwork, original wallpaper and a rare 17th century painted window by Abraham Van Linge.

Original family furnishings are mostly late 18th, early 19th century. St John family portraits date back to Elizabethan times and include works by Riley, Lely, Hoppner, Jansens and Mary Beale. Bust by Ryesbrack and chimney pieces by Henry Cheere. Curious little blue Dressing Room devoted to 18th Century society artist Lady Diana Spencer.

Special Victorian exhibition with M'Lady and Maid runs all year. 'Story Box' audio guides explain the fascinating history of Lydiard Park and the people who lived there.

Throughout December 'Country House Christmas' displays

transform the State Rooms (all of which are on the ground floor) with Victorian style decorations.

There is a full schools service and annual events programme, childrens activity sheets, holiday trails and exciting adventure playground.

St. Marys Parish Church behind the house is renowned for its 17th century monuments like the 'Golden Cavalier'. Coach parties are welcome by appointment.

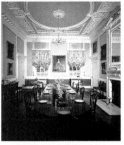

▲ The dining room

### Opening times
Open all year
Monday to Friday
10.00am to 1.00pm
2.00pm to 5.00pm
(10.00am to 5.00pm
during School
Summer Holidays)
Saturday
10.00am to 5.00pm
Sunday
2.00pm to 5.00pm
Early closing November
to February 4.00pm

### Directions
Exit Junction 16 M4,
follow brown signs to
Lydiard Park. From
Oxford/Cirencester
directions take A419 to
Junction 15 M4 and run
one Junction. Rail
Station: Swindon. Bus:
Thamesdown transport
No's 1 and 1a.

▲ 17th century window
by Abraham Van Linge

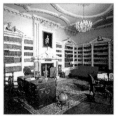

▲ The Library

## FOX TALBOT MUSEUM

Lacock Abbey Estate, Lacock, Chippenham, Wiltshire SN15 2LG
Telephone 01249 730459 Fax 01249 730501

The Fox Talbot Museum houses the archives of William Henry Fox Talbot, inventor of
the photographic positive/negative process. Regular changing exhibition programme of
19th century and contemporary photographs both British and European. Coffee shop
and restaurant in village.

> *Opening times* Open March to October 11.00am to 5.00pm (closed Good Friday),
> November to February, Saturdays and Sundays only. Please telephone for other
> opening times

## ATHELSTAN MUSEUM

Town Hall, Cross Hayes, Malmesbury, Wiltshire SN16 9BZ
Telephone 01666 822143

Local history museum with collections of archaeology, coins, photographs, paintings,
Malmesbury lace, early bicycles, costume, information on Malmesbury Branch railway,
18th century fire pump and the Civil War history in Malmesbury. Nearby parking and
restaurants.

> *Opening times* Please telephone for details of opening times

## WILTON WINDMILL

Marlborough, Wiltshire SN8 3SS
Telephone 01672 870266 Fax 01672 870105

Wilton Windmill was built in 1821, it milled until 1920 and was then idle for 50 years.
It was restored in the seventies and is now fully working.

> *Opening times* Open Easter to end September, Sundays and Bank Holidays,
> 2.00pm to 5.00pm. The grounds are open at any time

## REDCOATS IN THE WARDROBE

58 The Close, Salisbury , Wiltshire SP1 2EX
Telephone 01722 414536

Displays 250 years of fascinating history of Royal Berkshire and Wiltshire regiments
housed in the 13th century Bishop's Wardrobe with attractive riverside garden giving
views to the renowned water meadows.

> *Opening times* Open 2nd February to 13th December 10.00am to 4.30pm.
> April to October, open daily, including weekends.
> February, March, November and early December, open Tuesday to Sunday.

WILTSHIRE

## SWINDON MUSEUM & ART GALLERY
Bath Road, Swindon, Wiltshire SN1 4BA
Telephone 01793 466556 Fax 01793 484141

The Museum's displays show Swindon's history from sea dragons to the recent past. The Art Gallery contains a superb collection of 20th century British art. Admission is free.

*Opening times* Open Monday to Saturday 10.00am to 5.00pm,
Sunday 2.00pm to 5.00pm.
Closed Bank Holidays

## RICHARD JEFFERIES MUSEUM
Marlborough Road, Coate, Swindon, Wiltshire SN3 6AA
Telephone 01793 466556 Fax 01793 484141

The Museum was the birthplace of the naturalist and writer Richard Jefferies. Admission is free.

*Opening times* Open on the first and third Sunday of each month,
May to September 2.00pm to 5.00pm

## THE TROWBRIDGE MUSEUM
The Shires, Court Street, Trowbridge, Wiltshire BA14 8AT
Telephone 01225 751339 Fax 01225 775460

A museum telling the story of Trowbridge, its people and its industries, concentrating on its once dominant woollen mills. Temporary exhibitions change regularly. Free admission. Coffee shop nearby.

*Opening times* Open all year Tuesday to Friday 10.00am to 4.00pm,
(last admission 4.00pm)
Saturday 10.00am to 5.00pm,
(last admission 4.30pm)

## THE WOODLAND HERITAGE CENTRE
The Woodland Park, Brokerswood, Westbury, Wiltshire
BA13 4EH
Telephone 01373 822238 Fax 01373 858474

Interpretation of woodland and forestry practice and the Barber egg collection.

*Opening times* Open daily except from Christmas Day to New Year.
Please telephone for details of opening times

# YORKSHIRE

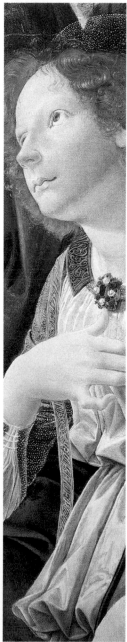

The 1974 reorganisation of the English counties created three new divisions of Yorkshire...north, south and west, replacing the three ancient ridings of north, east and west. Despite incorporating sections of the old ridings into neighbouring counties, Yorkshire still remains Britain's largest county...a county of amazing variations in landscape and character. North Yorkshire includes the glorious Dales, Wharfedale, Wensleydale and Swaledale, with the windswept North York Moors in the east and the Vale of York in the centre. Dominating the Vale of York, indeed the whole county is the historic city of York. North Yorkshire is mainly rural in character, whereas South Yorkshire is industrial. West Yorkshire on the other hand is a mixture of both and offers magnificent Pennine and moorland scenery including the dramatic Bronte Country. Many of the heavy industrial towns and great woollen regions created by the Industrial Revolution have, with the decline of their various industries, been required to diversify and adjust to other crafts and disciplines. Their remarkable stories of achievement are recorded in the quite considerable number of fine museums scattered throughout the county. The list is almost endless. The Abbeydale Industrial Hamlet is a fine example of this style of museum and a very fitting memento to Sheffield's great steel manufacturing days. Similarly, the Armley Mills Museum nostalgically recalls Leeds mill days. Once the world's largest woollen mill this museum is sited on an island in the River Aire. Bradford also recalls its nineteenth century days of mill working in the Bradford Industrial and Horses at Work Museum, a complex complete with mill owner's house, back-to-back cottages and job master's stables with working shire horses. In one form or another such museums as these are found in most of the larger towns in the county. Not that the artistic and cultural aspect of Yorkshire life is omitted...Leeds City Art Gallery and the City Museum, Temple Newsam House, Mappin Art Gallery, York Minster and St.Williams College and the National Museum of Photograph, Film and Television...and many more cater more than adequately for the rich cultural life of the county. However the museums which so charm and enthral the visitor are the fascinating working museums such as the Yorkshire Museum of Farming and the Skidby Working Windmill and Museum of East Riding Rural Life.

YORKSHIRE

# BAGSHAW MUSEUM
Wilton Park, Batley, Yorkshire
Telephone 01924 326155

You don't have to go far - see the world in Wilton Park, Batley. Bagshaw Museum surrounds you with sights and sounds of past times and far-away places.

Follow members of the Bagshaw family - founders of the museum - on their travels. Marvel at the vitality of Violet Bagshaw who brought back gifts from Alaska in her 100th year! Then travel through Asia, Africa and the Americas with an array of objects including many representing real and mythical animals. Glimpse the ancient Egyptian way of life (and death) in the Kingdom of Osiris where dramatic sound and light effects recreate the interior of a tomb. And let yourself be transported to the breathtakingly beautiful enchanted forest and discover why the tropical rainforest is important to us all.

And it's not just the far away that fascinates. Wilton Park has its own Nature Trail and Butterfly Centre (open in Summer) as well as a shop full of beautiful cards and gifts. The local history collections and the gothic decor of the mansion will keep you spellbound.

### Opening times

Open
11.00am to 5.00pm
Monday to Friday
12.00pm to 5.00pm
Saturday to Sunday

### Directions

From M62 take Junction 27. Follow A62 towards Huddersfield. At Birstall, follow Tourist Signs. Bagshaw Museum is approached through a small housing estate.

▼ The Kingdom of Osiris

▼ Mythical Beasts at Bagshaw

# OAKWELL HALL COUNTRY PARK

Nutter Lane, Birstall, Batley, West Yorkshire
Telephone 01924 326240 Fax 01924 326249

Oakwell Hall is an Elizabethan manor house now set in over 100 acres of country park offering extensive visitor facilities.

The house is displayed as it might have looked in the 1690's when the Batt family lived there, each room is furnished to give an impression of gentry life at the time.

The house was visited by Charlotte Brontë and features in the novel "Shirley".

There is a visitor centre with an attractive gift shop.

The Discover Oakwell exhibition (open afternoons only) appeals especially to family groups and many special events are held on site throughout the year.

Outdoor attractions include a period garden picnic areas, children adventure playground and nature trails to enjoy.

Close to the house visitors will find the Oaktree cafe which serves hot and cold drinks, cakes and light lunches.

Oakwell is close to a number of other interesting sites, especially Red House,

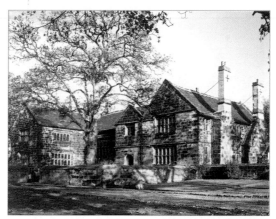

▲ Oakwell Hall built in 1583

Gomersal, home of Charlotte Brontë's friend Mary Taylor which is only a mile from Oakwell and has the same opening times.

### *Opening times*

Open Monday to Friday
11.00am to 5.00pm
Saturday and Sunday
12.00pm to 5.00pm
Please telephone for opening hours over Christmas and Easter

### *Directions*

From Junction 27 of M62 take A62 towards Huddersfield. turn right at traffic lights onto A652 where you see Oakwell brown sign. After mile turn right when you see large signboard

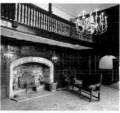

▲ The magnificent Great Hall at Oakwell

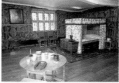

▲ Oakwell's painted chamber furnished with reproduction oak furniture

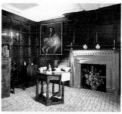

▲ Dining Room furnished as it might have looked in 1690

**447**

YORKSHIRE

# BRADFORD INDUSTRIAL MUSEUM & HORSES AT WORK

Moorside Mills, Moorside Road, Eccleshill, Bradford,
West Yorkshire BD2 3HP
Telephone 01274 631756 Fax 01274 636362

▲ Back to the 1950's

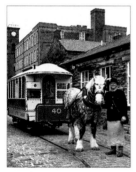

▲ Anyone for a tram ride?

Think of industry in Bradford and you think of wool. Think of Mills and you think of machinery, steam engines and horses. All these can be found at Bradford Industrial Museum!

Moorside Mills, an original spinning mill, is alive with magnificent machinery which once converted raw wool into the world's finest worsted cloth. The Mill yard rings to the sound of iron on stone as the shire horses give rides, pull a horse tram or haul a horse bus. In the Mill, you can experience the sounds and smells of the engines which once powered the mills throughout Yorkshire.

John Moore, the original mill owner and his family lived in the shadow of the mill at Moorside House, which is furnished as they knew it at the turn of the century.

A step across the street takes you to the mill workers' houses in Gaythorne Row - typical back to back cottages, ranging from late 19th century decor through to the 1950's.

Motive power, textile and horse demonstrations twice daily. Free admission.

▼ All aboard!

### Opening times

Open
Tuesday to Saturday
10.00am to 5.00pm
Sunday
12.00pm to 5.00pm
Closed Mondays except
Bank Holidays

### Directions

Signposted from the
Bradford Ring Road and
Harrogate Road (A658).
Buses 614, 634 from the
Tyrls. 608, 609 from
Bridge Street. Minibus
896 from Interchange.
All stop at Moorside
Road.

▲ Now what shall we buy?

# NATIONAL MUSEUM OF PHOTOGRAPH, FILM & TELEVISION
Pictureville, Bradford, West Yorkshire BD1 1NQ
Telephone 01274 202030 Fax 01274 723155

expanded film programme to complement the museum galleries in bringing to life the past, present and future of photography, film and television.

After major development work, the new National Museum of Photography, film and television will open in Spring 1999.

New attractions include an upgraded Imax Cinema capable of both 3D and 2D projection. A world first gallery to the digital image, new galleries exploring

▼ Still from Imax film at NMPFT

▲ Artist's impression of new NMPFT

advertising and animation. A much enlarged temporary exhibition gallery to enable the museum to accommodate more and larger special exhibitions.

A multi media theatre with state of the art facilities will allow an

### Opening times

Open early Spring 1999
Tuesday to Sunday
10.00am to 6.00pm
(closed Mondays except
Bank and main school
holidays)

### Directions

From the M62 follow the
M606 to Bradford City
Centre following the
brown heritage signs to
the museum

YORKSHIRE

# THE COLOUR MUSEUM

Perkin House, PO Box 244, Providence Street, Bradford,
Yorkshire BD1 2PW
Telephone 01274 390955 Fax 01274 392888

This unique museum has two galleries packed with visitor-operated exhibits.

The World of Colour gallery looks at the concept of colour, how it is perceived and how important it is.

You can see how the world looks to other animals, mix coloured lights and experience strange colour illusions.

In the Colour and Textiles gallery you can discover the fascinating story of dyeing and textile printing from ancient Egypt to the present day.

You can also use computerised technology to take charge of a dye making factory or to try your hand at interior design.

A European Regional Development Fund grant, awarded in 1996, has enabled the museum to enhance its facilities by: building a new entrance and shop on Providence Street, reorienting the galleries; and improving visitor amenities, particularly those for the disabled and school groups.

▼ Tableau of an Indian cloth trader in the Turkey Red gallery

▲ In the textile printing section of the museum

▲ In the Turkey Red gallery

A variety of temporary exhibitions are held each year. Please telephone for forthcoming exhibitions.

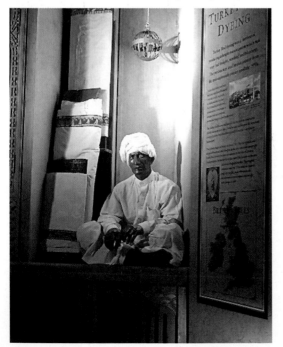

### Opening times

Open all year
Tuesday to Friday
2.00pm to 5.00pm
and Saturdays
10.00am to 4.00pm
(last admission 30
minutes before closing)
Also open for groups
Tuesday to Friday
9.30am to 12.30pm
Booking essential for
groups

### Directions

In the centre of
Bradford just off
Westgate the B6144.

# SKIDBY WORKING WINDMILL & MUSEUM OF EAST RIDING RURAL LIFE

Skidby Windmill, Skidby, Cottingham, East Riding of
Yorkshire HU16 5TF
Telephone 01482 848405 Fax 01482 848405

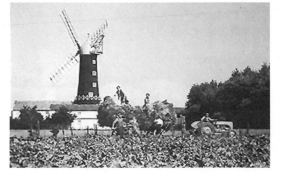

◀ Haymaking in the
1930's: Part of Skidby's
historic photograph
collection

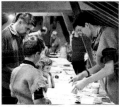

▲ A regular venue for
family workshops - here
it's "Anglo-Saxons" Day

Dominating the rolling
farmland of the
Yorkshire Wolds, Skidby
Windmill and Museum
of East Riding Rural
Life was built in 1821
and is the last working
windmill north of the
River Humber; indeed it
has been working
continuously since it
was built.

The granaries, barn and
stables are used to
display the tools and
equipment illustrating
the different stages of
the farming year and
the history of milling is,
of course, treated
comprehensively.

The mill is usually
working at weekends,
but this naturally,
depends on wind
conditions!

Wholemeal flour
produced at the mill is
sold in the museum
shop, along with a good
selection of books and
souvenirs.

The cafe serves light
refreshments and there

is also a picnic area in
the miller's garden, plus
a small wildlife garden.

The mill is open every
weekend, 10.00am to
5.00pm and Wednesdays
to Friday during the
Summer Bank Holidays.

School parties are very
welcome and a teachers
pack is available.

### Opening times

Open weekends
10.00am to 5.00pm
throughout the year
14th July to 22nd
September
Wednesday to Sunday
10.00am to 5.00pm
Open may, Spring and
August Bank Holidays
10.00am to 5.00pm
(last admission 4.30pm)

### Directions

Four miles south of
Beverley on A164
Beverley to Humber
Bridge Road. Signposted
from main road

▲ Skidby Mill towering
over a field on ripening
corn

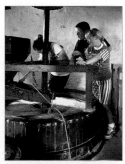

▲ Local school children
enthralled by the
millstones at work

# CONISBROUGH CASTLE

Castle Hill, Conisbrough, Doncaster,
South Yorkshire DN12 3BU
Telephone 01709 863329

Conisborough Castle was the principal northern stronghold of the Earls of Surrey: the title lands having been given to William de Warenne (son-in-law of William I) as a reward for his role in the Norman Conquest. Although the site of an existing Saxon settlement.

William de Warenne built a timber defence here in the year 1070. This followed by the present stone castle in about 1180, built by Hamelin Plantagent (half brother of Henry II).

The castle rapidly lost its importance in the early 1400's and quickly fell into disrepair. Ironically, this saved the Castle from destruction during the English Civil War as it was indefensible by the 1600's.

▼ Aerial view of Conisbrough Castle new roof reinstated

▲ Impressive tower standing 90 ft -
Conisborough Castle

The visitor centre contains static displays as well as information panels, which give the visitor an insight to the history of the castle and its surroundings.

As well as being the point of sale for admission tickets, the Visitor Centre shop provides a range of souvenirs and books.

All through the summer, Conisbrough Castle is the venue for a wide variety of family events such as falconry and archery.

### Directions

Go off A630 Doncaster then to Rotherham on A6023. South Yorkshire area.

▲ Aerial view
Conisbrough Castle

### Opening times

Open all year
1st April to
30th September
Monday to Friday
10.00am to 5.00pm
Saturday and Sundays
10.00am to 6.00pm
1st October to
31st March
10.00am to 4.00pm
every day
(last admission 40
minutes before closing)

# FILEY MUSEUM

8 - 10 Queen Street, Filey, North Yorkshire YO14 9HB
Telephone 0101723 515495/513640

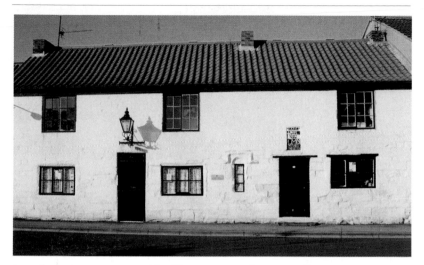

An independent Museum, run by volunteers and housed in the oldest surviving dwelling in Filey.

Built in 1696 and Grade II Listed. Seven rooms of exhibits, on two floors, plus an outside area with other exhibits and garden.

The exhibits cover Filey's fishing history, a fishing coble, baiting shed and farming implements.

The Fisher Collection of old photographs of Filey cover the 19th and 20th Century.

There is an extensive collection of rocks, shells and fossils, plus rooms covering rural and domestic crafts.

The Victorian period, bygone Filey and a walk down memory lane.

School parties for groups welcome by prior appointment. From time to time special exhibitions are changed regularly.

### Opening times

Please telephone for details of opening times. Closed for Winter at the end of October

### Directions

In centre of town go to Methodist Church crossroads, along Union Street to Mitford Street over to Providence Place onto Queen Street turn left, Museum on left hand side 50 yards.

▲ Frontage of Filey Museum

▲ Rural and domestic crafts room

▲ Section of Victorian Room

▲ Down Memory Lane Room

**YORKSHIRE**

# RED HOUSE MUSEUM

Oxford Road, Gomersal, West Yorkshire BD19 4JP
Telephone 01274 335100

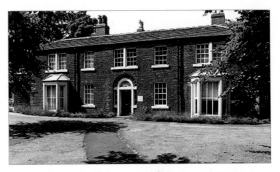

Red House gets its name from its unusual red brick construction, setting it apart from surrounding houses of local stone.

Mary Taylor, daughter of the house in the early 19th century, was a close and lifelong friend of Charlotte Brontë who stayed there often and featured the house as 'Briarmain's' in her novel 'Shirley'. The house now looks very much as it would have done in Charlotte's time.

Wander around the period rooms with their mixture of original and reproduction furnishings - each brings you closer to the 1830's.

Take a stroll through the beautiful period gardens recreated from 19th century maps of the site.

Explore Charlotte's connection with the Spen Valley in 'The Secret's Out' exhibition. How did people react when they found out they knew a famous writer?

Then move along to the 20th century and the new "Spen Valley Stories" exhibition in the renovated cartshed. The memories of local residents are explored through tape, pictures

▲ Delightful Red House - the 'Briarmanis' of Charlotte Brontë's novel 'Shirley'

and mementoes. Find out just how much Gomersal has changed.

And before you leave, don't forget to pick up a souvenir from the Museum shop. With its period crafts, books, gifts and preserves, you'll want to take home a taste of 19th century Gomersal.

***

### *Opening times*

Open
Monday to Friday
11.00am to 5.00pm
Saturday to Sunday
12.00pm to 5.00pm

***

### *Directions*

M62 Junction 27, follow A62 towards Huddersfield. At Birstall follow Tourist Signs. Red House is on the A651 in Gomersal.

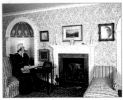

▲ The 1830's Parlour portrays life in this cloth merchant's house

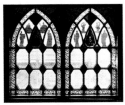

▲ Stained glass windows vividly described by Charlotte Brontë in 'Shirley'

▲ The latest audio technology brings Charlotte Brontë's story to life

# KNARESBOROUGH CASTLE & OLD COURTHOUSE MUSEUM

The Royal Pump Room Museum, Crown Place,
Harrogate, Yorkshire HG1 2RY
Telephone 01423 556188 Fax 01423 556130

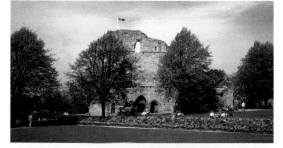

### Directions

Take A59 from York to
Knaresborough
signposted to Castle.
A6055 from A1
signposted to Castle.
A59 from Harrogate
signposted to Castle.

Knaresborough's Royal castle stands towering over the River Nidd, a symbol of the wealth and authority of mediaeval kings.

Visit the keep, the mysterious underground Sallyport, and step back into an original Tudor Courtroom in the Castle's Old Courthouse Museum to discover the legends and characters of this medieval town.

What was life like during the Civil War? - A new gallery shows home life and conflict during the Civil War, including the linen shirt Sir Henry Slingsby wore to the gallows.

▲ The King's tower

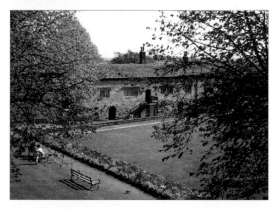

### Opening times

Open Easter to
30th September
10.30am to 5.00pm
(last admission 4.30pm)

▲ The Old Courthouse Museum from King's tower

▼ The Old Courthouse Museum

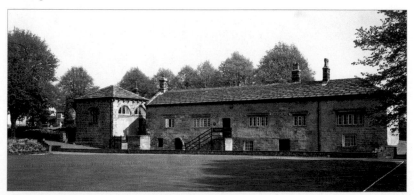

# COLNE VALLEY MUSEUM
Cliffe Ash, Golcar, Huddersfield, West Yorkshire HD7 4PY
Telephone 01484 659762

Experience the atmosphere of a hand Weaver's home and working life circa 1840-1850 at Colne Valley Museum.

The loom chamber (with working hand loom and Spinning Jenny). The Spinning Room (with great wheel and Saxony wheels), while the gas lit Clogger's shop is fully equipped with period tools. All these working exhibits are frequently demonstrated by museum members who preserve the skills.

The Weaver's Living room is furnished and equipped circa 1850 to show the home life of the period when the three cottages, in which the museum is housed, were built.

Special exhibitions change every 4 to 6 weeks. In April and October Craft Weekends are held with 15 or so craft demonstrations.

There is a gift and coffee shop.

A small admission charge is made.

Party visits can be made at other times by arrangement.

School parties wishing to spend a 'Victorian Day' in the Weaver's cottages must book in advance. Colne Valley Museum is financed, and operated, by volunteers from the community.

▲ The three Weaver's cottages of Colne Valley Museum

*Opening times*

Open each Saturday, Sunday and public holiday (except over Christmas and New Year period), from 2.00pm to 5.00pm (last admission 4.30pm)

*Directions*

Museum is 3 miles south west of Huddersfield in the village of Golcar, opposite Parish Church, follow Oldham (A62) signs from Huddersfield. Brown Tourist signs start after 1.5 miles.

▲ Let's get this straight - synchronised carding

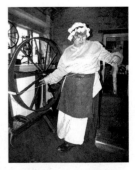

▲ Aunt Lizzy and her great wheel

◄ A taste of a Yorkshire welcome at Colne Valley Museum

# TOLSON MUSEUM

Ravensknowle Park, Wakefield Road, Huddersfield,
Yorkshire HD1 8DJ
Telephone 01484 223830

Unearth the remains of a Bronze-age Huddersfield and find out when the region was first inhabited.

Meet the Romans, The Vikings and the "Comers-in" who shaped the town we know today.

Come closer to your own time and visit the industrial revolution. See the machinery that changed the lives of the workers forever, putting many of them out of work.

Then it's all aboard for going places. How have we come from the horse-drawn carriage and the boneshaker bicycle to the kind of cars we drive today? Check out our collection of historic vehicles and find out just how exciting (and hair-raising!) these early rides could be.

There's lots to discover at Tolson, with plenty of models and maps to help put Huddersfield into perspective. And, with a year-round programme of special exhibitions, you'll see something new every time you visit.

Don't forget to stop in at the Museum shop - with its hundreds of souvenirs, you won't want of leave empty-handed!

▲ Textiles at Tolson Museum

And, if you're interested in collecting, Tolson is definitely for you: it has private collections started as early as last century and as late as last week. How about displaying your own collection? Anything's possible at Tolson!

### Opening times

Open 11.00am to 5.00pm
Monday to Friday and
12.00pm to 5.00pm
Saturday and Sunday

### Directions

From M62 (Junction 23
or 25) follow signs
towards Huddersfield.
Join ring road. Follow
signs to Wakefield.
Tolson Museum
is on main road
approximately 2 miles
from Huddersfield
town centre.

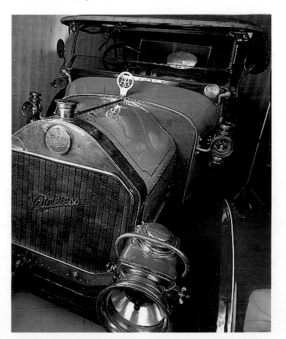

◀ Going Places at
Tolson Museum

YORKSHIRE

# STREETLIFE MUSEUM OF TRANSPORT
High Street, Hull, Yorkshire HU1 1NQ
Telephone 01482 613902 Fax 01482 613710

Take the journey of a lifetime discover Britain's oldest Tramcar, Hull's smallest bicycle and the world's first £100 car!

Period displays on railways, horse drawn carriages, cycles, cars and trams take you on a thrilling ride through over 200 years of transport history.

Animated horses, costumed figures, sounds and smells together with a series of breathtaking recreations of Victorian Hull.

Add to these a simulated carriage ride on a replica Victorian mail coach and you have the most imaginative carriage exhibition in the country.

At Streetlife the barriers are down- experience a hands-on encounter with history, explore inside the larger exhibits, the interactive displays use sounds, smells and images to sweep the visitor back in time to see Hull's historic 'Old Town; brought vividly to life!

Streetlife has something for everyone!

Admission £1. Under 13s and residents pass holders free.

▲ Streetlife Museum of Transport

▲ "The Carriage Gallery", Streetlife Museum

▲ 'Coach Yard', Streetlife Museum

### Opening times

Open daily
Monday to Saturday
10.00am to 5.00pm
Sunday
1.30pm to 4.30pm
(last admission 15 minutes before closing)

### Directions

M62 from major cities to A63 to Town Centre. Follow fingerpost signs to High Street Museums. All within easy walk from T.I.C. in Town Centre. Telephone 01482 613902 for further details.

◄ Railway Guard, Streetlife Museum

## SPURN LIGHTSHIP
Hull Marina, Hull, Yorkshire
Telephone 01482 613902 Fax 01482 613710

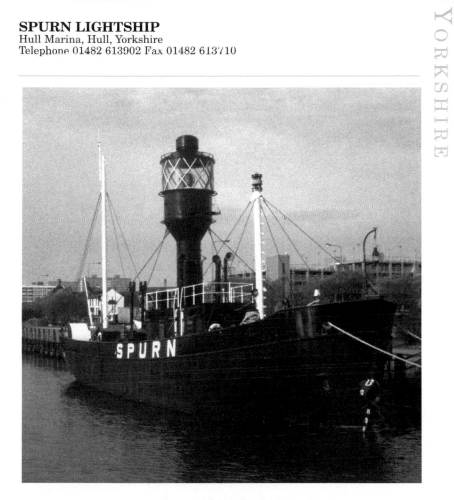

▲ The 'Spurn' Light Ship. Berthed in Hull Marina

Welcome aboard the Spurn Lightship! This 200 ton vessel once guided shipping through the treacherous mouth of the River Humber. Now moored in Hull's vibrant Marina, the Spurn can be explored from stem to stern with the help of its knowledgeable "crew".

Admission £1; under 13s and residents pass holders free.

### Directions

M62 from major cities to A63 to Town Centre. Follow fingerpost signs to High Street Museums. All within easy reach from T.I.C. in Town Centre.
Tel: 01482 613902 for further details.

### Opening times

Open
April to September
Monday to Saturday
10.00am to 5.00pm
Sunday
1.30pm to 4.30pm
(Subject to weather conditions)

# THE HULL MARITIME MUSEUM

Queen Victoria Square, Hull, Yorkshire HU1 3BX
Telephone 01482 613902 Fax 01482 613710

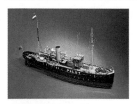

◀ Model of Hull Pilot Cutter

The magnificent Victorian building tells the story of Hull's whaling and fishing trade, using a superb collection of models and artefacts.

A full size whale skeleton is displayed to demonstrate the awesome size of these amazing creatures. Along with the tools and implements of whaling industry and a fine collection of "Scrimshaw" - the Folk art of the Whaler.

Other galleries explore ships and shipping, fish and fishing and Hull and the River Humber.

The opulent Courtroom with its impressive friezes and scagliola columns host a busy schedule of temporary exhibitions ranging from photography to Egyptology.

The museum is fully accessible to the disabled and the Museum shop offers an interesting range of souvenirs, including prints maritime books and small gifts.

▲ "Hull North Sea Trawler, 1912"
▼ "Whalers beset in the ice"

### Directions

M62 from major cities to A63 to town centre. Follow fingerpost signs to High Street Museums. All within easy reach from TIC in town centre. Telephone 01482 613902 for further details.

### Opening times

Open daily
Monday to Saturday
10.00am to 5.00pm,
Sunday
1.30pm to 4.30pm
(last admission 15
minutes prior to closing)

◀ Scrimshaw: "Hunting the sperm whale in the South seas"

# HANDS ON HISTORY
South Church Side, Hull, Yorkshire
Telephone 01482 613902 Fax 01482 613710

Hull's oldest spectacular building, Hands on History has been designed as a history resource for use by both the public and school children, "Victorian Britain" displays include sections on Victorian life, design, exhibition archaeology and school life, and activities such as trying Victorian clothes. Games and lessons are available.

"The Story of Hull and its people" covers birth to death using artefacts, stories and recollections of Hull residents, and visitors can play "The Game of Life" along the way! "Ancient Egypt" on the first floor, uses Hull Museums excellent

▲ "The story of Hull and it's people" Hands on History

collection of replicas, of the treasures from King Tutankhamun's tomb, as a unique study resource enabling us to marvel at the mysteries of the past. A mummy of an Egyptian noble woman is the highlight of this fascinating collection.

With a well equipped Lecture Room and 100 seat lecture theatre planned, Hands on History is ideal for group and school bookings.

There is a museum shop and tours are available.

***Opening times***

Open to public
Saturdays
10.00am to 5.00pm
Sundays
1.40pm to 4.30pm
and weekdays during
school holidays
10.00am to 5.00pm
(last admission 15
minutes prior to closing)
available to school
groups weekdays
during term time

***Directions***

M62 from major cities to
A63 to town centre.
Follow fingerpost signs
to High Street
Museums. All within
easy reach from TIC
in town centre.
Telephone 01482 613902
for more details

▲ "Childhood story of Hull and its people" Old Grammar School

▲ "Ancient Egypt" Hands on History

**461**

YORKSHIRE

# FERENS ART GALLERY
Queen Victoria Square, Hull, Yorkshire HU1 3RA
Telephone 01482 613902 Fax 01482 613710

◀ "Perseus (arming)"
bronze by Alfred Gilbert,
C 1881-1883

A remarkable loan to the
gallery created during
the past 20 years has
further bolstered The
Feren's contemporary
holdings. The gallery
aims to involve as many
people as possible in its
varied programme of
talks, tours, art
workshops and
curriculum linked
activities and The
Ferens was one of the
first British galleries to
use "Living History" to
interpret its collections.

The gallery shop stocks
an extensive range of
reproductions from the
collections and the
popular "La Loggia" cafe
offers quayside views.
The galleries and live art
space may be hired for
corporate events,
lectures, recitals, etc.

Winner of the museum
of the year award 1993
The Ferens Art Gallery
is one of the most
exciting and important
in the north of England.

The gallery boasts an
extensive collection
ranging from Dutch and
European old masters to
contemporary art. The
gallery plays host to an
exciting programme of
temporary exhibitions,
workshops and live art
events housed in a
purpose built
auditorium.

## Opening times

Open
Monday to Saturday
10.00am to 5.00pm
Sunday
1.30pm to 4.30pm
(last admission 15
minutes prior to
closing)

## Directions

M6 from major cities to
A63 to town centre.
Follow fingerpost signs
to High Street
Museums. All within
easy walk from TIC
in town centre,
telephone 01482 613902
for more details

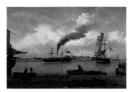

▲ "Antonio Canaletto"
view of the Grand Canal

▲ "SS Forfarshire
leaving Hull on her last
voyage" John Ward

◀ "The Firstborn"
by Frederick Elwell

# VINTAGE RAILWAY CARRIAGE MUSEUM

Ingrow Railway Centre, nr. Keighley, West Yorkshire BD22 8NJ
Telephone 01535 680425 Fax 01535 646472

▲ Coat of Arms on the Great Central Railway carriage

The fascinating Museum is a small gem with large exhibits - very elderly railway carriages!

It is owned and run by the Vintage Carriages Trust, a fully volunteer educational charity.

The carriages are displayed to tell the history of rail travel for the ordinary passenger. Enter the carriages and imagine (or remember!) what rail travel used to be like.

Listen to the sound cameos "Travellers' Tales" and hear the Duke of Keighley, or the cheeky Cockney, or Sherlock Holmes and others describe experiences in their railway journeyings.

Look at the restoration work in progress, as the carriages are lovingly restored.

Also there is a chance to meet some film stars: our carriages have appeared in over 30 cinema and TV productions.

As a bonus spend time browsing in the Transport Relic Shop. Out of print magazines, books, Guard's lamps, cast iron railway signs and many other items of railwayana.

Make this a real treasure chest. We are proud to be the winners of the 1998 ADAPT Museum Millennial Award for the provision of facilities for the disabled. There is access for all to enjoy this Museum with a difference.

***Opening times***

Open daily throughout year except Christmas and Boxing Day
11.30am to 4.30pm
(last admission 4.15pm)

***Directions***

At Ingrow one mile south of Keighley Town Centre on the main A629, Keighley to Halifax Road. Look out for the brown signs indicating Ingrow Station and the Museum.

▲ Facilities for all to access and enjoy the Museum

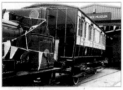

▲ The Carriage Museum showing the oldest carriage built in 1876

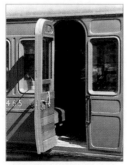

▲ Enter the compartments and listen to the "Travellers' Tales"

YORKSHIRE

## CLIFFE CASTLE
Spring Gardens Lane, Keighley, West Yorkshire BD20 6LH
Telephone 01535 618231 Fax 01535 610536

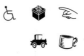

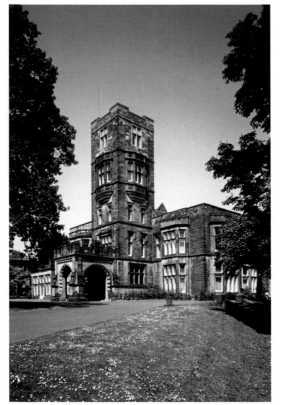

### Opening times

Open daily
except Mondays,
Tuesday to Saturday
10.00am to 5.00pm
Sunday
12.00pm to 5.00pm
Open Bank Holidays,
Closed Christmas Day,
Boxing Day and
Good Friday

### Directions

Cliffe Castle lies in a
park on outskirts of
Keighley off the A629
Skipton road.
About twenty
minutes walk from
bus and train stations.
Buses pass gates.

◀ Cliffe Castle
- a former textile
millionaire's mansion,
now the museum

Cliffe Castle is a
Victorian millionaires
mansion and listed
building, now a lively
museum, set in a
delightful park.

Displays include the
Bird Gallery and local
natural history;
"Molecules to Minerals",
a glittering array of a
thousand crystals and
rocks; the Airedale
Gallery featuring the
300 million year old
giant fossil newt and
other local fossils;
bygones, dolls and toys,

working beehive, and
Morris Stained Glass;
changing temporary
exhibitions.

Holiday activities.
Admission free.

▲ The Airedale Gallery.
Reconstruction of the
giant fossilised newt.

◀ Molecules to Minerals
- a thousand glittering
stones

# WILBERFORCE HOUSE MUSEUM

25 High Street, Kingston Upon Hull, Yorkshire
Telephone 01482 613902 Fax 01482 613710

YORKSHIRE

Hull's oldest Museum, founded in 1906 to preserve the memory of William Wilberforce's struggle to abolish slavery. Over the years the house has become a rich and diverse museum of history.

▶ "Slaves on the coast of West Africa" By F A Biard

Step back in time into the Victorian parlour, Georgian Rooms and colourful costume displays, look back over centuries of childhood in the toys and dolls gallery, and picnic or relax in the tranquil gardens overlooking the River Hull.

◀ The Slaver "Orange Grove" By Stuart Henry Bell

There is partial wheelchair access to the ground floor, including the Georgian Rooms, gift shop and garden. Although there is yet no access to the first floor slavery displays, a video with plenty of seating available is shown throughout the day in the ground floor gallery on the subject of Wilberforce and the slave trade.

There is a disabled toilet and baby changing facilities at Streetlife Museum next door to the house.

Full access to research facilities upon request and staff are on hand to help with access. Audio guides and talking displays are also available.

### Opening times

Open daily
10.00am to 5.00pm
Monday to Saturday
1.30pm to 4.30pm
(last admission 15
minutes prior to closing)

### Directions

M62 from major cities to
M63 to town centre.
Follow fingerpost signs to
High Street Museums,
All within easy reach
from TIC
in town centre
Tel 01482 613902 for
more details.

▲ William Wilberforce effigy

▲ Wilberforce House, Hull

YORKSHIRE

# BRONTË PARSONAGE MUSEUM

Church Street, Haworth, Keighley, West Yorkshire BD22 8DR
Telephone 01535 642323 Fax 01535 647131

The Brontës were an extraordinary family. Charlotte, Emily and Anne wrote some of the greatest novels in the English language, including 'Jane Eyre' and 'Wuthering Heights'. Haworth Parsonage was their lifelong home, and its Yorkshire moorland setting provided them with inspiration. The building is now a Museum containing period rooms with original furnishings, displays of their personal treasures, pictures, clothes and manuscripts, and an exhibition interpreting their lives and works.

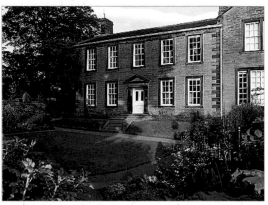

▲ The Brontë Parsonage Museum, Haworth

▲ Parsonage Dining Room

The Museum runs talks and activities, and produces a free children's guide. The Shop contains a comprehensive stock of books by and about the Brontës, and a range of souvenirs.

### Directions

From M62, Junction 24, follow signs to Halifax, then towards Keighley (A629). Haworth signposted left at mini-roundabout five miles before Keighley. Descend hill, bear left at station, then right over bridge. Follow road as it rises to brow of hill and swings left. Pass one car park, then turn left and immediately right into Parsonage Car Park. Museum is at top of short path at far end.

### Opening times

Open daily except 11th January to 5th February, 24th to 27th December 1999, 1st January and 10th January to 4th February 2000

Opening hours:
10.00am to 5.30pm, April to September (Wednesday in August - 7.00pm) 11.00am to 5.00pm, October to March (Final admission half an hour before closing)

▶ Emily Brontë diary paper 26th June 1837

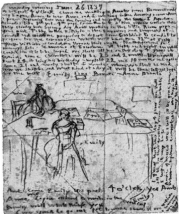

◀ Collars worn by the Brontës' dogs 'Keeper and Flossy'

# THE HULL & EAST RIDING MUSEUM

36 High Street, Kingston Upon Hull, Yorkshire
Telephone 01482 613902 Fax 01482 613710

Take an incredible journey through 248 million years of history from when Hull lay just North of the Equator, through ever changing environments of deserts, subtropical oceans, and icy wastelands. A place inhabited by ferocious sea monsters, woolly mammoth and native tribes.

The Museum was created to give maximum visual impact, with multisensory scenarios including "Celtic World" and the "Undersea Dome".

A stunning collection of Roman mosaics and the unique 'Hasholme Boat' being preserved in its immense 'boatlab' make this museum. A must for all ages; tracing the archaeology, geology and natural history of the Hull and East Riding area from pre-history to the coming of the Romans.

There is a Museum shop stocking an interesting an varied selection of souvenirs and books, and guided tours are available on request.

Admission £1; under 13s and residents pass holders free.

### Opening times

Open daily
10.00am to 5.00pm
Monday to Saturday
1.30pm to 4.30pm
Sunday
(last admission 15 minutes before closing)

### Directions

M62 from major cities to A63 to Town Centre. Follow fingerpost signs to High Street Museums. All within easy reach from T.I.C. in Town Centre. Tel: 01482 613902 for more details.

▲ "Grimston Sword"

▲ 'The Roos Carr figures and boat'

▲ 'The Hasholme Boat in its unique boatlab'

◄ 'The Venus mosaic from Rudstone Villa'

# LEEDS CITY ART GALLERY
The Headrow, Leeds, Yorkshire LS1 3AA
Telephone 0113 2478248
Fax 0113 2449689

Founded in 1888, the Art Gallery is home to "probably the best collection of 20th century British Art outside London", also outstanding collection of English Watercolours, Victorian and late 19th century, French pictures and a extensive display of 20th century sculptures from Gill to Gormley.

▼ The Venus by Canova on display in the Gallery

### Opening times

Open
Monday to Saturday
10.00am to 5.00pm
Wednesday until 8.00pm
Sunday
1.00pm to 5.00pm
Closed Bank Holidays

### Directions

In the City Centre next to the Town Hall.
A short walk from the railway and coach stations

▲ External view of Art Gallery with Reclining Figure by Henry Moore

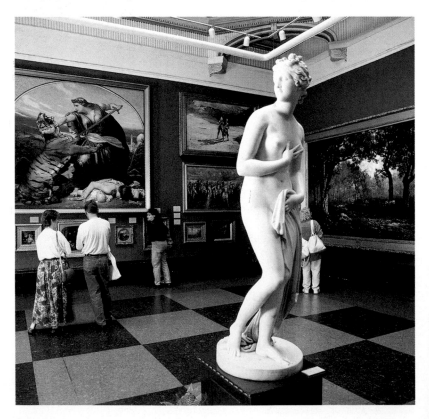

# YORKSHIRE MUSEUM

Museums Gardens, York, Yorkshire YO1 7FR
Telephone 01904 629745 Fax 01904 651221

The Yorkshire Museum is set in 10 acres of beautiful botanical gardens in the centre of the historic city of York.

'Climb through time' at the award winning Museum and discover Roman, Anglo-Saxon, Viking and Medieval treasures, including the exquisite Middleham Jewel, a mediaeval gold pendant with a stunning sapphire. The jewel was unearthed near to Middleham Castle, once home to York's own king, Richard III.

As well as archaeological treasures, experience the treasures of the underwater world of Jurassic times in the Hunters and Hunted Gallery, with it's huge skeletons of marine reptiles and their prey.

Watch out for our new exciting temporary exhibitions 'Myths and Monsters' - from Easter 1999, and 'Tracking Dinosaurs' - from 10th March to 21st September 1999.

Unravel the truth at Myths and Monsters'. Dragon, unicorn, yeti, mermaid, the Loch Ness monster... Are these creatures real or imagined? See them and decide for yourself!

Group rates available.

▲ The Yorkshire Museum, Museum Gardens, York

▲ The traditional Roman kitchen at the Yorkshire Museum

## *Directions*

By Road: A1/M1 and M62 link A19, A59 or A64 for York. Regular park and ride services operate near A64, A19, A1079 and A166 roads into York. Five minute walk from York Station.

## *Opening times*

Open daily
10.00am to 5.00pm
except 1st November
to 1st April
Monday to Saturday
10.00am to 5.00pm
Sunday
1.00pm to 5.00pm
(last admission 4.30pm)
Closed Christmas Day,
Boxing Day and
New Years Day

▶ The Middleham Jewel on display at the Yorkshire Museum

**469**

# ARMLEY MILLS INDUSTRIAL MUSEUM

Canal Road, Armley, Leeds, Yorkshire LS12 2QF
Telephone 0113 263 7861

Formerly one of the
largest woollen mills in
the world, Armley now
illustrates the city's
impressive industrial
past.

The vast array of
nostalgia includes a
1930s working cinema
collection of steam
locomotives and a
journey through the
working world of
textiles and fashion.

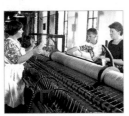

▲ Volunteer
demonstrates the
spinning mule

▲ View of Armley Mills
from canal

▲ Family look at giant
water wheels

### Opening times

Open
Tuesday to Saturday
10.00am to 5.00pm
Sunday
1.00pm to 5.00pm Open
Bank Holiday Mondays
(last admission 4.00pm)

### Directions

Turn south off the A65,
Kirkstall Road one mile
west of the city centre
and near the Kirkstall
viaduct. Proceed up
Viaduct Road to the
Canal Bridge, turn right

◀ Jack, 100 year old
locomotive goes for the
steam

# HORSFORTH VILLAGE MUSEUM

5 The Greet, Horsforth, Leeds, West Yorkshire LS18 5JB
Telephone 0113 2589411

◀ Victorian leisure
monthly lectures
demonstrations

Horsforth was once
described as the largest
village in England, and
has somehow managed
to retain some of its
village like identity,
character and sense of
community.

Horsforth Village
Museum aims to reflect
this heritage in its
interesting exhibits
which are drawn from
all aspects of life in and
around Horsforth and
have a great nostalgia
and educational value.

The Museum which
opened in July 1988, is
situated on the The
Green in the very heart
of the old village. Just
over the road is the
Civic Trust Award-
winning "garden of rest"
built on the site of the
original chapel, and the
museum itself has
previously been
vicarage, council offices,
with the village doctor's
surgery next door.

There is ample free
parking within 200
yards, and the Museum
is close to the town
centre with a variety of
shops, pubs and
restaurants.

Nearby is the open
space of Hall Park
where there is a
Japanese Garden and
children's playground.
Research facilities are
available, school visits
and other interested
parties may visit out of
normal hours by
arrangement.

New exhibition
"Flappers and Flower
Power" 1920s to 1960s
opens October 1998.
Detail ring -
0113 2589411

### Opening times

Open
March to December
Saturday
10.00am to 4.00pm
Sunday
2.00pm to 5.00pm
Lectures third Tuesday
every month 7.45pm

### Directions

Six miles north west
from Leeds, turn right
off A6120, Horsforth
War Memorial traffic
lights. Car park 200
yards on the left. Find
Museum opposite
entrance to Hall Lane.

▲ Horsforth at War
'Albert' the Air Raid
Warden

▲ The Museum
Victorian Hearse, on
opening day

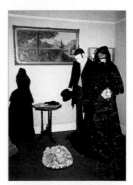

▲ The Funeral room,
Victorian mourning
clothes

**YORKSHIRE**

# TEMPLE NEWSAM HOUSE
Temple Newsam Road, off Selby Road, Leeds,
Yorkshire LS15 0AE
Telephone 0113 264 7321

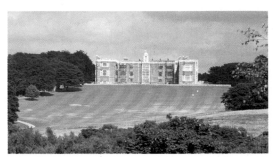

This house contains one of the most important collections of decorative arts in Britain including splendid Chippendale furniture and silver.

Birthplace of Lord Darnley, husband of Mary, Queen of Scots. 1200 acres of parkland surrounds the house along with Home Farm, one of the largest rare breed centres in Europe.

▲ A view of Temple Newsam and park

### Directions

Situated in Temple Newsam Park 4 miles east of Leeds off A63, exit 30 from M62

### Opening times

Open
Tuesday to Saturday
10.00am to 5.00pm
Sunday
1.00pm to 5.00pm.
Closed January and
February

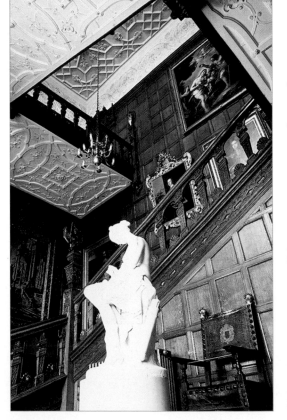

◀ The staircase at Temple Newsam

▲ The restored Picture Gallery

▲ The Edwardian Library

# THWAITE MILLS
Thwaite Lane, Stourton, Leeds, Yorkshire LS10 1RR
Telephone 0113 2496453

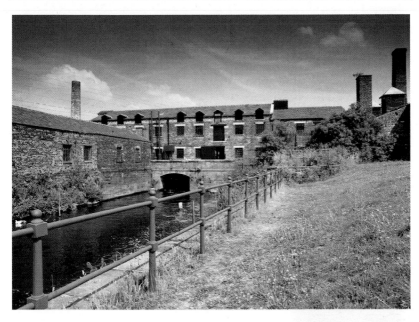

▲ Thwaite Mills from the River Aire

Still powered by its gigantic water wheels a visit to Thwaite Mills is like stepping back in time to a less hurried and pressurised world after a guided tour around the working mill there is the Manager's House to explore, canalside walk and picnic areas as well as extensive ground walks and a home to many rare species of wildlife.

### Directions

2 miles south of Leeds City Centre off the A61, half a mile from Junction 43 off the M1. Near to the Royal Armouries

▲ Volunteer shows working machines at Thwaite Mills

▲ Tour Guide talking to children inside Thwaite Mill

### Opening times

Open
Tuesday to Saturday
10.00am to 5.00pm
Sunday
1.00pm to 5.00pm
Open Bank Holidays
Closed January to February

YORKSHIRE

# BECK ISLE MUSEUM OF RURAL LIFE
Bridge Street, Pickering, North Yorkshire YO18 8DU
Telephone 01751 473653

▲ Wheelwright's Shop

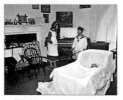

▲ Children room and nursery

▲ Victorian parlour complete with aspidistra

Regency mansion with many rooms each with its own theme printing, models, dairy, cobblers, shop, old time pub, chemist's shop, hairdressing, militaria, children's room, village shop and 1920's haberdashery.

Victorian parlour cottage kitchen outside yard with farming implements and machinery, hardware shop, domestic room with old washing machines, tack room with stuffed horse and saddlery.

Something for all the family. The most common comment by visitors is "We did not realise there was so much to see in the museum".

## Opening times

Open end March until end October open daily 10.00am to 5.00pm

## Directions

Large mansion house centre of Pickering around corner and over bridge from North Yorkshire Moors Railway Station. Seven miles from Malton A169 fifteen miles from Scarborough or A170

▼ Village store of 1920's era

# THE GREEN HOWARDS MUSEUM

Trinity Church Square, Richmond,
North Yorkshire DL10 4QN
Telephone 01748 822133 Fax 01748 826561

The museum's collection spans three centuries of travel, campaigning and war.

Artefacts and photographs of the Crimean War, the North West Frontier of India, The Boer War and archive film of World War I form part of the vivid presentation of the Green Howards' story in both peace and war.

The unique Collins' collection of uniforms include rare examples from 1768 to the present day.

There are more than 3,000 medals and decorations including eighteen Victorian crosses and three George crosses awarded to members of the regiment for acts of supreme courage.

Discover the role of the 'Ladies, wives and women of the regiment' and find out more about the Green Howards' link with Richmond and the people of North Yorkshire and Teesside.

School parties of up to twenty can be accommodated in the resource centre where they can see archive film on video, play CD rom discs and use "Hands on" material, all linked to the national Curriculum.

▲ A Victoria cross

### Opening times

Open February, March and November
Monday to Friday
10.00am to 4.30pm
April to mid May
Monday to Saturday
9.30am to 4.30pm
Easter day
2.00pm to 4.30pm
Mid May to September
Monday to Saturday
9.30am to 4.30pm
Sundays
2.00pm to 4.30pm
October
Monday to Saturday
9.30am to 4.30pm.
Closed December and January
(last admission 4.15pm)

### Directions

You will find the Green Howard Museum in the converted Church of the Holy Trinity at the centre of Richmond's Market Square.

▲ The raising of the regiment

◄ A Russian drum captured at The Battle of Alma

► A visiting party of school children

YORKSHIRE

# RUSKIN GALLERY
101 Norfolk Street, Sheffield, Yorkshire S1 2JE
Telephone 0114 203 9416 Fax 0114 203 9417

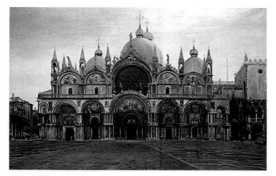

***Opening times***
Open
Tuesday to Saturday
10.00am to 5.00pm
Closed Saturday
1.00pm to 2.00pm
Also open Monday
10.00am to 5.00pm
from Summer 1999

◀ Facade of St Marks
by JW Bunney

Founded by John Ruskin in 1875, and housing the Collection of the Guild of St George, the Ruskin Gallery provides a view of the world as seen through the eyes of John Ruskin.

This outstanding collection of paintings, ornamental casts, minerals, books and prints reflects Ruskins' own interests and travels and includes material which he collected for the museum in Sheffield which he intended to benefit working people.

Alongside the main collection, the Ruskin Craft Gallery has on-going exhibitions featuring the contemporary craft works of local, regional and national craftspeople.

▼ Turner on Varnishing Day by SW Parrott

▲ C.J. Herringham Study after the Angel Gabriel in the Annunciation by Verrocchio

***Directions***
City centre location, on the corner of Tudor Square, opposite the Crucible Theatre. On street parking. 5 minute walk from bus and train station. Nearest tram stop is Cathedral.

YORKSHIRE

# CLIFTON PARK MUSEUM

Clifton Lane, Rotherham, South Yorkshire S65 2AA
Telephone 01709 823635 Fax 01709 823631

The Museum, set in a delightful 18th century house, once the home of the iron magnate Joshua Walker, displays one of the best collections of Rockingham porcelain in the country. "Made in Swinton" a new gallery telling the story of the pottery, opened in February 1998.

The museum also displays glass, social history material and furniture, together with period rooms and a Victorian kitchen.

A programme of temporary exhibitions and family holiday activities ensures there is always something new to see and do.

For our younger visitors, the new Lion's Den provides a child friendly introduction to the museum. Under fives can enjoy the toys and books, draw Nelson The Lion or his friends and add their pictures to Nelson's own art gallery.

There is free parking.

◀ The rhinoceros vase, made at the Rockingham works in 1826

### Opening times

Open Monday to Thursday and Saturday 10.00am to 5.00pm Sunday 2.30pm to 4.30pm (last admission 10 minutes before closing)

### Directions

Follow signs for Rotherham town centre. Then brown signs for Clifton Park Museum. The Museum is situated on Clifton Lane in Clifton Park

▲ Clifton Park Museum, Rotherham

▲ Children enjoying the Lion's Den

**477**

YORKSHIRE

# ABBEYDALE INDUSTRIAL HAMLET

Abbeydale Road South, Sheffield, Yorkshire S7 2QW
Telephone 0114 2367731 Fax 0114 2353196

◀ A Billhead from 1833 showing the Hamlet

Abbeydale Industrial Hamlet is a unique water powered scythe and steel works.

The houses, workshops, crucible steel furnaces, waterwheels, tilt hammers and machinery date back to the 18th century.

In its heyday it was major industrial complex and one of the largest water powered sites on Sheffield's River Sheaf, manufacturing scythes and agricultural tools. Work continued at Abbeydale until 1933 when Tyzack Sons and Turner ceased production on the site.

Abbeydale Industrial Hamlet offers an atmosphere where little imagination is required to re-create the past. What life was like at home and at work can be seen along with the whole process of making scythes from producing steel to paying the workforce.

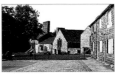

▲ The courtyard at Abbeydale Industrial Hamlet

▲ The teeming bay in the crucible steel shop

### Opening times

Due to reopen Spring 1999, Please call to confirm opening times

◀ Childrens activities at Abbeydale Industrial Hamlet

### Directions

The Hamlet is approximately 4 miles south west of Sheffield City Centre, on Abbeydale Road South which is the main road from Sheffield to Bakewell (A621). Buses to Totley from the City Centre stop at the entrance.

# BISHOPS' HOUSE
Norton Lees Lane, Sheffield, Yorkshire S8 9BE
Telephone 0114 255 7701

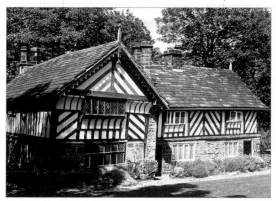

**Opening times**
Open
Wednesday to Saturday
10.00am to 4.30pm
and Sunday
11.00am to 4.30pm
Opening times
may vary during 1999
- always phone before
planning your visit

◀ Bishops' House

Bishops' House is a
16th Century timber
framed farmhouse set
at the top of
Meersbrook Park with
panoramic views over
the city. It has
furnished rooms
showing the lifestyle of
the time, and an
exhibition on Sheffield
in Tudor and Stuart
Times, which explores
the lives of Sheffield
people during the 16th
and 17th centuries.

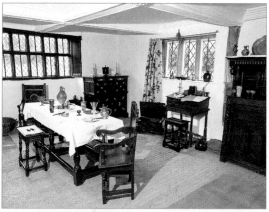

▲ The parlour depicting
life in a Yeoman farmer's
home

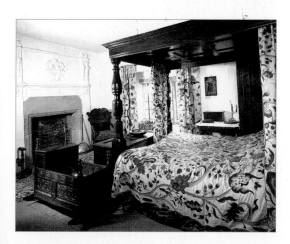

**Directions**
Two miles south of
Sheffield off the A61
Chesterfield Road.
On street parking.
Buses from city centre
fairly frequent.
Sign posted

◀ The new chamber
furnished in the style of
mid 17th century

**479**

YORKSHIRE

## GRAVES ART GALLERY
Surrey Street, Sheffield, Yorkshire S1 1XZ
Telephone 0114 273 5158

Situated in a prime city centre location on the third floor of the City Library, this gallery has on display paintings by famous 20th Century British artists. Also on display is the stunning collection of Chinese Ivories given to the Gallery by JG Graves.

Temporary exhibitions throughout the year include works by internationally renowned artists.

The coffee shop is open in the gallery until 4.00pm each day.

▼ The Eating House by Harold Gilman (1876-1919)

▲ Graves Art Gallery

### *Opening times*

Open
Tuesday to Saturday
10.00am to 5.00pm
Also open Monday
10.00am to 5.00pm
from Summer 1999

### *Directions*

City centre location above central library. Vehicle access from Arundel Gate. On street parking. 5 minute walk from bus and train stations. Nearest tram stop is Cathedral.

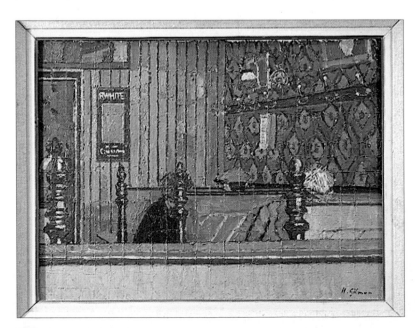

# CITY MUSEUM AND MAPPIN ART GALLERY

Weston Park, Sheffield, Yorkshire S10 2TP
Telephone 0114 276 8588 Fax 0114 275 0957

Set in the grounds of Weston Park, the City Museum has comprehensive displays relating to natural history, archaeology and ethnography. The weather station is also the oldest in the country.

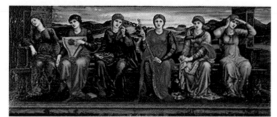

▲ Sir Edward Burne-Jones, The Hows, oil on canvas, Mappin Art Gallery

▲ Old Sheffield Plate Jug, about 1780 Richard Morton, City Museum

### Opening times

Open
Wednesday to Saturday
10.00am to 5.00pm
and Sunday
11.00am to 5.00pm
Also open Tuesday
10.00am to 5.00pm
from Summer 1999
Admission free.

### Directions

From City Centre follow signs for A57, University and hospitals. Opposite Children's Hospital, next to Weston Park. On street parking. Buses 51 and 52 from High Street. University tram stop.

The Mappin Art Gallery which adjoins the museum houses masters from the Victorian era, including works by Burne-Jones. Contemporary works are shown throughout the year as part of the temporary exhibition programme.

Workshops, activities and events are held regularly. Group visits can be arranged by prior appointment.

▶ Polar Bear
at the City Museum

YORKSHIRE

## VICTORIAN HARMONIUM MUSEUM

Victoria Hall, Victoria Road, Saltaire, Shipley, West Yorkshire
Telephone 01274 585601 Mobile 0976 535980

▼ Welcome to our museum with many different types of harmoniums

Come and enjoy a personal tour of Britain's only Harmonium Museum as featured on TV and radio.

We set up our museum here in Saltaire in October 1985. We have been keen collectors since 1976 when we acquired our first Reed Organ - by accident! Phil will tell you the rest of the story when you visit!

We have collected 95 fine and even unique instruments. A carved Harmonium which won a prize in the 1862 London exhibition, for the splendour of its case is here. There is a 3 manual and pedal Reed Organ made in Birmingham, specially for Dr Marmaduke

Conway when he was organist at Ely Cathedral. Also included are a tiny Book Harmonium, so-called because it is about the size of a family bible, a combined Piano and Reed Organ specially made to accompany silent movies, and a combined Pipe and Reed Organ. Player Reed Organs, from a small one that stands on the table, to a special model built in Paris.

Phil will demonstrate these instruments and there are some that you can play. We believe that you will have a surprising and enjoyable time. We look forward to seeing you!

### Opening times

Open
January to November
daily
11.00am to 4.00pm
except
Friday and Saturday

### Directions

Saltaire is on the A650, three miles west of Bradford. The museum is in Victoria Hall on Victoria Road which is Saltaire's main street leading to the railway.

◀ A typical parlour organ. Many homes will have had one

▼ A group of early harmoniums. Displays of pictures and information

# EMBSAY & BOLTON ABBEY STEAM RAILWAY

Bolton Abbey Station, Bolton Abbey, Skipton,
North Yorkshire BD23 6AF
Telephone 01756 710614 Fax 01756 710720

▲ Right away from Embsay Station

***Opening times***

Please telephone for
opening times

***Directions***

Embsay Station is just
off the A59 Skipton
Bypass and is
signposted by brown and
cream signs. Bolton
Abbey Station is on the
A59 Skipton  Harrogate
road and is also
signposted with brown
and cream signs.

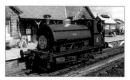

▲ The award winning
new station at Bolton
Abbey

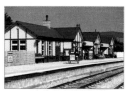

▲ Childrens Day at
Embsay Station

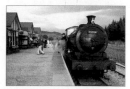

▲ A visiting locomotive
prepares to depart from
Bolton Abbey Station

The Embsay and Bolton
Abbey Steam Railway
runs almost 5 miles
between the new award
winning station at
Bolton Abbey and
Embsay Station built in
1888.

The railway a registered
museum has a fine
collection of industrial
tank locomotives which
largely operate the
services which run every
Sunday throughout the
year and up to 5 days a
week during Summer.

Facilities at both
Embsay and Bolton
Abbey Stations include
gift shop, refreshment
facilities and picnic
areas, there is also a
picnic area at Holywell
Halt midway between
the two stations.

The railway has limited
disabled facilities at
Embsay and a disabled
lavatory and baby
changing facilities at
Bolton Abbey station.

Travel through the
glorious Yorkshire Dales
on Yorkshire's friendly
line.

**YORKSHIRE**

# THE CRAVEN MUSEUM

Town Hall, High Street, Skipton, North Yorkshire BD23 1AH
Telephone 01756 706407 Fax 01756 706412

The Craven Museum is gloriously old fashioned, crammed full of exhibits exploring the social history, archaeology and geology of Skipton and the Craven Dales.

With displays on farming, leadmining, the canal, the Cotton Mills, home life and much more, there is bound to be something of interest for everyone.

Skipton is the ideal starting point for exploring the Yorkshire Dales and The Craven Museum is the best place to begin.

Phone us for details of our temporary exhibitions, events and activities.

Children are especially welcome and the Museum always provides some kind of hands-on activity to capture their imagination.

▲ Celtic stone head found in local stream C2000 years old

### Directions

The Craven Museum is located at the top of Skipton High Street in the Town Hall. As you face Skipton Castle the Town Hall is on your right.

### Opening times

Open Summer
(April to September)
Monday, Wednesday, Thursday and Friday
10.00am to 5.00pm
Saturday
10.00am to 12.00pm and 1.00pm to 5.00pm
Sunday
2.00pm to 5.00pm.
Closed Tuesdays. Winter
(October to March)
Monday, Wednesday, Thursday and Friday
1.30pm to 5.00pm
Saturday
10.00am to 12.00pm and 1.00pm to 4.00pm.
Closed Sundays and Tuesdays

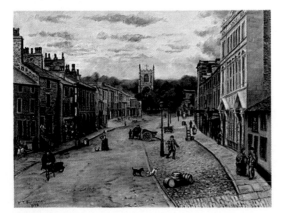

◄ Skipton High Street 1890 By W H Shuttleworth, The Craven Museum

# SHANDY HALL
Coxwold, York, Yorkshire YO61 4AD
Telephone 01347 868465

Here in 1760-67 the witty and eccentric parson, Laurence Sterne wrote Tristram Shandy and A Sentimental Journey.

Sometimes between writing he stepped out into his garden 'to weed, hack up old roots or wheel away rubbish'.

The early 15th century house, added to by Sterne, is surrounded by 2 acres of garden, part is walled garden full of old fashioned roses and unusual cottage garden plants; part a wild garden in the adjoining disused quarry.

Shandy Hall holds the world's foremost collection of editions of Sterne's novels, plus an interesting background of contemporary prints and paintings illustrating his work.

Its appeal therefore spans a broad range of interests, from the academic, the architectural and the horticultural.

This is a lived in house where you are sure of a personal welcome.

▲ Shandy Hall

---

### Opening times

Hall open 1st June
to 30th September
on Wednesday
2.00pm to 4.30pm
Sunday
2.30pm to 4.30pm
Gardens open
1st May to
30th September daily
except Saturdays
11.00am to 4.30pm
Groups at other times
by appointment

---

▼ 'A Sweet Pavilion' in the garden at Shandy Hall

▲ The Kitchen of Shandy Hall

▲ Garden and West Front of Shandy Hall

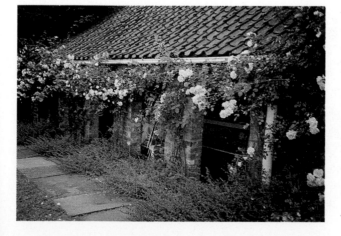

### Directions

Shandy Hall is the last house at west end of Coxwold village, 4 miles east off A19, 20 miles north of York. Coxwold is signposted between Easingwold and Thirsk.

YORKSHIRE

# RYEDALE FOLK MUSEUM

Hutton Le Hole, York, Yorkshire YO6 6UA
Telephone 01751 417367 Fax 01751 417367

◀ A view of the museum grounds - Richard Clive Photography

There are the tiniest neolithic flints, the magnificent cruck timbers from the 16th century and the splendid Merry Weather fire engine.

▲ The village shop and post office in 1953

The museum lies in the heart of the North Yorkshire Moors. Set in 3 acres, there are resumed and reconstructed historic buildings including shops, thatched cruck cottages, Elizabethan manor House, barns,and workshops.

The museum has the oldest daylight photographic studio in the country and the renowned Hayes collection of photographs.

▲ 1850 Merry Weather Fire Engine

The museum records the daily life of the North Yorkshire people from the earliest inhabitants to1953.

There are a number of special days throughout the season including crafts, rare breeds of domestic livestock, engine days and much more besides.

Winner of many awards including Museum of the Year.

### *Opening times*

Open March to October daily 10.00am to 5.30pm (last admission 4.30pm)

### *Directions*

Travel east on the A170 from Helmsley to Scarborough, half a mile east of Kirkbymoorside, turn left, proceed 2 miles to Hutton-le-Hole. The museum is in the centre of Hutton

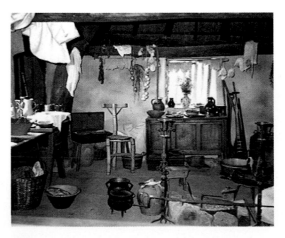

◀ Medieval Crofter's cottage

# YORKSHIRE MUSEUM OF FARMING
Murton Park, Murton Lane, York, Yorkshire YO19 5UF
Telephone 01904 489966 Fax 01904 489159

Murton Park, two miles from York, offers a variety of attractions for all ages.

The Yorkshire Museum of farming has two large display buildings where you can see farm and domestic equipment of a bygone age.

Special feature's are the chapel, land army exhibition, a hardware shop, James Herriott Veterinary Surgery, Blacksmith's Forge and Weaver's loft, paddocks and pens house a variety of rare breeds, farm animals and poultry.

▲ "Mediaeval Children" guarding the entrance to Danelaw Village

▲ Derwent Valley Light railway locomotives and signal box

See the Bee Pavillion, dovecote and grass maze.

Stroll round Danelaw dark age village, an open air classroom, where 20,000 school children per year experience life as a Saxon, Viking or Mediaeval farmer.

Opening shortly, another living history project, is a Roman Fort and Celtic roundhouse.

The Derwent Valley Light railway allows you to ride on a steam train (Sundays, Bank Holidays and Special Events).

The outdoor play arena, picnic site, gift shop, and cafe, with a replica farmhouse kitchen, add to the family atmosphere.

Free parking, disabled toilet, baby changing facilities.

Special events include: "Easter Eggstravaganza", Murton Park show and Sheepdog Trial (July), and "Santa Specials".

Guided tours by arrangement. Send for information pack of vast educational programme.

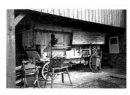

▲ Threshing machine (one of many items of farm machinery)

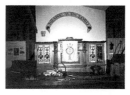

▲ The chapel situated in the Four Seasons Building

### Opening times

Open daily
10.00am to 5.00pm
until end of October
November to February
10.00am to 4.00pm.
Closed Christmas and
New Year's Day

### Directions

York ring road
(A64/A1237) follow signs
for Hull and Bridlington
(also brown museum
signs). Take A166
Bridlington Road, first
left (Murton Lane), then
third on left signed
Murton Park

YORKSHIRE

## YORK MINSTER & ST WILLIAM'S COLLEGE
York Minster, York, North Yorkshire YO1 7JN
St William's College, College Street, York, North Yorkshire YO1 7JF
Telephone 01904 639347 Fax 01904 613049

York Minster & St William's College lie at the heart of the mediaeval city and are a must for all visitors.

The Cathedral is the largest Gothic Church in northern European and an awe inspiring place, notable also for its huge collection of original stained glass windows, mainly 14th and 15th century.

Free entry for individuals and families, daily services, free voluntary guides and information leaflet, make it a welcoming place to visit.

Commercial parties pay a small charge per person. School parties are welcome especially if they have booked through our schools centre which gives teachers all kinds of help.

▼ York Minster from the south east

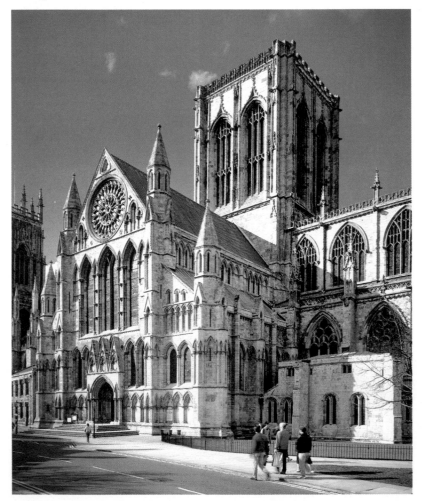

▼ Looking up the interior from the west window

▶ St Williams College from the Minster

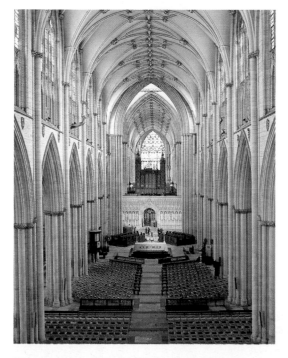

### Opening times

Open 7.00am to dusk
through the year
(later in summer)
College is open
9.00am to 5.00pm daily
Restaurant is open
10.00am to 5.00pm
6.30pm to 9.30pm daily

### Directions

York Minster is in the
centre of the city visible
from the station and
most other points. Once
inside, the entrance to
the Foundations is in
the south transept.

Photography for private use is unrestricted but not permitted during services or in certain areas.

Small charges are made to visit the Foundations and Treasury to see the Roman and Norman remains under the ground, the Crypts, the superb octagonal Chapter House, where there are sometimes special exhibitions and to climb the central tower!

There is a shop to provide souvenirs, cards as well as booklets on all aspects of this famous Church.

The adjoining college, situated only metres from the east end, provides toilets and a restaurant and there is a small charge to view the Historic rooms (subject to functions).

▶ One of the many 14th century windows

# MERCHANT ADVENTURERS HALL
Fossgate, York, Yorkshire YO1 9XD
Telephone/Fax 01904 654818

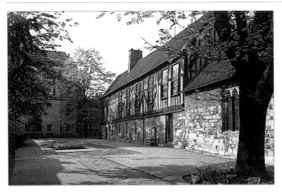

▲ The Hall from the south

The Hall is of major national importance and is scheduled as an ancient monument. It was built in 1357-61, and is one of the largest buildings of its date in Britain, apart from castles, barns or churches.

▼ The Great Hall

Probably nowhere else in the world can there still be seen in one building the three rooms serving the three functions of a mediaeval guild; business and social in the Great Hall; charitable in the undercroft of hospital; and religious in the Chapel.

The Great Hall is framed in timbers of English Oak which grew plentifully in the vale of York.

The undercroft's walls are made of brick, the oldest known use of brick since the Romans left almost one thousand years before.

The Chapel is at the far end of the undercroft. It was rebuilt in 1411, and both stones and bricks were used.

Today the company continues to maintain the Hall with its

▲ The Undercroft

charitable status for the education and enjoyment of the public. It administers charities for the poor. It is seeking to create a wider public understanding of the nature of business enterprise and of its value to the whole community in the creation of wealth.

*Opening times*

Open
8.30am to 5.00pm
daily from 14th March
to 14th November
8.30am to 3.30pm
except Sundays
15th November
to 11th March

*Directions*

Enter from Piccadilly
(opposite Marks
and Spencer)
or from Fossgate

▶ Chapel of the Holy Trinity

**YORKSHIRE**

# NATIONAL RAILWAY MUSEUM
Leeman Road, York, Yorkshire YO26 4XJ
Telephone 01904 621261 Fax 01904 611112

◀ Rocket

To experience a fun-packed day out, make tracks to the National Railway Museum - it's full of fantastic surprises.

Our exhibitions have stories to fascinate you, hands-on interactive displays to get to grips with, entertaining shows and mind-racing quizzes.

Here at the world's biggest railway museum, the amazing story of the train is brought to life in front of your very eyes.

Travel back to 1829 and be amazed by the inventive brilliance that made Rocket one of the world's most famous steam locomotives. Then speed right up-to-date in

front of a life-size section of the Channel Tunnel and mock up of the Eurostar.

You can find out what it was like inside a Royal train in our lavish Palaces on Wheels exhibition, or feast your eyes on Mallard which still holds the world speed record to this day, at an amazing 126mph.

Then if you've worked up an appetite, take a break at Brief Encounter - our licensed restaurant which serves a variety of full meals or light snacks stopping off at the children's play area and the miniature railway.

And with an ever-changing programme of special events and exhibitions, there's something for the whole family to enjoy.

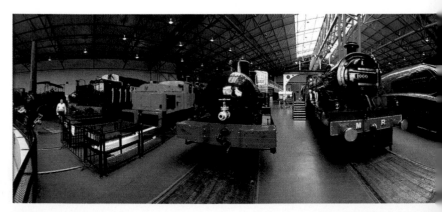

### Opening times

Open 7 days a week
10.00am to 6.00pm
Closed 24th, 25th
and 26th December

### Directions

The Museum is just 540
metres (600 yards) from
York Railway Station. It
is signposted from the
city centre for
pedestrians and from
York's ring road for
those travelling by road.

▼ Queen Victoria's
favourite saloon

▼ 360 degree photo of Great Hall

YORKSHIRE

## ARCHAEOLOGICAL RESOURCE CENTRE (THE ARC)
St Saviourgate, York, North Yorkshire YO1 8NN
Telephone 01904 643211 Fax 01904 627097

Sister attraction to the world famous Jorvik Viking Centre, the ARC is the ideal next stop for those wishing to discover more about how archaeologists are piecing together York's past.

The ARC lets you get your hands on real history and find out what archaeology tells us about the Roman, Viking and Mediaeval city. At this completely interactive centre you become the archaeologist.

Following an audio-visual presentation on archaeology in York, there is the opportunity to handle ancient finds and discover the clues that reveal their origins.

You can then try your hand at bygone crafts, using accurate replicas and traditional materials to sew Roman shoes, weave on a primitive loom and write in Viking runes.

The ARC uses the latest information technology, allowing you to view archaeological sites and objects and discover the value of today's technology in uncovering the past.

◀ Sifting real finds at the ARC

◀ Quizzing computers at the ARC

A team of skilled volunteers are on hand to help you learn what real archaeologists do, but don't expect them to do all the work - everyone is invited to get involved and find out as much as they can for themselves!

### Directions

Housed in a restored mediaeval church, the ARC is centrally located on St. Saviourgate, near to York's famous Shambles and just five minutes' walk from the Jorvik Viking Centre.

▶ Weaving cloth on a primitive loom

### Opening times

Open Monday to Friday
10.00am to 3.30pm
(last admission)
Saturday
1.00pm to 3.30pm
(last admission)
Closed Sundays
and last two weeks
in December

◀ Getting down to the bare bones of the past

YORKSHIRE

## JORVIK VIKING CENTRE
Coppergate, York, North Yorkshire YO1 9WT
Telephone 01904 643211 Fax 01904 627097

At the world famous Jorvik Viking Centre, visitors are sent on a journey of discovery to a lost age, released by archaeologists from the grip of time.

A time car transports you back through the centuries to a recreation of Jorvik as it was in October AD 948, with its bustling market, dark smoky houses and busy wharf side.

Every aspect of the reconstruction is based on accurate archaeological evidence.

▶ Eymund the Fisherman - a face from the past

Viking models have been created using Viking Age skulls, laser-scanned then sculpted to produce a real 'face from the past'. Even the clothes worn by the Vikings have been accurately recreated: the cloth has been hand spun, coloured with original dyestuffs, hand woven and then hand stitched, all using the same techniques as the Vikings. Real Viking age timbers have been stabilised and re-erected where they were

◀ Woman returning from the well

### *Opening times*

Open daily
April to October
9.00am to 5.30pm
(last admission)
November to March
10.00am to 4.30pm
(last admission)
Closed Christmas Day

### *Directions*

Jorvik is situated in the
Coppergate shopping
area in the centre of
York. Follow the green
and gold fingerpost
signs for "Castle Area"
then signs for
"Jorvik Viking Centre"

▼ Viking cess pit

actually discovered and
hundreds of artefacts,
from the York
Archaeological Trust's
excavation on this site,
are displayed in the
modern Skipper Gallery.

Throughout the school
holidays, special
activities and Viking
entertainment are on
offer, whilst Jolablot -
the annual Jorvik
Viking Festival - takes
place at the Jorvik
Viking Centre and
venues around York's
city centre in February.

▲ Unloading cargo on
the banks of the River
Foss

**YORKSHIRE**

## CRAKEHALL WATERMILL

Little Crakehall, Bedale, North Yorkshire DL8 1HU
Telephone 01677 423240

The Mill, on the site of a doomsday mill is restored as you see it today, its machinery being 18th and 19th century, some made nearby at Leeming.

*Opening times* Open Easter to end September, open daily from 10.00am to 5.30pm except Mondays and Tuesdays

## BEVERLEY ART GALLERY

Champney Road, Beverley, Yorkshire HU17 9BQ
Telephone 01482 883903 Fax 01482 885136

The gallery hosts an exciting programme of changing exhibitions featuring both contemporary art and crafts and selections from the gallery's collection, which includes paintings by Beverley born artist Fred Elwell.

*Opening times* Open all year Wednesdays to Friday 10.00am to 5.00pm, Saturday and Sunday 10.00am to 12.30pm and 1.30pm to 5.00pm

## MUSEUM OF ARMY TRANSPORT

Flemingate , Beverley, Yorkshire HU17 ONG
Telephone 01482 860445 Fax 01482 872767

Two acres inside over 120 vehicles: last Blackburn Beverley aircraft, Sir Patrick Wall model display with over 4,000 models. From a motorcycle to a tank and railway trains and more.

*Opening times* Open every day except 24th to 26th December from 10.00am to 5.00pm, (last admission 4.00pm)

## DONCASTER MUSEUM & ART GALLERY

Chequer Road, Doncaster, Yorkshire DN1 2AE
Telephone 01302 734293 Fax 01302 735409

Regional museum collections and a lively temporary exhibitions programme. The museum of the King's Own Yorkshire Light Infantry is also in the building. Please telephone for further details.

*Opening times* Open daily Monday to Saturday 10.00am to 5.00pm, Sunday 2.00pm to 5.00pm. Admission free.

## THE ROYAL PUMP ROOM MUSEUM

Crown Place, Harrogate, Yorkshire HG1 2RY
Telephone 01423 556188 Fax 01423 556130

The town's premier spa building illustrates Harrogate's development as the Queen of Inland spas. The highlight of a visit is the chance to sample the sulphur waters.

*Opening times* Open April to October 10.00am to 5.00pm, (last admission 4.40pm), November to March 10.00am to 4.00pm, (last admission 3.40pm)

Y
O
R
K
S
H
I
R
E

## THE MUSEUM OF SOUTH YORKSHIRE LIFE

Cusworth Hall, Cusworth Lane, Doncaster, Yorkshire DN5 7TU
Telephone 01302 782342 Fax 01302 782342

Social history illustrating life in South Yorkshire over the last 200 years, set in a
country house. Temporary exhibitions, seasonal events and much more!

>  *Opening times*  Open all year except Christmas Day, Boxing Day and Good Friday
>  Monday to Friday 10.00am to 5.00pm, Saturday 11.00am to 5.00pm,
>  Sunday 1.00pm to 5.00pm. Closed at 4.00pm December and January

## BURTON AGNES HALL

Driffield, East Yorkshire YO25 0ND
Telephone 01262 490324 Fax 01262 490 513

A lovely Elizabethan Hall filled with treasures collected by the family over four
centuries including a collection of modern and impressionist paintings.

>  *Opening times*  Open 1st April to 31st October 11.00am to 5.00pm

## THE MERCER ART GALLERY

Swan Road, Harrogate, Yorkshire HG1 2SA
Telephone 01423 556188 Fax 01423 556130

Housed in a Victorian Promenade Room, the Mercer Art Gallery is now a place to
enjoy exciting art exhibitions.

>  *Opening times*  Open Tuesday to Saturday 10.00am to 5.00pm,
>  Sundays 2.00pm to 5.00pm. Closed Monday's except Bank Holidays

## WAR ROOM & MOTOR HOUSE COLLECTION

Broadwater House, 30 Park Parade, Harrogate, Yorkshire HG1 5AG
Telephone 01423 500704

The War Room comprises relics and models related to the World Wars. The Motor
House collection is made up of some 12,000 die-cast model vehicles covering the
history of transport.

>  *Opening times*  Open March to October by appointment only

## MANOR HOUSE ART GALLERY AND MUSEUM

Castle Yard, Ilkley, West Yorkshire LS29 9DT
Telephone 01943 600066 Fax 01943 817079

Former Manor House situated on the ruins of Olicana Roman Fort. Permanent local
history and archaeology displays on ground floor and contemporary/regional art
exhibitions in upper galleries.

>  *Opening times*  Open Wednesday to Saturday 11.00am to 5.00pm,
>  Sunday 1.00pm to 4.00pm and Bank Holiday Mondays 11.00am to 5.00pm

YORKSHIRE

### EAST RIDDLESDEN HALL

Bradford Road, Keighley, Yorkshire BD20 5EL
Telephone 01535 607075 Fax 01535 691462

A homely 17th Century merchant's house with beautiful embroideries, carved oak furniture, fine patterned ceilings and stonework. Delightful walled garden with mixed herbaceous borders and herbs.

*Opening times*  Open 27th March to 31st October, Sunday to Wednesday and Thursday in July and August, 12.00pm to 5.00pm, Saturday 1.00pm to 5.00pm, (last admission 4.30pm)

### ROYAL ARMOURIES MUSEUM

Royal Armouries, Armouries Drive, Leeds, Yorkshire LS10 1LT
Telephone 0113 220 1948 Fax 0113 2201955

Award-winning home of the Royal Armouries' National Collection of arms and armour. Five galleries explore different aspects of the subject: hunting, war, tournament, self defence, oriental. Exhibitions throughout the year.

*Opening times*  Open daily except Christmas Day 10.30am to 5.00pm

### MOUNT GRACE PRIORY

Staddlebridge, Northallerton, North Yorkshire DL6 3JG
Telephone 01609 883494 Fax 01609 883361

The best preserved Carthusian monastery in England. Monks cell and herb garden. Award winning exhibition and gardens. Special events through the year. Beautiful picnic area, abundant wildlife. No dogs please.

*Opening times*  Open 1st April to 31st October daily 10.00am to 6.00pm, 1st November to 31st March, Wednesday to Sunday 10.00am to 1.00pm and 2.00pm to 4.00pm, (last admission 30 minutes before closing)

### OTLEY MUSEUM

The Mechanics' (Civic Centre), Cross Green, Otley, West Yorkshire
LS21 1HD  Telephone 01943 461052

The object and archive local history collection reflects all aspects of the Otley settlement from Mesolithic flints to the "Wharfedale" printing machine. Documents available to researchers by appointment only please. Guided tours by appointment.

*Opening times*  Open Monday, Tuesday, and Friday mornings, 10.00am to 12.30pm and first Saturday of every month. Closed August and Bank Holidays

### THE NIDDERDALE MUSEUM

King Street, Pately Bridge, North Yorkshire HG3 5LE
Telephone 01423 711225

The museum has twelve large rooms depicting every aspect of past Dales life. National Heritage Museum of the year award 1990. Admission £1.50, Concessions and Children 75p.

*Opening times*  Open Easter to October 31st daily 2.00pm to 5.00pm, August 11.00am to 5.00pm, November to Easter Saturdays and Sundays only 2.00pm to 5.00pm, (last admission 4.30pm)

### NORTH YORKSHIRE MOORS RAILWAY

Pickering Station, Pickering, North Yorkshire YO18 7AJ
Telephone 01751 472508 Fax 01751 476970

Journey along the country's favourite steam railway, between Pickering and
Grosmont. The 18 mile route offers outstanding scenery and waymarked walks.
Goathland is "Aidensfield" in the YTV "Heartbeat" series.

**Opening times** Open daily 20th March to 31st October 10.00am to 5.00pm.
Sundays in November and 27th December to January 2nd

### MORAVIAN MUSEUM

55/57 Fulneck, Pudsey, West Yorkshire LS28 8NT
Telephone 0113 256 4862

This small museum features the world wide Moravian Church plus social history,
ethnography, Victorian parlour and kitchen. Specially notable arc artefacts from
Ladahk, 1822 fire engine and Moravian Whitework embroidery. Parking and
restaurant nearby.

**Opening times** Open Easter Wednesday to end of October,
Wednesdays and Saturdays, 2.00pm to 4.30pm, (last admission 4.00pm)

### RICHMONDSHIRE MUSEUM

Ryders Wynd, Richmond, North Yorkshire DL10 4JA
Telephone 01748 825611

Displays about leadmining, transport, local history. Attractions include James
Herriott's TV vets surgery, chemist's shop and Dales post office. Reduced rates for
parties.

**Opening times** Open daily Good Friday to end Of October 11.00am to 5.00pm,
(last admission 4.30pm)

### ROTHERHAM ART GALLERY

Rotherham Arts Centre, Walker Place, Rotherham,
Yorkshire S65 1JH
Telephone 01709 382121 Fax 01709 823653

Rotherham Art Gallery runs a programme of contemporary exhibitions throughout
the year from contemporary photographs to thought provoking contemporary art, to
delightful Victorian paintings.

**Opening times** Open Monday to Saturday 10.00am to 6.00pm.
Closed Sundays and Bank Holidays

### YORK AND LANCASTER REGIMENTAL MUSEUM

Rotherham Arts Centre, Walker Place, Rotherham, Yorkshire
S65 1JH
Telephone 01709823635 Fax 01709 823631

Over 200 years of military history from 1758 to 1968 are vividly brought to life in
this unique regimental museum.

**Opening times** Open Monday to Saturday 10.00am to 6.00pm.
Closed Sunday and Bank Holidays

YORKSHIRE

## KELHAM ISLAND MUSEUM

Off Alma Street, Sheffield, Yorkshire S3 8RY
Telephone 0114 272 2106 Fax 0114 275 7847

The story of Sheffield's industry and people, including the mighty 12,000hp
River Don Engine in steam, working crafts people and children's hands-on displays.
Regular special events.

*Opening times* Open all year except some times over Christmas (please check)
Sunday 11.00am to 4.45pm, Monday to Thursday, 10.00am to 4.00pm
(closed Fridays and Saturdays)

## SHEPHERD WHEEL
Whiteley Woods, Hangingwater Road, Sheffield, Yorkshire
Telephone 0114 236 7731 Fax 0114 235 3196

The small grinding hull powered by water wheel on the River Porter was used to
sharpen knives. The buildings date from the late 1700's.

*Opening times* Please telephone for details of opening times

## BRACKEN HALL COUNTRYSIDE CENTRE

Glen Road, Baildon, Shipley, Yorkshire BD17 5EA
Telephone 01274 584140

The centre houses traditional and interactive displays on the natural history, geology
and local history of Shipley Glen. The centre is accessible to the disabled. Shop,
toilets and wildlife garden.

*Opening times* Please telephone for details of opening times

## WHITBY MUSEUM
Pammett Park, Whitby, North Yorkshire YO21 3UB
Telephone 01947 602908

A treasure of Whitby's past. From giant fossils to model ships. From the famous
"Hand of Glory" to intrically carved Whitby jet, the museum is filled with interesting
things.

*Opening times* Please telephone for details of opening times

## THE BAR CONVENT

17 Blossom Street, York, Yorkshire YO4 1AQ
Telephone 01904 643238 Fax 01904 631792

Our museum outlines the industry of Christianity in the North of England and also
tells the story of Mary Ward, the Foundress of the Institute of the Blessed Virgin
Mary. Car park across the road.

*Opening times* Open 1st March to 18th December Monday to Friday
10.00am to 5.00pm, (last admission 4.00pm)

# SCOTLAND

Northern Scotland, that magnificent region of awesome mountains and rugged storm-lashed coastline is the region most outsiders consider typical of this nation, but of course Scotland consists of a south as well as a north and the two regions are as different as chalk and cheese. The Highlands and the Lowlands each have their own very particular charm and peculiarities. In the distant past, the Highlanders were mobile pastoralists counting their wealth in cattle and sheep and avoiding towns. The Lowlanders on he other hand restricted themselves to the coastal plains, establishing their burghs and planting their crops. The Scottish Lowlands, within the rift valley comprising the River Clyde and the Firth of Forth are really at the heart of Scotland...the most thickly populated area containing the rival cities of Edinburgh and Glasgow. This is the region of Sir Walter Scott and Robert Burns, writers who did much to familiarise the world with romantic Scotland.

Scotland is a nation with a proud and ancient heritage, its story told through a long list of museums ranging from the grand to the humble but each with its particular story to tell. Glasgow and Edinburgh are singularly well endowed with splendid museums and galleries. The Scottish National Portrait Gallery in Edinburgh provides a visual history of Scotland from the sixteenth century to the present day. The National Gallery of Scotland houses the nation's greatest collection of international painting, drawing and prints, while the Scottish National Gallery of Modern Art displays a magnificent collection of twentieth century painting, sculpture and graphic art. Glasgow boasts the largest municipal collection in Britain including the wonderful Burrell Collection and the Gallery of Modern Art.

These fine museums represent only one small section of Scottish culture. There is a wealth of wonderful small museums portraying the life, work and aspirations of each of the regions. With over 3,400 miles of coastline and 50 inhabited islands, Scotland's maritime history is recorded in some fine museums...the Aberdeen Maritime Museum, The Scottish Fisheries Museum, and the Scottish Maritime Museum. Many of the ancient Scottish castles have their own museums... Brodie Castle, Cawdor Castle and Lauriston Castle; in fact there can be few aspects of Scottish history, folk lore and legend that are not examined in the wonderful museums of Scotland.

**503**

SCOTLAND

# ABERDEEN MARITIME MUSEUM
Shiprow, Aberdeen, Scotland AB11 5BY
Telephone 01224 337700 Fax 01224 213066

Aberdeen Maritime Museum was awarded Scottish Museum of the year 1997 for its outstanding contributions to the presentation of the history of the North Sea to the general public.

Exhibitions cover the offshore oil and gas industry, fishing and shipping.

The multi-media displays include diaries keep on board Aberdeen clipper ships, harbour developments and a visitor operated remote TV camera.

Central to the museum is the 8.5 metre high 'Murchison' oil production platform model showing the engineering achievements of the offshore oil industry.

The story of Aberdeen's famous clipper ships is told through 'Captain's Paintings' of the ships and exquisite models.

The museum hosts a café and shop as well a multipurpose auditorium.

▼ Entrance to Aberdeen Maritime Museum

### Directions

From Bus/ Train Station : East towards harbour to Virginia Street, turn left on Shore Brae to Shiprow. From Union Street : East towards Town House, right to Shiprow.

### Opening times

Open year round except Christmas and New Year
Monday to Saturday
10.00am to 5.00pm
(last admission 4.30pm)
Sunday
11.00am to 5.00pm
(last admission 4.30pm)

SCOTLAND

# CONOCO NATURAL HISTORY CENTRE

Zoology Building, University of Aberdeen, Tillydrone Avenue,
Aberdeen, Aberdeenshire AB24 3TZ
Telephone 01224 493288 Fax 01224 493169

The Conoco Natural History Centre was set up in 1995 with funds from Conoco (UK) Ltd. to enable everyone to find out about natural history.

Using the resources of Aberdeen University's Cruickshank Botanic Garden and Zoology Museum, the centre is open to the public, interested groups and to schools.

Within the Cruickshank Botanic Garden a great diversity of plants and indigenous wildlife are to be found.

The museum, the fifth largest in the UK, houses collections of animals from all over the world.

Botanic attractions contained within the 100 year old, 11 acre botanic garden include amongst others, a rose garden, birch lawn, sunken garden, herbaceous border, rock and water garden and arboretum.

Zoological attractions include skeletons from all the biggest animals in the world, creatures from the highest mountains, creatures from the deepest seas,

creatures from since time began.
Contact Paul Doyle or Mandy Tulloch for further information.

### *Opening times*

Open all year
Monday to Friday
9.00am to 5.30pm.
Open at other times by arrangement.
Cruickshank Botanic garden open also Saturday and Sunday between May and September from 2.00pm to 5.00pm

### *Directions*

On King Street (A596) heading north, turn left at the roundabout onto St Machar Drive. At next roundabout turn right onto Tillydrone Avenue. Zoology Building is on right-centre in basement

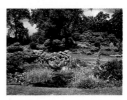

▲ View of the rock and water garden

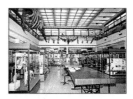

▲ The Cruickshank Botanic garden in Spring

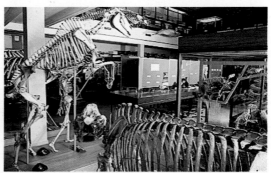

▲ Ground Floor of Zoology Museum

▼ Some of the larger animals found in the Zoology Museum

SCOTLAND

# MYRETON MOTOR MUSEUM
Aberlady, East Lothian EH32 0PZ
Telephone 01875 870288

Motor cars from 1896,
Motor cycles from 1902,
commercials from 1919.
Word War II military
vehicles. Cycles from
1880. Automobilia,
petrol pumps, tins.

Period advertising and
a large collection of
enamel signs. Aircraft
engines. Two world
speed record breakers -
motor cycle and car.

▲ Triumph, Humber,
Triumph, Dunelt and
Lambretta.

### Opening times

Open every day
October to Easter
10.00am to 5.00pm
Easter to October
10.00am to 6.00pm
Closed Christmas Day

### Directions
Seventeen miles from
Edinburgh, off A198
between Aberlady and
Gullane. Two miles from
the A1 at Haddington.

▲ 1923 Hillman Sports
and 1927 Darracq DTS

▼ 1941 Hillman light
utility

▶ 1937 Wolseley 'ten'
and 1919 Ford 'TT'
Charabanc

# SCOTTISH FISHERIES MUSEUM
St Ayles, Harbourhead, Anstruther, Fife KY10 3AB
Telephone 01333 310628

SCOTLAND

The Scottish Fisheries Museum at Anstruther in Fife is housed in a group of attractive and historic buildings, the earliest of which dates from the early 16th century.

The buildings themselves have a long association with fishing, as stores, net lofts, sail loft and boat building yard. The premises are ramped throughout and were extended by 60% between 1993 and 1997; and a further large extension will be added by late 1999.

Displays cover the development of fisheries and their ancillary industries from the early 6th century to the present including the lives of the women and their work onshore.

Artefacts include many fine models and paintings, full sized vessels and tableaux of various aspects of the fishing story.

The museum has a reference Library which includes a collection of some 20,000 photographs and slides.

Other elements include a shop and tearoom and the premises house the Memorial Room to Scottish fisherman lost at sea.

The Museum is open 361 days a year. There is an entrance charge.

## *Opening times*

Open April to October
Weekdays
10.00am to 5.30pm
Sunday
11.00am to 5.00pm
November to March
Weekdays
10.00am to 4.30pm
Sundays
2.00pm to 4.30pm
(last entries 45 minutes before closing)

## *Directions*

Ten miles south of St. Andews on B9131. Twenty three miles east of Kirkcaldy on A917.

▼ Ninety five year old Fifie Herring Drifter "Reaper"

▲ Entrance courtyard of Fisheries Museum

▲ Fisherman's cottage 1900-15

▲ Steam drifter "Noontide"

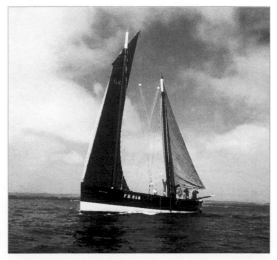

# GRAMPIAN TRANSPORT MUSEUM

Alford, Aberdeenshire AB33 8AE
Telephone 019755 62292 Fax 019755 62180

The Grampian Transport
Museum is devoted to
the road and rail
transport history of
Grampian and
Aberdeenshire.

The main gallery houses
around 100 vehicle
exhibits that are changed
seasonally. Many are
unique and have strong
local associations.

A prime example is the
famous Craigievar
Express, a 19th century
steam tricycle that was
built by a local postman
before the dawn of the
motoring era.

The displays feature both
humble and exotic
motorcars, motorcycles,
cycles, horse drawn,
steam and commercial
vehicles.

Functional vehicles are
well represented
including a 6x6 1940
Mack Snow plough,
Scotland's oldest steam
roller and a Series One
LandRover that climbed
Ben Nevis!

▲ The gates to the
GTM are reused cast
iron bridge spans

Many vehicles are 'climb
aboard' and there are
also working exhibits. A
double decker bus

doubles as a video
theatre with a show that
describes the develop -
men of Grampian's road

Alford Village station where displays describe the effect that the arrival of railways had on Donside and the immediate locality. The museum is famous for its programme of outdoor events that helps to bring the subject alive.

These are staged in the specially developed 15 acre site that boasts an RAC licenced road circuit, Grandstand and control tower! A great family attraction.

### Opening times

Open 28th March to 31st October daily
10.00am to 5.00pm
(last admission 5.00pm)

### Directions

The Grampian Transport Museum is situated in the village of Alford, 25 miles west of Aberdeen on the A944. Bluebird buses run a regular service from Aberdeen. Look for the huge cast iron main gate!

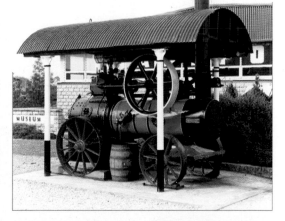

network from pre-history to the present day. Railway history is covered in the restored

◀ 'Craigievar Express' the famous steam tricycle is still run on local roads

▲ The Birkhall steam engine was donated by HRH the Duke of Edinburgh

**509**

SCOTLAND

## ARBROATH MUSEUM

Signal Tower, Ladyloan, Arbroath, Angus DD11 1PU
Telephone 01241 875598

Beside Arbroath's picturesque harbour stands the elegant Regency Signal Tower complex. Now Arbroath's Museum, it was built in 1813 as the Shore Station and family home for the famous Bell Rock Lighthouse, which lies on a sunken reef 11 and a half miles out from Arbroath.

Life-like models which speak in rich local dialect bring history alive. Smell Arbroath smokies as you listen to a fisher couple bickering as they work with the fish. A baby cries and a cat miaows in the Victorian Lighthouse keeper's parlour while next door wash day is in progress with evocative smells.

The massive lenses of the last manually operated lamp from the Lighthouse is displayed. Each August Arbroath Seafest celebrates the maritime traditions with a re-enacted Fisher Wedding walk through the fit o' the toon (the Fisher Quarter). Maritime wildlife of cliffs and beach form another display.

Step back into a 1950s class room or explore Arbroath's great industries of Flax textiles and engineering. The ambience of the Museum is fun and relaxation. Photos of children's activities and their appreciative letters adorn the walls.

With the tang of salt on your lips come in and discover the hidden treasures of Arbroath - St Tammas's Town.

### Opening times
Open all year
10.00am to 5.00pm
Monday to Saturday also
in July and August
Sundays
2.00pm to 5.00pm

### Directions
Museum is on A92, 13 miles north of Dundee. Railway and Bus Stations are 7 minutes walk away. Museum is situated just south of Arbroath Harbour.

▲ Traditional method of curing Haddock to produce Arbroath smokies

▲ Signal Tower, Arbroath's Community Museum dominating the Harbour

# ATHOLL COUNTRY COLLECTION

Blair Atholl, Perthshire PH18 5SG
Telephone 01796 481232

A stuffed Highland cow, horse harness, an old Post Office and a 1900's kitchen, along with many implements and photos are used in this lively but unsophisticated museum to give an atmosphere of reality to the social history of the people of Atholl. A people tied to the land by their occupation.

Displays feature a wide variety of subjects - road, rail and postal services. The Kirk, the School, the Smiddy and stunning photographs of local wild flowers.

The gamekeepers' corner has a range of stuffed wild animals. Many aspects of farming are shown.

Trinafour Post Office has its well stocked shelves of yesteryear products. In the kitchen the young lass makes breakfast while her father arises from his box bed.

Scotland's largest and most handsome trophy, the Caledonian Shield for rifle shooting is a magnificent example of Scottish art.

Children are most welcome and can handle objects in the kiddie's kist.

### Opening times

Open
end of May to October
1.30pm to 5.00pm
every day.
July, August, September
from 10.00am on
weekdays

### Directions

Turn off the Perth to Inverness A9 for the highland village of Blair Atholl. The Museum is in the centre of the village at the White Stallion Statue

▲ The kitchen

▲ An Atholl curler with the shepherding section beyond

◄ Milking time in the byre

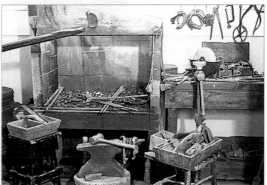

▶ The Smiddy

**SCOTLAND**

## PETER ANSON GALLERY

Town House West, Cluny Place , Buckie, Moray AB56 1HB
Telephone 01309 673701 Fax 01309 675863

▲ Findochty

The gallery is located within the Public Library at Buckie and features an important collection of water-colours by the Maritime artist, Peter Anson, depicting scenes of fishing and fishing life in Scotland, and elsewhere.

▲ Fish selling in Buckie in 1921      ▼ Buckied dated 1929

### Opening times

Open all year
Monday to Friday
10.00am to 8.00pm
Saturday
10.00am to 12.00pm

### Directions

Gallery situated in Buckie Library. Buckie is on A98 Aberdeen to Elgin coast road. Library is in town centre.

▲ Nearing the Fishing Grounds, 1880

# THE FIFE FOLK MUSEUM
High Street, Ceres, nr Cupar, Fife KY15 5NF
Telephone 01334 828180

The Fife Folk Museum is celebrating its 30th Anniversary this year.

The museum is housed in historic buildings, including a 17th century tolbooth and linen weaver's cottages, in the old High Street of Ceres.

These delightful old buildings are home to a large collection which brings to life the rural past of Fife.

The tolbooth, later a weighhouse, features a 17th century dungeon and an immense variety of weights and measures.

In the cottage a 19th century linen weaver's room with box-bed has been re-created. Lively displays show the history of village crafts such as dairying, the clothes people wore and the way they got around - especially on amazing early bicycles!

The tools and machinery of the farmer are attractively laid out on terraces that lead down the Ceres Burn and the ancient Bishops Bridge.

Fife Folk museum has gained many awards, including a Special Commendation in the 'Museum of the Year Award, Scotland' 1985, a Diploma of Merit in the Europea Nostra Awards for restoring the historic buildings, a Commendation in the Civic Trust Awards 1984 and the Tennant Caledonian Community Award 1988.

### Opening times

Open
10th April to 19th April
and 16th May to
11th October daily
except Friday
2.00pm to 5.00pm

▼ The museum front: the weighhouse and adjoining cottages

### Directions

The Museum is on Ceres, High Street, at the crossroads of the Cupar, St. Andrews and Kirkaldy Roads, with car parks fifty yards along the Kirkaldy road.

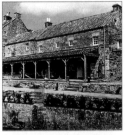

▲ Terraces by the Burn: the rear of the museum

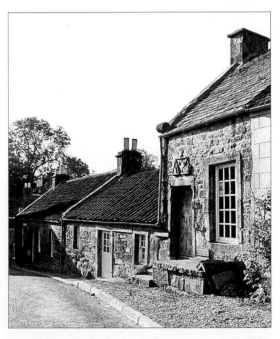

SCOTLAND

# THE OFFICIAL LOCH NESS EXHIBITION CENTRE

Drumnadrochit, Inverness-shire IV3 6TU
Telephone 01456 450 573 Fax 01456 450 770

This is the home of the authoritative exhibitions on the mysterious phenomenon of Loch Ness. Centred upon a 40 minute audio visual 6 room presentation walk through, the exhibition displays much of the active equipment used in the exploration of Loch Ness.

From March 1999 the exhibition will possess the latest technologies in graphic, laser and animations, coupled with all the latest findings of our environmental research team - The Loch Ness project.

This exciting experience is a large multi-media presentation which leads you through themed areas covering the whole subject from the prehistory of Scotland, exploring the cultural roots of the story in Highland Folklore and into the present controversy with all the phases of investigation and exploration that this has entailed.

Also encompassed in the exhibition are video's, music, photographs, animations, lasers, graphics, special effects and many authentic relics of the search.

The centre also offers a hotel and restaurant, The Moffat Arms bar, a Whisky shop, a house of Heraldry, a Keeper's Cottage, a Kilt maker and a Nessie shop.

As a bonus you can introduce the children to our life-size monster in our outdoor Lochan. There are disabled facilities and ample parking area.

## *Opening times*

Open Winter
10.00am to 4.00pm
Easter to May
9.30am to 5.30pm
June to September
9.30am to 6.30pm
July and August
9.00am to 8.30pm
October
9.30am to 6.00pm
(last admission 1 hour
before closing)

▶ Viking exhibit

▼ Loch Ness

### *Directions*

The Exhibition Centre is situated 14 miles south of Inverness on the A82, between Inverness and Fort Augustus. As you enter Drumnadrochit we are directly on the right hand side.

▲ The Official Loch Ness Centre

▲ Scotland exhibit

# ROBERTS BURNS CENTRE
Mill Road, Dumfries, Dumfriesshire DG2 7BE
Telephone 01387 264808 Fax 01387 265081

This award winning visitor centre tells the story of the connections between Robert Burns and the town of Dumfries.

A well researched exhibition is illuminated by many original documents and relics of the poet.

There is a fascinating scale model of Dumfries in the 1790s and a haunting audio-visual presentation, as well as a book shop, a cafe - gallery with a lively exhibition programme and facilities for visitors with disabilities.

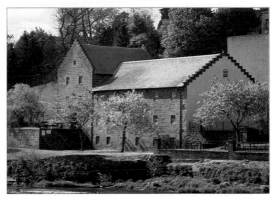

▲ Robert Burns Centre, Dumfries

▼ Model of Robert Burns as an Exciseman

### Opening times

Open
Monday to Saturday
10.00am to 8.00pm,
and Sunday
2.00pm to 5.00pm
(April to September)
Tuesday to Saturday
10.00am to 1.00pm,
2.00pm to 5.00pm
(October to March)

### Directions

From the Whitesands cross the River by Buccleuch Street Bridge. Turn left before the traffic lights then left again onto the Riverside, and continue to the Robert Burns Centre car park.

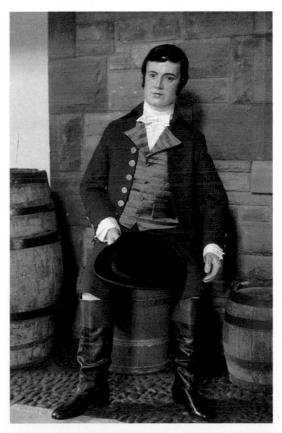

# SAVINGS BANKS MUSEUM

Ruthwell, Dumfries, Dumfries and Galloway DG1 4NN
Telephone 01387 870640

The Savings Banks Museum in Ruthwell village is housed in the original building where savings banks were founded on May 10th 1810.

In Ruthwell church stands a 7th century preaching cross dating from the first great Christian Age in Britain. The history of both is linked to one man, the Rev Henry Duncan DD.

Although his calling and greatest commitments were to the church and literature, Henry Duncan was much more.

He was: Antiquarian (restorer of the Ruthwell Cross), Geologist ( he worked on the first British study of quadruped footprints), Publisher (founder of the Dumfries Courier and Dumfries and Galloway standard), Philanthropist (as father of Savings Banks) Author, Artist and Businessman.

On display are: the original 3-lock money box used in the Ruthwell Parish Bank - the first trustee savings bank; a collection of savings banks and bank notes from many countries and a beeswax replica of the Ruthwell Cross made by Henry Duncan.

The Museum commemorates his remarkable life and charts the progress of the Savings Bank movement.

## *Opening times*

Open Easter to October daily 10.00am to 1.00pm and 2.00pm to 5.00pm Closed Sundays and Mondays in Winter

## *Directions*

From M6 Carlisle take A74 to Gretna, A75 to Annan then B724 to Ruthwell. From Dumfries take A75 towards Annan then B724 for Clarencefield and Ruthwell

▲ Ruthwell Runic cross dated 680AD restored by Rev Henry Duncan

▲ Collection of Savings Boxes from Savings Banks throughout the world

▲ Cottage in Ruthwell where Savings Banks were founded in 1810

▲ Internal view of Museum display

# DUMFRIES MUSEUM & CAMERA OBSCURA
Dumfries Museum, The Observatory, Dumfries DG2 7SW
Telephone 01387 253374 Fax 01387 265081

Dumfries Museum is centred around the 18th century windmill tower which stands above the town.

You will see fossil footprints left by prehistoric reptiles, the wildlife of the Solway salt marshes, tools and weapons of the earliest people, stone carvings of Scotland's first Christians and everyday things of the Victorian farm, workshop and home.

The Camera Obscura, installed in 1836, is on the top floor of the table top screen. You will see the panoramic views of Dumfries and the surrounding countryside.

### *Directions*

From the Whitesands cross the River by Buccleuch Street Bridge. Turn left before the traffic lights and continue up Church Street. The Museum is on the crest of the hill

▲ Camera Obscura

▶ The Observatory

▲ Penannular Brooch, C800 Carronbridge

### *Opening times*

Open
10.00am to 5.00pm
Monday to Saturday
2.00pm to 5.00pm
Sunday
(April to September)
10.00am to 1.00pm
and 2.00pm to 5.00pm
Tuesday to Saturday
(October to March)

▶ Plaster cast of the skull of Robert the Bruce

# MCMANUS GALLERIES
Albert Square, Dundee, Scotland DD1 1DA
Telephone 01382 432020 fax 01381 432052

The architectural gem, and flagship building of the Dundee Arts and Heritage, houses human history and art collections.

Providing permanent displays and changing exhibitions, (Natural history displays, including the skeleton of the famous Tay Whale - opening in Spring 1999).

It opened in 1867 as a memorial to Prince Albert, promoting science, literature and the arts. The building was designed by Sir George Gilbert Scott, the eminent Victorian "Gothic-style" architect. Superb Scottish paintings from the 19th and 20th century provide the focal point of the art collection, notable especially for the Red Victoria Gallery with its gold-framed, densely hung 19th Century paintings (look out for the William MacTaggart oils!).

An exciting ever-expanding collection of Scottish Contemporary Art (Selection on permanent display), European paintings, early pianos, clocks and decorative art, including Dundee Silver, also feature.

A key historical item is the outstanding bronze

mariner's astrolabe (It is the world's oldest complete navigational instrument dated 1555).

The atmosphere of Dundee life in the Edwardian era, is evoked within the kitchen of a working class tenement or at a Victorian pub, through life-scale set pieces. Inquire also about the infamous Tay Bridge disaster.

### Opening times
Open
Monday to Saturday
10am to 5pm
with late opening on
Thursday until 7pm
Sunday
12.30pm to 4pm

### Directions
From Train Station take bridge to Union Street. Turn Right along High Street. Turn Left into Reform Street. At the top of Reform Street lies Albert Square and McManus Galleries. From Bus Station turn left along Seagate. Go right along Commercial Street. McManus Galleries is on your left.

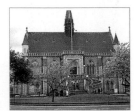

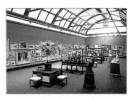

▲ The Victorian gallery with it's gold-framed, densely hung 19th century paintings

▲ The magnificent stained glass windows - a tribute to Mary Slessor

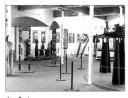

▲ A temporary exploring the atmosphere and mythology of iron relating to ship building

◄ McManus galleries with it's famous "Gothic-Style" architecture and Victorian splendour

# VERDANT WORKS

West Hendersons Wynd, Dundee, Scotland DD1 5BT
Telephone 01382 225282 Fax 01382 221612

Verdant Works explores the full and fascinating story of jute, once Dundee's most important industry, from its beginnings in the fields of India and Bangladesh to the finished product in all its myriad forms.

The story begins in India then follows the journey of a Jute Baron's Clipper Ship as she makes for Dundee. Dramatic sounds and light effects and working machines bring the past vividly to life.

Hear the gossip of the mill workers and discover what conditions were like in a turn of a century textile mill. Computer inter-actives bring the story up to the present, and beyond, in what is a truly living Museum.

A specially commissioned film showing contemporary footage of workers in one mill provides a superb insight into the period and the lives of ordinary people.

▶ Verdant Works - Scotland's new Textile Museum

### Opening times

Open all year except 25th December, 1st January and 2nd January
April to October 10.00am to 5.00pm
Sundays from 11.00am to 5.00pm
November to March 10.00am to 4.00pm
Sundays from 11.00am to 4.00pm

### Directions

From Edinburgh/Glasgow travel to Perth via M90/A9. Perth to Dundee at the Swallow roundabout follow the Dundee Airport/railway sign along the riverside drive and then the historic ships sign for Discovery Point. Follow the brown tourist signs.

## DISCOVERY POINT & RRS DISCOVERY

Discovery Point, Discovery Quay, Dundee, Scotland DD1 4XA
Telephone 01382 201245 Fax 01382 225891

Discovery Point is the home of Captain Scott's famous ship Discovery that took him and his brave crew on a heroic journey to the unknown waters of Antarctica in 1901 to 1904.

At Discovery Point the story unfolds in dramatic fashion with spectacular lighting, graphics and a 3D audio presentation, before visitors move on to the quayside where they can explore above and below deck of the Discovery.

### Opening times

Open daily

April to October
10.00am to 5.00pm
Sunday
11.00am to 5.00pm

November to March
10.00am to 4.00pm
Sundays
11.00am to 4.00pm

### Directions

By road, Motorway A90 from Edinburgh to Perth then A92 to Dundee. Follow brown tourist signs within Dundee.

By rail to Dundee and Discovery Point is opposite the railway station.

▼ The Royal research ship Discovery at home at Discovery Point

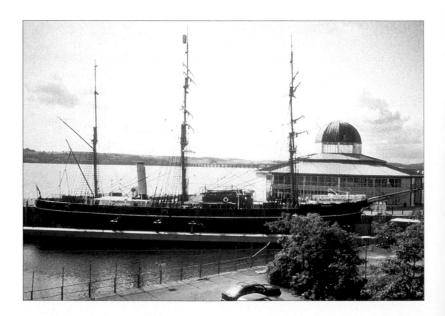

# MILLS OBSERVATORY
Balgay Park, Glamis Road, Dundee, Scotland DD2 2UB
Telephone 01382 435846 Fax 01382 435962

The Mills Observatory opened in 1935 and is Britain's only full-time public observatory. It is open throughout the year, with evening opening during the winter months.

Under a clear sky, visitors can explore the Moon, planets and stars with the Observatory's historic 10-inch refracting telescope. An open balcony gives an unobstructed view of the starry sky overhead, and panoramic views of the River Tay and Fife.

The Observatory's main exhibition features displays, models and videos on various aspects of astronomy and space science, and there is also a small shop with astronomical posters, postcards, star charts, books and souvenirs.

The Observatory is an excellent educational resource for schools; talks and planetarium shows are available to any group of children or adults. There is also a regular programme of public planetarium shows and special children's events during school holidays.

Admission to the Observatory and the main telescope is free. Charges apply for planetarium shows and

special events, and for group visits which must be booked in advance. There is free parking immediately outside the Observatory. Wheelchair access is limited to the ground floor and planetarium only.

## Opening times

Open
April to September
Closed Monday
Tuesday to Friday
11.00am to 5.00pm
Saturday and Sunday
12.30 to 4pm
October to March
Monday to Friday
4.00pm to 10.00pm
Saturday and Sunday
12.30 to 4pm

▼ Children taking part in a special event about the weather

### Directions

From Dundee City Centre follow A923 (Coupar Angus). Follow signposts at Junction with Ancrum Road into Glamis Road. From entrance to Balgay Park follow Park Road to Observatory.

▲ The Mills Observatory in Balgay Park, Dundee

▲ View across the city to the Observatory from the Law-Hill

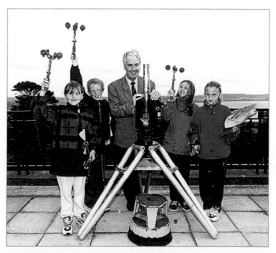

# ANDREW CARNEGIE BIRTHPLACE MUSEUM

Moodie Street, Dunfermline, Fife KY12 7PL
Telephone 01383 724302 Fax 01383 729002

Thirty minutes from the centre of Edinburgh lies Dunfermline, the ancient capital of Scotland.

Here, in the shadow of Dunfermline Abbey can be found the Birthplace Cottage and Museum which tell the extraordinary story of Dunfermline's most eminent son, Andrew Carnegie.

In the cottage where he was born in 1835 the family's story prior to their emigration to the United States is told. A Jacquard handloom clacks into action on the first Friday of every summer month.

Adjoining the cottage is the Memorial Hall endowed by Mrs Louise Carnegie to chart the meteoric business career of Andrew Carnegie from bobbin boy, telegraph operator and railroad developer to steel king of America.

The business empire he forged was sold in 1901 for $400 million and he became the richest man in the world. However, Andrew Carnegie believed that the rich were merely trustees of their wealth and should distribute it for the elevation and benefit of humanity.

By the time of his death in 1919 he had given away over $350 million to provide free libraries, church organs, schools and colleges.

On display are many of the treasures showered on Mr Carnegie by grateful towns, cities and institutions throughout the world.

Special arrangements can be made for groups wishing to visit the museum out of normal opening times.

## Opening times

Open
November to March
2.00pm to 4.00pm daily
April to October
Monday to Saturday
11.00am to 5.00pm
Sundays
2.00pm to 5.00pm
June to August
Monday to Saturday
10.00am opening
(last admission
20 minutes before
closing time)

## Directions

From Train Station:
along Comely Park to
Priory Lane. By car:
Follow signs for Abbey,
Museum 400 yards
downhill from Abbey.
From High Street: down
Guildhall Street and
past Abbey.

▲ The Birthplace Cottage with the Memorial Hall in the background

▲ The small room in which Andrew Carnegie was born

▲ A recreation of Mister Carnegie's study at Skibo Castle

▲ A display of freedom caskets presented to Mister Carnegie

# MUSEUM OF FLIGHT

East Fortune Airfield, East Fortune, East Lothian EH39 5LF
Telephone 01620 880308 Fax 01620 880355

The Museum of Flight is Scotland's National Museum of Aviation, displaying a wide variety of aeroplanes, rockets, engines and associated items.

Highlights of the collection include Britain's oldest aeroplane (Percy Pilcher's "Hawk" of 1896), pre-war biplanes, World War II fighters, supersonic jets and a Comet jet airliner, a Vulcan Bomber and the huge Blue Streak space rocket.

Hundreds of artefacts are attractively displayed in two large hangars, which also contain a variety of special exhibitions.

These currently include an Aviation Art Gallery, a "hands-on" interactive display and a "Rockets and Spaceflight" exhibition. The museum is based at East Fortune Airfield, which dates back to 1915.

The display hangars and buildings all date from World War II. The airfield is listed a historic monument, probably the best preserved 1939 - 1945 airfield in Britain.

The museum is suitable for all ages and visitors should allow at least 2

hours per visit. There is a cafe, gift shop, ample parking, toilets and facilities for the disabled.

A full programme of events is run through the year including a major air show each July called "Festival of Flight".

### Opening times
Open
March to November
daily 10.30am to 5.00pm
(late opening until 6pm
July and August)

### Directions
The museum is situated 20 miles east of Edinburgh, near Haddington. It is well signposted from the A1 in both directions

▼ Blue Streak - The largest rocket on display in Great Britain

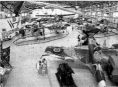

▲ Interior view - main Museum Hangar

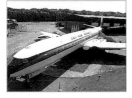

▲ De Havilland Comet - the world's first jet passenger airliner

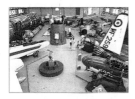

▲ Interior view - jets and aerospace hangar

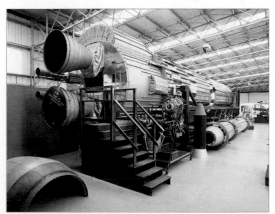

## SCOTTISH NATIONAL PORTRAIT GALLERY

1 Queen Street, Edinburgh, Scotland EH2 1JD
Telephone 0131 6246200 Fax 0131 3433250

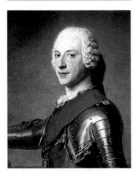

▲ Prince Charles
Edward Stewart by
Maurice Quentin de la
Tour

The Portrait Gallery is
situated in the heart of
the New Town on
Queen Street. It
provides a unique
visual history of
Scotland, told through
portraits of the figures
who shaped it: royals
and rebels, poets and
philosophers, heroes
and villains. All the
portraits are of Scots,
but not all are by Scots.

The collection also
holds works by great
English, European and
American masters such
as Van Dyck,
Gainsborough, Copley,
Rodin, Kokoschka and
Thorwaldsen.

The Portrait Gallery
was built in the 1880s
largely thanks to
private generosity. It is
an imposing neo-Gothic
building in red

▲ Sir Walter Scott by
Sir Henry Raeburn

Gallery gift shop and
cafe. Disabled access
throughout building.

*Opening times*

Open all year
Monday to Saturday
10.00am to 5.00pm
Sunday
2.00pm to 5.00pm
Closed 25th and
26th December

sandstone, designed by
the architect Sir Robert
Rowand Anderson.

In addition to paintings,
it displays sculptures,
miniatures, coins,
medallions, drawings,
watercolours and
photographs.

The Gallery pursues an
active policy of acquiring
and commissioning
portraits of celebrated
living Scots. These
include John Bellany's
Sean Connery and
Avigdor Arikha's
portrait of the Queen
Mother.

The National
photography collection
is also based at the
Portrait Gallery. The
core of this collection is
its vast holding of work
by the Scottish pioneers
of photograph, D.O. Hill
and Robert Adamson.

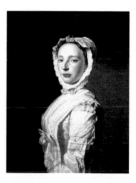

▲ Anne Bayne by Allan
Ramsay

*Directions*

5 minutes walk from
St Andrew Square Bus
Station and 10 minutes
walk from Waverley
Railway Station.

◀ Jean Muir by
Glenys Barton

SCOTLAND

# CITY ART CENTRE, EDINBURGH
2 Market Street, Edinburgh, Scotland EH1 1DE
Telephone 0131 529 3993 Fax 0131 529 3977

Located in the heart of the capital, the City Art Centre is both home to the City's collection of Scottish Art, and one of the UK's leading temporary exhibition spaces.

Since 1980, the City Art Centre has mounted exhibitions drawn from as far afield as China and Peru. The variety of exhibitions, from rare Egyptian antiquities to the latest installation Art, from Michelangelo drawings to Star Trek, has made it one of Britian's most visited exhibition centres.

The City's fine art collection consists of around 3,500 works of Scottish Art: paintings, watercolours, drawings, prints, photographs, sculpture and tapestries including works by McTaggart, Fergusson, Peploe and Eardley.

Through purchase funds provided by the Jean F. Watson bequest, the collection has been kept up-to-date by the acquisition of works by contemporary Scottish artists such as Davie, Blackadder, Paolozzi and Bellany.

The holdings also include topographical views of Edinburgh, and portraits.

Exhibitions drawn from the permanent collection are a regular feature of the City Art Centre's programme.

### *Opening times*

Open
Monday to Saturday
10.00am to 5.00pm
Sunday during the
Edinburgh Festival
2.00pm to 5.00pm
Operates extended opening hours for major temporary exhibitions

▼ 'Scotland's Emporium of the Visual Arts', Edinburgh's City Art Centre

### *Directions*

Located in the City Centre across Waverley Bridge from Princes Street, at the Market Street exit from Waverley Station.

▲ Fergusson's 'The Blue Hat' from the City's Fine Art collection

# THE GEORGIAN HOUSE

7 Charlotte Square, Edinburgh, Scotland EH2 4DR
Telephone 0131 2263318 Fax 0131 2263318

Edinburgh's New Town is known throughout the world and at its heart is Charlotte Square. The Georgian House is furnished as it would have been in 1796 by its first owners.

There is a wonderful array of china, silver, paintings, and furniture reflecting the social conditions of that age. Video programmes.

Property owned by the National Trust for Scotland.

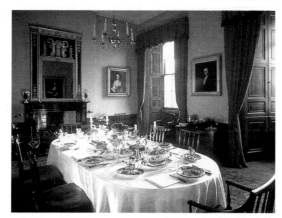

▲ Georgian House, dining room

▼ Georgian House

### Opening times

Open
1st April to 31st October
Monday to Saturday
10.00am to 5.00pm
Sunday
2.00pm to 5.00pm
(last admission 4.30pm)

### Directions

In Charlotte Square, two minutes walk from west end of Princes Street.

▲ Georgian House, kitchen

**SCOTLAND**

## SCOTTISH NATIONAL GALLERY OF MODERN ART
Belford Road, Edinburgh, Scotland EH4 3DR
Telephone 0131 624 6200 Fax 0131 343 3250

Set in beautiful, leafy grounds, the Gallery of Modern Art lies to the west of the City Centre in a handsome neo-classical building.

The gallery first opened in its present location in 1984. The building was designed by William Burn in the 1820s and was formerly a school.

It has bright spacious rooms and its extensive grounds provide the perfect setting for sculpture by Henry Moore, Barbara Hepworth, Anthony Caro, William Turnbull and Eduardo Paolozzi.

When the gallery first opened it inherited a small number of works from The National Gallery of Scotland, including paintings by Kokoschka, Peploe and Hunter and sculptures by Bourdelle, Epstein and Gill.

The bulk of the collection however, has been acquired since 1960 and in the space of only three decades, the gallery has amassed a collection of some 4,000 items.

Among these are major works by Vuillard, Matisse, Kirchner, Picasso, Magritte, Miró, Dali and Ernst.
The gallery also houses an unrivalled collection of 20th century Scottish art including work by Redpath , MacTaggart, Gillies, Peploe, Cadell, Hunter and Fergusson.

▲ Woman with her Throat Cut by Alberto Giacometti

▲ Rocky Mountains and Tired Indians by David Hockney

▲ The Indian Rug by Anne Redpath

Disabled access throughout building. Car parking available. Gallery Café and Gift Shop.

▲ Maternité by Joan Miró

### Opening times

Open all year except December 25th, 26th Monday to Saturday 10.00am to 5.00pm and Sunday 2.00pm to 5.00pm

### Directions

Bus 13 from George Street to Belford Road or any of the following 32, 40, 41,52, 82, to Queensferry Road (get off at Queensferry Terrace) or 3, 4, 30, 31, 33, 36, 43, 44, 69 to Palmerston Place and walk

SCOTLAND

# THE DEAN GALLERY
Belford Road, Edinburgh, Scotland EH4 3DR
Telephone 0131 6246200 Fax 0131 3433250
Recorded Info 0131 3322266

Opening in Spring 1999, the new Dean Gallery will provide a home for temporary exhibitions of modern and contemporary art, a major library and archive centre, particularly rich in Dada and Surrealist material, along with the extensive Sir Eduardo Paolozzi gift of sculpture and graphic art.

Designed in the 1830s by the noted Greek revivalist Thomas Hamilton, the Dean Gallery has spectacular city views.

Significant landscaping with the adjoining Gallery of Modern Art will create a unique parkland setting for sculpture.

The Dean Gallery will have a regular and changing exhibition programme throughout the year.

Admission to the Permanent Collections will be free, but charges will be made for most major loan exhibitions.

Gallery shop and cafe. Wheelchair access to all parts of the building.

Study Rooms and guided tours by appointment.

▼ The Dean Gallery, Edinburgh (designed and built by Thomas Hamilton in 1831-33)

## Opening times

Opening in
Spring and Summer
in 1999
Monday to Saturday
10.00am to 5.00pm
Sunday
2.00pm to 5.00pm
Extended hours during
the Edinburgh Festival
Closed Christmas Day,
Boxing Day and New
Year's Day only

## Directions

15 minutes walk
from Haymarket
Railway Station, 30
minutes from Waverley
Railway Station or
bus number 13 from
George Street,
westbound. 10 minute
taxi ride from
City centre.
The Gallery has a
free car park.

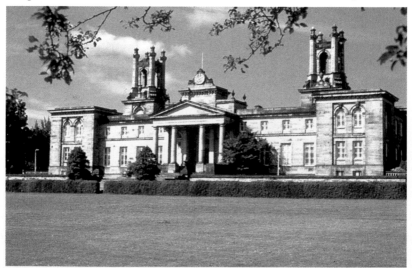

# NATIONAL LIBRARY OF SCOTLAND

George IV Bridge, Edinburgh, Scotland EH1 1EW
Telephone 0131 226 4531 Fax 0131 622 4803

♿ ▣

The Library, which was founded as the Advocates' Library in 1682, was established as the National Library of Scotland by Act of Parliament in 1925.

The Library is entitled, under Copyright legislation, to claim works published in the UK and Ireland, receiving as many as 350,000 items annually. They include books, pamphlets, periodicals, maps and music. Popular and local material as well as scholarly works are preserved with a particular focus on Scotland and Scots at home and abroad.

The collections include over 7 million printed items; 18,500 current periodicals; 252 newspaper titles and more than 100,000 MSS as well as microforms and other non-print materials.

The Library has a regular programme of summer exhibitions, mainly of Scottish interest. From 8th June to 31st October 1999, a major exhibition "Churchill - The Evidence" will be on display, at the heart of which will be Churchill's own original documents, including family correspondence, school reports and notes for

some of his famous speeches. These will be supplemented by photographs from Churchill's extensive collections, and brought to life with recordings of his voice and a display of some of his cherished possessions. The exhibition will be accompanied by a series of lectures.

### Opening times

Open Monday to Friday
10.00am to 5.00pm
(8.30pm during
Edinburgh
International Festival)
Saturday
10.00am to 5.00pm
Sunday
2.00pm to 5.00pm
Summer exhibition 1999
"Churchill - The
Evidence" - 8th June to
31st October

### Directions

From Edinburgh's famous Princes Street, travel south up The Mound to its intersection with the Royal Mile. Cross the traffic lights. The Library is about 50m down on the left.

▲ The National Library of Scotland

▲ "Punch" cartoon, November 1910, depicting Churchill in Scottish National Dress

▲ Personal minute of 10th May 1941

▲ Portrait of Churchill 1942

## NATIONAL GALLERY OF SCOTLAND
The Mound, Edinburgh, Scotland EH2 2EL
Telephone 0131 6246200 Fax 0131 343 3250

The National Gallery of Scotland is situated in the heart of Edinburgh on The Mound. It is home to Scotland's greatest collection of European paintings and sculpture from the Renaissance to Post-Impressionism, and one of the very finest galleries of its size in the world.

The building was designed by William Henry Playfair (1790-1857). Its foundation stone was laid in 1850 by Prince Albert, and the gallery opened to the public in 1859.

At the heart of the gallery's collection is a group of paintings which includes masterpieces by Bassano, Van Dyck and Tiepolo.

Masterpieces by artists such as El Greco, Titian, Rembrandt, Bernini, Monet, Gauguin, Raphael and Poussin are also included.

▲ Three Tahitians by Paul Gauguin

▲ Reverend Robert Walker Skating on Duddingston Loch by Sir Henry Raeburn

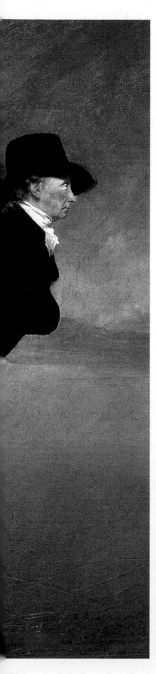

The gallery's collection of Scottish paintings is particularly comprehensive. All the major names of Scottish art, including Ramsay, Wilkie, Raeburn and McTaggart are well represented.

The Turner Watercolours from Henry Vaughan's Bequest of 1900 are shown each year in January, a highlight of the annual exhibition programme.

▲ The Three Ages of Man by Titian

### Opening times

Open
Monday to Saturday
10.00am to 5.00pm
Open all year except
25th and 26th
December

### Directions

Situated off Princess Street, 5 minutes walk from Waverley Railway Station.

▼ Diego Martelli by Edgar Degas

SCOTLAND

## THE PEOPLE'S STORY

♿

Canongate Tolbooth, 163 Canongate, Royal Mile, Edinburgh EH8 8B9
Telephone 0131 529 4057 Fax 0131 557 3346

Housed in the late 16th
century Canongate
Tolbooth in Edinburgh's
historic Royal Mile,
The People's Story is a
Museum with a
difference.

As the name implies, it
uses oral history,
reminiscence, and
written sources to tell
the story of the lives,
work and leisure of
ordinary people of
Edinburgh from the
late 18th century to the
present day.

The museum is filled
with the sounds, sights,
and smells of the past -
a prison cell, town
crier, reform parade,
cooper's workshop,
fishwife, servant at
work, dressmaker, 1940
kitchen, a wash-house,
pub and tea room.

These reconstructions
are complemented by
displays of
photographs, everyday
objects and rare
artefacts, such as the
museum's outstanding
collections of Trade
Union banners and
Friendly Society
regalia.

A twenty-minute video
presentation
supplements the
museum's storyline.

### Opening times

Open
Monday to Saturday
10.00am to 5.00pm
and Sundays
during Edinburgh
Festival from
2.00pm to 5.00pm

### Directions

Located in the
Canongate Tolbooth,
towards the foot of
the Royal Mile,
close to the
Palace of Holyrood
House

▶ Reconstruction of an
18th century prison cell

▼ An example of the
Museum's outstanding
banner collection

▲ The People's Story
Museum in Edinburgh's
historic Royal Mile

# LAURISTON CASTLE

Cramond Road South, Davidson's Main, Edinburgh, Scotland EH4 5QD
Telephone 0131 336 2060 Fax 0131 312 7165

Left in trust by its last private owners, Mr and Mrs William Robert Reid, who lived there from 1902-1926, Lauriston Castle's Edwardian-period interiors have been preserved to reflect the taste of wealthy middle-class collectors of the period.

As proprietor of Morison and Co., one of Scotland's leading cabinet-makers, Mr Reid brought a lifetime's experience to enhancing his collection of furniture and varied objects d'art by the Castle's carefully considered decorative schemes.

Originally a 1590s Tower House, the Castle was built for Sir Archibald Napier, and extended during the 1820s by the architect William Burn for its then owner, Thomas Allan.

The tranquillity of its setting, overlooking the Firth of Forth, combined with its proximity to the centre of Edinburgh, makes Lauriston typical of the large suburban villas favoured by the powerful and wealthy. John Law, who rose to High Office in the French Court during the 1720s, was one the

notable Scots who lived at Lauriston. Each year Lauriston hosts a programme of outdoor and indoor events.

Its superb croquet lawns are home to the Edinburgh Croquet Club.

### Opening times

Open April to October daily except Friday 11.00am to 1.00pm and 2.00pm to 5.00pm: November to March Saturday and Sunday only 2.00pm to 4.00pm (last admission 40 minutes prior to closing)

▼ Edwardian interior

### Directions

Buses from The Mound/ George Street. LRT routes 40 and 27; from the Royal Mile LRT routes 6 and 1; from the Bridges LRT route 14; from Frederick Street LRT route 80.

▲ Tranquil setting

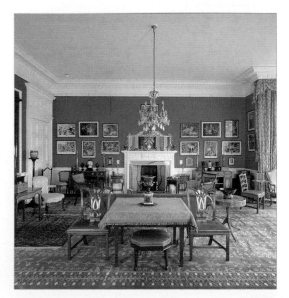

SCOTLAND

# THE WRITERS' MUSEUM

Lady Stair's Close, Lawnmarket,Royal Mile, Edinburgh  EH1 2PA
Telephone 0131 529 4901 Fax 0131 220 5057

Situated in Lady Stair's House, built in 1622, The Writers' Museum is dedicated to the lives and work of Scotland's great literary figures, in particular Robert Burns (1759 - 1796), Sir Walter Scott (1771 - 1832) and Robert Louis Stevenson (1850 - 1894).

The rich collection of portraits, manuscripts and personal exhibits include Burns' writing desk, Scott's chess board, dining table and the printing press on which his Waverley Novels were produced.

The Stevenson collection is the most significant in the United Kingdom. Other prominent Scottish writers, including contemporary authors, are featured in the museum's programme of temporary exhibitions.

The courtyard immediately outside The Writers' Museum has been designated as Makars' Court.

Here, thanks to recent developments funded by Lothian and Edinburgh Enterprise Limited, you can find inscriptions commemorating famous Scottish writers from the 14th century to the present.

▶ 'Teller of Tales' Robert Louis Stevenson

*Opening times*
Open
Monday to Saturday
10.00am to 5.00pm and
Sunday during the
Edinburgh Festival
2.00pm to 5.00pm

*Directions*
Located in a close off the Royal Mile just down-hill from the entrance to Edinburgh Castle

▲ The Ballantyne press on which Scott's novels were printed

◀ Robert Burns depicted in Sibbald's circulating library Parliament Square, Edinburgh

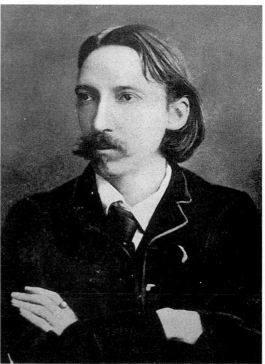

# NEWHAVEN HERITAGE MUSEUM

Pier Place, Newhaven Harbour, Edinburgh, Scotland EH6 4LU
Telephone 0131 551 4165

What was it like to live in the tightly-knit fishing community of Newhaven, and to earn a living as a fisherman braving the sea or a fish wife selling the catch?

Find out in the lively and informative Newhaven Heritage Museum. It is situated in the historic Fishmarket, next to Harry Ramsden's fish and chip restaurant, overlooking the picturesque Newhaven Harbour.

The story of the former fishing village and its people is told through reconstructed sets, historic objects and photographs and first-hand accounts of people's lives.

Discover the origins of Newhaven as a naval dockyard. Between 1507 and 1511 the 'Great Michael' was built at Newhaven. It was the largest ship of its time and the pride of the Scottish navy. Listen as the people of Newhaven tell you of their community, trade, customs and superstitions through reminiscence and song.

### Opening times

Open Monday to Sunday
12.00pm to 5.00pm

### Directions

Buses from Princes Street, LRT Routes 10,11,16,17,22 and 25

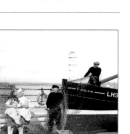

▲ Reconstruction of fisher folk

◄ Times recalled by picturesque Newhaven Harbour

▶ Heritage Museum set in historic Fishmarket

SCOTLAND

# HUNTLY HOUSE MUSEUM
142 Canongate, Royal Mile, Edinburgh, Scotland EH8 8DD
Telephone 0131 529 4143 Fax 0131 557 3346

Huntly House Museum is home to important collections relating to the history of Edinburgh, from prehistoric times to the present day.

If you know the story of 'Greyfriars Bobby', you will be thrilled to see his collar and feeding bowl, and the original plaster model for the bronze statue in Candlemaker Row.

One of the museum's great treasures is the National Covenant, signed by Scotland's Presbyterian leadership in 1638, while the collections of Scottish pottery and items relating to Field Marshal Earl Haig are of national importance.

The Museum also features Edinburgh silver and glass, and a colourful collection of old shop signs.

The oldest part of picturesque Huntly House dates from the 16th century. It was extended in the 17th and 18th centuries, and has been home to a wide variety of owners and tenants, ranging from aristocrats to merchants and working people.

By 1871, the house had been sub-divided to accommodate 250 people! Robert Chambers, a Victorian antiquarian, called Huntly House 'the speaking house' because of the Latin inscriptions on its facade.

It is appropriate that 'the speaking house' now tells the story of Edinburgh's past.

Huntly House regularly mounts temporary exhibitions drawn from its diverse collections.

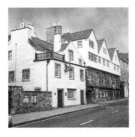

▲ The 'speaking house'

▲ Edinburgh - made silver tea kettle and stand with lavish Rococo chasing

***Opening times***

Open
Monday to Saturday
10.00am to 5.00pm
Sundays during the
Edinburgh Festival:
2.00pm to 5.00pm

***Directions***

Located towards
the foot of the
historic Royal Mile,
close to the
Palace of Holyrood
House.

▶ Reconstruction of a clay pipe-making workshop, late 19th century

# THE MUSEUM OF CHILDHOOD
42 High Street, Royal Mile, Edinburgh, Scotland EH1 1TG
Telephone 0131 529 4142 Fax 0131 558 3103

&

Described as 'the noisiest museum in the world', the Museum of Childhood is a favourite with adults and children alike. It is a treasure house, crammed full of objects telling of childhood, past and present.

The Museum was opened in 1955 and was the first museum in the world to specialise in the history of childhood.

Extended in 1986, it has five galleries in which you can re-live memories of the joys and tribulations of childhood.

There are toys and games of all kinds from many parts of the world, ranging from dolls and teddy bears to train sets and tricycles.

Listen to the children chanting multiplication tables in the 1930s schoolroom.

Watch the street games of Edinburgh children of the 1950s, and find out how children have been brought up, dressed and educated in decades gone-by.

The Museum of Childhood organises a regular programme of temporary exhibitions and events. So there is always something new for you to see and do!

### *Opening times*

Open
Monday to Saturday
10.00am to 5.00pm
Sundays during the
Edinburgh Festival:
2.00pm to 5.00pm

### *Directions*

Located at the half-way point on Edinburgh's historic Royal Mile

▲ 'Automata' and dolls houses are firm favourites with young visitors

▲ Dolls galore at the Museum of Childhood

▼ There's every kind of toy animal in the museum.

**SCOTLAND**

# GLADSTONE'S LAND
477B Lawnmarket, Royal Mile, Edinburgh, Scotland EH1 2NT
Telephone 0131 226 5856

Gladstone's Land is a typical example of a 17th century tenement building in Edinburgh's old town. Completed in 1620, it was originally the home of a city merchant.

Now it is furnished and decorated to show life at the time. Features include the remarkable painted ceilings and the reconstructed shop booth with replicas of 17th century goods.

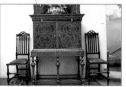

▲ Painted chamber

◄ Gladstone's Land - The study

A property of the National Trust for Scotland.

### Opening times

Open
1st April to 31st October
Monday to Saturday
10.00am to 5.00pm
Sundays
2.00pm to 5.00pm
(last admission 4.30pm)

### Directions

On the Royal Mile, five minutes walk from Princes Street via The Mound

▶ Gladstone's Land

# THE BRASS RUBBING CENTRE

Trinity Apse, Chalmers Close, Royal Mile, Edinburgh, Scotland
Telephone 0131 556 4364

The Brass Rubbing Centre occupies Trinity Apse, the only surviving fragment of the Gothic Trinity College Church, founded about 1460 by Queen Mary of Gueldres, wife of King James II of Scotland.

In the centre, you will find a fascinating collection of replicas moulded from ancient Pictish Stones, rare Scottish brasses and mediaeval Church brasses.

No experience is required to make a rubbing, and staff are on hand to help. The centre also stocks high-quality ready-made rubbings, brass rubbing kits, booklets, post cards and gifts.

Look out for details of special events.

▲ Making a brass rubbing

▼ Sir John D'Abernoun, 1277, example of an early English brass

### *Opening times*

Open
Monday to Saturday
10.00am to 5.00pm
Sunday during the
Edinburgh Festival:
2.00pm to 5.00pm

### *Directions*

Located in Chalmers Close which runs off the historic Royal Mile close to its half-way point

▼ Celtic patterns found on ancient Scottish stones

**SCOTLAND**

# ELGIN MUSEUM
1 High Street, Elgin, Moray IV30 1EQ
Telephone/Fax 01343 543675

The award winning museum aspires to offer something for everyone. Visitors may enjoy a wide range of displays. The museum is internationally important for the Elgin Reptiles - pre-dinosaur, fossils unique to the area.

Of particular interest are the Pictish Stones and their elusive carvings. Natural history and social history give evidence of local heritage.

A table of 'hands on' items is appreciated by adults and children alike, whilst activity sheets and colouring pencils make the visit enjoyable for families.

Temporary exhibitions have covered topics such as Dolphins, Dr Who, Jacobites and Biodiversity. Workshops, museum clubs, lectures and conferences are all part of the museum scene which contribute to a vibrant friendly organisation.

The museum is an independent museum run by the Moray Society which was founded in 1836. The listed building was opened to the public in 1843.

▶ Model of *Elginia mirabilis*, one of the unique Elgin Reptiles

### Opening times
Open April to October
Monday to Friday
10.00am to 5.00pm
Saturday
11.00am to 4.00pm
Sunday
2.00pm to 5.00pm
Winter by appointment
(last admission 4.30pm)

### Directions
Elgin Museum is situated at the east end of the High Street. Drivers should follow the brown signs. Elgin is on the A96, halfway between Aberdeen and Inverness.

▲ Elgin Museum opened 1843

▲ Class I Pictish Stone: The Burghead Bull

▶ The Museum Discovery Club investigate the mediaeval gateway to Elgin

# CALLENDAR HOUSE

Callendar Park, Falkirk, Scotland FK1 1YR
Telephone 01324 503776 Fax 01324 503771

An imposing mansion within attractive parkland with a 900 year history. Facilities include a working kitchen of 1825 where costumed interpreters carry out daily chores, including cooking based on 1820s recipes.

There are four other interpreting areas: clockmaker's shop, general store, printers' workshop and Georgian garden.

There are two permanent galleries, The Story of Callendar House, tracing the history from 1345, including its famous visitors, Mary Queen of Scots, Bonnie Prince Charlie and Oliver Cromwell. The "William Forbes Falkirk" exhibition deals with changing Scotland 1750 - 1850 when Falkirk area played an important role in the nation's history.

There are also two temporary exhibition galleries with regular changing exhibitions. The Victorian library forms a History Research Centre and the Local Authority archive.

There is a gift shop and a Georgian tea shop at the nearby stables. Callendar House also has an audio visual

theatre and business meetings facility and educational suite providing schools services.

Business facilities: Joyce Noonan 01324 503787 Schools Services: Margaret Bowden 01324 503781 History Research Centre: Elspeth Reid 01324 503778

## *Opening times*

Open April to September
Monday to Saturday
10.00am to 5.00pm
Sunday
2.00pm to 5.00pm
October to March
Monday to Saturday
10.00am to 5.00pm
(last admission 4.15pm)

## *Directions*

From M9 Motorway take Falkirk turn off follow signs to Falkirk and pick up brown signs directly to Callendar House

▲ Costumed interpreter prepares goose for spit roasting in 1820s kitchen

▲ History Research centre in Victorian Library, Callendar House

▲ Gift Shop, Callendar House

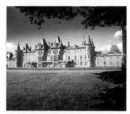

▲ Callendar House, centuries of Scottish legend and history

SCOTLAND

## THE MEFFAN
20 West High Street, Forfar, Scotland
Telephone 01307 464123

In the historic heart of Forfar is "The Meffan" built in 1898. Originally the library and museum it is now a lively art gallery and museum. Monthly touring art exhibitions are staged bringing a diverse range to Forfarians.

"The Forfar Story" demonstrates the zenith of Pictish stones. An interactive screen enables visitors to "see" every Pictish stone in Angus.

A log canoe from the 11th century in the process of being excavated forms a diorama with two life-size archaeologists.

Visitors then wander down a narrow cobbled street "The Vennel" where they can peer into a clock maker, a hand loom weaver, a shoe maker, a sweetie shop and last but not least a real Forfar Bridie baker.

Round the corner and the visitor can be horrified as a witch is about to be strangled and then burnt, testimony to Forfar's darker history. All sorts of sounds bring the street to life.

This museum and gallery is much loved by our local population and is developing activities for children.

▲ The Art Gallery

### Opening times

Open all year
Monday to Saturday
10.00am to 5.00pm

### Directions

The Meffan can be found on West High Street around 50 metres up from the Town & County Hall which is situated in the middle of Forfar's town centre

▼ On display late Neolithic - early Bronze Age

▲ The Meffan

▲ The Goosecroft log boat dated 1090 AD

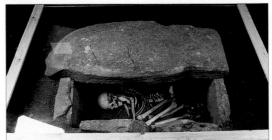

# ANGUS FOLK MUSEUM

Kirkwynd, Glamis, Forfar, Angus DD8 1RT
Telephone 01307 840288 Fax 01307 840233 &

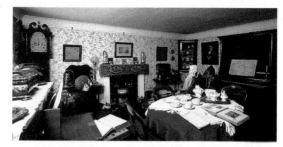

One of Scotland's finest folk collections, housed in a row of six late 18th century cottages. Displays reflects domestic life in this area of Scotland.

Also reconstructed steading where life on the farm is displayed. A fascinating step back in time! Property owned by the National Trust for Scotland.

Free admission to NTS members and members of the National Trust.

### *Directions*
Off A94, in Glamis, 5 miles south west of Forfar.

▲ Angus Folk Museum parlour

▼ Life on the land exhibition

### *Opening times*
Open Easter weekend and 1st May to 30th September daily 11.00am to 5.00pm Weekends in October 11.00am to 5.00pm (last admission 4.30pm)

▼ Angus Folk Museum

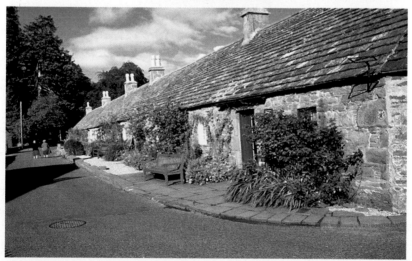

SCOTLAND

## BRODIE CASTLE
Brodie, Forres, Moray IV36 2TE
Telephone 01309 641371 Fax 01309 641600

Seat of the Brodies of Brodie for 800 years, Brodie is a 16th century castle with 17th and 19th century additions. It has over 20 furnished rooms, with unusual plaster ceilings and a fine collection of furniture, porcelain and clocks.

There is an extensive art collection particularly 17th century Dutch paintings, 19th century water colours and early 20th century works including Scottish colourist.

Also a nursery, Victorian kitchen and dairy. There is a shop, tea-room, children's playground, and the grounds contain a shrubbery, woodland walks and a large pond with waterfowl.

In Spring there is a display of unusual varieties of daffodils.

Throughout the Summer there are outdoor and indoor events including concerts, lectures, craft fairs and open air theatres.

▶ The Red drawing room

### Opening times

Castle opens:
1st April (or Good Friday if earlier) to 30th September
Monday to Saturday
11.00am to 5.30pm
Sunday
1.30pm to 5.30pm
Weekends in October,
Saturday
11.00am to 5.30pm
Sunday
1.30pm to 5.30pm
(last admission 4.30pm)
Other times by appointment
Grounds: all year, daily
9.30am to sunset

▶ "The Philosopher and Pupils" by William Van Vliet

### Directions
Quarter of a mile off A96 Inverness-Aberdeen road at Brodie village, between Forres. 4 miles and Nairn 6 miles.Main Inverness Aberdeen bus route. Railway Station at Forres.

▲ Brodie Castle

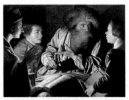

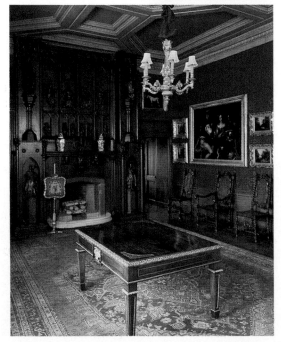

## CCA

350 Sauchiehall Street, Glasgow, Scotland G2 3JD
Telephone 0141 3327521 Fax 0141 3323226

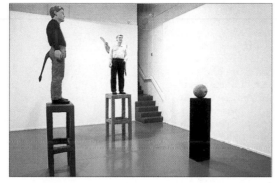

CCA is one of the UK's leading venues for the contemporary arts. The Centre offers a programme of ground-breaking exhibitions, innovative performance a full interpretation programme in a relaxed and friendly City Centre location.

Admission to all exhibitions is free and the centre also has an excellent café and specialist arts bookshop.

In March 1999 CCA will close for substantial redevelopment following a £7.5 million SAC Lottery award.

The centre will re-open in 2001 offering unrivalled facilities in Scotland. During the period of closure CCA will operate from a City Centre venue. Please telephone for further details.

### *Directions*

CCA is on one of Glasgow main shopping streets - Sauchiehall Street - ten minutes walk from main Train Stations. A number of buses stop right outside.

▲ Stephan Balkenhol, 'Angel, Devil, World' from CCA's House in the Wood's exhibition (1998)

▼ CCA's impressive premises in Glasgow's City Centre

### *Opening times*

Open all year round, 7 day opening Galleries open Monday to Wednesday 11.00am to 6.00pm Thursday and Friday 11.00am to 8.00pm Saturday 11.00am to 6.00pm Sunday 12.00pm to 5.00pm

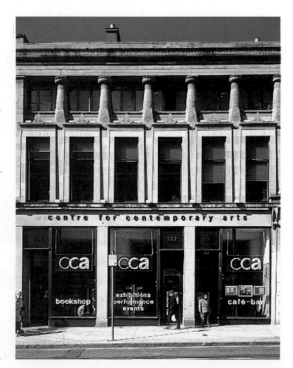

# GALLERY OF MODERN ART
Queen Street, Glasgow, Scotland G1 3AZ
Telephone 0141 2291996 Fax 0141 2045316

In the heart of the City the Gallery of Modern Art houses four floors of today's finest paintings, sculpture and installations from around the world.

Included is work by Nick De Saint Phalle, Sebastian Salgado and Andy Warhol, acclaimed Scottish artists such as John Bellany, Peter Howson and Ken Currie as well as featuring state of the art computer technology.

The different levels are themed on the natural elements, fire, earth, water and air.

▼ Beryl Cook "Karaoke"

▲ Gordon K Mitchel "Not mad, just a wee bit daft"

***Opening times***
Open
Monday to Saturday
10.00am to 5.00pm
Sunday
11.00am to 5.00pm

▶ Ken Currie "In the city bar"

***Directions***
Based in Queen Street in the City Centre. For local transport information, Telephone 0141 2264826

# COLLINS GALLERY

University of Strathclyde, 22 Richmond Street, Glasgow G1 1XQ
Telephone 0141 5482558 Fax 0141 5524053

Part of the University of Strathclyde, the Collins Gallery is situated in the very centre of Glasgow, only ten minutes walk from railway, underground and bus stations as well as the Gallery of Modern Art and the main shopping areas.

Our annual programme offers a diverse, and often unusual, range of contemporary exhibitions covering fine art, illustration, craftwork, mixed-media installations and design in all shapes and forms.

Entrance is free and in addition to the publications, videos and postcards available from the Sales desk, visitors of all ages and abilities are often encouraged to actively participate with the exhibitions through practical workshops, artists' residencies, demonstrations, dance, music, storytelling and drama.

We are always happy to welcome and make provision for specialist groups, visitors with special needs, nurseries, schools and colleges by prior appointment.

▶ "Chocolate": performance artist Rikki Traynor, of Walkabout Theatre, entertains visitors

▲ "Designers' Habitats": installation by Glasgow designer, Rob Mulholland

### Opening times

Open Monday to Friday
10.00am to 5.00pm
Saturday
12.00pm to 4.00pm
Closed public holidays
and during exhibition
installations

### Directions

From George Square
follow signs to
Strathclyde University,
left from George Street
up Montrose Street and
right at NCP. 5-10
minutes from rail
stations and Buchanan
Street Underground.
From M8 take exit 15.

▲ "Submarine": multi-media installation including ceramic sculpture by Tom McKendrick

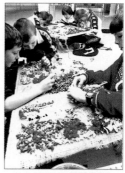

▲ Layers of Meaning: the rag rug, a contemporary approach. Children's practical workshop

**549**

# THE BURRELL COLLECTION

Pollok Country Park, 2060 Pollokshaws Road, Glasgow
GU3 1AT
Telephone 0141 6497151 Fax 0141 6360086

More than 8,000 objects
amassed in a lifetime by
the Glasgow shipping
magnate Sir William
Burrell are housed in
the award winning
Burrell collection in
Pollok Park.

Gifted to Glasgow in
1944, the collection
includes ancient
classical artworks,
European stained glass,
Impressionist paintings
and some of the world's
finest mediaeval
tapestries.

▲ The Burrell
Collection

### Opening times

Open
Monday to Saturday
10.00am to 5.00pm
Sunday
11.00am to 5.00pm

### Directions

The Burrell Collection is
well served by public
transport and main
roads. For further
information on how
to get there phone
0141 2264826.

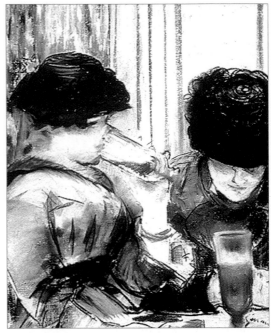

▲ Manet - Women drinking beer

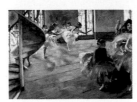

▲ Degas - Jockeys in
the Rain

◄ Degas - The
Rehearsal

550

# THE TENEMENT HOUSE

145 Buccleuch Street, Garnethill, Glasgow G3 6QN
Telephone 0141 333 0183

SCOTLAND

This first floor flat is a typical late Victorian example of a Glasgow tenement.

It consists of four fascinating rooms and retains most of its original features, such as bed recesses, kitchen range, coal bunker and bathroom.

The furniture and furnishings present a vivid picture of domestic life at the beginning of the 20th century, which is further explained in the ground floor exhibition area.

A property of the National Trust for Scotland.

▲ The Tenement House

### Opening times
Open
1st March to
31st October daily
2.00pm to 5.00pm

### Directions
3rd left off Rose Street
or Cambridge Street,
north west of
Sauchiehall Street
shopping area

▼ The Tenement House parlour

▶ Box bed in kitchen

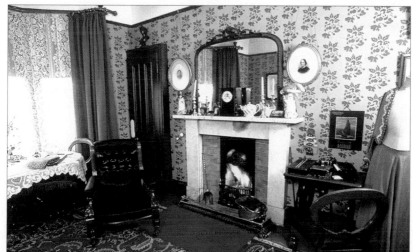

**SCOTLAND**

# HUNTERIAN ART GALLERY
University of Glasgow, 82 Hillhead Street, Glasgow, Scotland G12 8QQ
Telephone 0141 330 5431 fax 0141 330 3618

The award-winning
Hunterian Gallery,
opened in 1980, houses
the University of
Glasgow's outstanding
art collections.

In the Picture Gallery
you can find a collection
of European paintings,
including works by
Rembrandt, Koninck,
Stubbs and Chardin, as
well as 18th century
British portraits by
Ramsay, Reynolds and
others.

There is also a fine
collection of Scottish
19th and 20th century
paintings including
McTaggart, Guthrie,
Fergusson, Peploe and
Eardley, and a group of
works by 19th century
French artists
including Pissaro and
Rodin.

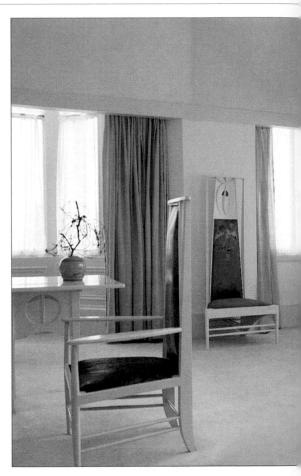

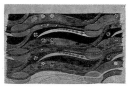

▲ C R Mackintosh -
Textile design

The University owns
the Estate of the
distinguished American
painter, J M Whistler.
Some 70 paintings and
a selection of personal
possessions and
painting equipment

make it the largest
display of the artist's
work anywhere.

The Mackintosh House
comprises the principal
rooms from the Glasgow
home of the architect
Charles Rennie
Mackintosh.

These have been
meticulously

reconstructed as an
integral part of the
Gallery.

Changing selections
from the University's
unrivalled collection of
Mackintosh's drawings,
designs and
watercolours are shown
in the Mackintosh
Gallery.

### Opening times

Open all year
apart from
local public holidays
Monday to Saturday
9.30am to 5.00pm

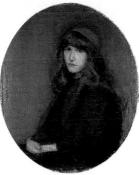

▲ J M Whistler Lillie -
An oval

### Directions

The gallery is 2 miles
west of the city centre,
buses 59 and 44,
underground to
Hillhead. Pay and
display parking on
University Avenue and
surrounding area.

▲ Drawing Room, The
Mackintosh House

▼ Paul of Vos Still Life

Changing exhibitions
from the University's
print collection, the
largest in Scotland, are
also held at regular
intervals in the
Exhibition Gallery.

## McLEAN MUSEUM & ART GALLERY
15 Kelly Street, Greenock, Scotland PA16 8JX
Telephone 01475 715624 Fax 01475 715626

The McLean's
permanent displays
include exhibitions on
local and social history,
fine art, ethnography,
Egyptology, ship and
engine models and
natural history.

Special exhibits include
the arms and armour of
a Samurai warrior and
mounted animals such
as an Indian tiger and a
Nile crocodile. There is
a lively programme of
temporary exhibitions.

Visitors facilities
include public toilets,
(including a toilet
adapted for disabled
use) and a gift shop.
The entrance to the
McLean is ramped.
Inverclyde Council.

▲ The recently
refurbished shop

▼ The interior of the
McLean Museum -
ground floor displays

### Opening times

Open
10.00am to 5.00pm
Monday to Saturday
all year except for
local and national
public holidays
(last admission 4.50pm)

### Directions

Close to Greenock Bus
Station and Greenock
West Railway Station is
a short walk away. By
road follow M8 and A8.
If travelling west from
Glasgow then Thistle
Road signs.

# THE WORLD FAMOUS OLD BLACKSMITH'S SHOP CENTRE

Gretna Green, Dumfries & Galloway DG16 5EA
Telephone 01461 338441 Fax 01461 338442
Internet :http://www.gretnagreen.com.

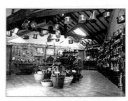

When people hear the name Gretna Green their thoughts often step back in time to the history of runaway marriages. The World Famous Old Blacksmith's Shop Centre is at the heart of this fascinating tradition.

As you step inside the Gretna Green Story Museum, imagine the hopes and fears of the young elopers as they plan their daring dash.

The Museum Shop, adjacent to the Horse-Drawn Carriage and Vintage Vehicle Museum, offers a unique collection of merchandise which is recognised as one of Scotland's most unusual.

Scotland is famous for its cashmeres, woollens and tartans. The internationally renowned Tartan Shop presents the finest independent collection of Scottish merchandise as well as a mouth-watering range of products in the Food Hall and a vast array of china, crystal, giftware and other Scottish products.

If you are seeking a relaxing coffee break or a full meal, either of the Centre's two restaurants offer a wide range of freshly prepared meals and snacks.

## Opening times

Open all year round
November to March
9.00am to 5.00pm
April to October
9.00am to 6.00pm
except July to August
9.00am to 8.00pm

## Directions

Located in South West Scotland on the Scottish/English Border just off the M74, 10 miles north of Carlisle. Follow the brown tourist board signs from the main road.

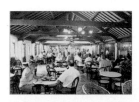

▲ Museum shop, with a most unusual collection of merchandise

▲ World famous Old Blacksmiths Shop - 'Old Clay Daubin' exterior

◄ View of Coffee Shop, along with restaurant, seat 550 visitors

▼ The original 'Marriage Room' with the famous wedding anvil

**S C O T L A N D**

## DUMFRIES & GALLOWAY AVIATION MUSEUM ♿ ◆

Control Tower, Heathall Industrial Estate, Heathhall,
Dumfries DG1 3PH
Telephone 01387 251623

Based around the original control tower of the former R.A.F. Dumfries, the Dumfries and Galloway Aviation Group Museum is a fascinating collection of aircraft and memorabilia reaching back to the golden age of flight.

The aircraft outside boasts amongst its collection, aeroplanes both unique and famous. The world's first operational jet fighter is represented by the famous Gloster Meteor T7, whilst the leap into supersonic flight comes in the form of a North American F-100 Super Sabre, Vietnam era attack jet.

The museum's prized exhibit is a Supermarine Spitfire Mk II. Recovered from the waters of Loch Doon, it is undergoing restoration and is due to return for display in the near future.

Unlike other collections the museum doesn't 'rope-off' its prized exhibits, but allows visitors the freedom to get up close to the aircraft.

Weather needn't be a problem as the control tower is home to a collection of artefacts and memorabilia, and literally is crammed to the roof.

Accumulated from many sources, the collection displays flying clothing from both World Wars, rescue equipment and many items recovered by the museum's archaeology team from crash sites.

Of special note is the aero-engine display, possibly one of the finest collections in the country.

### Opening times

Open
Easter to end October
Saturday to
Sunday only
10.00am to 5.00pm
Other opening
hours contact local
tourist office

### Directions

From the A75
Dumfries Bypass take
the A701 road for
quarter of a mile,
turning right at ESSO
service station follow
brown museum signs.
Or approaching
from north on A701
turn left.

▲ Engine display Merlin Griffon Kestral Jets Goblin Spey Avon ect

▲ Control tower containing extensive displays of aircraft memorabilia

▲ Spitfire MK II a restoration project shows fusilage and tail

▲ Mystere IV, Meteor T7, Vampire TII, Flood Super Sabre, Canbera T4, Sycamore T33

SCOTLAND

# INVERNESS MUSEUM & ART GALLERY

Castle Wynd, Inverness, Scotland IV2 3EB
Telephone 01463 237114 Fax 01463 225293

In the centre of this busy tourist and market town, Inverness Museum and Art Gallery offers a welcome diversion.

Exhibitions on the ground floor explore aspects of the manmade and natural environment in an around Inverness.

It is an extravaganza of natural history, archaeology and local history. Upstairs a pot-pourri of silver and taxidermy from Inverness, weapons and bagpipes from the Highlands and Scottish contemporary art awaits the visitor.

The ever changing temporary exhibitions gallery presents a range of events and displays which reflects the cultural activity of the town.

### *Directions*

In Inverness town centre, off Bridge Street, between the Tourist Information Centre and the Castle. Coming by car, park in the town centre multi-storey car park.

▶ Osprey in flight

▲ Home life 500BC

▶ Punch and Judy from Morris Family's Highland Show

### *Opening times*

Museum opens
Monday to Saturday
9.00am to 5.00pm
Coffee Shop opens
Monday to Saturday
10.00am to 4.00pm
Closed 25th and 26th
December and 3 days
at New Year

▶ Pair of Jacobite drinking glasses

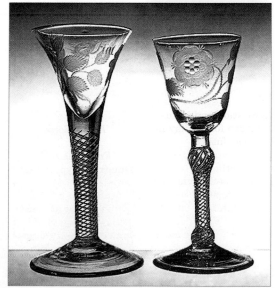

SCOTLAND

## WEAVER'S COTTAGE
The Cross, Kilbarchan, Renfrewshire PA10 2JG
Telephone 01505 705588

This typical 18th century handloom Weaver's cottage houses the last example of the 800 looms working in the village of Kilbarchan in the 1830's.

Most Fridays, and weekends the clack, clack of a weaver at work brings this cottage to life again.

Locally woven shawls cover the box beds. In one room the wall beside a box bed has been cut away to allow long legs to stretch.

There is an important display of looms, weaving equipment, domestic utensils and local historical and weaving items.

On the walls, portraits of former spinners and weavers look at home in the midst of their tools of trade.

Attractive cottage garden. Video programme.

### *Directions*

12 miles south west of Glasgow. M8 Junction 28A, A737 follow signs for Kilbarchan. 1 mile from National Cycle Routes 7 and 75. Frequent bus service from Glasgow, Paisley and Johnstone rail station.

▲ The Cottage garden, where the weavers grew dye plants

▲ The weaver at work

◀ Weaver's cottage Kilbarchan (N.T.S)

### *Opening times*

Open Good Friday to end of September daily 1.30pm to 5.30pm (last entry 5.00pm) Weekends in October

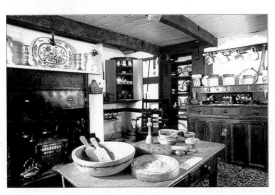

▶ The kitchen

# HIGHLAND FOLK MUSEUM

Duke Street, Kingussie, Inverness-shire PH21 1JG
Telephone 01540 661307 Fax 01540 661631

Founded in 1935 by Dr I F Grant, the Highland Folk Museum gives a fascinating insight into the way life was lived in the Highland days gone by.

Today it is the major social history museum for the Highlands and is internationally recognised for the wealth of its collections. These distinctive collections depict the life of the Highland (crofter to clan) over the last three centuries.

The visitor can experience the atmosphere of a reconstructed Isle of Lewis Black House and a gain sense of the hardship and toil of the crofter from the implements and farming machinery in the Farming Museum.

Based in the heart of Kingussie, this picturesque six acre site provides visitors with not only a museum, but also a Tourist Information Centre, shop, picnic area and ample car parking facilities.

Throughout July and August there is a varied programme of craft skills, sports and traditional music.

▶ Spinning

Visitors are invited to participate in many of the activities.

The Iona Gallery houses a series of visual arts exhibitions from April to October.
The programme includes national and international touring exhibitions, group shows by Highland artists and some work by artists living in the area.

### Opening times

Open April to October please telephone for opening times

▶ Visible store

### Directions

Located in Kingussie just off the A86, follow the sign posts to the Highland Folk Museum from the A9

▲ Isle of Lewis Blackhouse

# BROUGHTON HOUSE
12 High Street, Kirkcudbright, Dumfries & Galloway DG6 4JX
Telephone 01557 330437 Fax 01557 330437

Home of E A Hornel, the renowned artist and member of the 'Glasgow Boys' he lived here from 1901 to 1933 and added an art gallery, studio and a fascinating Japanese-style garden.

The house still contains many of Hornel's works and paintings by other artists.

A property of the National Trust for Scotland.

Free admission to NTS members and members of the National Trust.

▲ Three Girls by the Sea by E A Hornel

▲ Brougton House Gallery

▼ Man in Red Coat by E A Hornel

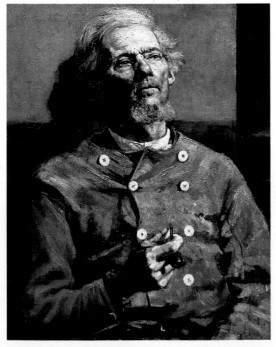

## *Opening times*

Open
1st April to 31st
October daily
1.00pm to 5.30pm
(last admission
4.45pm)

## *Directions*

Off A771/A755 in
Kirkcudbright

▲ Broughton House and garden

# THE DOLLY MIXTURE

Finlaystone Country Estate, Langbank, Renfrewshire
PA14 6TJ
Telephone 01475 540285 Fax 01475 540285

"The Dolly Mixture" is a private collection of "Allsorts" of dolls from around the world. It was started by Jane MacMillan's mother with her own doll in 1903.

As a result of her study of anthropology and extensive travel her interest grew.

There are now over 700 dolls. Most are on show under various headings - What is a doll? What is a doll made of? Colourful dolls. Dolls houses. Victorian toys.

Finlaystone Country Estate has extensive gardens, woodlands walks with waterfalls, adventure playground, picnic area. Ranger Service.

Within the Visitor Centre are nature displays, Celtic art, a gift shop, the MacMillan Clan Centre and "The Dolly Mixture".

There is an entrance charge. Meals are available in the Celtic Tree in the walled garden.

Further information and group booking telephone Ranger 01475 540505 House 01475 540285 Fax 01475 540 285

▶ Austrian Girl with chicken, c1932 felt

### Opening times

Open April to September daily 12.00pm to 4.30pm Weekends October to March

### Directions

Finlaystone is on the A8 west of Langbank, 10 minutes west of Glasgow Airport.

▲ Pyjama Case Doll, Velvet face Mexican, Nora Welling

▲ Queen Victoria, from the 1851 exhibition, wax face (photo N. Nicholson)

▲ Chinese Mission Dolls, c1920, wood face

SCOTLAND

# THIRLESTANE CASTLE

Thirlestane Castle Trust, Lauder, Berwickshire TD2 6RU
Telephone 01578 722430 Fax 01578 722761

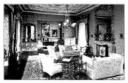

One of Scotland's oldest
and finest castles,
Thirlestane was the
historic seat of the
Earls and Duke of
Lauderdale. It is still
home to the Maitland
family and is haunted
by the Duke of
Lauderdale.

The castle has the finest
plasterwork ceilings of
the restoration period, a
newly restored picture
collection, fine
furniture, Maitland
family treasures, a huge
collection of historic
toys with children's
dressing up facility
Victorian kitchens and
country life displays.

Gift shop, tea room,
woodland walk and
picnic tables, free
parking for castle
visitors. Group visits
outside normal opening
times can be arranged.

Visit us on the world
wide web at www.great-
houses-scotland.co.uk

### Directions
Off A68 at Lauder.
Follow signs on all main
approach roads

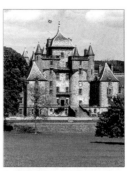

▲ Thirlestane, one of
Scotland's oldest and
finest castles

▲ The green drawing
room

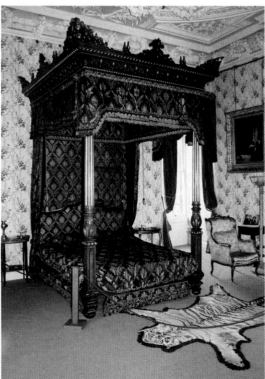

▲ Dressing up chest in
the family nurseries is
for use

### Opening times

Open 2nd to 9th April
11.00am to 5.00pm
1st May to 31st October
Daily except Saturday
11.00am to 5.00pm
(last admission 4.15pm
each day)

▶ The Grand Bed
chamber at Thirlestane
Castle

**562**

# ALMOND VALLEY HERITAGE CENTRE

Millfield, Livingston Village, West Lothian EH54 7AR
Telephone 01506 414957 Fax 01506 497771

Innovative museum exploring the history and environment of West Lothian and the Scottish shale oil industry.

▲ Vintage diesel locomotive on the narrow-gauge railway

Museum displays are supported by a range of award-winning children's activities and educational demonstrations. The site also includes an operating 18th century watermill, a farm steading with traditional breeds of livestock.

There are trailer and narrow-gauge railway rides, indoor and outdoor play areas and a full range of visitor facilities.

▲ Magical Boots - The children are examining hooves and jaws

◀ Howkin' tatties at the annual harvest event

### Opening times
Open daily throughout the year
10.00am to 5.00pm

### Directions
The Heritage Centre is only 15 miles from central Edinburgh and less than 2 miles from Junction 3 off the M8. Follow the Heritage Centre signs from the A899, Livingston dual carriageway

▶ A school group within the main museum building passing around newly hatched chicks

# BURNS HOUSE (MAUCHLINE) TRYST LTD

2-4 Castle Street, Mauchline, Ayrshire KA5 5BZ
Telephone 01290 550045

Robert Burns lived in Mauchline from 1784 till 1788 at the farm of Mossgiel on the outskirts of Mauchline. Here he was to meet and marry Jean Armour a local lass, setting up house in Castle Street.

This house holds many relics of interest to lovers of Robert Burns. The room occupied by Burns and Jean Armour is preserved and furnished in style of that period with gallery displaying family Bibles of the Armour family and numerous manuscripts in Burns own handwriting.

A Fishu (Neckerchief) once owned by the "Lass of Ballochmyle" together with her diary and a copy of the original letter sent to her by Burns is proudly on display.

Mauchline itself is not forgotten; an immense display of Boxware products too numerous to mention finished in plain photographic, tartan and fern collected by enthusiasts worldwide with display panels explaining the industry which ceased to produce as the result of a fire in 1933.

Curling stones are also a unique industry. On display are stones at different stages of manufacture from rough hewn state to highly polished products, again with display panels depicting curling through the ages. Video films available to view on site enhance museum.

## Opening times

Open seasonal 1st May to 30th September, daily except Monday; Tuesday to Saturday 10.30am to 5.00pm (last admission 4.30pm) Sunday 2pm to 5pm Or by appointment out with season

▶ Models of Burns and Jean

▼ Portrait of Robert Burns

## Directions

Museum can be found in centre of Town at traffic lights. Slip road leading to the Church Hall adjacent to the Churchyard is Castle Street. Building is on right hand side.

▲ Burns House Museum

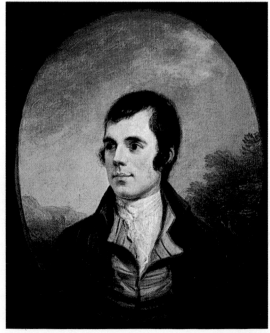

# MOFFAT MUSEUM

The Old Bakehouse, The Neuk, Moffat, Dumfriesshire DG10 9EG
Telephone 01683 220868

Moffat Museum which opened in 1984 incorporates an old Bakehouse and the oven used for over 100 years is focal point of the Museum.

The Museum tells the story of Moffat and its people through the ages through various exhibitions and displays. Amongst the subjects covered are farming, religious life, including the Covenanting period of the 17th century, and education.

See also fossils of some of earth's earliest creatures uncovered near Moffat and mementos of the coaching days and of the railway when Moffat was on a Spur Line feeding the LMS Railway between Glasgow and London. Featured are school items of yesteryear, memorabilia of sporting pastimes, and the Covenanter's cup from the 1670's.

Memorabilia from the Clan Moffat from around the world is also displayed.

Moffat was the birthplace of Air Chief Marshall Lord Dowding and his ribbons and uniforms can be seen together with those of other distinguished servicemen.

We have photographs of elegance in the great days of the late 18th and early 19th century when Moffat was a spa town.

A new addition to our Museum in 1998 is a video production of the history of Moffat from Roman times to the present day.

### Opening times

Open Easter and Whit to September daily except Wednesday
10.30am to 1.00pm and 2.30pm to 5.00pm
Sunday
2.30pm to 5.00pm

### Directions

Entering the town on the A701 on the left hand side is St Andrews Church opposite to Main Gate in an arch of Bank of Scotland is the Museum.

▲ A step back in time, entrance to the Museum

▲ The spa and rise of Moffat's prosperity

▲ Famous people

▼ The old bake oven, central feature of the lower floor

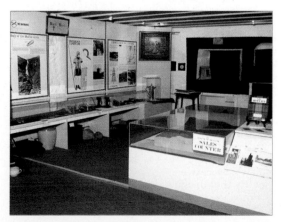

SCOTLAND

## CAWDOR CASTLE
Nairn, Scotland IV12 5RD
Telephone 01667 404615 Fax 01667 404674

This splendid romantic castle dating from the late 14th century was built as a private fortress by the Thanes of Cawdor, and remains the home of the Cawdor family to this day. The ancient mediaeval tower was built around the legendary holly-tree.

Although the House was evolved over 600 years, later additions mainly of the 17th century were all built in the Scottish vernacular style with slated roofs over walls and crow-stepped gables of mellow local stones.

This style gives Cawdor a strong sense of unity, and the massive, severe exterior belies an intimate interior that gives the place a surprisingly personal, friendly atmosphere.

Good furniture, fine portraits and pictures, interesting objects and outstanding tapestries are arranged to please the family rather than to echo fashion or impress.

Memories of Shakespeare's Macbeth give Cawdor an elusive, evocative quality that delights visitors.

The flower garden has again a family feel to it, where plants are chosen out of affection rather than affectation.

This is a lovely spot between spring and late summer. The wild garden beside its stream leads into beautiful trails through a spectacular mature mixed woodland, through which paths are helpfully marked and colour-coded.

The walled garden has been restored over the last fifteen years by Lord and Lady Cawdor to recreate a 16th century atmosphere, the date of the garden walls. It comprises a holly maze, paradise garden, knot garden and orchard.

### Opening times

Open
1st May to 10th
October 1999 daily
10.00am to 5.30pm
(last admission
5.00pm)

### Directions

Situated between Inverness and Nairn on the B9090 off the A96 or from the A9 on the B9006.

▲ Cawdor Castle and Gardens

▲ Cawdor Castle Tower Sitting room

▲ Cawdor Castle and Gardens

▲ Cawdor Castle Gardens

**566**

# THE MUSEUM, NEWTON STEWART
York Road, Newton Stewart, Scotland DG8 6HH
Telephone 01671 402472

The Museum aims to preserve evidence from the past, in Newton Stewart and District, for present and future generations.

The trustees have owned the former St John's Church since 1978, to house the collections started by Miss Helen Drew.

A working committee of interested people looks after the exhibits, while volunteer custodians are on duty during opening hours.

The museum is popular with tourists and is an educational resource available freely to schools.

The collections have been donated by local people and are believed to represent the life and spirit of the Newton Stewart area, that is Middle Galloway.

The functions of the museum are to conserve our heritage, to engender local pride, and to nurture nostalgia.

▶ The Museum, Newton Stewart

▲ Some of the costumes on display

### Opening times
Open Easter to October Monday to Saturday 2.00pm to 5.00pm and July, August and September Sundays 2.00pm to 5.00pm and July and August Monday to Friday 10.00am to 12.30pm and other times by appointment

### Directions
From the tourist information centre in Dashwood Square, follow Jubilee Road, Church Street and York Road to the Museum

▲ The Nursery display

# HIGHLAND FOLK MUSEUM, TURUS TÌM

Aultarie Croft House, Newtonmore, Inverness-shire PH20 1AY
Telephone 01540 661 307 Fax 01540 661 631

SCOTLAND

On this 80 acre site, history is being brought to life and the past is being rediscovered. At Aultarie Croft life and work still goes on at this early 20th century farm alongside the furnished home of an agricultural worker.

In the Open Air Museum, a clockmaker's workshop, a single teacher school and a water-powered sawmill are in various stages of reconstruction.

Baile Gean, a Highland Township of about 300 years ago, where houses and barns are being built by traditional methods, is being recreated from the traditional materials of turf, wood, stone and thatch. Long-obsolete crafts are being practiced again and the warmth of these highland homes of long ago and the furniture and fittings which were the pride and joy of the housewife can now be enjoyed by the visitor.

Events, activities and demonstrations are held during the summer presenting a programme of music, handicrafts, trades and traditional games and sports.

On site there are reception, toilets, car park and picnic facilities and pleasant woodland and farm walks.

***Opening times***
Open May to October
Monday to Friday
please telephone for
opening times

***Directions***
Located on the A86
on the north side of
Newtonmore. Follow the
signposts to the Highland
Folk Museum off the A9.

▲ Traditional building skills

▲ Scything

▲ Highland Township 1700

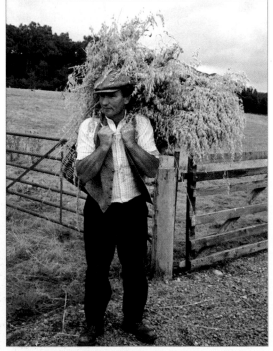
▲ Crofter bringing home the harvest

# THE BLACK WATCH REGIMENTAL MUSEUM

Balhousie Castle, Hay Street, Perth, Perthshire PH1 5HR
Telephone 01738 621281 Fax 01738 643245

The Black Watch Regimental Museum records the history of Scotland's senior Highland regiment - "The Gallant Forty TWA" by means of pictures, silver medals, colours, uniforms and weapons.

Two and a half centuries of British Military History - an audio tour is available to hire. Please allow at least one hour for your visit.

### *Directions*

Situated on the North Inch of Perth approx one mile from city centre. Take stagecoach bus services 5,6, 9 or 10 from Kinnoull Street to Muirton

### *Opening times*

Open May to September
Monday to Saturday
10.00am to 4.30pm
October to April
Monday to Friday
10.00am to 3.30pm
Closed the last Saturday
in June, Christmas
and New Year
(last admission 4.00pm)

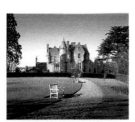

▲ Balhousie Castle, Perth home of The Black Watch Regimental museum

▲ Room four of the Museum The Volunteer/Territorial Army Room

▲ Room six of the Museum World War II

▼ Room two of the Museum, Waterloo to Ashantee period

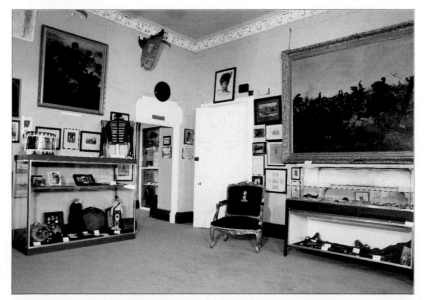

# GROAM HOUSE MUSEUM

High Street, Rosemarkie, Ross-shire IV10 8UF
Telephone 01381 620961 Fax 01381 621730

Groam House Museum is an award-winning Pictish centre for Ross and Cromarty. The museum houses a stunning collection of originally carved stones all found within the village - the most recent in 1998. The centre-piece is the magnificent Rosemarkie cross-slab, of the late 8th century.

There are three videos. One is an introduction to the Picts; the other two are about the mysterious highland prophet, The Brahan Seer.

Hands-on activities for children and adults include Pictish images for making rubbings and a reconstructed Pictish harp to play. For the very young a toy-box is provided.

The museum has a full photographic record of Pictish stones in Scotland, plus a local photographic archive.

Temporary exhibitions held in the upstairs gallery may be about local history or Pictish interest.

Last year's exhibition was on the life and work of George Bain (1881 - 1968) the artist responsible for the revival of Celtic art. The success of this exhibition resulted in the donation of over 150 pieces of original material. This collection is of National importance and is currently being conserved in order to make it more accessible to the public.

The shop sells items of Pictish, Celtic and local interest.

## *Opening times*

Open Easter Week,
1st May to 1st October
10.00am to 5.00pm
Monday to Saturday,
2.00pm to 4.30pm
Sundays
1st October to 1st May
2.00pm to 4.00pm
Saturday and Sunday

## *Directions*

The museum is 15 miles north east of Inverness from A9, B9161, then A832 to Rosemarkie. Train to Inverness Bus from Inverness to Rosemarkie (not Sundays)

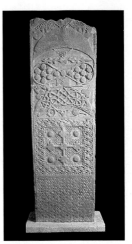

▲ Back of late 8th century Cross-slab with Pictish symbols

▲ From title page of Douglas Young's "Braird o Thristles", 1947

▲ Design for greetings card by George Bain

◄ General view of the Pictish display

# BUTE MUSEUM

Stuart Street, Rothesay, Isle of Bute PA20 OBR
Telephone 01700 505067

Experience the Archaeology, history and natural history of the Island in the Bute Museum. Extensive display of birds and Island wild life.

Wild flower display throughout the Summer. Exhibits from every period of Bute's history from early stone tools to Clyde steamers. special displays for children include a touch table, toddler's case and small aquarium.

A Museum quiz is available free of charge. Paintings and photographs of old Rothesay. The Museum shop stocks an interesting range of souvenirs, gifts and books.

The Library has local history research and genealogical records.

Admission Adults £1.20; Senior Citizens 70p; Children 40p. School parties welcome. Please book admission free.

### *Opening times*

Open April to September
Monday to Saturday
10.30am to 4.30pm
Sunday
2.30pm to 4.30pm
October to March
Tuesday to Saturday
2.30pm to 4.30pm
Closed Christmas and New Year

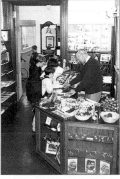

▲ The gift shop and a visiting school party

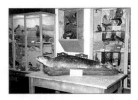

▲ The Natural History Gallery

▲ The McAlister stone

### *Directions*

The Museum is situated in Stuart Street at the rear of the Castle.

▶ The Archaeology Gallery

SCOTLAND

# HALLIWELL'S HOUSE MUSEUM
Market Square, Selkirk, Scotland TD7 4BL
Telephone 01750 20096 Fax 01750 23282

This award winning museum recreates the building's former use as a home and ironmonger's shop. The story of the historic Royal Burgh of Selkirk is told in the upstairs galleries, audio and video programme enhance the colourful displays. The Robson Gallery hosts an exciting programme of temporary exhibition. Also incorporates Tourist Information Centre.

### Opening times
Open March to October
Monday to Saturday
10.00am to 5.00pm
Sunday
2.00pm to 4.00pm
(July and August open
daily until 6.00pm)

### Directions
On the A7 between Hawick and Galashiels. The Museum is placed just off the Market Place and is well signposted. Forty miles from Edinburgh.

▼ Ironmongers shop

# QUEENSFERRY MUSEUM
53 High Street, South Queensferry, Scotland EH30 9HP
Telephone 0131 331 5545

SCOTLAND

Situated in the historic former Royal Burgh of Queensferry, the museum commands magnificent views of the two great bridges spanning the Forth. Its collections trace the history of the people of Queensferry and Dalmeny, the historic ferry passage to Fife, the building of the road and the rail bridges, and the wildlife of the Forth Estuary.

Queensferry's unique history is highlighted by the 'Burry Man'. Clad from head to toe in a costume made from the burrs of a burdock plant, he parades through the town for nine hours on a Friday in early August.

The origins of the ceremony are lost in the mists of time. Was it intended to invoke good fortune in harvesting the land or sea, or as a device to drive out evil spirits?

See the full-sized model in the museum and ponder.

### Directions
Buses from St Andrew Square Bus Station and George Street. Route numbers SMT 43/X43 and Midland Bluebird 47/47A

▼ Commanding views of the bridges spanning the Forth

### Opening times
Open
Monday, Thursday, Friday and Saturday 10.00am to 1.00pm and 2.15pm to 5.00pm
Sunday
12.00pm to 5.00pm
Closed Tuesday and Wednesday

▲ The 'Burry Man' an ancient local custom

# DALMENY HOUSE
South Queensferry, West Lothian EH30 9TQ
Telephone 0131 3311888 Fax 0131 3311788

First Tudor Gothic revival house in Scotland built in 1817 by William Wilkins. Family home of the Earl and Countess of Rosebery set in beautiful parkland on the shores of the Firth or Forth within easy reach of the City of Edinburgh and two miles from the historic town of South Queensferry and the Forth Road Bridge.

Magnificent art collection of 18th century French furniture, tapestries and porcelain from the Rothschild House, Mentmore, and the Rosebery collection based on the 5th Earl's political and historical interests which include the Napoleon room and fine 18th century British portraits and architectural drawings.

There are limited opening times to the general public but groups are welcome outside normal opening hours through the year by arrangement.

The Art collection is of particular interest to specialist groups who can have time to enjoy the collection in detail.

▶ Front Hall showing staircase and furniture designed by William Wilkins

**574**

▲ Drawing room contains Rothschild collection of 18th century French furniture and tapestries

Grand Dinners and Lunches can be held in the house using the family Dining room and Library.

The extensive grounds are also available for outdoor events and activities.

Please ask for further details and for our corporate brochure.

*Directions*
Dalmeny House lies seven miles west of Edinburgh and is signposted off the A90 Forth Bridge road. From the Edinburgh By-pass follow signs for 'Edinburgh North' until you reach the A90. The route is signposted to South Queensferry and Dalmeny. From other directions follow the signs for South Queensferry and Dalmeny.

▲ Napoleon room

*Opening times*
Open July to August only Sunday 1.00pm to 5.30pm, Monday and Tuesday 12.00pm to 5.30pm (last admission 4.45pm)

▶ Dalmeny House, Tudor Gothic revival house designed by William Wilkins

# STIRLING SMITH ART GALLERY & MUSEUM

Dumbarton Road, Stirling, Scotland FK8 2RQ
Telephone 01786 471917 Fax 01786 449523
EMail museum@smithartgallery.demon.co.uk

Situated in Stirling sometimes described as "the brooch which clasps the Highlands and the Lowlands together", the Stirling Smith Art Gallery and Museum nestles beneath Stirling Castle. Founded in 1874 from the bequest of the artist Thomas Stuart Smith, the Stirling Smith has one of the most important, and least known, Scottish history collections.

It has a fine collection of Scottish paintings and many remarkable pieces including the world's oldest football, oldest curling stone (1511), the Stirling Jug, dating from 1457, the measure by which all other Scottish measures were regulated, ancient tartans from Bannockburn, and a figure of Justice so old, that she does not have the traditional blindfold.

With exhibitions changing every few months, there is a rich array of items waiting to be discovered at the Smith, and all exhibitions are accompanied by a varied programme of events, many activities particularly aimed at the younger visitor.

The Stirling Smith is a good base from which to explore Stirling with free parking and a short walk to other attractions in the town.

Refreshments are available in the Smith's café. The Smith also has a lecture theatre with seating for 100 people which is ideal as a conference venue.

### Opening times

Open
Tuesday to Saturday
10.30am to 5.00pm
and Sundays
2.00pm to 5.00pm
Closed Mondays

### Directions

Exit Junction 10 on M9 follow Stirling Castle signs to Dumbarton Road. For pedestrians, the Smith is 200 yards past the tourist information office and Albert Halls in Dumbarton Road

▲ Stirling c1660 by Dutch artist Vosterman

▲ The world's oldest football c1560 found in the rafters, Stirling Castle

▲ Bruce and de Bohun Battle of Bannockburn 1314 by John Duncan

▼ Cattle by J. Denovan Adam.The Smith has it's own Highland bullock

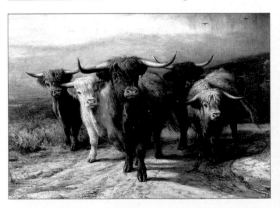

# STRANRAER MUSEUM

The Old Town Hall, George Street, Stranraer,
Dumfries & Galloway DG9 7JP
Telephone 01776 705088 Fax 01776 705835

Stranraer's historic Old Town Hall, built in 1776, is the home of Stranraer Museum. Step inside and discover Wigtownshire's fascinating past.

See one of Scotland's oldest ploughs, look at Victorian Wigtownshire in 3-D photographs and follow in the footsteps of Stranraer's own Polar explorers. Plus displays on archaeology, local history, farming and dairying.

A temporary exhibition programme runs throughout the year and there are activities for all the family.

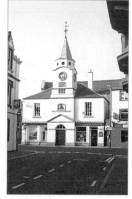

▲ The Old Town Hall, built 1776, is the Museum's home

▼ Meet a Viking! One of the Museum's many family events

▲ A view of one of the Museum's galleries

▲ The Museum has a fine collection of old farming tools

### Opening times

Open all year
Monday to Friday
10.00am to 5.00pm
and Saturday
10.00am to 1.00pm
2.00pm to 5.00pm
Closed Christmas Day,
New Year, Easter and
May Day Bank Holidays

### Directions

The Museum is in the Town Centre and a short walk from the ferry terminals. Follow the signs outside the Castle of St John and the Seacat Terminal.

# THE ARGYLL & SUTHERLAND HIGHLANDERS REGIMENTAL MUSEUM

The Castle, Stirling, Scotland FK8 1EH
Telephone 01786 475165 Fax 01786 446038

The museum portrays the history of the Regiment from 1794 to the present day.

The result is a display which gives a fascinating insight into the Military history of the last centuries and shows how the most famous of all Highland regiments played its part in shaping our destiny from the Napoleonic Wars to today.

There are sections devoted to The Crimea, The Indian Mutiny, the Colonial Wars of the 19th century, The Boer War, The First World War, between the Wars and The Second World War.

Some of the most interesting exhibits concern more recent events such as Korea, Suez, Cyprus, Borneo, Aden and Northern Ireland.

The story told to visitors as they move round this unique Museum is also a very human one and shows how The Argylls, a family and County Regiment, have derived strength from the people of Scotland.

Included in the displays are uniforms, weapons, colours and banners, silver, dioramas, a

▲ The Dining Room

▲ Stirling Castle, the home of the Museum

World War l trench, pictures, medals and personal artefacts.

Further information is available on the internet at
http://www.argylls.co.uk

The Museum is located in Stirling Castle.

### Opening times

Open
Easter to September
Monday to Saturday
10.00am to 5.45pm
and Sunday
11.00am to 4.45pm
October to Easter
every day
10.00am to 4.15pm

### Directions

Stirling is located
at the junction of
A84, A811, A9,
A905, A907
and is close to
junction 10 of the M9.
Brown tourist signs
indicate the route
to the Castle.

▲ A small selection from
the silver on display

◄ The first parade of
the 91st Argyllshire
Highlanders in 1794

SCOTLAND

# TOMINTOUL MUSEUM
The Square, Tomintoul, Moray AB37 9ET
Telephone 01309 673701 Fax 01309 675863

The Museum can be
found in the village
square of Tomintoul,
one of the highest
villages in Britain.

It features a recreated
crofter's kitchen and
smiddy, with other
displays on the local
wildlife, the story of
Tomintoul and the
Cairngorms.

### Directions

Tomintoul is on A939
Grantown, Ballater
road. Museum situated
in Town Square and
includes Tourist
Information Centre.

▲ Displays at the
Tomintoul Museum

▼ A demonstration of
weaving

### Opening times

Open seasonally
April to October Monday
to Saturday

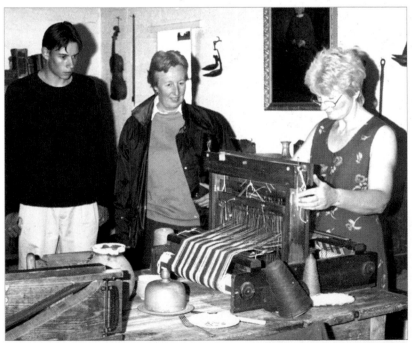

## BRODICK CASTLE

Isle of Arran KA27 8HY
Telephone 01770 302202 Fax 01770 302312

Brodick castle sits in a magnificent island setting with gardens and parkland. Superb silver collection, fine art, porcelain and furniture. Gift shop, licensed restaurant and plant sales. Information in 8 languages.

*Opening times* Open 1st April to 31st October daily, 11.00am to 4.30pm,
(last admission 4.00pm)

## PROVEST SKENE'S HOUSE

Guestrow, Off Broad Street, Aberdeen, Aberdeenshire
Telephone 01224 641086 Fax 01224 632133

16th Century house named after Provost George Skene who owned the building. Plaster and painted ceilings, refurbished room settings from 17th and 18th centuries, costume gallery and local history displays.

*Opening times* Open January to December, Monday to Saturday, 10am to 5pm,
(last admission 4.30pm) Closed 25th, 26th, 31st December and 1st and 2nd January
Admission £2.50 adults, £1.50 concessions, £6.00 family

## WEAVERS COTTAGE MUSEUM

Wellwynd, Airdrie, Lanarkshire ML6 0BN
Telephone 01236 747712

Reconstructed cottage explaining the role of weaving in the development of Airdrie. Display includes loom and domestic settings. Exhibitions of art and crafts. Weaving workshops and crafts held by arrangement.

*Opening times* Open all year Monday to Saturday, 10.00am to 5.00pm, Closed
Wednesdays and Sundays, Closed for lunch 1.00pm to 2.00pm

## BANFF MUSEUM

High Street, Banff, Aberdeenshire AB45 1AE

The museum is the oldest in Aberdeenshire, now being 170 years old. It has a beautiful display of Banff Silver, natural history displays, some armour and local history exhibits. Car parking nearby.

*Opening times* Open June to September from 2.00pm to 5.15pm, daily on Mondays,
Tuesdays, Wednesdays, Fridays, Saturdays and Sundays.

## BENNIE MUSEUM

9 -11 Mansfield Street, Bathgate, West Lothian EH48 4HU
Telephone 01506 634944

Bennie Museum is a local history museum displaying artefacts depicting the social industrial and historical past of Bathgate.

*Opening times* Open all year, Monday to Saturday, 10.00am to 4.00pm,
April to September 11.00am to 3.30pm October to March

**SCOTLAND**

## MOAT PARK HERITAGE CENTRE
Biggar, Lanarkshire ML12 6DT
Telephone 01899 221050 Fax 01899 221050

Models and artefacts describe and explain how life evolved here from geological times to the 19th century. Ongoing archaeological research ensures displays are constantly updated with new discoveries, (activity sheets available).

*Opening times* Open Easter to mid October, 10.00am to 5.00pm daily except Sunday, 2.00pm to 5.00pm, (last admission 4.30pm)

## GREENHILL COVENANTERS HOUSE
Burn Braes, Biggar, South Lanarkshire ML12 6DT
Telephone 01899 221050 Fax 01899 221050

As well as providing a window on domestic life of the period, this reconstructed 17th century farmhouse tells the turbulent story of the Scottish covenanters. Optional guided tours.

*Opening times* Open May to mid October daily 2.00pm to 5.00pm, (last admission 4.15pm)

## GLADSTONE COURT (STREET MUSEUM)
North Back Road, Biggar, South Lanarkshire ML12 6DT
Telephone 01899 221050 Fax 01899 221050

Children of all ages can enjoy a stroll along this "real" Victorian street, visiting the shops and school room of the not-so-good-old-days, (activity sheets available).

*Opening times* Open Easter to 31st October, 10.00am to 5.00pm every day except Sunday, which is 2.00pm to 5.00pm, (last admission 4.30pm)

## GREENFARM STEADING
Broughton, Biggar, ML12 6HQ
Telephone 01899 830 223

Life and work of John Buchanan.

*Opening times* Open May to October and Easter weekend, 2.00pm to 5.00pm

## SCOTTISH RAILWAY EXHIBITION
Bo'ness & Kinneil Railway, Union Street, Bo'ness, West Lothian EH51 9AQ
Telephone 01506 822298

Display of historic Scottish Railway rolling stock. Two restored steam locomotives, former Royal coach, wagons and an early diesel locomotive. Admission charge £1. All facilities are in nearby station.

*Opening times* Open May to mid October Saturdays and Sundays: daily except Mondays in July and August. 11.00am to 4.30pm, (last admission 4.00pm)

## STRATHSPEY RAILWAY Co LTD

The Station, Boat-of-Garten, Inverness-shire PH24 3BH
Telephone 01479 831692

Small relics only, railway interest from north of Scotland. Steam trains operate to and from Aviemore.

> *Opening times* Open March 28th to October 31st 9.45am to 4.30pm Saturdays, Sundays, Wednesdays and Thursdays, daily from May 29th to September 30th

## THE BUCKIE DRIFTER MARITIME HERITAGE CENTRE

Freuchny Road, Buckie, Banffshire AB56 1TT
Telephone 01542 834646 Fax 01542 835995

Enter The Buckie Drifter for a journey back in time to find out why thousands of North East Scottish Fisher folk spent their lives following the herring.

> *Opening times* Open April to October Monday to Saturday 10am to 5pm, Sunday 12pm to 5pm, October to December Saturday 10am to 5pm, Sunday 12pm to 5pm

## AUCHINDRAIN TOWNSHIP OPEN AIR MUSEUM

By Inverary, Argyll PA32 8XN
Telephone 01499 500 235

Original West Highland township. Restored, furnished and equipped to present a taste of the way of life of The Highlander in a past age.

> *Opening times* Open April to September daily, 10am to 5pm, (last admission 4.30pm)

## LAIDHAY CROFT MUSEUM

Laidhay, Dunbeath, Caithness, KW6 6EH
Telephone 01593 731 244

Croft house incorporating byre one end stable other. Appropriately furnished. Separate crock constructed barn and threshing mills and other tools.

> *Opening times* Open Easter Sunday to end October daily, 10.00am to 6.00pm

## CAMPBELTOWN MUSEUM

Hall Street, Campbeltown, Argyll PA28 6BS
Telephone 01586 552366

Social and natural history exhibits. Important local archaeological finds including a bronze age jet necklace.

> *Opening times* Please telephone for details of opening times

## CASTLE DOUGLAS ART GALLERY

Market Hill, Castle Douglas, DG7 1BE
Telephone 01557 331643 Fax 01557 331643

The Castle Douglas Art Gallery is an exhibition venue with a varied programme covering fine art, crafts, printmaking and photography. Exhibitors are organised by the Museums Service and local artists group.

> *Opening times* Please telephone for details of opening times

SCOTLAND

## SUMMERLEE HERITAGE PARK
Heritage Way, Coatbridge, ML5 1QD
Telephone 01236 431261 Fax 01236 440429

Scotland's leading industrial heritage museum. 22 acres with working machinery, electric tramway, recreated addit mine, miners cottages and large under-cover display area. Also 'Ironworks Gallery' exhibition area. Free admission. Guided tours by arrangement.

*Opening times* Open all year April to September 10.00am to 5.00pm, October to March 10.00am to 4.00pm. Closed 25th, 26th December and 1st and 2nd January

## COLDSTREAM MUSEUM
12 Market Square, Coldstream, Berwickshire TD12 4BD
Telephone 01890 882630

Local history museum with Coldstream Guards section and contemporary exhibition gallery which changes throughout the season. All on one level with excellent access for disabled. Toilets include disabled and baby facilities.

*Opening times* Open Easter to end September Monday to Saturday,
10.00am to 4.00pm and Sunday 2.00pm to 4.00pm.
October, Monday to Saturday, 1.00pm to 4.00pm.

## CRAIL MUSEUM
62/64 Marketgate, Crail, Fife KY10 3TH
Telephone 01333 450869

Crail Museum is a small local history museum housed in two 18th century cottages beside The Tolbooth. It provides an insight into the past life of the ancient Royal burgh of Crail, etc.

*Opening times* Please telephone for details of opening times.

## FALKLAND PALACE
Falkland, Cupar, Fife KY15 7BW
Telephone 01337 857 397 Fax 01337 857 980

Built between 1501 and 1541 the palace is a fine example of renaissance architecture. It includes The Chapel Royal, The Royal Tennis Court, which is still used today.

*Opening times* Open 1st April to 31st October daily, Monday to Saturday, 11am to 5.30pm, (last admission 4.30pm), Sunday 1.30pm to 4.40pm, (last admission 4.30pm)

## SCOTTISH MARITIME MUSEUM DENNY
## SHIP MODEL EXPERIMENT TANK
Castle Street, Dumbarton, G82 1QS
Telephone 01389 763444

Denny Tank is an unique chance to step back into the world of the Victorian ship designer: built 1882 retains original features restored to working condition, still used for testing ship designs.

*Opening times* Open all year Monday to Saturday 10.00am to 4.00pm,
(excluding the Christmas to new year period)

**584**

## SHAMBELLIE HOUSE MUSEUM OF COSTUME

New Abbey, Dumfries, DG2 8HQ
Telephone 01387 850375 Fax 01387 850461

Set in a Victorian country house, this museum has a remarkable collection of period costumes displayed in appropriate room settings. Guided tours available if booked in advance.

*Opening times*  Open April to October daily 11am to 5pm, (last admission 4.30pm)

## UNICORN PRESERVATION SOCIETY

Victoria Dock, Dundee, DD1 3JA
Telephone 01382 200900 Fax 01382 200923

Unicorn is Scotland's oldest historic ship and Scotland's only example of a wooden warship.

*Opening times*  Open all year round with exception of weekends in winter and the Christmas and New Year holidays

## ST MARGARET'S CAVE

Chalmers Street Car Park, Dunfermline, Fife
Telephone 01383 314228 Fax 01383 313837

This is a cave where St Margaret, Queen of Scotland came to pray. There are several steps down to the cave.

*Opening times*  Open Easter to last weekend in September, 11.00am to 4.00pm, other times by appointment (01383 313838). Admission free

## PITTENCRIEFF HOUSE MUSEUM

Pittencrieff Park, Dunfermline, Fife KY12 8QG
Telephone 01383 722935 Fax 01383 313837

There are permanent exhibitions about the history of Pittencrieff Park and a costume display. An art gallery is situated at the top floor of the museum.

*Opening times*  Open 11.00am to 5.00pm, April to September every day. Open 11.00am to 4.00pm, October to March everyday. Admission free

## DUNFERMLINE MUSEUM

Viewfield Terrace, Dunfermline, Fife KY11 4XU
Telephone 01383 313838 Fax 01383 313837

Exhibitions on local history, textiles, are permanent. Entrance to museum is free of charge.

*Opening times*  Open all year round weekdays only, 11am to 5pm. Closed public holidays

## SCOTTISH TARTANS MUSEUM

The Scotch House, 39/41 Princes Street, Edinburgh,
Telephone 0131 556 1252 Fax 0131 556 9529

Full display of tartan and Highland dress, history of the kilt. Over 700 tartans on display.

*Opening times*  Open all year Monday to Saturday 9.00am to 5.30pm, Thursday 9.00am to 7.30pm. Extended hours in Summer season

**585**

## MANDERSTON

Duns, Berwickshire TD11 3PP
Telephone 01361 883450 Fax 01361 882010

Manderston, the swan-song of the great classical house, standing in 56 acres of gardens. See the only silver staircase in the world, "upstairs and downstairs", princely stables and biscuit tin museum. No guided tours on public open days. Group visits any time of year by appointment.

*Opening times*  Open from 2.00pm to 5.30pm on Thursdays and Sundays, from 13th May until 26th September, 1999 and Bank Holiday Mondays end May and August

## THE JIM CLARK ROOM

44 Newtown Street, Duns, Berwickshire TD11 3AU
Telephone 01361 883960

Trophies, photographs and memorabilia related to the career of Jim Clark, Berwickshire farmer and twice World Motor Racing Champion in 1963 and 1965. Souvenirs sales point. Free parking.

*Opening times*  Open Easter to end September, Monday to Saturday 10.30am  to 1.00pm, 2.00pm  to 4.30pm, Sunday 2.00pm to 4.00pm October, Monday to Saturday 1.00pm to 4.00pm

## THE WRITERS' MUSEUM

Lady Stair's House, Lady Stair's Close, Lawnmarket, Edinburgh, EH1 2PA
Telephone 0131 529 4901 Fax 0131 220 5057
EMail enquiries@writersmuseum.demon.co.uk

The Writers' Museum displays collections relating to the lives and works of Robert Burns, Sir Walter Scott and Robert Louis Stevenson. Programme of temporary exhibitions.

*Opening times*  Open all year Monday to Saturday 10.00am to 5.00pm, (open Sundays 2.00pm to 5.00pm during Edinburgh festival only)

## MUSEUM OF FARMING LIFE

Pitmedden Garden, Ellon, Aberdeenshire AB41 7PD
Telephone 01651 842352 Fax 01651 843188

Farmhouse has four rooms, circa 1920. Implement steading with yard, tools, looms, etc.

*Opening times*  Open 1st May to 30th September daily, 10.00am to 5.30pm, (last admission 5.00pm)

## MUSEUM OF TRANSPORT

1 Bunhouse Road, Glasgow, G3 8DP
Telephone 0141 287 2720 Fax 0141 287 2692

The history of transport on land and sea comes to life. Dramatic displays of cars, trains, bikes, buses and boats provide a great day out for all of the family. Admission free.

*Opening times*  Monday to Saturday 10.00am to 5.00pm, Sunday 11.00am to 5.00pm

## GLASGOW BOTANIC GARDENS
730 Great Western Road, Glasgow, G12 0UE
Telephone 0141 334 2422 Fax 0141 339 6964

Educational garden with extensive glasshouse based plant collections including ferns, orchids and begonias. Interpretation plant labelling, leaflets, guided tours and visitor centre. Exhibitions. School groups are specially welcome.

*Opening times* Open all year daily Grounds 7am till dusk Glasshouses 10am to 4.15pm

## THE TENEMENT HOUSE
145 Buccleuch Street, Garnethill, Glasgow, G3 6QN
Telephone 0141 333 0183

Typical late Victorian tenement flat, retaining most of its original features, including bed recesses and kitchen range. Home to Glasgow shorthand typist for over 50 years. Exhibition on ground floor.

*Opening times* Open 1st March to 31st October daily 2.00pm to 5.00pm,
(last admission 4.30pm)

## ART GALLERY & MUSEUM
Kelvingrove, Glasgow, G3 8AG
Telephone 0141 287 2699 Fax 0141 287 2690

Scotland's most popular free tourist attraction, one of the finest civic art collections in Britain, including Botticelli, Rembrandt, Whistler and Cadell. Also European arms and armour and Scottish Natural History.

*Opening times* Open Monday to Saturday, 10am to 5pm, Sunday 11am to 5pm

## GRANGEMOUTH MUSEUM
Victoria Library Building, Bo'ness Road, Grangemouth, FK3 8AG
Telephone 01324 504699 Fax 01324 503771

Single gallery charting history of Grangemouth, its industries and social life.

*Opening times* Open all year Monday to Saturday, 12.30pm to 5.00pm

## TIMESPAN
Dunrobin Street, Helmsdale, Sutherland KW8 6JX
Telephone 01431 821 327

Multi award winning dramatic presentation of Highland history with superb audio-visual programme and riverside herb garden. Purpose built art gallery showing international contemporary work.

*Opening times* Open Easter to October Monday to Saturday,
9.30am to 5.00pm and Sunday 2.00pm to 5.00pm,
(6.00pm closing during July and August),
last admission 1 hour before closing

## LENNOXLOVE HOUSE

Haddington, East Lothian EH41 4NZ
Telephone 01620 823720 Fax 01620 825112

Collection once housed at Hamilton Palace of furniture, paintings and porcelain. Also mementoes of Mary Queen of Scots.

*Opening times*  Open Easter to October Wednesday, Thursday, Saturday, Sunday and Bank Holidays 2.00pm to 4.30pm, or by prior arrangement

---

## JANE WELSH CARLYLE MUSEUM
Lodge Street, Haddington, East Lothian EH41 3DX
Telephone 01620 823738 Fax 01620 823738

Regency style house and gardens, childhood home of Jane Welsh, wife of philosopher and genius Thomas Carlyle.

*Opening times*  Open April to September, Wednesday to Saturday, 2.00pm to 5.00pm

---

## THE HILL HOUSE

Upper Colquhoun Street, Helensburgh, G84 9AJ
Telephone 01436 673900 Fax 01436 674685

A house designed by Charles Rennie Mackintosh and fittings are original. An exhibition of modern furniture by new designers is also included.

*Opening times*  Open 1st April to 31st October daily 1.30pm to 5.30pm, (last admission 5.00pm)

---

## ROBERT SMALL'S PRINTING WORKS

9 High Street, Innerleithen, Peebleshire EH44 6HA
Telephone 01896 830206

A 120 year old printers. See how printing was accomplished; watch the printer at work and try typesetting by hand. A reconstructed water-wheel which used to power the machines.

*Opening times*  Open Easter weekend May 1st to September 30th 10.00am to 1.00pm and 2.00pm to 5.00pm, Sundays 2.00pm to 5.00pm. October Saturday/Sunday only Saturday 10.00am to 1.00pm, 2.00pm to 5.00pm and Sunday 2.00pm to 5.00pm, (last admission 45 minutes before closing)

---

## INVERKEITHING MUSEUM

The Friary, Queen Street, Inverkeithing, Fife KY11 1LS
Telephone 01383 313595 Fax 01383 313837

There are permanent exhibitions about World Wars and local history. Museum entry is free of charge.

*Opening times*  Open 12.00pm to 4.00pm, Thursday to Sunday all year round

---

## CULLODEN MOOR VISITOR CENTRE
Culloden Moor, Inverness, IV2 5EU
Telephone 01463 790607 Fax 01463 794294

Visitor Centre with multi lingual A.V. presentation and permanent exhibition of Jacobite weapons and objects associated with the rising of 1745 and Culloden battlefield.

> *Opening times* February 1st to March 31st and November 1st to December 31st
> 10.00am to 4.00pm. April 1st to October 31st 9.00am to 6.00pm.
> Closed 24th,25th and 26th December

## SCOTTISH MARITIME MUSEUM
Laird Forge, Gottries Road, Irvine, Ayrshire KA12 8QE
Telephone 01294 278283

Special exhibition each year, historic vessels to board including puffer, tug and fishing vessel, also S.V. Carrick which is being restored to her former glory. Gift shop and coffee shop. Only limited facilities for disabled people.

> *Opening times* Open 1st April to 31st October 10am to 5pm, (last admission 4.15pm)

## KIRKCALDY MUSEUM & ART GALLERY
War Memorial Gardens, Kirkcaldy, Fife KY1 1YG
Telephone 01592 412860 Fax 01592 412870

Features superb collection of 19th and 20th century Scottish paintings, an award-winning permanent local history exhibition and a lively changing exhibition programme. Enquiry and outreach services available. Café closes at 4.30pm.

> *Opening times* Open Monday to Saturday 10.30 am to 5pm and Sunday 2pm to 5pm

## TOLBOOTH ART CENTRE
High Street, Kirkcudbright, DG6 4JL
Telephone 01557 331556 Fax 01557 331643

Set in one of Kirkcudbright's most historic buildings, the Art Centre presents the story of the Kirkcudbright 'Art Colony' through an audio-visual presentation and the permanent display of paintings.

> *Opening times* Open 11.00am to 4.00pm Monday to Saturday

## THE STEWARTRY MUSEUM
St Mary Street, Kirkcudbright, DG6 4AQ
Telephone 01557 331643 Fax 01557 331643

The museum opened in 1893 and has extremely varied collection featuring the human and natural history of the Stewartry, (The Eastern half of Galloway).

> *Opening times* Open 11.00am to 4.00pm, Monday to Saturday

## NEW LANARK VISITOR CENTRE

New Lanark Mills, Lanark, ML11 9DB
Telephone 01555 661345 Fax 01555 665738
EMail visit@newlanark.org

Conservation village by the Falls of Clyde. Award-winning visitor centre includes fascinating audio-visual ride "The Annie McLeod Experience", mill workers' homes, working machinery. Family tickets, group discounts. Website www.newlanark.org

*Opening times*  Open daily all year 11.00am to 5.00pm

## SHETLAND MUSEUM

Lower Hillhead, Lerwick, Scotland ZE1 0El
Telephone 01595 695057

Collections consist of archaeology, maritime and social history, folk life, textiles and natural history. Also regular temporary exhibitions by local artists.

*Opening times*  Open all year round except Sundays, 10.00am to 7.00pm on Mondays, Wednesdays and Fridays, 10am to 5pm on Tuesdays, Thursdays and Saturdays

## HOUSE OF THE BINNS

Linlithgow, EH49 7NA
Telephone 01506 834255

17th century merchant's house built by Thomas Dalyell 1612 to 1630. Still home of Dalyell family. Gifted to NTS in 1944. Portraits, furniture, porcelain, tell history of family, notably General Tam Dalyell (1615-1685).

*Opening times*  Open 1st May to 30th September every day except Friday, from 1.30pm to 5.30pm, (last admission 5.00pm)

## ROBERTSON MUSEUM & AQUARIUM

University Marine Biological Station, Millport, Isle of Cumbrae
KA28 0EG
Telephone 01475 530 581 Fax 01475 530 601

Recently refurbished museum and adjoining aquarium house, unique displays from the world of marine science, including variety of sealife exhibits and a collection of animal species from Clyde sea area.

*Opening times*  Open Monday to Thursday 9.30am to 12.15pm and 2.00pm to 4.45pm, Friday 9.30am to 12.15pm and 2.00pm to 4.15pm, Saturday (June to September only), 10.00am to 12.15pm and 2.00pm to 4.45pm

## MOTHERWELL HERITAGE CENTRE

High Road, Motherwell, ML1 3HU
Telephone 01698 251000 Fax 01698 268867

Superb modern facilities with award winning audio visual display on heritage and local area from Romans to rise and fall of heavy industries. Viewing tower and exhibition gallery. Study rooms. Guided tours by arrangement.

*Opening times*  Open all year Monday to Saturday, 10.00am to 5.00pm, (Thursday until 7.00pm) Sunday 12.00pm to 5.00pm, Closed Christmas and New Year

## THE SCOTTISH AGRICULTURAL MUSEUM

Ingliston, Newbridge, Midlothian EH28 8NB
Telephone 0131 333 2674 Fax 0131 333 2674

Scottish country life over two centuries, fascinating displays and tape slide presentations.

*Opening times* Open April to September daily, 10.00am to 5.00pm, October to March, Monday to Friday, 10.00am to 5.00pm, Closed Christmas, New Year and during The Royal Highland Show (June)

## PERTH MUSEUM & ART GALLERY

George Street, Perth, Perthshire PH1 5LB
Telephone 01738 632488 Fax 01738 443505

Wide range of displays including local history, natural history and art. Changing exhibition programme.

*Opening times* Open Monday to Saturday 10.00am to 5.00pm

## ARBUTHNOT MUSEUM

St Peter Street, Peterhead, AB42 1QD
Telephone 01771 622906 Fax 01771 622884

Fishing, shipping and whaling displays. Coin and inuit art collections. Temporary exhibitions gallery.

*Opening times* Open Monday to Friday, 10.30am to 1.30pm and 2.30pm to 5.00pm, Wednesdays 10.30am to 1.00pm. Closed Sunday and Public Holidays

## ABERDEENSHIRE FARMING MUSEUM

Aden Country Park, Mintlaw, Peterhead, Aberdeenshire AB42 5FQ
Telephone 01771 622906 Fax 01771 622884

Relive the farming heritage of north east Scotland in the beautiful surroundings of Aden country park. Guided tours of the museum and working farm, audio visual shows and temporary exhibitions throughout the season.

*Opening times* Please telephone for details of opening times

## BOWHILL HOUSE & COUNTRY PARK

Bowhill, Selkirk, TD7 5ET
Telephone 01750 22204 Fax 01750 22204

Home of Duke of Buccleuch. Internationally renowned art collection. French furniture, silver, porcelain, Queen Victoria, Monmouth and Sir Walter Scott relics. Theatre. Victorian kitchen. Adventure playground. Woodland walks. Audio-visual.

*Opening times* Please telephone for details of opening times

## HOPETOWN HOUSE

South Queensferry, West Lothian EH30 9SL
Telephone 0131 331 2451 Fax 0131 319 1885

Hopetown House, a unique gem of Europe's architectural heritage and undoubtedly "Scotland's finest stately home" celebrates its 300th anniversary in 1999. Some facilities for disabled people.

*Opening times* Open 2nd April to 26th September, then every weekend in October 1999

## CRAWFORD ARTS CENTRE

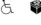

93 North Street, St Andrews, Fife KY16 9AL
Telephone 01334 474610 Fax 01334 479880

Temporary exhibition space run by an independent charitable company, showing a year-round programme of all kinds of visual art and craft. Also art activities for adults/children, studio theatre.

*Opening times* Open Monday to Saturday 10.00am to 5.00pm, Sunday 2.00pm to 5.00pm, open all year except for Christmas to New Year

## BANNOCKBURN HERITAGE CENTRE

Glasgow Road, Stirling, FK7 0LJ
Telephone 01786 812664 Fax 01786 810892

Site of most famous battle in Scottish history. Visitor centre with exhibition of Scottish history from 1290 to 1603. Audio-visual film of battle. Rotunda and equestrian statue of Bruce outside.

*Opening times* Please telephone for details of opening times

## FARM LIFE CENTRE

Dunaverig, Ruskie, Thornhill, Stirling, FK8 3QW
Telephone 01786 850277 Fax 01786 850404

See and touch a wide variety of farm animals including goat milking, pony rides, feeding time plus farm walks, lots of indoor activities. Picnic and play areas, tearoom and craftshop. Guided tours to be booked.

*Opening times* Open week end before Easter up to end of October, 10am to 6pm daily

## TOLBOOTH MUSEUM

Old Pier, The Harbour, Stonehaven, AB39 2JU
Telephone 01771 622906

The oldest building, 1587, in Stonehaven used as a jail and courthouse until 1767, sea fishing and local artefacts from the Neolithic age onwards are displayed. Entry is free. Access for disabled people.

*Opening times* Open 1st June to 30th September, Please telephone for details of opening times

# WALES

Wales is a wonderfully compact country and yet close as it is to England it is singularly remote. It is a land of glorious scenery, and not unnaturally of National Parks. The Brecon Beacons National Park, arguably the most spectacular offers a wide variety of majestic sights including the Black Mountains, while in the Snowdonia National Park North Wales has the highest mountains in England and Wales. The Pembrokeshire Coast National Park acknowledges the scenic grandeur of the Welsh coastline. But Wales is far from being merely a country of spectacular scenery. There is a rich tradition of choral singing and of Nonconformism, both admirably expressed in the Welsh chapels. The Welsh mining industry was in the past the cradle of many fine Welsh choirs, and although superficially Wales may be seen in the tourist guide as a land of singing miners against a background of mist-wrapped mountains, the reality is very different. There is a strong tradition of music, literature and art, as witnessed by the numerous Eisteddfods in which poetry, song, drama and the fine arts feature.

This tradition is well represented in the museums and galleries of Wales. The National Museum and Gallery Cardiff offers a dazzling range of displays on art, natural history and science. Claimed to be the finest in Britain, the museum has a spectacular exhibition showing the creation of Wales, complete with animated Ice Age creatures and simulated Big Bang. This is incidental to one of the finest collections of art treasures in Europe. The Museum of Welsh Life is one of Europe's foremost open-air museums featuring everything from life in a castle to a humble moorland cottage. The delightful Plas Newydd, the home of the Ladies of Llangollen, although hardly a humble cottage is nevertheless described as a Gothic cottage with intriguing oak carving.

Most of the collieries have now gone and with the smoke and dust cleared and many of the tips landscaped, the valleys are conscious of tourist potential. There are now guided tours of the pits and casting sheds and blast furnaces of the old iron works. At the Cefn Coed Colliery Museum at Neath, the story is dramatically told of the men and machines involved in the mining of coal at the former Cefn Coed colliery, and at Torfaen, a former working colliery, underground tours are given 300 feet below the surface.

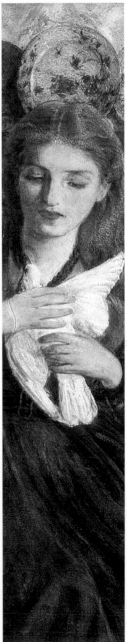

WALES

# SCHOOL OF ART GALLERY & MUSEUM
University of Wales, Buarth Mawr, Aberystwyth, Ceredigion SY23 1NE
Telephone 01970 622460 Fax 01970 622461

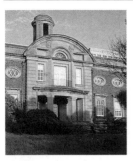

▲ School of Art Gallery and Museum

Extensive teaching and research collections of fine and decorative art. European prints from 15th century to present, drawings, watercolours and photographs. George Powell of Nanteos collection of pictures, bronzes and objet d' art (including works on paper by Turner, Burne-Jones, Rossetti, Poynter, Rebecca and Simeon Solomon).

5,000 wood engravings for periodicals of the 1860s and a fine collection of prints representing the Etching Revival since Whistler, particularly etchings of the inter-war years including works by Sutherland, Griggs, Webb and Brockhurst. Art in Wales since 1945 and contemporary printmaking. Contemporary Welsh photography and an outstanding collection of post-war Italian photographs.

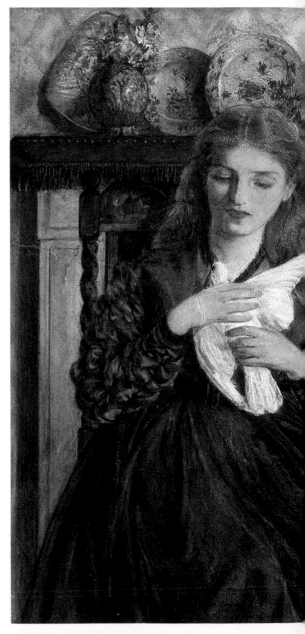

▲ Rebecca Solomon (1832 - 1886)
The Wounded Dove 1872 George Powell Collection

594

### Directions

Turn off the A44
Uphill on to Buarth
road at crossroads
located 200m from
the A487/A44
Junction. Continue
300m, turning left
at the telephone
kiosk. The School of
Art is immediately
ahead.

Changing exhibitions
from the collections,
touring shows and
exhibitions by invited
artists. All housed in a
magnificent Edwardian
building overlooking
Cardigan bay and a few
minutes walk to the town
centre and railway
station.

Contemporary British,
European, American and
Japanese studio pottery,
18th and 19th century
Welsh and English
slipware, Swansea and
Nantgawr porcelain, Art
Pottery and Oriental
ceramics. Important
collection of early 20th
century British pioneer
studio pottery
(Martin Brothers,
Leach,
Hamada,
Cardew et al)
displayed in
Aberystwyth
Arts Centre on
the University
campus.

▲ Keith Vaughan
(1912 - 1977) Blue Boy
1953 lithograph

### Opening times

Open Monday to Friday
10.00am to 5.30pm
(last admission 5.00pm)
Closed Easter week,
Christmas and
New Year
Admission free.

▼ Michael Cardew
(1901 - 1983) Stork
slipware pie dish,
earthenware

**595**

WALES

## CEREDIGION MUSEUM
Coliseum, Terrace Road, Aberystwyth, Ceredigion SY23 2AQ
Telephone 01970 633085 Fax 01970 633084

County Museum housed in a restored Edwardian theatre.

Displays include agriculture, seafaring, furniture and clocks, archaeology and geology, paintings, prints, costume and transport.

Temporary exhibitions of reserve collections and from other museums, changed quarterly.

Art exhibitions in the gallery changed monthly.

***Opening times***

Open all year Monday to Saturday 10.00am to 5.00pm except Christmas Day, Boxing Day.

▶ A quilt from the collection

▼ The theatre galleries now house museum exhibits

▲ The Archaeology Gallery

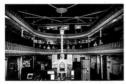

▲ The auditorium from the stage

***Directions***

The Museum is located above Peacock's shop between Boots and the Tourist Information centre on the main street between the railway station and the sea.

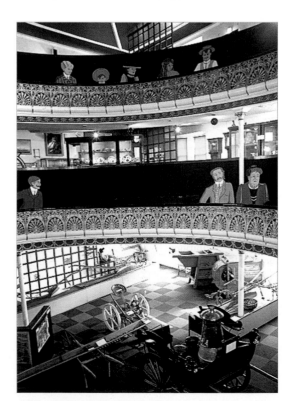

# BANGOR MUSEUM & ART GALLERY
Ffordd Gwynedd, Bangor, Gwynedd LL57 1DT
Telephone 01248 353368

### Opening times

Open all year
Tuesday to Friday
12.30pm to 4.30pm
and Saturday
10.30am to 4.30pm
Closed Sunday, Monday,
Public Holidays and
Christmas period

▲ Browse around the
shop with its varieties of
quality craftwork.

### Directions

On A55 take A5122
Bangor. Follow city
centre signs. Left by Post
Office into Ffordd
Gwynedd. Museum is
after library on left by
taxi rank opposite
Deiniol Centre car park

Welcome to Bangor
Museum.......Gwynedd's
only general Museum.
Learning about the
ways of life led by
previous generations
help us to place our
own experiences in
the context of an
unfolding story.
This understanding
enriches our lives.

◀ Welsh Not
- worn to
discourage
the use of
Welsh in
19th
Century
schools

▲ What will your
favourite object be?

Every visitor will leave
with a particular
memory of a favourite
object. What will yours
be? You'll find
something of interest in
our gallery too.

Its varied programme of
temporary exhibitions
includes paintings,
photography and
sculpture.

▶ "Lots of ideas and
great carving..." Andrew
Jones, Art Student

# BALA LAKE RAILWAY

The Station, Llanuwchllyn, Bala, Gwynedd LL23 7DD
Telephone 01678 540666 Fax 01678 540666

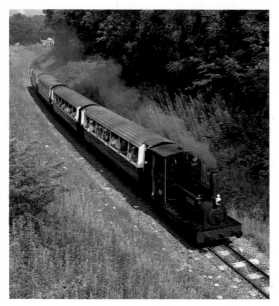

Car parking - There is adequate car parking at Llanuwchllyn Station. At Bala Station there is roadside car parking with large Car Parks in the town centre.

The line's main station at Llanuwchllyn includes a well-stocked buffet and souvenir shop.

Visitors can watch the engine being prepared for its trip to Bala and can visit the loco shed to see the other engines.

Why not stroll into the village for a view of the rural Wales at its most peaceful?

For a perfect day out, why not ride a narrow-gauge train on the Bala Lake railway, along the shores of Wales' largest natural lake.

Llanuwchllyn ("the village above the lake") is the headquarters of the Railway and regular trains link the village with the delightful market town of Bala.

Rheilffordd Llyn Tegid (Bala lake railway) is one of the Great Little Trains of Wales. The 2 ft gauge line offers a delightful 9 mile return journey along the shores of Llyn Tegid, through the beautiful scenery of Snowdonia National Park.

The little trains give excellent views of the lake amid its surrounding pastoral and woodland scenery, and of the nearby mountains, Arenig Fawr and Aran Benllyn.

◀ Holy War - Hunslet No 779 from 1902 still at work

### Opening times

Open April 2nd to
October 3rd, 1999
Trains operate daily
except on certain
Mondays and Fridays
in early and late season

### Directions

The railway is accessible
from all the National
Motorways which link to
the A5 or A55 and then
onto the A494 to Bala or
LLanuwchllyn from
where we are signposted

◄ The train leaves Bala
on its way to
Llanuwchllyn

▼ A lakeside view on a
crisp day in early Spring

▲ Maid Marian dated
1903 runs round to join
its train

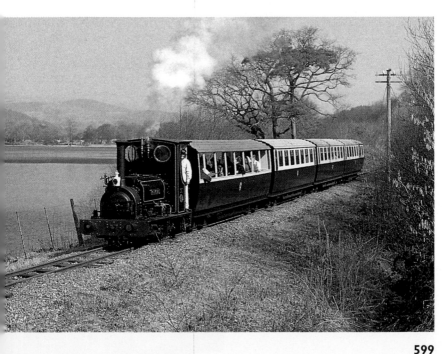

**WALES**

# MUSEUM OF CHILDHOOD MEMORIES
1 Castle Street, Beaumaris, Anglesey LL58 8AP
Telephone 01248 712498 Fax 01248 716869
Website http://nwi.co.uk/museumofchildhood

### Opening times

Open
2 weeks before Easter
until end of October
Weekdays
10.30am to 5.30pm
(last admission 4.30pm)
Sundays
12.00pm to 5.00pm
(last admission 4.00pm)
Admission charged
Discount for group visits

An independent museum celebrating its 25th anniversary this year, opened in 1973 by its founder Bob Brown a retired engineer.

It is located in Beaumaris a seaside town with a 13th century Castle and Victorian pier. The exhibits are displayed in 9 rooms of a Georgian house, each room having a theme reflecting the happier side of family life over the past 150 years. Include - Audio and Visual entertainment items, pottery and glass used by and depicting children and adults from 1800 - 1960, Clockwork tinplate toys, trains, cars, ships, etc, over 250 toy money boxes, Prince of Wales corridor, Teddy Bears nursery furniture etc.

Art gallery, paintings, prints, samplers of children at work and

▲ Old toys

play, rocking horse, early cycles. Dolls house, dolls, educational toys, games and Disney characters. Something to delight and fascinate all ages in 26 cabinets.

A Sunday Telegraph magazine features "1001 days out" selected the museum as "Star Choice" by its travel writer from 35 of the best museums in Great Britain.

School visits are invited key stage I and II work cards are available covering toys, artefacts and simple technology.

▶ Old dolls

▼ Toy Money Boxes

### Directions

Turn right onto Anglesey off the A55 at Britania Bridge, Bangor, take A345 3 miles to Beaumaris. We are opposite the castle in the centre of town

## BEAUMARIS GAOL

Bantiers Hill, Beaumaris, Anglesey LL58 8EP
Telephone 01248 724444 or 810921

This is an unusual museum set in the dramatic surroundings of a former prison building.

Visitors can wander down gloomy corridors and explore the maze of prison cells, work rooms and places of punishment such as the whipping room for isolation cell.

From the condemned cell, visitors can follow in the condemned man's footsteps along the lout walk to the scaffold.

Built in 1829 the Gaol is a grim reminder of the harshners of Victorian justice.

Visitors of all ages will thrill to a visit here. In fact this is one of the few places where it is possible to lock up the kids and put your mother in law behind bars!

The Museum shop stocks an unusual array of books and merchandise with a crime and punishment theme.

▼ Beaumaris Gaol: The left hand door leads to the scaffold; the right hand door leads to a typical cell

### Opening times

Open Whitsun to September also Easter weekend to May. Open throughout the year by arrangement for groups and educational users.

### Directions

Follow signs for Beaumaris along A545. Court is at the end of Main Street opposite castle. For Gaol take first left up Steeple Lane and left into Bunheris Hill.

WALES

## OLD COURTHOUSE
Castle Street, Beaumaris, Wales LL58 8BP
Telephone 01248 811691/72444

The Old Courthouse dates from 1614 and with its oak beamed roof and much of the original court furniture.

It is a powerful evocation of an earlier age. Visitors can stand in the Dock or sit in the seat of judgement.

Courts inflicted harsh punishments in earlier times and there is an array of former instruments of punishment like the stocks and pillory.

Executioners and public whippings were also carried out. Many former prisoners stood in the dock with beating hearts. Occasional courts are still held.

Many visitors combine a visit to the Courthouse with a visit to nearby Beaumaris Gaol.

Prisoners found guilty were taken there to serve their sentence.

Joint tickets to both places can be purchased at a bargain price and the museum has a small shop with an unusual range of souvenirs.

### Opening times

Open Whitsun to September also Easter and weekend in May. Open by arrangement throughout the year for groups and educational use

### Directions

Follow signs for Beaumaris along A545. Go to the far end of Castle Street (main street). The Courthouse is a white building on corner opposite Castle

## BRECKNOCK MUSEUM
Captain's Walk, Brecon, Powys LD3 7DW
Telephone 01874 624121 Fax 01874 611281

Brecknock Museum is located in the old Shire Hall building which dates from 1842.

This attractive Greek Revival building still contains the original Assize Court now interpreted with figures and a court room drama set in 1880.

The museum also holds galleries focussing on town and country life in the Brecknock area, an archaeology and prehistory section, a wildlife display and a Victorian schoolroom.

In addition there is a large Lovespoon collection and an interactive display of archival film and photographs of the area.

As well as the local history on offer the Museum holds regular art exhibitions in its two galleries.

The main gallery has been splendidly refurbished with lottery money.

### Opening times

Open Monday to Friday
10.00am to 5.00pm
all year
Saturday
10.00am to 1.00pm
2.00pm to 5.00pm
all year
(Close 4.00pm
November to February)
Sunday
12.00pm to 5.00pm
(April to
September only)

### Directions

Brecknock Museum is situated to the east of the town at the end of Brecon High Street. It is accessible by car and limited parking is available

▼ 1880's courtroom drama with sound and light at Brecknock Museum

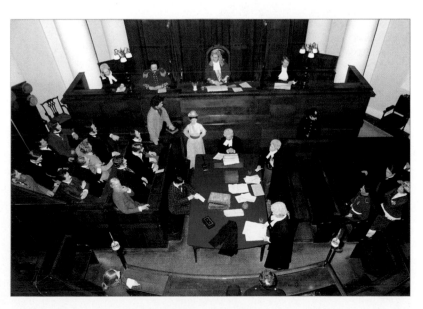

## THE SOUTH WALES BORDERERS AND MONMOUTHSHIRE REGIMENTAL MUSEUM OF THE ROYAL REGIMENT OF WALES
The Barracks, Brecon, Powys LD3 7EB
Telephone 01874 613310 Fax 01874 613275 EMail rrw@ukonline.co.uk

When you come to Brecon be sure to reserve at least one hour to see the treasures of the 'Old 24th', South Wales Borderers, the Monmouthshire Regiment and, more recently The Royal Regiment of Wales.

Marlborough's campaigns, the American War of Independence, until the present day. It is now recognised for its modern professionalism and for its distinct Welsh flair.

Sir Stanley Baker's film "Zulu" recreated the events surrounding the heroic defence of Rorke's Drift by B Company, 2/24th in the Zulu war of 1879.

record of cheerful courage whatever the odds, the Royal Regiment of Wales, and its predecessors have won 29 Victoria Crosses, Britain's highest award for gallantry, and over one hundred Battle Honours.

The Regimental Museum, which is located at Brecon in mid-Wales, the Regiment's home for over 120 years, tells the compelling story. The Zulu War Room contains a fascinating display of artefacts.

Few regiments of the British Army have such varied and exciting tales to tell from the time it served in Ireland as long ago as 1689, then throughout

The Regiment has taken part in every major campaign and war, winning high praise wherever they have gone. In their long

◀ 24th Regiment Soldier during the Zulu War of 1879

▶ Zulu Warrior

### Directions

### Opening times

◀ Lieutenants Melvill and Coghill saving the Colour after Isandhlwana 1879

Brecon is 42 miles north of Cardiff and close to the Brecon Beacons National Park. The Museum is adjacent to the Barracks in Brecon in The Watton (B4601).

Open 1st April to 30th September 9.00am to 5.00pm every day 1st October to 31st March 9.00am to 5.00pm Monday to Friday (last admission 4.15pm)

WALES

# WELSHPOOL & LLANFAIR LIGHT RAILWAY

The Station, Llanfair, Caereinion, Powys SY21 0SF
Telephone 01938 810441 Fax 01938 810861

◀ Imagine a journey on a country railway over steep hill

### Opening times

Open Easter to September Bank Holiday with special event weekends Open daylight hours during Summer. Trains run to a timetable. Posted on request

### Directions

Welshpool and Llanfair Stations are alongside the A458 Shrewsbury - Dolgellau road. Welshpool is served by trains on the Birmingham - Shrewsbury - Aberystwyth service of Central Trains. Their station is one mile from ours via Severn Road and Broad Street.

Steam trains on a narrow gauge railway in the Welsh Borderland.

Imagine a journey on a country railway which ambles through picturesque and ever changing scenery, over steep hills, past quiet farms along a secluded river valley. Conjure up the sights and sounds of a steam hauled train from your grandparents' youth, run by dedicated yet friendly staff who maintain a tradition of a railway working that has all but disappeared from the modern world.

Free car park, riverside walk, coaches welcome. Special discounts for groups. Driver experience. Courses on special days. Tourist information.

▼ Sir Drefaldwyn passing quiet farms along a secluded river valley

# SEGONTIUM ROMAN MUSEUM, CAERNARFON

Beddgelert Road, Caernarfon, Gwynedd LL55 2LN
Telephone 01286 675625 Fax 01286 678416
Website www.nmgw.ac.uk

Segontium Roman Museum, Caernarfon, vividly portrays the story of the conquest and occupation of Wales by the Romans and displays finds from the nearby auxiliary fort of Segontium, one of the most famous forts in Britain.

Designed to accommodate a regiment of auxiliary infantry up to 1,000 strong - all of whom would have been non-citizen soldiers serving for twenty five years, Segontium was the military and administrative centre of north west Wales throughout the Roman period, due to its strategic position controlling access to the fertile lands of Anglesey and later guarding against Irish raiders and pirates attacking the Welsh Coast.

The site was garrisoned from AD 77 to about AD 394. Excavated remains include the headquarters building, the garrison commanders' house, the soldiers' barracks, store buildings and a bath house.

The Museum and Fort are situated on the A4085, on the road leading to Beddgelert about one mile from the centre of Caernarfon.

Visitors facilities include a gift shop and parking close to the building.

▲ Segontium Roman Museum displays the discoveries from the auxiliary fort

▲ Explore the remains of this most important Roman Fort

### *Opening times*
March to October
Monday to Saturday
10.00am to 5.00pm
Sunday
2.00pm to 5.00pm
November to February
Monday to Saturday
10.00am to 4.00pm
Sunday
2.00pm to 4.00pm

### *Directions*
Segontium Roman Museum is situated on the A4085, on the road leading to Beddgelert; it is approx 1 mile from the centre of Caernarfon.

◄ Sandstone altar to Minerva found in the underground strong room

▲ Excavations have shown that the original fort accommodated up to 1,000 men

WALES

## REGIMENTAL MUSEUM 1ST THE QUEENS DRAGOON GUARDS

Cardiff Castle, Cardiff, South Glamorgan CF1 2RB
Telephone 01222 222253 or 781232 Fax 01222 781384

The Museum houses an excellent collection of uniforms, weapons, accoutrements, medals and documents which span 300 years of history.

The Museum has been laid out chronologically through the centuries from 1685 to this present day.

It tells an exciting story told with much imagination and embracing a complete spectrum of

presentation from original uniforms worn at the Battle of Waterloo and the Indian Mutiny of 1857 to video footage of the First World War, Second World War and more recently action in the Gulf War of 1991.

Items include early swords and muskets to Iraqi equipment captured during the Gulf War.

1st The Queens Dragoon Guards was formed on the 1st January 1959 by the amalgamation of the two Senior Cavalry Regiments of the Line. The 1st Kings Dragoon Guards and the Queen's Bays (2nd Dragoon Guards).

▲ Wellington riding over to congratulate the KDG after their 1st charge at Waterloo 1815

▼ The KDG capturing French standards and drums at Ramillies 1706

### Opening times

Open March to October
daily except Friday
10.00am to 6.00pm
(last admission 5.45pm)
November to February
daily except Friday
10.00am to 4.30pm
(last admission 4.15pm)

TROOPER
...S WHO, ALTHO' WOUNDED
BROWNLOW, FALL TO THE
...HIM, TO TAKE HIS HORSE,
8TH JANUARY, 1881.

1
DG

HARRY PAYNE

▲ Private John Doogan winning the Victoria Cross at Laing's Nek South Africa, 1881
▼ The Queens Bays in action charging at Lucknow during the Indian Mutiny, 1858

### Directions

By road: A470 into the centre. By bus or rail: Central Station/Central Bus Station - Wood Street - St Mary's Street - Cardiff Castle.

WALES

# NATIONAL MUSEUM & GALLERY, CARDIFF

Cathays Park, Cardiff, CF1 3NP
Telephone 01222 397951 Fax 01222 373219

▲ National Museum
and Gallery, Cardiff

Unique among British
Museums and Galleries
in its range of art and
science displays.

The Art Galleries
provide magnificent
settings for works
by some of the
worlds most famous
artists, including
the Impressionists.

There are displays
of Bronze Age gold,
early Christian
monuments, Celtic
treasures, silver,
coins and medals,
ceramics, fossils
and minerals.

A programme of
exciting temporary
exhibitions and
events for families
and for school
parties includes a
wide range of
activities.

▶ From the
'Kalighat Icons'
exhibition

### Opening times
Open
Tuesday to Sunday
10.00am to 5.00pm

### Directions
The National Museum
and Gallery is situated
in Cathays Park, at the
heart of Cardiff's
elegant civic centre.
Entrance is free to the
Main Hall with its
restaurant and shops.

▼ Henry, Prince of
Wales in the hunting
field by Robert Peake
the Elder, (1604)

# MUSEUM OF WELSH LIFE

St Fagans, Cardiff, Wales CF5 6XB
Telephone 01222 573500

They say the past is a different country. Nowhere is this more evident than at Europe's leading living history museum, the Museum of Welsh Life.

Located in St Fagans, on the site where on 11th May, 1648 Royalist South Wales fell to Parliament, the museum is a time machine connecting people with history.

Thirty period furnished and re-erected original buildings include farmhouses, a tollhouse, a cockpit, miners' cottages, and a Workman's Institute. Museum visitors find themselves stepping back in time, whether it be into an Iron Age Celtic village reconstructed from the excavated remains of buildings from Clwyd and Gwynedd or into a 17th century South Wales farmhouse, with red interior walls and its rowan berries designed to protect from evil spirits. There are also shops, a portrait studio, a bakery, a chapel and a school house.

It's a "hands-on" place, where you can see people practising the traditional means of earning a living, from wood turnings to milling.

At special times of year, events and festivals take place to coincide with the ways people celebrated the seasons.

Theatre and educational activities enhance and deepen the interpretation of the site and its exhibits.

### *Opening times*

Open summer
10.00am to 6.00pm
and winter
10.00am to 5.00pm

### *Directions*

The museum is in the village of St Fagans, 4 miles west of Cardiff plus 3 miles from Junction 33 on the M4 along A4232

▼ Re-enhancement of the battle of St Fagans

▲ Aber-nodwydd Farmhouse, Llangadfan, Powys built 1678. Re-erected 1955

▲ Rhyd-a-car cottages from Merthyr Tydfil, a row of five - each recreated in a different period

▲ During the summer visitors can ride in the pony and trap

*WALES*

# AMGUEDDFA
# LLOYD GEORGE MUSEUM

Llanystumdwy, Nr Criccieth, Gwynedd LL52 0SH
Telephone 01766 522071

### Directions

A497 between
Porthmadog and
Pwllheli turn off for
Llanystumdwy directly
after Criccieth (from
Portmadog) or before
Criccieth (from Pwllheli)
museum is signposted

◀ Lloyd George bust
outside the Museum

Discover the life and
times of David Lloyd
George - "The cottage
bred boy who became
Prime Minister".

You can follow the rise
of the cottage bred boy
to world statesman.
Marvel at the unique
collection of
memorabilia in one of
only two museums
dedicated to ex-Prime
Ministers. See a film
about Lloyd George in
the audio-visual
theatre.

Wonder at the
astonishingly lifelike
"talking head".
Visit the Victorian
school room. Step back
to Victorian times in
Highgate, his boyhood
home and Uncle's
shoemaking workshop.

Enjoy the Victorian
cottage garden. Stroll to
Lloyd George's grave in
a leafy glade above the
River Dwyfor.

Education service
available. Guided tours
by appointment. Cafe
nearby in village.

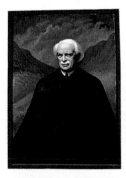

▲ Step back to Victorian
times in Highgate, his
boyhood home

### Opening times

Open Easter daily
10.30am to 5.00pm.
May
Monday to Friday
10.30am to 5.00pm.
June
Monday to Saturday
10.30am to 5.00pm.
July to September daily
10.30am to 5.00pm.
October
Monday to Friday
11.00am to 4.00pm.
Other times by
arrangement

◀ Silver replica of
Criccieth castle
presented to Lloyd
George, 1919

▲ Portrait of Lloyd
George by John Petts

# SCOLTON MANOR MUSEUM

Spittal, Haverfordwest, Pembrokeshire SA62 5QL
Telephone 01437 731328 Fax 01437 731743

▲ Scolton Manor Museum

### Opening times

Open Easter to October
Tuesday to Sunday
and Bank Holidays
10.30am to 5.30pm
(last admission 4.30pm)
Open by appointment
out of hours

### Directions

3 ½ miles north of
Haverfordwest on
B4329. Haverfordwest
to Cardigan Road

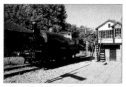

▲ Railway area: "The Margaret" locomotive and sarnau signal box

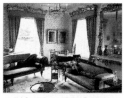

▲ "Above and below stairs" - The Drawing Room

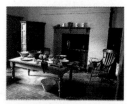

▲ "Above and below stairs" - The Kitchen

Pembrokeshire's best kept secret! Scolton Manor Museum - One of the finest Victorian interiors in West Wales set in beautiful woodlands.

Period rooms. Life below stairs. Costume gallery. Pembroke Yeomanry display. "The Field" farming exhibition. "Railways of Pembrokeshire" display. The "Margaret" locomotive and signal box. Stables. Carpenter's work shop. Blacksmith's forge. Coach House. Gamekeeper and poaching display. Rural Crafts. Local Life. The Pembrokeshire Prospectors. Archaeology. World War II "Homefront " exhibition. A country camera: "Rural Life". Art Exhibitions. Guided tours. Nature trails. Special events. Picnic and play areas. Countryside centre. Tea Rooms. Ample parking. Disabled access. Shop.

An enjoyable day out for all the family whatever the weather!

# GREENFIELD VALLEY HERITAGE PARK

Greenfield, nr, Holywell, Flintshire CH8 7QB
Telephone 01352 714172 Fax 01352 714791

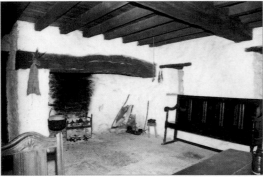

▲ 17th century Pentre Farmhouse reconstructed in 1990

A country park set in 50 acres of woodland with Saint Winefride's Holy Well at one end and the remains of a 12th century (Basingwerk) Abbey at the other. It is an attraction which has something for everyone.

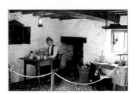

▲ The farmworker's quarters

Within the Abbey Farm complex you will find a a farming museum. complete with machinery, equipment and farm animals.

▲ The blacksmith's shop, demonstrations on most weekends.

There too, you will see lovingly restored houses furnished to depict a past way of life and a Victorian school is frequently brought to life by children taking part in the Victorian school room experience.

Explore further and you will discover the ruins of mills which once played an important role in the industrial revolution. Here the silence is broken now only by the sound of the wind and the rush of water pouring over the spillways where water wheels once turned.

There are many picturesque paths to follow, picnic spots and silent places alive with bird life. Excellent facilities are available, toilets, cafe, free parking.

Discounts are available for groups and guides will assist, provided by the Friends of Greenfield Valley.

### Opening times
Open 1st April
to end of October
10.00am to 5.00pm
(last admission 4.30pm)

### Directions
From the A55 leave at the Holywell exit and follow the B5121 until you see Car Park signs

▲ Part of Basingwerk Abbey

# KIDWELLY INDUSTRIAL MUSEUM

Broadford, Kidwelly, Carmarthenshire SA17 4LW
Telephone 01554 891078

Kidwelly Industrial Museum was established in 1980 on the site of the second oldest tinplate works in Britain. It was founded mainly to preserve and interpret Britain's sole surviving pack mill and to act as a Heritage Centre for Kidwelly and the surrounding area.

Tinplate consists of iron or steel rolled to a wafer thin thickness and then coated with molten tin.

At Kidwelly tinplate production started in 1737 and carried on more or less continuously until the works finally closed in 1941.

The Museum allows a fascinating insight into a process that for over 200 years has been part of The Heritage of South Wales. The Museum is constantly developing.

As well as the splendid mechanical relics that were once part of the tinplate industry, the scope of the museum covers such wide ranging subjects as coal, printing, industrial transport and the history and development of the area.

A truly unique experience. Guided tours if booked in advance.

## *Opening times*

Open Bank Holiday: Easter, May Day and Spring/June to August Monday to Friday 10.00am to 5.00pm and weekends 2.00pm to 5.00pm (Last admission one hour before closing)

## *Directions*

Kidwelly Industrial Museum is located mid-way between Llanelli and Carmarthen off the A484. It is clearly signposted from several points along this road. Look out for chimney stack!

▲ Edwin Foden engine in hot roll mill

▼ Ex Brynlliw Colliery Loco

▲ Donkey engine to assist main cold roll engine

▲ Main fly wheel for 18 ton cold roll engine

*WALES*

# WELSH SLATE MUSEUM
Padarn Country Park, Llanberis, Gwynedd LL55 4TY
Telephone 01286 870630 Fax 01286 871906
Website www.nmgw.ac.uk

See the story of slate come alive at this living working Museum set among the towering quarries at Llanberis.

Here amidst stunning landscape is a pocket of the past: Victorian quarry workshops with daily craft demonstrations, a narrow gauge steam locomotive and the largest working waterwheel on mainland Britain.

Wander through the newly re-furbished Chief Engineer's home - to see how he and his family lived at the turn of the turn of the century and be amazed at our stunning new 3D multi media show TO STEAL A MOUNTAIN - which gives an insight into life in the quarries.

Speak to our craftsmen as they demonstrate the difficult task of splitting and dressing the slate or casting brass in the foundry and relax in our

new cafe and large gift shop.

Why not take a guided tour to our unique working slate incline - once used to transport the massive amounts of slate from the high quarry ridges to wagons to be exported to the rest of the world.

Exciting new developments include the re-location of a terrace of quarrymen's houses to the Museum and a children's educational play and discovery area.

Temporary exhibitions programme and annual events including Model railways, Winter Fair, St Daivd's Day celebrations and much more.

For more information please contact the Marketing Officer on 01286 870630 Fax 01286 871906.

▲ Gifts to suit every pocket and taste in the shop

◀ Craftsmen demonstrate traditional skills like splitting and dressing the slate

▶ The waterwheel can now be seen by everyone

### Opening times

Open Easter to October
daily 10.00am to 5.00pm
November to Easter
Sunday to Friday
10.00am to 4.00pm

### Directions

Situated within Padarn
Country Park in the
village of Llanberis.
Follow the signs for
Llanberis from the A55
expressway and the A5,
and take the A4086 to
Llanberis.

▼ The Welsh Slate Museum is located in Padarn Country Park

# LLANDUDNO MUSEUM

17 - 19 Gloddaeth Street, Llandudno, Conwy LL30 2DD
Telephone 01492 876517 Fax 01492 876517

◄ Llandudno Museum

Llandudno Museum presents the history of the local area and exhibits some of the fine collection of the artist F E Chardon.

After an introduction to the Museum its back into prehistory to explore the evidence of the earliest inhabitants of Llandudno. This includes a practical display and explanation of archaeological techniques.

Llandudno's history is then traced through to the present century.

Investigate the prehistoric era, daily life in a Roman Fort, the importance of farming and seafaring.

The dramatic copper mining boom of the last century is illustrated by a full scale model of miners working underground, while domestic life is represented by a Welsh country kitchen.

Tourism and transport developments characterise the last 150 years of the town, and there is also an exhibition dedicated to the impact on Llandudno of the two World Wars.

In addition there is a display of Chardon's delicate pastel paintings and a sample from his impressive collection of fine and decorative arts.

A programme of temporary exhibitions ensures a new discovery each time you visit.

▲ An ivory figure from the Chardon collection

▲ Tram No. 3, the Llandudno and Colwyn Bay Electric Railway

### Opening times

Open Easter to
31st October
Tuesday to Saturday
and Bank Holidays
10.30am to 1.00pm and
2.00pm to 5.00pm
Sunday
2.15pm to 5.00pm
1st November to Easter
Tuesday to Saturday
1.30pm to 4.30pm
Closed Christmas

### Directions

From Llandudno's main promenade with the sea to your right turn left at the cenotaph and continue straight on beyond the large roundabout. The museum is on your left

▼ The imprint of a child's foot in a Roman tile

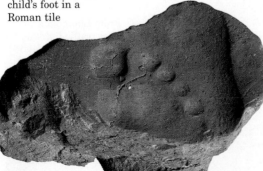

# PLAS NEWYDD
Hill Street, Llangollen, Denbighshire LL20 8AW
Telephone 01978 861314

Black and white gothic
cottage set in pleasant
grounds.

Permanent exhibitions
on the "Ladies of
Llangollen".

The cottage contains
fine oak carvings and
stained glass windows.

The Ladies of Llangollen
set up home at Plas
Newydd, and lived a
romantic lifestyle there
for almost 50 years.

Their story captured the
imagination of Regency
England and they
attracted many famous
visitors.

### Opening times

Open 1st April to
31st October
10.00am to 5.00pm

◀ Plas Newydd

▶ The Ladies of
Llangollen

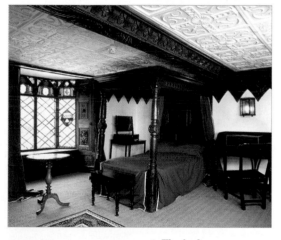

▲ The bedroom,
Plas Newydd

### Directions

From Llangollen turn
left at traffic lights in 50
yards turn right (signed)
and immediately turn
left continue up road for
200 yards Plas Newydd
is on the left. Parking
down drive

◀ The oak room,
Plas Newydd

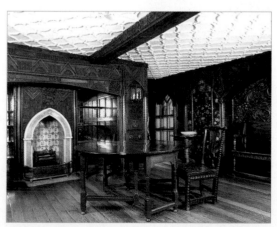

WALES

# CEFN COED COLLIERY MUSEUM
Neath Road, Crynant, Neath, SA10 8SN
Telephone 01639 750556 Fax 01639 750556

*Opening times*

Open April to
October daily
10.30am to 5.00pm
November to March
Groups welcome by
arrangement

*Directions*

The museum is located
on A4109 just south
of the village of
Crynant. Take A465
(north or south)
to Aberdulais
roundabout and
follow signs

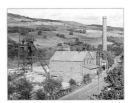

The museum is located
in the surface buildings
of the former Cefn Coed
Colliery.

▲ Shaft headgear, Cefn
Coed Museum

▼ Steam winding
engine

▲ Aeriel view, Cefn
Coed Colliery Museum

Highlights include a
recreated mining gallery
and a huge steam
winding engine which
once raised coal from a
half a mile below
ground.

Exhibitions tell the
story of coal mining in
the area, and temporary
exhibitions are staged
ranging from art to
photography.

Group bookings are
welcomed.

# NEWPORT MUSEUM & ART GALLERY

Newport, South Wales NP9 1PA
Telephone 01633 840064 Fax 01633 222615

The museum contains a wealth of material which tells the story of rural and industrial Newport and the surrounding area.

There are important displays of prehistoric and Roman artefacts, including a wonderful large mosaic floor from a Roman villa in Caerwent.

The natural history displays explore the geological evolution of the area, and the flora and fauna native to Newport soils.

A weather station in the museum allows visitors to see the weather develop in front of their eyes!

The permanent art collection includes work by Welsh artists and the popular Wait teapot collection.

During the year there is an exciting exhibition programme.

Disabled access. Coffee shop. Car parking nearby. Children's activities are run during school holidays.

For further information please phone 01633 840064

### Opening times

Open all year
except Sundays and
Bank Holidays
Monday to Thursday
9.30am to 5.00pm
Friday
9.30am to 4.30pm
Saturday
9.30am to 4.00pm

### Directions

Just of Junction 24 of the M4. A short distance from the bus and train station

▲ "Minerva" goddess of war and wisdom - Roman artefact

▲ Doctor's surgery part of Newport's 'into the 20th century' display

▲ Kitchen part of Newport's 'Into the 20th Century' display

◄ Art gallery exhibition space

## GLYNN VIVIAN ART GALLERY
Alexandra Road, Swansea, Wales SA1 5DZ
Telephone 01792 655006 Fax 01792 651713

The Glynn Vivian Art Gallery is the City and County of Swansea's award-winning municipal Gallery.

The Gallery was founded in 1909 by benefactor Richard Glynn Vivian, who gave his collections of fine and decorative art together with £10,000 to build a splendid Edwardian-baroque style Gallery to house them.

Since the Gallery opened in 1911, the collections have grown and the Glynn Vivian now houses a superb collection of work by Welsh artists as well as extensive collections of British and European fine and decorative art.

Since the 1970s the Gallery has been renowned for its lively programme of temporary exhibitions covering all forms of art and craft of the past and present, of local, national and international significance.

As well as the permanent collection displays, the Gallery houses four dedicated exhibition spaces, including a large, modern, air-conditioned gallery and an outdoor sculpture court.

The Gallery is also acclaimed for its pioneering Education service, offering schools throughout South Wales (and beyond) the opportunity to work with exhibitions and the permanent collections of all four of Swansea Museums Service's venues.

For further information, please contact the Gallery on 01792 655008.

### Opening times
Open all year daily
Tuesday to Sunday
10.00am to 5.00pm
(last admission 4.45pm)
Closed Mondays

### Directions
Junction 48 M4 leads directly into Swansea City Centre. 1 minute walk from Railway Station. 5 minutes walk from Quadrant Bus Station. NCP car park in Orchard Street.

▲ A student group visiting the main exhibition gallery

▲ The Gallery shows a wide range of temporary exhibitions

▲ The outdoor sculpture court at the Glynn Vivian

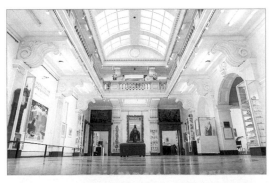

▲ The entrance hall of the Glynn Vivian Art Gallery

# PLANTASIA TROPICAL HOTHOUSE
Parc Tawe, Swansea, South Wales SA1 2AL
Telephone 01792 474555 Fax 01792 652588

For something a little different, visit Swansea's giant hot house garden, Plantasia.

Home to exotic plants from all over the world. Plantasia offers a fun voyage of discovery for visitors young and old.

See the unusual insects, fish and reptiles on show.

Wander through the popular butterfly house where a variety of species fly freely and different stages of butterfly development can be viewed.

The excellent shop is packed full of unusual gifts and mementoes from this unique attraction.

▲ The Butterfly House

### Opening times

Open
Tuesday to Sunday
and Bank Holidays
10.00am to 5.00pm.
Closed Mondays

### Directions

J48 M4 leads directly into Swansea City centre. 5 minutes walk from railway Station. 5 minutes from Quadrant Bus Station. Car parking available in Parc Tawe complex

▲ Tropical region

▼ Arid region

▲ Guided tours

**623**

# SWANSEA MUSEUM
Victoria Road, Swansea, Wales SA1 1SN
Telephone 01792 653763 Fax 01792 652585

*WALES*

▲ Swansea Museum

See the ancient
Egyptian mummy, visit
the "Cabinet of
Curiosities" or admire
the superb display of
Swansea and Nantgarw
porcelain and pottery in
this, the oldest museum
in Wales.

▼ Toby Jug, Swansea
pottery

Swansea Museum has a
fascinating range of
permanent displays as
well as an exciting
programme of touring
exhibitions.

Spend a few hours
learning about the past -
it can be fun as well as
educational.

▶ Cartonnage of
Egyptian mummy, Hor

▲ View of Swansea from
Kilvey Hill. Attributed
Thomas Horner c1818

### Opening times

Open all year
Tuesday to Sunday
plus Bank Holidays
(closed Mondays)
10.00am to 5.00pm
(Last admission 4.45pm)

### Directions

J48 M4 leads directly
into Swansea City
centre. 10 minutes walk
from Railway Station.
8 minutes walk from
Quadrant Bus Station.
Limited free parking
available in front
of museum

# POWYSLAND MUSEUM

The Canal Wharf, Welshpool, Powys SY21 7AQ
Telephone 01938 554656

♿

▲ Powysland Museum
and the Canal Wharf

The Powysland Museum
illustrates the history
and development of life
in Montgomeryshire from
the earliest prehistoric
settlers to the 20th
century population.

The collection is housed
in a carefully restored
and renovated 19th
century warehouse by
the Montgomery Canal.

In 1993 the museum won
the prestigious
Gulbenkian Award for
most improved museum
in a rural area.
The museum has a
temporary exhibition
programme with
changing displays on a
large range of topics.

The museum also offers
education facilities such
as worksheets, handling
collections and talks
geared toward the
requirement of the
National Curriculum for
history.

There is parking and
easy access for disabled
visitors.

### Directions

The museum is situated
off Severn Street close to
the town centre. Five
minutes walk from the
station on the road into
the town.

▼ Memorabilia of French
Prisoners of War from the
19th century

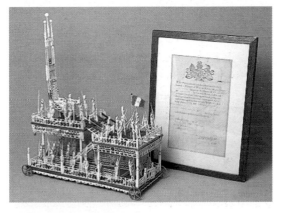

◀ Bronze Age finds

### Opening times

Open weekdays
except Wednesday
11.00am to 1.00pm
and 2.00pm to 5.00pm
May to September
weekends
10.00am to 1.00pm
and 2.00pm to 5.00pm
October to April
weekends Saturday only
2.00pm to 5.00pm

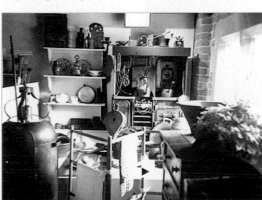

◀ Victorian kitchen

WALES

# SWANSEA MARITIME & INDUSTRIAL MUSEUM

Museum Square, Maritime Quarter, Swansea, SA1 1SN
Telephone 01792 650351 or 470371 Fax 01792 654200

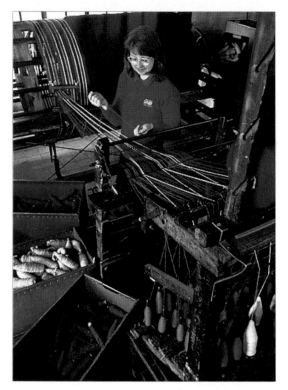

Swansea is home to the first passenger carrying railway in the world which ran between Swansea and Oystermouth from 1807.

The tramshed, open in the summer months, tells the story of the Mumbles train.

The MIM offers a programme of events and touring exhibitions and an excellent gift shop which sells Welsh craft.

◀ The 150 year old Abbey woollen mill

The MIM is located in the heart of Swansea's Maritime Quarter and holds the largest collection of floating exhibits in Wales, including a lightship and steam tug.

The Abbey woollen mill is over 150 years old and still working today. Carding, dying, spinning and weaving are all carried out on the premises and traditional products such as rugs, shawls and turns are for sale in the excellent museum shop.

▲ The Helwick lightship, part of the museum's floating collection

### Opening times
Open all year
Tuesday to Sunday
and Bank Holidays
(Closed Mondays)
10.00am to 5.00pm
(last admission 4.45pm)

### Directions
Located on north side
of Marina. Junction 48
leads directly into
Swansea City Centre.
10 minutes walk from
Railway Station.
5 minutes walk from
Quadrant Bus Station.
Parking available in
Leisure Centre Carpark.
(Charged)

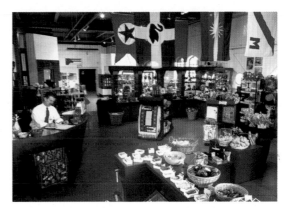

▲ The museum shop sells Welsh craft and produce

▼ Transport display

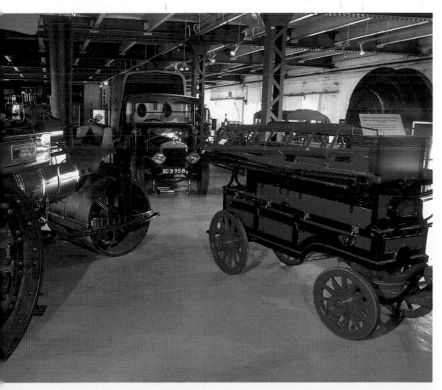

WALES

# BIG PIT MINING MUSEUM
Blaenavon, Torfaen, Wales NP4 9XP
Telephone 01495 790311 Fax 01495 792618

Big Pit is the only coal mine in Wales where you can explore real underground workings.

Experienced miners guide visitors through underground roadways, engine houses and stables up to the coalface, 300 feet underground.

It is a site where the atmosphere of a working colliery has been retained and the original colliery buildings now house exhibitions, displays, a licensed cafeteria and gift shop.

Sensible shoes are recommended and children must be at least 5 years old to go underground because the safety equipment that everyone has to wear weighs around 5 kilos.

Disabled access: there are ramps throughout the site and adapted toilet facilities. Wheelchair users may join the underground tours if prior notice is given.

For further information please contact Big Pit, on 01495 790311 or fax 01495 792618

▶ Big Pit headgear and pit top

## Opening times

Open daily from the beginning of March to the end of November 9.30am to 5.00pm. Last tour every day begins at 3.30pm. Please telephone for opening times between December and February

## Directions

from Midlands: via M5/M50 to A465 'Heads of the Valleys' road to Brynmawr. Take B4248 to Blaenavon. From south: via A4043 and A4042 from M4 motorway. Route is well signposted

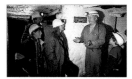

▲ Underground stables dating back to 19th century

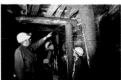

▲ Children underground with Mine Deputy

▲ Blacksmith at work in colliery blacksmith's shop

## ABERGAVENNY MUSEUM & CASTLE

Castle Street, Abergavenny, Monmouthshire NP7 5EE
Telephone 01873 854282 Fax 01873 736004

Set in grounds of 13th century Marcher Castle, displays trace history and
archaeology of this quiet Welsh market town from prehistoric times to the present
day - regular temporary exhibitions. Limited facilities for disabled people. Guided
tours by arrangement.

*Opening times* Open March to October daily 11.00am to 1.00pm 2.00pm to 5.00pm
Sunday 2.00pm to 5.00pm November to February open daily
except Sunday 11.00am to 1.00pm and 2.00pm to 4.00pm

## SOUTH WALES POLICE MUSEUM

Police Headquarters, Bridgend, CF31 3SU
Telephone 01656 869315

Two exhibition galleries tell the story of policing in Glamorgan from the dark ages to
the present day.

*Opening times* Open Monday to Thursday 10.00am to 1.00pm and
2.00pm to 4.30pm Friday 10.00am to 1.00pm and 2.00pm to 4.00pm

## CAERNARFON MARITIME MUSEUM

Victoria Dock, Caernarfon

Maritime and industrial history of Portof Caernarfon including ships and seamen.
Exhibition of HMS Conway.

*Opening times* Open Spring Bank Holiday to mid September 11.00am to 4.00pm
(7 days a week)

## CAERPHILLY CASTLE

Caerphilly, CF83 1JD
Telephone 01222 883143

The largest castle in Wales dating from the 13th century. there are exhibitions and
working replicas of mediaeval seige engines.

*Opening times* Open April to October 9.30am to 6.30pm daily October to April
9.30am to 4.00pm Monday to Saturday 11.00am to 4.00pm Sunday

## CHEPSTOW MUSEUM

Gwy House, Bridge Street, Chepstow, Monmouthshire NP6 5EZ
Telephone 01291 625981 Fax 01291 625983

In an elegant 18th century house the museum's attractive displays focus on the
history of Chepstow, its people, their work and leisure. Special exhibitions, workshops
and activities. Facilities for educational visits.

*Opening times* Open daily Mondays to Saturdays (including Bank Holidays)
11.00am to 1.00pm and 2.00pm to 5.00pm, Sundays 2.00pm to 5.00pm
Extended hours July August and September.

WALES

## JOSEPH PARKY'S IRONWORKS COTTAGE
4 Chapel Row, Georgetown, Methyr Tydfil
Telephone 01685 723112

A superb example of a skilled ironworker's cottage, 4 Chapel Row is also the
birthplace of Joseph Parky, probably Wales' best known musician composer.

*Opening times* Open April to October Thursday to Sunday 2.00pm to 5.00pm

## LLANGOLLEN MOTOR MUSEUM
Pentrefelin, Llangollen, Denbighshire LL20 8EE
Telephone 01978 860324

Motoring from the 20s to the 60s. Toys, memorabilia, library. 50s garage. Canal
history exhibition and classic spares department.

*Opening times* Open March to October daily (except Mondays) from
10.00am to 5.00pm. Open weekends in winter or by arrangement

## CYFARTHFA CASTLE MUSEUM
## & ART GALLERY
Brecon Road, Merthyr Tydfil, CF47 8RE
Telephone 01685 723112 Fax 01685 723112

A fine Gothic mansion built in 1825 housing a wonderful collection of porcelain, fine
art, social and industrial heritage, plus curios from around the world in a beautiful
Regency setting.

*Opening times* Open April to September daily 10.00am to 5.30pm October to March
Tuesday to Friday 10.00am to 4.00pm Saturday and Sunday 12.00pm to 4.00pm

## THE NELSON MUSEUM & LOCAL HISTORY CENTRE
Priory Street, Monmouth, NP5 3XA
Telephone 01600 713519 Fax 01600 775001

Life and commemoration of the famous Admiral through letters, silver, models,
ceramics, pictures, weapons. Plus local history of this Wye Valley town, including
section on Charles Rolls of Rolls Royce fame.

*Opening times* Open daily all year 10.00am to 1.00pm and 2.00pm to 5.00pm
Monday to Saturday, 2.00pm to 5.00pm Sunday

## SOUTH WALES MINERS' MUSEUM
Afan Argoed Country Park, Cynonville, Port Talbot,
West Glamorgan SA13 3HG
Telephone 01639 850564

Traditional miner's kitchen, cottage scene, old photographs vividly illustrating
miners' life, dramatic story, children underground, early mining equipment displayed
in realistic setting. Guided tours by arrangement.

*Opening times* Open Summer 10.30am to 6.00pm Winter 10.30am to 5.00pm

## PORTHCAWL MUSEUM
Old Police Station, John Street, Porthcawl, Glamorgan
Telephone 01656 772211

Local social and maritime history, regimental history 49 Recce. Regt. formed 1942. History Sker House, wreck of S.S. Samtampa 1947, history of 12th century parish church, costume display of Victorian dresses.

> ***Opening times*** Open daily 2.00pm to 4.30pm Saturday 10.00am to 12.00pm
> and 2.00pm to 4.30pm

## TENBY MUSEUM & ART GALLERY
Castle Hill, Tenby, Pembrokeshire SA70 7BP
Telephone 01834 842809 Fax 01834 842809

The museum is situated in part of the mediaeval castle, overlooking the sea. Permanent collections include art, archaeology, geology, natural maritime and local histories. Special annual exhibitions. Activities for children.

> ***Opening times*** Open Easter to end October daily 10.00am to 5.00pm
> November to Easter Monday to Friday only 10.00am to 5.00pm
> (last admissions 1/2 hour before closing). Closed over Christmas and New Year

## THE NARROW GAUGE RAILWAY MUSEUM
Wharf Station, Tywyn, Gwynedd LL36 9EY
Telephone 01654 710472

Locomotives, wagons, signals, track, tickets, nameplates from about sixty narrow gauge lines in the UK and Ireland. Talyllyn Railway with steam trains.

> ***Opening times*** Open March to October 9.30am to 5.00pm Also Boxing Day to
> New Years Day Other times by arrangement

## GWENT RURAL LIFE MUSEUM
The Malt Barn, New Market, Usk, NP5 1AW
Telephone 01291 673777

Independent museum run by volunteers. Portrays life in the Welsh Border Country from Victorian times until end of second World War. Parties at reduced rates.

> ***Opening times*** Open April 1st to October 31st Monday to Friday 10.00am to 5.00pm
> Saturday and Sunday 2.00pm to 5.00pm (last admission 4.30pm)

## BERSHAM HERITAGE CENTRE & IRONWORKS
Bersham, Wrexham, LL14 4HT
Telephone 01978 261529 Fax 01978 361703

Permanent exhibitions on the industrial history of The Clwedog Valley include iron-manufacture, lead mining and corn milling. Lively programme of temporary exhibitions and events are also available.

> ***Opening times*** Please telephone for details of opening times

Bath, Bristol & North East Somerset

Bedfordshire, Berkshire, Buckinghamshire & Hertfordshire

Cambridgeshire & Northamptonshire

Cheshire, Merseyside & Greater Manchester

Cornwall

Cumbria

Derbyshire & Staffordshire

Devon

Dorset

Essex

Gloucestershire

Hampshire & Isle of Wight

Herefordshire & Worcestershire

Kent

Lancashire

Leicestershire, Nottinghamshire & Rutland

Lincolnshire

London & Middlesex

Norfolk

Northumbria, Cleveland & County Durham

Oxfordshire

Shropshire

Somerset

Suffolk

Surrey

Sussex

Warwickshire & West Midlands

Wiltshire

Yorkshire

Scotland

Wales

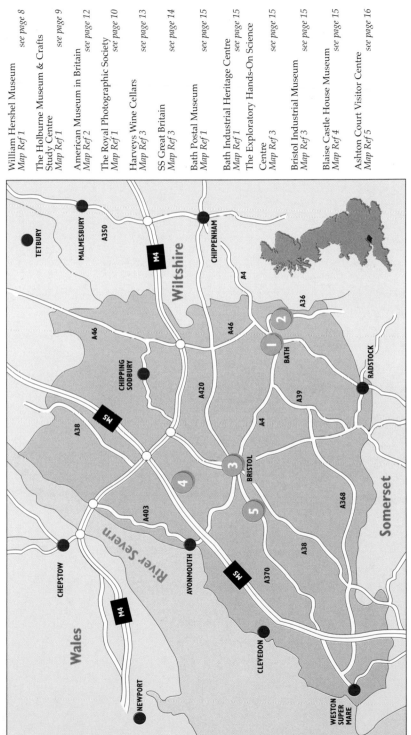

BATH, BRISTOL & NORTH EAST SOMERSET MAP

BEDFORDSHIRE, BERKSHIRE, BUCKINGHAMSHIRE & HERTFORDSHIRE MAP

Bromham Mill & Gallery
*Map Ref 1*                    *see page 20*

Cecil Higgins Art Gallery
*Map Ref 2*                    *see page 18*

Stanley Spencer Gallery
*Map Ref 3*                    *see page 21*

Ure Museum of Greek Archaeology
*Map Ref 4*                    *see page 22*

Museum of English Rural Life
*Map Ref 4*                    *see page 23*

Buckinghamshire County Museum
& Roald Dahl Children's Gallery
*Map Ref 5*                    *see page 24*

Waddesdon Manor
*Map Ref 6*                    *see page 26*

Cowper & Newton
*Map Ref 7*                    *see page 25*

Mill Green Museum & Mill
*Map Ref 8*                    *see page 28*

Hitchin Museum
*Map Ref 9*                    *see page 29*

Lowewood Museum
*Map Ref 10*                   *see page 30*

Roman Theatre
*Map Ref 11*                   *see page 31*

Museums of St Albans
*Map Ref 11*                   *see page 32*

Verucamium Museum
*Map Ref 11*                   *see page 33*

St Albans Organ Museum
*Map Ref 11*                   *see page 34*

Stevenage Museum
*Map Ref 12*                   *see page 35*

Welwyn Roman Baths
*Map Ref 13*                   *see page 36*

Stockwood Craft Museum & Gardens
*Map Ref 14*                   *see page 38*

West Berkshire Museum
*Map Ref 15*                   *see page 38*

Wycombe Local History Museum
*Map Ref 16*                   *see page 38*

Ashwell Village Museum
*Map Ref 17*                   *see page 38*

Rhodes Memorial Museum
*Map Ref 18*                   *see page 37*

Harpenden Railway Museum
*Map Ref 19*                   *see page 37*

First Garden City Heritage Museum
*Map Ref 20*                   *see page 37*

Letchworth Museum & Art Gallery
*Map Ref 20*                   *see page 38*

Royston & District Museum
*Map Ref 21*                   *see page 37*

Watford Museum
*Map Ref 22*                   *see page 37*

CAMBRIDGESHIRE & NORTHAMPTONSHIRE MAP

# CHESHIRE, MERSEYSIDE & GREATER MANCHESTER MAP

CORNWALL MAP

## CUMBRIA MAP

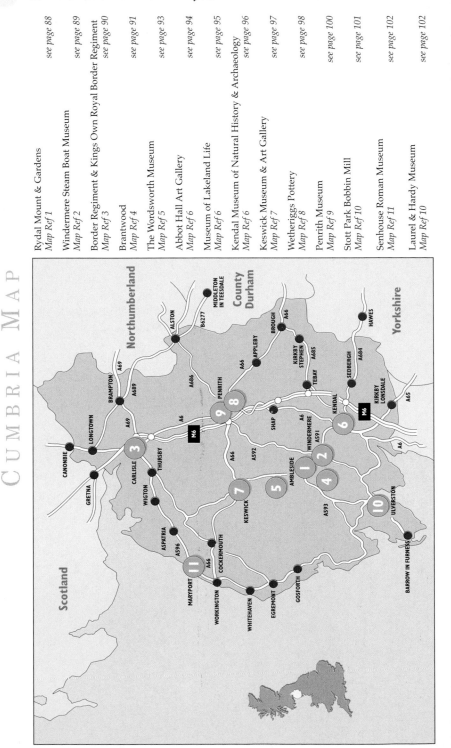

DERBYSHIRE & STAFFORDSHIRE MAP

# DEVON MAP

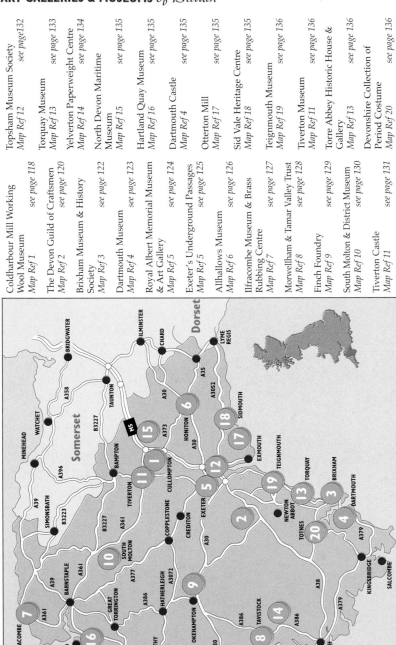

DORSET MAP

# ESSEX MAP

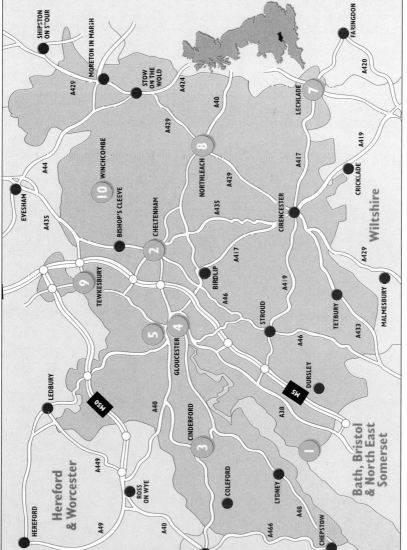

GLOUCESTERSHIRE MAP

# HAMPSHIRE & THE ISLE OF WIGHT MAP

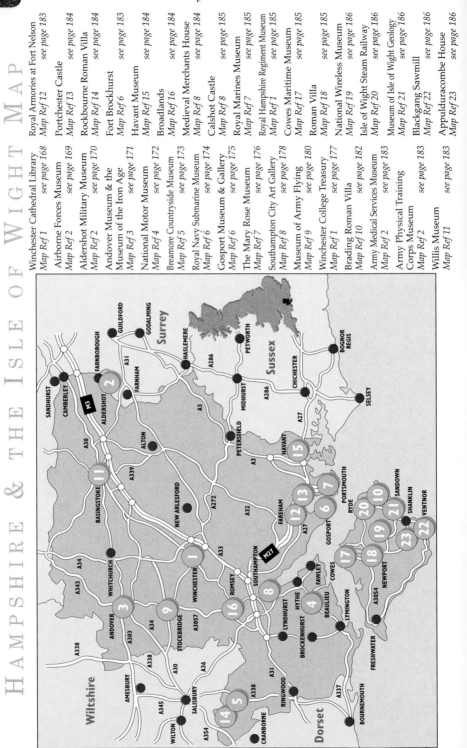

HEREFORDSHIRE & WORCESTERSHIRE MAP

# KENT MAP

LANCASHIRE MAP

647

# LEICESTERSHIRE, NOTTINGHAMSHIRE & RUTLAND MAP

# LINCOLNSHIRE MAP

Norfolk

KING'S LYNN

HUNSTANTON

WISBECH

Leicestershire

Nottinghamshire

NEWARK ON TRENT

BAWTRY

TUXFORD

M180

M18

A1

A631

A159

A15

GAINSBOROUGH

A46

A158

A15

A57

A1031

A16

A16

A18

A631

BRIGG

CAISTOR

GRIMSBY

CLEETHORPES

WALTHAM

MARKET RASEN

B1202

WRAGBY

LOUTH

MABLETHORPE

PARTNEY

SKEGNESS

A52

A52

A155

A16

HORNCASTLE

CONINGSBY

A153

A17

SLEAFORD

A52

DONINGTON

BOSTON

A16

A17

HOLBEACH

LONG SUTTON

A17

SPALDING

BOURNE

MARKET DEEPING

A15

A1

GRANTHAM

A1

STAMFORD

LINCOLN

WADDINGTON

NEWTON ON TRENT

A17

A15

A46

1

2

3

4

5

6

7

8

Ragged School Museum Trust
*Map Ref 1* *see page 272*

Ranger's House
*Map Ref 2* *see page 286*

The Horniman Museum &
Gardens
*Map Ref 3* *see page 287*

William Norris Gallery
*Map Ref 4* *see page 288*

Church Farmhouse Museum
*Map Ref 5* *see page 291*

Gunnersbury Park Museum
*Map Ref 6* *see page 296*

Ben Uri Art Society
*Map Ref 7* *see page 297*

Burgh House - Hampstead
Museum
*Map Ref 8* *see page 303*

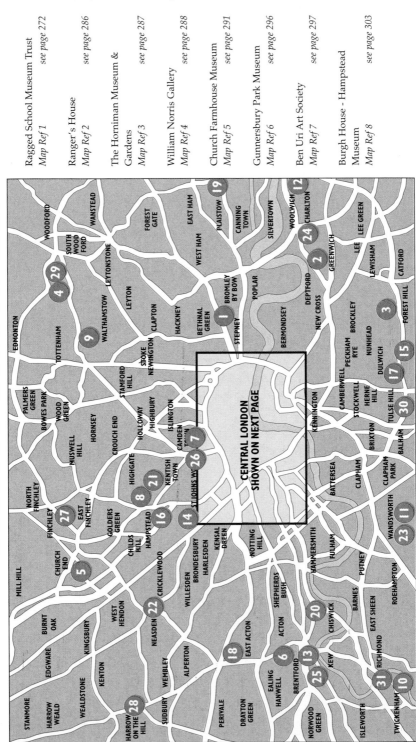

GREATER LONDON MAP

CENTRAL LONDON
SHOWN ON NEXT PAGE

Markfield Beam Engine & Museum
Map Ref 9    *see page 309*

Orleans House Gallery
Map Ref 10    *see page 312*

Wimbledon Lawn Tennis Museum & Croquet Club
Map Ref 11    *see page 313*

Museum of Artillery in the Rotunda
Map Ref 12    *see page 314*

Kew Bridge Steam Museum
Map Ref 13    *see page 315*

The Saatchi Gallery
Map Ref 14    *see page 316*

The Crystal Palace Museum
Map Ref 15    *see page 317*

Camden Arts Centre
Map Ref 16    *see page 317*

Dulwich Picture Gallery
Map Ref 17    *see page 317*

Pitshanger Manor Gallery
Map Ref 18    *see page 318*

East ham Nature Reserve
Map Ref 19    *see page 318*

Hogarth's House
Map Ref 20    *see page 318*

Keats House Museum
Map Ref 21    *see page 319*

Grange Museum, London Borough of Brent
Map Ref 22    *see page 319*

Wimbledon Society Museum of Local History
Map Ref 23    *see page 319*

Woodlands Art Gallery
Map Ref 24    *see page 320*

The Musical Museum
Map Ref 25    *see page 320*

The Jewish Museum
Map Ref 26    *see page 320*

The Jewish Museum - Finchley
Map Ref 27    *see page 321*

Old Speech Room Gallery
Map Ref 28    *see page 321*

Vestry House Museum
Map Ref 29    *see page 322*

Vintage Wireless Museum
Map Ref 30    *see page 322*

Marble Hill House - English Heritage
Map Ref 31    *see page 322*

GREATER LONDON MAP

Museum of the Royal
Pharmaceutical Society
*Map Ref 1*    *see page 262*

Pollock's Toy Museum
*Map Ref 2*    *see page 263*

Leighton House Museum
*Map Ref 3*    *see page 264*

The Cuming Museum
*Map Ref 4*    *see page 265*

Mall Galleries / Federation of
British Artists
*Map Ref 5*    *see page 266*

Linley Sambourne House
*Map Ref 6*    *see page 267*

Florence Nightingale Museum
*Map Ref 7*    *see page 268*

Design Museum
*Map Ref 8*    *see page 270*

Museums of the Royal College
of Surgeons of England
*Map Ref 9*    *see page 269*

The Dickens House Museum
*Map Ref 10*    *see page 273*

# CENTRAL LONDON MAP

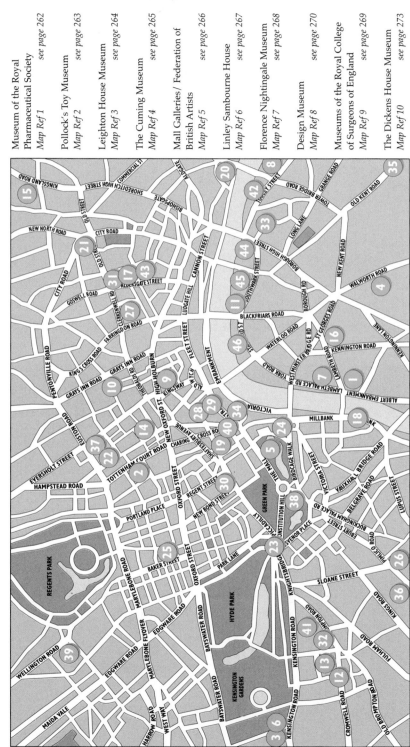

CENTRAL LONDON MAP

## NORFOLK MAP

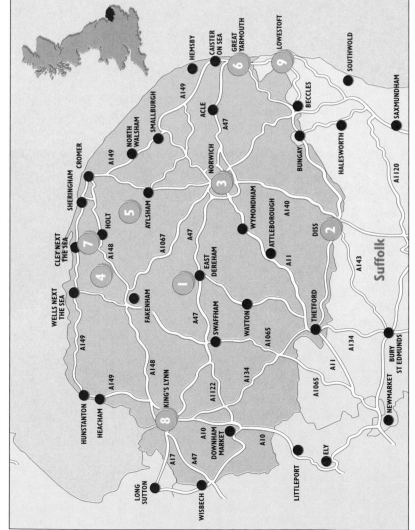

NORTHUMBRIA, CLEVELAND & COUNTY DURHAM MAP

## OXFORDSHIRE MAP

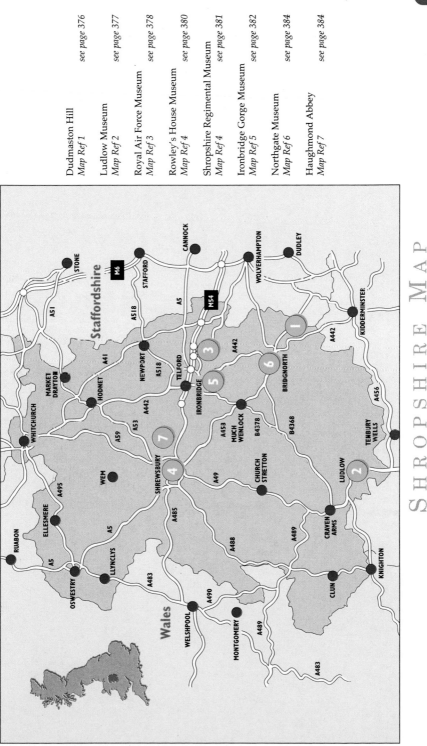

SHROPSHIRE MAP

# SOMERSET MAP

SUFFOLK MAP

# SURREY MAP

SUSSEX MAP

WARWICKSHIRE & WEST MIDLANDS MAP

Leamington Spa Art Gallery &
Museum
*Map Ref 1*     see page 426

The Cadeby Steam & Brass Rubbing
Centre
*Map Ref 2*     see page 427

Nuneaton Museum & Art Gallery
*Map Ref 3*     see page 428

The Market Hall - Warwickshire
Museum
*Map Ref 4*     see page 429

St John's Museum
*Map Ref 4*     see page 430

Warwick Doll Museum
*Map Ref 4*     see page 431

Blakesley Hall
*Map Ref 5*     see page 432

Walsall Leather Museum
*Map Ref 6*     see page 434

Wolverhampton Art Gallery
*Map Ref 7*     see page 435

Birmingham Museum & Art Gallery
*Map Ref 8*     see page 436

Selly Manor
*Map Ref 9*     see page 436

Lapworth Museum of Geology
*Map Ref 10*     see page 436

Herbert Art Gallery & Museum
*Map Ref 11*     see page 436

The Coventry Toy Museum
*Map Ref 11*     see page 437

Black Country Living Museum
*Map Ref 12*     see page 437

Kenilworth Castle
*Map Ref 13*     see page 437

Broadfield House Glass Museum
*Map Ref 14*     see page 437

Warwickshire College Department
of Art & Design
*Map Ref 1*     see page 438

Bosworth Battlefield Visitor centre &
Country Park
*Map Ref 15*     see page 438

RSC Collection
*Map Ref 16*     see page 438

Devizes Museum
*Map Ref 1*                    see page 440

Salisbury & South Wiltshire Museum
*Map Ref 2*                    see page 441

Lydiard House
*Map Ref 3*                    see page 442

Fox Talbot Museum
*Map Ref 4*                    see page 443

Athelstan Museum
*Map Ref 5*                    see page 443

Wilton Windmill
*Map Ref 6*                    see page 443

Redcoats in the Wardrobe
*Map Ref 2*                    see page 443

Swindon Museum & Art Gallery
*Map Ref 7*                    see page 444

Richard Jeffries Museum
*Map Ref 7*                    see page 444

The Trowbridge Museum
*Map Ref 8*                    see page 444

The Woodland Heritage Centre
*Map Ref 9*                    see page 444

WILTSHIRE MAP

# YORKSHIRE MAP

YORKSHIRE MAP

# ART GALLERIES & MUSEUMS *of Britain*

SCOTLAND MAP

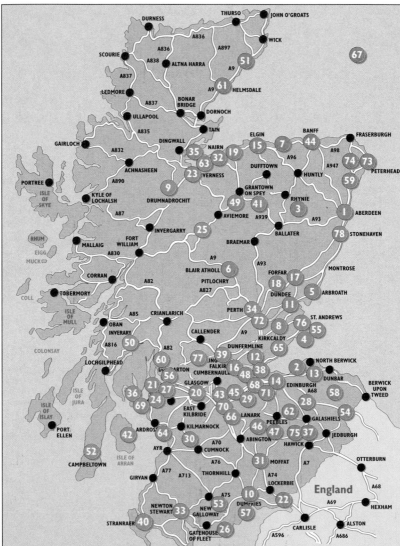

SCOTLAND MAP

School of Art Gallery &
Museum
*Map Ref 1*    *see page 594*

Ceredigion Museum
*Map Ref 1*    *see page 596*

Bala Lake Railway
*Map Ref 2*    *see page 598*

Bangor Museum & Art Gallery
*Map Ref 3*    *see page 597*

Museum of Childhood
Memories
*Map Ref 4*    *see page 600*

Beaumaris Gaol
*Map Ref 4*    *see page 601*

Old Courthouse
*Map Ref 4*    *see page 602*

Brecknock Museum
*Map Ref 5*    *see page 603*

The South Wales Borderers
and Monmouthshire
Regimental Museum of The
Royal Regiment of Wales
*Map Ref 5*    *see page 604*

Welshpool & Llanfair Light
Railway
*Map Ref 6*    *see page 606*

Segontium Roman Museum
*Map Ref 7*    *see page 607*

WALES MAP

WALES MAP

NOTES

**ART GALLERIES & MUSEUMS** *of Britain*

NOTES